captured

a film/video history of the lower east side

The following articles were previously copyrighted and/or published under the same or different title and were submitted and authorized by the original author to FEVA for publication in this book: *No Wave Cinema, 1978–87 - Not a Part of Any Wave: No Wave* by Matthew Yokobosky first appeared in New American Film and Video Series. Oct. 3, 1996–Jan. 5, 1997 • Parts of *Cool Actor, Luis Guzman* by Mark Binelli was published in a different form by the author in *Rolling Stone*, April 2003 • *Whoremoans* and *Clayton's Lower East Side Show* are copyrighted by the author in 1998 and 2001 • *Nick Zedd* by Nick Zedd was written in October 1997 • Parts of *The Cinema of Transgression, Where Are They Now?* by Cricket Delembard was published in other versions by the author under different name(s) • *Radical Software (1970–1974)* is an excerpt from www.radicalsoftware.org • *The Videofreex, 1969, Raindance, 1970* are excerpts from under are *The New York Video Collectives* by Davidson Gigliotti, published in www.davidsonsfiles.org/Exhibitions.html

Library of Congress Cataloging-in-Publication Data

Captured : a Lower East Side film & video history / [conceived and produced by] Clayton Patterson;
edited by Paul Bartlett and Urania Mylonas.
p. cm.
Includes bibliographical references.
ISBN-10: 1-58322-674-5 (pbk. : alk. paper)
ISBN-13: 978-1-58322-674-2 (pbk. : alk. paper)
1. Motion pictures—New York (State)—New York—History. 2. Experimental films—New York (State)—New York—History and criticism.
3. Video recordings industry—New York (State)—New York—History. 4. Lower East Side (New York, N.Y.)
I. Patterson, Clayton. II. Bartlett, Paul. III. Mylonas, Urania.

PN1993.5.U77C36 2005
791.43'09747'1—dc22
2005003180

Printed in Canada

captured

a film/video history of the lower east side

EDITOR/CURATOR/PRODUCER
CLAYTON PATTERSON

EDITORS
PAUL BARTLETT, URANIA MYLONAS, CLAYTON PATTERSON

CONTRIBUTING EDITORS
ELSA RENSAA, MICHAEL CARTER, LANE ROBBINS, MIKA DEUTSCH, SARAH HAUSER, RON KOLMS, JAMES RICKS, ERIC LA PRADE, CARL WATSON, JEROME POYNTON, KURT C. GOTTSCHALK, CHRIS RAEL, RUTH GALM, JAMES FEAST, JOSHUA ROTHENBERGER, JAMIE RASIN.

TRANSCRIBERS
MIKA DEUTSCH AND LANE ROBBINS

BOOK AND COVER DESIGNER
ALEXANDRA BOURDELON

WARRIOR
DAVID LESLIE

OFFICE SUPPORT
CHARLES PHANEUF, DAOUD TYLER-AMEEN, NICOLE HEIDBREDER, MIKI FUUJIWARA, MATT NEUFELD, ANA TRIAIDAD, MEGAN FRIDDLE, LANE ROBBINS, MIKA DEUTSCH, BARBARA SAUERMANN

SEVEN STORIES PRESS
New York

AUTHORS:

RACHEL AMODEO, ANNTELOPE, PENNY ARCADE, AARON BEALL, MARK BINELLI, JENNIFER BLOWDRYER, MICHAEL BOWEN, GARY RAY BUGARCIC, JACOB BURKHARDT, JIM C. AKA JIM CORNWELL, CALMX, MICHAEL CARTER, MICHELLE CLIFFORD, ROBERT CODDINGTON, MITCH CORBER, THOM CORN, CRICKET DELEMBARD, BRADLEY EROS, LARRY FESSENDEN, DAVID FINKELSTEIN, EBON FISHER, HENRY FLESH, AMANDA FORTIER, TESSA HUGHES FREELAND, RUTH GALM, DAVIDSON GIGLIOTTI, JESSICA GLASS, GARY GOLDBERG, BILL GORDY, JASON GROTE, ERNEST GUSELLA, DEEDEE HALLECK, ROBERT A. HALLER, ED HALTER, ANNE HANAVAN, MATTHEW HARRISON, LEON HARTMAN, RAY JADWICK, TOM JARMUSCH, BAIRD JONES, INJU KABOOM, SWAMI KAPRINDA, CARLOS KASE, JULIUS KLEIN, RON KOLM, SANDRA KOPONEN, ERIK LA PRADE, BILL LANDIS, KYLE LAPIDUS, RODGER LARSON, RIK LITTLE, JESSICA LOOS, ANN MAGNUSON, ALINE MARE, GREG MASTERS, JONAS MEKAS, CASANDRA STARK MELE, MAX VON MEYERLING, ERIC MILLER, MATT MITLER, ALAN MOORE, MISS JOAN MOOSEY, BILL MORRISON, JAY MURPHY, JEREMIAH NEWTON, DAVID NG, VALERY OISTEANU, FRANCIS PALAZZOLO, CLAYTON PATTERSON, JEROME POYNTON, JOE PURE, BILL RADEN, BILL RICE, LANE ROBBINS, BOB ROSENTHAL, JOSHUA ROTHENBERGER, SCOT-FREE, PETER SEMPEL, SKY SITNEY HARRIS SMITH, NICO SMITH, RACHELLE STARR, HOWIE STATLAND, ALAN STEINFELD, AALBERT STRACKE, NELSON SULLIVAN, ALDO TAMBELLINI, JAMES TULLY, LAKI VAZAKAS, RAY WARNING, CARL WATSON, GRAHAME WEINBREN, LEE WILLIAMS, JEFFREY CYPHERS WRIGHT, JUD YALKUT, MATTHEW YOKOBOSKY, LAURA ZAMBRANO, NICK ZEDD

Table of Contents

Foreword - Abel Ferrara page xiii

Introduction - Clayton Patterson page xv

Editors' Note - Paul Bartlett and Urania Mylonas page xv

1 Making Movies With Kids On The Lower East Side
 - DeeDee Halleck page 1

2 Young Filmmakers - Rodger Larson page 5

3 Yankin' On Pull My Daisy - Jessica Loos page 7

4 Harry Smith: A Lower East Side Legend
 - Amanda Fortier page 11

5 Tell all the Scum Of Baghdad the Legacy of Jack Smith
 - Penny Arcade page 15

6 Baroque on the Lower East Side:
 Jack Smith's *Flaming Creatures* and
 Telephone Messages from Ed Marshall
 - Jerome Poynton page 25

7 Wait For Me at the Bottom of the Pool:
 The Writings Of Jack Smith - Nick Zedd page 29

8 Media Mecca and Mayhem:
 Ferment on the Lower East Side - Jud Yalkut page 31

9 Paul Morrissey on the Lower East Side - Erik La Prade page 35

10 A Syracuse Rebel in New York - Aldo Tambellini page 41

11 A Bowl of Cherries - Erik La Prade page 57

12 Bill Rice - Clayton Patterson page 59

13 Emile de Antonio 1989 - Jay Murphy page 71

14 Twenty Questions with Taylor Mead in Love
 - Michael Bowen page 79

15 On the Importance of Anthology Film Archives:
 A Historical Overview and Endorsement
 - Carlos Kase page 85

16 Jonas Mekas - Peter Sempel page 89

17 A Few Notes on My Life on the Lower East Side & Cinema
 - Jonas Mekas page 97

18 The Millennium Film Workshop in Love
 - Ruth Galm page 101

19 25 Years, 26 Books: The Millennium Film Journal
 - Grahame Weinbren page 105

20 The Lower East Side on Film - Max Von Meyerling page 107

21 The 60s; Notes on the Underground
 - Sandra Koponen page 113

22 Scotch and Kodak; After Hours: A Look At Rafic - Tom Jarmusch page 121

23 Ginsberg at Home - Bob Rosenthal page 131

24 Allen Ginsberg to New Realties - Alan Steinfeld page 135

25 Henry Flesh - Henry Flesh page 137

26 Shooting on Seventh Street - Laki Vazakas page 139

27 The Provocative Confessions of a Poet/Video Artist - Valery Oisteanu page 143

28 Jeffrey Lerer Interview - Clayton Patterson page 149

29 More Than a Few Words:
 Amos Poe Speaks the Truth - Jeremiah Newton page 169

30 No New Cinema: Punk and No Wave Underground Film 1976–1984
 - Harris Smith page 173

31 No Wave Cinema, 1978–87 - Not a Part of Any Wave: No Wave
 - Matthew Yokobosky page 179

32 Video Vapors - Ernest Gusella page 185

33 Michael Auder - Jason Grote page 189

34 Arleen Schloss Interview - Clayton Patterson page 193

35 Lower East Side Video X-Ray Warning - Matty Jankowski page 207

36 Radical Player, Radical Mind, Radical Video - Davidson Gigliotti page 213

37 Mon histoire de la Cinema c. 1984 - Nico Smith page 219

38 (Dead)panning Through the Lower East Side with Jim Jarmusch
 - Joshua Rothenberger page 221

39 Pizza, Beer & Cinema - Greg Masters page 233

40 Short Film From Matthew Harrison - Matthew Harrison page 235

41 Films Charas - David Ng page 237

42 Sleazoid Express: Clayton Patterson Asks Us
 What it's Like Being Us - Bill Landis and Michelle Clifford page 241

43 Live Video as Performance on New York City's
Lower East Side in the 1980s - Eric Miller page 249

44 Rockets Redglare - Miss Joan Marie Moossy page 255

45 "I'd Work in Mexican Car Wash for Her": Rockets Redglare in Love
- Lee Williams page 257

46 Films & Video at Darinka: A Performance Studio 1984–1987
- Gary Ray Bugarcic page 263

47 The Cinema of Transgression: Where Are They Now? - A Recollection
- Cricket Delembard page 265

48 Nick Zedd - Nick Zedd page 273

49 Richard Kern - Jennifer Blowdryer page 275

50 Why I Left the "Cinema of Transgression" Behind, or Why It Left Me
- Casandra Stark Mele page 277

51 Media Mystics - Bradley Eros and Jeanne Liotta page 281

52 Erotic Psyche - Bradley Eros and Aline Mare page 283

53 Film/Video in the LES/EV - Julius Klein page 287

54 An Overview: Film and Video in the LES/E-Village - Julius Klein page 291

55 Making A Movie: What About Me? - Rachel Adodeo page 293

56 Shooting A Movie On The Lower East Side - 1986
- Jacob Burkhardt and Bill Gordy page 295

57 The Ballad of Wideo Wim: Jim C.,
Nada Gallery and the East Village Scene - Michael Carter page 299

58 Once in a Lifetime - Jim C., aka James Cornwell page 303

59 Tom Jarmusch Profile - Bill Raden page 309

60 Naked Eye Cinema at ABC No Rio - Carl Watson page 313

61 Philly - Clayton Patterson page 319

62 M. Henry Jones & Snake Monkey Studio - Ray Jadwick page 343

63 Smile for the Camera: East Village Through the Lens
- Jeffrey Cyphers Wright page 349

64 Baird's Fish Eye View and Reminisces of the L.E.S. Video - Baird Jones page 351

65 Just A Glimpse: The New York Film Festival Downtown
- Tessa Hughes-Freeland page 353

66 Tompkins Square Park: The Prabhupada Sankirtan Society
- Kaprinda Swami page 355

67 Copy of Original Yes No Script - Gary Goldberg page 357

 Gary Goldberg - Bill Rice page 359

 Gary Goldberg - Rachelle Starr page 360

68 Rik Little and the East Village Camcorder - Rik Little page 361

69 Interview with Edward Braddock III, aka Red Ed,
 aka Carol Anne Braddock - Calmx page 367

70 Filming in the Wild, Wild, East: An Extended Interview
 of East Village Filmmaker Mary Bellis - Calmx page 369

71 Multiple Ejaculations: M.M. Serra on Sex and Cinema - Ed Halter page 373

72 Beyond Raw Nerve and Cheap Metaphors - Francis Palazzolo page 381

73 Performing the Lower East Side: A Conversation With Steve Buscemi
 - Joshua Rothenberger page 387

74 The Monday-Wednesday-Friday Video Club - Alan Moore page 397

75 Holding a Torch to the Gargoyle Mechanique
 - Ebon Fisher Interviews Steve Jones page 403

76 Technoromanticism Grows in the Belly of the Gargoyle
 - Ebon Fisher Interviews Video Artist, Bigtwin page 411

77 Collective: Unconscious - Interviews with Jamie Mereness
 and Bryan Frye - Inju Kaboom, Kyle Lapidus, and Joe Pure page 415

78 Mitch Corber, Documenter of the Unbearables - Ron Kolm page 421

79 How I Became NY Poetry Video "Kingpin" - Mitch Corber page 423

80 East Village Memories: Club 57 - Ann Magnuson page 429

81 This Revolution Must Be Televised! - Jim C. page 431

82 Tompkins Square Park Police Riot Tape - and the Road to Victory
 - Clayton Patterson page 435

83 A Peek Inside the Archives - Clayton Patterson page 447

84 Marc Friedlander - Miss Joan Marie Moossy page 461

85 The Eyes Have It - Clayton Patterson page 463

86 The Non-Narrative Life - Alan Steinfeld page 467

87 The Pravda of the Matter - Robert Coddington page 471

88 The Art and Video of Elsa Rensaa - Lane Robbins page 473

89 Clayton and I - Anntelope page 479

 Clayton's Lower East Side Side Show - Anntelope page 484

90 Whoremoans - Anna Lombardo Ardolino page 485

91 Jim "Mosaic Man" Power and Video Work - Lane Robbins page 487

92 The Movie of the Month Club 1991–1992 - Matt Mitler page 491

93 Bill Morrison Filmmaker - Bill Morrison page 495

94 Notes from an East Village Filmmaker - Larry Fessenden page 497

95 Robert Beck Memorial Cinema: Weekly Visit to the Supernal Realms
 - David Finkelstein page 499

96 Bradley Eros and Brian Frye Interview - Ed Halter page 501

97 Why the Lower East Side? - James Tully page 515

98 Videos of Angel Orensanz - Jessica Glass page 517

99 Angel Orensanz: Times and Spaces - Aalbert Stracke page 521

100 Cool Actor Luis Guzman - Mark Binelli page 525

101 NYC Smoke - Howie Statland page 527

102 When I Met Clayton - Anne Hanavan page 531

103 Thom Corn as East Village Video/Filmmaker...
 - Thom Corn page 533

104 Gentrifucked - Scot-Free page 535

105 Amy Greenfield - Robert A. Haller page 537

106 The Film, Video, and Animation History of Todo con Nada 1988–2000
 - Aaron Beall with Laura Zambrano page 539

107 East Village Memories - Ann Magnuson page 545

108 10 Questions for Phil Hartman - Leon Hartman page 547

109 LES in Video - Alfredo Texidor Irizarry page 549

110 Third World Newsreel - Christine Choy page 553

111 The Search for the Invisible Cinema - Sky Sitney page 559

112 Taylor Mead: Underground Legend - Robert Cavanagh page 565

Foreword

by Abel Ferrara

I i was a kid growing up in Peekskill my father having long since taken our family out of the Bronx and to this small riverside town where a growing suburbia met rural upstate NY. it was a town that produced nicky St. John mel gibson t coraghessan boyle gov pataki and peewee herman but back in 1967 we were all still a bunch of hicks. in fact some of my friends had to milk their families cow before getting on the school bus. but school started that year and the revolution was full on. hendrix and warhol and viet nam and we were ready for it.

one fall nite my moment came. brendan jones, an older more experienced buddy of mine, just back from nam had to pick up some paperwork for his mother at nyu. i was to tag along. at last, my destination, my mecca greenwich village. taking the train, the hudson line, workplace of my uncle and most of the work force of the community ran along the hudson river. past sing sing, tarreytown yonkers, sputyn duyvil till going underground for the last 10 miles, ending at the grand cathedral/grand central. my heart pounded as we found the rr that one day i would consider my own private limo but not that nite. i was getting my subway cherry busted. with my heart pounding i climbed the final flight of steps to astor place. god knows what i expected but there it was - bleecker bobs, the purple onion, music blasting from inside clubs and outside on the street. drugs being used and sold like it was legal. freaks that made me and my group look like the schoolboys we were. from washington square to st.marks place my eyes were burned open for good whatever i expected i got in spades first time reading the voice where mekas the edgiest filmmaker you ever saw was the editor of the film section. tom tom the pipers son david holzmans diary fellini godard hustler sleep resnais. there was no going back now. we learned these films, memorized them spent hours in front of the bathroom mirror aping our king joe dallasandro.

ny became our only school and we made that trip by train or else in nickys black house painted vw a 1000 times. the elgin the thalia losey bresson altman jean vigo cocteau decameron satyricon brakhage see through your own eyes michael snow seeing kazan arguing with nicholas ray on a street corner but always ending on the lower east side where 5 years or so later i saw mean streets and the conformist back to back on the same afternoon and i knew i was to be a filmmaker or die and watching films was more or less over for me.

our time was still far ahead though now it seems so long ago: beth b, scott b, amos, jarmusch, maxs, cbgbs, neon leon, miguels short eyes, michael carmines, the entermedia, the film forum, 8st playhouse, st marks, john lurie, johnny thunder, deedee shooting his bb gun out the window of the chelsea but always back to the les.

we lived on union square under andys watchful eye shooting driller killer under his studio window him always watching always making sure we got in the party even when we were nobodies. but the les, alphabet land was and will always be the mystery place, the magic other, forever uncharted, where we always got our best shots. nicky d debby harry baybi day rockets red glare jimmy jean michel frenching my wife in the doorway of the world keith haring hustling 16mm equipment on rivington st zoe bringing us and her mother so far downtown to her new apt you thought you were in santo domingo ...

theres 600 pages of memories here everyone expressing 600 million lives. if you were there you know what i mean.

I don't want to be buried
in Puerto Rico
Or some Long Island Cemetery
I want to be near the shooting
stabbing, fighting, gambling
unnatural dying new birth
crying so don't take me
far away just keep me
near by
Just take my ashes &
Scatter them through the
Lower East Side.

—Miguel Piñero, from "A Lower East Side Poem"

abel ferrara
roma 2005

A Lower East Side Film/Video History Intro

by Clayton Patterson

Getting this book to a publisher has been a feat. I first started this project for the 2003 HOWL festival. The energy around this festival made building *Captured* exciting and I had some exceptional help. First, Phil Hartman, the executive director of HOWL, believed in the idea and told me to go ahead. Then David Leslie, HOWL's energy force added his unique vitality flow and inspiration. I was fortunate to have Paul Bartlett and Urainia Mylonas as the editing team and as support. The project would have been very difficult and smaller with out their efforts. Paul and Urainia put together, a team of editors, and were the backbone of the massive editing project.

Once we had everything edited, we were stuck for a designer. Barbara Sauermann introduced us to Alexandra Bourdelon. Alex was a pleasure to work with. Alex, did the amount of work of a general leading an army into war, and the seven slaves carring the generals' bags. Without the festival office interns we would have been locked in the subway stuck between stations. This crew consisted of: Charles Phaneuf, Daoud Tyler-Ameen, Nicole Heiderbreder, Miki Fujiwara, Matt Neufeld, Ana Trinaidad, Megan Friddle, Lane Robbins, Mika Deutsch, and the office manager Barbara Sauermann.

But because of lack of funding it became impossible to get more than a limited edition finished. Enough books were printed to provide a copy for each of the authors.

I now was stuck with a tremendous responsibility. Too many people had worked so hard to make this book happen and we had a school yard full of authors, and dozens of subjects. I felt like I had a Clydesdale work horse on my back. All the people that had worked on the book had moved on and I was left holding the stick. What to do?

Ron Kolm, whose collection of *Unbearables* books and ephemera are in the New York University Fales Collection gave Marvin Taylor the Director, a copy of *Captured*. Mr. Taylor saw the uniqueness and importance of the book and was kind enough to alert the NYU Publishing Department, who showed an interest in publishing the book.

NYU asked to widen the project to include people who they thought should be in the book, OK we can add in some NYU people, all excellent filmmakers and writers. Jerome Poynton came aboard and introduced me to Christine Choy, a Chair/Associate professor of the Tisch School of the Arts and I added more chapters.

We needed to do more editing, and for this I am thankful to Jim Feast, James Rasin and Josh Rothenberger for stepping up to the plate.

Then NYU asked me to raise $7000.00 for printing. I thought you have got to be kidding, but began an effort to raise the money because it seemed to be the only way to get *Captured* off the ground. Al Orensanz of the Angel Orensanz Art and Cultural Foundation was very kind to accept donations and do the accounting. I tried for a few months to come up with the money, but this was too much of a task. Now I had two Clydesdales on my back. This was a staggering burden to carry and I was back at point zero again.

Then I had the good fortune to meet Allan Antliff who introduced me and the book to Seven Stories Press. Lars Reilly, whose parents are documentary video makers, took my struggling hope, read the book, understood it immediately, and said we must do something with this. Lars introduced the tome to his Dan Simon, who thankfully, said yes. Then Lars, along with Phoebe Hwang and Jon Gilbert got the book through all the rest of the hoops. Anne Hanavan saved the day by introducing me to Abel Ferrara who came through with a foreword at the last second, like a true champion of the lower east side.

I believe that the Lower East Side (LES) has passed the point of beginning gentrification, like SoHo and Greenwich Village, and artist madness has stopped. Now you can look over the

landscape of history, and see who was here and what they did. The days of glancing down the street in the morning light and seeing what creative mushrooms have sprouted up over night is gone. Creative anarchy is gone and the dust has settled. Not to say no more art will be made, but the beautiful chaos has ended. The LES is now definable and contained.

People who lived in the Lower East Side have changed the history of America at least 500 times. American creative history is full of people who originated or passed through here. One of the challenges of this book was to give a history to people who had not received the recognition they had earned. This history includes those who are usually missing in action of the final "grand" stories. People who were in everything and are remembered in nothing. The backbones and pillars. For example you always hear about Andy Warhol, but without his support system (the Factory) he would have been only a single person. The LES was considered Andy's bedroom but I think that it has been much more than that: Taylor Mead, part of the Andy Warhol's scene has made about 3 movies a year since 1960. Without Taylor and many like him, there would have been a big hole in the projects of several filmmakers, as well as in the Warhol legend. Taylor, years later is still making a contribution, is still innovative, and is still riding the next new wave. In the '90s, Taylor, who is now 80, had a live on-line show on pseudo.com one of the real ground breaking internet efforts. Who else has done so much? Artistic neglect does not mean irrelevance and Taylor is very relevant, just neglected

Rafik who ran a film and video production facility, sold supplies at a reasonable price and gave free advice made it possible for LES film and video makers to create a finished product, yet not many sing the praises of Rafik.

Jonas Mekas has a well-documented history. Millennium is equally important to another group of people. Steve Buscemi and Louis Guzman are movie stars. Jim Jarmusch is one of the few commercially successful directors/actors who still is an independent yet owns the rights and controls to all his own work. We tried to be equal to everyone, because all the players are important. The people could write as much as they deemed necessary to tell their story and the editors took care of spelling, grammar, and continuity. The content was up to the writer. We tried to make a perfect platform.

This has been a labor of love, fun, excitement, hard work and heavy caring. I am hoping that it helps educate people to the phenomenal and important history of LES film/video history.

It would be impossible to do this alone. I want to thank everyone who worked on this project. Without everyone's help this book would never have been possible. Without you I am only just me.

Clayton Patterson, the captain of this dream.

Editors' Note:

A little background, some laments, a lot of hope

Captured: a Film/Video History of the Lower East Side. It is the ethnographic notebooks of those who have lived, observed, and created the Lower East Side (and the East Village), in film and video.

We cajoled extensive writings and interviews out of LES/EV (Lower East Side/East Village) film/video makers to bring you behind the camera. Animator Jeffrey Lerer says in his interview with Clayton, "One of my ideas about art making is that you're inviting the viewer to look over your shoulder and get glimpses of what it is you're fascinated with." We attempt to do the same with you, the reader, and the film/video makers in this book.

It is not often that we get the opportunity to see history unmediated by the confines of the "experts in the field" or subject to the reductive demands of the "realities" of publishing house marketeers. We are presenting here the stuff, the raw material of what the "expert" sorts through for their opinionated columns or jabbering tomes. We have the rare luxury in this extensive limited edition to present the reader with the stories directly, as told by the protagonists. We let the reader decide what they want to read or skip. We, the editors did not decide for you. We have no constraints. The straight jacket is in the closet.

Trials and Tribulations: Pomp and Circumstance

The sheer volume and extent of this edition was not by design, we originally had a target of 40 pieces—roughly, five pages per piece. We calculated that if we brought 50 writers on board, we could have a chance at 40; we were gambling against LES/EV odds, the "land of mis-opportunity," as Steve Canon, director of the A Gathering of the Tribes, is fond to lament. However the LES/EV is also the land of high hopes, and dogged earnestness, which opens itself up to opportunity in the first place and then to very unpredictable results.

As the first deadline approached, we started getting nervous; the articles were trickling in— Peter Sempel from Germany, DeeDee Halleck from the Catskills, Lee Williams from the Adirondacks—but where were the rest? What was up with the LES? We were working with quite a few writers back and forth, helping them shape their stories, get unstuck, find new leads, et cetera, but how often have we been through that before only to have a few follow through? (For every film you see from the LES, there is at least another to be forever unfinished.) Not being able to get writers to cover some important subjects, Clayton went out and interviewed them himself. Lane Robbins and Mika Deutsch, interns, helped Clayton transcribe and do more interviews. We badgered the writers. After the deadline was more than a week past, SURPRISE: we had a flood of articles, bringing our total up to 40, then a week later to 60. Editing became maddening. We found more contributing editors.

Michael Carter ran into Tom Jarmusch on the street, and said, "What's up?" He said I'm writing a story for a LES/EV History of Film/Video book." Michael says, "Hey, me too." A third passersby overhears and says, "Me too!" Nearly 100 writers in this book are running around the LES/EV streets.

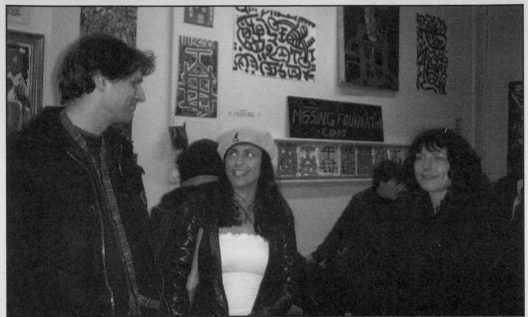

Paul Bartlett

Ozlo, Urania, and Rachel at
Clayton's Gallery, Peter
Missing's show

Urania Mylonas

Paul Bartlett

Tracey St Peter

Alexandra Bourdelon
designer

100 Stories

100 stories does not mean we have the complete history of film and video in the LES/EV. We have a lot on some topics, just enough on others, a short look on some (e.g. animation and video projection), and practically none on others (sorry!). This is unbalanced, a product of our constraints combined with the LES community's unbridled enthusiastic contributions.

LES/EV came together as a community and pulled off an amazing feat, producing a book on a scale not seen here in a long time. We are fortunate to have as many high quality, unique stories as we do. It happened because the same dedication that is bringing this book to you, short on resources and time, went into most of these chapters. And that is also how many of the films and video were made in the LES/EV, short on resources, short on time. We tell the stories of their making in this book.

Many Artists; Many Viewpoints

Kurosawa's film, *Rashomon*, about a rape filmed successively from four points of view demonstrates how invaluable it is to include many viewpoints; we tried to do something similar in this book. Take these contrasting views of two filmmakers on the same avenue in the '60s, a performance artist and a video artist in the '80s/'90s.

Jud Yalkut living on 2nd Avenue in the '60s expresses a common refrain in his piece "Media Mecca and Mayhem: Ferment on the Lower East Side":

"I was blessed, throughout my career, to often be at the right place at the right time, making connections with the right people and finding new sources of creativity. This atmosphere of collaboration and simultaneous individual development has been essential to my entire vision and being."

Paul Morrissey living on 2nd Avenue in the '60s says something quite different in his interview:

Q: "Was there a particular film making scene or community?"

A: "No. None whatsoever. It's all a journalistic illusion. There were people that Jonas would write about and show their films, but I didn't know them."

Jim C, writing of the '80s and the '90s in the LES and EV:

"The city drew us into her spell. The force of her attraction was greater than any of us could have guessed. Pulled into her vortex, we collided with each other in the paved swamp where a tribe called Manhattan buried their dead in the "bush of ghosts." Invented and reinvented, we cast our spiritual personas to the wind, reemerging as a community, a new tribe, surfacing out of ancient sacred burial grounds to re-inhabit the hallowed soil of rebellion.

Of the articles that came in, the Paul Morrissey point of view of the isolated artist is rare, but important. Radical innovative artists don't always see themselves in historical context. What cannot be questioned is that an art community did evolve out of Paul Morrissey's and Jack Smith's work. What they can question is whether the artists that followed were creators in an art community or cheap imitators, as Paul Morrissey thought of his camera man, Andy Warhol, and Jack Smith thought of the drag queens and other misfits that followed his film Flaming Creatures.

Jim C. arrived in the LES/EV when yet another art community was forming, building on the legacy of the earlier one. Now living upstate with more distance in time and space, Jim C. makes an excellent case on the development of a bona fide avant garde art movement in the LES/EV in his article, "Once in a Lifetime."

We believe that the numerous stories in the first person presented here, as a collection, provide strong evidence that ultimately it was the community of LES/EV artists that was crucial to what the art was produced here.

A Tribute to Rockets Redglare and Rafic (Rafik)

Rockets Redglare, who passed away recently, may not be a well-known actor nationally, but he is ubiquitous in the LES, and in our book. We have two articles about Rockets from Miss Moosey and Lee Williams; and Rockets is mentioned in many interviews and first person stories (e.g. Steve Buscemi, Jim Jarmusch). Rockets was interesting, likable and dear to all around him, despite, or because of, the personal adversity he faced. This book is a tribute to Rockets Redglare, as Rockets' life is a tribute to the LES/EV.

Rafic, another person not known much outside the LES/EV, was also dearly loved by the

LES/EV filmmaking community, or at least amused by him. Rafic's film/video editing business "Rafik" with a "k," brought many people together in one place, that would not otherwise have ever met. Spontaneous gatherings would result, and Rafic was a great host: he inspired us to savor the everyday life of the artist community that he helped create. Rafic made much of what you read about in this book possible. In this book, Tom Jarmusch brings Rafic to you and what many of his cohorts thought of him.

The East Village vs. the Lower East Side: art, ethnicity, real estate, and politics

Are you confused yet? Two people may refer to the same place with two different names, the Lower East Side, or East Village, and both could be right. What you call it depends upon the historical period, and who you think you are. As editors, we have left the name, as the individual writers wanted it.

THE HISTORICAL LOWER EAST SIDE'S borders were from 14th Street, to the Brooklyn Bridge, the East River, to the Bowery. As Davidson Gigliotti and Jud Yalkut document in their stories, rising rents in the late 50s and 60s forced Greenwich Village bohemian artists to migrate east to the Bowery (once called the Bouwerie), 3rd, 2nd and 1st Avenues in the Lower East Side. This converged with the tail end of the 2nd Avenue Yiddish theatre district and perpetuated many of the inexpensive ethnic restaurants that still exist to this day. This constituted a trans-formation of this region of the Lower East Side to the East Village, the "New Bohemia." The name East Village was an attempt to associate this area with the artist elements of Greenwich Village rather than the poorer, more ethnic, and immigrant elements of the Lower East Side. For many, the boundary of the LES has never changed and the East Village is contained within the Lower East Side. For others, the East Village is not the Lower East Side, and the Lower East Side is relegated to the projects to the east and the mixed neighborhoods south of Hous-ton Street.

ALPHABET CITY: Avenues A through D are sometimes called Alphabet City, at one time to distinguish itself from the East Village. The East Village gentrification however, continued to move block by block, expanding first to Avenue A in the 80s, Avenue B in the 90s, and at the time of this book it includes Avenue C. Many believe that the projects on the East River have stopped the East Village march at Avenue D, not leaving much for the alphabet.

LOISADA (lo-ee-saade-ah): The Lower East Side is called by some of its Latina/Latino resi-dents Loisaida, and this name includes the East Village, at least the Avenues A through D. Puerto Ricans often refer to themselves as Nuyoricans in the Lower East Side and other parts of New York City. Puerto Rican film/video is not centered in the LES/EV, but includes it.

LES vs. EV: Many people living in the East Village resisted the name change and the attempt to expand the East Village eastward block by block. The role of real estate interests fed this resistance. The brazen gentrification and displacement is documented in Rik Little's video and in his story in this book.

POLITICS: DIVIDE AND CONQUER: The LES and EV was represented by one City Council Member, the last being Miriam Friedlander, a fiery leftist loathed by her conservative oppo-nents, especially Ed Koch in the '80s. When the political machines redrew the borders of the City Council districts, they attempted to smash the political resistance of the LES/EV by divid-ing it in two: appending the lower and western part of the LES and EV to the Council District of SoHo, Tribeca, and the West Village, and appending the eastern and northern part of the LES and EV to the City Council district of middle class Stuyvesant Town and wealthy Gramercy Park to the North. Nevertheless, after the succeeding, corruption-backed, unpopular conserva-tive rule of City Council Member Antonio Pagan, an insurgent Margarita Lopez won an upset victory, becoming the first openly leftist, lesbian Puerto Rican to hold office. Aside from Ms. Lopez's defense against the eviction of the Charas community cultural center (unsuccessful) and protection for public housing, artists find themselves with few fervent political allies as they continue to lose their space. To the West, City Council Member Kathryn Freed defended artist's rights (see Clayton Patterson's story, "A Peek Inside the Archives") and was recently suc-ceeded by Alan Gerson, who was brought to office by SoHo, West Village and Tribeca artists. It remains to be seen what success he will have. As Clayton points out in the story about his archives, the Democratic Party and their gatekeeper clubs have historically held things back rather than moved things forward for the arts. One thing is for sure; the art has been pro-duced in the LES/EV more often in spite of the political apparatus than because of it. We hope that can change with the formation of the FEVA, the Arts Advisors to the Select Committee to the City Council to Rebuild Lower Manhanttan (AASC) and the birth of new similar groups.

Some people outside the magic expanding borders of the East Village felt that there was, and still is an "us vs. them" discriminatory attitude between the Lower East Side and the East Village. The recent move of upscale restaurants and wealthy people to the Lower East Side is beginning to blur the economic distinction, but many of the ethnic divisions remain. At a meeting at the East Village Howl Festival for instance, a Lower East Side artist was not sure if the name of the festival was meant to exclude or include him. He was told it was meant to include him, and it was just a name. The editors of this book live below Houston Street in Lower East Side "proper."

Many people that were part of the LES/EV art community never lived in the LES/EV; it was the place where they created art, showed their art, and socialized. The rapid gentrification and displacement of LES/EV has resulted in a dramatic loss of affordable housing and art spaces, and the LES/EV is in jeopardy losing its identity as an art community. See the articles in this book by Rik Little, Jim C, and Aaron Beall. Also look at the interviews with Talyor Mead and Mark Zero. There still remains a critical mass of artists in the LES/EV, but the question is whether we are an endangered species.

LES/EV on the Margins of Markets, Capital, and Art Schools

The mainstream film industry was simply not interested in the film making of the LES/EV, and the LES/EV was not much interested in the mainstream. DeeDee Halleck found that the after-school Puerto Rican kids from the projects found experimental and avant garde films more interesting than the Hollywood films. This may be because Hollywood films were alienating to them. Hollywood did not typically speak to life in the LES, while experimental films can be more fundamental about the human condition and freer to express alienation from society.

Capitalist imperatives were on the margins in the LES; people did not live by those rules. Markets did not create or drive the original creativity in the LES. Artists moved to the LES for the cheap rent, so they could produce art and not work long hours for somebody else. They resisted the motors of capital. Davidson Gigliotti quit his mainstream job as a UPI reporter and moved to the LES for cheaper rent so that he could work less and ultimately create art out of video. Gigliotti had an ally in a network that provided him access, but not for long; his allies were fired and his program discontinued. Video was used by mainstream TV to sell stuff; the networks could not deal with the subject matter of Davidson and his fellow Videofreex. DeeDee's kids made movies, not to make money, but to make movies they liked and movies they could make.

The LES/EV was the audience for LES/EV filmmaking, not the marketing departments of Hollywood film. Having artists as the "market" improved the art. Penny Arcade writes:
"There was as yet no national or international market for radical and experimental art. Consequently, the audience for these works was made up of fellow artists, painters, photographers, poets, writers, and, as always, the cognoscenti, who inhabit every era, to whom creative expression is manna. The results sought were intellectual, spiritual and creatively stimulating, the inspiration to break through boundaries and restraints imposed by society and the status quo."

Jeffrey Lerer makes animation that seems to be innocuous enough and marketable, but he doesn't find the marketing imperatives artistic collaboration, and at odds with what makes his art interesting:

"My position in this is that I work on what I think is interesting and then I try to find a way to get it out there. If I make one wiggle, and this is where it really does matter, I have been offered deals from the studio people. "If you're willing to mainstream this concept, we will back you." That's the difference. It's not that I'm trying not to be successful. It's not that I'm trying not to be mainstream. I just don't see that way. It's not that I can sit here and define mainstream for you, but I know what it isn't. Here's what happens. I do this: "Wow, that's fascinating." They come and say, "If you're willing to tilt this four degrees, we'll back you." But if I tilt it four degrees, it isn't what it is anymore."

Aldo Tambellini agitated against the commodification of the artists. Here, Tambellini explains: "As a counter-culture activist, I wrote, edited, and published a newsletter called The Screw with its slogan 'Artists in an Anonymous Generation Arise.' Written mostly in poetry form, I first published it in 1961. The newsletter was created to raise the social consciousness of the artists. In the newsletter, I voiced my objection to the manipulation I saw in the art establishment, which used the artists as commodities and financial investments rather than cultural entities."

Many of the key innovators in filmmaking of the '50s and '60s in the LES/EV were outside

the professional art training grounds. Penny Arcade tells the story of this interchange with Jack Smith and a would-be acolyte:

"Mr. Smith, Mr. Smith," he said, "I'm a big fan of yours. I go to the School of Visual Arts and I just need to know, what art school did you go to?"

"Art school? Art school?" Jack replied. "I didn't have the luxury of going to art school. I had to come to New York and go straight to work making art." The LES/EV took the place of organized art institutions.The Beats produced a film, *Pull My Daisy*, which transgressed mainstream norms and is considered one of the beginnings of independent film. Jim Jarmusch, Steve Buscemi and others brought independent film to the nation, and some may say into the mainstream. Art and film started to come to the LES/EV. Phil Hartman sees a cost to the success of the independent film, and a value to maintain the original independent roots in the Lower East Side/East Village, as seen in the interview by Leon Hartman, his brother: "And much like Hollywood has co-opted the concept of the independent film, the EV is in danger of being co-opted by market forces. There needs to be a healthy balance between 'progress' and 'regress.' We need to look to the future, while maintaining the legacies of the past. There's always got to be a place that the counterculture calls home; the EV's been that place for fifty years, and we hope for at least fifty more."

The question raised by this collection of stories about LES/EV filmmaking is the one we started with: How important was the LES/EV as a place for all this to have happened? What made it work? Cheap rent and the space for artists of all stripes to meet and exchange ideas were very important. The legacy of immigrants living outside of the box of America provided a home for artists to let art take them where it goes, without dictates. People who found themselves dysfunctional in the mainstream found their alienation to be a source of creativity nurtured and supported by the peculiar LES/EV community. However, affordable housing, studios and cultural spaces are now in critical short supply. The LES/EV arts community is in danger of becoming marginalized, overwhelmed and made invisible by the current wave of gentrification and blind market forces.

If artists can do anything, they can help people see what is possible in the world and community around them

—Paul Bartlett
Queens College, City University of New York
AASC, member
—Urania Mylonas
Columbia University

Making Movies with Kids
on the Lower East Side

by DeeDee Halleck

In 1959 I dropped out of college and moved to East 4th Street and Avenue B, vowing to find work in film. I had been especially impressed with some experimental films I had seen at the Hunter Gallery, my hometown Chattanooga's only art museum. My job prospects were slim. I was turned off commercial work, having worked for an animator during high school making pork sausage TV ads of pigs in a calypso band playing harmonicas made of ears of corn. There wasn't much of an "independent film scene" in New York at the time, but the Donnell Library across from MoMA had a great collection of experimental films and documentaries, and I was determined to see them all. This was before the days of videocassettes, before Anthology Film Archives and it was pretty much impossible to see anything beyond Hollywood product.

I got a job at Lillian Wald Recreation Rooms and Settlement in the basement of the projects on Avenue D and Houston Street. The job was to show films to kids in the evenings, and my main qualification was being able to run a projector, having learned to screen the rushes at my pork sausage job. I used to check out a shopping bag full of films at Donnell: some for the kids and some experimental films for my own media education. But the savvy sophisticated young people at the Settlement disdained the films from the "children's" category and liked the art shorts and documentaries better. We saw Burt Haanstra, Arne Sucksdorf, Lotte Reininger and Shirley Clarke. Their favorite was Norman McLaren, a Canadian animator, who pioneered the technique of painting and scratching directly on film. The kids wanted to try some out and we made some scratch films and they loved seeing their own film run through the projector. My friend, Kirk Smallman, brought a Bolex into the class and filmed them making these experiments. We later spliced it together with their film and made a film called *Children Make Movies*. We had a big premiere at the Settlement, and the kids were proud when their parents came to see their effort. We screened Norman McLaren's films also that night, in what was probably the first public experimental film night for the Lower East Side Projects.

There was a theater on Avenue B near 14th Street that showed experimental films on Tuesdays. You could get in free if you brought a film to screen. I took the film over there one night, and along with Ken Jacobs, Len Lye, Stan Vanderbeek, Ron Rice, Kenneth Anger and Robert Frank, they screened *Children Make Movies*. The year was 1961 and the film became a sort of cult favorite with both experimental filmmakers and educators who wanted to promote filmmaking in the classroom. Jonas Mekas, Maya Deren, David Brooks and others had founded the Film-Makers Coop and asked me to submit the film for their distribution list. It was the first film that actually sold a print: to the education department of the Ford Foundation.

In the hierarchy of settlements, Lillian Wald Rec Rooms were pretty far down the list, and I began to get calls from the more prestigious institutions such as University Settlement, Grand Street Settlement and Henry Street from people who had heard about my film project with kids. I was offered a big raise to teach at Henry Street. Lillian Wald paid five dollars for the three-hour after school class. Henry Street was ready to pay me the astronomical sum of fifteen dollars for the same amount of work, plus give my new family (I had a year old son, Ezra) a subsidized apartment in a settlement-owned building. So we moved from East Fourth Street to Henry Street and I started teaching art and film in what was a very appreciative environment. Henry Street Settlement had a long tradition of support for the arts. It was sort of segregated: on the weekends, mostly Jewish children from Long Island would come to the music school for lessons. It was part of a weekend ritual for them. Many of their parents had grown up on the Lower East Side and they would drop off their kids for their piano lessons, while they went shopping in their old neighborhood on Orchard Street. On the other hand, the Puerto Rican and African American residents of the nearby projects would take art lessons in

the after school classes, with some of the best art teachers in the city. As I recall a young Red Grooms taught ceramics there for awhile. Helen Hall, a formidable eighty-year-old matron in the grand old settlement house tradition of Hull House presided over the main Henry Street building, where formal dinners were sometimes held, in part, to teach the neighbors manners, in their elegant Georgian dining room. Miss Hall had taken over the Settlement from Lillian Wald (for whom the Avenue D organization was named), who was the founder of Henry Street Settlement and also the founder of the Visiting Nurse Society. Hall and Paul Kellogg were instrumental in initiating social security at the National Conference on Economic Security in 1934. Hall continued at Henry Street, in what many professional social workers felt was a pretty anachronistic lifestyle: surveying the streets from her somewhat elegant headquarters at Henry Street. This was truly "noblesse oblige": Miss Hall and her lady friends dispensed charity in the old style. You half expected them to be dispensing crusts of bread out of a basket as they cruised the streets in their turn-of-the-century clothing.

Miss Hall had a genuine respect for art and the after school programs were groundbreaking in terms of their ambitious use of art as socially beneficial work. One of my first projects at Henry Street was a ceramic mural for a building that was then under construction, the Guttman Building. Lillian Ann Killen Rosenberg and Susan Shapiro Kiok, who later founded the City Arts Workshop that was responsible for literally dozens of murals around New York City, especially in Chinatown and the Lower East Side, initiated the mural. The theme of the Henry Street mural was "The Friendly Jungle," a gesture towards reconciliation in what was seen as a gang-besieged area. There was a movement at the time to stamp out teenage violence. Father Myers, the pastor of Saint Augustine's, the church across the street from the Settlement, initiated a campaign called "Light the Dark Streets" (also the name of his book) to prod the city into putting up more streetlights. This resulted in a law requiring all apartments to have two lights by the vestibules in front of each city building: a big plum for city electricians at the time.

To prepare for the mural, we took kids and senior citizens to the zoo and had them sketch the animals. These drawings were then transferred to a big mock up of the mural and later painted and incised onto structural tiles. Kirk Smallman and I filmed the mural making and the resulting film, *The Mural on Our Street*, was shown as a short with some French New Wave films at the Plaza Theater on 59th Street and eventually was nominated for an Academy Award in 1965.

The mural project was fun and the resulting work on the ceramic tiles still stands at 301 Henry Street. But what I really wanted to do was make movies with my classes. I started an animation workshop, not only painting and scratching directly on film, but also shooting frame by frame as kids moved cutout characters. We had asked the Henry Street board to donate magazines, but the only ones we received were *New Yorkers*, so many of the films had liquor bottles as characters. The kids did a version of The Hulk that took place in a bar. The animation process we also filmed and the result was called *Mini-movie Makers*, which was distributed for years by McGraw Hill Educational Films. The film club prospered at Henry Street. Harry DeJur, one of the members of the Board of Directors, donated some 16mm film equipment and we made shorts that we screened during the summer on a sheet strung between two of the newly installed streetlights. We also showed some of the classics from the Donnell collection. I recall a screening of Buster Keeton's *The General* which I had to leave in the middle: my two-year-old son, Ezra, got hysterical when a Confederate train fell off a bridge into a ravine. I recall one evening in which we showed films about Puerto Rico, including a great experimental film from Donnell called *Que Puerto Rico!*

Down a few blocks, near the river on Cherry Street, Stan Vanderbeek had a live-in studio. Terry Gilliam of Monty Python was an intern with him at that time. They were working with cutout animation and collage and loved the work the kids did. But he and his wife, Johanna, were evicted in a new wave of project building and he moved to Stony Point, New York, where he built a "moviedome" out of the top of a silo, projecting on the round walled ceiling with three projectors.

In 1966 I moved upstate to Bloominburg, NY, to find more room for my growing family of three children, but the Henry Street Film Club continued under the brilliant leadership of Bruce Spiegle and Ted Glass. By this time there was a lot of film activity and the Young Filmmakers Foundation had opened on Rivington Street. Jaime Barrios, Rodger Larson, Lynn Hofer and Jaime Caro were teaching film to young adults.[1] YFF later became Film Media Arts, as their clientele grew to include the many artists and experimental filmmakers who were moving into the Lower East Side. Bruce and Ted had several dozen young filmmakers spooling out dramas from the Vladick Houses on Henry Street across the street from the Settlement. They had obtained the ground floor of one of the projects and built a screening room, editing

Clayton Patterson

DeeDee Halleck 1988

suites and even a small film processing plant, where they could develop the reversal reels the kids were shooting. Many of their films are in the collection at Donnell Library. They are some of the best images of the Lower East Side in the 1960s. The clubhouse was a very cool place to hang out. Literally. On hot summer days, the cool basement was filled with teens writing scripts, watching each other's reels or just listening to music. Many of the films were about drugs and death, though there was a lively share of comedies also. Mike Jacobson, who came down on the train from the Bronx to attend the workshop, made a poignant drama about Vietnam, in the days before Vietnam was a household word.

I went on to teach filmmaking to incarcerated youth at Otisville School for Boys in upstate New York. I was teaching a similar population of young black and Puerto Rican youth, but there were few from the Lower East Side who ever ended up at Otisville. In discussing this fact with the institution's social workers, I was informed that the Lower East Side has so many arts and after school programs, what with all their settlement houses and youth centers, that young people there tended not to get in trouble as often as those from the Bronx or Bed-Stuy.

The films from the Lower East Side found their way to many venues. My first film, *Children Make Movies* was shown at a UNESCO conference in Norway in 1962. Marchall McLuhan had his own personal copy of it, and a Catholic priest (later lapsed), Father John Culkin, who initiated the media program at the New School, showed it at many conferences as an example of how children could make films. There was the Child-Made Film Symposium, which Maureen Gaffney and I organized in 1976 at Minnewaska Mountain House, which brought together film teachers from many countries. The favorite films were always the ones from Henry Street: *What's It Gonna Get You Pepe?* a fantasy about drugs and *The Thief*, about a seven-year-old thief. Pedro Rivera and Susan Zeig taught at Young Filmmakers and their favorite student film was from Rivington Street: *The Lady Who Had a Baby.*

One of my most gratifying moments as a teacher was when one of my students from the University

of California in San Diego, Luana Plunkett, got a job teaching film to young mothers at Henry Street in the late eighties. She was working with Branda Miller on an experimental program to have teen moms make cautionary sex education films. Somehow seeing Luana go off to take that job, and then make a terrific film, *The Birth of a Candy Bar*, with fourteen-year-old mothers seemed like the closing of some cosmic circle. It also showed the enduring importance of the arts at Henry Street. Lillian Wald and Helen Hall would have loved it.

[1] Rodger Larson, Lynn Hofer and Jaime Barrios founded the Young Filmmakers Foundation. Larson's book, made with Ellen Meade, *Young Filmmakers*, EP Dutton, 1969, was an important document of this early work.

DeeDee Halleck is a media activist, the founder of Paper Tiger Television and co-founder of the Deep Dish Satellite Network. She is Professor Emerita at the University of California, San Diego, and the author of the recent book, *Hand Held Visions: The Impossible Possibilities of Community Media*, Fordham University Press, 2002. Her films have been featured at the Venice Film Festival, Cannes, the London Film Festival and many other international venues.

Young Filmmakers

by Rodger Larson

I first developed a filmmaking project for the federally funded Neighborhood Youth Corps at the University Settlement on Eldridge Street in 1966. In 1968 I established an independent nonprofit agency, the Young Filmmakers Foundation, which conducted film and video making projects for neighborhood children and adolescents. We maintained storefront operations at 8 and 11 Rivington Street (now the SoHo Hotel) until 1972 when the projects were consolidated at 4 Rivington (now a Chinese Christian church). In 1984 our name was changed to Film/Video Arts and we moved to 817 Broadway at 12th Street, NYC. I retired from F/VA in 1996 and am no longer active.

Many of the films, tapes, and other materials created in those years are archived at the Donnell Media Center of the NY Public Library, 20 West 53 Street. Former director of the Henry Street Movie Club project. The Media Center Director Marie Nesthus 212-621-0663 or mnesthus@nypl.org. They also have copies of at least three publications, which document has my early work in this field, 1964–1973. *YOUNG FILMMAKERS*, by Rodger Larson with Ellen Meade, EP Dutton, 1969; *YOUNG ANIMATORS*, a report from Young Filmmakers Foundation, Praeger Publishers 1973; and *A GUIDE FOR FILM TEACHERS* to Filmmaking by Teenagers: a booklet produced by The NYC Administration of Parks, Recreation and Cultural Affairs, 1968.

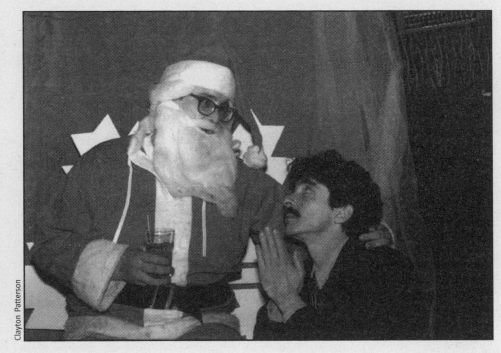

Clayton Patterson

Nelson Sullivan

Yankin' On **Pull My Daisy**

by Jessica Loos

"Early morning in the universe . . . "& iT's a sophisticated 16 mm mud grain black & white blur about nothing. life gets pondered in pantomime with wine. It's light hearted with a formal vein & delicate hand----al dente & a noodle on yr wall, a veritable, realistic, post atom bomb, cold war film billed as wholesome family fun but deflowered fags & flags & diners bobble over, dormant bubonic plague waitin for psychedelic yoo-yo & huh' americana. america. americana. avenue abcd 123 circa 1959. duz sun' shy boodelie boo wang agh . . . inebriation on the horizon, strange beads drip from melting pigeons & fire gardens escape the setting is sun deplete East Village cockroach infested loft where railroad conductor cum saxophone playing poet Milo lives with his wife and farina eatin' for breakfast school aged son & at end of work stint on big locomotive he roollss on home choo choo in uniform & poets waitin & BIg jUG o' red wine & can beer chug chug chooo----marijuana already smoked . . . kewp fooa ahhh. Let's sit around some, they say, spend the day, sit around, recite . . . poetry! ah. talk all about cool sacred nothings like Apollinaire, Jung, Buddha & Hart Crane, & all thru dinner's *invited guests*. heee. the bishop Romano . . . gulp. & as innocence ladel plucked a ladel wild poky bowery cherubs ran from blake . . . !! pOp tooth brush & dish are 1. . . . disintegrate & roob greedie & baseballs' lil' amulet chess sets. "Okay fellas, no flutes and no nonsense. I'm going back here to take my coat off . . ."

Pull My Daisy, directed by Alfred Leslie and Robert Frank, brings together a singular cast that includes Allen Ginsberg, Gregory Corso, Peter Orlovsky, Alice Neal, Larry Rivers, Delphine Seyrig, and Richard Bellamy. It was filmed in Leslie's 12th Street studio (there's a few exterior shots in front of a Brooklyn warehouse) in January 1959. It has music composed by David Amram (and three short excerpts that sound like The Cecil Taylor Trio, with Dennis Charles and Buell Nielinger; one that sounds like it might be the Sun Ra Arkestra) and is narrated by Jack Kerouac. The film is based on the third act of Kerouac's unfinished play The *New Amarean Church, The Beat Generation*, inspired by an incident at Neal & Carolyn Cassady's California ranch house where Kerouac was staying in fall 1955, after a jaunt around Mexico. But MGM had just made a movie called *The Beat Generation* so they had the title copyrights. *Pull My Daisy* is a better, more whimsical title anyway, and it was first the name of a jazz poem written by Kerouac, Ginsberg & Neal Cassady in 1949.

The first two verses of the poem are the lyrics to the film's opening song *Crazy Daisy*, sung by Anita Ellis, but lines were changed, so as not to have blatant sexual connotations...pull my juju jack . . . on me bend me over twice . . . euphemistic nursery rhyme (masturbation, colloquial strip club lingo, etc.). G String

Enterprises (name of Leslie's production company for the making of the movie) fun fun . . . woe is a nut in an egg & so is yr ass on wine free friday lady with a green bean in its nos e & all the vegetables hide in cans cans vrooommm . . . vrooommm . . . ga mee zeeee ga meezee ga meeee . . . mmmmmmmmmmmmm. . . .

. . . here, the line "hop my heart on" was changed to "hop my heart song"-----

Bone my shadow
dove my dream
start my halo bleeding
Milk my mind &
make me cream
drink me when you're ready
Hop my heart on
harp my height
seraphs hold me steady
Hip my angel
hype my light
lay it on the needy

Pull My Daisy filmed silent & then sounDed oUt. s h Hhh...Kerouac watched footage & listened to Amram on ear phones at same time... posie bop bie liddel sQueeek . . . & performed in 3 or 4 different takes & on breaks . . . microphone never turned off-----to get every damn word he said, says Frank in *Naked Lens*----then----spliced & edited a tiny bit. But Kerouac preferred spontaneous work technique & published a list of 20 essentials of this. He was influenced by Harlem jazz & Cedar Bar action painters...art calls for real, immediate expressions about NOw! As Amram explains in his memoir *Offbeat*, Kerouac was not happy about doing the narration "over," he felt it wasn't necessary, because he was "touched by the hand of God." "Up you go little smoke, up you go little smoke, up you go little smoke" . . . sings Kerouac, taking it higher each time . . . his voice, a bit out of sync with the actors' body language charade adds to careful, labor epiphanic loppiness of the kooky quirky child's play *Pull My Daisy* pulls off. His mirthful underscore pOps like a muse & frolics diminutive songs, taking on the voices of the characters & making onomatopoeia . . . he calls Gregory the "hero of stove and pipe butter," & narrates Allen saying "The Lower East Side has produced all the strange gum chewing geniuses," to which Gregory replies "I could ah, tell you poems that would make you weep with long hair. Goodbye, goodbye."

Kerouac's narration becomes the focal point of the film, holding Frank's discriminate camera work, Leslie's inspiration and the renegade cast together. Rehearsals, as Amram recalls in *Offbeat*, were chaotic & anarchistic, with Ginsberg dropping his pants and Gregory throwing ketchup on him; Orlovsky wandering in wet towels carrying a toilet plunger, "cleaning up America"; Seyrig not knowing how to deal with the structureless insanity. But there was a commitment to the project. These artists wanted to make an ebullient, subversive film that stood in contrast to the media's bastardized distortions of them. They are saying, "This is the way we are in real life and if you don't like it, I don't care!" As Amram told the *New York Times*:

"*Pull My Daisy* came about largely from a group of painters and writers who wanted to make a movie to show their children and grandchildren what we were really like. The image of a beatnik had

become so horrific that we couldn't identify with it anymore. In *Pull My Daisy* nobody looks like a beatnik. We all shared a joy of life, the ability to work hard at what we were trying to do, artistically, at having fun. The film is so lighthearted and joyous and funny, it's the antidote to the beat label."

The directors let things happen. The "actors" created scenes, despite the fact that the film was shaped through an intensive editing process. Some vignettes were blocked and scripted, others spontaneous. With the exception of Seyrig, no one in *Pull My Daisy* is cast as an actor. Instead they scribbled mad alphabets, played flutes, colored canvas, or performed various combinations thereof. *Pull My Daisy* is a crystalline gesture about the clarity of fog. The gaps between life, art, and art mediums are hazy, like the backs of dinosaurs in mountains . . . blur bod eee bop deei. BoNG! It's one of the first films of transgression, an experiment in trespassing & camouflage. Places like The Five Spot, a Bowery jazz bar, located across the street from painter Herman Cherry's loft, seminated these streets. Artists of all means hung out there. Poets played, musicians painted----Kerouac, Cecil Taylor, Julian Beck, Charles Mingus, Jack Micheline, Judith Malina, Franz Kline, David Smith, Robert Rauschenberg----all colluded, fertilizing wawooka! Kaliedin' in yerdat.

Even *Pull My Daisy's* directors transgress artistic homogeneity. Leslie was a prominent abstract painter who also made short films that he showed at the rural styled, paper cup, rot gut red wine, banjo, saxophone & potato chip poem rent parties. Splaaat! Grrrrrah. Frank was a still photographer. He had just published *The Americans* (1958), which Kerouac wrote the introduction for. *The Americans* influenced John Cassavetes' film *Shadows*, as mentioned in *Naked Lens*. *The Americans* rapes America of its pastoral innocence, in a very subtle way.

Frank's other films include *Me and My Brother*, (1965–68) a collaboration with Sam Shepard, Ginsberg, Peter & Julius Orlovsky; *Cocksucker Blues* (1972), about The Rolling Stones; and *This Song For Jack* (1983), an homage to Kerouac. Leslie went on to make *The Last Clean Shirt* (1964) narrated by poet Frank O'Hara; *A Birth Of A Nation* (1965) featuring William de Kooning, and just recently, *The Cedar Bar*, with music by David Amram.

Despite its deliberate blobbiness and relevant nothingness, when *Pull My Daisy* premiered on November 11, 1959, at Amos Vogel's Cinema 16, alongside the equally groundbreaking *Shadows*, (*Shadows* won the First Film Culture Independent Film Award, *Pull My Daisy* won the second one in 1960), it at first left its audiences confused. In a 2000 *New York Times* review, Leslie explains:

"*Pull My Daisy*, in 1959 looked like an insane work to people. It looked chaotic and unstructured, and people didn't know how to deal with it. But the film had a very, very wide influence because it opened up a way for people to think of being more independent in their vision."

People finally got it, and *Pull My Daisy* has influenced filmmakers ever since, beginning with Ron Rice's *The Flower Thief* (1960), featuring poet Taylor Mead, and Vernon Zimmerman's *Lemon Hearts* (1961), both of which showed in the Charles Theatre's (Avenue B) experimental film series, curated by Jonas Mekas in the early '60s. The Charles went broke because artists didn't have to pay admission. In a promotional flyer, Myron Lounsberry bills these films as:

"two of the latest and most successful examples of post–*Pull My Daisy* cinema. . . . They merge and combine the spontaneous cinema of *Pull My Daisy*, the freedom of image of "Brakk-age," the uncleanliness of "Action Painting," the theatre of Happenings (Kaprow) and the sense of humor of Zen. Their imagination, coming from deeply "deranged" and liberated sens-es, is poetry and wisdom of the irrational, of nonsense, of the absurd----the poetry which comes from regions which are beyond all intelligence . . ."

In *Movie Journal*, Mekas explains the significance of *Pull My Daisy,* analogizing it to *The Liv-ing Theatre's* play *The Connection,* which was made into a movie by Shirley Clarke:
"I don't see how I can review any film after *Pull My Daisy* without using it as a signpost in cin-ema as *The Connection* is in modern theatre. Both *The Connection* and *Pull My Daisy* clearly point toward new directions, new ways out of the frozen officialdom and mid-century senility of our arts, toward new themes, a new sensibility."

Za goobel gee ze me ba zam bombieeee, ah, teonistor, roses for lLulU & raggedy lil' ann climbin on daddy's knee . . . ShaKe! holy porridge nunzio. the sun is hot comin" i had said . . . so are the ya-ya, pulchritudinous rhinocerous pulpits that just escaped the zoo . . . lean on my knee & Stetson with cowboy bAng! BaNg! pukka. we never used that part. vroooom vroommm. Awagga. Humpty Dumpty sat on a wall & had a great fall. six gallery sneaker cherry on avenue A. "Don't worry boys, we'll find something, we can go play with fires in the Bowery . . ."

Pull my daisy
tip my cup
all my doors are open
Cut my thoughts
for coconuts
all my eggs are broken...

Harry Smith:
A Lower East Side Legend

by Amanda Fortier

Harry Smith has been called a transcendental genius, the greatest and most interesting artist of his time, and a creator on the order of Da Vinci. He influenced Bob Dylan and Ry Cooder with his American folk-revival music of the '50s and '60s, while Andy Warhol and Jean-Luc Godard both admired his surrealist and Dadaistic films. Allen Ginsberg helped find housing on the Lower East Side for this acerbic, intriguing visionary when he became more concerned with collecting lost anthropological materials than making monthly rent payments.

Harry was an unheralded genius of grand proportions. His work, in all its vast complexities, succeeds in challenging what accepted notions predicate a work as being scientifically or artistically based. Combining an uncanny ability for precision, for diagrams, and for structured classifications, Harry had an inarguably scientific logic to his work. Using this maniacal attention for detail and exactitude, Harry was able to produce an incredibly complex and eclectic mix of artistic work. Though the remainder of this final collection is comparatively small, it continues, to this day, to serve as a tremendous inspiration for countless other artists.

Harry Smith

Harry's repertoire spans a variety of disciplines including film, painting, and music. Though his artistic methods may elude many, his endless knowledge of so many seemingly unrelated fields, including numerology, alchemy, ethnography, linguistics, and the occult, is in itself fascinating. Harry's efforts link many media, and yet his mastery in each foretells an unbelievable authenticity that presumes its own logic and artistic creativity. To recap within any deserving amount of pages what Harry Smith has accomplished, what he has precipitated, and what he means to so many contemporary artists is a task that may never

fully be realized.

Harry's early past is a bit hazy, filled with contested facts and differing dates.

"Harry would tell different people different things," recalls Robert Haller, a friend and the Director of Collections and Special Projects at Anthology Film Archives. "He lived a life filled with factoids, one never really knew what was truth and what was made-up," Haller says.

It is agreed that Harry Everett Smith was born in 1923. There is some debate, though, as to whether he grew up in Seattle, Washington, or on a Native reservation outside the city where his mother worked. It is also rumored that he was the bastard son of occult master Aleister Crowley, which as Haller contends, "is conceivably possible, though unlikely, considering Crowley hadn't even been to the West Coast during the first three months when Harry was growing up and living there!"

As a young adult Harry attended the University of Washington where he studied Anthropology. Never fully completing his university studies, Harry was propelled to move south by the emerging beatnik arts scene in California. Taking part in the Berkeley Renaissance in 1948, Harry began painting to music. In particular, he painted to Dizzy Gillespie's work, and eventually transposed his canvas work into non-objective films. Harry started experimenting with how music could be visually portrayed, breaking down musical pieces note by note and creating individual images to coincide with each sound. When the Baroness Hilla Rebay, from the Guggenheim Museum (formerly the Museum of Non-Objective Art), noticed Harry's work she was deeply intrigued by the newfound ingénue and offered to finance his trip out to New York City. It is from this point that Harry Smith left the West and embarked on his path to become one of the most diverse and complicated artists to grace the hotbed of creative activity in the Lower East Side.

It is difficult to systematically break down what came next, in what order, and in what degree of importance. Harry was simultaneously involved with so many people, undertaking so many projects, and interlacing it all with the drugs and alcohol that so predominantly characterized the social environment at this period. In Paola Igliori's book *American Magus*, she interviews various people who had come into contact with Harry over the years. The stories and interactions vary to some extent from person to person, though some conclusions remain the same. "Harry was very eccentric, and yet very thoughtful," recalls Haller. "His noted fits of rage were less personal attacks than drawbacks to his medication and internal frustrations."

Without the financial and personal aid from many friends and supporters, Harry might not have been able to maintain himself or his projects in New York City. Constantly moving (Harry moved back and forth between the Chelsea Hotel and the Breslin, with intermittent stops at the George Washington Hotel, Anthology Film Archives, and Allen Ginsberg's home), Harry was infamous for neglecting rent payments. Unfortunately during some of these sporadic moves there were haphazard losses of some of his art collection. "Harry sold all his films to Anthology so they could be preserved," informs Haller. "In exchange for this we allotted him an allowance, which was strung out over many years, because he was afraid he would otherwise spend it all at once."

Very much the reluctant artist, Harry was quick to announce his dislike for the fine arts. He preferred to be known for anthropological endeavors. He had an enormous collection of obscure items in his various residences for "anthropological study." These artifacts included his noted American song collection, Ukrainian Easter eggs, Seminole Indian textiles, paper planes, cans of Coke, Native American Indian string figures and other folk crafts, and a wide variety of books, cassettes, phono-recordings, and artwork.

"He was also particularly interested in kabbalah and Arthurian literature and legend," recalls Haller. "At one point he had acquired some Arthurian materials of great interest to me and yet he refused to relinquish with any of it." Harry was constantly collecting, researching, and noting a massive variety of cultural and historical artifacts.

It is clear that Harry had a particular curiosity with how different cultures communicate. His assortment of peculiar and unrelated objects was extensive, and they were all, in his mind, valuable, interrelated pieces of evidence. How each object stood in relation to another was an all-encompassing topic that was reflected in much of Harry's art. Various anecdotes attest to his preoccupation with attempting complex investigations on obscure topics, such as relating

Clayton Patterson

Harry Smith and Linda Twigg at Chelsea Hotel

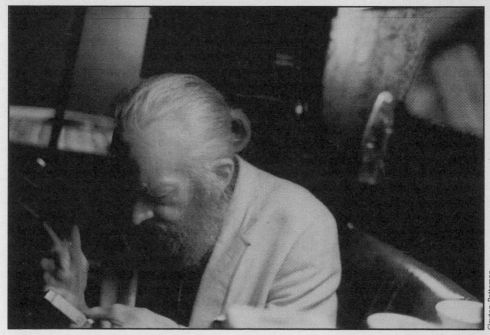

Clayton Patterson

Harry Smith Doubling Cube at the Chelsea Hotel

the Enochian system to patterns of tartan colors. Harry was endlessly trying to challenge the boundaries of art by reinventing and reinterpreting meanings, symbols, and relationships.

Harry had a heightened sensitivity and an obsessive need to record and collect data. Some stories recount Harry recording countless hours of the arbitrary sounds outside his window-- breaking glass, chirping birds, and passing people. Harry had an incessant need to preserve a sense of civilization, which dually served to propel many of his random experiments and inspire much of his own artwork.

To discuss Harry's artistic creations is like trying to understand his peculiar anthropological studies--they both require a complicated rationale. Certainly one may be stunned at the visual array of colors and designs that prevail in his paintings, drawings, and films. However, what may appear as chaotic and random images are actually precise and highly synchronized patterns that have been carefully premeditated.

For example, his three most important films, *Early Abstractions*, *Late Superimpositions* (*No 14*), and *Heaven and Earth Magic* (*No 12*), are all complicated and abstract visual collages. The superimpositions of films on top of each other, as in *No 14*, are strategically placed to evoke an exact image. In *Early Abstractions*, Harry synchronized the paintings of Gillespie's music to every note and projected this image onto filmstrip. Though only prints of these films exist (the originals no doubt destroyed or lost by Harry himself), Jonas Mekas, the director of Anthology Film Archives, has these copies as part of the archives' *Essential Cinema Collection*. Harry's film work, though not extensive, helped inspire the underground film scene in the Lower East Side, which continues to this day.

Rather than call himself a filmmaker, Harry preferred to be known as a painter and an anthropologist. He was highly fascinated by the North American native culture and language. Many hours were spent meticulously gathering data and acquiring artifacts from the Seminole and Kiowa Indians to use as inspiration for his artwork and serve informational purpose for his ethnographic studies.

In 1991, shortly before his death, Harry was awarded a Grammy for editing the American Folk Music Collection (1953). This three-volume, six-record anthology is an essential contribution to the preservation and promotion of folk music in the United States. The years of Harry's relentless effort, rescuing and collecting rare and otherwise lost American songs, were all a part of his tireless need and respect for cultural artifact.

There is little doubt Harry Smith was a unique and greatly respected man. "Harry was a genius," says Haller. "It was extraordinary for me to meet this man. I tried very hard to bring him back to (my hometown) of Pittsburgh, though he would never go." Nearly every person to have come into contact with this man has some incredulous story, statement, or remark about Harry. He was anything but ordinary.

Without a doubt Harry's creations reflect an artist and visionary born well before his time. Inspired by myths and legends, this creative magus has himself become a man of folkloric mystique. Harry's work and life cannot be succinctly summarized nor facilely explained. He was always seeking reaction and reinvention, and in this pursuit put forth some of the most complex and strategically organized pieces. Whichever label one chooses to describe Harry -- filmmaker, painter, ethnomusicologist, anthropologist, magician— he can clearly be considered it all! Few who have come into contact with this man have been left untouched, unfazed, or uninspired by his intensity and intrigue. One thing is clear: the dynamic history of the counter-culture growth in the East Village would never have been the same had Harry Smith never walked the streets of this unique neighborhood. May the legend of this modern alchemist live on and his creative energy continue to inspire for generations to come!

*The information and facts gathered are attributed to:

Haller, Robert, director of Collections and Special Projects at Anthology Film Archives. Phone interview, July 25, 2003.

Igliori, Paola, *American Magus* (Inanout Press, 1996).

Tell all the Scum Of Baghdad the Legacy of Jack Smith

by Penny Arcade

Between 1957 and 1967, Jack Smith was a major catalyst in New York's downtown art scene. Smith, the director of the groundbreaking underground classic *Flaming Creatures*, is also widely considered the grandfather of contemporary performance art. The most successful artists in avant-garde theater—Robert Wilson and Richard Foreman—credit him as well as artists as diverse as painter Mike Kelly, photographer Nan Goldin and filmmaker John Waters—as the major influence and inspiration for the direction of their life's work.

Smith dismissed most of his contemporaries, with the exception of composer La Monte Young, who he revered as a true genius—not only because of his undeniable talent and vision, but probably because Young chose to remain an obscure and underground figure through the years.

Smith was particularly hard on artists whose work was influenced by him, with the exception of Playhouse of the Ridiculous director John Vaccaro, whose own theatrical aesthetic, which rejected traditional acting and traditional theatrical forms, had a deep impact on him. They later fell out when Vaccaro would not reveal his source for high quality glitter.

Playwright and director Richard Foreman's statement on Smith's influence has been quoted many times. Smith, who found his influence on Foreman less an "influence" than outright copying, made fun of him in his Pontologic-Hysterical Penguin Rustling Out by the Old Archives. He felt justified because Foreman used a penguin in his 1978 Public Theatre show, which Smith felt was his signature symbol. He used the opportunity to get a poke in at Jonas Mekes at the same time by setting the piece in the "Old Archives." Nonetheless, Smith quoted Foreman in the 1987 brochure he designed to promote his midnight slide shows and as a general promotional device.

"Jack Smith is the hidden source of practically everything that is of any interest in so-called experimental American theater today. Absolutely. And I mean everyone from Wilson, to myself, to Ludlam to Vaccaro and many, many other people owe a great deal to Jack Smith" —Richard Foreman.

"Seminal influence?" roared Jack in 1981, when he heard himself referred to as one. "Legend? What do those words mean? That I will never be able to pay my rent?"

"Jack was a force!" exclaimed Larry Re, founder of The Gloxinia Trocadero Ballet, a week after Smith died of AIDS in 1989. "His energy, what he thought about. Remember, New York was a small scene in the early '60s. It's almost impossible to describe the force of the impact he had on everyone."

When Re called Smith "a major force," he meant that he was like an "original cause," rather than someone at the effect of the culture around him.

In the early '60s, Jack had established artists like Robert Rauchenberg running around New York tearing up linoleum to his battle cry "Linoleum is the enemy!" The early '60s was a period in New York's history when major energy fields cross-pollinated with ravishing results. The dreamed for and worked for counterculture that artists and social activists had been brewing in New York since the early '40s drew dreamers and visionaries from across the country and across the globe, and gathered speed as the late '50s turned into the early '60s. It was a time of intense intellectual and artistic cross-fertilization, when high ideals bolstered and informed low art. A time of collaborative thinking and action, which only occurs two or three times in a century, in periods where innovation and experimentation are seen as more valuable than material gain. When ideas in themselves are currency. These periods, as the history of art shows us, are brief and rare indeed.

Careerism in art as we know it today did not yet exist. The lines of critical thought were not blurred, and the lineage of one's influences was proudly celebrated, the artists who had come before, deeply revered. There was as yet no national or international market for radical and experimental art. Consequently, the audience for these works was made up of fellow artists, painters, photographers, poets, writers, and, as always, the cognoscenti, who inhabit every era, to whom creative expression is manna. The results sought were intellectual, spiritual and creatively stimulating, the inspiration to break through boundaries and restraints imposed by society and the status quo.

Oh yeah, and sex. Not sex in the sense of '70s promiscuity, but the allure and power that comes from the promise of the fully integrated life force. The psychedelic era, long associated with the late '60s, was in its most serious if not sacred period in the late '50s and very early '60s, long before it would filter down to masses and become associated with youth culture and rock and roll. Early '60s New York was a time of dynamic innocence and investigation that left no subject or concept unturned, and was marked by a rigorous devotion to the purity of ideas and ideals.

"Jack Smith only had five ideas," proclaimed poet, painter and art critic Rene Ricard when I informed him of Jack's death, "but they were five *huge* ideas. Every artist who came after Jack is still working with those five ideas."

I had run into Rene at 7:30 a.m. on East 2nd Street, an hour after Jack's death. He was walking alone in the early sun carrying a huge bouquet of almost-dead flowers. At the time it had seemed normal, not even synchronistic, but that was in 1989 when the East Village was still an unmapped territory, and larger-than-life artistic entities still roamed its streets.

As a teenager in 1967, I came into an artistic milieu that was still reverberating with the impact of Jack's most fertile period. It was no longer really dominated by Jack, although there were few as charismatic. He was secretive, always lurking, and ready to spring forward when what he referred to as his "male fire" set him off. The early '60s fun house think tank he had formed with some of the greatest and most twisted minds of his day, which had been fueled by a giddy rebellion against a society filled with hate and hypocrisy and mediated by marijuana and psychedelics, was still the best show in town. Better than any passing rock band.

Jack himself, already legendary because of his film *Flaming Creatures*" and the dynamic, albeit laconic charisma he brought to the films of Ken Jacobs, Ron Rice, Gregory Markopoulis and others, was just beginning to create his performance work. He was just beginning to develop what would become his characteristic performance style, trying it out kamikaze style at various openings, and even during other artists' theatrical events. He was heavily influenced by the controlled chaos of John Vaccaro and the Playhouse of the Ridiculous, with whom he had collaborated and for whom he had created costumes and posters.

From the late '50s to the late '60s, the Lower East Side was dominated by what can only be described as a cult of amphetamine and meth-amphetamine users. These were legendary speed freaks whose apartments and lofts were epic installations that the art world would never know. The first time I went to Jack's Greene Street loft, in pre-Soho 1968, it set off the kind of brain frenzy now associated with certain Japanese animation. Over that year, he increasingly added to this melange. When I return to it in my mind's eye, I see—along with 100 dead Christmas trees—a toilet, huge twists of barbed wire, broken sewing machines, mannequin torsos, and—I swear—an entire wrecked car!

In the middle stood a one-and-a-half story pile of plaster, courtesy of Angus MacLise. (MacLise, legendary Scottish poet-composer, founder of the Velvet Underground, and confirmed speed freak, remains firmly underground—along with a handful of seminally important artists like Piero Heliczer, La Monte Young, Irving Rosenthal, and Brion Gysin—still unknown to the general art world years after his death, despite the dedicated efforts of poet-photographer Ira Cohen to bring this group visibility in the past 20 years). MacLise, using a kitchen knife, in 72 sleepless hours had carved away by hand nearly the entire ceiling that divided the two floors of Smith's rented loft. Later, a disbelieving landlord was struck mute as she pondered the resulting catwalk, which was all that was left of what had been a second floor loft. The months of unpaid rent must have seemed a secondary issue. From this grey-white pile of plaster, all kinds of detritus collected from the street poked out: dolls' limbs, old radios, lamp

Clayton Patterson

Jack Smith's kitchen

stems, plastic flowers, pitchforks.

What bothers me most about revisionist history is that all too often it seeks to make the past understandable by taking it out of the context of its own time. It seeks a glib and easy definition, usually to bolster some agenda or other, by framing it in contemporary experience.

Entrepreneurial, working-class, non-academic artists largely defined the '60s, much in the same way that art school–educated artists from a middle-class background defined the experimental art of the '80s.

Jack Smith, was self educated, not an "academic" artist. Too young to fight in World War II, he and many others who ended up in New York in the early '50s were not part of the vast legions of Americans who filled the art schools both here and in Europe on the GI Bill of Rights in the mid-1940s.

In 1985, after one of Jack's performances at Millennium, a young man ran up to Jack as he and I were going backstage.

"Mr. Smith, Mr. Smith," he said, "I'm a big fan of yours. I go to the School of Visual Arts and I just need to know, what art school did you go to?"

"Art school? Art school?" Jack replied. "I didn't have the luxury of going to art school. I had to come to New York and go straight to work making art."

Jack's was a "found" aesthetic, culled from the silent pictures of the '20s through the movies of the '40s, his eclectic reading habits, which tended to nonfiction and self help, and what can only be regarded as a serious obsession with function regarding architecture, junk-yards, thrift stores, and the detritus of everyday American popular culture.

One of Jack's business cards from the 1980s read, "Exotic art consultant—everything from ancient Egypt to 1940s."

All of this was no doubt sharply highlighted by his Depression and post-Depression era experiences of poverty, something he shared with Andy Warhol, whose peasant immigrant upbringing isolated Warhol from the Joneses and the Cleavers, as much as the sometimes grinding poverty and physical hunger of Jack's trailer-park childhood.

"Now I know why we cannot have bowls of gravy!" Jack would sometimes unceremoniously yelp. Somehow he associated the poor canned and bland foodstuffs of his childhood, served without condiments, with what he perceived as a similar poverty of recognition in his career.

The typical store-bought packaging of convenience foods and products, highly touted and coveted in newly prosperous post-war America, must have seemed highly singular to Jack, whose own mother appeared to be eccentric and remote. She fed them from cans, and once left Smith and his sister alone without food or money for two weeks, to forage among neighbors for food. These packages and containers were exotic, glamorous and unreal. They were objects in the most literal sense of the word, in many ways both foreign and impenetrable to both the Warhol and Smith households.

For instance, as one looks closely at Jack Smith's 1976 poster for his slide show "How Can Uncle Roachcrust Have a Bi-Centennial Zombie Underground?" one slowly realizes that the border of the poster is the everyday generic paper placemat, decorated with lobsters and nets, found in nearly every American fast food seafood joint.

Like Warhol, who shared Jack's level of entrepreneurial and aesthetic intelligence, there was a fascination with the tacky alongside the sublime. However, where Warhol was filled with a lust for wealth and luxury and a desire to mingle with celebrities and old wealth, Jack had a burning pragmatism regarding function. He never lost his identification with the proletariat or his distrust of the establishment.

It is not a mystery why Andy Warhol named his studio The Factory. The factories of Pittsburgh were what he knew, and Warhol knew the difference between working long hours manufacturing for someone else's profit and working for yourself. Rodin's example, the workshop with its many assistants, was not lost on Andy.

This assembly line mentality was where Andy Warhol and Jack Smith differed the most, and this concept ultimately spurred Jack's unabashed resentment of Warhol.

"Manufacturing and making art are two opposite ways of thinking," Smith said. "They don't agree at any point. The aesthetic part of something is ultimately the most functional part. Farming is very close to making art. Have you ever driven through the German countryside? It's art. There are rows of crops in stripes, gently winding around the curves of the hills. In stripes! You have got to have an aesthetic sense that the Germans are not generally credited for. They are making art and they don't know it because they want strength: they want something that is going to last. That's art." (from William Niederkorn's *First True Comedy Symposium*, 1988.)

Much has been said about Jack Smith's involvement with the "Ridiculous movement" and "camp." Certainly Susan Sontag's essay, On Camp, in 1964 drew a great deal of attention to Smith's work, coming as it did from outside the confines of the underground.

Once again, this is where current revisionist thought does the public a disservice. In the 1960s, camp meant amusing and stimulating with a hidden subtext. Generally, the object or action was removed from its usual everyday setting. Camp was not another word for gay as such, a definition the word took on in the '70s.

According to playwright H. M. Koutoukas, "Camp was an attitude. You set up your camp. In the king's court, no one could disagree with the king. So the couriers would stand with the people who they agreed with, and the king would then see what you thought by who you stood with. 'Camp' stood for setting up your camp, your point of view."

In the '60s, when one said someone or something was camp, one meant it was amusing in a frivolous way, which might or might not convey a hidden message. Camp also implied transcendence over the ordinary. One could say the ordinary became extraordinary, or was raised to where its true singularity could be seen.

This was accomplished through a great formality marking the work of Smith and Vaccaro, and later Vaccaro's talented acolyte, Charles Ludlam. In other words, they took this shit seriously! Faced with the dilemma of mid-century Americana, apple pie, racism and the atom bomb, all couched in a very unchristianlike Christian morality, what else was there to do? Pop art and camp flourished because they cannibalized and remade the culture and the ethics around them in their own image.

The original camp theater of Smith, Tavel, Vaccaro, and later Ludlam, was one of serious political questioning couched in a crazy, silly, big spectacle that dared take on the big machine

Jack Smith

Clayton Patterson

from the grungy storefronts of New York's Lower East Side. Accepting that sex was sex, whether it was heterosexual, gay, lesbian or onastic, they turned their guns on the big political issues of the day.

The Ridiculous Manifesto, which was declared by Vaccaro and Tavel, who had met at midnight screenings of Maria Montez films at the Beaver Street Cinematique, stated, "We have gone beyond the absurd. Our situation is absolutely ridiculous!" As early as 1968, Vaccaro turned his back on the idea of theater, saying in a 1968 documentary on the Playhouse for Swiss television: "We don't do theater. I hate theater. This is not theater. This is performance." Vaccaro ridiculed even the idea of acting, saying over and over to his performers, "You are all Coke machines!" This point of view thrilled Smith. Later, at the end of a performance at Smith's Greene Street loft, Jack screamed at Marie Antoinette Rogers, a star of Vaccaro's who was in all of Jack's early Plaster Foundation shows, and whoever else was on stage, "Get off the stage! Go home! I don't need you anymore!"

In Jack's 1985 show "Death of a Penguin" at Millennium, when the actress playing the serving girl rolled her eyes while delivering her lines, Jack shouted, "If you can't be serious while saying your lines, just get off the stage. Lest we all end up like poor Charles Ludlam!" A damning epitaph on the transformation of Ludlam's heavily politicized camp aesthetic of the late '60s and '70s into farce in the '80s.

In 1989, within months of Jack Smith's death, the terms "gay film maker" and "gay artist" were used to preface his name and his work, something he railed against while he lived. Jack Smith was certainly homoerotic, although it is clear that he had romantic obsessions with women as well. Ken Jacobs remembers a girlfriend of Jack's in the late '50s, who he claimed he wished to marry and move with to the suburbs of New Jersey. Smith had one romantic homosexual liaison, which was quite brief and more intellectual than emotional (and apparently more violent than sexual). To think that Jack Smith's work was fueled by the kind of "gay identity politics" that began in the 1970s and came of age in the '90s is absurd and masks the complexity of Jack's thinking.

"I don't make my work for any specialized audience," Jack stated. "I make my work for everyone on earth."

Like many artists of his generation who were homosexual, he was stunned by the idea of being branded as a "gay" artist. He found the term condescending and restraining. Jack did not break the world down into the gay-straight model. For Jack, there were only flaming creatures against the pasty normals, gay or heterosexual. Nowhere in any of Jack's work is there anything that could be defined as a "gay" theme. The gay film festivals of the 1990s cringed

when they found that the great "gay" filmmaker's masterpiece *Flaming Creatures* has a male-female theme, and while many of the performers are in drag, there are real women. The central character in a protracted comedic "rape scene" is a woman, Marion Zazeela.

While Jack was an extremely political artist and touched on all areas of human oppression, the last 20 years of his life were devoted to the "politics of art," and his endless struggle against the curatorial class that sought to mediate him and act as middleman between him and the general public.

"The way they get artists is with the one night stand! No artist can develop their work or make any money with a one night showing," he raved.

"Landlordism" was his term for class struggle. His was the voice crying in the desert of a rented world. Jack grasped that private property was a building block of oppression.

"These buildings were bought and paid for, yet we have to keep paying rent and paying rent on buildings that were paid for long ago," he would say.

It is fascinating to ponder how in 1981, Jack foresaw and criticized the coming era, in which we currently find ourselves. In 2003, it is common for critics, curators and gallerists to glorify student art, as they troll among art schools, film schools, and now performance programs looking for the next art stars.

"It's the sacred baby poo-poo of art!" Jack would exclaim.

One wonders what the man who prayed, "O Maria Montez, save us from a rented world"—whose last, unmade film was titled *Sinbad In A Rented World*, and from whose aesthetic spring many elements that we now associate with "downtown" or East Village art and style—would have to say about the Broadway musical *Rent*, its co-option of downtown forms and its mainstream success, its cannibalization of these forms, aesthetics, and even the tragedy of AIDS, while not creating any mainstream market for the people it ripped off.

Very competitive, often mean spirited, Jack Smith was very aware of his place in the history of art and his contributions. He hated comparisons to other living artists, seeing himself instead as their source. He saw Warhol, another working-class artist, as one who had succumbed to "landlords" and a user, and was appalled. He hated that Warhol had "borrowed" his idea of flaming creatures as the model for Warhol's "superstars," and that he had copied Jack's use of drag in his films.

When I tried to comfort Jack with the idea that he had influenced Warhol and others, he replied, "I didn't want to influence them. It's not a good thing that I influenced them, and I don't believe they were influenced."

And: "I never intended to create a race of prostitute drag queens."

And: "Warhol made objects of people who have no way of using that objectification."

He believed that it was he who had been used, his work and ideas stolen.

"They've all been fertilized by me," he would weep.

Yet even the artists who claimed him as a friend in the '80s, all of whom had based their style on basic elements of Jack's performance aesthetic, were terrified of his opinions of their work. Even upon learning that he was dying, several refused to honor him with a seat at their performances, frightened that he would cause a scene.

Jack Smith believed artists should be entrepreneurs with no middlemen of any kind between them and the public, or the public's money. This idea extended to critics and what he called "moldy journalism." At one point in the '70s, Jack called the *Village Voice's* theater department,

"I want to write my own review of my new show," he told the receptionist. "I'm sorry, Mr. Smith," she replied, "but if we let you write your own review, then everyone would want to do that."

"Isn't that what newspapers are for," Jack exploded into the phone, "to give people what they want?"

At one point in 1987, when the *Voice* had still not sent a reviewer to one of my shows after four months, I asked the *Voice* to run an ad that said, "Fuck the theater editor!" but they refused. Instead, I settled for "beat the critics," figuring I would draw attention to the fact that the show still hadn't been reviewed. At 3 a.m. the day the ad came out, Jack woke me saying, "You're a genius! I had no idea of your true brilliance!"

Too confused to be flattered, I pressed him. He replied, "You said 'beat the critics!' That's it! The critics must be beaten!"

However, in another run I used a quote of Chris Kraus's in my ad copy which said, "Penny Arcade's performances outrace contemporary performance aesthetics." Jack called, outraged and indignant. "I'm the greatest artist, not you!" he screamed into the phone.

"But," I protested, "it doesn't say that I am the greatest artist."

"But it sounds that way," Jack replied.

"Well, what if I add 'except for Jack Smith'?"

Jack paused a second, and with deep sincerity replied, "That would be alright."

When he moved from Greene Street to an apartment on East 2nd Street, Marie Antoinette helped him. She lifted a box that was extremely light. She turned to Jack and asked, "What is inside this box?" Jack turned and said, "Oh, those are my cockroaches." Jack's sense of self extended not only to his belongings and his work, but to everything around him, to his surroundings.

Jack Smith had his own vocabulary. His list of adjectives—"moldy," "pasty," "oily"—expounded on emotional, spiritual and intellectual elements. He had a series of alter ego names . . . Sinbad Glick, Sinbad Rodriguez . . . names he thought more glamorous and stageworthy than Jack Smith.

Jack not only refused to separate his persona from his work, he literally refused to physically separate himself from his work. In other words, one couldn't just screen a Jack Smith film. Jack himself had to be physically present each and every time. Subsequently, his work was shown less and less. Part of this stemmed from his fears that all along people had made bootleg copies of his films, and *partly because of his belief* that he was continuing to develop and refine the genre of silent film, which he felt had been dropped when talking films began.

Clayton Patterson

Penny Arcade at the FEVA
benefit at Oransanz
Cultural Center

He had developed a concept of "live editing" during the showing of a film, in which he would replace scenes and add and take away as he wished, which no doubt caused much confusion among people who saw different screenings regarding the sequences in this or that film.

His fear of his work being purloined extended to every area of his life. "Everyone wiping their feet through this place has to take a souvenir," he complained. Consequently, his para-noia became part and parcel in his approach to his work, and he applied his genius and cre-ativity equally to all of it. Thus, his enmities were legendary and often violent.

After Jack's death, filmmaker and former partner Ken Jacobs told me a story that illustrates this best: Jacobs and Jack had a long partnership, and after it ended Jacobs tried in vain to get a copy of a script they had worked on together, which he felt had been among his very best work. Finally, after several years of refusing to hand it over, Jack called Jacobs to collect it. When Jacobs arrived at Jack's apartment, Jack handed him an envelope. Looking at the envelope Jacobs said, "But it was pages and pages long. How could it possibly fit in this small envelope?"

"It's all there," replied Jack, slamming the door. Jacobs opened the envelope and found that it was filled with ashes.

Jack's bitter competitiveness and his personality disorders made it next to impossible for him to execute his gifts as a teacher, although he constantly tried to get interns. Jack was painfully conscious that teaching and mentoring were among his greatest personal needs, as well as his desperate need for help in facilitating his unfinished projects. Jack made an effort to recruit interns, advertising in the art schools with posters like Jack Smith's Night School. "I deliver bejeweled art history lectures," he promised. In his last years, he had a series of interns who started out wide-eyed at Jack's brilliance, only to run screaming within days or weeks from his Lower East Side apartment.

In 1982, I was working with Jack one day sewing costumes to help him prepare for a show at the East Village's Pyramid Club. A young intern from the School of Visual Arts was painting a frieze around the 12 x 12 salon. When Jack left the room, the young man leaned down from the ladder and whispered to me, "You seem to have a lot of influence with Jack. I've been painting this frieze over and over for 3 weeks. I'm going crazy. Please help me."

I turned to Jack and said, "The frieze looks wonderful, but he's been painting it over and over for three weeks. Couldn't he stop now?"

"What's three weeks?" screamed Jack, leaping to his feet. "Look at the pyramids. It took 300 years to build them! Do we know the names of any of the people who built them? Their suf-fering went into the pyramids." He directed the intern to keep painting. "Your suffering has to go into the wall."

The next morning my phone rang at 8 a.m. "Where are you?" Jack demanded. "You should be here sewing."

"But Jack," I replied, "I've got my own stuff to do today. I have to work here, run errands, do my laundry, go to work and make money for six hours . . ." etc.

"No one is that surrealistically busy!" Jack whined into the phone. "No one helps me. You are like the rest. You just want to be fertilized. If you don't come and sew today, you can't come to my performance Friday at the Pyramid. If you show up, I will refuse to perform."

I made up my mind that I wasn't going to cave in to Jack's demands. I couldn't; I needed my job. The next few days were filled by a series of violent messages from Jack on my answering machine. I was shocked by the depth of Jack's cruelty and abuse, as he had never turned it on me before. The night of the performance arrived, and I told everyone I didn't dare go. "We'll smuggle you and protect you. He won't even know you're there," everyone said. So I did end up going.

Bundled up and hidden, I stood in the middle of a group of Jack's friends, as far from the stage as I could while still being able to see and hear. The lights rose on Jack at the edge of the stage. Raising his hands high above his head, he turned and intoned, "So you didn't want to sew!" and for the briefest instant I thought he saw me and was speaking to me. As he con-tinued a monologue in which he said many of the things he had said in his numerous phone messages, I realized that all of Jack's rage toward me had gone into his performance, which was indistinguishable from his tirade of the days leading up to the show.

Jack was legendary for torturing his guests with strange and grotesque food. Once he served cold octopus aspic in its own ink, made all the more horrible by its presentation in the container in which it had been chilled, the plastic bottom drawer of a refrigerator.

I was once presented with a tray of open-faced sandwiches made from a puree of sardines and legumes, brown and torpid.

In August of 1989, Ira Cohen called to tell me he had heard that Jack had been in the hospital, but was now at home. He asked me to go and see Jack, which I immediately did. I found him thinner than I had ever seen him. Physically exhausted, he hadn't eaten in several days and had been virtually alone, without visitors. He was evasive about why he had been in the hospital, briefly mentioning that he had walked out during an Bactrim I.V. treatment, which I knew was the standard treatment for pneumocystis.

Later Ira called, wanting to know how Jack was. "I really want to help Jack out," Ira said. "Do you think that now that he's ill with AIDS and knows he is dying, he'll be easier to deal with?"

"What do you mean?" I asked Ira.

"Well, you know Jack has always been a mean person. Do you think it's safe to go over there? Do you think he's going to be horrible?"

I replied, "Jack is meaner than ever!"

Ira Cohen, Mitch Markowitz and I, along with Ivan Galietti and Jack's upstairs neighbor, the few people to whom Jack was still speaking, looked in on him and took on the tasks of getting him fed, taking him to doctors, and trying to make him comfortable.

A short time later, he went into Beth Israel Hospital and died peacefully on September 16, 1989. He was just two months shy of his 57th birthday.

When Jack died, I called the NEA, seeking some funding to preserve his work. "We had a lot of problems with Jack Smith," came the response. "But Jack is dead and he's left an extraordinary archive where you can trace the past 30 years of art," I said. "I'm sorry," the administrator said, "but dealing with Jack Smith was very difficult."

"Yes, I know Jack was a very difficult person," I replied. "But he's dead now, and he's left all this work."

"Well," came the stubborn response, "I still have a bad taste in my mouth from dealing with Jack Smith in the '70s."

"I understand," I countered, "but you see, Jack Smith is dead now and he left all this extraordinary work. The beauty of it is you don't have to deal with Jack because he's dead, but the work is still here." But to no avail . . .

Later, I invited Jim Hoberman, the *Village Voice* film critic who had kept Jack's name alive through the '80s in his reviews of Lucas and Spielberg and whom Jack considered his personal critic, to join me when I formed The Jack Smith Archive. The late Tony Vasconsellas and Alanna Heiss of PS1, a long-time admirer of Jack's, had agreed to give Jack's work a deeply merited retrospective at PS1 Contemporary Art Center, in Long Island City, New York.

I had been fighting to keep Jack's apartment as a museum, and it would be another year and a half before I was willing to give up that idea. After all, hadn't Eisenstein's apartment been preserved for over 50 years at that point? Frederick Fisher, the renowned museum architect who had redesigned PS1 in the early '90s, agreed to look at Jack's apartment for me and wrote a statement calling the apartment "one of the greatest combinations of art and architecture that I have ever seen" and a made a strong case for its preservation.

Keeping the apartment at 21 First Avenue proved impossible, even though the landlord eventually brought a suit against me when Jack's estranged sister said she wanted nothing to do with it and abandoned the property along with Jack's debts, after taking a few pieces of small furniture she thought she could sell at a flea market.

Jack's friends didn't seem to understand the value of keeping the apartment that Jack had modified with paint, plaster, bricks and paint to be the film set for *Sinbad In A Rented World*. The kitchen, Jack explained, was a "ruined sambuca in a papyrus swamp," a boat that had run aground. The walls of the rest of the apartment were covered with Jack's scrawl: aphorisms, oaths against certain people and society, as well as lists and exclamations. In other words, an extraordinary work of art.

"Jack's dead," complained several of his friends when I explained the concept of keeping

the apartment as a museum. "What's the point of keeping the apartment?" I found this attitude incomprehensible. I went forward trying to save the apartment. In the end it was videoed, photographed, measured, catalogued (with paint chips, etc.) for posterity before the landlord demolished it without notice.

The retrospective at PS1 in 1997 was fraught with problems, and the wished-for touring of the show, with the exception of The Warhol Museum in Pittsburgh, was not to be.

The Plaster Foundation has struggled along for 13 years, its only income derived from the sale of films to institutions and the gifts of a generous artist who worked with Jack as a young man. The foundation has restored all of Jack's films with the help of Jerry Tartaglia, a man with some psychic connection to Jack, who recovered the long missing internegative of *Flaming Creatures* from a pile of film cans left out on the street in the late '70s.

While Wooster Group actor Ron Vawter's successful one-man show Roy Cohn/Jack Smith did much to raise awareness of Jack to a new public in the mid-'90s, it was very problematic in that it presented Jack in contrast to a very "straight" acting Roy Cohn. Vawter, choosing his artistic agenda first, and never having seen or known Jack, represented Smith as a very effeminate man, far from Jack's persona.

I fear that as much as Jack has been ignored, he will soon be devoured and spit out, without real attention to his own very specific and rigorous definition, in ways that will further the agendas of what Jack used to refer to as "brain pickers," people without vision, people without ideas of their own.

In 1991, when the news announced that Basra had been bombed during the first American-Iraqi war, I sat watching the television with my mouth open. Jack often referred to Basra as his personal Mecca, and as often as I had heard him mention it, I had never actually considered that it existed. Almost everything that Jack ever told me has come to pass. The loss of American freedom, which was always uppermost in his mind, has been tested like never before, and while there are champions against the machine, it looks like the Lobster is winning.

When Jack lay dying at Beth Israel Hospital, he begged me to destroy his work. "But what about all the people who never hurt you, who want to know about you? What about 200 years from now?" I asked. "It will only get worse," Jack countered.

In the late '70s or early '80s, Jack held a screening at the St Mark's movie theater, which stood at the corner of St Marks Place and Second Avenue and whose demise in 1985, when it was turned into a Gap, marked the beginning of the end for the East Village for many people. It was the first time that I had seen *Flaming Creatures* on a big screen. At the end of the screening Jack leaned over the balcony and shouted, "Go! And tell all the scum of Baghdad!"

It appears that there is once again a great interest in all things East Village—a cyclical event that has happened every few years for the past 20 years. But perhaps, as with many things remaining behind in the 20th century, the last great art scene of post-World War II New York is attracting unprecedented attention. What remains of utmost importance to me is the way Jack is perceived, and most of all, to grant Jack his wish that his work be seen by the widest public possible, in as many forms as possible.

Many people have opinions of Jack Smith, and many more will continue to interpret Jack's ideas, but as with all artists and thinkers, what anyone thinks of Jack Smith is not important in the least. What matters is what Jack Smith thought of Jack Smith, and to that end I pray for a return to original and primary research based on a true interest in the subject, not a fact finding mission for variously biased agendas.

Jack's time for real consideration seems on the horizon. We can only wait to see if the prescience of Jack's views on society and the art world continue to be accurate.

Baroque on The Lower East Side

Jack Smith's *Flaming Creatures*
And telephone messages from Ed Marshall

by Jerome Poynton

The 1960s on New York City's Lower East Side—scenes from an era hard to imagine, unless you were there, in which case it may be impossible to remember. It was the time of the great amphetamine explosion—an explosion of creativity and illness—moving from street to street and described by writer Herbert Huncke as "an invasion of locusts."

Outside the Lower East Side, in traditional American culture, the Cadillac was the car of choice and I imagine one pulling to the curb the night of April 29, 1963, in front of the Bleecker Street Cinema for the world premier of Jack Smith's film *Flaming Creatures*. I imagine several baby boomers jumping out of the elegantly finned caddy; gals wearing pleated skirts, ideal for dancing "The Twist," and guys in button-down Oxford shirts.

Car radios blaring up and down Bleecker Street trailed popular AM radio into the night: "Surfin' USA," by the Beach Boys; "It's My Party," by Leslie Gore; "Walk Like A Man," by the Four Seasons, or Elvis Presley's "Devil In Disguise."

Quite a contrast to what was about to be seen at the *Flaming Creatures* premiere: stark black-and-white images of Lower East Side locals filmed in various degrees of dress, undress, costume and makeup. These images were accompanied by a blended sound track of Japanese music, pop and eerie screams. The film begins with a continuum of faces (as in 19th century photographic portraiture) coming in and out of frame, as the eye plays "peek-a-boo" with opening credits. The film was almost immediately banned and in one fell swoop, the film underground, which began with Robert Frank and Alfred Leslie's *Pull My Daisy* in 1959, became above ground.

"I was in the opening sequence of *Flaming Creatures*," Eila Kokkinen recounted. "Jack wanted to make me look as terrible as possible. 'You don't look terrible enough,' he said. He put dark makeup on me. Irving Rosenthal [editor of *Big Table*] was sitting next to me. 'There, there,' Irving said, reassuring me."

Eila settled into the Lower East Side community in 1959. She came from the University of Chicago where she was art editor of the *Chicago Review*.

"I introduced Jack to Heinrich Wolfflin, who wrote *The Principles of Art History*," Eila continued. "Wolfflin wrote about the stylistic concepts of Classical and Baroque. David is Classical; Rubens is Baroque, full of swirling rhythms. High Renaissance art—great big altar pieces, angels flying around, virgins ascending—starting with Caravaggio and builds up to these very grandiose altar pieces and ceilings. That, and turning it into a style, Jack started doing Baroque compositions—piling bodies on top of bodies, flowing drapes."

"The films were made with very minimal equipment. What was at hand—developing a fantasy—using friends. Jack had a notorious reputation for how long it took to complete a film."

More than anything I've read, Eila helped me understand the undeniable beauty of *Flaming Creatures*. The nudity is captured with religious modesty and naturalness—as if the subjects were privately nude—with neither forced naiveté nor hyped sensuality—flaccid penis behind rounded shoulder.

Eila's comments, and the 1968 entry in The Congressional Record (after the film was screened by the late Strom Thurmond as an example of pornography), are perfect bookend reviews of the film for anyone who hasn't seen it:

"[It] presents five unrelated, badly filmed sequences, which are studded with sexual symbol-isms . . . a mass rape scene involving two females and many males, which lasts for seven minutes, showing the female pubic area, the male penis, males massaging the female vagina and breasts, cunnilingus, masturbation of the male organ, and other sexual symbolisms . . . lesbian activity between two women . . . homosexual acts between a man dressed as a female, who emerges from a casket, and other males, including masturbation of the visible male organ . . . homosexuals dancing together and other disconnected erotic activity, such as massaging the female breasts and group sexual activity."[1]

Flaming Creatures, running 42 minutes, was made on the roof of the Windsor Theater at 412 Grand Street during the summer of 1962. "He almost always had a script," Irving Rosenthal recalled, "but it just dissolved." Rosenthal continues:

"His charisma, in large part, he was, Jack was, absolutely a pure artist and everyone knew it. That is why everyone put up with so much shit from him: because of his purity. He was a totally devoted artist, completely devoted to art. That is the truth of it. The other stuff, the drugs, everything else, that wasn't as important. That was a little important, actually. Every-body was on drugs. Heine[2] was on drugs. Heine was interesting. He was an artist also, but not with Jack's intensity, or with Jack's devotion and not with Jack's novelty, genius, and imagi-nation. That is the word. It was his imagination, which was incredible. And also his schooling, I would say, his self-taught schooling in art. Jack knew painting very well. Warhol did too, I believe. But, anyway, Jack was a much more imaginative artist than Warhol, anyway, that's my take on it."

Flaming Creatures put the director on the map and there is obviously much more to learn about Jack Smith other than from this film. It is a hard film to describe. It was immediately banned, prints were seized and that, as I said earlier, brought the underground and Smith into the spotlight. I was amazed, while watching, at how faces and body parts came into the frame at such odd angles, seemingly unnatural at first and then becoming quite natural and comfort-able. Smith creates a living sculpture and, using Eila Kokkinen's imagery, transports the viewer to a surreal church of living marble bodies; parts of the bone shiny from being rubbed by many hands, parts of the bodies old and sullen. There is a short segment in the film where a transvestite emerges from a coffin with a flower. He kisses another person—I can't remember if it is another man or a woman—sexy just the same (as if either could be more or less sexy)—creating fantasy material for subjective exploration. I disagree with the Senator, who, upon seeing *Flaming Creatures* with Strom Thurmond, commented, "that movie was so sick I couldn't even get aroused."[3]

The poet Ed Marshall, living in the Lower East Side community during this time, was part of the cast for *Flaming Creatures* and a member of the extensive writing and drug scene which included poet John Wieners, actor Joel Markman[4], writer Herbert Huncke and artist and musi-cian Bill Heine. (Marshall's poem "Leave the Word Alone," one of the great beat poems of the time, influenced A. Ginsberg's writing of *Kaddish*.)

I caught up with Ed on the telephone and the following transcriptions were gathered from his quirky and dreamy paced response to the memory of Jack and *Flaming Creatures*, on which Ed spent one day in action and other days in friendship:

*"Jack Smith, kind of an amazing thing. I'm trying to recollect [*Flaming Creatures*]; it came on a basis of design. I had met him; he had gotten involved with photography—either lamp or lamp-shades—doing pictures—taking on human characteristics. And from this he got the idea to devel-oping this into motion.*

The thing that comes to the fore is the idea of an oval or a base. It might be a chiseled diamond—it could be possibly an etching—the thing that hangs down from a ceiling or an imaginary ceiling could be more round like a light bulb or taking on more of a thing. But it does have, according to many, it would have the ideas of fresh balls, those feature[s] to be found in human beings, either male or female, that kind of overlap in suggestion and the idea of a cherry picking.

So often, Jack would be so dense but given the right focal points, or objects to put into his hands, or something like that, is kind of the way you talked to him. You didn't get into the deep conversations because he would be lost, or even the suggestion to him that he could be a great person in this way or that way.

I didn't get the picture Jack would ever go to talk with someone philosophically unless there was some key object, which would stand out over and above the personality. If you were talking about diamonds, I don't think you would go to some pictorial book and discuss the grades. It would be what could be seen through it: the rise and action and emotion.

I think [Flaming Creatures] is dealing more with the natural things because he was not involved, to my knowledge—maybe only very minimally—dealing with the drug scene, other than marijuana, unless it is something I missed. Now you take the old amphetamine community, so many of them were rolling cloths [cloth origami] that brought in that multiple thing, at the Episcopal Church down there, and I mentioned it to a clergyman once. He looked at me rather strangely. I mentioned to him one of his churches that had developed into quite a place for design—he was the Chaplain at Bellevue—he didn't have the faintest idea.

Bill Heine, I would say that he probably did more [cloth origami] than anyone.

It is kind of what was happening in photo stretches and relationships. Instead of cloth, it developed into skin itself. The idea of patching a room full of quilt and skin. I don't know where it developed from but it was something Jack Smith worked on and developed overnight. I don't know if it developed from the Noxema Lady— I don't know what it is he produced with it unless it was to be used as a basis for the skin and to develop color on it.

I'll give you a quick illustration: There was an older lady when I was a kid and she was the first to tell me what a mental institution or state hospital was like and there was always a person who dressed in a certain way and who had a mammoth stretch of toilet paper on her, and so on, and dressing up like as if she were a queen. You can do anything you want to do with that imagery. The idea is that I learned later on in life that anyone in a mental hospital doing something like that is a pure exaggeration of what we all do in real life. We're always putting on something. If we're not right in one area, we're going to make it up somewhere else.

Clayton Patterson

Jack Smith playing Death in the Shadows in the City

In other words, all I'm saying is that what Jack doesn't do in the university's understanding of art, and so on; he just takes a thing and just says I deal with "universals" and I'm taking it from the bits of clothing and the bits of china and that is what I'm working with. You don't have to come with a bag full of ideas. Gregory Corso's answer to all that trajectory verse—he called it a sand trap—using words and ideas and what the poets were doing, just making a sand trap which stopped the real flow of things.

Something to be said there.

You might look into Gregory Corso.

I can't say Jack got into the development of ideas. These were self-propelling [events]. He was amazing all right. It took on other features that went overnight. Take a painter like Andy Warhol— some of the unusual stunts that developed before he was involved with any craft of paint. It was kind of going from studio to studio. You could see it was a huge canvas set up on the Lower East Side, unfolding itself and stretching itself for eventually one or two personalities to emerge and for this one person, Jack Smith, to be all of a sudden be appreciated after the tragic death of Andy Warhol—it produced another thing—Jack didn't have to be thinking of what he could salvage from Campbell Soup. I don't think Jack thought of all the social things, the history of it, partly to do with advertising, partly to do with his own acquisition to new things. Of the two, I would say that Jack made things far more fluid and maybe Andy Warhol provided something like the great container. In other words, one was doing something with potential liquid and the other was melting it or solidi- fying it to his own art form.

It is not my specialty to be involved in that enterprise and I was always amazed that I just had a little finger in it and brought this to a head and taught me a few things. I must confess, I didn't do a bigger job in the actual setting up.

Jack had the cooperation. This is one thing. He showed freedom in letting people do what they wanted as long as he could photograph it primarily for effect. The people he was filming were just as free as a bird. I don't think anything was suggested to me as to how I should stand or what should be done. There was no idea as to how to control me as long as he could get some kind of motion. Part of it has to do with the oval shape in different dimensions—whether it takes on the form of the egg or a vase, or ultimately, the human body itself.

You could see the unfolding all around on the Lower East Side. That was part of the early Warhol; but as I said, the container took over but it looked tasty just the same. The idea of the soup can. If you wanted to you could easily turn it around and put a lot of paint in it."

Jerome Poynton is a filmmaker, writer and literary executor to Herbert E. Huncke.

[1] Congressional Record—House (9/4/68) p. 25562, as per *On Jack Smith's Flaming Creatures* by J. Hoberman, page 48.

[2] Bill Heine—*Bill India* in Irving Rosenthal's *Sheeper* and *The Magician* in Herbert Huncke's writing—introduced cloth origa- mi, related to tie dyeing, into the Lower East Side in the late 1950s. and '60s Heine is referenced in Bob Dylan's song "It's All Over Now, Baby Blue": The highway is for gambler's, better use your sense. Take what you have gathered from coincidence. The empty handed painter from your streets is drawing crazy patterns on your sheets. The sky, too, is fold- ing under you it is all over now, Baby Blue.

[3] *On Jack Smith's Flaming Creatures* by J. Hoberman, Granary Books/Hips Road NYC, page 49.

[4] Joel Markman, one of the leads in *Flaming Creatures*, traveled to Canada several months prior to the filming of *Flaming Creatures*, with writers Herbert Huncke and Janine Pomy Vega to recuperate from the Lower East Side drug scene. Searching Joel's bags, the customs agents found various pamphlets and books, including *Naked Lunch* by William S. Burroughs. "What do you intend to do with these?" the customs agent asked Joel. "Why, distribute them," Joel magnan- imously replied, "to the youth of Canada." On the basis of this, they were immediately denied entry into Canada.

Wait For Me At The Bottom Of The Pool
The Writings Of Jack Smith

Flaming Creature Jack Smith: His Amazing Life & Times
The Jack Smith Show at P.S. 1 Contemporary Arts Center Till March, 1998

Reviewed by Nick Zedd

Having been airbrushed out of the Jack Smith story by a pack of vultures who came to feast on his corpse following his demise, I can offer some insights into the skewed dissemination of his legacy in our distorted era. With the release of two books and the astonishing retrospective of his collected ephemera at the P.S. 1 Contemporary Art Center, the general public is offered the spectacle of an exploitation bonanza in wax coated golden brazen upturned hindu containers.

Having witnessed the truncated single-screen presentation of *Normal Love* concocted by Jerry Tartaglia, blissfully ignoring Smith's epic two-screen edit in order to spare an imagined audience of an excess of tedium, I was first made cognizant of the repugnant nature of second-guessing a genius in order to appease the lowest common denominator.

Not wanting to rock the boat, Tartaglia, J. Ostrich Hoberman and a contingent of vultures carefully packaged Smith's treasures as an appealing funhouse mirror, depriving audiences of a complete experience in order to save time and make things easier on the projectionist. Since everything must be prepackaged and conveyed in bite-sized bits, the pleasing celluloid presentations have been edited down to 90-minute lengths in order to offend the least number of people. The problem with this equation is that it seriously erodes the intent of the creator, whose aesthetic imperative always included the dictum that hard work must be endured before comprehension of lightness and polymorphous perversity.

Attending a Jack Smith event was a long march of endurance, a challenge: the realization of a way of life not lived by people on time schedules dictated by jobs, personal responsibilities or the need to be distracted and amused. His work could be vastly amusing while simultaneously tedious and pointless, but the entire experience had to be confronted in order to know it.

Probably the most distorted and parasitic appropriation of Smith's work was Ron Vawter's play Roy Cohn/Jack Smith in which the actor parodied Smith's performance of *What's Underground About Marshmallows?* in a mincing and shrill portrayal, surgically removing the man's dignity in order to get a few laughs. Knowing Jack myself, I'm sure he would have been enraged to witness this emasculated caricature and the fact that the Wooster Group put it on long after refusing to let him perform there, adds insult to the injury. The tragic deaths of both men to AIDS in no way diminishes the calculated malevolence of Vawter's disingenuous rape and pillage.

I confess a soft spot for Miss Arcade, however, due to the fact that she appears to have loved Jack and wrote a touching and sincere account of his last days and moments, included in *Flaming Creature* Jack Smith; *His Amazing Life And Times*. It's probably the best thing ever written about Jack.

Jack's work was an evocation of travesty, of the carnivalesque, according to Nayland Blake, and as a longtime follower and afficionado, I concur. The effect he had on other artists was astonishing. Jack was the high priest of creativity. He gave of himself in everything he did, in the sense that he was true to himself and utterly selfish in his refusal to compromise. He made no concessions to other people's feelings while at the same time attempting to make them laugh.

The sheer magnitude of his creativity on display in the P.S. 1 show is a miracle. The elaborate costume designs displayed on mannequins, surrounded by Smith's drawings on the walls, done for a Sinbad epic that never was completed, when compared to the vacuous garments done by major designers aping Warhol's style in his show at the Whitney are a stark rebuke. As is the Smith collection of Maria Montez stills—a far more exotic and

unexpected source of glamour when compared to the gallery of photos of Liz Taylor and Marilyn Monroe in the Warhol show. Warhol's choices seem obvious, connected to the mass market, majoritarian and mundane. Smith's are a celebration of the mediocre, bathed in the accoutrements of the extraordinary, according to Hollywood's design staffs.

I think Smith cared less for genuine acting talent than for a nostalgia of surface glamour. It was an evasion of recognition that continues to baffle. But it also redirects our attention to ourselves as we sit and squirm. He got a malicious glee out of forcing people to confront their own willingness to be passive in an ordeal by entertainment.

Having participated in a performance with Smith in the early eighties at the Pyramid (conveniently omitted from the P.S. 1 show by the Ostrich Squad), I recall a stage covered in chiffon obtusely decorated by some long-forgotten art fag which Jack elegantly ripped to shreds, bursting someone's bubble, while I recited a story about a breakup I was going through.

This was my first public reading. I didn't know what I was doing and I didn't particularly want to be doing it, but having been talked into it by the late Ela Troyano, who projected slides onto the stage, I'm grateful for having done it, for it gave me the first realization that I could entertain an audience through confession.

The event was documented in photos, which were also conveniently omitted from the P.S. 1 show. A committed group of plotters toe the line in excluding me and others from inclusion in Jack's existence. They remind me of the drama queens who have blackballed me from showing movies in nightclubs, due to a bottle I threw at the head of a malignant clown begging to be silenced.

When I typed up a play Jack wrote, called *Clash Of The Brassier Goddesses*, which he had scrawled on a couple sheets of paper and thrown on the floor of his apartment, he didn't seem to care. I handed the typed pages to him in Howard Travelplan's *Insane Asylum*. Jack gave me permission to print the play in the first issue of the Underground Film Bulletin. When it came out, he stopped talking to me. The play has been airbrushed out of the Jack Smith show, as has chapter three of my book *Totem Of The Depraved*, in which I cover the two years that I knew him.

Were these omissions made consciously, or are the curators of his work unaware of our involvement with each other, minor though it was? I suspect there are dozens of other humans who interacted with Jack and produced work of merit who have also been excised for dubious reasons. You don't break or alter a dominant hierarchy by imitating it; you must offer a compelling alternative, and in this respect Smith was a revolutionary, whereas his doppelganger, Warhol, was a court jester.

I am grateful that the vultures arrived at the funeral party to pick and claw at Jack's corpse, for in publishing his writings in *Wait For Me At The Bottom Of The Pool*, they give us voluptuous evidence of his brilliance. That said, Jack could have used an editor. At times he seems to have no awareness of what a long-winded bore he could be. Long, pompous diatribes of a ridiculous nature are interspersed with brilliant displays of verbal wit.

"That night of the Lobstermoon charade of the Narco goon squad the potted palms of the Broadway Central ballroom bristled and spawned strange coconuts."

A sentence of this ilk is worth the hours of slogging it takes to get through Smith's detritus delirium.

Likewise the beautiful color photos of Smith and his cohorts festooning the *Flaming Creature* book is a feast for the cornea, conjunctiva and choroid coat.

Little did I expect such a cornucopia of pulsating perversity to be published. My accolades to the scabby carnivores who disgorged this compendium of mirth into the charnel house of our lives. To have fecundated this pandemonium of palpitating pulchritude is a blessing in disguise. But what was left out?

Media Mecca and Mayhem: Ferment on the Lower East Side

by Jud Yalkut

The Lower East Side of New York has always been a state of mind as well as a physical location. In the amorphous transformations of the broad area between 14th and Houston Streets, there has always existed an almost mythical entity called "The Village." West of Seventh Avenue with its stellar center at Sheridan Square, it became the realm of rising or established characters in the increasingly gentrified West Village. Extending approximately to Third Avenue and Cooper Union, the Village assumed mythological proportions and attracted an increasing tourist trade with a focal center around Washington Square Park and nearby McDougal and Bleecker Streets amid Italian espresso machines and the early roots of New York's Bohemian culture. Within these areas, streets wove strangely through and into each other, following transplanted trajectories derived from European city structures, violating the later grid structure superimposed on Manhattan Island.

But east of Third Avenue, once called the "Bouwerie," the East Village extended to the East River past the rallying grounds called Tompkins Square Park. East Village was a place where struggling artists of all descriptions found nesting places, as cramped, outmoded, and unfinished as they might have been. The difference in the early 60s between a small "luxury" apartment between one and two hundred dollars in the West Village, and a thirty dollar- a-month "crash" pad within the lettered streets of the East Village, was the survival ticket for many of that generation's intelligentsia and cultural renegades. Below Houston Street in the East, there also flourished the remnants of a rich Jewish immigrant culture, still immortalized on Houston in Katz's ("Send a salami to your boy in the Army") delicatessen and the amazingly cozy but unglamorous confines of Yonah Schimmel's knishery.

Between Third Avenue and Tompkins Square is St. Marks Place, once the "gateway" between the East and West Villages. I first moved there in 1960 after brief forays into Bank Street in the West Village and East Seventh Street between Avenues C and D. It was a relatively quiet thoroughfare. With its rent-controlled price of fifty dollars a month, upped from thirty three for the previous tenant to compensate for an extra radiator and a new tiny toilet which replaced the shared facility in the hallway, this fifth floor walk-up railroad flat with its bathtub next to the kitchen sink, and its convenient location between Third and Second Avenues, was a relative godsend which I relished for over thirteen years.

As a native New Yorker, born in the Bronx, who left the city for two years of college in the exotic "foreign" atmosphere of Montreal, Canada, I returned to New York for a year in 1956 before going "on the road" to California for three years in the spring of 1957 during the consciousness explosion of Big Sur. The year I returned to New York was centered around, first, a rented room on McDougal Street, and then a shared storefront on Sullivan Street in the Village proper, but allowed me my first full tastes of the East Side through friends such as the painter/poet Ted Joans, who lived in and maintained a studio/gallery on St. Marks between First and A. I shall never forget the gig of painting the interior of "the Pad" jazz club on Sheridan Square with Ted, while Charlie Mingus and his "Pithecanthropus Erectus" band, with Jackie McLean and J. R. Montrose, rehearsed endlessly and marvelously as we, in our coveralls, applied our rollers to the walls.

As a young poet who oscillated between the resonance of the written and spoken word and exaltation of the visual arts, I worked odd jobs during the year I pursued my chosen métier reading poetry at the original downstairs Gaslight Café on McDougal Street. I shared the stage with others like John Brent and Hugh Romney, later known as Wavy Gravy, while future musical notables like Ritchie Havens played extended breaks between our impassioned recitations. While the

Village was a main center of activity, there emerged an alternative gallery row on East 10th Street, while small, short-lived coffee shops spotted around the East Village encouraged hit-and-run readings and performances, producing a cultural blossoming both in and out of season. This was the period that saw the birthing of the *Village Voice*, with its then "radical/liberal" support of Ed Koch as City Councilman, and house-rent parties, like the one that was disrupted by the police for spilling out onto the pavement.

This was a period when so-called Bohemianism was evolving into the Beat ethos and, though one always remained the same, the sobriquets imposed upon one from outside were in the process of change. Later into the 60s, it would suddenly become Hippie-ism and black turtle-necks would metamorphose into Indian kurtas, occasional Nehru jackets, and Carnaby Street clothing. The Beat scene was oscillating between the metropolitan centers of New York's various Village areas, San Francisco's North Beach, and Venice Beach in Los Angeles, with side "tripping" forays to then amenable ports in Mexico, Paris, and North Africa. The scene was so fluid that during my first week on Grant Avenue in North Beach in 1957, I ran into a half-dozen friends and acquaintances from the scene in New York, by simply hanging out in the right places.

When I returned from California, including the year-long epiphany of Big Sur, where I gave up writing poetry at the tender age of nineteen like Rimbaud to simply live in the glory of nature and bake bread in wood-burning ovens, New York was a transitioning cultural mecca. Ornette Coleman and his group started revolutionizing jazz at the original Eastside location of the Five Spot on the Bowery, where earlier that year John Coltrane and Thelonious Monk had galvanized the scene. Alternative music would spring up during the next few years in loft and Second Avenue storefront concerts from jazz renegades like Don Cherry and Sam Rivers, and the emerging group of "minimalist" composers like La Monte Young, Steve Reich, Terry Riley and Philip Glass. Pop and Op, and Psychedelic Art were displacing the prevalence of Abstract Expressionism, American poetry was influencing world literature, and there was no turning back. I loved every second of it, and New York was the place to be

From late 1959 through 1960, I worked alternately as a sales clerk between two bastions of alternative culture on the main Village thoroughfare of 8th Street. This included two long periods at the collectors' and import record store, Discophile, as the store's limited budget permitted. These periods were separated by a relatively short tenure at one of the literary hotspots of Beat culture, the Eighth Street Book Store, which became the publisher of broadsides and chapbooks by prominent Beat poet Philip Whalen to Le Roi Jones, on its imprint labels, Totem and Corinth Books. At Discophile, I was resident avant-gardist, co-working with jazz soprano sax virtuoso Steve Lacy and Paul Rothchild later to become producer for Elektra Records of albums by the legendary rock group, The Doors. It was at Discophile that I served customers from writers Anais Nin and Arthur Miller to my eventual long-time friend, composer/writer and publisher of the seminal Something Else Press, Dick Higgins.

There were extreme ups and downs throughout the scene, particularly on the East Side. Drugs of every description proliferated and there were many casualties, mainly from smack and amphetamines. I had the unfortunate experience of seeing talented photographers and composers permanently rendered into babbling idiots. Others merely never survived. In this frantic atmosphere of experimentation with a sometimes edge of self-destruction, there were also the other motivations of honest spiritual search for inner development. However, in the unguided quest for the dissolution of the ego, the body and mind were oftentimes abused. There was fertile ground for the gurus and teachers, mainly from India, who made their appearances during that next decade. The beginnings of the Hare Krishna movement, which established local headquarters in the Lower East Side, was one of the most visible gleaning centers for those seeking their center in an uncertain time.

The spiritual quest had been one of the driving factors behind my peregrinations across the United States, and led me through the extraordinary good luck of involvement with powerful enlightened teachers like the Indian Sufi Pir Viliyat Khan, and the way of life of the macrobiotic teaching of George Ohsawa and his extraordinary wife, Lima. The Lower East Side became a haven for those pursuing the macrobiotic way, and the first fully macrobiotic restaurant, aptly entitled "The Paradox," was its bastion on East 7th Street off of Second Avenue, now the ubiquitous home of myriad purveyors of Indian cuisine. The Paradox was the origin of "all the free

Bancha tea you can spill on the floor," and the site for the realization of "Stone," the Zen-like burlap bag isolation piece by Yoko Ono, another denizen of Second Avenue.

My quest also sought the resolution of the ultimate means of fashioning my creative vision. Being given a used regular 8mm film camera by the English woman who was later to become my first wife and who was also, as I was, an independent film buff, transported me back to my early teens when I had briefly experimented with the film medium. A devotee since the age of twelve, when I was able to acquire a student membership to the Museum of Modern Art and devour its burgeoning alternative film collection, I knew my creative direction from the start. One of my earliest films was made with the assent of the first Bread and Puppet Theatre on Delancey Street. That street also boasted the brief existence of the Delancey Street Museum, featuring the works and environments of Red Grooms, Jay Milder, and an old friend from my five-month stay in Louisville, Kentucky, on the way to California, the African-American painter Bob Thompson.

Within the limitations of this relatively primitive device that had a separate viewfinder which did not show directly what was in the lens, I superimposed sections of film, running the film through the camera multiple times, using my visual memory as a construction tool. Thus was produced an extensive early body of work, until I was able, in 1964, to purchase a used 16mm Bolex at the Willoughby-Peerless camera store on 32nd Street. This was the "dream machine" that helped fulfill my dream of composing moving visuals directly within the camera.

There were no film teachers at that time, and my progression to optical sound, synchronized editing, and completed release prints was a gradual, self-taught process that eventually led to my being one of the early teachers of Experimental Film at the School of Visual Arts on 23rd Street in 1968. It also led to my being a second-generation film artist of the New American Film Group, co-founded by the inestimable Jonas Mekas. This centered around the artist-run Film-Makers Cooperative, where I eventually served on the Board of Directors for five years in the early 70s. It also centered around the peripatetic roaming Filmmakers Cinematheque, which revived itself in innumerable locations from lower Manhattan and the Wurlitzer Building on 41st Street, including an old neighborhood theater on Avenue A, where it featured the premiere of *The Flower Thief* by another Lower East Side filmmaker, Ron Rice, and his Lower East Side poet/actor/star Taylor Mead. The community of filmmakers was an intercommunicative world at that time, with people often helping others with projects or technical know-how, sharing each others' work in open screenings and attending one another's shows at the limited, but dedicated, venues around town, the majority being in the Lower East Side. These included the Bridge Theater, across the street from my St. Mark's apartment building, and the Black Gate Theater on Second Avenue, run by film/video and performance artist Aldo Tambellini, who styled all of his productions in shades of black and white as a personal philosophical premise.

The year 1965 became a pivotal one for my career, when I began working as resident filmmaker with the groundbreaking multimedia group, USCO. I toured shows and museum/gallery installations through 1972, and later that year began my still ongoing collaboration with pioneer Korean video artist Nam June Paik, whose loft space on Canal Street became the production center for our series of video films. I was blessed, throughout my career, to often be at the right place at the right time, making connections with the right people and finding new sources of creativity. This atmosphere of collaboration and simultaneous individual development has been essential to my entire vision and being.

My involvement with Paik brought me full force into the emerging world of alternative video. This exploded with socially corrosive force with the advent of the portable video camera and recorder, the Sony Porta-Pak configurations from the CV to the AV series, which permitted instant playback and editing capabilities, and changed the face of the media/performance/gallery worlds forever. The increasing demands of the video artist fomented the rise of the hippie-engineer genius that could fashion the creative technical tools demanded by the video movement's surging impetus. From the almost simultaneous development of the Paik-Abe Video Synthesizer, the Eric Siegel Synthesizer and Colorizer, the Rutt-Etra Digital/Analog Video Synthesizer, and the West Coast Digital Video Synthesizer by kindred brother Stephen Beck, many other devices became tools for fashioning formerly unimaginable visual worlds in motion.

A good deal of this evolutionary video story, most often told in the words of its creators and practitioners in first-hand accountings as it was happening, is compiled in my 400-page unpub-

lished manuscript, *Electronic Zen: The Alternate Video Generation*. This manuscript, completed with the aid of a writing-In-media grant from the New York State Council on the Arts in 1984, is available in the archives of the Experimental Television Center in Oswego, New York, with selected portions available on the Internet through several early video history websites.

I was seduced back into writing in 1966 when I was invited to contribute a regular Critique column to a newly refurbished *ARTS* magazine, a national publication published in New York. For this column, I covered many non-traditional events, from Timothy Leary's multimedia psychedelic celebrations at the Village Theater, later to become the Fillmore East, to the first group video art survey, "Television as a Creative Medium," at the Howard Wise Gallery on 57th Street. From 1967 through 1969, I was avant-garde critic, one of the first and only in the history of journalism, I believe, for *The New York Press*. My ties with my chosen neighborhood were solidified when I became the film/video columnist from 1969–1970 for *The East Village Other*, the Lower East Side's answer to the *Village Voice*, and a charter member of the national Underground Press Syndicate.

St. Mark's Place was a chameleon of a street, changing its colors almost overnight from the mid-sixties on. Things closed and opened unceremoniously like moss roses from day to day. The Polish Dom Club a few doors down from my building became the home for a "Trips Festival," where I participated with light artists Jackie Cassen, Rudi Stein and others. It then became the birthing place for Andy Warhol's Exploding Plastic Inevitable with the Velvet Underground, transforming further into the Electric Circus, where bands like Canned Heat cavorted amid surround light shows. I well remember attending the opening of the Circus with a few friends as we traversed the rooftops of St. Mark's Place to enter below, circumventing the maddening crowds converging from the street.

The eternally open Gem Spa, still on the corner of Second Avenue, where they served chocolate egg creams with their secret ingredient, "rettzles," led the path to the magic deliciousness and narrow capacity of the B&H Dairy Restaurant. The Fillmore East, where I attended many shows and virtually all of the New York appearances of the Grateful Dead courtesy of my Light buddies, the Joshua Light Show, was next door to the twenty-four hour Ratner's dairy restaurant, to which I could repair in the wee hours before dawn after all-night film editing sessions, alongside other famous and unknown denizens of the night.

The Fillmore became the meeting ground for what was called the United Alliance of Light Artists with a community of information sharing by people like Glen McKay's Headlights, who toured with the Jefferson Airplane, the collective Pablo, and other light artists ranging from gallery neon makers to multimedia filmmakers like myself. The Lower East Side was a cultural rallying point for artists in all media, who, like the interlocking of Venn diagrams in mathematics, found continuous sources of interaction and collaboration: poets, composers, filmmakers, video artists, dancers, choreographers, new theater people, happening and visual artists, radical revolutionaries and Yippie leaders. It was a dynamic, creative community from the mid-sixties through the early seventies akin in its magnitude to Montparnasse in Paris in the twenties and Zurich, Switzerland, where the Dada movement was born after the First World War.

Paul Morrissey
on the Lower East Side

by Erik La Prade

Before Paul Morrissey began making films with Andy Warhol in 1965, he had already made twelve films. His first film, *Ancient History,* was made in 1961, and his last film, *All Aboard the Dream Land Choo-Choo,* was made in 1965. All of these films are silent and most of them are between ten and forty minutes. Nine of these films were made and filmed indoors on the Lower East Side. However, three films, *Mary Martin Does It* (1962), *Civilization and Its Discontents* (1962) *and Taylor Mead Dances* (1963) were primarily filmed outdoors, in and around Fourth Street where Morrissey's cinema was located: 36 East 4th Street. Here is a short synopsis of these three films.

Mary Martin Does It "parodies a clean-up commercial that featured Mary Martin and others putting trash into cans. In Morrissey's version, a pretty girl goes about putting garbage in garbage cans, but she also poisons the neighborhood bums with booze, after entrapping them with outdoor living-room sets of trash furniture. An older bag lady, who empties the garbage cans, see the girl's murders, chases her, then throws her under a large street sweeper."[1]

Civilization and Its Discontents is a series of four separate encounters between alienated characters: "A hood in a pea jacket strangles a fat albino in Cooper Square; a flower-bearing young man climbs out of a garbage scow and watches a girl jump into the Hudson River."[2]

Miraculously, I found a print of *Taylor Mead Dances* at the Filmmakers' Co-op and was able to watch it. It is fourteen minutes long. The narrative of the film is simple: Taylor (or his character) ventures forth from his home carrying a basket of money, which he randomly distributes to any various lucky souls that he meets. Outside on the street he hails his Rolls-Royce and proceeds to Second City. During his trip there, he stops to pick up a young woman hanging out on a street. Before Taylor arrives, we see her speaking with a man dressed in sheik's clothing.

The scene suggests he is a pimp she apparently works for. The Rolls stops and Taylor emerges from the car wearing a false beard and a longhaired fur jacket. Taylor begins to enchant her, while in the background, we can see the neighborhood kids playing stickball in the street. Taylor removes his false beard, revealing his face to her and suddenly they begin to dance together, a symbol of the cosmic bonding occurring between them. Taylor climbs back into his Rolls and she freely follows him, closing the door behind her. As the car drives away from the curb, the sheik appears from a

nearby doorway, displays a knife and attacks the car, trying to force it to stop but to no avail. During their drive to Second City, Taylor and his new companion throw money from the car window and drink glasses of champagne.

Once at Second City, Taylor appears on stage, wearing an assortment of tin cans and pots suspended from his arms and belt by various pieces of rope. Taylor dances for ten minutes, a kind of dance of the seven veils. During Taylor's performance, I never saw a shot of the audience, but I assume the audience consisted exclusively of his new lady friend. When the dance is over, Taylor and the beautiful woman exit the club. A small crowd of on-lookers/admirers are gathered outside the exit doors. Taylor suitably rewards them as he proceeds to throw loose bills to them.

Between the time Taylor spends rewarding his fans and entering the Rolls, a man, perhaps a bum or irate citizen, begins what appears to be a tirade against Taylor's blatant disregard for money/wealth. The actor, Roberts Blossom, tries to incite Taylor's fans against him, but Taylor's good will prevails. The couple enters the car and drive away. The narrative theme of this film is simply a magic Christian story, featuring Taylor as a slightly bored but happy rich man trying to uplift the lives of those around him. The final shot of this film is charming even now, forty years after it was made: Taylor Mead in a Rolls Royce drinking champagne with a beautiful woman next to him while the car drives north on the Bowery, circa 1963.

Morrissey credits the idea of making his own movies and renting a space to show them in when he first saw some films being screened in a Tenth Street gallery. The films he watched were made by Joe Marzano, then "a member of the Film Workshop, a group of experimental New York filmmakers." Marzano was considered to be "one of the most promising figures of the new American cinema."

Morrissey's first film, *Ancient History,* was made in 1961. Since his cinema only existed for "a number of months, a spring and a summer," we can surmise how early on he was working on the Lower East Side and how isolated his activities were.

Jonas Mekas visited Morrissey's Fourth Street storefront cinema and in a recent conversation, Mr. Mekas told me "he (Morrissey) had a little empty place in which there was nothing, nothing, absolutely empty walls, nothing in the room but an Arriflex, his camera. That's when I met him for the first time."

A year later, according to a "Filmmakers Festival" program presented at The Charles Theater on July 2, 1962, Morrissey's film, *Mary Martin Does It*, is listed as the eighth film in a group of twelve films shown that evening. The same film was shown again on July 14, 1962, at "The Filmmakers' Festival" at the Charles Theater along with eighty-four other films. Clearly, Morrissey was making films before there was a "scene."

In an unpublished 1964–65 interview with Gerard Malanga, Morrissey talked about his particular interest in making films before he became involved with Andy Warhol:

"The so-called poetic cinema that avoids the need for sound by piling together shots of objects, people, color patterns, lights, editing flashes, and so on is a trashy bore and simply a form of moving wallpaper to be used within four or five minutes and to my mind has little worth even in advertising, except to attract attention by annoying. . . . They will never have any appeal to other people who are not directly involved in 16mm film. . . . Commercial films are more fascinating and lively, but I, myself, have always thought that there was room for self-made 16mm films that are not commercial, that do not pretend to be poetry, that simply exist as films with some sort of life of their own and not necessarily an extension of some already existing art form."

In the following interview, Paul Morrissey talks about his time and activities as a filmmaker on the Lower East Side.

ELP: In a photograph taken of you standing outside the exit to your cinema, the wall on the right side of the door announces the showing of a film called *Icarus,* by Brian De Palma. How did that come about?

PM: He was a student filmmaker at Columbia University. He had a film and I asked him to give it to me for some showings, that's all. It was an interesting film, because all he did was copy scenes from well-known art movies of the day. He was copying other filmmakers from the start.

ELP: What other films did you show at your cinema?

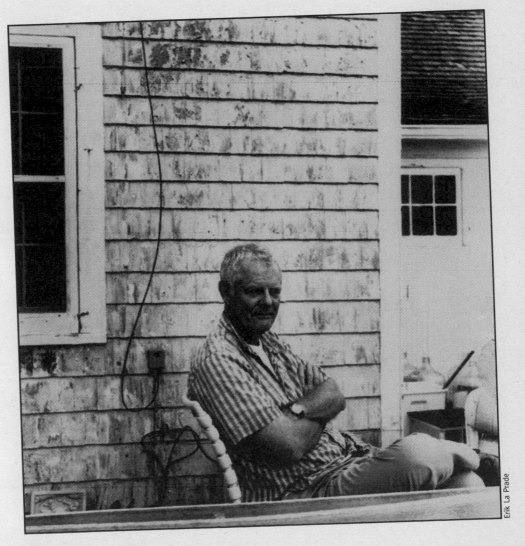

Paul Morrissey in Montauk

PM: I'm pretty positive I was the first person to use in a publication that term I hate, "underground films." I put it in my ad, I know. It was hardly ever used before that. I heard somebody use it once in a conversation, and I used it in that ad. I guess it was 1961.

ELP: How did you come to make *Taylor Mead Dances?*

PM: I met Taylor Mead and I told him how much I liked him in *The Flower Thief.* I told him I made movies and he said, "Let's make a movie." That's all. I happened to have a friend who had a 35mm camera. He said, "You want to borrow it?" Well, I'd never used 35 but I took the camera and liked it. *Taylor Mead Dances* was just done as a way of testing the camera and coming up with something. I put Taylor in front of the camera. It was just a spur of the moment thing. You ask the question of how did it come about, as if there was some huge thing here, but these things are impulsive and anything good creatively is impulsive and a bit spontaneous. All this planning crap and deliberation and "what I mean to do" and "my vision," that's all the mark of a talentless person who is trying to give himself importance.

The Flower Thief certainly had an effect on me but I don't know if it affected anybody else. It was an hour-and-a-half film of Taylor walking around San Francisco. It was a silent narrative. It was the only one of the experimental films of the period I saw that had a narrative and that I have any recollection of. None of them meant anything to me. But that one was a simple showing of how you could take an interesting person and follow him and give him a narrative. I think that's the only thing that films are, narratives about interesting characters. That's the basis of all fiction. Films are no different or ever can be.

ELP: Did you write *Taylor Mead Dances?*

PM: Of course not. I had Taylor and a girl and this car. It was as spontaneously done as it looks.

ELP: The Rolls-Royce driving on the Bowery at the end of the film is a beautiful image.

PM: It's just a combination of the stuff I had at hand.

ELP: Let's try this, let's try that.

PM: You never seem to see anything spontaneous coming from these film school people.

ELP: The improvisational fun has been taken out of it?

PM: Absolutely. The word improvisation to me is a horrible word because its been used to such terrible effect by Cassavetes and all these people who pretend to do serious, heavy-handed stuff. They use improvising endlessly but the endless calculation that goes into it inhibits the possibility of anything good coming out of it. And none of those people used a spontaneous type of improvisation for humor. They used it for heavy-handed, soap opera emotional crap. I never would do that.

ELP: Can you say anything about the films you showed at your cinema?

PM: Whatever I could get my hands on. Brian's film was the main one because it was sixty minutes. Or at least fifty minutes. Sequences of scenes he copied from famous films of the day. Scenes from films like *The Virgin Spring* or a copy of a scene from *La Dolce Vita.* There were these students that appeared in it and it was charming in its way. I played classical music on the tape recorder. I played that film for two or three weekends, I guess. Jonas Mekas might have steered something my way and I rented some things from the Donnell Public Library, not rent them but just checked them out like a book. And I'm sure I had something from Stan Vanderbeek. I showed them on Saturday and Sunday, put an ad in the *Village Voice* and people showed up. I wasn't the first to do it. Someone named Joe Marzano started doing that at an art gallery on Tenth Street between Second and First Ave. Around 1960 or 1961. And that's when I went there and said, "Gee, that's a good idea. Make your own movies and show them yourself." Although he didn't have anything to do with the gallery. I think the gallery just let him bring his friends and show the films. I happened to live in an old storefront and on weekends I would rent chairs and a projector, but Tenth Street was an art gallery.

ELP: Joe Marzano?

PM: Nobody remembers him. He died about a year or two ago. He made his own films on Long Island with members of his family and the films are all very Orson Welles type things.

ELP: Was he a painter?

PM: No. He was a radio announcer on classical radio and he had a good voice. He was an Orson Wells type character in a way. Little over weight. Nice guy. Very serious. Then I did these screenings. I was only doing it a number of months, a spring and a summer, I suppose. Then the police said, "Do you have permission to have an assembly room?" and I said "no" and had to stop. Then Jonas started. I don't know what the sequence was but there was a theater called the Charles Theater, a big theater on Twelfth Street and Avenue B with 600 seats and a balcony. Nobody went to the movies on Monday nights, ever. The people at the Charles got in touch with him, I think, and said, "What happened to those films, do you want to show more?" And they started putting ads in the papers for films to be shown. So you brought your film to the Charles, and you put it on a stack and they projected it. That's how it worked. Later, Jonas rented Off-Broadway theaters on Monday nights when they were closed. He rented the Gramercy Arts Theater. (It was at 138 East 27th Street, near Lexington Ave.) He would show films on Monday nights. Some years later, he then started showing, when I met Andy in 1965, every Monday for a while at the Astor Place Theater, which is still there. He did it the same way. You brought a film and put it on the stacks and the projectionist just went to the stacks and projected it. And it worked out. Many people brought films. But that was not all coming from the Lower East Side, I don't think. I made two films: *Mary Martin Does It,* running around on the Lower East Side, and *Civilization and Its Discontents,* which was photographed around Cooper Union. Of course, parts were photographed on Fourth Street in front of my storefront where I lived.

ELP: Was there a particular filmmaking scene or community?

PM: No. None whatsoever. It's all a journalistic illusion. There were people that Jonas would write about and show their films, but I didn't know them.

ELP: Did you make *Civilization and Its Discontents* on the Lower East Side?

PM: Mostly, if I recall. I don't think all of it but there are many sections of it on the streets. But the best movie about the Lower East Side is *Mixed Blood.* It was supposed to be called *Alphabet City*, but somebody else took the title.

ELP: Your film *Ancient Histories* is funny.

PM: I brought newsreel footage and pasted it together, trying to make it funny. I tried to make everything humorous. That's what put me outside of the entire group or whatever existed of filmmaking of the period, which was all experimental in a very deadly serious way.

ELP: In *Taylor Mead Dances*, there are sections where the scene flares and the film goes blank.

PM: I guess I was doing that even then.

ELP: Any point?

PM: No. I just saw it and liked it and kept it. It was similar to the light leaks that were going through Andy's camera later when I was directing those things. He stopped and started the camera only because I prevailed upon him to do it. Those things were there and they looked perfectly okay to me, no reason to take them out. Andy had no problem with them. The burden I've lived under is that people have to think I must've had such a great experience working with Andy Warhol and learning those things. Andy was subservient to a degree that is mind-boggling. If anybody else had said, "we'll cut this out now," it would have been cut out. No matter what I said, he agreed to it. He didn't come up with things himself. He was so hesitant and frightened of his own things that when he would make suggestions, unless the suggestions were seconded by somebody, and this only person was me, they wouldn't have happened. He was not a creative person and so many creative things he's been given credit for are things that I deliberately did. He was just terribly insecure. This idea that he had such an enormous gift for these offbeat things really came from somebody else. Somebody before me was doing these things and telling him what to do. Then when I left, everybody tried to step into the vacuum but there wasn't even the slightest degree of anything interesting done. He never had ideas about what to do himself.

ELP: What was your film about Stanley Fisher's paintings? (It was called *Peaches and Cream,* 1964.)

PM: I think it was a friend of Joe Marzano who asked me to photograph paintings. I photographed these collage paintings as a favor to the guy. It really had nothing to do with me. Then he put my name on it. Charles Silver. I think he's still alive. But it's not my movie in any way.

ELP: Do you think the whole retrospective history of what was happening on the Lower East Side in filmmaking is sort of mythologized now?

PM: Yes. I wasn't aware of anybody else making films, certainly nobody else on the Lower East Side. I was aware of films Jonas Mekas would write about but who these other people were who made them and where they were, I never knew, and I don't think I ever met them. One time two people came to my cinema and looked in and asked, "Is this one of those happenings?" That was a much better known scene at that time; self-made films hardly existed.

[1] *The Films of Paul Morrissey*. Maurice Yacowar. Cambridge University Press. N.Y. 1993. Page 16.
[2] *The Films of Paul Morrissey*. Maurice Yacowar. Page 17.

A Syracuse Rebel in New York*

by Aldo Tambellini

In the late summer of 1959 I moved to the Lower East Side, renting a $56-a-month railroad type apartment on 10th Street and Avenue C. This was once a Jewish neighborhood, which had become Puerto Rican, except for the bakery where I regularly bought a large round loaf of rye bread for 50 cents. My apartment was one flight up, a few blocks from where Allen Ginsberg lived; the bathtub was in the kitchen. I met a few artists and joined the co-op gallery called "The Brata" located on 3rd Avenue and 10th Street, one of the remaining co-ops from the previous 10th Street era. At the gallery, I had a one man show and participated in group shows.

I had developed my own method of making sculpture by using sand to cast hydrocal, so I needed a space on the ground floor. I found a single storefront at 217 East 2nd Street near Avenue C for $60 a month. My companion Elsa and I loaded all of our belongings in a rented push cart and making several trips at night, we moved. The neighborhood looked tough. I had several skulls and bones from cows and hung them on the front store window together with one of my early sculptures, which was coated with black tar. I lit the whole thing with candles. It was a strange voodoo-like sight in the night. In today's terminology, it would probably be considered the earliest installation by an artist in that area. The neighbors and the Puerto Rican children on the following days gathered around the window thinking I was a "brujo." One day, when my door was opened they saw a big black box that I used for sand casting. One of the children remarked, "That's where the magician cuts the lady in half." The gypsy living in the storefront at the end of the block came over, knocked on my door wanting to know why I, who was not a gypsy, was living in a storefront. I invited her in, told her I was an artist, and showed her some of my work.

Soon, my storefront was invaded by the Puerto Rican children and teenagers from the neighborhood with whom I had become friendly. Elsa nicknamed one of the children "Peanut," who, inspired by my artwork, began to draw some of my sculptures— my wooden trap doors which I had found and had intentionally burned and carved with a chisel—as well as creating his own work which I exhibited in the storefront. Past Delancey Street, in the Jewish neighborhood, they were tearing down block after block. It looked like a bombed out area from World War II. I vividly remember a dismembered wall remaining standing from an old synagogue with a big mural of the Lion of Judah. In the rubble is where I found the inspiration for what became a rapid succession of my new development in sculpture. With the help of some Puerto Rican teenagers, we fenced in the empty lot outside of the

storefront facing Houston Street, creating an outdoor studio for my sculpture. It's now 1961–62. This space was filled in with my concave and round sculptures of hydrocal coated with epoxy to waterproof them. This became the outdoor exhibit available to the neighborhood. Concurrently, I was working very intensely on painting black enamel or black acrylic on paper, some of them cut out in the shape of a circle. I worked with the blowtorch burning large pieces of wood, sometimes applying some paint.

One day, from my back window, through the cracks of the wooden fence, I saw two well dressed men in the outdoor studio with guns pointed towards Houston Street. I went out and asked what they were doing. They hushed me and waved me back. I left them alone figuring that they were probably undercover agents conducting a drug investigation. A reporter from the *Syracuse Post-Standard*, Syracuse, New York, came to visit me. On January 27, 1963, Walter Carroll in the *Syracuse Post–Standard Sunday Pictorial Magazine* wrote with the heading, "A SYRACUSE REBEL IN NEW YORK." He wrote, "Two weeks ago we went into the tough Lower East Side of New York City to visit a sculptor . . . 32 years old Aldo Tambellini, native of Syracuse, is a rebel with a following. He and his pleasant wife, Elsa, live in a drab, cramped little storefront studio at 217 East 2nd Street. In the back yard of this environment, Tambellini uses concrete and jagged pieces of metal from junkyards to create dramatic often brutal sculptures. He creates raw, primitive, forms from industrially created shapes . . . iron, steel nails, pieces of pipe."

I lived under constant threat of eviction by the New York City Building inspectors, who were claiming that my sculptures in the outdoor studio were considered "debris." Despite my keeping the place clean and stacking all the found objects neatly to one side of the yard, I could do little to please them.

Across the street from the storefront is where the black poets from *UMBRA* (a magazine) were gathering. They had come to the Lower East Side from Harlem, Bedford Stuyvesant and the south. These included: Ishmael Reed, H.N. Pritchard, Calvin Hernton, and Roland Snelling, subsequently known as Askia Toure. Later, many of these poets participated in my multi-media performances which I called "Electromedia." We all hung around Stanley's Bar farther up on Avenue B where we often exchanged views and had heated discussions. We all worked together in the same neighborhood and grew while things developed in all sorts of directions. Stanley later became the owner of the "DOM" on St. Mark's Place.

As a counter-culture activist, I wrote, edited and published a newsletter called *The Screw* with its slogan: "Artists in an Anonymous Generation Arise." Written mostly in poetry form, I first published it in 1961. The newsletter was created to raise the social consciousness of the artists. In the newsletter, I voiced my objection to the manipulation I saw in the art establishment which used the artists as a commodity and financial investments rather than cultural entities. This newsletter consisted of a mimeographed legal-size yellow sheet of paper sometimes folded in half. Each issue, of which there were several, had a different variation of an image of a hardware screw. Elsa and I handed out copies and accepted donations of 10 cents which were dropped into a glass jar. It was mostly distributed in the then very popular artists' The Club (on the West Side), frequented by a large art community that held monthly meetings and discussed current art topics.

The "Event of the Screw," a protest in the form of a performance, took place on July 12, 1962, in front of the Museum of Modern Art. There, in front of many artists who attended the "Event," the media, and law enforcement, I, dressed in a black suit and tie with a gold screw tie-clip, read the "Manifesto of the Screw." The Belltones, a Puerto Rican trio from my neighborhood, also dressed in suits and ties, accompanied me by singing a cappella the "Song of The Screw," which I composed satirizing the conforming artistic "rules of the game." Elsa Tambellini danced in leotards inside a five-foot Paper-Mache screw. The American flag was placed on top of the screw, a requirement stipulated by city ordinances for any demonstration. I presented to one museum official "The Golden Screw Award," which was a hardware screw dipped in gold paint and placed on a black cushion. Similar awards were given that day to the Whitney and Guggenheim Museums. Despite the 18 reporters present at the demonstration, not one of them wrote a line about the performance. A large photograph of the "Event," however, was published on the front page of *EL Diario*, the daily Spanish newspaper. Gabe Pressman, a muckraking television reporter, covered the "Event" and interviewed me while

Amish Sinclair, from WBAI, interviewed the Director of the old Whitney Museum for his reaction to the "Event."

There was no scene at the East Village in the early '60s; but the beginning of an underground sub-culture of creativity was brewing. In 1962, with a group of artists, Elsa Tambellini, Ron Hahne, Ben Morea, Don Snyder and, later, Jackie Cassen and Peter Martinez, I founded what was called Group Center. It was formed without financial resources but with a larger idealistic vision of a better connection with the community. The goal was described in a flyer distributed to raise both the social and artist consciousness: "For the purpose of forming a community of the arts, of individuals and groups, of poets, actors, dancers, painters, musicians, photographers, sculptors, film-makers, and all those vitally interested in the creative expression of man." The flyer continued with a credo:

"We believe that the artistic community has reached a new stage of development. In a mobile society, it is no longer sufficient for the creative individual to remain in isolation. We feel the hunger of a society lost in its own vacuum and rise with an open active commitment to forward a new spirit for mankind."

I wrote at that time that "creation is not the commodity of a status seeking class. Creation is the vital energy of society. We believe that the 'our system' is an enormous dinosaur extinguishing at a fantastic rate which opposes truth and freedom and that it has squeezed out of man the essential vitality which made him part of the human race." For that reason, "Group Center" consciously and intentionally chose to become a counter-culture, underground group trying to find ways to change and impact that harsh closed-in system.

David Bourdon wrote about Group Center on January 11, 1965, for the *Village Voice*: "The Group has made itself known in original ways. They picketed a Monday night opening at the Museum of Modern Art . . . passing out handbills protesting the taste-making policies of the museum. Last March they paid a stealthy 3 a.m. visit to the most powerful up-town galleries

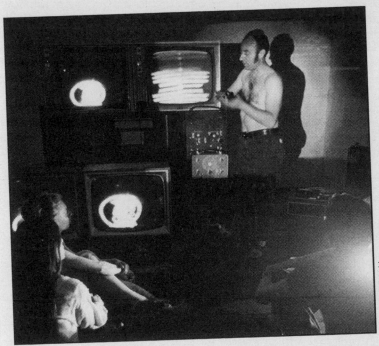

Aldo Tambellini Archives

Aldo Tambellini

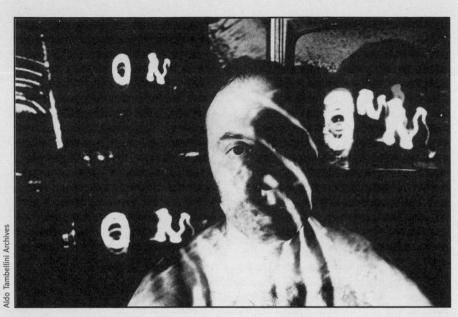

Aldo Tambellini Archives

Aldo Tambellini

and museums; equipped with a masonite stencil and a can of spray paint, and disguised as workmen, they branded the sidewalks with a circle about two feet in diameter containing the word 'centerfuge.'" Centerfuge was the term used for many of the activities of Group Center.

Group Center organized a Festival-of-the-Art in collaboration with LENA (Lower East Side Neighborhood Association). This festival, for the first time, brought out the new generation of artists who lived in the Lower East Side. One newspaper referred to the festival as the "Lower East Side Artists Having a Coming Out." A two-week marathon of art shows, poetry readings, underground films and jazz concerts was organized and held at and around the Church of St. Mark's-in-the-Bouwery. This festival proved Group Center to be a catalyst in the artistic movement in the area. This was the first time the press and the public became aware that something new and meaningful was happening among the creative people in the Lower East Side, sometimes called the "New Bohemia," as referred to in the seminal book of the same name by John Gruen.

As a result of the successful festival, Michael Allen, minister of the St. Mark's-in-the-Bouwery Church, appointed Group Center as the official organizer of the artistic programs at St. Mark's. In October 1963, around the churchyard and in the church, "Aldo selected the largest sculpture and drawing show ever independently organized in New York City," wrote Elsa in an article for *Arts Canada Magazine*, in October 1967. Interest in the show grew as it neared its opening. "Forty living U.S. sculptors were brought together with work ranging from forty-foot-high pieces to small indoor works and drawings," stated Elsa in *Arts Canada*. This show was unique because it brought together well-known artists such as Peter Agostini, Phillip Pavia, Marc De Suvero, Richard Stankiewicz, while giving less known and obscure local artists the opportunity of exhibiting their work. The sculpture show lasted well over a month. The artist Ad Reinhardt, showing support for Group Center, gave a lecture at the church on the topic, "The Next Revolution in Art." I designed the flyer for this event. Jazz performances were planned by Freddie Redd, known for his original music in Jock Gelber's play, *The Connection* at the Living Theatre. Among the jazz artists who played outdoors among the sculptures was Booker Irving, saxophonist from the Mingus Group. Elsa Tambellini concluded in the same *Arts Canada* article, "It was another way of bypassing the establishment."

During this time, I rented a large space located in a former synagogue at 106 Forsythe

Street near Broome Street. This space was primarily rented for the activities of Group Center. Group Center presented Jazz Concerts, which included the artists, Freddie Redd on piano and avant-garde musician Archie Shepp. Well-attended fund-raisers, to help support the work of Group Center, were also held in this space in the form of parties where drinks were sold, mixed with cheap liquor that was home brewed by our supplier.

Among the most memorable activities of Group Center was the event which brought Julian Beck and Judith Malina from the legendary Living Theatre to hold an open discussion on March 10, 1962. The topic of the evening was "Revolution as an Alternative." Admission to the program was only 50 cents. I designed the flyer with the title of the event with a photo taken by Don Snyder of my large hydrocal concave sculpture with one East 2nd Street Puerto-Rican child sitting inside it. These flyers were hung by Elsa and me at 2 a.m. in long rows on Lower East Side buildings and pasted with double coats of wallpaper glue. This was done for a stronger adhesion so that the announcement would not be vandalized. The next day, the posters had been either defaced or scratched out. Some landlords threatened to sue us. The word "Revolution," that later became the rallying cry of the '60s, was at this time a fearful and disturbing word for many people.

I had a bulk of 35mm slides which were ready to be discarded. One day, around 1963, I instinctively used needles and other tools to scratch the emulsion. I scratched spirals and other round forms, sometimes piercing holes through them. With a small gathering, I projected these slides onto the façade of the building across the street from a tenement rooftop on 6th Street and Avenue D using a Kodak carousel projector. This marked the beginning of my involvement with multi-media.

In 1965 with Group Center, I organized another large art exhibit, Quantum 1 and Quantum 2, which ran simultaneously at the Noah Goldowsky and at the A.M. Sachs Galleries. Quantum 2 presented American and European artists. I exhibited the "Echo," a spatial black painting 14 by 7 feet. I represented Group Center with Hahne and Morea. Group Zero, from Germany with Piene, Mack and Uecker, a group I had not yet met but borrowed their work, Peter Agostini, Louise Bourgeois, Ad Reinhardt and Charles Mingus Jr. (the son of the musician) and many other young and unknown artists were also exhibited. We became friends with Irene Rice Perreira and borrowed her painting with layered corrugated glass from the Metropolitan Museum for this show. The *New York Herald Tribune* in a review of the show on January 16, 1963, said, "Aldo Tambellini, leader of the 'Center,' shows enormous canvases where the circle becomes a sun—a source of energy." I had poetry in the show, written in spiral and circular forms on silver discs suspended and turning, hung from the ceiling by strings. *The Herald Tribune* continued in the review of the Quantum 2 show, "Lights blink on and off, discs rotate, canvasses with moving panels alter their shapes and color . . . the meeting of technological concepts with those of art."

Concurrently with the Quantum Show, I presented my first "Electromedia" performance, "BLACK," at the International House in Manhattan. David Bourdon in the *Village Voice* described "BLACK" as a "Hypnotic Bounce." He goes on to talk about the performance:

"'BLACK' was an overlapping series of evenly pitched performances by a painter, a dancer and two poets. Handsome poet Norman Pritchard chanted nonsense words in sequences in groovy repetitions like stuck record, bouncing hypnotically at the same time. . . . Ishmael Reed's oratorically delivered poetry was more traditional in form and marked by raw powerful imagery. Lovely Carla Blank performed two dances. In the first, she writhed, choked, and coughed as though she had a sore T-Zone, then rose slowly on tiptoes to emit a big scream; she also hurled one of the two folding chairs into the auditorium. Returning in white tights she improvised a dance before a sequence of slides projected against the back of the stage by Tambellini."

During the performance, as the creator of "BLACK," I interacted with over forty 2 1/4 x 2 1/4 , hand-painted glass projected slides which I called "lumigrams." Don Ross from the *New York Herald Tribune* later, on June 13, 1965, describes the "lumigrams": "Some of the lumagrams are reminiscent of slides of diseased tissue . . . Tambellini said he is interested in evolving an art form from the revelation of the microscope. He is also interested in the revelation of the telescope in the cosmos, and some of the lumigrams are reminiscent of sidereal space. Others

have a kind of fetal, placenta look . . . I work from intuition, he (Tambellini) says, and not from intellectualization."

As a result of this performance, Elaine Summer, who was in the audience, invited me to repeat the performance at the Bridge Theatre at St. Mark's Place, where she was special program director. I accepted and began my relationship with the Bridge Theatre. "BLACK" became a work in progress which continued to grow with each performance through the dynamic exchange of the participants involved. It expanded to include jazz musicians Cecil McBee; Herby Lewis and Bill Dixon and in many performances, avant-garde amplified cellist Galo Scott, black poets, dancers "lumigrams," films and video, inflatable screen, gas masks and a huge variety of experimental sounds such as evenly pitched siren, the sound of air and light equipment. Ultimately "BLACK" included videotapes playing on four TV monitors. "BLACK" progressed to "BLACK 2" to "BLACK ZERO."

Don Ross, a journalist, attended a performance of my "Electromedia." On June 13, 1965, he wrote a leading article in the *New York Herald Tribune,* "Rebellion in Art Form—Tambellini's 'Black 2.'" He writes:

"Aldo Tambellini has survived, thanks to his toughness, his belief in himself and his vision of life, . . . Tambellini is an artist and a rebel . . . he's not only a rebel but a leader of rebels. Last Monday as producer and director, he put on a hour-and-twenty minute show called 'Black 2' at the Bridge Theatre, 4 St. Mark's Place . . . the performance brought into an organic form . . . the fusion of abstract and social commitment. Among those associated with Tambellini in this enterprise are Lorraine Boyd, a dancer (a student of Katherine Dunham) Cecil McBee, who thumbs a bass, Calvin, C. Hernton, a poet who reads his own poems of racial conflict with a flashlight. Tambellini has made what he calls lumagrams...he projects 200 of them during the performance, sometimes while Ms. Boyd, dressed in black tights, is dancing in a way that seems to represent the plight of the Negro and while Mr. McBee is thumping and bowing his bass beautifully."

Visiting my studio, Don Ross continues:

"Tambellini dressed in a black shirt, black pants . . . the largest of his paintings (14 x 7 feet) in the loft studio is a double image of a black circle within a larger white circle in a vast black space. Black fascinated him. Recently, the double image, or, as he calls it, the echo, has been reoccurring in his work. 'This two in one thing appeals to me,' he said, 'it seems to be happening in my work. I have no explanation why this is.' He is an easy mark for ridicule for those who don't know him. Those who do respect him. They may not know what he is doing and they might even doubt that he does, but they will know that he will not swerve from his path. In a time of opportunism, they find something splendid in this principled obstinacy."

"BLACK ZERO" was performed in 1965 for the New Cinema Festival I taking place at the Film Makers' Cinematheque at the Astor Pl. Playhouse at 434 Lafayette Street. This performance had Bill Dixon on trumpet and Alan Silva on bass and Calvin Hernton's poetry. When *The New York Times* on a much later date was beginning to acknowledge the multimedia that became a phenomenon in the late '60s, in the article of September 1967, "For the TV Generation, Multimedia Techniques Bombard and Overload the Senses," reporter Grace Glueck quoted me defining the multimedia after a performance of "BLACK ZERO": "With multimedia you create an effect that is not based on previous experience. You saturate the audience with images. It happens now-it has a live quality. It's a total experience in itself."

Paul Mandell, staff reporter for the newspaper *The Gazette* recorded the full impact of the work of "BLACK ZERO" on the audience at the University of Western Ontario, Canada, in his article entitled "It was a gas Inter-media Warped, Twisted impact": "Galactic intensity, the direct result of inter-media by Aldo Tambellini and Company, has superimposed itself on the warped and twisted minds of a Western audience and left them more warped and twisted than they were before...This is the entertainment that Orwell and Huxley have been speculating about in the past few years. It was *1984* and *Brave New World* all wrapped in one." Jeremy Heymsfeld from *The New York World-Telegram* reviewed "BLACK ZERO" and stated: "The series of experiences presented last night was designed to propel the audience into what the Center calls 'the new reality,' the psychological re-orientation of man in the space age 'BLACK ZERO' is a vehicle for expressing these changes as well as the violent social revolution now sweeping

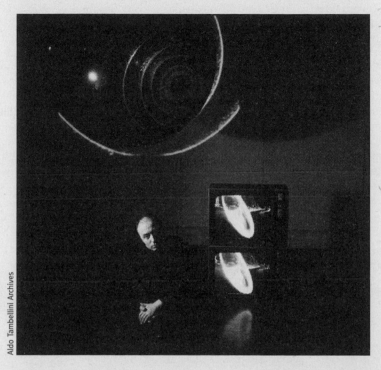

Aldo
Tambellini

Aldo Tambellini Archives

the world. . . . There are enough blank stares in the audience for 'BLACK ZERO' to rate an avant-garde label." The last performance of "BLACK ZERO" culminated at the Brooklyn Academy of Music in the program INTERMEDIA "68" in a double-billed program with Carol Lee Schnemann's "Illinois Central Transposed."

Elsa wrote in her article in the October 1967 issue of *Arts Canada*, "The word 'Intermedia' and 'Mixed Media' did not exist at that time. Aldo was an originator of a form which did not even have a vocabulary and it was a challenge to describe it to the Theatre press and all the people who were to become involved in the presentation of his work." The work was so controversial at the time that some of the press defined it as "theatre of the senses," while others, such as Gene Youngblood, later included the work in his book *Expanded Cinema*. For me, "Electromedia," at that time, was the fusion of the various art and media forms, breaking media away from the "traditional" media role bringing it into the area of art—bringing the other arts, poetry, sounds, painting and kinetics and film and later video into a time and space re-orientation toward media transforming both the arts and the media. I acknowledged an historical shift into the culture, defining the time in both the social and technological revolution, I defined the role of the "new" artist in my 1962 Art Manifesto, "The Seed," as a "primitive of a new era."

In a Sal Fallica interview in 1967 and reprinted by *CENTERVIDEO* at the Center for Advanced Visual Studies at MIT in 1981, I stated, "I came to media as a social reaction against what kept the art media under control—for media was outside of Art. No gallery or museum in New York in 1967 would give serious thought to a CV tape. A media in the hands of the artist could create its own audience. Like creating images directly on film-video had the reality of directness."

I was invited by Rudy Stern and Jackie Cassen to perform "MOONDIAL." I collaborated with professional dancer Beverly Schmidt. I created Beverly's costume from clear plastic with silver discs. I made a mobile headpiece. She powerfully interacted with my projection of film and lumagrams specifically made for her dance and the percussive drumming of Lawrence Cook. Jonas Mekas reviewed "MOONDIAL" in his movie journal column on June 23, 1966 which appeared in *The Village Voice*: "The flashes and glimpses of light and slides, and the dancer, all together, produced an aesthetically unified performance." Jonas Mekas goes on to describe my intimate involvement with the performance: ". . . I turned and looked where the slides and projections were set . . . I saw this amazing, almost phantastic thing happening: I saw both Tam-

bellinis immersed in a deep trance of their own. Moving, with handheld projectors and slides, shaking, and trembling, no more conscious of themselves . . . they were going through similarly phantastic changes and it seemed that the things on stage were directly, physically connected to their fingertips, their face movements and their very flesh . . . through their flesh to their souls."

A three-part program called "Outfall" was presented by the Bridge Theatre in conjunction with "Group Center" under the auspices of the New York City Department of Parks at the fountain in Washington Square, being dry because of a drought, on September 25, 1965. Part one of this program was my "BLACK ROUND," a kinetic ritual for dancer, gas masks, large screen projections and sound. This program was conceived by me and Judy Dunn, dancer from the Judson Church and formally with the Merce Cunningham Company. Other performers included Meredith Monk, Kenneth King, Phoebe Neville and the core of "Group Center," Ron Hahne, Ben Morea and Elsa Tambellini. I projected hand painted slides over my hand-painted film onto a huge screen in the middle of the fountain. "Thirty of us wearing gas masks, carrying flash

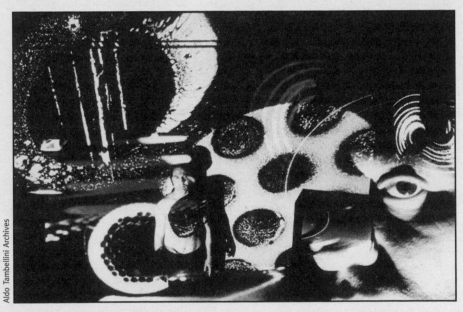

Aldo Tambellini Archives

Aldo Tambellini

lights and an assortment of sculptural objects pierced through the enormous crowd of people which had formed a solid mass of bodies around the rim of the pool," Elsa recalls in her September 1967 article for *Arts Canada*. She recalls, "That night the city became our theatre and the endless variation of people who gathered in the park our audience."

My films began to be used in many ways not only shown in the movie theatre as a traditional projected film, but also as part of my "Electromedia" performances de-materializing the space where it was projected and producing a dislocation of the senses of the viewer. I consider my films to be an "experience." Sometimes, the films were used as an environment projected on a given space and sometimes films and the zooming of the animated slides became one. At times, the films were projected on bodies of performers and objects such as inflatable screens (black weather balloons) and other times the films were projected on split screens or in simultaneous multiple projections.

Very often, I was asked, why black? Here is my quote from *Arts Canada*, October 1967 on

the special issue on the subject of "Black" with the new editor, Anna Brodzky, where I answered that question:

"Black to me is like a beginning. A beginning of what it wants to be rather than what it does not want to be. I am not discussing black as a tradition or non-tradition in painting or as having anything to do with pigment or as an opposition to color. As I am working and exploring black in different kinds of dimensions, I'm definitely more and more convinced that black is actually the beginning of everything, which the art concept is not. Black gets rid of the historical definition. Black is a state of being blind and more aware. Black is a oneness with birth. Black is within totality, the oneness of all. Black is the expansion of consciousness in all directions." I continued, "Black is one of the important reasons why the racial conflicts are happening today, because it is part of an old way to look at a human being or race in terms of color. Black will get rid of the separation of color at the end. Blackness is the beginning of the re-sensitizing of human beings. I strongly believe in the word 'black power' as a powerful message, for it destroys the old notion of western man, and by destroying that notion it also destroys the tradition of the art concept."

Holding true to the philosophy of the underground that art can be created outside the restriction of expensive equipment and materials, I continued to work in many art forms. Therefore, it was a natural progression to treat my films in a physical way by experimenting with painting, drawing and burning on clear leader and scratching, punching holes and eating away the emulsion on black leader later, using chemicals which caused me to develop severe allergies.

Simultaneously, I was working on 35 mm sequential images on slides. I produced my first 4 minute film called *BLACK IS*. The Grove Press Film Catalog, which later distributed almost all of my films, described *BLACK IS*: "To the sound of a heartbeat and made entirely without the use of a camera, this film projects abstract forms and illuminations on a night-black background and suggests, says Tambellini, 'seed black, seed black, sperm black, sperm black.'"

One day, while walking on the street, I found a large discarded roll of what was then computer tape. The punched out holes was data in a language understood by a computer. I transferred this language onto clear leader by using this tape as a stencil, spraying the holes with black paint. By projecting this leader, I realized the frantic action that the frames produced forming a new visual language through its images. I began to collect leader from Japanese films whose markings were different, other found footage and scraps of film. A filmmaker sold me a used Bolex camera for $300 and I started shooting film. After endless hours of editing, viewing and re-editing, a series of film which were "sensory experiences" was born. My 10 films became paintings in motion.

The 4 1/2 minute *BLACK TRIP* of which the *New York Times* said, "It is a trip for blind America. It is an experience of the destruction of the senses." The *Japanese Film Review*, Tokyo, said that, "It is excellent work . . . Tambellini stepped into a new stage of imagery and his work is a pioneer piece of electronic age."

Another film, *BLACK TRIP 2* is an internal probing of the violence and mystery of the American psyche seen through the eyes of a black man and the Russian Revolution.

The only film totally shot with a hand-held camera was the 8 1/2 minute *BLACK PLUS X*. Grove Press said of the film, "The time is summer and the characters are black children spending the day playing in Coney Island. The extra, the 'X' of *BLACK PLUS X* is a filmic device by which a black person is instantaneously turned into white by a mere projection of the negative image. It is Tambellini's tongue-in-cheek "solution" to the race problem.

About the film *MOONBLACK*, 14 minutes long, Grove Press says:

"Tambellini employs action painting on film and videotape with white on black abstraction projected in split-second cuts, rapidly changing their forms, and moving ever upwards into the blackness of the cosmos. The sensation of a space flight is further heightened by the continuous roar of the rocket engine and the conversations between astronauts and Houston Control.

BLACK TV, a 10 minute film, is my most social and political movie. It was made from a compilation of pre-taped videos of news events of the times including the assassination of Bobby Kennedy, the race riots, police brutality, the Vietnam War and special programs such as "Hunger in America." The tapes were re-shot in a re-edited form using the Bolex camera and then underwent more extensive editing. It was originally conceived and presented in a split

screen form. *BLACK TV*, reports Grove Press in its catalogue, "won the Grand Prix at the 1969 Oberhausen International Short Film Festival (shown as a single screen). The film is the artist's sensory perception of the violence of the world we live in, projected through a television tube . . . *BLACK TV* was broadcast by ABC-TV News." (Actually, what was broadcast was my first "black" video.) "Tambellini's *BLACK TV* is a great work in video tape. Of Tambellini's work so far, this is a masterpiece. Here video TV has become a personal and artistic medium," reported the *Japan Film Review*. Some of my films were shown at the Jewish Museum in New York in the show "Film as Art."

On September 16, 1966, Elsa and I opened the 200 seat Gate Theatre on 2nd Avenue and 10th Street, a building whose sign is still carved in the entrance as a "Presbyterian Tabernacle Church." The Gate Theatre was the only theatre to show avant-garde, underground films in continuous showing, till midnight, seven days a week. The theatre charged $ 1.50 admission. We advertised our weekly programs on the the *Village Voice* and the *New York Times*. The outside of the theatre had a flag, which I designed with the word Gate inside of a black circle. Our wall marquis held huge photostats of the programs. We displayed photographs of artistic events as well as poems on the walls in the lobby. Young and old, educated and uneducated flocked to the Gate Theatre. We were trying to expose the general public to a type of film which was usually reserved for a small and more sophisticated audience as well as supporting up-and-coming filmmakers who had a difficult time finding a theatre that would risk showing their features because they were not established.

At the Gate, we premiered Brian De Palma's first full length feature *The Wedding Party*, that he made while studying at Sarah Lawrence College. I remember De Palma's 16mm film being shown in the theatre while he personally was projecting his trailer with an 8 mm projector on the glass of the front door of the Gate. One of the early shows at the Gate was Robert Downey's first feature, *Chafed Elbows*. It starred his wife who came often to my theatre holding a baby who grew up to be Bob Downey Jr. of Hollywood fame. Downey's film was shown in a double billing with *Scorpio Rising* by Kenneth Anger. This program ran for over a month.

We were showing Jack Smith's feature film *No President* when a funny incident happened. We usually hired young students as projectionists from New York University who would sit and study and periodically attend to the film. Jack Smith, who was also in the projection booth, was changing his mind about the editing and wanted to re-edit the film when the projectionist was changing reels. This re-editing caused a major problem in the projection booth and a major disruption with the projectionist threatening to quit. Jack ran down the stairs screaming as he ran out of the theatre, "I am going to kill the projectionist! I am going to kill him!" I ran to the projection booth and pacified the young projectionist, excusing Jack Smith's actions by describing him as a very good, but difficult artist who needed our understanding.

On one occasion while sitting in the audience in a fully packed house viewing one of my films as part of the weekly program, I sat next to a man who was becoming progressively more uncomfortable with the film. He became very agitated, covering his eyes,

looking down saying, "This is awful." "This is terrible." He kept on asking me if the film was over, to which I kept on answering "No." When it was over, I told the man, and relieved, he responded, "Thank God!" I never told him that that was my movie. At the end of the same program, however, a woman in the audience went to the ticket seller to ask who had made that film. They brought her to me. She said that one of her very close friends was almost totally blind and she felt that he would have appreciated "the experience" of watching my film. Young people loved my films. I had problems with the older generation.

An example of a typical special, sold-out program which we had at the Gate was "Psychedelia Tune In." This program brought Dr. Ralph Metzner, chief associate of Dr. Timothy Leary, on stage with a discussion, "Psychedelic No-Art." Richard Aldcroft also presented his Infinity Machine which had been featured on the cover of *Life* magazine, 1966 issue. The rest of the program included the screening of experimental films by Jud Yalkut, Bruce Conner and my first film *BLACK IS*. Dan Sullivan, in the October 29, 1966, review for the *New York Times* titled "Gate Theatre Screens a Psychedelicate Subject," calls *BLACK IS*, "the most interesting . . . a dazzling succession of black-on-white and white-on black splotches, dots, zig-zags and starbursts painted directly on the film...suggested that action painting might have found, in film, a home that suits it far better than canvas ever did."

A rare movie event occurred when we projected the rare and seldom seen *Salome*. An older Russian dancer Alla Nazimova starred in a film as the young Salome. Natacha Rambova (later the wife of Rudolph Valentino) patterned the set and costumes after the Aubrey Beardsley illustrations.

The Elder and Spiritual Leader of the Hare Krishna who had brought the movement to the Lower East Side had his gathering place in a storefront near the Gate. He came to ask me if he could have an evening at the theatre. There, he conducted their rituals, which included chants, dances and songs.

Saul Gottlieb, a member of the Living Theatre, presented a political play utilizing the whole space and involving the audience. Months later, together, we organized a demonstration called "Black Death." We called for a midnight mass in "mourning for atrocities in Vietnam with an offering for Cardinal Spellman" for his public support of the war. The flyer asked people to wear black and to carry a flashlight or a candle. We started on 2nd Street and 2nd Avenue on Sunday night at 10:30 p.m. There was a procession a half-mile long with people joining us en route with candles lit and carrying what seemed to be dead bodies on their shoulders. I was in front of the procession carrying a six foot cross while a drummer was beating a funeral march. We ended up at the Chancellery up-town but Cardinal Spellman was not there. The press covered this event while a far right magazine called our efforts "anti-American."

Typically, each program at the Gate Theatre, which changed weekly, consisted of an hour and a half compilation of individual short films. Often we challenged the censorship laws with erotic shows, one of them called "Erotica Neuratica." Very often we showed the films of Stan Brakhage, Robert Breer, Bruce Conner, Maya Deren, Ed Emshwiller, the Kuchar brothers and others, as well as having my films. George Kuchar asked me to take a minor role in one of his films, playing a rapist who was raping a woman in the upstairs Gate bathroom. As he

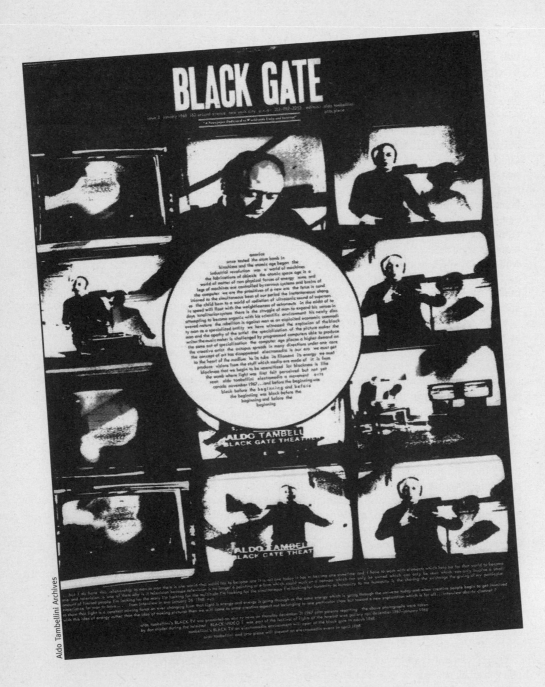

Aldo Tambellini Archives

filmed, he was on top of the water fountain, broke it and water started to gush out, running down the stairway just 15 minutes before the theatre was due to open. We quickly mopped the floor and tried to repair the damage; but, in all of this, we could not find George Kuchar, who felt so badly about what happened that he ran away from the action.

Many of the films came from the West Coast, but also we had several programs of Japanese underground. Taka Imura, a Japanese experimental filmmaker, whose films we often showed, was our contact in Japan and many times brought us the Japanese underground films. He also brought the American underground to Japan, including several of my films.

The Gate was located within a five/six block area that in other times had been called the "Jewish Broadway." It is that very area that exploded as the new cultural center of the "Hippie Generation." There was so much activity that one of the major TV stations ran a 5 minute spot of programming at the Gate and the Black Gate.

On the weekends, the theatre became the home of the Theatre of the Ridiculous, directed by Charles Ludlam, which performed there between the hours of 1 a.m. and 3:30 a.m. Its plays were parodies and most of the female parts were played by men. Some of the members of the cast included Mario Montes, Black-Eyed Susan and Jack Smith, who had a fight with the cast and separated from the company. They were presenting such outrageous plays as *When Queens Collide*, *Dracula* and *Grant Hotel*, to name a few. They attracted a large, faithful audience. One evening, I saw a delegation of diplomats from the Indian Embassy enter the theatre. Men and women were dressed in their national garbs, all looking very proper and formal. They sat to watch what they thought would be a serious play. The Theatre of the Ridiculous was putting on a play called "Indira Gandhi's Secret Desire." The guys in drag were bad enough to shock the new audience which sat motionless, but the culminating blow came when an actor came out sporting a three-foot stuffed penis.

One weekend evening between the main showing of the film and the beginning of the Theatre of the Ridiculous program, the ticket seller was talking to two men who were sitting on a bench. Suddenly, one of them pulled out a gun, and holding it to the temple, asked him for the box office evening take. The young man came upstairs to my office, very scared—but very concerned about the fact that he had to hand over the money. Since this was not the only robbery, we had been previously robbed of one of our 16 mm projectors, I decided then to buy a large German Shepard puppy. "Jet" grew up in the theatre and became a permanent addition as an excellent guard.

"Our lives held many struggles, controversies and harassments for those of us on the fringes of a society." In her article for *Arts Canada*, Elsa described the kind of artistic life steeped in problems: "One is never sure when subject matter (political or social) revolutions in artistic form and structure, will place everything in a state of jeopardy. . . . Sometimes rather subtly, there is a rash of city inspectors and policemen who think they can find some technical way to close the doors. . . . At other times, war is openly declared." Battles with the various departments at the city became a common occurrence.

In March 1967, using the large space above the Gate Theatre, Otto Piene and I founded the Black Gate Theatre, the first "Electromedia" theatre in New York City. I painted with black the three-inch-thick wooden platform covering the floor. Someone volunteered to make black cushions which were placed on the platform and used by the audience to sit on. The space had three large, rectangular pillars. The walls were painted white. The room had no lighting facilities but had plenty of AC outlets in which one could plug numerous projectors. This room was to be considered an open space for experimentation by the artists working with the new media for performances and installations.

Carman Moore from *The Village Voice*, after a visit to the Black Gate in 1968, wrote: "The vibrations of the Black Gate room seem to be about thinking."

Otto Piene and I opened the first Black Gate program with "BLACKOUT," which was the simultaneous showing of my hand-painted film projected slightly out of synch and four carousel projectors zooming lumagrams of concentric circles continuously onto the environment, covering the entire wall. Otto Piene's "THE PROLIFERATION OF THE SUN" was a series of hand-painted slides projected around the room as the audience sat on the floor. The program notes given to the audience included Otto's description of his presentation and I included a

series of philosophical statements such as "blackout—man does not need his eyes but to function with 13 billion cells in his brain."

Future programs had performances by, to name a few: Nam June Paik, who performed without the use of video; Charlotte Moorman, who zipped herself inside a bag and played the cello; Kosuki made an installation experimenting with radio sound; the Group USCO with Gert Stern and Jud Yalkut did an installation projecting on balloon screens; Preston McClanahan used light and fog for an installation which surprisingly was visited by the Anthropologist Margaret Mead; Jergen Klaus brought an evening of short German films on conceptual and other German artists including an early work by Hans Haaker shot on a Berlin Street. Carman Moore in *The Village Voice* in 1968 talks about a visit to the Black Gate: "I dropped in on a rehearsal of composer Jacques Beckaert's (from France) piece of tape, viola, and voice last Saturday. Composer-violinist David Behrman owned the electronic equipment and was whipping out just the right box with the right switch to get the right sound all afternoon. An Intense work of strong musicality and social statement on the black man's plight seemed in the making."

Memorable is Kusama's performance called "Obliterations" with music by Joe Jones, a Fluxus artist. In this case, the music or sound consisted of about thirty live frogs in a tank of water that Joe Jones would rub under their bellies to stimulate their production sound, as Kusama painted dots over the bodies of female models. The frog music was to be amplified by microphones. Kusama advertised in the *Village Voice* with a photograph of herself lying naked on a mat, her back completely covered with painted dots. There were several days of preparations and Joe Jones, besides coming to change the water and stroke the frogs on a daily basis, had rented a delivery tricycle and rode around 2nd Avenue with a sign to advertise the show. Joe Jones was hit by a car. With his leg in a cast, I saw him one early morning arguing with Kusama, because she thought the frogs had no sense of rhythm as she was painting the dots. She took a small drum and beat out the timing saying, "I want beat dot, beat dot, beat dot." Joe Jones screamed back, "My frog music is not polyphonic, your drum is." The day of the event, it was pouring rain and full of heat and humidity, the Black Gate was packed with a standing room only audience. The place looked eerie with purple lights and it was full of undercover police as they thought it was going to be a sex show. Her performance was going to be preceded by a talk by art critic Gordon Brown. As the time to begin came and went, and Gordon Brown left and did not return, Kusama became very agitated. The more agitated she became, the more difficult she was to understand. She wanted someone to go to her loft, break the door down and get him out of bed. She ran around nervous and crazy. Finally, Gordon appeared, the show began, and with all the noise, we never knew if the frogs croaked. Kusama painted the dots on the models and the police made no arrests.

On March 1968, I presented *BLACK TV* an "Electromedia" environment using several monitors. At other times, in informal gatherings, I presented my videotapes.

Keeping with the concept of media at the Black Gate, I published two newspapers in the form of posters called "The Black Gate." The first had philosophical statements by Otto Piene and me and announcing the future programs. The second one had a circle in the center with a social statement about the social reorientation of America in the Space Era that I wrote surrounded by still photos of my first videotape as it was rebroadcast with an interview on ABC TV Channel 7, New York City, on

December 21, 1967.

In 1966, at Willoughby's on 32nd Street I purchased the first model of video-recorder on the market, a Sony CV 2000 before the portable was sold. At the Black Gate Theatre, I mounted the camera on a tripod, set up a microphone, set up a feedback with the sound, took a portable light and created simultaneous live movements by shining the light directly into the camera. The recording of these movements, in 1966, was my first videotape. These lights slowly began to burn out the vidicon, leaving permanent black spots that showed on the recorded tape. That day on the Lower East Side, I produced the first half hour segment and the following day it became an hour. This tape was shown on Channel 7, ABC TV News in New York on December 21, 1967. It was difficult at that time to find labs where I could make copies of this tape. I did find a place near La Guardia Airport called Video Flight, which was transferring movies onto tapes for the airline companies. They copied the tape. As they were duplicating the tape, I saw test patterns and other electronic images on the monitors that excited me. I spoke with the young engineers and decided to collaborate with them, returning to make a second tape of the electronic images. This manipulation of the test patterns became my second tape. The sound heard on the tape was from an oscilloscope, which I controlled, and through the sound manipulating the images. Further into the tape, the sound is my own voice improvising as I reacted to the images.

I received a grant from the NY State Council of the Arts to show the film and video in several locations in upstate New York. The Knickerbocker News reported my presentation of the program at the campus center of the State University of Albany on March 27, 1968:

". . . the audience was sitting and lying on the floor in the assembly room of the Campus Center . . . Mr. Tambellini turned out the lights . . . what emerges is a audio-visual bombardment that mesmerizes and attacks the senses. Light leaps out, falls back, scrawls itself into squiggles. New images merge with the other images left from the image before. One tries to identify, to seek contact, it is impossible. Hypnotic light takes over, the sound screams whistles and crawls up and down through a cycle of tones, the biggest fingernails in the universe is being scratched over a blackboard. The audience becomes to get uneasy, one girl flees hands over her ears. Physiological factors begin to emerge and one begins to wonder somewhat uneasily if there is not limit to human endurance . . . Then comes the threshold and the mind takes no more...or cannot. One sits waiting for the end . . . Part 2 is a similar bombardment only using the four TV consoles, two motion picture projectors and two slide projectors plus the sound...a vast subterranean rumbling that never ceased while on the walls and ceiling flickered sudden images . . . coiling tubes, clinical-looking non identifiable objects. It was an ever-moving Rorschach test, updated . . . At the end of the performance last night when the lights went up everybody looked at each other dazed, their eyes looking like road maps.

In the issue of *The East Village Other* of January 26–February 1, 1968, the art critic Lil Picard asked, "Why is it television?" I answered:

"Because television is no longer a painting or a form which could work on a canvas which can only be owned, which can only be seen, which can only involve a small, limited amount of people. I am looking for the many. I am looking for the multitude. I am looking for the simultaneous. I looking for humanity as humanity. . . . To me humanity is the sharing, the exchange, the giving of my particular experience for man to have. For man to have it there should be no dictatorship or owning a particular work as if owning someone's particular life. Like somebody might say 'I own a Van Gogh.' I want to say that somebody does not own anything but he has the same experience, the same life, the

same fucking heart, the same human concept as anybody else can have."

I also worked with engineer Tracy Kinsel from Bell Laboratories, whom I had met during the show at the Brooklyn Museum called "Some More Beginnings," in November 1968. The show was sponsored by EAT (Experiment in Arts and Technology), organized by Rauschenberg and Billy Kluver at the museum where I showed "BLACK VIDEO 2," a combined or television sculpture later shown at the "Howard Wise Galley show "Festival of Lights." I approached engineer Tracy Kinsel, who later introduced me to Hans Reinbold, because I wanted to have a black and white television set broadcast news in a spiral configuration. A set was re-circuited for me so that all regular broadcast imagery was transformed into a constantly moving spiral that is drawn into the center of the tube. After many attempts, we finally got the results we wanted. I called the piece "BLACK SPIRAL," a television sculpture, later exhibited at the Howard Wise Gallery in the show "TV as a Creative Medium," the first television show in an art gallery.

In 1968, I came upon the idea of photographing an image directly from the TV screen without using the camera. Upstairs, at the Gate Theatre, next to the projection booth, I placed the emulsion side of the photo paper in front of the TV monitor in the dark, turned on the TV set and when the beam flashed on the paper, I immediately shut it off. I developed the paper in the sink and a black dot appeared in the image of the beam. I made many variations using this method. One of them was a self-portrait made by playing back a pre-recorded tape of myself, stopping the recorder and reproducing in photo paper my self portrait. I called these prints "Videograms." They were exhibited with other works of mine about television on January 21–February 22, 1970, at the "Vision & Television Show" at the Rose Art Museum at Brandeis University, Massachusetts. As part of this show, there was also the experimental program with children which I was invited to make for Channel 25, Board of Education Television in New York, which the producer entitled, "Aldo Tambellini: TV Media Pioneer." The whole exhibit was the first acknowledgement of television as an art form by a museum in the United States.

I was in the first show of video at the Whitney Museum, called a "Special Video Show" in 1971. This was the first New York museum to acknowledge videotape as an art form.

Otto Piene and I were invited to make the first ever one-hour broadcast by television artists at WDR-TV, German television in Cologne in 1968. My "electromedia" environment and Piene's helium-inflated polyethylene tubing became, "Black Gate Cologne."

Subsequently, in 1969, six artists were invited to work with television technicians for the creation of "The Medium Is the Medium," the first broadcast in the U.S. by artists making use of television as an art form on WGBH, Boston. The program was nationally broadcast. "Aldo Tambellini's work *Black* features images from slides, films, and television monitors and the responses of children. The work, which is black-and-white, opens with abstract circular designs and moves into street scenes and images of children's faces. At one point the children are heard discussing blackness and racial identity." (Quoted from the description found on the web site of the New Television Workshop Collection.)

Recently, I was in New York's Lower East Side and saw the old Gate Theatre; it is now a clothing store and the storefront at 217 E 2nd Street is an empty lot.

*Title quoted from the *Syracuse Post Standard* article with the same title.

A Bowl of Cherries

by Erik La Prade

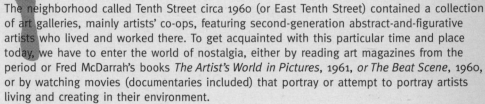

The neighborhood called Tenth Street circa 1960 (or East Tenth Street) contained a collection of art galleries, mainly artists' co-ops, featuring second-generation abstract-and-figurative artists who lived and worked there. To get acquainted with this particular time and place today, we have to enter the world of nostalgia, either by reading art magazines from the period or Fred McDarrah's books *The Artist's World in Pictures*, 1961, *or The Beat Scene*, 1960, or by watching movies (documentaries included) that portray or attempt to portray artists living and creating in their environment.

A Bowl of Cherries is part of a trio of art films that present a satirical look at artists and their work, particularly the work of an abstract artist. The other two films, *Day of A Painter (or Day of The Painter)* and *Call Me Genius*, which is a British film, also satirize the abstract painters. Since I have not watched *Day of A Painter* or *Call Me Genius*, I can't comment on them or compare them to A *Bowl of Cherries*. A fourth film made during the 1960s is based on Joyce Cary's novel, *The Horse's Mouth*. Yet, this film is not really a satire as it presents a more picaresque story of a painter in his quest to find a blank wall. *The Horse's Mouth* is a serious film with a tragic perspective.

Before I describe *A Bowl of Cherries,* it might be worth considering what exactly this film was satirizing and why. Because of a limited amount of space, I can only summarize in brief general terms the art/political situation which marked a turning point in the New York art scene/world, circa 1960.

Abstract Expressionism was the dominate style of painting throughout the 1950s, but with the end of the decade, it was now considered to be a decorative style, exhausted as an innovative approach to painting and powerless as a new art form. It was also during 1960(?) that John Cannady, *The New York Times* art critic, began critically attacking the New York art scene and the works of various abstract painters; in a sense, the establishment rose up against the phoniness of the art world.

Two years earlier, 1958–1959, The Museum of Modern Art organized *The New American Painting* show, which toured in eight European countries. While this show "won for American art widespread recognition and acclaim abroad," it also drew the lightning:

"The international success of the New York School had brought immediate reaction at home, ranging from serious second generation departures to outright rejections. The press, which by now understood the news value of art marketing, spurred its readers to expect constant shifts and novelties. By 1960 it had dropped even derisive references to abstract expressionism and was exploring new fields for hyperbole."[1]

The assault by *The New York Times* was so vitriolic that a protest letter was drawn up, signed by 120 artists and sent to *The Times*. There are other elements that also fell into the media's spotlight as it attacked the image of what an American artist should or should not be. Nineteen sixty was also the height, or close to it, of the beatnik period in America. The Beats were also seriously attacked by the media as antiestablishment figures. Looking back today, we can see that the image of the abstract painter and the beatnik overlapped in the public's mind, combining to make an antisocial figure.

The cold war reached its peak in 1960, and the American government, specifically the CIA, may have been covertly attacking the image of the abstract/beatnik artist through the newspapers. Perhaps, the focus of this attack was the need to eliminate what the radical/leftist aspects abstract expressionism stood for: individuality and a kind of "grass-roots" approach toward society; elements possible to trace back to political parties of the 1930s and 1940s. In its need to establish an American, anti-Communist image overseas, the

government also provided grants to American writers to write pro-American material. On top of this list, we can add the intense infighting occurring between certain artists suddenly making a lot of money through the sale of their paintings, as opposed to other artists whose work was not selling.

After forty-three years, all the political-and-aesthetic arguments of the period have faded away in this film's humorous portrait of an artist and his situation. What is left is the satire and the only thing you need when you watch this film is your heart and mind and eyes.

A Bowl of Cherries was written and directed by William Kronick and produced by George Edgar. It is fully scored to accompany the film's story. The story of the film is a kind of every-man's tale: a young artist comes to New York to be discovered and become famous. After hitchhiking cross-country, a young Jackson Pollock look-alike arrives in New York and makes his way via the subway to Greenwich Village. Once in the village, our painter finds a studio and immediately begins to visit various art galleries in the hope of getting a show. The following evening at an art opening our painter meets a woman, they fall in love and begin living together.

As soon as our painter begins his village life, his painting style changes, shifting from a realistic style to an experiential, abstract expressionist style, and as a result of this change, one of his paintings is included in an uptown group show. He has arrived. I cannot continue describing the film's story without giving away the surprise ending.

The exterior scenes in this film were shot on 10th Street. The gallery entrances are real.

The Area Gallery was located at 80 East 10th Street and the March Gallery was located at 95 East 10th Street. The art opening scenes were filmed in the March Gallery and present a real art opening. During the opening we see the figure of the painter Sam Goodman holding forth, standing in the middle of a trio of beautiful women.

The interior scenes were filmed in the Great Jones Street studio of the painter Natalie Edgar. Ms. Edgar was the sister of the film's producer, George Edgar. I recently spoke with Ms. Edgar about this film and she commented on how it contained "an awful lot of verity."

Clayton Patterson

ELP: It's a vignette of what was going on and the neighborhoods?

NE: And the attitudes, the general, psychological attitudes which were playful.

ELP: You mean, the art attitude at the time?

NE: It's playful.

Ms. Edgar appears in the film as one of three women dressed in black, smoking a cigarette, standing in front of a real, well-known book store called *The Paperback Gallery*, which was located in Sheridan Square. Other artists also appear in the film: Jim Dine, Lucas Samaras and Robert Whitman. Bruce Glazer, then an art director for the Howard Wise gallery, was the contact/go-between person who may have enlisted these three artists to appear in the film.

A Bowl of Cherries is twenty-five minutes long. The production values are high and it clearly is not an "underground film" typical of the period. It should be seen by anyone interested in knowing what the art scene on the Lower East Side was like.

[1] This information is derived from a conversation I had with Robert Whitman.

[2] *The New York School: A Cultural Reckoning*. Dore Ashton. Penguin Books. N.Y. 1972. Pg. 229-230

Eric La Prade

Bill Rice

by Clayton Patterson
Transcribed by Lane Robbins and Mika Deutsch

Clayton Patterson: So you just finished a book on Gertrude Stein.

Bill Rice: Yeah, twenty years later . . . it was a lot of work, but it was a lot of fun, too. I can't wait to read it because we put every fucking chapter through—at least four revisions. It's with footnotes—not endnotes—thank you very much, and Northwestern Press is publishing it.

CP: That's amazing. I did a book about the Lower East Side, from 1985 to 2000, and it's going to be 2004 and it's sitting in a box at the printer's. I'm on a twenty-year deadline too.

BR: We should do something. This book has a history you don't want to hear about. It was really tough along the way because the texts Ulla [Dydo] is dealing with, Gertrude Stein, are what she considers to be the modernist texts, beginning with an elucidation, on up until she came here to lecture in 1934. One of the unique things about her book was that Ulla was the first person to go through the Gertrude Stein archives [at Yale] . . . I did some editing and some manuscript preparation. As I said, we went over each chapter, over and over and over, and there were a lot of problems. But she finally did it.

CP: So why Gertrude Stein? Is this a feminist history kind of thing?

BR: No. Not at all. It's a very careful examination of all those texts, including the lectures on the autobiography, of course. In going through the archive, which was not catalogued at the time, it was just random stuff. When Gertrude packed her manuscripts up and sent them over here, she probably didn't go through everything. The war was coming, it was 1936 or 1937, I think; she was nervous. Wilder said, your stuff has to be in a safe place, so it went to the binding company. That was in '36 . . . for most of the published texts, the editors never went back to the original manuscripts or typescripts.

CP: I believe it—that's how it works.

BR: We went through all the original manuscripts and typescripts and published the reader in '94. That's what that book was. It was a compilation, in order of their writing, and she found a whole series on carnets and cahiers. The carnets, as you know, are the little black notebooks, and the cahiers are the student notebooks. They're a beautiful design and have a history of travel, and have a picture of a pelican or something like that. Gertrude loved those books and when she started writing she would scribble in these little notebooks. Sometimes she would write in the dark. Sometimes she would write while walking. Then she would transcribe from the carnets to the carhiers, and Alice would type it up. Ulla would sort of map and organize, and collate this massive material. She actually started working on Stein in '69, or 1970. She'd collate every week and work on Stein material, and annotate, and organize. So then she decided to work on the book, because she'd amassed all this information. No one had ever seen these little notebooks before. Only Gertrude knows, and there are probably countless miss-

ing. Anyway, to make a long story short, she started working on this book. I came along because Ed Burns—I don't know if you know Ed Burns; he's a teacher; a scholar—but I was working with him on a compilation of letters of Carlton Van Vechten and Gertrude Stein.

CP: Were you interested in this because of theater, or the period, or art?

BR: Well, kind of. This isn't my work. I'm a painter. I started painting when I was nine years old.

CP: You were interested in the French period.

BR: I came to New York in July of 1953. During the 1950s, before abstract expressionism came in and the school of Paris went out—when I was in high school and college I wanted to go to Paris. I lived over on Bank Street and I wanted to go to Paris.

CP: Where are you from originally?

BR: Vermont. I went to school at Middlebury.

CP: The whole romantic American artist wasn't really the thing at the time.

BR: Well, we had some wonderful romantic artists. We had Charles Birchfield. We had Reginald Marsh, who was the great chronicler of this neighborhood.

CP: [Paul] Cadmus I loved . . . But the real deal was the Paris school and Picasso.

BR: At that time I didn't give much of a shit about Picasso. I thought he was a clown. [I wanted] to go to France because of Cezanne. And he was and still is my god as far as painting goes.

CP: I look at this [one of Bill's paintings] and it reminds me of, totally different, but it's got kind of the same feel –

BR: Edward Hopper.

CP: Ah, Edward Hopper. Yeah, a little bit, but loneliness, isolation, and, what was the other person's name? George Tooker. You know the subway series.

CP: That was pretty dangerous in those days, cruising around [Tompkin's Square Park].

BR: Not in those days. Not in the 1950s and early 1960s. It became really dangerous about 1966. There was a murder. Avenue A used to be jumping in the early 1960s. You had the two Stanley bars, you had the Annex, which was a Micky Rustin establishment. It was very hot. It had a great mix of blacks, Latinos, Asians, you know, hippies, you name it—junkies. It was a great, great bar. There were several other bars that were very successful. The Charles Theater where Taylor first showed *The Flower Thief* in 1962—'63, perhaps . . . on Avenue A between 11th and 12th, I think, or maybe 12th and 13th . . . so there were a lot of establishments, but I forget exactly when it was, maybe 1965 or 1966—1966 it was, I remember, when the shit hit the fan. There were a couple of hippies living on the block, at the Annex, I think, and they were murdered. And it was a big thing.

CP: That wasn't the Groovy Case, was it?

BR: I don't remember what it was called. The one where he boiled his girlfriend's head in the pot?

CP: No, that was Rakowitz, [laughter] no, that was much later.

BR: See how time marches on, and progress. But anyway, they were slaughtered, and also, the city was taking over buildings from landlords for non-payment of taxes, driving people out of the neighborhoods. So what do you have? You have the hippies from the East Village/Lower East Side, who would hang out in these progressive, radical places, but they were basically white. A lot of the people who were being dis-

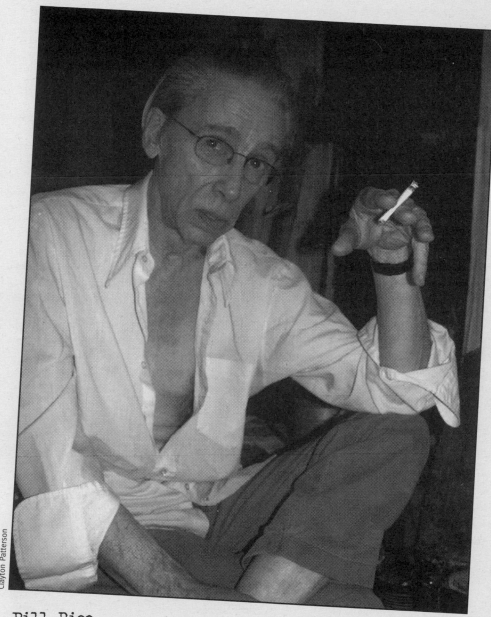

Clayton Patterson

Bill Rice

placed were Hispanic, Puerto Rican, Dominican, Jewish, Ukrainian—and the landlords were forced to give up their properties to the city. So there were those confluences . . . in 1969, '70, I had a friend I used to visit on 3rd Street between A and B, I guess it was. On 2nd Street the landlords were burning up their own buildings for the fire insurance. They would hire young kids to do the job, and give them a nickel, or a drink, or something.

BR: Well, the 1970s were a misery. Some say it didn't happen at all. There was nothing there at all—except disco. Can you think of anything else? I first did theater in the 1970s—1976 during the tall ships, bicentennial celebration. A friend of mine cast me in a play. We did it at the WPA Theater. It was a mime drama—silent, right. Mind you,

I had never acted. I acted in college; I acted in high school. But I was a painter. So I can't really say that nothing happened in the 1970s to me. That was the beginning of a very good time, which extended over the years. It was also the beginning of Super 8 filmmaking. You had Scott and Beth B, and I did my first film with them in 1978. You had Eric Mitchell, Amos Poe who did shooting clubs and blah, blah, blah for years, used to show at the Millennium, and this poet, James Nares—not Jim Jarmusch yet because he was a little bit younger, and you know, Rafik who you were talking about. That was all '78, '79, and into the early 1980s. Then Charlie Ahearn did *Wild Style*; I think he shot it in '80. It took him forever to edit it. . . . So when you see *Wild Style* you are seeing a master editor, Steve Brown, at work.

CP: And that was shot in Super 8?

BR: No, I think it was shot in 16. I don't know, but I don't think that was Super 8. [It was 16mm]

CP: But is was filmed on video, right?

BR: [16mm] I'm in it for an eye blink. You wouldn't know. I play a TV producer. I was trying to talk to this kid, Lee, I can't remember his last name—Lee Quinones—wonderful kid, graffiti artist. You know the film?

CP: Yeah, I've seen it. I mean I'm not a real specialist on it.

BR: Patti Astor, Glen O'Brien and Lee—they introduced me to this kid because I'm a TV producer. The script, as originally scripted, I was supposed to say something like, "Well, by the way, can you just give us the addresses and the yards where you work?" . . . [he says,] "I can't say these things, they're going to kill me." This isn't information you give out. So I went to Charlie, and I said, "Charlie, Lee is very uncomfortable with this, will you let us just improv something? If you don't like it we'll do another improv, but he doesn't want to use this dialogue." So Charlie said okay, and we just improved. I forget the dialogue exactly, but I said something like, "Well, what kind of music do you do?" And he says, "Well, basically it's rap." And I say, [whispers] "Rat. Rat music." Or something. It's a very short scene. So all those things happened. You know, Stan Brackage was working . . .

CP: Well, certainly *Wild Style* was a classic and important movie . . . very well done.

BR: But nevertheless, it was Charlie's eye. He did another wonderful film called *The Deadly Art of Survival*. It's about basketball players in Harlem . . . and there are some wonderful images there. . . . That was a nice one. Then I did several films with Scott and Beth B. The first one we did was *G-Man*. I had to take my clothes off—the first time I ever went in front of the camera buck naked wearing a little apron and a dog collar. A dominatrix—a very sweet lady, was paddling me. That was the first one, and then the second one was a little short called, *Letters To Dad*. It was basically talking heads about the Kool-Aid Massacre in Jonestown (Guyana). These were letters these people had written to their families after they got involved in the James Jones experiment, basically saying goodbye, and that they were going on to a much better life, but they still loved them—*Letters to Dad*. It's a powerful little film, if you haven't seen it. I guess the next one was *Trap Door*. I played a so-called Fuller Brush salesman and I tried to charm John Ahearn, no, Charlie, no John—I always get them mixed up—they're twins. What a nightmare. To this day I never know whom I'm talking to until they're kind enough to say—Charlie will say, "When we were working on that film," and I'll say, "Okay, got it, that's Charlie." Or John will say, "You know, you were my first death mask."

CP: Those portraits that he made, "Blast" or whatever, he made one of you.

BR: Yeah, that was the first one. I was his guinea pig. I think that's true, but maybe I'm stretching it.

CP: But mostly he started off with Hispanics and blacks, and browns or whatever. That's interesting. So he did that down here?

BR: I'm probably the only white man—do you think I'm the only white man? Yeah sure, he was living down here. He did it at my studio. Yeah, and Amos Poe did a whole thing on "Subway Rides," and the time after that I had my first painting show in 1984 at the Patrick Fox Gallery. So I got back into painting, and I did quite a lot of painting from '71 up until about '78. Yeah, my father died, whom I had done. Anyway, about '86 I guess it was, oh no, it was earlier than that, because I did a movie with Jim Neu called *Doomed Love*, and that was '81. That was very big in Europe. They loved it in Yugoslavia in the early 1980s, and it used to play around a lot. It's Neu's script—Andy Horn shot the film, and I play a very lonely man who is in mourning for his wife and has a picture of her, which he's always looking at. He's very depressed, and this young woman played by Rosemary Moore visits him and she befriends him. He's very stiff and very conservative, and I think his profession is a lecturer in art history, because at one point in the film I give a slide lecture [with] these gorgeous black-and-white, sometimes sepia images from pre-Raphaelite paintings. It's stunning to look at, and the set was built for it and we filmed it at Millennium, in that room. That comes from a very lush score, a German film composer, I keep thinking Stachauser, but anyway, it will come to me. [It's] beautiful music and there's some lip-synching. ["Black-Eyed"] Susan does a scene from *Private Lives* with Charles Ludlam, and I sit and look at this little primitive cardboard TV set, and you can see the moon up there and I'm sitting in a chair like this. So that was that film, and that was '81.

CP: So that was an interesting cast.

BR: Yes, and, oh, Alan Frame played the boyfriend—they made songs together. There's some really interesting photography. So then *Trap Door* was later, it must have been. Anyways, in '85/'86 I got thrown out of the building—'85 we stayed there, and finally I was relocated to number seven and I had a studio there which I sort of miss—it was huge. So that's '87/'88.

CP: That's on 3rd Street.

BR: Third Street, number seven. It was downstairs. There used to be a lot of bars; they played a lot of love music, thank you, which I'm just getting back to . . . I don't like CDs. I have 78s even, which I love because that's real sound. So then about 1981–82, I started working with Ulla on her book; so it's been just about 20 years.

CP: How did you hook up with Gary Goldberg?

BR: I was in a play with Jim Neu at St. Mark's Church called *Buffalo Dreams*. S. K. Dunn wrote the play, Jim was in it. It was one of the first—I'm backtracking now. Jim Neu wrote the script for *Doomed Love* and after that, in 1981 and 1982 I started working with him doing readings and that sort of thing. I think I'll get the chronology right—in '86 he did this play, musical actually, *Buffalo Dreams*. It was at St. Mark's Church. We did it in a vestry there, whatever you call it. So then he wrote a play called *An Evening with Jesse James* and I played Jesse James's mother, Zerelda James. That was in '88, there's a year missing here but so what. Well, in the meantime I did a film with Jacob Burkhardt called *Landlord Blues*, which you may have seen, about bike messengers and pillaging landlords and that sort of thing. That was '86.

CP: Was that 8mm?

Clayton Patterson

Clayton Patterson

Bill Rice

BR: No, I don't think he's ever worked in 8mm. Jacob always works in 16. It was shown around. That was '86 and '87. So we did that play. Then I do nearly a play a year with Jim, and then I expect I'll be doing something in September with him at LaMama, usually, sometimes P.S. 122. Then there's Charles Allcroft. He's one of the great geniuses of American theater. We all have been working with him for—I don't know—ten years at least. He used to perform, or his work would be performed, on Pier 26, which is like an old hangar of some kind, and they had all the cars that they found here. That was wonderful because it was right on the water and his plays are absolutely a match. [That was] nearly every year. Then Gary Goldberg—I started working with him. We did *Yes No* at Westbeth, I think in '86 . . . I met him when we were doing *Buffalo Dreams* and he said, "I want to write something for you and Taylor Mead, sounds like it might be a good idea." So he did and the piece was called "Yes No," and Taylor and I don't speak—we never did. None of the films that we made have any dialogue. There's sound but no dialogue. We never talk to each other. Never ever until Jim Jarmusch came along and said, "Would you be in a piece?" and we said, yes, and that's our first talkie. It's part of his *Coffee and Cigarettes*.

CP: And which one was that?

BR: Jim shot that in February this year. He's been making his short films apparently for years, since '86 or so. And he's putting them all together as one evening.

CP: And that's the first speaking film role that you've had?

BR: With Taylor Mead.

CP: And how many films have you been in together?

BR: Oh, together? Six? [ten, but six are on tape]. They're all on one tape. I've got it here somewhere—called *Double Trouble*. It has nearly all the films.

CP: That you did with Gary Goldberg.

BR: Yeah, six or seven of them. Then there's a lot of video. . . . Sometimes he didn't always go from theater to film, you know how he did early on with *Plates*. We performed [Plates] at LaMama for a Bob Holman festival, but no, not always. Sometimes we would do a live performance and he wouldn't turn it into a film. You know what I mean.

CP: Sometimes he would do a live performance and then show the film, or a film.

BR: Yes, we did at—

CP: Nada.

BR: That's right!! Yes we did. Was that *Usher*? Oh, I know; I have the tape actually. I think I banged on the piano at one point or something.

CP: So that whole performance was meant to be theater and then film?

BR: Something like that. I think we were acting out. I think we did *Plates*. We couldn't have done *Mesmer*. And I don't know what else we did. I'll look at the tapes and find out. [laugh]

CP: Before that Gary Goldberg would also design the costumes.

BR: They were fabulous. I've got a whole lot you know.

BR: Portfolio; big stack. A whole envelope full of designs. It was just wonderful fun working with Gary. If we actors wanted a bottle of wine, he'd give us a bottle of wine and I would always have at least two tall-boys of Budweiser and sometimes other condiments. You know his scripts—I told Tom this—were like this: "Bill enters stage left. With a plate. Walks over to table. Puts plate on table. Bill exits stage left. Bill

enters stage left with another plate." And it goes on. "Bill sits." . . . But you know we had a good time doing it, so hopefully, they don't know the joke or don't want to.

CP: There was a real kind of theatrical feeling with those, I mean, like when the play was going on and the films would come after. I think there was like a mood, an atmosphere, a tension, a point of view—a little bit ridiculous, a little bit not really about—not really about... It was more like theme than really plot; it was not plot oriented.

BR: It was very much situational.

CP: Situation oriented—exactly—mundane situations a lot of times.

BR: Absolutely. You can't get more mundane than pacing around and putting down a plate. So Taylor sits there expectantly in his big Little Lord Fauntleroy collar and he looks at me and I'm not doing anything. So then I have three plates from right before stuck to the front. So I take the first one and I place it very carefully on top of his plate. Taylor looks at it and he looks at me. Pause. Endless pause. I pick up another plate and put it on top of that plate, but this one, I smash it down. I think when he was doing nothing he was actually slowly pulling down his pants. Taylor looks at the plate, looks at me, jumps up, his pants fall down and he takes all the plates and smashes them on the floor. Exit. I sit there as though nothing had happened and dawdle with my apron string, or whatever—endless. I finally walk off. Beat. Beat. Beat. A plate comes sailing out from backstage and smashes on the floor. And that's the story. It was our first film.

CP: How long was the film?

BR: Well, I have a story about that to tell. Taylor might never say this. We were walking down 4th Street, toward Millennium, and Gary has the film, and I run into Robert Frank. I say, "Hi Robert. Hi, how're you doing? You want to come in and see Gary's film that Taylor and I are doing?" So Robert said "Sure." So we go in and there's Robert Frank, me, Taylor, and Gary in a row. The film starts and all I can think is, for one thing, Gary really liked to print dark; it was part of his atmospheric aesthetic or whatever. His prints are always beautiful but they are very, very hard to see. You can barely make out what was happening. We'd never seen it. It took fucking forever— the credits, the titles, and what not. I was bored out of my fucking mind and I thought, "Oh my god," what can I say to Robert Frank or what is he going to say to me. I did say to him, "It does take a little while, but Robert, it's real time you know. That's why we're working in real time, and this was our one take," which it was. I've got the exact time. Ten [minutes]. I don't see any of that anymore because ten minutes of real time on film is . . . people start to leave amongst other things. Plus, the fact [was] that you could hardly see anything.

CP: Right, and Gary was loving it.

BR: He was given some kind of award and we appeared at some fabulous place uptown to receive the award, and it was for *Plates*. Well, by this time he'd shown it several times, sometimes it was dark, sometimes it was lighter, and I used to piss and moan all the time—we all did. "Gary, you can't see anything. This is supposed to be a movie. You're supposed to see at least a hint of an image." I'm not kidding. It's black on black. It was like that you see the drapery, only not that clear. So we're receiving the award and Kitty Carlyle-Hart is the presenter, and they give out the other awards, and of course you know ours is probably the last one; maybe not. Anyway, Kitty Carlyle-Hart was late for the event because she tripped on the tarmac in the airport on the way into town. So she was on a crutch and not looking quite as glamorous, but you know the spirit was there. Comes to show *Plates* and the lights go down. The lights go down. The lights go down. And I swear to god nobody

knew when the film started. Total darkness. They had to bring up the lights in the house so we could see anything. Then Kitty Carlyle-Hart had to get up and say something wonderful about what a wonderful film this was. So she had two events that really made it a very bad day for Kitty. She did her best because she's a trooper, but under those circumstances—anyway.

CP: What did Robert Frank say about the film?

BR: You know, I don't remember. If he said anything, being Robert he probably didn't say a word. He just said, "Oh, thanks," and wandered off with his hands in his pockets. I'm sure he didn't say anything. But I worked with him on his film *The Last Sup-*

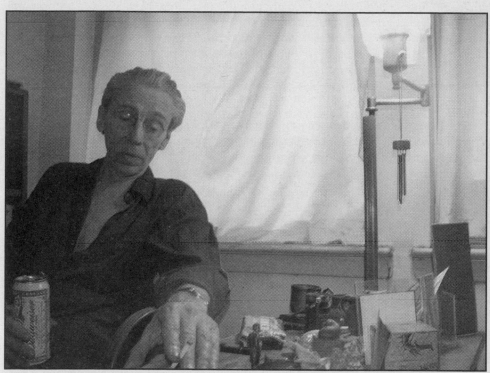

Clayton Patterson

Bill Rice

per, and it was a lot of fun. Very strange. . . . That was wild. It was in Harlem and they were filming between streets—somewhere up at 137th, 138th Street.

CP: Adam Clayton?

BR: Adam Clayton Powell Blvd. I think it was somewhere along one of those side streets. One block there was a connecting vacant lot, and Robert set up camp on this huge vacant lot, and it was huge—it was a block in width, and he was shooting there. It took forever. It took so long and it was so hot. The premise of the film, as I remember it, is a book signing—for a famous author. So everybody's waiting for the famous author and he doesn't show up at all. There are messages from his wife, and things like that, that he's coming—that he's on his way. Anyway, he never shows up. What fascinated me, and lots of us, was the intense drama that was going on as people went on the path from one block to the other. They were wonderful. Sometimes they would be a little bit edgy; you know, we were intruding on their fucking territory. It's their block.

CP: Right. Was that part of the film?

BR: He did some long shots of this back and forth, but none of the drama of those walks back and forth on that block. Anyway, it all ends up with a huge banquet for the people on the block. [There's] lots to drink, lots of food—that's the last supper. At the very end of that they throw all of their paper plates into a huge bonfire. And I am French—I'm sort of like the silent butler. I walk around serving appetizers and making sure that people have enough to drink, and I don't say a word through the early part of the film. The only words of dialogue I think that I had were in French. I cannot remember for the life of me, and I could not get my French together, and finally with some coaching I got it together and that's the end of the film. Robert put Taylor and me in that hour long video which he was filming for French TV. The premise for the award was [that] you couldn't cut; you had to keep shooting continuously for one hour. Robert marked off a series of blocks from his place on Bleecker down to Second Avenue to Houston and then back up, so you see these same characters a couple times. It was all video.

CP: And that was hand-held?

BR: Yup. He was holding the camera. He had a lot of assistants running around, but the logistics were such that he had to get everything set up to the split fucking second as a matter of direction. What does he want from his actors when he comes across from 2nd? It was a little complicated and we rehearsed quite a lot.

CP: In the end he used people from the neighborhood because he then threw a big banquet—

BR: No, that was *The Last Supper*. That was 1988. But what I'm talking about is, I think, the year before. This was the video. *The Last Supper* was a film. This was the video and Peter Onlovsky was in it, and he lost control in the subway—or, I don't know. I have a print of it somewhere. It was for French TV. All these video artist or film artists had 60 minutes, I think it was, and they couldn't stop shooting. Taylor and I had some dialogue in front of that wonderful antique shop, which is now gone. We were standing in front of that and talking absolute nonsense; I don't know where Robert came up with the dialogue. The script is in a little Hanuman book with little tiny pictures. Then I had a painting show curated by Richard Milazzo at the Sidney Janis Gallery in '96. Nearly every year [I was] doing a play with Allcroft and Jim Neu. Gary, Taylor, and I did our last film together—I'm pretty sure it was in '94 across the street from that school on Suffolk and Rivington. It was an old movie theater; maybe you remember it. It was in the middle of the block between Delancey and Rivington.

CP: On Suffolk Street?

BR: I think it was—yeah I'm sure. And that's where Gary shot his last film with us.

CP: I know there was a school there called Cemente-Soto Vela; that big school.

BR: That was right across the street. Anyway, it went out of business but it was a beautiful old movie theater. He shot our last film called *Box Heads*. Taylor and I are in boxes; I'm in one box and he's in the other. The lid comes up and we hide from each other and I chase him from box to box. That was our last film. Gary never told anybody really that he was sick, but he did tell me. I didn't know he was sick until '98 perhaps; several years. He got very, very sick and he went on a macrobiotic diet and it nearly killed him. He developed anemia and then leukemia, and he died a couple months ago.

CP: How old was he—56 maybe?

BR: We were trying to figure the other day. Rochelle would know. I don't. His sister found some wonderful photographs of him as a teenager. He would have been a teenager in the '60s. So he's what, 50—early 50s wouldn't you say?

CP: Yeah. He was not an old man, but what wonderful work. The film he did with George Gajek? I'm embarrassed, his name I can't remember, the big guy—

CP: You mean Rockets?

BR: No, not him. Oh boy, you wanna hear the stories I have to tell about Rockets? Woo! That's another [story]. To get back to Gary—I wish I could remember his name because he's a wonderful man; a wonderful artist [and] filmmaker. He was one of Gary's very, very closest friends. Gary made a film of this man who's very large—very beautiful in a wonderful way, and Gary saw that.

CP: Who made the film?

BR: Gary Goldberg made the film. Yeah, this was maybe '97–'98, somewhere in there, that he made this film. What you first see is this room full of chairs. There are these beautiful old bent wood chairs—you know the ice cream chairs, the wooden chairs you see at the bars, or rarely anymore—but they're beautiful—full of those. They're at all different angles and some of them look like they couldn't hold anybody. In the middle, off to the left-hand side, there's this big overstuffed chair, and George comes in. It's very, very slow; the establishing shot with the room seems like five minutes. It's like looking at an object coming to life gradually. That's the way an object should come to life—don't you think?—gradually, so you get a chance to take everything in, and then you see George's butt appear to the right. You don't really even know what it is. Then you see a little bit more of his huge, humungous back, and his arm, and he has a broom with him. He slowly backs into the room from right to left, turns around, examines the furniture, looks at the chair—he looks exhausted as though the thing he most wants to do in the world is sit in that big overstuffed chair. But he can't because he's disturbed about the condition of some of the chairs and the position of some of the chairs. So that is what the film is about. At one point he loses control completely and demolishes two of the chairs. Then I think he sits down; I can't remember.

CP: What was that one called? Do you remember?

BR: I can't, but I know that Rochelle would have a copy of it [Chairman I & II, 1998]. That reminds me, I must ask her tomorrow if I could get a print of that film. It is so beautiful; the cinematography. The images are so sharp and so crisp. . . . You can see every pore in the furniture. It was wonderful, just a beautiful film.

CP: And that was Super 8.

BR: No, Gary Goldberg never worked in Super 8.

CP: Didn't he? What'd he work in?

BR: Sixteen—He wasn't making films until 1985. He was a photographer before he was a filmmaker. He used to do photograms where you place objects onto the photo paper [and expose it]—some beautiful still shots—a wonderful photographer. So that's where he came from into film. But no, I never worked with him in Super 8.

CP: Did you ever work with Jack Smith?

BR: He was in *Trapdoor*. He played this mad swami who tries to hypnotize John Ahearne with his Maria Montez Medallion—with his heroine from the B-movies.

CP: What was it like working with Jack Smith?

BR: I didn't have a scene with him, so in that sense, no, I never worked with Jack

Smith and I think very few people ever did. They did as they were told. I've heard stories from John Voccaro and other people about what it was like to be on one of Jack's films. You know it was total madness on the set, everybody [was] absolutely gaga and Jack would decide, "You don't look like a lobster, John." Everything. Stop. Then he'd get more and more high. He once said, "Did you hear about Bill Rice? He fell down and he broke his hair." No, I didn't work with him.

CP: Did you ever know Harry Smith?

BR: No, but Sandy Daly, now that's somebody. Do you know Sandy or her work? She's a filmmaker.

CP: I'm terrible at names.

BR: Her film was, one of her many films, was called *Robert Gets His Nipple Pierced*, about Robert Mapplethorpe. She and Robert were tight. I just saw her yesterday— you might want to talk to her. She goes back to the Chelsea Hotel, and it was she who introduced Robert Mapplethorpe to Patti Smith and together they would go off to Max's Kansas City. She taught Robert Mapplethorpe how to take photographs and how to show them.

CP: —which is important to his work; that's true.

BR: She has his first camera, or his first photograph.

CP: Yeah that's great. So you've been around for a while doing this. Do you paint a lot now?

BR: No, I don't paint a lot at all. My latest thing for the last six or seven years—I decided I would recreate Picasso's "Les Demoiselles d'Avignon." And so it goes . . .

Emile de Antonio | 1989

by Jay Murphy

Emile de Antonio would often say in the 1980s that "I have done with the documentary form of film." He appeared full of script ideas, often written early in the morning. Sometimes he would claim he made three script treatments a day as "a perversion." There were commercial ideas, comical ideas, theater of the absurd vignettes where De plumbed his "Dada politics," all too well abetted in an era when a "B film actor" ran the United States: "It's not because I'm a director that I find it so shaming that the old mummer is our president, a broken down actor, deaf and not very intelligent with his palsied hand on the nuclear trigger while his wife swishes through what really matters, Galanos and Oscar de la Renta." A tyro of energy even into his sixties, De usually thrived on four-and-a-half hours of sleep. Often he had to rely on valium or a more organic preparation to get to sleep at all. De was a fount of early morning poison pen letters, scripts and assiduous journal pasting. De's frenetic energy could often, as John Cage observed of him when they met in Rockland County, New York in 1954, lack enough "priority"—"I didn't feel he was always putting his energy in the best direction." At that time De was a consummate dealmaker and macher, and became a freelance artists' agent for a number of notables, including the then commercial art team of "Matson Jones"—Jasper Johns and Robert Rauchenberg—who De met when he produced Cage's first retrospective concert in October, 1955. A rollicking partier and bon vivant, it was during that period that according to De he excelled in drinking many bottles of single-malt whiskey, sleeping with other men's wives and at onetime making hundreds of thousands of dollars selling surplus Navy equipment he didn't own. Often fascinated with guns, De used a tin policeman fascimile like that used for school stops for target practice; one night drunkenly and by mistake, he blew out the lights in his house by hitting the power lines with his shotgun. He also played Russian roulette with a loaded pistol, a tempting of fate De would pursue in various forms throughout his life, whether through gargantuan intake of alcohol at parties at Elaine's, or in the aftermath of the Kennedy assassination drunkenly walking train tracks in Dallas late at night even after being threatened by the Dallas police homicide department. Whatever was in front of him that moment had his entire attention and devotion and enthusiasm, whether it was a concert, a political intrigue, or glass of poire. "Intensity," said John Cage, "if there is one word that sums him up. If De had a beer, it had to be the best beer. Some people think of that as elitism, but it's not. It's intensity."

De credited his fifth wife, the poet and professor Terry Brook, with steadying him through his most focused and prolific period of the mid '60s through to the mid '70s, in having him hold to action and cease the frenetic competing and macho posturing, De's frag-

mentation of ideas. This was the period (1964-76) when he made eight of his ten films, taking on issues like the televised demagoguery of Joseph McCarthy, the murder of his Harvard classmate John F. Kennedy, Jr., the Vietnam war, Nixon, the flawed and tumultuous 1968 Democratic convention, antiwar students metamorphosing into the bomb-planting Weather Underground. In taking on the "big issues" De had become in his fellow cineaste Jonas Mekas' opinion "the Shakespeare of American documentary . . . unique in this country especially. There is no one else dealing with politics on that level." His last, much younger wife, Nancy Mindlin, kept him on a regimen of maybe six glasses of wine over two months and on a health food diet. "She must be a strong person," one acquaintance of De's claimed, to slow down drinking that was "so willful and uncontrolled." Long before he made his mark with filmmaking De was legendary in New York as a Falstaffian figure with huge sensual appetites; De claimed he often spent $10,000 a year on the bar bill alone at Elaine's on the Upper East Side. In what was supposed to be a series of films of body functions with Eat and Sleep and Blow Job De had starred in Andy Warhol's Drink, where he downed a quart of Scotch in twenty minutes. Despite De's commitment to slow his prodigious drinking in his last decade, there were frequent lapses whenever his wife was out of town. One night after dinner and a few drinks with former U.S. attorney general Ramsey Clark and Father Daniel Berrigan, De ended up sharing spirits with some of his street mates on the Lower East Side; De called himself a "storybook lush." Often in hangovers there were dialogs with his arch nemesis, J.Edgar Hoover, or favorite Surrealist Luis Bunuel. Obscure, never seen phrases of "Hooverisms" or "Reaganisms" would crop up in his voluminous journals. He pledged that his "ancient frame" would hold out for another film and for completing his journals. And in that he succeeded. His last film Mr. Hoover and I premiered in September at the Toronto Film Festival just months before his fatal heart attack outside his home on December 15, 1989. De's own life had wound down and subsided as the Cold War he had chronicled in so many of its facets (De had dubbed one of his essays "American History—A Fiction") too had come to an end.

Acquaintances in the '80s would suggest he make a film on the Iran-contra scandal or President Reagan; De felt he had already made those films—Point of Order (1964) on the Army-McCarthy hearings, and Millhouse (1971) on Nixon (which contains a startling presentiment of Reagan's ascendency). As De wrote, "subjects abound, forms are more difficult"—"Millhouse was the first political biography told in terms of the media on film of any major political figure anywhere. A form was made for that film. A new one. I could not repeat it." De was indebted to Cage for this notion of the "perpetual avant-garde"—do a work once, why do something similiar again? De often seemed to suggest he had finished off the documentary form not just for himself, but others as well. De had retained some of that youthful enthusiasm that fueled the formation of New American Cinema in the early '60s; when his scathing and laced with black humor look at American involvement in Vietnam, In the Year of the Pig, was nominated for an Academy Award in 1969, it seemed confirmation that films could break through Hollywood entertainment and have a political impact. By the time De made Mr. Hoover and I in 1989, not much of that optimism remained: "Films are an industrial product, like cars and shampoo." "I really saw Pig as changing things," De said. "I was happy when it was nominated for an Academy Award. Few people, I thought, maybe a small segment of the major American form of art would see the importance of doing a film like that instead of Apocalypse Now. Now I see it makes no difference at all because we've been inundated. When I started that film we didn't have that shit! We had thirteen major stations. Now we have fifty-two channels and all those bad movies, VCR." It was primarily due to television that De believed that in the United States "we have devised the most effective form of the police state in the world, barring none, barring none . . . Orwell was twenty years ago. They don't have the resources to watch me or you. They get us to watch that fucking tube. Big Brother doesn't watch you. You stare at the fucking screen. That's why there won't be any important social changes. No way." "Truth and its forms make hard demands in our police state," De had told me when I first interviewed him for the literary magazine I was doing at the time Red Bass. De saw this as ranging from the political and aesthetic self-censorship of the Public Broadcasting System (PBS), that De dubbed the "Petroleum Broadcasting System," to the fear of audits and harassment on the part of once liberal rich, to the everyday street level—"Try telling a cop he's wrong." De, who had a healthy

Clayton Patterson

Emile de Antonio

pummeling dealt to him one night after drinking by police in Virginia when he taught at the College of William & Mary in 1947-8, maintained that "your sense of class privilege leaves you the first time a cop punches you."

In his new film he planned to make "the most minimalist film ever made," an "anti-film," at times "intentionally boring." The end result, woven through with De's wit and the extraordinary record of Keystone Cop foibles bequeathed to us by J. Edgar Hoover and the FBI, turned out more audience friendly than the original plans. And De spoke of "new forms of resistance" he could begin to see, as in the decade he "came alive," the '60s—"in the '60s we had politics." De's pungent autobiographical play and counter-play based on versions of his life recounted by himself and through the prying eyes of the FBI succeeded in creating an even more dialogical "counter cinema" than his previous films. De relished misinformation like the FBI report that in his youth he had "emptied his wallet" at a Communist Party meeting. Anyone who really knew him, De maintained, would know that "the only place I ever emptied my wallet was in a bar." The FBI had kept tabs on De since he was a 16 year-old freshman at Harvard where he had joined the John Reed Club of the Young Communist League. In 1941 De had already been recommended for "preventative detention" by J. Edgar Hoover, shortly before De served a stint in the Air Force in the Pacific Theater. Later during his filmmaker career, the agency would plan to mug him, steal negatives of his film, and break into his studio. The Nixon White House solicited "derogatory" information from the FBI to smear him as part of the "plumbers" campaign: "Bombing Cambodia, planning Watergate, the Huston plan, and there they were worried that Larry O'Brien [Democratic Party chairman during the 1972 McGovern campaign] would use my film."

Mr. Hoover and I was a "new form," and it became part of a wave of personal essay films during that same period, ranging from Ross McElwee's hapless romantic search innovatively chronicled in Sherman's March (1986) to Derek Jarman's monochromatic meditation on his art and life with AIDS Blue (1993). But it remained true, as De said, that "the main contradiction of my work is that I use a mass medium aristocratically." There was a period in the late '60s, early '70s when De spoke of making films that would reach working class whites and blacks and other groups rarely addressed by intelligent films, but most of the time De maintained that as an artist his main audience was himself. As the New York Times repeated in its obit, De said he was primarily "interested in working things out." "I make the films almost privately," De said, "but that's the way I see the world." Intentionally trying to change people's point of view in the usual left-wing project was too much like "Madison Avenue trying to sell granola." De saw his audience as "those who are disgruntled, interested in looking at a new form of film, or those interested in an anarchic view of the world." He often claimed the only contemporary documentaries he liked were his own. Michael Moore's 1989 Roger and Me broke records as documentary film; it was also a pointed critique of corporate America. De didn't bother to see it. He prided himself on the difficulty and intellectual dryness of his product; perhaps for De Roger and Me was too close to entertainment.

De's "use" of a "mass medium aristocratically" was reflected in the paradox of his life as a radical who rarely lacked money, whose own excesses were fueled by the pleasures and perks of a haute bourgeois lifestyle. Despite his self-presentation and statements to the press, several of his friends saw De as more of a classical conservative, raging against the abuses of power. One of his English drinking pals from the mid '60s, Lord Hugh Cavendish, who joined the House of Lords as a Tory, asked if he was really a leftist—"I never heard him say anything egalitarian in his life. He was anti-establishment for the very best of reasons—that power corrupts." De's rage was fueled by the perception that America was going bad too soon. How could nation that had attained vast superpower status with its victory over the Axis Powers in 1945 only twenty years later be mired in such a colonial misadventure in Indochina? In Lord Cavendish's words, "How could a freshly minted coin be tarnished so quickly?" Certainly De was fueled by a genuine patriotism he felt missing in most of his erstwhile New Left colleagues. De felt that many of the main players of the Students for a Democratic Society or SDS "deep down hated America." He didn't appreciate his psychiatrist nephew who wore surplus U.S. Army fatigues when he hung out at the downtown New York punk club CBGB's; it was a sign of disrespect. De, as his friend sculptor Carl Andre explained, "was a mystery, even though he was always talking about himself."

The son of an affluent doctor who owned four hospitals in Scranton, Pennslyvannia, De was firmly rooted in the ruling class he professed to despise. His Harvard class of 1940 included John F. Kennedy, Jr., Donald T. Regan (who would serve as President Reagan's chief of staff), and several Roosevelts, Morgans and Vanderbilts along with Pete Seeger. During the '80s, the "powder puff" arrest was not foreign to him. De was arrested in March, 1985 for "disorderly conduct" at a protest at the Consulate of South Africa on Park Ave., and released the same day in time for dinner at a sushi restaurant that evening with his wife and friends. "It's not exactly hardship," De said of the "do good demonstration." Unlike many of his cohorts from the '60s he never cut to the center politically. As a film colleague in London recalled, 'When De took you out to lunch it wasn't to any hash house, and it would be the best champagne. I think it's called "think Left, live Right."' De's pride of place as the only artist on Richard Nixon's "enemies list" was perhaps only equaled by having his own table at Elaine's, where he could be rushed by Senator Edward Kennedy and his party waiting outside. De often tried to rationalize the peculiar meritocracy of Elaine's, which catered not only to her favorite New York writers and the Warhol entourage De had introduced there but to Hollywood producers and directors as well – people who De as a rule despised. As De saw it, Elaine Kaufman's "sensibility is as wide as her body." When Millhouse came out, Kaufman told De he had gone too far. 'I told him, "Nixon can't be that bad." Then Watergate happened.' The proprietor had told Rolling Stone magazine that de Antonio was not just the best documentary filmmaker in the world but also "the best drinker in the world."

He started,but didn't finish, an autobiography, and worked on the collage-history and random reminiscences in his journals. There was a marked self-absorption about De in the '80s, so much so that some friends started to stay away. "I may seem garrulous and outgoing" De wrote, "but I'm really not." He claimed to spend as much time talking and writing to myself and Arno Luik, a journalist and philosopher in West Germany, both of whom had proposed book projects on his work, than with most anyone else. He was discreet, another friend observed, about how he exposed himself. Even in the more rambunctious and activist past, De was someone who eschewed a certain kind of New York social scene. His presence slipped in and out, and his influence was wielded quietly. This quality benefitted his films. Each film, different in form, was defined by its subject; it had to be perceived on its own, usually rigorous grounds, as an "intellectual cinema." They were more likely to be filed by subject: Vietnam; Kennedy assassination; Joe McCarthy; Nixon; instead of name brand. Insisting that any film was a social art and a collective process, French auteurism theories, along with notions of cinema verité were De's favorite bete noires. At the same time De would bark "I'm as much a director as Woody Allen," or "I could make a piece of shit like Casablanca, but I don't want to. Those high moments people wait for. They don't come for me." When film historian Bill Nichols first wrote De about his work the filmmaker fired back a letter demanding to find out why he wasn't writing about Jerry Lewis or Peter Bogdanovich instead.

Annabelle Gherbout, a great-granddaughter of Victor Hugo who onetime married the son of novelist Raymond Queneau, worked for De as an research assistant in Paris and then as an art film distributor with Pascal Dauman in France and later Daniel Talbot in New York, remembered De as a "very primitive person," very "animalistic in how he organized spaces, where he felt comfortable." She "loved the space display . . . if you are allowed to approach him." At his East Village basement studio 313 E. 6th St. off 2nd Ave. graffitti splayed by Futura 2000 was featured on the otherwise bare concrete walls of the backyard. Inside, rows upon rows of Perrier bottles filed along 50 feet on the east side of the interior wall, and the whole was surrounded by the raw material for the films—shelves filled with his 3200 books. Close by De's desk in the upper back corner of the wall along with the unabridged volumes of the Oxford English Dictionary were the twelve volumes of Henry David Thoreau's Journals—De's reading material in the 1980s suggested by his friend John Cage. Reinforcing the impression of a bunker were the huge iron bar, the heavy chains and locks at the door. "The shotgun"—De would tell her—"it's right here. Because those junkies are here. Bam bam bam!" It was a performance she enjoyed. "It was a play he knew I would love it." De never stopped being "a little actor." De would also pull out his .57 Magnum, closeted away in a small chest, on one occasion to half-playfully threaten this writer if he included mention of an affair with a young admirer he had in the early

'80s in this book. The same chest included a few art treasures—a "Diamond Dust" shoe, a Rorschach of a cock, Valerie Solanas' gun by Andy Warhol; a self-portrait and early collages by Robert Rauschenberg; a Swiss biscuit iron by Claes Oldenburg. Another time somewhat paranoid and extremely hungover, De would get out the Magnum and shuffle (his bad knee) over to the barred windows next to the door if there was a lot of sound and unusual activity, suspicious of the street traffic. De despised the drug scene and junkies, perhaps ironic for someone who lived next to a halfway house. "In my republic there would be the death penalty for selling heroin," De maintained. De had moved to the East Village in 1972 from Park Avenue and 61st St. at the insistence of his wife Terry Brook, who thought his proclamations to the press that he was a "Marxist" belied his extremely "bourgeois" lifestyle. "You make enough money to live like this? Say you are a Marxist to all the newspapers and have a full-time maid? It's terrible." Slowly gentrified, the East Village was a genuinely bohemian district when De first moved there, and often dangerous with the explosion of drug traffic that arrived, much like in San Francisco, after the 1967 "Summer of Love." De bought the building he lived in, which rented for $125 a floor at the time. In the '80s during winter holidays De would grouse and lower the thermostat for his "yuppie" tenants.

De's office, like his life, became a model of compartmentalization where the parts would rarely mesh. He would also be surrounded by the memoirs of the traveler and lyricist for Don Giovanni, a fabulist who recounts Casanova-style his putting himself in various situations. "De had a notion of how people put themselves on the stage of life," Gherbout said. "He was a very old-fashioned, educated man, that's another reason he suffered. I think he wanted to die at some point. Very bored with life and society. Masochists would enjoy the shit around. He couldn't stand it." Gherbout saw the aging Marxist dutifully reading the daily stocks in The New York Times as "very depressing . . . it was a bitter situation" she felt for De to buy on market, against his intellectual and moral values. De had "an classic, old-syle moral approach towards money. Sometimes I think it would have been enjoyable for him to lose money." Gherbout has a conversation with De in 1989 very unlike him, along the lines of "I'm old, maybe I won't see you again"—she sensed a great fatigue and the idea that he had done what he had to do. His sixth and last wife Nancy Mindlin told her she was wrong, that he was excited about several new projects he had lined up and encouraged by the critical reception Mr. Hoover and I had garnered. The critic for the Toronto Globe Jay Scott had written that it was "funnier than Swimming to Cambodia." De and Nancy expected him to live another decade, thanks to the regimen she had kept him on of health food and off heavy booze. Others weren't so sanguine. The artist Richard Serra who De advised and helped organize against the government decisions in the Tilted Arc public sculpture controversy of the mid-'80s, thought "He didn't look so well. He looked as if his life, his drinking, had really taken a toll," despite the loss of weight. For someone who followed the daily details of politics in the papers, Gherbout felt he had to be "humiliated by the heavy, huge idiocy going around. . . . He would be crying with Clinton. What a shit!"

The English lyricist and poet Fran Landesman had an affair with De in the '60s and stayed in touch decades later, through to 1986-7 when De would still run his hand up her skirt in a New York taxi ride. 'I was never sure who he was. He was kind of schizophrenic, like Lenny Bruce. I knew Lenny Bruce. Lenny Bruce had this straight little Jewish boy in him. You'd say "Fuck" and he'd say "Have you been hanging around hoodlums?!" I was in no way puritanical except about one thing—honesty, being straight about things. I didn't feel De was as honest as he should have been. De's politics and lifestyle didn't match. I didn't believe his politics. Talk about a champagne socialist—the term was invented for him! His lifestyle didn't jibe with this militant leftism." Lady Dev-avidor Goldsmith, who described herself as "to the right of Margaret Thatcher" held soirees in the '60s with a catholic list of guests ranging from literary critic Cyril Connolly to English aristocrats to visiting bon vivants like De. She remembers chastising De at one point for his prodigious weight, the product of on principle unrestrained drinking. "Why should I refuse anything that gives me pleasure?" was his concise reply. "This gang," Janet Lyle Cooper recalls of the gaggle around De in his many 1960s trips to England, "all in their 20s, enjoyed a lack of responsibility, didn't want real life exactly. De was 25 years older but always behaved like he was in his 20s. He had the knowledge and sophistication of an older man but behaved like one of us—didn't think of him as a different generation at all." De was in some ways Janet Cooper said "an odd man out, scruffy among rich, strong people." As another colleague remembered, De's Oxford shirts "that were always out and terrible tweed jackets that never really suited him" perhaps made him "so out he was in". According to Cooper De during his visits to England "loved being the enfant terrible, the left-wing figure, rather a star, and that was irresistible too."

De's social life in the '50s and '60s masked the extremely serious and sober artist who would make the hard hitting, left-leaning political documentaries. As actor Peter Eyre said, "Later seeing the films, they were difficult to connect with the person I knew who made them. If he was engaged with things here you wouldn't have known it. In the way people are perceived to be serious today De is impossible. He was truly frivolous." Eyre's first meeting with De was at one of the many parties at London's 6 Milburn Grove where Mark, Chlöe, and Clare Peploe lived "like children in a '60s kind of scene." De had taken a popper of nitrous oxide, passed out, and had turned blue laying on the floor. Clare said to Eyre "I think De's dead." As a small crowd quickly gathered wondering what to do De rebounded with a huge guffaw. The party continued. "When did De do all this work?" Marguerite Littman asked. "We didn't see him during the day. He was frivolous in those days almost as if he was trying to cover it up. Knowledge would seep through anyway even though he would act so ridiculous."

For all the good times in the early '60s, De's drinking was always of mythic proportions. It worried Littman to a degree. 'He would say "I'm going into the rocket"—and disappear for two, three days.' "Without sheer physical energy, I would have died back there," De thought. As the notion of Point of Order grew out of De's hanging out at The New Yorker Theater with owner Henry Rosenberg and manager Daniel Talbot and De began to be the sole driving force for editing the 188 hours of messy, flaky kinescope material into a real film, De remembered "it is nearly impossible to describe how difficult it was at the beginning." De had begun a relationship with Vogue editor Tina Fredericks, who continually pushed him, and who had told others "only De can do this." An exception to what De felt

was a gaping void of emotional support, he said "Tina was the yeast. She was beautiful." "I always wanted to be a writer," De said, "I was a freak in the art, film worlds." It was through brainstorming on what was the greatest televised event of the last decade that Rosenberg, Talbot and De came upon the idea of showing edited portions of the 1954 Army-McCarthy hearings, where a sneering, bullying McCarthy had the rug genially pulled from under him by the Eisenhower White House and the Army's silver-tongued lawyer Joseph Welch. Like so many things in De's life, it was in strong relation to alcohol. De had watched the '54 hearings in upstate New York's Rockland County with John Cage, over many bottles of single malt whiskey. "I got very decadent while making Point of Order," De admits. Due to his lack of faithfulness and fatigue with his drinking, his four-year romance with Fredericks ended during this time. De became involved with model Marilyn Ambrose who photographer Dick Rutledge had "sent to him" and married her for six months. She returned home one afternoon to find De sitting on the floor amid all the shards of glass in their mirrored apartment, bottle of whiskey and hammer in hand. He had smashed all the mirrors in the apartment, one by one.

De tended to account for his intensified drinking during the making of what would be Point of Order in terms of the dysfunction of the artist: "I work best with anxiety of hangovers. That incredible sensitivity makes me very sharp. I've solved many problems with my films that way. You occupy another space than you do when you are a normal person." This splaying of the rational mind, often so dominant despite everything in De, allowed associations to come through, and for De as for so many other filmmakers, "film is putting together associations." Henry Rosenberg remembers De as being "at loose ends" at the time. Literally winning a coin toss with Dan Talbot for who was to edit the final version of the film after all their fundraising had been spent on a disastrous succession of failed narrators for the project, starting with Orson Welles, "met so many of his needs at the time." De to Rosenberg was an "intellectual confidence man," an artists' agent and hustler, known for his drinking, skills as raconteur and social connector and outrageous behavior—"There was a side to De that would do absolutely anything. I saw that a lot in the '60s." He had no background in film and claimed to rarely even see any excepting old Westerns on 42nd St. to help cure hangovers. When De took over the project, Rosenberg recalls, "There was no great wave of enthusiasm. Nobody had that much faith in De." When Point of Order opened and became an unlikely smash hit in January, 1964, De's drinking and eccentric behavior continued—at a party distributor Walter Reade threw at the Cannes Film Festival De in a fit of enthusiasm dived into an empty swimming pool, breaking two ribs—but his nebulous, already notorious reputation solidified. As De noted more than a decade later when the first FBI documents started coming in from his Freedom of Information Act (FOIA) request, when he started making films even the tone of "the feebees" changed and became more serious. After the success of Point of Order De would say he was "no longer just a leftist who knew lots of wealthy people." Or, as Henry Rosenberg put it, "the world lost a great con man when De became a Marxist."

Twenty Questions with
Taylor Mead in Love

by Michael Bowen

Self-described as one of the greatest movie stars of the twentieth century—he reckons himself to have appeared in well over a hundred films—Taylor Mead may not be a household name to the Betty Crocker crowd, but he has been so in every corner of Bohemia for more than 40 years. One of the protean stars of the New York underground, Taylor Mead is the Mary Martin of merry pranksters, a reckless cherub whose battle with the gravity of 20th century life has earned him a place in the Pantheon of urban legends.

"I first started coming down to New York while I was in boarding school," Taylor remembers, settling into a corner of the one of the Lower East Side eateries that tend to his nutritional needs (the check is generally optional). "Then I hitchhiked around the country for 10 years, but I always came back to New York. My first movie role was in 1959 in a film that played on 42nd Street called *Too Young, Too Immoral*. I played a deaf-mute dope pusher who falls in front of a subway car. It was a stupid film, but the casting was good."

The following year, however, Taylor would become an overnight celebrity by teaming up with filmmaker Ron Rice to produce and star in what would become one of the seminal films of the "New American Cinema". "I think we made *The Flower Thief* for like $500. Ron Rice shot it on this World War II machinegun film that he bought at a great discount in Los Angeles," Taylor says. The film became an international *cause célèbre* among devotees of the new do-it-yourself aesthetic and Taylor became the first movie star of the underground cinema.

"Bolex really should have given Ron Rice a fortune," Taylor opines, "because when Jonas Mekas and *Time Magazine* wrote about *The Flower Thief*, the handheld Bolex thing came on like crazy. Everybody wanted to make his or her own underground movies. They should at least have given him a free camera, although he probably stole the one that he had," Taylor says.

During the tumultuous decade to follow, Taylor's career as a stage and screen actor took him on to numerous roles in the films of Jack Smith, Andy Warhol, Adolfus Mekas and others. He embraced the stage as well, earning an Obie for his inimitable performance in Frank O'Hara's *The General*. His appearance as Peter Pan in Charles Ludlum's *The Conquest of the Universe*—populated by Factory regulars like Ondine and Ultra Violet—led to an appearance on *The Tonight Show with Johnny Carson*. "I was high on speed and the set looked so beautiful. Johnny was not the host that night—it was Bob Crane, that closet queen. And I'm singing 'I'm Flying' from *Peter Pan* on this big swing and I must have hit my nose on the swing. Anyway, my nose started bleeding and Bob Crane got real nervous. So he said, 'Well, Taylor, I guess you've got to be going to the set of your new movie,' and the next thing I knew, was standing in the empty halls of NBC."

Since the heyday of his work in the underground, Taylor Mead has also been a poet and novelist. "I've always written. Back in the early

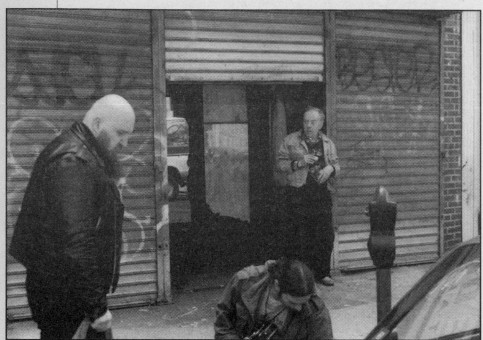

Clayton Patterson

Ari Rousimoft, Taylor Mead filming Shadows in the City

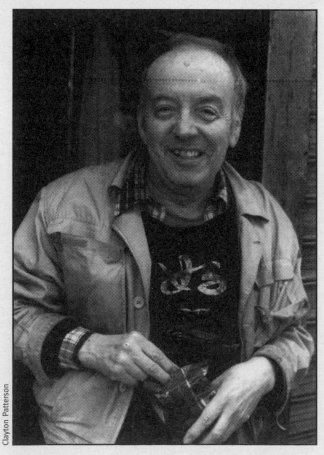

Clayton Patterson

Taylor Mead

Sixties, I was working on two novels at the same time. I was on about page 200 of each of them, but while I was hitchhiking to California someone broken into my apartment and left the door open. The fire inspector saw the mess and ordered the superintendent to throw all my stuff away. All my manuscripts, everything thrown out. Somebody said, '*That's the way Taylor edits.*'"

A similar disaster visited the author just a year ago, when his Ludlow St. landlord emptied his apartment of most of its belongings, claiming that Mead's 25-year accumulation of random treasures posed a fire hazard. In the confusion of attempting to retrieve his mountain of dislodged papers and other memorabilia from the trash heap, Taylor estimates that many things were lost. "So much stuff has been devastated by my manner of living and my poverty," the 77 year-old observes with disgust but also with a certain acceptance.

Still, much seems to have been preserved. These days Taylor Mead is as well known as a poet as he is as an actor, a seemingly bottomless stock of his daily writings making up the substance of his poetry readings and his "forth-coming" books. He has recently published a small book of verse and is also searching—"rather lazily," he notes—to publish a memoir of his days in the Warhol circle entitled *Son of Andy Warhol; Sequel of the Son of Frankenstein*. Given his penchant for aphorisms and his ready supply of anecdotes about the glory days of New York's artistic and underground circles, I thought it might be a worthwhile game to ask Taylor for his observations on a few of the following subjects.

Manhattan
TM: Oz.

New shoes
TM: Makes me think of Andy Warhol. His fortune came from drawing for I. Miller Shoes. Do you know he used to get $50,000 a year in the 1950s for drawing those shoes? Son of a bitch! And he was always going around pretending to be poor.

The Village Voice
TM: They've been my great champion for years. Their greatest thing was an interview they printed with Tennessee Williams in which he said, 'All art is a scandal that life tries to imitate. Taylor Mead succeeds; I come close.' And they used to print all of my letters. But they didn't print the letter I sent a few weeks ago, so I may have to drop them.

Underground Movies
TM: They were really just a segue from the French *Nouvelle Vague*, but they influenced American cinema tremendously. Godard's *A bout de soufle* changed everything. Then Ron Rice and I went to see *Pull My Daisy* in San Francisco and we thought, 'We can do that.' It looked like it only cost a few thousand bucks. So we made *The Flower Thief* for $500, plus forged checks—but I really shouldn't talk about that.

Old People
TM: I really can't tell most people apart unless they're old. You know, the epitome of Rembrandt's work was when he started to use older and older models. He loved the lines on their faces. Old people should really be used more in our society, but that's probably a redundant sentiment. When Betty Davis got old and they tried to put makeup on her, she said, 'I've earned every one of those lines and I want every one of them to show.'

Breakfast
TM: I usually skip breakfast and take a pill instead. Otherwise, I eat a little Raisin Bran or some oatmeal. But I only eat breakfast about 3 times a week.

Acting
TM: Acting is the easiest thing on earth. You know, people go to study the Method—I, of course, was 9 months at the Pasadena Playhouse and a year with Herbert Bergoff. To study

Clayton Patterson

Taylor Mead

the Method with a sympathetic teacher, I think you really need about 6 months. But especially with women who have tremendous talent, after 6 months they would start trying to remake you. It's like Lee Strasberg did with Marilyn Monroe. It just ruined her.

Rap Music

TM: The only rap music I ever liked I saw down at the court building on Centre Street. This busload of women prisoners was being driven into the courthouse and they were doing this rap. It was wonderful—acapella, the whole bus rapping. So I would have to see more to say, but otherwise it just seems dreadful—full of evil and hatred, just bullshit.

Nirvana

TM: I don't believe in any of that stuff. Pretty words, but that's all. I say that meditation is for people who haven't had a happy childhood, although God knows I didn't.

Literature

TM: I was a great reader when I was a kid, but boarding school almost killed it. When the teacher said we had to memorize 500 lines of poetry it almost turned me off from reading forever. As far as writers go, Jack Kerouac, Allen Ginsberg and Bernard Shaw were the three people who got me out of all my traumatic, upper-middle class bull. But I think I have 'TV eyes' now. Reading kind of exhausts me, but I watch television 5 or 6 hours a day. I love everything—*The Price Is Right*, *The View*, *Married with Children*, *Roseanne*, all the nature specials, *Charlie Rose*. If I had cable, I'd never get out of the house!

Telephones

TM: I never answer them. That's why I think the answering machine is one of the greatest inventions in the history of the world. I don't like to talk on the telephone.

Vegetarians

TM: When I was at boarding school, I saw a trainload of cattle go by and I wouldn't eat meat for a couple of weeks. Then once I read Shaw, I didn't eat meat for the next 40 years. And for 10 years I wouldn't even eat fish, but then I realized that fish eat each other, so I had no moral compunction about that anymore. Now I cheat occasionally at parties and eat meat. I had some pâté last week and that night I dreamt about a cow being hung up on a hook going to slaughter and begging me for mercy. Just terrible. But if people ate meat like I do,

Please note this is a letter to the judge. Taylor is a senior citizen is in danger of being thrown onto the street. Please help. Taylor is important to the LES.

Friend of the Court
For Taylor Mead
November 02,

Taylor has many friends in this community and is well loved, his apartment is fine for him and he loves his home. Prior to the arrival of heavy duty gentrification Taylor's building and apartment were typical of this area. I am sure that the Tenement Museum has similar apartment models on display.

Taylor has been a positive force in the neighborhood for almost one quarter century. For years he has fed local stray cats at his own expense; during the years when drugs were being sold in almost every doorway. It is true that Taylor has aristocratic bearing and presence and comes from a well connected Detroit family, but from early in his life he has been an independent self realized performance artist, painter, poet and film actor.

It is also true that Taylor eats out every night at expensive restaurants and drinks in high end bars which he is able to do because he is a guest at such establishments. Many proprietors consider his presence and stories as draws for customers. For this reason Taylor does not cook in his apartment.

Taylor has also helped several neighborhood businesses because he knows all parties. When the Pink Pony was about to close, Taylor brokered a deal for the present owner to take over and turn it into a lucrative business that continued to give the neighbor, Max Fish, necessary use of the exit door. A good neighbor and Taylor gets to eat in style.

One of Taylor's major difficulties is being 10 years ahead of the curve which may sound romantic and wonderful, but it makes selling art and concepts to the public and making a living much harder.

Taylor worked in Hollywood years ago doing independent low budget films with Dennis Hopper and other Hollywood stars but returned to New York to become an Andy Warhol Super Star while still working in numerous small venues like ABC No Rio. Taylor has been in a lot of movies, and some real art classics like "The Flower Thief" by important film maker, Ron Rice. Bob Weigan and I put together a benefit show for Artist Talk On Art at the Pyramid Club that presented Taylor with an award for his contribution to the organization. Taylor also had a weekly show, "The Taylor Mead Show", on Pseudo.com, a high budget internet/ television production featuring interesting New York guests. Unfortunately, at that time live internet video streaming was not yet up to speed. Taylor is also an extraordinary painter. I am happy to have one of his works in the Outlaw Art Museum collection.

The building where Taylor lives is now on one of the hottest blocks in New York City; Ludlow street has been in all the papers numerous times. Taylor's building is a clean looking building that appears to need minimal repairs. Clean but a little worn at the edges just like Taylor. He pays the rent on time and he has cleaned up his whole apartment with the help of Amy Wallin (137 Duane Street NYC).

Taylor also deserves some protection because of his age, limited finances and because of certain naturally occurring disabilities .

What are we to do? Throw elderly people out into the street, because a new young person with more money is standing in the hallway dying to take over Taylor's apartment. Taylor was a great tenant when the block was real dangerous, drug infested, and not many "respectable" people would walk these streets, never mind live down here. The New York Times friday November 16 did a big story about all the new super cool art galleries popping up in the neighborhood like pop corn.

Please show Taylor some mercy, kindness and justice when dealing with him. Taylor Mead is without question a substantial, important American avant-garde artist. Think of yourself and the education of America. Help save New York from destroying itself.

Sincerely Yours
Clayton Patterson

Clayton Patterson

Taylor Mead in his apartment with landlord photographer taking pictures of the apartment

the animals could live their full lives. You'd leave them out in the field and shoot them full of opium when they're ready to go—which tenderizes the meat!

Affluence
TM: Coming from people of affluence and knowing a lot of them, the best thing about having money is that you never have to think about it. It's great to be rich.

Pedophiles
TM: Well, I once wrote that anybody who doesn't want to screw a five-year-old girl or lick a nine-year-old boy's ass is a pervert. Otherwise, I avoid all that.

Jack Smith
TM: I actually turned down being in *Flaming Creatures* because I had just done *The Flower Thief* and I thought I had this image to uphold: I heard there was going to be nudity in it. I didn't realize what a wonderful film it was going to be. Once Jack had me playing a violin while he was showing the film, but the audience told me to stop. And I was in some of his later stuff. But Jack Smith was very cruel to animals. He let a pet python die in his closet— didn't feed it. And he left a stray cat out in his hall—said it wasn't a 'star cat.' I don't care how brilliant someone is, if they're sadistic or cheap, I'm not interested.

On the Importance of Anthology Film Archives:
A Historical Overview and Endorsement

by Carlos Kase

Standing on the corner of Second Avenue and Second Street, within the walls of a converted early 20th century courthouse building, is Anthology Film Archives. It is a film museum that houses one of the most remarkable movie collections in the world. It is also one of the most important screening venues in the history of avant-garde cinema. In short, it is a Lower East Side landmark of massive cultural import. However, Anthology's cultural value transcends location. Its lofty, critical and aesthetic aspirations are unique: it is the first film museum/movie theater dedicated to the notion of *film as art*.

The formulation of Anthology's distinctive cultural, critical project can be traced back to an historic debate about the essence of film, its status as an art form, and its most substantive achievements. The founding fathers of Anthology decided that they would regularly present a cycle of films that constituted the greatest artistic accomplishment that the medium had to offer. When the committee was determining which films would collectively form the basis of this cinema cycle, the group decided that historical importance would not be a criterion for inclusion. Instead, the only principle of the selection process was to be artistic achievement. The value of a film would sit squarely and exclusively on the merits of its aesthetic content. When a film happened to be both artistically successful *and* historically important, it was to be seen as a kind of unlikely, albeit pleasant, coincidence. Over more than thirty years, Anthology itself has come to represent a similar type of coincidence. However, a better word choice may be appropriate here, because the historical achievements of Anthology Film Archives are the results of a great force of will. Jonas Mekas, the founding father of Anthology, and its current band of dedicated and sincere fellow travelers have fought long and tirelessly for a cinematic mode that has little public recognition despite its infinite artistic merit.

Founded in 1969 by Jonas Mekas, Stan Brakhage, P. Adams Sitney, Peter Kubelka, and Jerome Hill, Anthology was intended to be a provocative critical statement. Sitney has stated this explicitly, writing, "Anthology Film Archives was conceived from the very beginning as a critical enterprise." Sponsored by Hill, a notable filmmaker and philanthropist, the group set out to create a film museum that would also be the premiere screening venue for avant-garde and independent film. The parties involved in the decision-making process were filmmakers, theoreticians, writers, and artists who were aware of the significance and challenge of their particular cultural endeavor.

And so, over the course of some years, a group of films was selected to form the first installment of this film canon. Other people contributed to the decision-making process, including James Broughton and Ken Kelman, who were added to the film selection committee, while Brakhage dismissed himself from the proceedings over a disagreement about the voting process. The 310 works that were eventually selected to comprise this series included many of the now canonical works of film history: *Trip to the Moon*, *Birth of a Nation*, *Battleship Potemkin*, *Nanook of the North*, *The Passion of Joan of Arc*, *Rules of the Game*, *Citizen Kane*. The list also includes what the group deemed to be the essential contributions of American experimental, poetic, and avant-garde film, represented in the work of Stan Brakhage, Michael Snow, Hollis Frampton, Bruce Baillie, Joseph Cornell, Kenneth Anger, Harry Smith, Maya Deren, and many others. The collection was named "Essential Cinema" and was designed as a corpus of films to be studied. The intention of the committee was to revise and reconsider this assemblage of films over the years, engaging in a continual debate, adding new films and discarding others. In fact, a later meeting of the film selection committee had been planned; it was to be chaired by Andrew Sarris, a close friend of

Mekas's, and it was intended to be a consideration of American commercial cinema and its possible role within the Essential Cinema oeuvre.

However, the list of Essential Cinema selections has remained essentially the same for thirty years—a historical result that is partially due to the passing of sponsor and co-founder Jerome Hill. Upon Hill's death, Anthology lost a substantial amount of its financial support, and was no longer able to purchase new prints to add to the Essential Cinema repertoire. As a result, the collection has remained static since its establishment in the early '70s, though it was intended to be a kinetic, changing entity. Indeed, much of the criticism directed at this canonification of American avant-garde film is predicated on a misunderstanding of Anthology's project and its intentions. Nonetheless, this group of films still demonstrates the aesthetic and philosophical underpinnings of Anthology Film Archives. Today much of film scholarship and criticism are tangled up in concerns of cultural representation, entertainment, and commodity. Anthology however poses a significant challenge to this critical framework: Its founding principles are confidently rooted in an unapologetic aesthetism.

To this day, Mekas remains at the helm of the Anthology Film Archives. An immigrant from Lithuania, Mekas and his brother Aldolfas (also a filmmaker) came to New York from a war-torn region, narrowly escaping the encroaching threat of fascism while living in forced-labor camps and refugee settlements throughout Europe. When Mekas got to New York, he quickly became immersed in the artistic developments of the fifties, eventually becoming a friend and spokesperson for the newly burgeoning movement in independent and avant-garde cinema within the city. He began showing films at various venues under the title Film-makers' Showcase or Filmmakers' Cinematheque. In order to distribute these films—works that had no distribution mechanism of their own—he co-founded the Film-Makers' Cooperative, and later, the Filmmakers' Distribution Center (with Shirley Clarke and Lionel Rogosin). A filmmaker himself, Mekas quickly became an outspoken evangelist for developments in independent film. He founded the magazine *Film Culture*, and presented a venue for serious discussion and scholarship about film as an art form. In the following year, 1958, Mekas began writing for the *Village Voice*, then a new bohemian weekly. His column had a personal, diary-like tone and an unpretentious title: it was simply called "Movie Journal." It was there that he preached the gospel of the new cinema. In the fifties, he was a vocal supporter of a number of independent filmmakers, including John Cassavetes, whose original version of *Shadows* provided an epiphany to the reviewer, and Alfred Leslie, whose seminal work *Pull My Daisy*, made with photographer Robert Frank, would be a touchstone for the movement. Eventually this development in film came to be known as New American Cinema, a stage of New York film history that included experimental film as well as narrative independent film, and even documentary practice. Mekas was often challenged, sometimes by his peers, and occasionally even by the police force of New York City. After showing Jack Smith's controversial *Flaming Creatures*, now recognized as a classic of experimental cinema, Mekas was arrested on obscenity charges. The public legal battle and the corresponding aesthetic debate over cinema and censorship instigated a call-to-arms in the film world. Mekas's provocateur spirit, with its dogged determination and unfailing faith in its mission, was the guiding principle of his work as a critic, and would become the philosophical backbone that would support Anthology Film Archives through its three decades of involvement with cinematic art.

In its first decade, Anthology had two locations. The earliest was a single-screen facility within Joseph Papp's Public Theater. It was there that the Invisible Cinema was built. It was a room designed by filmmaker Peter Kubelka in which the viewer was stationed in a viewing cubicle of sorts, blocked off from his or her surroundings; this design was intended to insure that the greatest degree of viewer concentration would be directed towards the image itself. During these first few years at the Public Theater, Anthology showed its regular cycle of Essential Cinema, as well as other ambitious repertory-based programs and work by new filmmakers. A Jean Epstein retrospective in 1971 was one of the first of these repertory endeavors.

In 1974 Anthology changed locales, becoming a hotbed for the Dada-inspired Fluxus movement. Anthology's home for the next ten years was an artist co-op building located in Soho, at 80 Wooster St. The co-op was run by George Maciunas, a lynchpin of Fluxus activity, and largely financed (at its outset in the late '60s) by the visionary Jerome Hill.

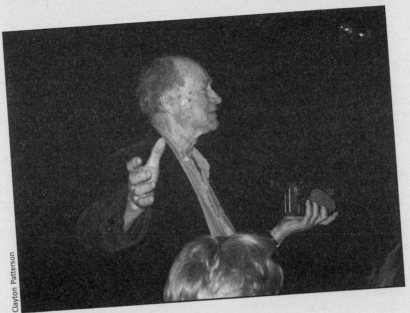

Clayton Patterson

Jonas Mekas talking and filming at
Anthology Film Archives

In that space, the interrelation between the arts in New York City produced a fertile cultural moment. In 1974 video came to Anthology. At the new Wooster St. address, Nam June Paik conducted some of his most well-known performance and video pieces. There were Richard Foreman's theater events, poetry readings, and Fluxus concerts. It was around the same time that Anthology began its preservation program, an integral part of that institution's contribution to film history. Eventually Anthology outgrew its physical constraints, and in 1979, Mekas made an important decision. He purchased a courthouse building from the city of New York that was to be the permanent home of all manifold branches of Anthology. The courthouse had been abandoned and officially out of use since 1960. It was a boarded-up building that had been occupied by squatters and had fallen into derelict condition. The building had a significant cultural history that preceded Anthology by a number of years: its basement had been an unofficial early home for the avant-garde film workshop, Millennium. Many important films were made in the courthouse's basement, in what was actually the former jail, well before it became part of Anthology—Warhol is said to have worked there, as did Jack Smith and Ken Jacobs, Millennium's founder. In 1983 Anthology left the Wooster Street location that had been its home for roughly ten years, and it would not show films again until October 12, 1988.

Over the next five years, plans were drafted, money was raised, and Anthology was eventually transplanted into its permanent home. The money for the building's purchase was generated largely from the donation of artwork from a number of Mekas's art-world friends and associates, including Andy Warhol, Harry Smith, and Claes Oldenburg. For some time, art donations and sales have provided a significant source of financial support. In 1988, Anthology opened, with two theaters and programming that includes the Essential Cinema repertoire, new independent and avant-garde film, and a diverse repertory program. During its first year-and-a-half at the new location, Anthology presented retrospectives of Hollis Frampton, Ernie Gehr, Marjorie Keller, Robert Breer, Yvonne Rainer, Alexander Hammid, Robert Frank, Maya Deren, Alain Robbe-Grillet, Alexander Kluge, Bruce Elder, Gunvor Nelson, Emile de Antonio, Su Friedrich, Peter Hutton, Warren Sonbert, Francis Lee, Michael Snow, and Rudy Burckhardt. The building also houses a priceless film collection, a massive print library, a gallery, offices, and a film preservation wing. Within the walls of this early 20th century courthouse/jailhouse on the Lower East Side, there now lives a dynamic movie theater, an incredibly unique film collection, and the entire human support structure that makes it all possible.

Today Anthology is an integral part of New York City's cultural discourse. It provides a venue

for films, both classic and contemporary, that often would not be seen otherwise, because of their distance from the means and methods of Hollywood filmmaking. There is a sense that this unassuming brick building provides an immeasurable service to the people of New York—indeed, that is an important part of any museum's purpose within the city. However, Anthology is not a typical museum. Proudly an entirely independent institution it has no endowment or substantial corporate affiliation that provides its financial support. One of the significant challenges of presenting films in a public setting is that there are often prohibitive rental costs. Anthology gathers its small operating budget from grants, individuals, members, theater rentals, and box office sales. Anthology does not have the resources to present massive, expensive retrospectives of commercial filmmakers on a frequent basis. Clearly, Anthology's focus lies somewhere else.

The initial model for Anthology was a European cinemateque type of film experience. In this sense, there were very few precedents for this variety of avant-garde film presentation within this country, or, more particularly, in New York. Amos Vogel's seminal Cinema 16 programs (1947–1963) and Mekas's own programs of the Filmmakers' Cinematheque were two precedents for what Anthology would do. But, unlike those forums and the other cine-clubs of the world, Anthology would become a permanent home for avant-garde and independent film, continually programming work from within the Essential Cinema collection. In addition, Anthology's film library—which includes a number of works personally donated by the filmmakers themselves, including Maya Deren and Joseph Cornell—is singular. Anthology has matchless artistic resources and also serves as a crucial force for film restoration and preservation, as well as for the publication of critical writing on cinema. Though vital experimental film is shown in other venues in New York City, it appears at Anthology with the greatest frequency and, arguably, with the greatest consistency. In this sense, it could be said that avant-garde film is Anthology's specialty. This is demonstrated by the Essential Cinema program, in which the work of Stan Brakhage and Harry Smith sits next to films by D. W. Griffith and Orson Welles. From the perspective of Anthology's founding fathers, these films are equally instructive and valuable. This is one of Anthology's most charming traits: it celebrates what Jonas Mekas has informally called "small films"—films made in small (or "amateur") gauges like 16mm, seen by a small number of people, and involving very little money. For these films, the popular appreciation may be small, but the aesthetic value is often inestimable. In this sense Anthology provides an antidote to the box office tallies that have poisoned film-related media since the late '70s. Philosophically speaking, Anthology is far removed from the multiplex movie theaters that dominate the city's cinema landscape. The substance of Anthology may seem obscure to the average moviegoer, but to Anthology's supporters, it is vast. Indeed, entire lifetimes of art can be found on the corner of Second Avenue and Second Street.

Jonas Mekas

by Peter Sempel

The taxi was just leaving Vagabond Theatre on Wilshire Blvd. A black little book came flying through the open window from someone who had just seen the last screening of *Dandy*. The cab was rolling and I wondered "What a good throw!" Off we were, there wasn't even a chance to say "thank you!" A short glance told me the title: *The Fall of America*, by Allen Ginsberg. I opened the book and on the first page I saw: "September on Jessore Road." I read the poem with enthusiasm, with big delight and pain at the same time. It seemed to be an American mantra, a long, long scream for humanity, justice and love for the poor, the outcasts, the mistreated children. The killer was capitalism, headquarters: New York. As I read, it carried me away; someone was fighting, bleeding, suffering, and praying his words, his poem, and his song, like howling. In the plane from LAX to JFK I read again and I thought: "I must ask Allen to read it and let me film, possibly for the Jonas Mekas project." We had filmed just some time ago, where he talks about Harry Smith, censorship etc., especially the end of the '50s and the '60s.

It was Sunday evening, I called Allen and he said: "Okay, I'm very busy and leaving Tuesday for Budapest. Come tomorrow evening, Monday at 9 p.m. I'll give you exactly half an hour, at 9:30 you leave. Is that okay?"

I answered: "Yes, that's okay, I want one take of the poem."

I was lucky because my favorite cameraman Jonas Scholz (from Hamburg) was in NY. We arrived in front of his house on 8th Street half an hour earlier; we waited till I rang his bell exactly 9 p.m. on the dot.

Allen greeted us friendly; we put up the camera, sound and one light in his room. He asked me: "How many lines do you want me to sing?" I said: "Oh, I thought the whole poem!" Allen, a bit surprised: "The whole thing? Okay!" He asked several times to make sure about the sound quality. His text was on 4 sheets of paper that lay on top of a huge William Blake book on the working table at the foot of his bed. The Arriflex camera was rolling with 16mm Kodak negative film, and to be sure if anything went wrong I had a video camera on from the same angle. A window and light behind him. So, we had one take, without stopping, the whole thing in one take, it was perfect, a perfect document of Allen singing "September On Jessore Road" with his harmonium.

At 9:30 pm we left the house.

It was 1992 and later when editing the Jonas film the Allen song was just too long, as I already had interviews with Allen. So, I planned to edit a short film, which I finished in 1997, by a strange coincidence 2 days before his leaving the earth (premiere: International Film Festival Berlin, 1998, 16mm, 20 min).

First time I met him was through Jonas' suggestion, and Allen then wrote me a fax: ". . . it's about time somebody made a film about Jonas . . . and I'd be very glad to participate!" (Just about the same fax I received from John Cage (twice) but he passed away a week before filming—a big pity he couldn't wait. So we put the fax in the film.)

Funny thing: when I started working on the Jonas project several art and film experts in New York said to me: "Why Jonas Mekas? He's too old and weak, he's out! You should choose a different subject!"

But they didn't know: I very seldom "choose" a subject. It just happens. In over 20 years of filming there is only one person I really seriously "chose," who I really wanted to film, that was Blixa Bargeld in Berlin. Some examples: When I was filming Blixa for *Dandy* 1986 in Berlin (filming, not "shooting" . . .), Blixa said: "Heh, why don't you put Nick in the film?" (I'm thankful to Blixa for all times, anyway). When Kazuo Ohno saw *Dandy* he said: "Lets make a long film!"—same with Nina Hagen, and when Jonas was special guest in the Ohno film for one minute, he said like "give me the apple over there." "You should make a whole film about me" (he doesn't remember). When I was filming Lemmy as special guest in the Nina film, I mentioned that I'm working on a long run documentary on Nick Cave and Lemmy says: "Why Nick Cave? He's not that important. You should make a film about me."

Funny: 1989 I met Lemmy first time, together with Nina in London, Portobello Road, and Nina told Lemmy to ask me to make a film about him—and I thought: "Gosh! Too much for me!" Now 14 years later I actually made it, the title: *Lemmy*—and he wrote a great support letter, gosh . . . Autumn 2002 we had a preview screening at Anthology Film Archives and Jonas, who till then had nothing to do with the "heavy rock scene" at all, said he was really wildly fascinated about Lemmy and the film.

Anyway . . . 1988 I ran (quite naive somehow) to every cinema and film-office asking (and nearly begging) to show my film *DANDY* - I was totally convinced it's the "New York" film. But nobody wanted it, I was often laughed at or treated like a bum . . . "even though" I had a special preview at the big disco Tunnel (with a beautiful photo exhibition) - so, I was just about to give up (which is impossible) when I came across Anthology Film Archives and Jonas Mekas. (I had thought Anthology was "just" an archives and no cinema . . .) I gave Jonas a VHS of the film and in December 89 we had the US theatre premiere with Blixa Bargeld and Nick Cave. I flew them in from Berlin and Brazil and took it from the box office, which got pretty well filled for 3 weeks. Those 3 weeks I greeted the audience at every show, sold many posters and postcards. Even had some T-shirts with Blixa and golden writing in Japanese. Then every couple of months we repeated *Dandy*. I was lucky to get the deal: box office pays my flight plus 50 percent of profit. It worked. I was pretty often in New York; also to show my next films and so became friends with Jonas. Our two main places were (and are) Café Creme and Mars Bar, both on 2nd Ave. Jonas is quite an expert on wines, meals, cheese, sausage, beers, tequilas, caipirinhas . . . Actually very first time I came across him was 1985 at the International Film Festival Torino. I went to his film because of the great title: *He Stands in the Desert Counting the Seconds of his Life*. The essence of this (in my eyes) was "simply" "*Life*" (I kept that film title in my mind but forgot Jonas' name, until 1989 when after viewing *Dandy* he said: ". . . a film with pain, humor and honesty, and a great way of music interwoven with images.") Jonas' film strengthened my idea of film being a free poem, the camera moves like the eye in the head, to and from, focusing, "zooming," sometimes, not knowing where to look, but in search . . . I suppose searching is the real adventure, 'cause if you know everything it probably gets boring. "His eyes were closed behind the Iris. No light should irritate his home movie. Silence . . ." (a song by Katrin Achinger and The Flight Crew in *Jonas in the Desert*).

Music was my reason to start making films in 1981. After I had seen some punk films called *AMOKOMA* with Abwärts by Klaus Maeck (who later made a doc. on Burroughs) in Hamburg, I thought: "Oh . . . how easy it looks! I want to do that too!"

I always laugh when Andy Warhol (in . . . *desert*) says: ". . . great peculiar movies I had never seen before. And actually all the movies looked like MTV now, so if you watch MTV now, it's like going to the Film-Makers' Cooperative a long time ago. Jonas Mekas was in charge, and he was the most exciting person." I think Warhol and Mekas must have been a great cou-

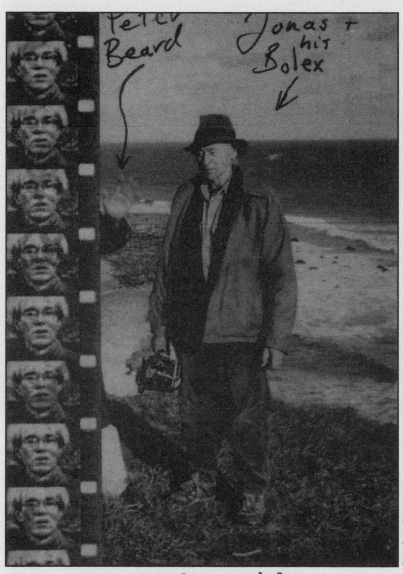

Jonas Mekas— Anthology card for
Peter Sempel

ple!— both originally from East Europe . . .

"Jonas, remember how you made your first film?" Jonas: "Well, I didn't start making films. Very often one doesn't start making films. One has a camera, one begins to film certain images, certain realities, I began filming, collecting images, but I was not sure what film that will be. I was not making a film, I was filming, I was filming, it's like, you know, breathing, like . . . It doesn't, I mean the film takes, the kind of material, the way I ended up, is, is, I mean that's not every, I don't say that everybody should, I mean, obviously not, not everyone makes the same kind of film, but it, it, it, had to, the material had to grow and more to a, to reach a certain point where it becomes a film. At first there is only one shot, pieces of film, life, reality . . ."

Again at the Torino Film Festival, I think in 1991, I filmed him and Kenneth Anger: ". . . he is also a wonderful poet of emotion, using the camera, held by hand, in a way that all the trembling reflects the inner emotion . . . a very sensitive artist working with the camera like it is his heartbeat and his breath . . ." I asked Kenneth and Jonas to let me film them on a playground, on the swings (because somehow I saw them as two big boys playing, with cameras, excuse me, I mean it in a positive way). And all the grownups, because they couldn't understand their language (maybe spoiled?), were hooraying them for how great they are (of course they are). Anyway, both were standing on the swings, swaying just a bit—and Kenneth flew down! The whole length of his body looked like it was smashing in the ground! Luckily he got up, hurt his knee a bit, but nothing crucial . . . (I was told I shouldn't show the scene, but I edited Kenneth after falling, right back on to the swing, it looks okay.)

"Don't hide the madness! . . . Like the Tibetan Buddhists . . . they have a thing called crazy wisdom, wild mind, just as the actual mind is . . . as the dadaists and surrealists found out long long ago," Ginsberg (. . . *desert*). Yes, and you can see this often in Jonas. He runs around in Anthology office in the middle of the day playing his trumpet like a madman (or child), he runs over wide fields in Lithuania to greet the cows and horses (in *Jonas At The Ocean*, part 2), he sings at the top of his voice when "partying" with his Lithuanian friends (after 2 beers), you think you are in a crazy house! It's so alive and wonderful! He dances wilder then Alexis Sorbas and better than Fred Astaire (Yoko Ono has some film footage of them together).

In Kassel, Jonas runs up the 10m high pole, he climbs trees to the top to sing Lithuanian songs about beautiful, cruel, seductive young women . . . (Truk Parkunas!). In Montauk, he stands on his head together with Peter Beard right at the edge of the cliffs . . . and he still runs Anthology . . . you must be mad, film mad, cinema mad, poetry mad, life mad.

That's fair enough isn't it?

Oh . . . and then he "plays Antonin Artaud" on Anthology stage, truly like a madman, racing to and fro, jumping up and down, yelling:"BURN!!BURN!!BURN!! I AM MADMADMAD!!!" . . .

To do all these things, one has to be pretty free inside. Just like his friends and companions: Warhol, Dali, Fellini, Lennon, Maciunas, Ginsberg, Nam June Paik, Rosselini, Anger, Cage, Beard, and and and . . . Of course: what is Free? Something like independent . . . Jonas (at the window): You see the light, the light of the street, this street. The light is coming from the street, and this street is in America, and I am here, and I am in America. This is American light coming through the window, from a street, which is quite independent in the country of

independence. Do you know what independence is? Nobody really
knows. In cinema, in cinema, like in any other art, independence,
maybe, independence is to free oneself from the content and forms of
those who preceded you or those who are doing important work
today and discover your own content and your own form to express
that content, so that in other words to descend to your deepest self
and work from there. That is the only way one can contribute some-
thing new. That's where freedom and independence really is, that's
what it means . . . —songtext: "Sehnsucht kommt aus dem Chaos, ist
die einzige Energie" (Einstürzenden Neubauten in both Jonas films).

Independent, independence in art means almost the same as inde-
pendence in, let's say, countries where the little individual cultures are
trying to gain their own individual voice and speak with their own
voice instead of, of following imposed systems, imposed languages,
in, where they have to follow the soul of some other let's say . . .
Lithuanians were asked more or less to get into the Russian pro-
crustean bed instead of talking or speaking their own or from their
own deepest past, their own history, or their own souls and their own
language . . .

In his book, *I Had Nowhere To Go,* Jonas describes the time of Russ-
ian oppression, how he fled to Germany near Hamburg and was forced
to a labor camp. He describes in very fine details and poetically the
days of hunger and despair, then the years in "camps for displaced
persons" near Frankfurt before being "deported" with his brother Adol-
fas and friend Algis to New York. We repeated the landing in 1949
exactly at the same pier on Hudson River, *Jonas at the Ocean,* over 40
years later! (filmed in slow-motion with orchestral music by Einstürzen-
den Neubauten). And he reads: " . . . sometimes I feel like a dog. Any
place I stay longer than a day, I feel at home . . . But . . . actually I
don't like traveling . . ." Well, I met and filmed Jonas just about all
over the place: in New York of course, his loft, at Anthology, at Mars,
in the streets, etc., in Washington (where he was in the Jury of Library
of Congress to choose films to "be declared important" and saved), in
Los Angeles at the International Documentary Film Festival, we went to
have a cold beer at a special place and the lady said: "Sorry, we don't
serve beer or alcohol, only alcohol-free . . ." Jonas had a face of sur-
prise and disappointment and we left. It is really hard to understand
how these Californian . . .

Another time I remember well, when I asked him to come to Brazil,
he said, no, he doesn't want to, no time, and when we were there (he
was invited with a retrospective at Sao Paulo International Film Festi-
val) he didn't want to leave anymore . . . (Sao Paulo is my favorite
city next to New York; I'd love to make a film there.) Then I filmed
him in Paris receiving a reward, a medal for being a chauvinist, no,
sorry, a chevalier... Some years later I filmed him again in Paris getting
a Pasolini award, where I also filmed Arrabal at home performing for
Jonas-film (will be in part 3: *Jonas in The Jungle,* maybe 2008?) —Oh
. . . we were driving at night through Sao Paulo, both in the back and
suddenly a car came racing from the side over a crossing, although
we clearly had green and hit the back, just about 10 cm behind us,
ripping off the back part of the car. Miraculously nobody got hurt and
we thanked Mary. Actually Jonas believes in I think . . . "Fatima"? . . .
near Avignon or where? We filmed in Hamburg and went to the place
of the working camp—now a childrens' playground . . . that evening
Jonas held a speech in Hamburg's Metropolis Kino and while talking

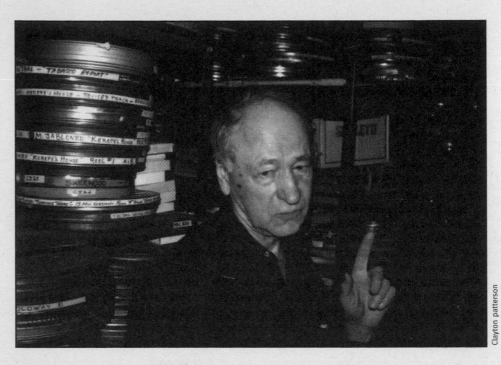

Clayton patterson

Jonas in Film Archives

about the past he all of sudden cried with tears, his memory of pain had over-whelmed him. It was strange for the audience because they didn't know the rea-son. Otherwise Jonas was happy to see Hamburg again. We did a little "film tour" with *Jonas in the Desert* to 12 towns in 11 days (in my old VW Golf). Once there was a heavy jam on the autobahn and because we had to get to a cinema on time I overtook on the forbidden right lane. A truck driver saw this and drove all of a sudden over and into my door, I reacted very fast, no one hurt, but the door was crushed and I had to climb out of the other door . . . and we made it in time . . . Once in Torino, I asked Jonas what do you have in your bag? "This and that . . . and a good salami-sausage from New York" with a big smile. I asked: "Why do you need to bring a sausage from NY to Italy? They have every-thing here! And more!" Jonas: "I never forget the days of hunger . . . so, just in case, I always have a good salami from NY with me . . ."

"I'm looking for the possibilities of order and simplicity through chaos," Jonas reads scribblings by Peter Beard (in *at the Ocean*). When I see all the friends and people around Jonas in the many years, there are so many great artists, charac-ters, intellectuals and "crazy" people from around the world. It is really unbeliev-able and impossible to count them all up. Also how others see him, two examples: Peter Beard: "Jonas is the Picasso of Film Art," Wim Wenders: "Jonas is the James Joyce of movies." (". . . I remember the first time at Anthology I saw

three Ozu films in a row, sitting in little black box so I couldn't see my neighbors left or right" . . . *at the Ocean*). One of the first admirers: in the '50s, Orson Welles: "*Filmculture Magazine* founded by Mekas is the best in the world!"

Heh! How about some critical people? I seldom met any, but Barbara Hammer, who represents the lesbian film world pretty well, said (some years ago, though): "I'm pretty upset about Jonas, 'cause he hardly pays attention to gay and lesbian filmmakers!" I asked Jonas and he answered: "Well, I respect some, but most are always stressing too much their sex and society situation, although by now they should be "normal between normals" and concentrate more on the possibilities of films "normally." (By the way, I'm working on another longtime project about transsexuals as an existentialistic subject, and also because they are still far away from being treated with the normal respect every person should have.) Some of you surely know about the famous film *Flaming Creatures* by Jack Smith, Ginsberg (. . . *at the Ocean*): " . . . over 30 years later, again, the authoritarian, neostalinist, neohitlerian, neogoebbels, neomaoists, culture vulture censors, people who want to reduce everybody to their mind, and want to control other peoples' mind, as with the Stalinists and the Nazis are beginning to take shape again in America and wanting to impose the same censorship that we broke out of, much to Jonas Mekas' efforts in 1958/59. . . . "

" . . . you should understand, there is a lot of history behind that, 1957 my own poetry went on trial, 1958/59 works of Henry Miller, Jean Genet, D.H. Lawrence . . . culminating in 1962 with a victory against censorship, liberating *Naked Lunch* as well as all the other books had been liberated. Lenny Bruce was arrested by the same district attorney who also prosecuted *Flaming Creatures* and *Naked Lunch*. Warhol films were seized, but Warhol's reaction was rather than fight in court, he would just make another film next week . . ." Robert Frank: "New York is charged with all kinds of shit." . . . Nam June Paik: "Over 20 years ago, when I applied for my first visa to stay in America, Jonas was my financial sponsor, although he didn't have a penny in the bank. Luckily the consulate didn't check his bank! And now today Jonas is financially just as bad as those days . . . but . . ."

He is nearly the only resource of visual language of the avant-

garde of the '50 and '60s, because of his diary . . . I am constantly reminded how one man can achieve so much with one will, such determination! One man can change the world in this very organized world, it's amazing! . . . that gives me lessons . . . I also used some of his films in my videos, for example, *The Brig* . . . Many people talk about Jonas, like Ginsberg and Nam June, there are many funny, strange and remarkable anecdotes. For me actually he reminds me often of the Monkees: "I'm A Believer"

A Few Notes on my Life

on the Lower East Side and Cinema

by Jonas Mekas

I came to New York in October of 1949 as a Lithuanian exile or, as they used to call us in those years, Displaced Person. I said New York, but actually I landed in Williamsburg, Brooklyn, which in those days was a paradise of Eastern European immigrants and exiles. I don't think I'd be exaggerating by saying that half of the Williamsburg population in 1950 was of Lithuanian origin. Some had settled down there during the 20's wave of Eastern European immigration, others came after World War II. There were dozens of Lithuanian saloons, restaurants, stores, all kinds of shops and businesses.

For some two long years I moved around Williamsburg— Meserole Street, Grand Street, Lorimer, South Fifth, Bedford Avenue, etc. But my real life was in Manhattan. I wanted to catch up with everything I had missed during the years 1940-1950, the war and postwar refugee camp years. For the next decade, between 1950 and 1960 I did not miss a single film opening, theater, ballet, music performance: I was so deprived of culture, arts, so hungry for it. But I also was still very involved in the local Lithuanian immigrant community. Around the end of 1952, however, I began to feel more and more like an outcast among my compatriots.

While I was obsessed with hungrily grabbing as much as I could of cinema, ballet, literature, jazz—all the arts with which America and New York were bustling, my compatriots seemed to be interested only in jobs, houses, politics and drinking. In April 1953 I reached a point of practically facing two choices: a nervous breakdown or an escaped from Brooklyn. I chose the latter.

In April 1953 I rented a small place on 95 Orchard Street. From my window I could see the incredible bustle of Jewish markets. And I paid only $14.95 per month to my landlord who played balalaika at Two Mandolins, on East 14th Street. I left my job in a small metal works shop in Williamsburg and took a job at the Graphic Studios on West 22nd Street as a messenger boy. Now I was in the center of life! In the center of everything that I cared about.

My first local friend was Lilly Bennett, who permitted me to live in her Essex Street studio while my Orchard Street place was being fixed. Lilly was a dancer and a budding writer. One of her close friends was Jackson McLow, the poet. He was one of my earliest Manhattan friends. Then I met Dorothy Brown, she lived on Ludlow Street, she worked with some silkscreen artists. When she found out that I was interested in at avantgarde film, she asked me to arrange a

series of screenings of avantgarde films at her Ludlow Street loft. I did that. That's where I met several of my new Lower East Side friends. One of them was Louis Brigante. He had just started publishing *Intro Bulletin*, a monthly literary and arts newspaper. He printed interviews with people like DeKooning, people like that. So he invited me to start a movie column in it, which I did. It was called "Movie Journal." This was four years before I began writing my "Movie Journal" column for the *Village Voice*.

Very few people know this and I don't think it's worth knowing, because I am embarrassed about some things I wrote in that column. But some of it was good.

Louis Brigante and a painter called Joel Boxer, he was my neighbor, were about to start an art gallery of their own. They called it Gallery East. It was located on the second floor of 7 Avenue A, corner of Houston and Avenue A, Library Bar is there now. They invited me to add the avant garde film component to it. On October 30th 1953, exactly to the day three years after my arrival in New York, my curatorial debut took place at the Gallery East with a program of films by Oskar Fischinger, Francis Lee, Sara Arledge, Jim Davis and Whitney Brothers.

From there on my life became more and more complicated and hectic. It was on 95 Orchard Street that in 1954 my brother Adolfas and myself issued the first issue of Film Culture magazine and were taken to court by Franciscan monks of Brooklyn whose printing shop we used, for not having money to pay for it; by the way, the Court to which Adolfas had to appear was 32 Second Avenue Courthouse, the present Anthology Film Archives. . . . It was also at 95 Orchard Street that we produced the first draft of the Film Institute which later became the American Film Institute. This is something that even the American Film Institute people to not know. But now I'll jump to 1961, when I had already moved to 515 East 13th Street, between 1st Avenue and Avenue A. I had already met the Beat gang, Allen lived just around the corner and he used to drop in with Burroughs now and then. Ed Saunders had his shop at the edge of Thompson Square. Stanley bar on the corner of Avenue A and 12th Street was the bar where we often met and had our beers. Stanley was something like the Mars Bar today. And right there, across the street from Stanley was the Charles Theater. It was a regular movie house. Around the time I moved into 515 13th Street ground floor flat, two unpractical, idealistic movie buffs, Edwin Stein, a young psychiatrist, and Walter Langsford, I think he worked as a publicist somewhere, rented the Charles Theater hoping that it may do well as a commercial neighborhood movie house. As it happened, it didn't do that well at all. So, while we were having some beer, they thought that I should add some independents, or, as they used to call us in those days, underground filmmakers, to the regular routine programs. So that's how I came into it. And, of course, I went into it with my usual obsessive enthusiasm. Many early retrospectives of avant garde film-makers such as Marie Menken, Willard Maas, Stan Vanderbeek, Joseph Marzano, Markopoulos took place at the Charles. The only public screening of the legendary Markopoulos film SERENITY took place there. Premieres of Ron Rice's *The Flower Thief*, Brakhage's *Anticipation of the Night* and my own *Guns of the Trees*, all dutifully reviewed by the New York Times, took place there. The notorious Open House film screenings were inaugurated by the Charles. Robert Downey had late weekend evening shows there. And Sun Ra, whom I had met a few months earlier in Chicago, had his first New York concert at the Charles. Jack Smith was one of our ticket sellers for a while as was the publisher of Mad magazine. Within weeks the Charles became a place to hang out for the New York undergrounders, a very very active, very alive, very contagious place. It heralded the beginning of the new wave of the American avant garde.

In addition to the avant-garde, the underground, the Charles became also champion of the auteurist cinema. It's to the credit of Stein and Langsford, that they were very open to the new ideas in cinema. We had a perfect collaboration going between us. I programmed Edgar Ulmer, Howard Hawks, Joseph Losey, Tay Garnett, Douglas Sirk, and later Fritz Lang, and others. It was all very very exciting.

Exciting or not, despite all our programming ingenuity and excitement, the theater did not make enough money, not enough to survive. After two years or so it had to be abandoned. However it will remain in the history of the American independent/avantgarde cinema a very important, very exciting chapter.

Now I jump again, now to the present, to Anthology Film Archives which is situated on the

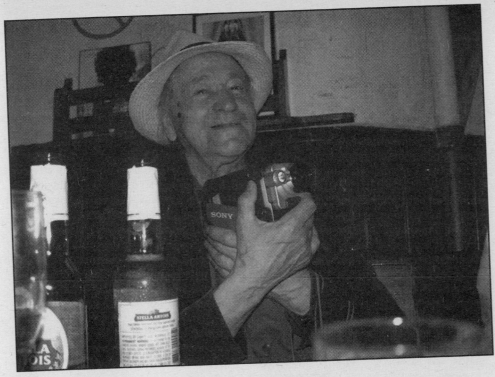

Clayton Patterson

Jonas Mekas

IS THERE A CREATIVE FILM AVANTGARDE IN AMERICA???

GALLERY EAST presents three programs of current
experimental films produced in the United States.

Program #1—OCTOBER 30-31, FRIDAY & SATURDAY EVES., 8:30 P.M.
Membership at door: $1.00

includes:
1—MOTION PAINTING #1, by Oscar Fischinger
2—FILM EXERCISES #4 and 5, by John and James Whitney
3—INTROSPECTION, by Sara Kathryn Arledge
4—THE IDYL, by Francis Lee
5—SHADOWS AND LIGHT REFLECTION, by James E. Davis
Programs arranged by Jonas Mekas

GALLERY EAST #7 - Avenue A
New York 3, N. Y.

Is there a Creative Film Avantgarde in America ??

GALLERY EAST presents three programs of current
experimental films produced in the United States.

Program no. 2: SURREALISM in the FILM

FILMS BY JAMES BROUGHTON, DOUGLAS CROCKWELL AND
SIDNEY PETERSON

FRIDAY EVENING NOVEMBER 27, 8:30 p. m.

PROGRAMS ARRANGED BY JONAS MEKAS

MEMBERSHIP INVITED
Tel.: ORegon 4-3980

GALLERY EAST #7 - Avenue A
New York 3, N. Y.

Charles Theatre

12TH STREET & AVENUE B • GR 3-6170

*'The Charles Theatre...is doing exciting things
in complementing its weekly revival showings
with weekend screenings of unfamiliar, off-
beat, and original films...Here's a clear and
most encouraging indication of a forward inter-
est in the culture of films'*-Bosley Crowther

*'This new movie theatre is a most welcome show-
case'*-Cue

'The home of new American cinema'-Scenario

'New, different, and imaginative'-Village Voice

The Charles is a new and different kind of
theatre, a movie house that offers a unique
variety of film programs and entertainment.
Among the many films you can see at the Charles
are the finest recent releases, revivals of
great classics, rare silent masterpieces, new
films by independent filmmakers, and the most
daring experimental works of both American and
foreign directors. Besides its regular program
of films, the Charles has a continuous exhibi-
tion of paintings and sculpture by New York
artists, weekly performances by a keen Baroque
chamber music ensemble, occasional live chil-
dren's matinees, and special kinds of enter-
tainment on Wednesday evenings. Also personal
appearances of important film personalities.
And Sundays, from 2 to 5, a live jazz concert.
Come to the Charles and see for yourself: you
will find it the most informal theatre in town.

corner of 2nd Street and Second Avenue. As you can see, I haven't moved very far away from the Gallery East, only two short blocks. The old Small City Court building was closed as an active courts around 1962 or thereabout. I have to do some checking regarding the correct date of closing. In 1967 St. Mark's Church received a grant to turn it into an art center. During the years of 1967-69, under the auspices of St. Mark's Church it was used by various art groups. Film-Makers Ken Jacobs and Stanton Kaye were in charge of the film component. Jack Smith developed his film *No President* in the basement of the building. I visited him there and he had freshly developed film drying, hanging on the basement pipes all over.

St. Mark's Church grant was not renewed and the building was left open to whoever wanted or could use it. For some time it was used by Peter Schumann's Puppet Theater, La Mama, Andy Warhol filmed some of his movies in it. Then it was abandoned completely because with nobody having money to take care the building, nature and vandals took it over. When I found it in 1978 it had practically no roof, no windows, the basement was flooded, all pipes were ripped out. The building was nothing but a beautiful skeleton. But I fell in love with it. I had to wage a fierce fight against the local Community Board in order to buy it from the City—it is a long story, it's for another occasion. It suffices to say that in the summer of 1979 I purchased the Courthouse from the City of New York. It took a full decade to transform it into what it is now all, but we did it, we made it into a Cathedral of Cinema, the only film museum in the world dedicated to the independent/avant garde cinema.

The Millennium Film Workshop in Love

by Ruth Galm

There are few places in New York City or around the country where aspiring filmmakers and artists can become involved in a "media arts center" dedicated to incubating the most independent and alternative cinema from concept to finish. A place where, for minimal cost, people can learn the craft of filmmaking and video art from experts, access a wide-range of equipment and facilities, view work from and interact with international avant-garde filmmakers, and study the theory and practice of experimental, noncommercial cinema through a semi-annual journal. In other words, there are few places like the Millennium Film Workshop.

Since 1966, the Millennium Film Workshop has offered this type of haven for "personal cinema" on the Lower East Side. An integral part of the film and video history of the area, Millennium pioneered an approach and ethos that became a model for organizations around the world and helped nurture the development of an underground genre of film and art. While other organizations around town offer services similar to Millennium's—workshops, equipment access, film series, exhibitions, a journal—none offers them all. And no other organization in New York has dedicated itself in the same way to the lesser-known art form of avant-garde, experimental film.

Millennium's mission today "to provide film, video, and new media programs and services to non-commercial artists and their audiences at the lowest possible prices" and "to provide access and freedom of expression to all regardless of experience and level of accomplishment" reflects the same spirit that hatched the organization 37 years ago. A look at Millennium's website (www.millenniumfilm.org) shows this mission come to life. For minimal membership fees, novices and veterans alike can come to 66 E. 4th Street—Millennium's city-subsidized home for almost 30 years now—to take courses in basic and digital filmmaking, optical printing, animation, perfecting the use of 16 mm, and mastering the Avid Media Composer editing system. Members and the public also can rent spaces and equipment at low costs for editing, producing, and screening their work.

Then there is Millennium's ongoing film series, the "Personal Cinema Program." Each year it features the cutting edge of avant-garde cinema from around the world, bringing in artists to discuss their work in person whenever possible. The program is inherently diverse. In spring 2003, for example, Millennium's eclectic menu included a guest-curated Invisible Film Series program; a tribute to the great avant-garde film artist Stan Brakhage; a multi-screen projection performance; a program showcasing three newcomers and a veteran of the Japanese experimental film and video scene; and a "Naughty Animation" summer solstice special.

In addition, Millennium holds regular "open screenings" once a month where anyone with work can come and show it. It is both open and free—there is no selection process, simply a card to fill out. Each open screening normally yields a couple of hours of film and videos.

The organization also publishes a semi-annual magazine, the *Millennium Film Journal*, which since 1978 has published articles about independent, experimental, and avant-garde cinema, video, and works using newer technologies. Finally, since 1999 Millennium has offered a regular series of photography and art exhibitions by and about film and video artists in its in-house gallery.

"It's always difficult for very non-commercial organizations like the Millennium to keep going," says Executive Director Howard Guttenplan, a filmmaker, photographer, and artist who has been the director since the early 1970s. "It's not popular art—the

Howard Guttenplan

films we show are often not easy and not entertaining to most people. To those who open themselves to this art form, it can be very rewarding and exciting, of course. But it surely is a minority art form. I think that the reason the Millennium has lasted so long is that it answers important needs of the art community and its audiences."

That Millennium emerged in the East Village is no accident. A hotbed of counterculture artistic and political activity in the mid-1960s, the area was ripe for an avant-garde film practice. In fact, "avant-garde" and "experimental" are vague descriptions that do not fully capture this revolutionary marriage of film and art. The late Stan Brakhage, an acclaimed filmmaker and supporter of Millennium, talked about the limitations of common labels for this genre in his first of many talks at the center, Guttenplan says. For Brakhage, "underground" film conjured up images of a Victor Hugo character traipsing through the sewers of Paris; "experimental" sounded like people were just puttering around; and "avant-garde" sounded too pretentious and French. Guttenplan shares this view. "I called it 'personal cinema' early on and I think that might be a better description and a more precise term," he says. "It's very personal, usually made by one person, free to investigate a wide range of ideas, subject matter, and forms. This work relates more closely to the art world than to traditional movies."

Today, various technologies for individual exhibition and distribution are commonplace. But the idea of making a personal film was a radical concept when it first emerged in the 1940s and 1950s, Guttenplan says. At the time, it was almost all-narrative film—Hollywood and stories for the masses, large studios with large cameras. The seeds for real personal cinema were planted during World War II, when light-weight, handheld cameras were developed to shoot during combat, he says. When the war ended, people realized they could use these cameras to make their own films in 16mm. Filmmakers began creating personal films; some were home movies and some aspired towards a cinema art. Pioneers like Maya Deren, Kenneth Anger, and later Brakhage produced personal works that were called "film poems" that launched an avant-garde cinema in the United States.

By the 1950s and particularly in the 1960s, personal cinema was becoming more and more a part of a developing counterculture movement, and places began to spring up around the country, Europe, and Japan where these films were screened and discussed. The idea of underground film became connected with the political and social movements of the era, drawing large crowds who related to its anti-establishment ethos and energy. Enter Millennium Film Workshop.

In 1965, the federal government, as part of its anti-poverty program, allocated money to organizations in New York City to provide creative activities for young people. St. Mark's Church and the New School received a large grant to implement a series of workshops in theater, film, and poetry. (This is where the Poetry Project got its start.) Filmmaker Ken Jacobs was appointed director of the film workshop, and in the fall of 1966 he set up a film series at the church on Sunday afternoons—mostly one-person programs of what were then called "underground films." This series was open to any filmmaker with a body of work. Jacobs also launched separate "open screenings" on Friday nights, where he led discussions about the films with the filmmakers present. Known to be both perceptive and provocative, Jacobs broke new ground with this format.

"Ken thought—and I agreed with him and kept this going when I became director—it was very important and useful for filmmakers to be present to make often very difficult work more understandable to people," Guttenplan says. "It was a way to have a feedback process between filmmaker and audience, to generate thinking, ask questions, and provide ideas. Millennium was one of the first to use that kind of format in the country."

In addition to the "one person, in person" shows, Jacobs established a film workshop in January 1967 that was held at an old courthouse on Second Street and Second Avenue, the building now used by Anthology Film Archives. Various filmmakers taught classes in cinematography, sound, and editing—with the editing rooms located in the courthouse's bloodstained former jail cells. All classes and equipment were free. Jacobs called these activities collectively the Millennium Film Workshop, " . . . because it was the future, like a sudden leap into my favorite future," he said in an interview in the *Millennium Film Journal's* 20th Anniversary edition.

However, Jacobs and Michael Allen, director of the St. Mark's Church at the time, did not see

Clayton Patterson

Howard Guttenplan, Millennium

eye to eye about this future. By March 1967, Allen had fired Jacobs, and Jacobs broke off to form a second Millennium Film Workshop that would evolve into the organization still operating today. Millennium took up residence in a building on East Second Street and Third Avenue, also showing films at the Washington Square Methodist Church and also at the Filmmakers' Cinematheque, through Jonas Mekas. In late 1967, Millennium became incorporated as a nonprofit organization and soon received its tax-exempt status.

The organization drew large audiences. Students, artists, political activists, young people, and others gravitated to its screenings and classes. One of these students was Guttenplan, who had just moved to the East Village and became interested in filmmaking. For him, Millennium seemed like a perfect space to meet other people interested in movies and art and to take free classes.

After about a year, Jacobs stepped down as Millennium's director to return to his own filmmaking. The next director was George Tennille (an African American, which was unusual at the time), and then Gary Smith took the helm in late 1968. Both men worked without salary and helped steer Millennium through its hatchling stage. But by the end of the 1960s, turnover and financial instability were weakening the organization and forcing it to hold fewer screenings. Guttenplan, who had become progressively more involved in the organization, was asked to take over when Smith stepped down. He has held the position since the early 1970s.

"There are times when it's been difficult," says Guttenplan, who taught himself many of the administrative skills required as executive director. He has striven to make time for his own art, including his acclaimed "diary" films, personalized documentations of his days in New York City and his overseas travel. His films have been exhibited extensively around the world. The Museum of Modern Art has described Guttenplan's work as "spontaneous, immediate celebrations of color, texture, and design."

"It's interesting," he says. "Much of my art is nonverbal, very intuitive, improvisational and hard to talk about in words. They are works of the visual imagination. Whereas much of what I do at Millennium entails the use of words in various ways and very practical, day-by-day problem solving and planning."

Guttenplan made a number of changes when he came on to strengthen the organization, including hiring the best possible teachers and workshop managers, designing new ads and writing copy for maximum impact, and seeking out new funding streams through state and federal grants. Millennium relocated to a loft on Great Jones Street at that time, relaunching its film

series there and setting up classes and editing rooms. To keep Millennium's programs as open, diverse, and focused on new work as possible, Guttenplan viewed as many films as he could and solicited ideas from other filmmakers. Uptown, the Museum of Modern Art in 1968 began regular programs of avant-garde film in its cineprobe series, and the Whitney Museum began showing films in 1970. But for several years, Millennium was one of the few places downtown *exclusively* devoted to the exhibition of new experimental work, Guttenplan explains.

In the mid-1970s, Guttenplan broadened Millennium's scope to include foreign filmmakers. After attending the London International Avant-Garde Festival of 1973, he discovered that Millennium was well known in other countries and decided it was time to broaden the initially parochial scope of North American avant-garde film that the organization reflected. Gradually, leading filmmakers from Britain, Germany, France, Hungary, Poland, Japan and other regions were invited to make their North American debuts at Millennium. Over the years, Guttenplan has also ensured a broad artistic vision for the center by regularly inviting guest curators to organize film screenings.

In the 1974–1975 year, Millennium moved to its current location at 66 E. 4th Street and has remained there ever since. The city leased space to the organization and others, such as co-tenant La MaMa Experimental Theatre Club, to use these buildings at very low rent, with the agreement that they would be responsible for renovations. Millennium has since upgraded its entire facility, including a large theater for screenings and production and various editing rooms.

The next frontier for Guttenplan was establishing a regular magazine about avant-garde film. In 1978, the *Millennium Film Journal* was born and is now the oldest continuously published journal of "avant-garde," "independent," or "experimental" cinema in existence. Since its launch, Millennium has printed one or two issues a year, each centered around a theme or general concern, such as *Politics and Landscape* (1979), *Feminism* (1980, 1982–83), *Book Reviews and Theory* (1984–85), *Mythologies* (1989–90), and *The Script Issue* (1991). In the last 15 years, *MFJ* has broadened its scope to include consideration of work in non-film media, including video and electronically based forms, releasing issues such as *Interactivities* (1995) and *Video and Video Installation* (1996). The open and creative form of the journal often distinguishes it, with long essays appearing alongside short reviews or works made up entirely of images, for example. Over the years, *MFJ* has endeavored to maintain a high standard of writing, even early on when few writers addressed avant-garde film.

Millennium has screened hundreds upon hundreds of films and has introduced numerous artists to the public through the years. There have been one-person shows with influential avant-garde filmmakers like Jon Jost, Su Friedrich, Birgit Hein, Hollis Frampton, Kenneth Anger, Paul Sharits, Valie Export, Yvonne Rainer, Bruce Conner, Carolee Schneemann, Robert Breer, Malcom Le Grice, and many others. Millennium worked closely with Jack Smith, who showed his landmark films and gave live performances there, and premiered many of the legendary Stan Brakhage's major works. In addition, Millennium has provided space for experimental theater works and personalities, including Charles Ludlam, Allen Ginsburg, Stuart Sherman, Tony Conrad, Jackson MacLow, and others. Along the way, figures like Andy Warhol, Oliver Stone, Jim Jarmusch, Susan Seidelman, Jean-Luc Godard, Amos Poe, and Joseph Kosuth have used its facilities and services.

But the vital other half of Millennium's mission has been its open-door policy to the community. Millennium has remained a highly accessible media arts center, making the tools and knowledge of filmmaking available to whoever wants to learn them and creating a censorship-free space for people to connect with and inspire each other. While its evolution has not been all "honey and roses," Guttenplan assures, along the way Millennium has made invaluable contributions to the history of film, video and art in the East Village and around the world. Most likely, it will continue to forge its own future in the years to come.

25 Years, 26 Books:
The Millennium Film Journal

by Grahame Weinbren

In the late 1970s there was a peak in independent filmmaking of all kinds after increasing activity throughout the decade. There were plenty of working filmmakers . . . but hardly a word was written about them or their work. As a response to this situation, the Millennium Film Workshop published the first issue of the *Millennium Film Journal* early in 1978. It was bound and printed to last, like a book: it looked serious and substantial. The editors were Alister Sanderson, Vicki Peterson, and David Shapiro, and the issue was given the theme title "Surrealism in Cinema/Autobiography/Diary." It included interviews (with Annette Michelson, and Ken Jacobs), articles on aspects of the history of avant-garde film, critical overviews and reviews of the work of individual filmmakers. Authors included P. Adams Sitney, Stuart Liebman, and Noel Carroll. Issue Number 2, "International Avant Garde/Structural Film," published in the summer of 1978, added statements and manifestos by filmmakers, shorter articles about individual filmmakers and single works, and surveys of avant-garde film scenes by geography: France, Spain, Japan. And so it

Clayton Patterson

Jeremiah Newton and Kenneth Anger

continued. These themes have remained a part of the journal over the last 25 years, while new themes emerge and are incorporated. The journal has always emphasized strong graphic design, and is richly illustrated with fill, stills, photographs, and drawings. Many well-known authors have written for the journal, including Paul Arthur, Noll Brinckmann, Fred Camper, Joan Copjec, Mary Ann Doane, David James, Birgit Hein, Chris Hill, Mike Hoolboom, J. Hoberman, E. Ann Kaplan, Scott MacDonald, Laura Marks, Vivian Sobchack, Amy Taubin.

Taubin contributed the first article about video, "And what is a fact anyway?" (On a tape by Martha Rosler) to MFJ Nos. 4/5, "Politics/Landscape" (1979), and in discussing a videotape work, opened a new direction for the journal. The journal acknowledged, with this article, that the experimental cinema cannot be broken down into separate subjects based on whether the recording media is chemical or magnetic. A misconception that generates much misunderstanding and misinterpretation of work in the field is the idea that there is one history of film, another of video, and yet a third of so-called digital works. Cinema has developed and is developing in several media simultaneously, and the only way to comprehend the complications of its past and present is to see it containing multiple streams of history that overlap and intermingle. In the last 15 years or so, the MFJ has made a deliberate effort to capture this epistemological multiplicity.

Noteworthy points in the 25 years of the MFJ include the *Performance Issue* (Nos. 10/11, 1981–82), *The Theory Issue* (Nos. 14/15, 1984), *Video Installation* (No. 29, 1996), and *The Millennium 20th Anniversary Triple Issue* (Nos. 16/17/18, 1986–87), which, on a personal note, was when I, along with Tony Pipolo, joined Noel Carroll on the editorial board. MFJ 16/17/18 includes a montage of 20 years of filmmakers' talks at the Millennium, as well as notes by and about many well-and lesser-known filmmakers, and three assessments of the state of avant-garde cinema at that time. The *New Technology Issue* (Nos. 20/21, 1988–89) includes Manuel De Landa's phallic "Urban Growth" drawings accompanying one of his first published theoretical articles. *The Script Issue* (No. 25, 1991) consists of filmmaker's notes, plans and drawings, and in *Interactivities*, spring 1995, there is a focus on the theory and practice of interactive cinema; German experimental film is the subject of the 1997 issue, and the millennium (The Millennium, 2000) was celebrated with a broad survey about the state of the field, and after collaborating as guest editor on this issue, Paul Arthur joined the editorial board in 2001. *Hidden Currents* (Nos. 39/40, 2003), the most recent issue, includes Barbara Lattanzi's computer code for manipulating any quick time movie so that it takes on the form of Hollis Frampton's structuralist film classic *Critical Mass*, plus a conversation between two "chatbots" designed by artist Susan Collins.

In 1995, the School of Visual Arts donated space on its server for the MFJ website, and consequently it was one of the first print journals with an on-line presence. The URL is mfj-online.org, and the web pages include two indexes, one alphabetized by writer and the other by filmmaker mentioned, a table of contents for each issue, and the texts (but not the images) of articles since 1993.

Unlike economically driven forms of culture, avant-garde film is not highly subject to shifts of fashion and currency: ideas and approaches often remain vital even as new practices emerge. The *Millennium Film Journal* is a reflection, a record, and a log of a quarter century of a culture that is in a state of constant metamorphosis while never denying or flushing away its earlier identities. Thus, the MFJ is always adapting to an ever-changing independent cinema, while maintaining a strong and explicit connection with its roots and historical underpinnings.

The Lower East Side on Film

by Max Von Meyerling

The Lower East Side is perhaps the district in New York City that is most represented in American Cinema. The most important reason for this is because of the self-reflexive nature of our culture. The Lower East Side was both ground zero of American show business and the classic homeland of celebrity—particularly for those who had risen from poverty and made a success of themselves. The Great American Success story was for decades played out against the backdrop of crowded slums, at the turn of the century, the most densely populated district in the world.

The classic of all classic Lower East Side movies is *The Jazz Singer* (1927), the first feature-length Hollywood "talkie" film in which spoken dialogue was used as part of the dramatic action. It combines the story of a child of immigrants who rises to become a success in the greater world, with a show business where-they-came-from tale. Jake Robbins, son of Cantor Rabinowitz, leaves the restrictions of home to become a jazz singer. His father takes ill on the eve of Yom Kippur the same night his show is due to open on Broadway. Jack walks from the show and fills in for his father, who dies, reconciled.

The *Jazz Singer* was remade twice. In 1953 show business was de-emphasized, and the focus became on assimilation, and Danny Thomas marries a blonde shiksa, Peggy Lee. Thomas, the Lower East Side boy who makes good, Gus Kahn, had already won and married Doris Day in *I'll See You In My Dreams* (1951). Assimilation is taken a step further. It's taken a step too far in the 1980 version, notorious for its over-the-top performance by Laurence Olivier as the rabbi. Only the opening title montage of the Lower East Side done to Neil Diamond's Coming to America is worthwhile.

The success of *The Jolson Story* (1946) proved to be the model for and paved the way for a steady stream of show biz biography pictures, including *The Eddie Cantor Story* (1952), another poor Lower East Side-boy-makes-good tale.

Will the dark underside of the American Success story make you forget where you're from? This was the question answered in *Symphony of Six Million* (1932). Ricardo Cortez (born Jacob Krantz) grew up the son of immigrants on the Lower East Side and became a doctor. Though he is perfectly happy working in a free clinic on Cherry Street, the pressure to provide for his family drives him first to join a practice on the Upper West Side, and then to start a society practice on Park Avenue. Instead of helping his family he becomes alienated from it and his father dies while he is operating on him. He quits medicine but resurrects his art

and renews his self respect once again back in the old neighborhood. The message is simple: he had lost his soul when he left the Lower East Side.

This is also the message of *The Heart of New York* (1932) except here it is done as comedy, Yiddish style. (This film is also the source of the famous quote, "From Poland to polo in one generation," once thought to have been used against Darryl Zanuck, but Zanuck actually produced this film years before he took up polo.) The film stars George Sidney who was to Jewish fathers what Warner Oland was to Chinese detectives. Smith and Dale, the original Sunshine Boys, are also featured. Sidney is Mendel, a nebbish inventor who is one jump ahead of the rent collector. He invents a dishwasher and the family moves up town and becomes ridiculously nouveau riche (and perhaps an inspiration for Woody Allen's *Small Time Crooks*). Eventually papa moves back to the old neighborhood and buys the tenement to turn it into his "palace." You don't have to be Alfred Adler or even Jacob P. Adler to figure out what's going on here.

Painful transitions between "ghetto" and the outside world were a specialty of John Garfield (Julie Garfinkle), born in the Lower East Side but raised in the Bronx. In *Humoresque* (1946) and *Body and Soul* (1947), he plays talented boys who manage to raise themselves out of the ghetto, the former with a violin and the latter with his fists as a prizefighter. *Humoresque* was filmed before in 1920 and is based on a Fannie Hurst short story about a boy who wants a violin for a birthday present and a mother determined that he should have it. Garfield's childhood friend Clifford Odets extended the story to the temptations and inevitable corruptions of society, which can prevent the realization of an artist's destiny. In *Body and Soul* the corruption is more graphic than an affair with a married woman. Garfield is involved with something sinister and dirty. He is fighting the crooked fight game run by Norris and Carbo. Both are examples of turning their back on the values of the old neighborhood. In both a man has to fight to regain his self-respect, especially in terms of the values of his neighborhood and class. Both of these films are well within the "legend" developed for Garfield by Odets. Odets wrote the boxing drama *Golden Boy* for Garfield and the Group Theatre but politics put Luther Adler in the role on Broadway and William Holden in the film version (1939). Here a talented musician from the ghetto must finance his music studies by prize fighting. Even for the habitually ethnically rinsed if not cleansed film of the period *Golden Boy* seems entirely too generic. Then there is *Rhapsody in Blue* (1945), the alleged biography of George Gershwin, perhaps the Lower East Side's most important product. Robert Alda is about as Jewish as Cary Grant's Cole Porter is gay in *Night and Day* (1946). Which is to say not at all.

The darkest tale of the Lower East Side must be *House of Strangers* (1949). Based on Jerome Weidman's novel, it is an Arthur Miller-like story based on the cataclysmic failure of the S. Jarmulovsky's Bank. When WWI was declared thousands withdrew their money from Lower East Side banks and Jarmulovsky's Bank went under, taking depositors hard-earned savings with it. The bronze lettering over the door is still visible at the main branch at 54 Canal Street. *House of Strangers* transposes the story to the post WWII period and makes the family Italian. When banks began to fail during the Depression the neighborhood was instantly gripped in remembered horror.

It must be remembered that even though the ethnic neighborhoods stretched east from Broadway, housing, in their turn, Irish, German, Jewish, Slavic, Italian and Chinese neighborhoods, the two main north/south roads, the Bowery and Broadway, were major thoroughfares not only of commerce, but also of entertainment. Known as the Boston Post Road and the Albany Post Road respectively, they originated just south of City Hall Park. Ann Street was the original New York theatre district once the British had thrown out the strictly anti-theatrical Dutch. By the 1830s and '40s the scene had moved north on Broadway led by P. T. Barnum and his American Museum. Frederick Catherwood built a Panorama of Jerusalem, which

later contained lintels and sculpture from the Lost Cities of the Maya, a precursor to the cinema at Broadway and Prince across the street from one of New York's principal entertainments, Niblo's Beer Garden. While the legitimate theater was located around Astor Place, the theaters they left behind were used for musical shows.

After the Civil War, an elevated railroad was built on the Bowery and it became the important theatre district. Amongst the numerous surviving buildings of the era are many theaters whose conversion to other uses is barely disguised. Eventually the theaters spread east along Delancey Street and the respectable trade went north again to 14th Street and Union Square. New York's grand opera, The Academy of Music, was built where Con Edison's headquarters is at 3rd Avenue and 14th Street. The Bowery still thrived with more down to earth entertainment. Tony Pastor's saloon on the Bowery became about the most famous show business location in America. Developments like the mechanical reproduction of music, the telegraph and the transcontinental railroad through the frontier meant an ever-increasing demand for entertainment throughout America and it was originated in the theaters and beer gardens of the Bowery. People building the country through cattle and farming and mining wanted amusement and it became a New York industry to supply it. Stars like Lillian Russell became the ideals of their age. *Lillian Russell* (1940) presents a proto-feminist version of Lillian Russell, incongruously starring Alice Faye, reduced to having to decide between Don Ameche and Henry Fonda. For historical interest there is a performance by original "Dutch" comics Weber and Fields, and Eddie Foy Jr. doing his father's vaudeville turn.

Songs that became popular on the Bowery spread across the country. It's no coincidence that Irving Berlin, a canter's son, began as a singing waiter in a Chinatown saloon, the Pelham Cafe. Actually he began by begging on the streets of the Lower East Side as an itinerant street singer.

This era was captured in the wave of nostalgia films engendered by the first wave of talkies in the early '30s. There was a glamour to the undigested past. *The Bowery* (1933) recounts, in absolutely fictionalized terms, the Bowery moment of Steve Brodie's alleged July 23, 1886, leap from the Brooklyn Bridge. George Raft and Wallace Berry play rival Bowery saloon owners and it is an act of one-upmanship that drives Raft as Brodie to take the plunge.

This celebrated event was also recounted in Sam Fuller's *Park Row* (1952), which is about the period when America's information industry was located on the streets around City Hall. The vigorous newspapers were encouraging the settlement of the west, sending Henry Stanley to Africa to find Livingston, sending Nellie Bly around the world to out do Verne's Phileas Fogg, assuring children that there was a Santa Claus, starting wars in Cuba. Park Row was the beginning of mass media.

A year earlier than *The Bowery*, Raft, a real life street guy from Hell's Kitchen, made *Night After Night* (1932), featuring the film debut of the notorious theatre performer Mae West. West's persona of the Gay Nineties showgirl with the hourglass figure was so overwhelmingly popular that she single-handedly saved Paramount Pictures, in receivership, from being dissolved. This was the persona she used on Broadway with great success in *Diamond Lil*, a play declared strictly verboten even by the lenient Hays office of the time. Instead she made *She Done Him Wrong* (1933) which was just *Diamond Lil* thinly disguised. With comments like, "When women go wrong, men go right after them," the floodgates were opened. There was a craze for gay Nineties nostalgia. Strangely enough, the settings for Mae West films are rarely specifically the Bowery, but whether it is designated as the Barbary Coast or the Tenderloin, it was pretty well understood what was happening. In one film Mae even has to leave town when a man friend sells a sucker the Brooklyn Bridge! Technically, the Mae West films didn't take place on the Bowery yet they were popularly perceived as having taken place in 1890s' Bowery. This is the same perception surrounding the 1892 hit song "The Bowery" (music by Percy Gaunt, lyrics by Charles H. Hoyt), which was from the San Francisco set musical *A Trip To Chinatown*.

The Bowery was synonymous throughout America for libidinous musical entertainment more often than not featuring women in various states of undress.

The Bowery was best pictured as the background to an alcoholic writer's desperate attempt to either write or get another drink in Billy Wilder's *Lost Weekend* (1945). Under the web-like shadows of the elevated train the Bowery is seen as an endless series of bars, pawn shops and flop houses. A decade later Lionel Rogosin's *On the Bowery* (1957), which today would be considered a "nonfiction film" documented the last days of the Bowery as the classic skid row. They tore down the old "El" and 40 years later the street is being gentrified.

The early thirties brought about an overwhelming nostalgia movement. This retreat to a simpler time past was due to America being in the throes of a depression and the nineties seemed to be a safe haven in the near distant past, conveniently forgetting about the economically devastation of the Panic of 1893 and its subsequent depression. These nostalgia pieces were inevitably based on show business themes, especially with the personalities and music from the recently deceased, but once dominant, form known as Vaudeville.

So not only was the Lower East Side famous as the place where the American show business industry was born and where many of its greatest stars were born, but a whole other new entertainment industry was born: motion pictures. As theaters continued to move uptown (*A Trip To Chinatown* opened at the Madison Square Theatre in 1891) the remaining properties around Union Square were taken over by operators specializing in amusing the poor and illiterate immigrant population. Marcus Lowe became a mogul with his string of penny arcades. He was the envy of New York and was imitated by fur manufacturers Adolf Zuckor and William Fox. They were willing to experiment with the penny booths showing hand cranked filmstrips and later nickelodeon theaters. Union Square became the center of the nascent film industry. The engineer W. K. L. Dickson, who actually invented and built Edison's camera (kinetograph), was so soured by Edison's lack of interest in his invention that he founded his own company, the American Mutoscope Company and invented another camera, the Mutograph, which would not infringe on Edison's jealously guarded patents. He decided that the key patent was the sprocket holes and the means by which the film was advanced through the camera. Dickson invented a camera where pins punched holes in unperforated film and advanced the film. American Mutograph and Biograph were established at Broadway and Twelfth Street and in the 1890s they made hundreds of short films per year throughout Lower Manhattan. Parades, public transportation, famous people, if you watch documentaries on A&E or PBS and you see snatches of film about the last decade of the 19th century it is likely that you're watching a piece of America Mutograph and Biograph film, probably shot by Billy Bitzer.

Later, story films were shot in a studio, first on the roof and then in the artificially lighted studio on 14th Street near 5th Avenue where one day an out of work ham actor named D. W. Griffith came in looking for day work followed soon after by Mary Pickford and the Gish sisters. Pickford became the first movie superstar and was hired away by Zuckor. All of this happened around Union Square. Dickson himself left the business in 1897.

The movie industry moved to the more spacious suburbs of the Bronx and Brooklyn and eventually to California but there were more notable Lower East Side films. The other major industry of the Lower East Side, besides show business, was gangsters. *Manhattan Melodrama* (1934) has become famous in film history because it was after attending a performance of *Manhattan Melodrama* at Chicago's Biograph Theatre with a couple of prostitutes that John Dillinger was ambushed. He liked Clark Gable pictures.

Manhattan Melodrama opens with the most important Lower East Side event ever—the General Slocum Disaster. A German-American church of St. Marks hired a steamboat, the General Slocum, to take the congregation and their friends for a

picnic on Long Island Sound. There was a fire, no lifeboats, rotten and useless life vests, and over a thousand died. There is a memorial unavailable to the public at large in Tompkins Square Park. The neighborhood was so traumatized that it moved, en masse, uptown to Yorkville. This is the subject of the first reel of *Manhattan Melodrama* (written by the same Arthur Caesar of *Heart of New York*). Because of the tragedy, two boys will grow up as brothers, with George Sidney as the single father. One turns to the rackets (Clark Gable), the other (William Powell) to the law. Circumstances cause William Powell to prosecute Clark Gable for murder and for Gable to sacrifice himself so Powell can become governor. Now this sounds like some half-assed corny movie plot, but this too is based on a true story.

In the late '40s there was a rare confluence of two parallel post-war film styles, film noir and neorealism, which marked a significant return to New York filmmaking. *The Naked City* (1948) was shot in the streets of New York with the climax shot on the Williamsburg Bridge. The cinematographer, Bill Daniels, shot the film with a gritty immediacy that recalls Helen Levett or Louis Hine. Daniels was Garbo's regular cinematographer and was known for his high glamour MGM style. It's as if Pierre and Gilles had been hired by the Farm Service Agency to go to the dust bowl to shoot as Daniels succeeds in capturing the reality of New York during a summer heat wave magnificently.

What lifts *Naked City* above mere police procedural was the unique post war belief in democratic institutions. The police department and the men who made it up thought of the New Deal as a force for social good. Like many of the post-war films with a Lower East Side background, several of the creative personnel were subsequently blacklisted during the HUAC witch-hunt period. The co-writer of *The Naked City*, Albert Maltz, was one of the Hollywood Ten. (Even Jane Alexander appears as a little girl.) *The Naked City* was later the inspiration for the TV series (1958-1963) which also featured performances by celebrated New York actors and soon to be stars, like James Caan, Robert Duvall, Dustin Hoffman, Robert Redford and others.

The Lower East Side has continued to be a fertile subject for filmmakers. Martin Scorsese has made a string of pictures about the post-war Italian American experience and now there is a steady flow of films about the Chinese American experience. The names change and so too the external mechanics but it has been a pretty identifiable constant in terms of a Lower East Side experience for nearly 200 years. The Lower East Side is the crucible wherein character is formed and identified.

However, there is one era of the Lower East Side which seems to have been deliberately passed over. Call it the Hippie Era, the Summer of Love, the sixties, the American Cultural Revolution, whatever you want to call it, the period had been studiously avoided as if Winston Smith has had at the past and it never ever happened. Interesting.

Max Von Meyerling
"The Bowery"
Music by Percy Gaunt
Lyrics by Charles H. Hoyt

This song was introduced by Harry Conor in the Broadway musical *A Trip to Chinatown* (1892). Although it had nothing to do with the plot of a show set in San Francisco, the number was so popular that it proved to be a major factor in the show's success. This is the lyric as it appears in the original sheet music, published by T. B. Harms & Co. (NYC) in 1892. The entire song is in 3/4 time.

Verse 1
Oh! the night that I struck New York,
I went out for a quiet walk;
Folks who are "on to" the city say,
Better by far that I took Broadway;
But I was out to enjoy the sights,
There was the Bow'ry ablaze with lights;
I had one of the devil's own nights!
I'll never go there anymore.

Refrain
The Bow'ry, the Bow'ry!
They say such things,
And they do strange things
On the Bow'ry! The Bow'ry!
I'll never go there anymore!

Verse 2
I had walk'd but a block or two,
When up came a fellow, and me he knew;
Then a policeman came walking by,
Chased him away, and I asked him why.
"Wasn't he pulling your leg?," said he.
Said I, "He never laid hands on me!"
"Get off the Bow'ry, you Yap!," said he.
I'll never go there anymore.

(Repeat Refrain)

Verse 3
I went into an auction store,
I never saw any thieves before;
First he sold me a pair of socks,
Then said he, "How much for the box?"
Someone said "Two dollars!" I said "Three!"
He emptied the box and gave it to me.
"I sold you the box not the sox," said he,
I'll never go there any more.
(Repeat Refrain)

Verse 4
I went into a concert hall,
I didn't have a good time at all;
Just the minutes that I sat down
Girls began singing, "New Coon in Town,"
I got up mad and spoke out free,
"Somebody put that man out," said she;
A man called a bouncer attended to me,
I'll never go there anymore.

(Repeat Refrain)

Verse 5
I went into a barbershop,
He talk'd till I thought that he'd never stop;
I, cut it short, he misunderstood,
Clipp'd down my hair just as close as he could.
He shaved with a razor that scratched like a pin,
Took off my whiskers and most of my chin;
That was the worst scrape I'd ever been in.
I'll never go there anymore.

(Repeat Refrain)

Verse 6
I struck a place that they called a "dive,"
I was in luck to get out alive;
When the policeman heard of my woes,
Saw my black eye and my batter'd nose,
"You've been held up!," said the copper fly.
"No, sir! But I've been knock'd down," said I;
Then he laugh'd, tho' I could not see why!
I'll never go there anymore!

(Repeat Refrain)

The '60s: Notes on the Underground

by Sandra Koponen

Safe to say that those who found their way to the Lower East Side (LES), or who found themselves there, weren't after the American Dream, the two-car garage, the air-conditioned nightmare or ennui on the installment plan. The predations of McCarthyism not long past, they wanted nothing to do with the Establishment, a government that was promoting militarism and slaughtering innocent Vietnamese. They were the young or young at heart: beatniks, bohemians, leftist intellectuals, anarchists, poets, artists, queers, utopians, all looking for a new way, ready to break taboos, explore new realms and make a different world.

By the '60s the West Village was too expensive for bohemians, and no longer the home of the beats. Allen Ginsberg, Gregory Corso and Jack Kerouac had relocated to the LES. Apartments there could be rented for as little as 30 dollars a month, furnished from street findings in a day, and clothes and food were cheap. It was the post-scarcity age, and people didn't have to work much to live well—why work when you can play? And so they did . . .

A sort of renaissance occurred. There were several places that held poetry readings: the Café Metro on Second Avenue, the Tenth Street Coffeehouse, Ed Sander's Peace Eye Bookstore, Café Les Deux Megots on East 7th Street, and St. Marks Church on the Bowery played a key role in fostering poetry and the arts. For jazz, the hot spots were The Five Spot on St. Marks and the Bowery, where Thelonius Monk could be seen almost any night. There was also Slugs on East 2nd Street, where beers were two for a dollar, and Dolphy, Miles, Mingus and Sun Ra could be seen. (Mingus and Sun Ra also lived on the LES for a time.) The anarchist rock band The Fugs formed in the LES, and The Velvet Underground played at The Dom on St. Marks. Avant-garde musician John Cage had a studio on the LES as did artists Jasper Johns, Robert Rauschenberg, Claus Oldenberg and Yoko Ono. Of course there were galleries and theatres: Theatre of the Ridiculous, La Mama, happenings on the Bowery, the Fluxus gallery, to name a few. Social resistance groups also had a strong presence; Black Panthers were housed in the Christadora on Avenue B and 9th Street, the Diggers had their Free Store on Second Avenue, etc.

As for film, Jonas Mekas had been screening underground films since 1953. He first curated at Gallery

East, a place run by poet/filmmaker Storm de Hirsch, at number 7 Avenue A at First Street. He and filmmakers Ken Jacobs, Jack Smith, and Shirley Clark had all attended the film program at City College run by early avant-garde filmmaker Hans Richter, and were forming friendships and making films. In 1955 Jonas and his brother Adolfas founded *Film Culture*, where Jonas published articles about the new films that were emerging, as he also did in his "Movie Journal" in the *Village Voice* beginning in 1958. However, it was in the early '60s when the underground film scene exploded.

September 28th of 1960, filmmakers called together by Jonas Mekas (then living at 515 E 13th Street) articulated the birth of the New American Cinema. (Jonas Mekas has called himself its midwife.) They cited Robert Frank and Alfred Leslie's *Pull My Daisy* (1958), John Cassavettes' *Shadows* (1957), and Shirley Clark's *The Connection* (1960) as evidence of the new cinema. As most underground films would never be screened in commercial theatres, they recognized a need to support each other and form a film distribution network. They called themselves the New American Cinema Group and proclaimed their commitment to low budget, independently produced films, stating in their manifesto: ". . . we are for art, but not at the expense of life. We don't want false, polished, slick films—we prefer them rough and unpolished, but alive; we don't want rosy films—we want them the color of blood."

The term "underground" can be used broadly to describe films that "involved a rejection of big production values, classical narratives, and all forms of Hollywood professionalism." Under this umbrella, very different types of films emerged. They included documentaries, film diaries, beat films, experimental films, expanded cinema, gay/camp films, psychedelic films, erotic films, structuralist films, animation and satirical comedy. The films varied in length from very short to very long, employed super-8 or 16 mm, or had special projection requirements that precluded many of them from enjoying a wlde audience.

In LES cinema, the roles of director, player/actor, presenter and audience were often intentionally blurred and creatively distorted. The connections between films and theatre companies, poets and social resistance groups were continuous. Consequently, an attempt at a filmographic or chronological description is fairly useless. So here is a list organized and described as:

LES Directors and Stars (not in alphabetical order)

Beat poet/actor **Taylor Mead** has appeared in more underground films of the '60s than any other person, making an average of three films a year since 1960. He hooked up with **Ron Rice** (both LESers at some point in time) in San Francisco and they captured the last of the North Beach beat scene in *The Flower Thief* (1960).

Rice was much inspired by the earlier beat film *Pull My Daisy*, not only for its spirit, but as it appeared to be made simply, spontaneously and cheaply.

The Flower Thief was shot on old black-and-white film stock and the overexposed film gives the images a dreamlike quality. The film shows a lanky, childlike Taylor Mead drifting through San Francisco, most of the time holding a teddy bear, playing with children, going to a wild beat party in an empty abandoned loft with broken windows, sitting at a beat bar in North Beach, riding down a hill in a child's wagon, being chased in slow motion by a curvaceous woman in a bathing suit, tied to a flag pole by two cowboys and strangled by an American flag. The scenes are all

Sandra Koponen and Joe Dallesandro

Sandra Koponen

improvised on the spot. Mead's expressive face and shimmering cantilevered movements lend themselves to comedic mime.

Holding the film together is the soundtrack consisting of a collage of music: jazz, flamenco, classical music (Pictures at an Exhibition, Peter and the Wolf), and blues. Interspersed with the music are stoned poetics: "holy, holy everything, holy, holy methadryne" and sound clips of fifties-style narrators talking about mental hospitals and prisons. The beat commentary on America is apparent in "we're all part of a sick society—troubled members of a troubled world" and in a slightly altered reading of the mad tea party from *Alice in Wonderland*.

Mead recalls that the film was made for no more than a thousand dollars (and bad checks), and about half of the film's budget went for drugs.

Rice and Mead made two other films together, *Chumlum* and *The Queen of Sheba Meets the Atom Man* (1962). Subsequently, Mead appeared in many of the Warhol films, such as *Couch*, *Taylor Mead's Ass*, and *Lonesome Cowboys*. Mead says the fun of the '60s was over when the cheap supply of speed ran out, thanks to the harsh Rockefeller drug laws.

Satirical filmmaker **Robert Downey** also put Taylor Mead's comic ability to good use in *Babo '73* (1964). Jonas Mekas wrote in his *Movie Journal*: "I think Robert Downey is the Lenny Bruce of the New Cinema."

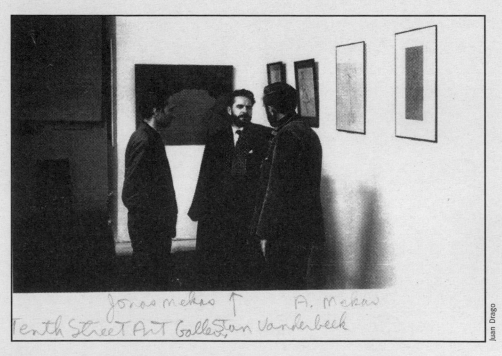

1961

Babo '73 is a political satire with Taylor Mead as president. To film *Babo '73*, Downey and Mead went to Washington to see the President speak, and managed to position Mead in such a way so that it appeared that Mead was on the podium and acting as President. Brendan Gill wrote of *Babo '73* in the *New Yorker*: "The funniest film I've seen in months . . . produced, directed by Robert Downey at a cost . . . of 3,000 dollars. Taylor Mead . . . as the president, looks like a cross between a zombie and kewpie and speaks as if his mind and mouth were full of marsh-mallow . . . "

Other Downey films from the '60s: *Chafed Elbows* (1967), *Putney Swope* (1968).

Jack Smith. Jack Smith often used his films in his performances. In fact, he had a falling out with Jonas Mekas when he wanted to use *Flaming Creatures* for a performance, but as Mekas was afraid he'd cut it up, he refused to give Smith his copy of the film, which enraged Smith. (Jonas managed to get many filmmakers to give him their films for safekeeping.) Those who saw Smith's performances that went on late into the night—which he did on a weekly basis at

MARZANO

Juan Drago

Lloyd Williams and Joe Marzano 1961

his loft and elsewhere—recall emerging from them as if from a dream.

Smith's *Flaming Creatures* (1963) is probably the seminal film from the LES. It was shot on the rooftop of an old Yiddish theater, the Windsor (412 Grand Street), bought by Walter Langsford in the early '60s. The "creatures" are men in drag, women, and men in gauzy ethereal costumes, engaging in erotic acts . . . with humor. It's shot in black and white, which emphasizes the tawdry glamour for which Smith is famous. The title sequence, which appears in the middle of the film, is the funniest title sequence in film history. The titles appear up on a board, and as ridiculous marching band music plays, men in medievalish headgear and Romanesque robes march back and forth in front of the titles.

Apparently the cops who were in attendance at the Bridge Theater at St. Mark's and the Bowery when Mekas screened *Flaming Creatures* in 1963 weren't too amused. Jonas, Ken Jacobs and his wife, Flo, were all arrested for showing a pornographic film. Mekas and Shirley Clark launched a defense of the film, but it was still banned in New York State.

LESer and experimental filmmaker **Ken Jacobs** is not easy to pigeonhole. Mekas has characterized his films from the early '60s as "Baudelairian Cinema."

These include: *Little Stabs at Happiness* (1958–1963), *Star Spangled to Death* (never completed but shown at various stages), and *Blond Cobra* (1962, a collaboration with Bob Fleishner). In *Little Stabs at Happiness*, Jack Smith wears some scraps of colored gel on his head and other found materials that make an odd costume, eating the crotch of a plastic doll and putting a cigarette out on it. The sound track consists of great old exotic records, and lighten the otherwise dark existential aspect of the film, as Jacobs narrates that he never sees any of

these people anymore . . .

In 1966, inspired by the Diggers Free Store and other anti-capitalists, Jacobs founded Millennium Film Workshop as a place where anyone could have access to film workshops and equipment and screen their work. First located at St. Mark's Church on Second Avenue and E 10th Street, Millennium moved to the courthouse at Second Avenue and East 2nd Street, now Anthology Film Archives. He and others converted the old holding cells in the basement to editing rooms, scrubbing them clean of blood and excrement—telltale signs of sadistic guards. Andy Warhol, Jack Smith and others did some editing in those old cells.

Lithuanian-born **Jonas Mekas** wears many hats. Probably most widely known for his championing of underground film, Jonas completed three films of his own in the 1960s: *Guns of the Trees* (1961—an existential, sparse narrative that includes some poetry read by Allen Ginsberg), *The Brig* (1964, film of a Living Theatre production), and *Walden* (1969—aka *Diaries, Notes and Sketches*). Although *Guns of the Trees* and *The Brig* won some acclaim, it was with *Walden* that Jonas found his genre: the film diary.

Calling himself a filmer (not a filmmaker), starting in the '50s Jonas started his film diaries, shooting anywhere from 10 frames to 10 minutes most days. Jonas's statement in *Walden*: "I live, therefore I make home movies—I make home movies, therefore I live," is borne out by the length of his films. (He continues to put together films from things he shot through the '60s and '70s.)

Walden has hand-held, fast-paced, jumpy scenes of weddings, children, the sunrise from a train, a circus, some celebrities like John and Yoko at their bed-in and unknowns through all seasons. Master of in-camera editing, Jonas did not edit the six reels that compose *Walden*. The film has a running time of three hours. Using single-frame techniques and double exposures, the film is visually alive and has an emotional intensity. The joy of vision it conveys is akin to Vertov's *The Man with a Movie Camera*. There is no sync-sound, but a soundtrack of Chopin, readings from his diary, and found sound.

Asked about the reference to Thoreau's Walden, Jonas says, "New York is my Walden." And once asked about the importance of the underground cinema, Jonas replied:

"The importance of the underground cinema is that it's not important at all." A funny statement coming from a man who's devoted his life to the underground cinema, yet it speaks of the lack of pretension in so many of the underground films.

When Jonas was living at 515 East 13th Street, Charles Langsford opened the Charles Theater on Avenue B and 12th Street. In 1961, Jonas began scheduling weekend midnight screenings of underground films there. LES filmmakers Ken Jacobs, Jack Smith, Ron Rice, Robert Downey, and Paul Morrissey had premiers there. Many of these screenings drew large crowds, even the critics from uptown, as there wasn't anything too refreshing coming out of Hollywood. The screenings at the Charles helped to put the underground on the map. In addition, Jonas proposed that Wednesday night be open for anyone who wished to screen a film—as long as someone brought a can of film to screen, the $1.50 admission was waived. Filmmakers would come with works in progress and show

films fresh from the lab. Ken Jacobs showed his *Little Stabs at Happiness* at a Wednesday night screening. As he hadn't put the soundtrack on it yet, he just brought some great old exotic records and popped them on the record player. These open screenings helped to promote the idea that filmmaking needn't be a big production. It also allowed for audience/presenter/performer interaction. Actors and filmmakers got immediate gratification seeing their work on the big screen right away, so the process of filmmaking wasn't at all stagnant.

Filmmaker, media artist, sculptor, activist, **Aldo Tambellini** opened up The Gate theatre at Second Avenue and E 10th Street in 1966. The Gate showed underground films (e.g., Stan Brakhage, Robert Downey, Jack Smith, etc.) on a daily basis from one p.m. until midnight. Admission was a $1.50. Tambellini recounts that Jack Smith upset a student projectionist when he insisted on editing one of the films as the film was being projected as part of one of his performances.

In 1967, Tambellini opened the Black Gate, just above the Gate. The Black Gate was a gathering place for black poets Ishmael Reed and others, and on Saturdays it was overtaken by the drag theater group The Theatre of the Ridiculous, which performed until 3:30 in the morning. It also served as a venue for multimedia performance and the "electro-media" theater. Black velvet cushions were on the floor and film and video projected on the ceiling or anywhere anyone happened to point the projector. The Gate was an important place as it was open to all people—even the Hare Krishnas had an event there.

Tambellini began making films in the '60s, first painting on films and later doing "intermedia" environments with glass slides, film and sculpture. He actively opposed the Vietnam War, staging marches with coffins as props.

The Gate remained open until the rents were hiked in 1969.

Emil de Antonio lived on East 6th Street. He contributed to underground films in many ways: He distributed *Pull My Daisy*, was on the board of the New American Cinema Group, and starred in Andy Warhol's *Drink* (1965—would have made a trilogy with *Eat* and *Sleep*, but when De saw the 70 minutes of film, shot after he had consumed a quart of whiskey in 20 minutes, he vowed to sue Warhol if the footage was ever screened). Quite a bon vivant, it must be stated that he made the most important documentaries in U.S. history.

His film *Rush to Judgment* (1967), made with Mark Lane, the lawyer hired to defend the deceased Lee Harvey Oswald, is a grave indictment of the Warren Commission's official report about the Kennedy assassination. In 1965, de Antonio went to Dallas with Mark Lane to film those witnesses to the Kennedy assassination who hadn't died in a suspicious manner, disappeared, or been frightened by the warnings and intimidation from the FBI and Secret Service.

Other de Antonio films from the '60s:

Point of Order (1963, a damning portrait of Joseph McCarthy), *In the Year of the Pig* (1967, about the Vietnam War).

Poet/filmmaker/performer **Piero Heliczer** lived on Ludlow Street for a time, though it is rumored that he lived in the New York subways—literally an underground character! His obituary in the the *New York Times* describes him as a renaissance man extraordinaire: multi-lingual, a poet, an accomplished musician, a playwright, actor and filmmaker. He started the Dead Language Press which featured Gregory Corso, Olivia de Haulleville and Angus MacLise. He acting career included de Sica's *The Bicycle Thief* (a child extra), *Flaming Creatures*, and Andy Warhol's *Screen Test* and *Couch*. He was close with Warhol superstar and assistant/poet/filmmaker **Gerard Malanga** (also a LESer), and Malanga and many from the Warhol crowd appeared in Heliczer's films. He did performances that included music with his films, as in Last Rites, where film is blessed amidst incense and candles and the live music of the Velvet Underground.

His films employed multiple super-impositions, split-screen and surreal jump cut effects. *Dirt* (1967) stars Jack Smith as God and includes Warhol, Ginsberg, and other underground luminaries.

Videographer/media activist **DeeDee Halleck** started out as a beatnik on the Lower East Side in the early '60s, and taught Puerto Rican kids how to make films at the Henry Street Settlement. This experience was the beginning of her career empowering others to make their own media. She went on to work with Robert Frank and Shirley Clark before founding Paper Tiger Television (low-tech productions that question and critique the mainstream media) and Deep Dish Network (distributor of leftist and political documentaries).

Superstars of Warhol's *Trash* (1969), gay icon **Joe Dallesandro** and transvestite **Holly Woodlawn** both spent time on the LES, Dallesandro on East 10th Street and East 6th, and Holly on East 3rd. *Trash* was filmed in a basement on East 6th Street. The characters they portray in *Trash* weren't far from their reality, as Dallesandro was a notorious junkie and Holly Woodlawn was living on welfare checks. Although *Trash* grossed millions at cult midnight screenings, the actors were paid a pittance.

Deserving Mention:
Don Snyder—producer of psychedelic light shows.

Barbara Rubin—filmmaker of *Christmas on Earth,* experimental/erotic film.

Scotch and Kodak; After Hours:

A Look at Rafic

by Tom Jarmusch

Rafic Azzouni was most widely known as the owner of RAFIK, his Film and Video supply and editing store, at 814 Broadway. But this is only a small part of his story. From sometime in the late 1960s until his death early in 1999, Rafic Azzouni played a very significant and rarely acknowledged role in the world of New York underground movies. This article is intended to recall the man, and to suggest the history with, and around him.

Rafic S. Azzouni was born in Jaffa, Palestine on the 12th of October, 1941. His father's name was Subhi Suleiman Azzouni, and his mother was named Rifka Khorsheed. Rafic's family was Muslim, although not especially devout. They had owned a lot of land and orchards in Jaffa. When the war began in 1948 Rafic was seven years old, and his family was part of the Palestinian exodus. Rafic went with his mother, and his infant brother, Anees, to Lebanon. They probably traveled on the back of a truck. His father, Subhi Azzouni joined them a little later, coming from Jericho. Besides Anees, Rafic has one other brother, David born in Lebanon in 1949.

Growing up in Lebanon, Rafic mostly attended boarding school. As a child Rafic was very creative and artistic. He was very well liked by his peers and by his teachers. When he was a teenager he wore the latest fashions, and was very popular with girls. If you were a boy and wanted to meet the girls, you became one of Rafic's friends.

In 1960 or 1961, Rafic went to see his father for six months in Saudi Arabia. Because of his Palestinian refugee status he was unable to work or stay. Soon after, an uncle offered to pay for his travel and for further education in the United States. In 1961, at the age of 19 Rafic came to New York City on a ship, and never would return to the Middle East. For approximately three years Rafic lived with his uncle, Nasouh Azzouni, and cousins in Brooklyn, and studied. Rafic was very interested in art, and he clashed with another uncle, Adel Azouni, about his education. Some of the family wanted Rafic to have a respectable and reliable career. Some time early in his stay, Rafic became a member of the Palestinian Students League. This group was informative, and at this time the subject was not so controversial. Another uncle, Omar Azzouni worked at the United Nations and was a public advocate for Palestinians. Rafic was very interested in this uncle.

In 1964 or 1965 Rafic disappeared completely from the family for almost ten years, until 1974. This was probably because of problems with immigrations, and because of his desire to pursue the arts and lead the kind of life he wanted. Through the years Rafic used different names, partly to protect his identity. Even since he died, there's been confusion with his name, often with his first name being spelled with a "k" at the end, like the name

of the store (RAFIK), or people would think his name was Raffe Azzouny. There has probably been some other spellings as well. Also he often referred to himself as Lebanese, since he had grown up there, but not always. He seemed to enjoy the mystery and confusion.

It's not clear, when or how Rafic became interested in filmmaking. Rafic was a filmmaker himself, and made several films in the late '60s and early '70s including THE ROOM, film documentation of Jack Smith's SECRET OF RENTED ISLAND, and others. He was briefly a member of the Millennium Film Workshop. Probably around 1970 Rafic began selling 16mm film, primarily short-ends, selling at unusual hours, and sometimes delivering the film stock.

Soon after this, Rafic became one of the original founders of the U-P Film Group located at 814 Broadway, where he had part of a fourth floor walk up loft. The U-P Film Group worked like a collective. Members contributed either a piece of equipment or money, making filmmaking accessible and inexpensive. U-P also had film screenings and performances. These events included work by David Vadehra, Jerry Tartaglia, Jack Smith, Rafic, Andrew Noren, Don Snyder, and probably others associated with the psychedelic movement.

Some time in the mid to late 70s the U-P film group dissolved. In its place the O-P screening room began. The U-P and O-P screening situations were quite significant. Screenings were sometimes programmed, sometimes open, or booked by the artist. U-P and O-P was not dogmatic, and were open to any artists, to the trained or not, abstract or narrative, performance, dance and slide shows. There were no rules and no criteria. At this time sound Super 8 became available, (video was still largely out of reach). O-P encouraged more novice filmmakers. Some of the artists who typically showed at O-P included: Jack Smith, Charlie Ahearn, Amos Poe, Nan Goldin, Vivienne Dick, Scott and Beth B, James Nares, Nick Zedd, Jacob Burchardt, and Sara Driver. One might see French-Algerian dance, or Jack Smith un-spooling the entire length of NORMAL LOVE onto the floor as he showed it, or Charlie Ahearn projecting early hip hop slides with Fab Five Freddy rapping over the mic, or Nan Goldin and her friend Butch reading a story with slides, or Windsor McKay's 1918 animated THE SINKING OF THE LUSITANIA with an Ave Maria soundtrack. Rafic might show Jean Genet's Un Chant D'Amour, old newsreels, or Nosferatu, or it might be somebody's Super 8 feature. Parties, and hanging out were also a big part of O-P.

Sometime around 1977 Rafic's immigration status was resolved when his uncles found him a lawyer. Also near this time his brothers David and Anees gave him some money, and this was really the beginning of the store. By the early '80s the store was taking off. Its hallmark, not surprisingly, was accessibility to the very low budget film or media maker. It included a very complete line of supplies like cotton editing gloves, fake blood, breakaway bottles, military surplus film, film editing and later inexpensive cuts only video editing, (for fifteen dollars an hour with an editor), as well as access to editing rooms at night and weekends. Rafic was extremely generous, reducing prices for some customers, giving away film stock sometimes, teaching Phoebe Legere video editing for free, lending his Frezzolini sound 16mm camera to Nick Zedd for his first feature, donating video duplication to Casandra Stark Mele for compilation videos she sent to artists in Sarajevo. All sorts of work was generated in the store, either in the editing suites or in the video duplication, from Rockefeller home movies, to countless videos for dancers and dance groups, to Richard Kern self distributed movies, to how-to industrials for dentists, Robin Byrd cable shows, which doesn't even begin to describe the variety.

Rafic was also known for his Thanksgiving dinners, for people who couldn't go home or didn't want to, with a mix of known and unknown artists and workers from the store. The evening usually included a projected movie. He also hosted canoe trips, (usually resulting in somebody falling in the river), and other outings in his old van. He was a lover of practical jokes. Rafic always had a mix of people around him, was always making things possible, allowing things to happen, encouraging creativity. After the O-P screening room faded he still went to screenings, going to some of Tessa Hughes-Freeland and Ela Troyano's Downtown Film Festivals, and showing one of his films, or appearing occasionally in friend's movies, such as Phil Hartman's feature NO PICNIC or Ida Applebroog and Beth B's video BELLADONNA.

But also Rafic could be tricky to know. He could drink a lot or too much, smoke a lot, could have an incredible temper, especially at the store. We don't know how many movies he made, or why he apparently stopped, but his passion and creativity just went out in all these direc-

Rafic store Archives

tions, giving so much. Art should always be so generous.

I worked at RAFIK in the mid '80s, and got to know him a little more later. In a way, working for Rafic was a rite of passage. The following are excerpts of conversations I had with artists, filmmakers, friends, and family about Rafic. Together, they make a portrait of Rafic.

CASANDRA STARK MELE, filmmaker, writer
I don't think he cared about the divisions. He tried to give everybody the same, you know he just believed in film, independent film, which at the time was underground film, very small projects. He liked knowing personally what you were working on, the way he'd acknowledge you when you came in to make dubs or buy stuff. He'd always ask what you were doing, what you were working on. It gave to me, it gave it dignity, that what we were doing was worthy of his respect and attention.

DAVID AZZOUNI, brother, former airline executive, businessman
He was very naughty at home, so my mother couldn't handle him at all. She thought he would get discipline if he went to a boarding school. He was very naughty at school. He was fired from school many times, but he was very, very liked by his teachers and they would always accept him back.

TOM OTTERNESS, sculptor
I first remember going there before I knew Rafic , going there in the early '70s when he showed film up at U-P, and these odd kind of broken down chairs, and dark theater and 16mm projections. It was almost like a filmmaker speakeasy or something, you know like just five people might show up, or you might show up and sleep on the couch while the film's going. I don't know, it seemed very different than anything else that I knew of around then.

BENTON—C (BAINBRIDGE), movie maker, former employee
I think Rafic was around for so long, at such a central point, that like it's a shame that no one really got his stories, but I'm not sure he really would've told so many stories. Rafic was pretty discreet actually. He was, I think he was always open to listening, but when I really think about it, he didn't really divulge too much. I mean if you asked him about something specific, or you asked about the screenings, or about the people who'd come through, he would tell you, he wouldn't hide anything, but he really seemed more interested in the present, and much more interested in listening.

JIM JARMUSCH, filmmaker
I worked for a few months one summer with Robert Cooney and Jorge Mendez doing construction. Rafic was expanding, and he had a new loft in the adjoining building. The funny thing is he wanted at least three doors in each room because he said, I'm Palestinian. I like to have a lot of doors because you never know what's going to happen. So he liked to have a lot of doors. We built one big room and two smaller rooms. You could exit through the front door of either building, and then there were a lot of doors connecting in different ways. You could go back and forth in a lot of doors, sort of like a labyrinth. I remember Robert Cooney saying, Rafic are you sure you need all these doors, you know, you don't need three doors, I think you only need two. And Rafic was like no, no, no I want three doors. You're lucky I don't ask for four.

NILE SOUTHERN, writer, filmmaker,

I don't know how many people had sex in those rooms, or what all was happening. There'd be these people you'd be encountering, like in that room which had no window, that was in between the suites, which was always kind of a weird scene really late at night, if somebody was actually in there. I remember sleeping in all those rooms, except for that one, you know, and having people in the room sometimes, sleeping or whatever. Of course people have done all kinds of projects there.

JODY AZZOUNI, cousin, fiction writer, philosopher
I remember this very tall person who would baby sit us occasionally. But I do know he was into painting, and initially when he showed up, his uncles, my father and another uncle, he was going to school and they wanted him to go to school for chemistry, or engineering, or something like that. He was doing painting all the time and I remember lots of little paintings in his room.

PENNY ARCADE, performance artist
I didn't really know him well. I knew him like as well as I ever did, you know I never got to know him more. It's funny because I'm really fascinated by him. He told me a lot of stories about the early '60s, and when he first came to New York, and his involvement. He was like so idealistic about art, and about the possibilities of transforming, if not the world, the world around you. I really loved Rafic a lot.

Rafic

LUC SANTE, writer
I went on one of his famous car trips once. He would do like a Fresh Air Fund thing for Lower East Side artists, and he would take people in his van on these exotic trips. I can remember going to Suffern, New York to look for some sauerkraut juice. We ate at that Japanese steakhouse, reassembled on a hillside over the thruway. And the sauerkraut juice was just like such a Rafic thing. I mean, I don't know, there was something that was quixotic and sort of semi-slapstick in his personality.

MINDY WYATT, former employee, owner RAFIK DIGITPOST
Rafic always wanted to make sure that everybody got to work on time. When I picked up the phones I wasn't sure where he was calling from, he had the phones rigged to look like he was in his office, in the hidden room under the stairs. But then I heard birds all the time, chirping in the background. I thought he was playing a joke on me, playing a tape recorder, you know, with birds in the background, because I have a good sense of humor. I finally asked him one day, Rafic, do you have birds? And he said, oh Mindy why

do you ask? You hear them, you finally hear the birds. And I was like what are these birds, they must be very small. They were canaries or something, you know, he had a few of them. One day I didn't hear the birds anymore when he was calling, and I go what happened? And he goes, oh I set them free, they needed to be free. I go, Rafic you set canaries free in the New York trees just like that. Oh I just put them on the fire escape, you know. Bad Rafic.

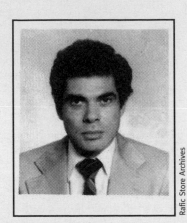

Rafic Store Archives

Rafic

RICHARD KERN, photographer, filmmaker
I remember he always hired cute girls. He hired Lung Leg. She got fired because she was such a bad worker.

PHOEBE LEGERE, musician, artist, video/filmmaker
Rafic loved women, and he always had a lot of beautiful young girls around him, working for him. But it's interesting because although he loved women, I was never really aware of him having affairs, or having sex with anybody.

ROBERT FRANK, filmmaker, photographer
He was a very happy man, but also he was very sad somewhere. He was very careful to show you the happy side, so he was very good with the parties, you know, and get all these people together that he knew. He was just truly, truly for the people to have a good time, have good food. He was very sentimental too. I went once to his house up to St. Marks Place, he had an apartment there. It was small and kind of dark. It had no comfort, you know, it had nothing fancy, nothing, I mean the minimal stuff, but I think his life was really out there with the people and his shop.

AMOS POE, filmmaker
I think what it was, was that Rafic was, you know, sort of an interesting conduit between this sort of underground, and kind of Lower East Side experimental filmmaking of the '60s, early '70s, and this sort of new narrative filmmaking, sort of you know, No New York, no budget filmmaking of like the late '70s, early '80s. He was the bridge.

BETH B, filmmaker
The first time I really ever came across Jack Smith, I remember it was really a great night, because Jack of course showed up hours late, you know, and everybody's waiting, waiting, and nothing's happening, and nothing's happening, and finally he arrived. He's doing it all live and it was like showing a film, but it's all live and all the music was live, and he brought records and he was playing them. It was just a totally different energy. So I think it was the uniqueness of, and the relaxed atmosphere that Rafic brought to the space. There might be a performance, there might be a film screening, or people might just hang out and talk. I think that was so much Rafic's personality, of just not having boundaries, that was what made it so special.

JODY AZZOUNI
I think this is connected to his politics in some way. You know he had a social vision of how things were supposed to go. But again I never got a lot of details about it. I remember one conversation when I was 15 with him and his brother (Anees), where he was laying out this utopian vision of how we would all be able to get along.

JACOB BURKHARDT, filmmaker
He had this Graflex projector, and I saw my film coming out the back of the projector split down the middle, you know it was 16mm film split down the middle. We were about 10 feet into the movie and I saw what was going on and we stopped it, and oh shit.

NICK ZEDD, filmmaker
I was showing The Bogus Man on the weekends, I'm trying to remember. I think I mentioned there's this place, the Mudd Club, I thought it would be good if we showed movies there. And then he says, all right lets just go there now. And I go, I don't know if they have a projector, and he goes, we'll just bring mine. I thought it was cool he was that spontaneous. When we got to the door they didn't want to let us in. They had a rope there. Then we did get in and we were walking around the place looking around, and it's pretty boring and there's nothing going on. So we go upstairs and that dude that ran it, what was his name, Steve Moss, I was like, we brought this movie to show, and he's like, oh that's not permissible. Fucking asshole.

BRIAN BURCHILL
One time there was something going on at O-P, I can't recall what, but then there was a party afterwards, and Rafic was in the projection room, and I guess he decided to double screen two films at once onto the one screen. One of the films was a porn film, which had some scenes of a dog and a woman together. I can't recall what the other film was, but it was something innocuous, like a tiger fighting a lion or something. Some of the women who were there were offended by this, specifically Maggie Smith from Tin Pan Alley, not to foist blame on anybody, and a couple of the other people who were there, were offended. Now that I look back on it, if Andy Warhol had been doing it, somebody would have said, oh genius. There was something about Rafic, when I describe him as being someone who didn't force himself upon you, there was a side to him where sometimes people take a little advantage. A lot of these women who were offended wrote him off, and started to give him a really hard time. Every time Rafic would come into the bar (Tin Pan Alley) after that, the people who worked there wouldn't talk to him. It was very disappointing, I just thought it was a really bad way to treat him.

TOM OTTERMAN
He was a little like that Wizard Of Oz, kind of on the side character, that would cook things up, you know and they would happen and he wouldn't quite be there. You know, it was really part of his style, you know raise the eyebrows, after it was done, and say, yeah nice, huh?

CHARLIE AHEARN, filmmaker
I remember showing a film I made, TWINS, this is Spring or June 1979. I came about an hour ahead of time to set up for my screening, and the front door was locked and I called the number and no one answered. There was like a large crowd starting to congregate on the sidewalk, and I kept telling people I don't know what's going on. So finally, I jumped up on the fire escape and climbed up to the top floor, and I opened the window and walked through to the back, and Rafic was asleep. That's a typical Rafic story.

M. HENRY JONES, animator, 3D photographer
It was interesting, that he made available so many supplies and stuff, that you really wouldn't have to go to the film center area, he made it more accessible, that made it a lot more possible for people that didn't go to film school to make films, to actually go through A and B rolling and everything, to do the Super 8 with the sound, and everything. He was, with the videotape, it was crazy all the stuff he would provide, the transfers, the film to tape, you know, that would've been a critical thing for a lot of people, taking the Super 8 film and turning it into videotape, so they could get the distribution, and they could do the presentations. A lot of people would shoot on Super 8, and that was a pretty heavy deal. I really loved to buy the pre-blacked tapes, those 3/4 u-matic tapes, and you could buy it from him so that when you went to your edit session, that was always exciting, you know, you have these cool RAFIK tapes and walk in, you could get real busy. He always had the sharpies, and the grease

pencils, and the lens cleaner and all that stuff you wouldn't think was important, but like a yellow grease pencil can be a real good friend when you're editing.

CLAYTON PATTERSON, video artist, photographer
The other great thing about RAFIK was walking up the stairs, the really tall stairs. You know, you'd come in and you'd have these old rickety stairs, you'd walk up and they'd creak, you know, that's the other thing I didn't do, I didn't photograph the stairs, or make a videotape going up the stairs, because the stairs were classic old New York City. The big heavy door you had to pull open. And then the old rickety elevator, and the elevator guy, I wish I could remember his name, Mario. I'd always see Mario.

PEGGY GORMLEY, actress, writer, producer
You know, that whole group of people that Rafic was involved with, and Jerry (Tartaglia), and myself, very peripherally through Jerry, were sort of the original avant -garde filmmakers in New York, Storm De Hirsch, they were all part of the Warhol crowd, you know, but on the film-making side, and on the art film side of it. They were really interesting people, very Bohemian, you know, I think people imitated who they really were in later generations. There was this drag queen, Frances Francine, but these were the originals, and Rafic was involved with these people. His spirit was very similar to that, it was definitely an outsider, sort of devilish humor. There was a great innocence to Rafic, and a sweetness, and that was true of all those people. There was complete lack of political correctness. They were funny people, and really rebellious, and really had a revolutionary spirit. And I think he was like that.

JOHNATHON GILES (NAVAL CASSIDY), video artist, former employee
I had locked myself out of the studio when I went to the bathroom. I blew my whole nights work, basically sleeping in the studio next door, which for some reason wasn't locked. So there was this little knock on the door, and I opened and I saw them, but it didn't actually register, so I closed the door, and then I opened it again, and got really scared. For some reason Rafic really liked this. I think it was the nicest thing I ever did for him. He talked about it for years. Do you remember, when I was with, I forget who she was, and we knocked on the door, and you looked at us, and you closed the door, and then you opened the door and yelled. Do you remember that? You had the funniest face.

CHARLIE AHEARN
There was a little card like a postcard that pointed up, and said U-P. When he changed the name to O-P, he just took a pencil and put it over the U, and made O-P screening.

JACOB BURKHARDT
I remember asking, why was it U-P before and it's O-P now? He said it became closed. It wasn't a collective anymore.

RASCID KERDOUCHE, filmmaker
Every time I stopped by we were talking about what was going on in the Middle East, because I'm a Berber from North Africa, we were always talking. When I did my second film I went to see him. He said I give you this gift. It was a tape that was from British studios, something like this, it was the story of the Irish people, where they were coming from, their origins from some place in Egypt, centuries ago. They stopped by in North Africa, which at the time was a Berber place, a lot about tattoos, dancing, stuff like that. So he gave me this three hour tape. He was a real nice guy.

DAVID AZZOUNI
One very big happening, happened I think, in 1979, I took my mother, whom he had not seen since 1961 really, to New York. That was really a very, very big thing because he really loved his mother, I think.

HARRY DRUZD, painter
After he fired me, I would actually drive his van around a lot, run errands for him, here and there, go out drinking with him. It was then that he had told me he had been a boy scout in Lebanon. I had actually been a boy scout here in New York. So we would tell each other stories about camping trips. He told me that's where he learned to do a lot of cooking.

NINA SHAKA, former employee
When I first came to work, the first thing I did was look at all the prices. He was selling everything below the cost. I went over his prices with him, it was very funny. Film stock he was selling for less than he was buying it. Rafic had a really sheepish grin and just laughed. He said maybe we should start having a free box, and he was half serious.

SUZANNE FLETCHER, actor
It seemed like basically he would hire anybody who needed a job, whether he needed the workers or not. He was so generous that way.

DON SNYDER, photographer, filmmaker
I knew him in the mid '60s, when new technology came along. Rafic would help you understand it and make it affordable; you didn't need much capital, a lot of capital. I did these light shows but not disco, not electronic, but light shows, multiple projections, slides and projections, other projections.

HOWARD GUTTENPLAN, filmmaker, photographer, director of Millennium Film Workshop
It was great talking to them at these parties. He would have lots of turkey, and food, and a little drink, and he'd get a little drunk. It was very pleasant; I'd look forward to these events. I used to go almost every year, for several years.

RICHARD PORTA, multimedia artist, former employee
Rafic was a big fan of practical jokes and he used to like to, if you were opening up the store in the morning, shut off all the lights and make believe he wasn't there, and hide behind one of the counters and as you're walking around quietly having your cup of coffee and maybe your first cigarette in the morning, thinking you have the place to yourself, he would all of a sudden grab you ankle and give it a good yank, and absolutely scare the living shit out of you. And then he would laugh hysterically, in that big Rafic laugh.

TESSA HUGHES-FREELAND, filmmaker
And then he had that other place, the

Rafic at work filming

Rafic Store Archives

second place on Lafayette Street (Fourth Avenue) and he was robbed sometime. He was so generous right. This is when he started to be a little more careful, I think. Somebody robbed him and took like two editing suites, but then again he didn't seem to mind, he said, oh well, you know.

BILL RICE, painter, actor, writer
Yeah sure I knew Rafic, You know I liked him a lot, he was a strange guy. I met him through Scott and Beth. You know he was the only one to go to back in those days, if you wanted to have your film screened.

M. M. SERRA, filmmaker, director of the filmmaker's co op
I never thought that Rafic was ill, he never gave any indication of his health. I always thought that to keep the business alive, it was very stressful. But it was the type of thing you did twenty four hours a day, and seven days a week. It was like a devotion.

RICHARD PORTA
I think those beliefs and principles, really, uh, were part of the store, a couple of times he did express to me you know, the fact that the store wasn't so much a money making thing, but we really do want to help people, we really want to make it possible for them to make their films, and then he laughed really hard.

TIM BURNS, filmmaker, artist
Rafik, the Lebanese trader, basically kept the independent film movement alive in New York, really, in a way, I worked on building the edit rooms up there. I mean he was always giving us jobs. One of the things about New York is, the artist kind of gives money to the other artist, kind of coming up. I used these rooms a lot doing karaokes and music videos and Robin Byrd was in the room next to me and she used to kick the wall and stuff. I didn't have cable TV and I didn't know who she was. This sort of blonde in cowboy boots, sort of bash and crash on the wall, and eventually she stuck her boot through the wall. A couple of times we went out and got stuck in it, boy I tell you, where we just kind of staggered out in the street.

JERRY TARTAGLIA, filmmaker, U-P film group member
I miss him terribly, actually.

CASANDRA STAK MELE
I saw him outside the window, I think it was at a falafel place, and shortly after that I heard that he'd died. I don't know I thought it was him, but he would have been dead. I think it's different going in there now without his presence, I'm glad they kept it going.
.

PHOEBE LEGERE
Rafic always said, talent is all in the eyebrows.

MARGARET COLLINS, ex-xray technician, activist
The only thing I can remember, Hello my name is Rafic. It means friend.

Thank you very much to everyone I spoke with about Rafic. A very special thank you to David Azzouni, and Jody Azzouni, and Mindy Wyatt. Unfortunately it wasn't possible to include everyone. And thank you Rafic.

Contact: Tom Jarmusch
212-941-8166
jarmuschtom@hotmail.com

Ginsberg at Home

by Bob Rosenthal July 10, 2003

I worked for many years inside Allen Ginsberg's house. His house was on the Lower East Side. He might have lived in Cherry Valley, New York, or Boulder, Colorado, but he always maintained his home base on the streets that are East and range in the numbers between 2 and 13. I don't recall him ever exclaiming his love for the Lower East Side yet it was evident in the way he lived his life. He was often offered free vacations in exotic, remote, utterly beautiful spots on the globe, which he declined. He loved to spend his few free days in the Lower East Side. It suited him to live simply; his Salvation Army furniture looked good in his East 12th Street dump. He made improvements like putting polyurethane on the floor and making kitchen cabinets, but he didn't make the luxury improvements that alter the true tenement out of utility. Allen lived his life as an open book. He put his world into his poems and of course was tops at putting his poems into the world. I think Allen loved the freedom of expression offered by a cheap neighborhood where nobody cared who you were. He needed strange characters to drop by at all times of day. He always fed people. He made soup. He shopped up and down First Avenue. When *Life* magazine asked him what he thought the meaning of life was, he contributed a photograph taken out his kitchen window with a tree of heaven and the back buildings along Avenue A (including the back building where Ed Sanders had once mimeographed *Fuck You: A Magazine of the Arts*). The meaning of life is the life you live. Through his welcoming nature, Allen has animated his neighborhood in writing and in film.

Pull My Daisy (1958), directed by Robert Frank and Alfred Leslie, was based on a Kerouac story about an incident in Neal and Carolyn Cassady's life. The film is set on the Bowery and is the most cinematic film Allen ever participated in. The story is about a visiting bishop and a burdened wife and mother with a rascal husband and his goofy friends. The bishop comes and her desire for respectability is shattered by the antics of Allen and Gregory Corso and Peter Orlofsky. They pester the bishop with essential questions on the nature of holiness. Larry Rivers plays the Neal character and Alice Neel plays the piano. Robert Frank's son, Pablo, is the boy. Kerouac's spontaneous narration is perfect. The Lower East Side is where life can both defeat and exhilarate at the same time—no harm done!

The Orlofsky brothers fascinated Robert Frank. Peter lived with Allen. He was sweet and giving and humorously maniacal. But Peter's brother, Julius, was the catatonic deep communicator. His face was ageless: never young, never old. In 1966, Robert Frank made a full-length feature centered on Julius. It's an early example of personal film. Allen is now a successful poet. Peter is now writing poems. Julius stays contained within himself as the film meanders its black and white Lower East Side world. Near the end of the film, Julius addresses the camera and delivers a stunning monologue.

In the late 1960s, Allen had expanded his interests beyond poetry to the expansion of democratic mindfulness to the global body politic. There was the Vietnam War to end. He had come back from India and was chanting mantra to bring change to the war mind. Allen participated in countless documentaries. Whether someone was making a full film on Allen or needed to interview him on their topic, Allen graciously allowed film crews into his apartment. I learned that filmmakers like outlets and circuit breakers. I scheduled Allen's time while the filmmakers set up their angles and lights. Allen was often shot in his small bedroom. The logical camera angle is through the door. Allen is cross-legged on his bright South American quilt. A bright Buddhist Thanka is behind him. Allen was a master of the interview form. He could find the Bodhisattva (little Buddha) in everyone and spoke to that Bodhisattva. He could look into the camera and his open eyes would offer a dark light illumination to

Clayton Patterson

Allen Ginsberg

his words. Allen was so well grounded: his bed, his room, his apartment, his street, his city, his country, his world, and his star! The inert camera was now a tool of the subject. Allen learned to reach through the camera to Whitmanically caress the viewer.

Many films were never finished. Weeks after I started to work for Allen, the poet Harris Schiff and a partner spent a week in Allen's apartment and going around with him through the city. Allen was very tolerant of this "fly on the wall" style of documentation. He could forget the camera as he did intimate things in his routine and go into the next room where there is a young man, looking confused, not knowing whether he is supposed to ignore the camera or play to it. Allen fixes this by introducing the lad to the camera and explaining who he is. Then the camera is forgotten again and they do what they do. That film lies in a trunk in Brooklyn. Allen himself was a photographer; he had an excellent sense of framing. He used his deep spiritual connectiveness to create portraits. The subject is looking at its deep friend, Allen. Allen would work with his filmmaker friends because they were his friends and not because he felt an affinity with their style. Allen was not avant-garde, he was transparently honest and grossly revealing. No one could out *out* Allen.

Friend filmmakers and friends like Bob Dylan (*Renaldo and Clara*), Nam June Paik (*Allan 'N" Allen's Compliant*), Jacob Burckhardt (*It Don't Pay To Be An Honest Citizen*), Morley Markson (*Growing Up in America*, 1988), Simon Albury (*It Was Twenty years Ago*, 1987), included Allen. In 1977, Bob Dylan's film crew came to a party in Allen's 12th Street apartment. I don't recall if the scene made the film (seldom was a film buried that quickly), but there are stills of Denise Mercedes (Stimulators) playing guitar for Dylan with Roger Mcguinn, Ratso, and others crowding around in Allen's tiny bedroom. The cracked plaster, the ancient window sash, the molding on the wall whitewashed so many times it is shapeless, are the indelible signs of the Lower East Side dump.

In 1987, the Sony Corporation and Kiki Miyake gave Allen an 8 mm video camera with the condition that he create a half hour film that they could show. Allen's office, which included myself, Victoria Smart, and Vicki Stanbury, was located off the kitchen in the 12th Street apartment. Steven Taylor was staying over. Julius Orlofsky was also staying over. Peter Orlofsky was in the next-door apartment and Harry Smith was living on the Bowery but coming over to Allen's often to work on his recordings, etc. It was a full and busy household. Allen started filming around him. I don't know if he formulated a shooting plan or not but the rules seemed to be three: Allen took all the tape except for when he handed the camera to someone. Allen

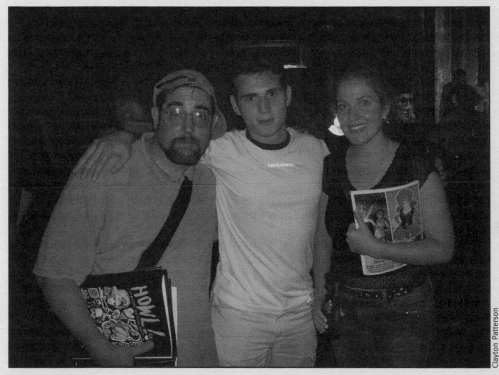

Clayton Patterson

Bob Rosenthal

did not narrate—he only spoke to other people, the camera never left the apartment—it could look out the window but could not go beyond. The video has been only shown once and to whom—I don't know. The original is at Stanford University.

Household Affairs opens in silence with Allen's hand penning the title onto a hot red background. He writes, "1987" and "edited by Steven Taylor" and then slowly draws an all seeing eye to finish the credits. Allen shot for many months but much of this first-time user's material was "too shaky" to use. The first shot is through the kitchen window. It is the same window of which Allen took thousands of still pictures. The first sound is the shrill calls of a blue jay. It reminds me of the crows ending "Kaddish" with their caws. The tree of heaven is leafed out and the *New York Times* is on the windowsill. Julius Orlofsky is the central character. He is visiting for a couple months. Julius prepares food. Allen emerges as a major Yenta (Archetypal Jewish Mother). "Allen, will you look at me?" Julius asks, "Smile?" Allen laughs, "OK." The kitchen window breaks the scenes. The *Times* headlines, although not legible, obviously do change. Julius is sitting at the kitchen table, cigarette lit, coffee poured and he looks down, distracted. Allen asks if Julius would like to get a simple job and live independently. "I don't think so Allen." Allen keeps at Julius "What was that last place you lived like?" "Just like here in a way," Julius replies.

Julius asks Allen how long he's lived on 12th Street. Allen says he moved in 1975. It is now 1987, neither one can do the math. Julius checks the *New York Times* for the exact date (November 10th). Allen asks Julius to read out the headlines. "They're all the same." Julius is the master of generalization. One cannot get him to express an opinion or a preference. The Stimulators used to try to verbally trap him into swearing or getting mad, yet he had them licked. I listened to music in the office and Julius would come in and ask if I wanted him to turn the music off. I'd say, "No. I'm listening to it." He would return in five minutes with the same question. I'd say, "No." Finally I asked him if *he* wanted to turn the music off—"Did I say that?" He would go into full denial mode. Julius holds the camera. Allen is in the kitchen in his pajamas. The hair on the back of head is sticking straight up. Allen asks, "What do you notice about me?"

Peter Orlofsky is in Allen's bedroom. He looks sad; he is smoking but keeps his eyes on the camera. Allen asks many questions about Julius's future; Peter says, "Yeah" to each question. It is awkward. They are no longer lovers. They can't rekindle their attachment. Peter just stares into the camera. Allen says, "I'll turn this

off now." Robert Frank and his wife, June Leaf, are visiting. Robert sits in the living room and tells Allen that church is letting out. Allen comes over getting a blurry shot on Robert then pans to the Mary Help of Christians Church steps, which are full of gaily colored folk streaming out of church. Julius is frying a hamburger. Its loud sizzle permeates the scene. Julius flips the burger and looks up at Allen. He puts his two fists either side of his face and looks at Allen. "I can do the same thing you're doing, Allen." Allen laughs.

Harry Smith comes over from his Bowery Hotel (Smith has been living on the Bowery and making clandestine recordings of his cohabitants. Sometimes he even records their last coughing moments on earth). The apartment is clearly shown in this film: the Berenice Abbot over the stove, the sink in the living room. Harry has just made a live recording in a church uptown. He talks about the microphone placement and the amount of overload. He bends over his tape; his hump looks enormous. Soon his music pours forth.

Peter Orlofsky makes his brother Julius do chin-ups. It's upsetting. Peter is being cruel and forces Julius to do more. Peter tries to chin himself and fails. Julius turns to the camera says, "Hard work. Once you get into that you never get out of it. That's a form of slavery, isn't it Allen?" Long window shot. Julius, back in kitchen, sees Allen and forces a smile without being instructed. Julius walks full face into camera and seductively talks about the camera recording his face so others can stare at it and watch it and know it. Then he sings, "When you smile, the whole wide world smiles with you." Julius opens the kitchen window for Allen's camera. It's December now. The leaves are off the tree. Allen asks, "So what does it all amount to?" Julius replies, "Nothing much."

Carl Solomon walks into the kitchen, sees the camera and sticks one thumb in his ear—wiggles his fingers. "Secret Kabalistic gesture," Carl sniggers. At end of his visit, Julius is lying on the bench-sized bed in the little guest room that holds the piano. I remember Allen lying there nine years later. His whole apartment was piled with boxes waiting to move to the 13th Street loft. Allen looks at Julius and says, "Bye."

An old Red Army Chorus recording is playing while Allen impassively eyes the Italianate church across 12th Street. Julius is back at his residence. Peter is talking to him on the phone; he says, "I love you." The last shot is through the kitchen window. Snow is on the ground and the sky is blue. Closing titles appear in hot red background with a vacuum cleaner roaring in the background. Allen writes out, "the end" and adds, "1987."

Allen's household was his world and his world was the Lower East Side. Allen was the All Seeing Eye. In his last years, he narrated for Jerry Aronson's documentary about Allen (*Life and Times of Allen Ginsberg*, 1993), and two films were made in his last year. Collin Still was doing a portrait of Allen but it turned into an elegy (*No More to Say & Nothing to Weep For*, 1997). Allen got sicker and could not continue the interviews. This film shows Allen in his new loft. Collin Still came back after Allen died to film the loft as it was before we had to dismantle it. But several months before Allen moved to the loft, Allen's old Hungarian writer friend, Istvan Eörsi, came to visit with a film crew. It was video for Hungarian TV shot by Gyula Gazdag. This was the fly on the wall film where the fly was the main guest. Allen invested much of his last strength touring the crew around and he ran them ragged. Countless hours were shot in the old 12th Street kitchen. Allen walked down St Mark's Place and showed where W.H. Auden lived and where Trotsky stayed. He took them to the 13th Street squatters on the night before the police assaulted the buildings.

Allen is completely relaxed in his home, cooking, cleaning, and talking on the phone. The interviews are conducted by Istvan, whose English is good, but not good enough, so Allen goes slowly for him. The video is limited in its ability to capture the spaces Allen takes them to. You would not easily know where the neighborhood locations are. The film remains a treasure despite its limitations. Some of its greatest moments are available for viewing at www.allenginsberg.org. The video even looks better in the small box format.

Allen didn't think theatre and didn't act. He was always just who he was. Natural down to his flaws, he has left us a rich record of his life on the Lower East Side. We of the Lower East Side were all his family and he shared us with the world.

From Allen Ginsberg to New Realties

by Alan Steinfeld

Allen Ginsberg was a familiar figure in the East Village and for me the first to show that you can be an artist and a seeker of Enlightenment as well. Once I asked him if his connection with Tibetan Buddhism influenced his poetry. He gave me a long drawn out answer about some of his practices, but he basically said it did not influence him and that they were two different parts of his life. I thought that was strange. But of course he was one of the original dharma bums and his stream of conscious rants were Zen moments for all times. Buddhism was merely a defining label of expression for his lyrical poetry.

But Buddhism was my doorway into the general field of metaphysical studies. In the 1990s I started to do my cable program *New Realities* on Manhattan Time Warner cable. It was inspired by what I had seen in the 1980s in the East Village. In my exploration of new realities I was able to take everything I had learned in the twenty years of hanging out in the neighborhood to another level. I knew that I could reinvent myself, because I saw some of the extraordinary characters that have inhabited the East Village do it.

My orientation of seeing men parading around as women, dancing in drag on the top of the bar at the Pyramid lounge bar took it a step further. Now I met people claiming to be ancient warriors from Atlantis or having been taken aboard UFOs. I met others who claim to have discovered a new form of cosmic healing energies or investigated the anomalous phenomenon of geometric pattern the fields of England. And it all brought me to higher levels of stimulation I had grown to thirst for.

Creating my life, seeing the patterns and not being afraid to look at what

Clayton Patterson

Alan Steinfeld

others wouldn't, I found a new rich niche in the New Age. And there was nothing, not even the most outlandish, that was too bizarre for me, because I had been initiated into the cult of the most strange, which was the East Village in its day.

My association with the unique and original figures that I met in the East Village convinced me that anything is possible, especially if you invent the scenario yourself. I openly embraced UFO abductions, gurus from the East and trance mediums from all time-space dimensions and magnetic personalities, which were just as authentic as any inventor of style on the fashion scene.

For me the New Age is a continuation of the lessons I had learned from the Masters of the East Village; seeing the underlying patterns of things; comprehending the illusion of time, as in non linearity of reality that quantum physics suggested, and inventing yourself and the reality you want. What began as looking for the avant-garde went to the limits with *New Realities* because it was all part of the experience of exploring that vanishing line between the impossible and the outrageous. After all it was still a non-narrative that I was living.

Alan Steinfeld still lives in the East Village and his cable program New Realities can be seen every Friday at 7:30pm channel 56 on Manhattan Neighborhood Network.

For a catalogue of the programs guests over the last 7 years check website: www.newrealitiestv.com
To contact him e mail: alan@newrealitiestv.com

Henry Flesh

by Henry Flesh

I dropped out of Yale in the spring of 1967, when I was 19. In retrospect, I often think that I'd had my fill of Gothic architecture, since I'd grown up in a conservative, upper middle class family, then had attended an equally conservative (and stifling) prep school in Connecticut (one whose architecture aped the Yale Gothic style). By the time I entered Yale, I felt everything about my background and education repellent, running counter to my gut, to everything that I sensed inside. Yale seemed the final straw. (Shit, my grandfather had gone there!) I was desperate for something else. This was during the Vietnam War and the drug and sexual "revolutions." At Yale, I started smoking pot and taking acid. And apart from my struggles to escape my past, I was trying to come to terms with the fact that I knew I was gay—instincts I didn't like at all, that I'd never acted on, and that I'd never mentioned to a soul. My image of a homosexual was that of a gratingly effeminate man in a cashmere sweater, one who owned an antique shop or hair salon and minced around with a perfectly groomed poodle. The very thought of my being that way sickened me.

All this changed one weekend when I visited New York City and saw Andy Warhol's *Chelsea Girls*. Although the queerness of most of its characters was not explicitly stated, I sensed that they were that way, and what they were conformed to none of my preconceptions. Here were men who were distinctly appealing, sexy (if also somewhat intimidating), definitely not screaming queens. Then, too, there was an element of danger that I sensed in them and in the film, which appealed to my need to make a total break. Three months later, I dropped out of school. My family, of course, was horrified. "You're ruining your life," my mother told me (if only she knew!). But I paid no attention to anyone's protests; I was determined to flee.

It took me time to get my bearings in the city. My first apartment was on 78th Street and Columbus Avenue, in a rooming house where my rent was $17.50 a week. While living there, I was determined to find what I had witnessed in *Chelsea Girls*. Yet, I had no idea where to go. The first time I tried, I took the No.7 train down to the end of the line, to what I thought had to be the Village. At that time, years before the World Trade Center was built, much of lower Manhattan was an almost deserted wasteland. After I got there, I walked around for an hour and a half, eager to discover something. If I saw a hippie or someone with long hair, I was sure

that I was nearing my goal. No such luck. By the end of the afternoon, frustrated, I gave up. Fortunately, things changed for me shortly thereafter. A friend from Yale took me to my first gay bar, which happened to be the Stonewall, and it soon became a regular haunt. Then, in the summer of '67, I met a guy there named Jacob and went home with him. It was at his apartment on the Lower East Side that I unearthed what I had been seeking. Here I discovered the then-thriving New York crystal meth scene, a scene that had as its epicenter Andy Warhol's factory; Andy being the king whose approval everyone sought. Jacob's was one of the many places where people from that world congregated and got high. Therefore, when Jacob asked me to move in with him, I was thrilled.

I met Ondine, the legendary "Pope" from *Chelsea Girls*. Once, in the dead of night and in the middle of a freezing winter, he showed up to borrow a pair of socks, since he was wearing none and felt that he was about to be busted. He was convinced that if he were arrested, his picture would be in the *New York Times*, and he wanted to make sure that he was wearing socks if that happened. I was happy to give him a pair, certain that it was a contribution I could make to what I saw as Lower East Side glamour. Another time I came home to find what I naively thought was a Park Avenue society girl wearing a strapless black dress and sitting beside Jacob on one of the mattresses strewn on the floor. Both were perusing hardcore gay pornography. How fabulous! I said to myself. How totally demented. Later I learned that this "society girl" was, in fact, Holly Woodlawn, the Warholian transvestite later immortalized by Lou Reed in his song "Take a Walk on the Wild Side." We became friends after that night, and I often joined her while she was prowling for men or on one of her many shoplifting expeditions. One afternoon we stole a huge plastic telephone that was displayed in front of a New York Telephone office. Another time she was arrested for posing as the French ambassador's wife and trying to cash a check. Because of this incident, she was in jail at the time *Trash* was released.

I met Jackie Curtis, too, and Candy Darling. One night the three of us got lost while trying to locate a party Candy knew about. Somehow we ended up at a prom held at a Catholic girl's high school on, I believe, Forsyth Street, with Candy wandering through the crowd while wearing a full-length white gown and holding a single red rose.

There were many others. Crystal George, was a tall, hairy Southerner, allegedly the heir to a North Carolina tobacco fortune, who dressed as a nurse and gave out shots of crystal. He starred in one Warhol movie in which he was filmed high on speed and masturbating for more than three hours. Then there was Eric Emerson, a blond, randy dancer who was featured in Warhol's *Lonesome Cowboys*. Years later he died mysteriously in what was called a biking accident. Many whom I met then had peculiar yet strangely alluring nicknames: Norman Billiardballs, Rotten Rita. All lived their lives as high as kites.

Most of them are dead now; I was lucky enough to survive. I managed to hold myself back, staying just short of the edge. Eventually I pulled away from that scene when I met a new lover. By then I'd grown wary of meth anyway, having seen enough of what was going down to know that the games being played could be deadly. Still, when I look back on it all today, I do so with a perverse fondness. After all, throwing myself into that Lower East Side scene enabled me to shed all traces of my suffocating past. For better or worse, I have never been the same since.

Shooting

On Seventh Street

by Laki Vazakas

In the fall of 1993, I began recording the lives of Beat eminence Herbert Huncke and photographer Louis Cartwright, who were living in a basement flat on Seventh Street between C and D. At that time, I had only a vague notion to document, with my Sony Hi-8 video camera, the goings-on at their apartment. Certainly I had no intention to follow through with a full-length documentary, but that's what I ended up with. Sort of.

Mirroring the hectically picaresque lives of Herbert and Louis, the video I came up with, *Huncke and Louis,* is dark, rough and uncompromising. Some might call it amateurish and I wouldn't entirely disagree. The video accurately reflects the improvised and often arduous quality of their lives. The making of the video was every bit as interesting as the finished work.

Herbert Huncke is, of course, a legendary figure in both the Beat and Lower East Side pantheons. He first gained notoriety for being the conduit to the 1940s Times Square underworld for Kerouac, Burroughs and Ginsberg, all of whom paid tribute to Huncke by portraying him (not always fetchingly) as the hipster incarnate in their respective works. After being incarcerated for almost all of the 1950s, Herbert resurfaced in the East Village, where he again found himself in the center of a vibrant, speed-fueled bohemian literary enclave, which included Alexander Trocchi, author of *Cain's Book*. Somehow, Huncke always gravitated towards transgressive writers, and vice versa. Certainly, anyone who spent time with Herbert came to appreciate his gift for marvelous, nonjudgmental storytelling. All the while, Huncke penned brilliant, self-consciously autobiographical stories, some of which were first published as *Huncke's Journal* by Diane di Prima in 1965.

In the late 60s, Herbert Huncke was introduced to Louis Cartwright at Allen Ginsberg's apartment. While their meeting may not have been love at first sight, it marked the beginning of a deep, often tumultuous 25-year relationship that ended with Cartwright's (unsolved) murder in June of 1994. Perhaps in sizing up Louis, Herbert recognized a fellow traveler, someone like himself who had fled a deeply discordant family in search of serendipitous connections and broader horizons. Like Huncke (who grew up in Chicago), Cartwright had spent his formative years in the Midwest (on a farm in Ohio), and was restless to see more of the world. Despite a more than 30-year age difference, the two savored each other's company through thick and thin. With Herbert, Louis saw perhaps more of the highs and lows of humanity that he bargained for.

After years that included some travel (to Nepal and Afghanistan) and some stability (they shared an apartment on Henry Street in Brooklyn for many years), Herbert and Louis found themselves back in the East Village, on Seventh Street. Their dimly lit basement flat was filled with ragged furniture and decorated with some of their own artwork, as well as artifacts that Louis had scavenged. A narrow kitchen in the back of the flat opened to a lovely, leafy backyard. My first impression in October of 1993 was that they had a cozy set up.

Friends like Linda Twigg and Dimitri Mugianis would stop by the pad on Seventh for late night visits. Late one autumn evening, Huncke told Dimitri and me the story of how he "found" money bags containing four thousand Canadian dollars in the back seat of an unopened station wagon. This was back in the 60s, a time when Herbert was down on his luck. He ended up cashing in the bills at 85 cents on the dollar, and lived pretty large for a spell. He smiled as he finished his recounting of that adventure, saying, "I love that story. It gave me a lot of faith." Herbert scribbled some notes in a spiral notebook after telling the story while Louis played with their teacup Chihuahua named Goonie. Little did I know that this outward harmony was something of a mirage, for rent had not been paid in several months. The fall of '93 was literally the calm before the storm.

The storm came in two fronts. First, winter ferociously sunk its teeth into Manhattan, leaving snow piled high and sidewalks ice glazed. Then Huncke fell on the treacherous streets, resulting in a prolonged stay in Cabrini hospital for a broken shoulder and pneumonia. It was while Herbert was in the hospital that Louis began to unravel. Fearing that Herbert, who had over the years become something of a father figure, would pass before him, Cartwright began a downward spiral fueled by heroin and cocaine, which were readily available in the streets and surrounding bodegas. The apartment that they shared began to resemble Louis's disheveled and exasperated appearance, as users came to fix at all hours.

I visited Louis several times during the long and very difficult winter. I tried hard to listen to him, and to videotape him. Even in the bleakest moments of junk sickness, Louis was writing what he called "dumpster poetry." These scattered musings (most of which have been lost) were compelling and surreal; perhaps some of Huncke's formidable creative resilience rubbed off on him. (Back in the 1940s, Huncke, homeless and desperate, did some of his writing in subway toilets.) Unfortunately, Louis could not see that he was transforming his own home into a lavatory of empty needles and other refuse. Shitty coke fueled his paranoia, and he alienated friends. As winter turned to spring, eviction notices began being posted on the front door.

Huncke stayed in touch with Louis, calling him several times each week throughout the winter. Still depleted from his hospital stint, he crashed with friends Jason Pilarski and Taketo Shimada in the Chelsea Hotel. (Huncke had previously stayed in the hotel in the late 80s, crashing in Linda Twigg's "Doubling Cube" gambling salon. Herbert was, after all, close to 80, and had been using drugs steadily since his early teens. Though he knew well Louis's jittery moods and whims, Herbert was deeply alarmed by Louis's incoherence on the phone. He was not, however, in any shape to intervene in his friend's disintegration. I recall videotaping Huncke in the Chelsea, chatting with Louis on the phone around this time. They talked mainly about the scarcity of money, and their exchange ended abruptly when Louis ran out of coins for the pay phone. Huncke looked up at me, disheartened, and said, "wouldn't you know it, the line went dead." I could not help but think this rupture in their conversation was an omen.

April of '94 brought some warm weather, splendid relief from the harsh winter. Emerging from the murky drug den, Louis began spending time in the backyard, where we chatted on several occasions. At times he seemed carefree, oblivious to his precarious situation. At other times he was filled with dark despair. He was ashamed of the festering track marks on his arms, which he tried to cover by wearing long-sleeve shirts.

Clayton Patterson

Herbert Hunke

(This did not work because blood stains dotted his sleeves.) When I asked him what he would do if he were to be evicted, he was vague and evasive. He replied that he might head down to Chinatown and find a cheap flat. He refused my offer to help him find housing and medical assistance. Louis seemed resigned to his fate.

My last foray to the apartment on Seventh Street took place in late May, a day or two before Louis was finally evicted. Late that night, after I'd had a few drinks at Blanche's, I knocked on Cartwright's door. He opened it cautiously, and then hurried me inside, where I found two guys preparing to shoot coke. The pad was strewn with garbage and shredded newspapers, and a used needle was marooned on a deck of playing cards fanned out on the kitchen table. As one of Louis's companions prepared his fix, he sang the lines to an Eric Burdon song: "In this dirty old part of the city/where the sun refuses to shine . . ." It was a most appropriate soundtrack, an elegy for the warm times Herbert and Louis had shared in that simple, unadorned basement flat. Before I left, Louis and another fellow took turns reading the eviction notice aloud. It was as if they were reciting their own declaration of dependence.

The phone rang early on the morning of June 6. It was Dimitri Mugianis, who was speaking Greek so that Huncke, who was at his pad on Avenue A, would not be able to comprehend the horror of his words. My Greek is lousy, but I understood what Dimitri was saying: "I believe Louis has died. We have to meet at the 9th precinct on Fifth Street to find out about him."

James Rasin, Jeremiah Newton and I met Dimitri at the 9th precinct, where the officers were puzzled by our interest in the fate of Louis Cartwright. One detective asked if we were part of a "church group," perhaps thinking that Louis might have been a homeless man we had assisted. One by one we were interviewed by the detectives, who did not come right out and

tell us what had happened to Louis. Gradually we learned that Louis had been stabbed to death on Second Avenue. He had been panhandling with another man, there had been an argument, and the guy pulled a knife. Now we had the unimaginably grim task of telling Huncke that his closest friend had been murdered.

We walked somberly over to Avenue A and Tenth Street, where we found Huncke sleeping, his slender frame curled up on a futon. Dimitri gently shook Herbert awake, and after a few moments explained that Louis had been killed. Huncke looked at our faces and recognized our sorrow. It took awhile for Dimitri's words to register fully. Tears began to flow, as Huncke slowly acknowledged the loss of his companion of 25 years.

I made a conscious decision to videotape most of that day of mourning. So many folks have told me that it's difficult to watch Huncke, emaciated and stooped, sobbing and trying to come to terms with such a deep loss. But what I see in that footage are Herbert's friends, myself included, comforting him, reminding him of the good times he shared with Louis. We reminded him that Louis was a gentle person, who, though troubled, had shared his artistic gifts (primarily his photographs) and uncommon warmth. We assured Herbert that Louis would not be forgotten.

A few month's after Louis's death, Herbert moved back to the Chelsea Hotel. He did what he had always done: he survived. Huncke became part of the Chelsea's karma circuit, and he continued to write and to host late night gatherings. He did a final reading tour of Europe, where he recorded a spoken word CD. In his last days, Herbert spoke fondly of Louis, his "ace-boom buddy." He said he felt guilty for "neglecting" Louis (Huncke was, in his own words, "guilty of everything"). But Huncke did not forget Louis: "Juxtaposition," one of the last stories he ever wrote, is a touching remembrance of his companion. Herbert Huncke died at the age of 81 in August of 1996, resilient to the end.

It's been almost ten years since Louis Cartwright was murdered on Second Avenue. Despite efforts by detectives working the cold case file, no one has been arrested for this brutal crime.

I've not visited Seventh Street in quite a while. I imagine it to be a quiet street now. The shooting gallery has been stilled.

The Provocative Confessions of a Poet/video artist

by Valery Oisteanu

When I had my literary debut as a poet-author in Romania in 1970, against the will of the communist officials and my family, the so called critics classified my verse as decadent and emulating foreign influences, so I was immediately black-listed (a badge of honor under the Red-rule) and my book of poetry, *Prosthesis* (Litera Press), was removed from libraries and bookshops.

The dadaists/surrealists and American writers such as Gertrude Stein, Hart Crane and Frank O'Hara, secretly, influenced my generation. The European avant-garde's ideas and art were also exported to New York from 1913 to the 1940s by Marius de Zayas Duchamp, Man Ray, Mina Loy, Julien Levy, and Peggy Guggenheim among others and by the publications such as those by Black Sun Press. During the war from 1940 to 1945 many of the European avant-garde poets and artists escaped to New York and collaborated with their American counterparts to solidify the experimental bridge. The interconnection between the Beats and European dada/surrealism is more than tangential. Dadaists had already experimented with the stream of consciousness approach to poetry: cut-up words selected randomly, creatively induced psychosis and drug induced artistic inspiration. Tzara, Artaud, Eluard and Jazz were the predecessors of the Beats. Nevertheless in his essays, Jack Kerouac insisted that the Beat movement is a true American discovery born out of a new spirituality (neo-Buddhism), employing literary technique paralleling jazz improvisations.

I started writing about experimental video and performance art in a column for the magazine *Cultural Weekly* in Bucharest in 1970 under the title, "The Dictionary of Experimental Arts," introducing art lovers in Romania to the new video art and radical films from Europe and America. The column lasted a year and a half over the loud condemnation of the critics and heavy censorship from the communist governmental censors. It was terminated in April 1971 because the tyrant of Romania, Ceausescu, criticized the bad influence on youth from the "degenerate and decadent Western avant-garde." My beginnings in "performance-video" experiments were in front of the camera as a spoken-verse author of underground poetry, an esthetic-dissident expressing freedom in a dada jazzoetry style, distributed on self-produced black-and-white videos at a student club "Club A" in Bucharest. One of these events, "Protest and Passion," was a love-folk song performed with the late musician Dorin Liviu Zaharia and Mircea Florian (musician and electronic sound sculptor living in Germany) in 1970 and was followed by a protest/ritual cutting of my long hair and my clothes on stage. The audio recordings survived but the video was confiscated by secret police and probably destroyed.

In April of 1972 I decided to take the road of exile to reunite myself with other "experimentalists of the world." But the so-called Utopia of the New World was a bitter pill, in most collaborative-encounters individualism prevailed and few artists were wiling to toss ego aside for a true-collective creation. The next few years I spent traveling through Nepal, India, France, Germany, and Italy. In 1973 I came to the United States partly to team up with my wife, Ruth, and together we traveled across the United States, stopping in places where the Beat movement left its mark following in the footsteps of Jack Kerouac.

Arriving in New York in 1973, I first I got in touch and I collaborated with other video-artists on small budget videos and appeared regularly on cable shows such as John Wilcock's show as a poet critic and on Paul Tschinkel's *Art Today* video program—reading poetry nude in a gas mask. I was also reading political and erotic poetry on Tuli Kupferberg's cable show on public access TV.

At this time the multimedia shows became my preoccupation. I introduced video in my

shows as a continually changing sculpture coupled with multi-screen, dissolve-slide projections, video clips of electronically geometric generated patterns and live rock bands. Among the musical collaborators were Gabriel Caciula, Liubisha Ristic from Ganesha, Otto von Ruggins of Kongress, Von LMO and jazz musicians Ken Simon saxophone, Dan guitar.

The contact with so many artist and writers in the East Village facilitated the birth of PASS—Poets & Artists Surreal Society—an international community interested in experimental processes that sponsored events at Hunter college in 1976 (Jazzoetry and erotic poetry in the nude with gas mask on by Valery, and experimental dance films by Leny Horovitz, slides collages by E.M. Plunkett, John Evans and live performances by David Ebony and Robin Cruchfield).

I began meeting with the local beat poets at the Poetry Project at St. Mark's Church (a poetry collective organized by Allen Ginsberg and Anne Waldman) in 1973–74 when I moved across the street and became a frequent visitor at their readings. Following one of their programs, I met Tuli Kupferberg and Ed Sanders (members of a group called the Fugs, quintessential of the '60s period), a duo that began a counter-culture, psychedelic, hippie revolution by publishing small magazines and organizing poetry readings. The word "hippie" comes from a beatnik word used commonly in a jazz environment, "hip cat." Soon after that, I became friends with Tuli and we paired up to read together in several venues for "radical video poetry theater."

I met Bill Burroughs for the first time at a lecture at Columbia University's creative writing program in the class of Michael Andre (editor of *Unmuzzled Ox*), who published most of the beat poets in his magazine. Burroughs impressed me with his deep voice and an uncanny black humor and the biting satire employed in his stories. I met Lawrence Ferlinghetti in 1975 in San Francisco, while driving cross-country in search of the beats, and later after reading at the launch of his new book in New York at Labyrinth Books uptown. One by one, I met all of the living beats either by accident or by karma being paired with Herbert Hunke to read together at Café Nico; a historic reading received with much interest. With Jeanine Pomy Vega I read at, among other venues, Bellevue Hospital for the Criminally Insane and at Art-Colony Café in Woodstock. Other video encounters include Marty Metz, Larry Rivers, Peter Orlofsky, Judith Malina and Gregory Corso, at the Poetry Project (Unedited video verite 2h).

I have to confess that at those meetings I often photographed the historical events and videotaped and also gave poetry books as presents to the beat-masters and bought in-kind books by the beats, asking them often to sign their work. Almost every time, the impression left on me by these poets generated a poem or an essay inspired by their life and their works. At all times, I was aware that I was in the presence of a true literary event. They always acted as outsiders, shamans of lost rituals, and not at all as mainstream educators or entertainers. Beats remain nomadic medicine men, priests of a new revolutionary thought, and revolutionary art. Julian Beck was such a poet and a theater magician, painter and a catalyst of new expressions involving not only actors, but also the audience, who participates in the interactive scenario. After his death, his wife and poet, Judith Malina, is continuing his work by teaching new theater in New York and Italy.

East Village venues did not always provide a secure environment for reading my erotic or political poetry. Churches and synagogues and federal parks were, sometimes, subject to censorship, as were public schools and colleges. I had to face either censorship again (this time in our democracy) or eviction by federal marshals at the Charlottes Moorman's Avant-Garde Festival for voicing my displeasure with the commodification of the avant-garde and radical artist. My first surrealist manifesto was called: "Fuck False Art"—it was unceremoniously removed because it used an obscene word.

Another forbidden activity was my collaboration with Alex Benet in his production "Midnight Blue." The first erotic cable show. I performed and read poetry burlesque in the nude surrounded by a number of nude models a la Dali. The programs were written and interpreted by Dr. Eroticus (V.O.) and included interviewing porn stars on camera or presenting comic sex advice. The producers of *Midnight Blue* were called in front of a congressional committee on pornography, under threat of being banned from broadcasting on cable, and had to prove on the spot that the show had some socially redeemable value and was funny and not pornographic.

I also appeared on Otto Von Ruggins's cable show in Brooklyn "Radio Free Dada" reading

Clayton Patterson

Valery Oisteanu

avant-punk poetry—a sampling of which is now on the web. On Sur Rodney-Sur's cable show live from the Mudd club called *Future-Sex*, I read, on-the-air live, erotic poetry. The whereabouts of the archival videos from these shows are unknown.

My first appearance in a feature length movie was ironically enough a speaking part in the soft-porn flick called *The Big Thumbs,* where I played the dashing flasher in Central Park. The Lippman Brothers directed it and in one of the surreal encounters in the park a male flasher gets a response flash back from a nympho and they fall in love from the first flash! The police are called in and we end up in the back of a cruiser making love.

Later I had another lead role, appropriately enough as a vampire, in *The Bride of Franken-stein*—a student movie by an NYU-Tisch class.

The redemption of radical-poetical surreali-ty started with my own production of videos verité in which I tried to capture the East Village atmosphere of the '80s—art gal-leries, Tompkin's Square art festivals, and performances in gardens. The working title of the series was "Zendada-Videos" pro-duced by The Yin-Yang Gang. I did inter-views with Charles Henri Ford, Lill Picard, Daniel Spoerri, Gellu Naum and others.

An archive of my video-related materials includes:
1. *Valery Oisteanu interviews Ira Cohen, Jeff Wright, Judy Altman* (1985), VHS, 1h 30m.
2. "Poets Society," poetical portrait of Valery Oisteanu. Brooklyn cable show host Mathew Paris in conversations about surrealism (ch.17, 18).
3. Articles in East Village publications about video: *The East Village Other*, *SoHo Arts Weekly*, *East Village EYE*, *Downtown*, *Cover*, etc.
4. Vol. 20 Sirowitz/Oisteanu, Poetry on video from Thin Air Video: "Recent Readings" (this series was launched in 1988 and recorded contemporary poets), produced by Mitch Corber.
5. Thin Air Radio cable show—Allen Ginsberg Memorial, Poetical Meditation by Valery Oisteanu.
6. East Village Wizard at the Vault, Director Tone Belizzi. Xtreme Erotic Poetry performances by Dr. Eroticus.
7. Phillis Bulkin Lehrer in collaboration with Valery Oisteanu, animated films and video-poetry performances, also collage photomontage on film for Ray Johnson.
8. Video Teatro da Camera (Chamber Video Theater) by Alessandro Figurelli Roma, Italy.
9. Five part documentary on Bali called *Rhythm and Rituals in Bali* (Romanian version 2h30min) written and filmed by Valery Oisteanu.
10. Rick Siegel-This is art-Poetry performance (36 min) for ICA London and Internet site, www.thisisart.com.
11. Over fifty poetry performances with music by Valery Oisteanu at, among others, The Knitting Factory, Galleria La Mama, Poetry Project at St Marks Church, Pyramid Club, Nuyorican café, Rhythm Club, Café Nico, Shuttle Club & TNC. My friends and fellow artists, including Angelo Jannuzzi, Phylis Bulkin Lehrer, Ruth Oisteanu, and others, produced these video-poetry-verite tapes.

33 First Avenue
to Jack Smith
by Valery Oisteanu

Jack Smith's ghost dressed in transparent gold lame
Falling down the scaffolding screeching
Claw of a red lobster locked onto a window sill
On the fifth floor of the penguin's cave
The rented cement paradise
The grand hole with no wall
Sacred debris fills the sacrificial alter of Atlantis
Strange angels of perversion dressed in exotic plumage
Multi-colored scarves covering the Fear of Shark Museum
The horizon is made from film cans, collages, photographs and props galore
Scribbled in dark corners "NINETEENTH PLANE CRASH!!!"
"Smashed by a helicopter on the New Jersey Turnpike"
"Impacted croissants from outer space" for breakfast
The phantom carries a message
I would sign anything to give you a moment of happiness
The theater of exotic aquatics in his bathroom
Self-flagellating in his dream prison
To stay free J.S. had to escape this world
This tormented priest with a silver face and
An aluminum hat in the form of a silver chicken
Take off your blindfold, now you are in Atlantis
You are in the grip of the lobster from the lotus land
A sacrificial harlequin in the orchard rot of a rented lagoon
Cannibalistic diva locked in the vault of her archives
Guarded by the milkshake goddesses with one breast apiece
Protected by the 15-foot marijuana plant
Guarded by the prayers of immortal pleasures and erotic torturers
Wearing the brassieres of Uranus and nothing else
Painting a cunt on a mirror
And fucking through a jagged hole in the reflection
With the face of a bird, the eyes of an alchemist
Laying on the floor next to Tally Brown
Next to Charles Ludlum, next to Andy
The theater of the lower depths of absurdity
This place should be a museum dedicated to the end of civilization

The fight against "Cultural AMNESIA" starts with archiving and video-documentation. "Video-verite" is a method of recording and editing in the camera while shooting and involves comparative anthropological commentary. For example: Poetry videos by the Ying Yang team documented East Village art and poetry readings by such infamous beat and post-beat poets as Gregory Corso, Herbert Hanke, Allen Ginsberg, Jeanine Pomy Vega, Marty Metz, Ira Cohen and Judith Malina. These video-verite performance tapes are a living museum of counterculture an allegorical collective recollection, a social memory of literary and artistic events in the Lower East Side and its struggle against gentrification.

I produced several video documentaries in the nineties, among them: *Eco-fest at TNC*; *Abe Lebenwohl park-summer music events*; *Art Around the Park*, *Wigstock in Tompkins Square Park*, and *Scenes from 33 Garden procession*.

I have also interviewed artists such as Lil Picard in bed in her studio on Ninth street, an interview with Daniel Spoerri in the dark at his opening at Emily Harvey gallery; a Valery Gallery interview with Charles Henri Ford, and many others.

Lifestyles in the East Village was the subject of the video *Sex In The Nineties* with Francoise Bernadi for Liebesunde Vox TV-Germany, and of several interviews for Romanian TV centering on the last beats in East Village: Allen Ginsberg, Larry Rivers and Hety Joans.

What is so provocative about erotic poetry that gets everybody shocked? In one word—Puritanism. The puritanical attitude towards alternative lifestyles, or soft-drug mind-expanding experimentation, stifles the radical arts so necessary to the East Village environment. The East Village cannot function as a tourist attraction or a branch of New York Disney World. The history of artistic revolution over the past five decades ranges from Dada to the beatniks to scat to the hippies to psychedelic rock to the radical theater to punk to graffiti to spoken word to hip hop to rap and to street theater—riots. As a poet-video artist I am always involved in the Save the Gardens movement and anti-gentrification and the anti-cultural-vandalism of the developers. By documenting the struggle of ecological and experimental theaters and artists and by contributing to the voices of opposition we keep the flame of creative freedom alive. Thirty years after my escape to New York I find myself still fighting the retrograde forces of the power elite.

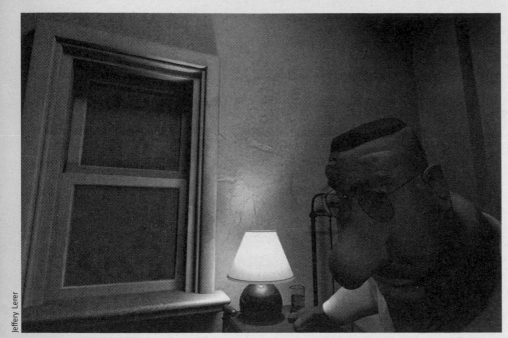

Jeffery Lerer

Gilbert Hotel

Jeffery Lerer

Gilbert Hotel

Jeffrey Lerer Interview

by Clayton Patterson
Transcribed by Lane Robbins

Clayton Patterson: What's your name?

Jeffrey Lerer: Jeffrey Lerer

CP: So, Jeffrey, you went to art school in Iowa?

JL: University of Iowa, 1965.

CP: Painter?

JL: Painter . . . In 1967, I transferred to the University of Arizona. I finished in 1970.

CP: Fine Arts?

JL: No. I changed majors to political science and psychology.

CP: Oh, you switched out of art entirely.

JL: Absolutely.

CP: So what degree did you get?

JL: Political science and psychology.

CP: So a B.A. You didn't get a B.F.A. Sounds like you were going in the same direction I was going. I was interested in art, obviously, but the whole art school concept didn't work out.

JL: Art stayed the central concentration, but what was going on in the art school was so detrimental to my process that I decided to get as far away from art school as I possibly could. I learned more about what I wanted to paint by watching laboratory animals.

CP: But you did take some painting classes?

JL: Oh, yes, several years. I had actually majored in art in high school on a bridge program to the University of Iowa. When I got to the University of Iowa after about a year and a half, it was just ridiculous.

CP: Right. Wrong personality for the art school. Although it's obviously a good art school because they have a fine reputation. They always turned out a lot of good people. They have a good library and collection.

JL: Yea, it's always been an interesting school.

CP: So how did you eventually wind up coming to New York?

JL: It was a multi-tiered process. First, everywhere I went my whole life, since I was very little, people said, "Oh, you must be from New York." So by the time I was in my middle teens I came to New York for the first time and hung around for a little while. Then I went back to high school. In the summer, I went to work up in the Catskills and came down when I was able. I'm trying to remember, I went down to Mexico after I graduated from college. I stayed for a year. That was my first stay in Mexico. Then I moved to New York in '71.

CP: What were you doing in Mexico?

JL: Painting. I was doing a number of things, primarily getting away from the [Vietnam] draft, because in my last year of college they were after me. Then

I left for Mexico and didn't come back until '71.

CP: But you went down there as a painter. How was it as a painter? Was it a good experience?

JL: It was [good] in the sense that I got away from all of the influences and I was in a place where people were looking at very different things. I was subjected to color and form like I had never seen.

CP: So there were other artists you were associating with?

JL: Most of the artists I met in Mexico who were seriously committed to their art, meaning with a certain formal approach, were in the shadow of what was going on in New York and Paris. More New York, but some still Paris.

CP: So we're talking kind of abstract expression. Abstract art for sure.

JL: And process art like pop art very influenced by Jasper Johns. Those were the people, the formalists; they were ignoring a lot of their own color and their own metamorphosis, drawing a lot from European and New York influences.

CP: The whole thing I consider a brainwashing mistake, and I wonder if the next thing to be eliminated is the Museum of Modern Art, because culturally there's a lot of fraudulent ideas attached to it. But basically you were painting on your own.

JL: I was represented by a gallery, but that was years later. I went back to Mexico in '74, and stayed for eight years. I would say from '71 to '74, I was much more private about my art and I did not share it very much.

CP: So you came back to the States—were you doing anything in particular?

JL: When I came back to New York, I had a job, and after a couple of years, I set my sights on how not to have a job. The idea was, "How am I going to be able to spend most of my time in my studio?" That took quite a while. That didn't actually happen until '77 when I could install myself in my studio full time.

CP: So between '71 and '74, you were in New York and you were private with your art. Then you went back to Mexico; which part of Mexico?

JL: To Mexico City.

CP: The same place you were the first time?

JL: Yes.

CP: What was different about this time in Mexico City?

JL: Well, my intention this time was to live there for an extended amount of time and to fully dedicate myself to painting. Art was a primary concern, but it didn't become a primary occupation until '73/'74. So when I returned to Mexico my intention was to find my painting language and find a way to be in my studio all the time.

CP: So, is that what happened in Mexico City?

JL: It did, but it still took about three years until a series of galleries began to pick up my work. So from '74 to '77 it was a little bit touch and go.

CP: Was it hard surviving in Mexico City, with a foreign culture and a foreign language?

JL: Let's put it this way, I consider time outside the studio hard. I still had to work at various things and time away from the studio was always hard.

CP: But you had learned the language?

JL: Oh, yeah, I had learned the language in '71. It didn't take long. If you're living there, and that's all you hear all day long, in six to eight months you're speaking the language. By the time I got back [to New York] I was fluent . . . I picked up a tremendous amount of vulgarities.

CP: By this time you started having galleries interested in your art.

JL: By '77.

CP: You were showing successfully?

JL: Yes. In '77 a gallery gave me a one man show and sold out most of the show. By '78 another gallery signed me to an exclusive. They had a series of shows which all sold out. I did quite well there. Then I moved from Mexico City to a small village about an hour south of Mexico City.

CP: What year?

JL: About 1980.

CP: So you were in Mexico City, you were successful, you were having shows, you were selling your work, you were able to survive full time as a painter, then you decide to stay with the gallery and move to a small town about 1980. How long did you stay in the small town?

JL: About a year.

CP: What was that like?

JL: Fantastic, for the first six months.

CP: Fantastic in which way?

JL: It was a very small village, animals walking all over the place, invading my garden. The craftspeople in the village, the carpenters, the painters, the welders, they regarded artists as fellow craftspeople. They'd all visit each other's studios. I don't mean just art studios. There would be a welder's shop, a house painter's shop, a carpenter's shop. They all regarded shops as shops.

CP: So you like the workman quality of being an artist and being considered a workman. You'd go to the studio at nine and end at, say, four, and that was your concept of being an artist and living as a studio. Like another craftsman, only you were dealing with pictures.

JL: It was the first time I found an environment like that and the first time I could engage in dialogue with a carpenter who may not have had more than a fourth-grade education but felt completely at ease discussing what he thought he saw on canvas. That was an amazing experience. The village life was something like I had never seen before and it also destroyed me. [I had] tons of stereotypes about what you think poverty is, what you think primitive is. It's all an illusion. When you're there it's a completely different thing than what we think here in the United States about primitive or poverty. It's all just words on paper.

CP: So they had a whole life, a lifestyle, enjoyment, and their freedom. So what made it go south?

JL: Right. Because it was like paradise, literally like paradise—

CP: Was it like a Gauguin thing where you had all these women running around?

JL: No. That wasn't a good idea. That could actually create problems. A couple of things happened. A couple of artists and writers came down from New York and visited the village. I spent about a week hanging out with them. When they left I was like, "NEW YORK, NEW YORK!"

CP: Were there other artists living in the town at the time?

JL: Oh yeah. It's a village that artists have always been drawn to.

CP: What was the name of the village?

JL: Tepoztlan.

CP: Basically there were other artists there, but you guys all had your own groove going.

JL: There's a very clear difference between provincial art and art with serious formal considerations. Even though I bury my formal considerations underneath what might appear very goofy sometimes, I'm very concerned with formal problems, and there was a complete lack of dialogue on that level.

CP: So you're once again alone doing your art. After about six months, these cool cats from New York came down and shattered your life.

JL: Suddenly I started thinking—

CP: There's a whole big world out there that I could be swimming in.

JL: Right. I woke up one morning and I just looked out at the garden from the window in my kitchen, and I thought, "This is over, I've gotta go to New York."

CP: At this time you were successful, showing, painting, and living in this oasis—what now had become wasteland?

JL: Oh, it was still beautiful. When I left, don't think it didn't hurt. When I got in the car that drove me out of that village, I felt like I had a hook in my stomach. It was very painful to leave. Let me explain something; there's a little subtle thing in there. I had been in Mexico for eight years straight this time and I'd already moved from a city to a village. That village was still too sophisticated for me, and I had visited a village even further out into the Mexican landscape, which was truly primitive. I was in a position where I thought, "I have either got to leave Mexico and go to New York, or I'm going further out into that really primitive village and

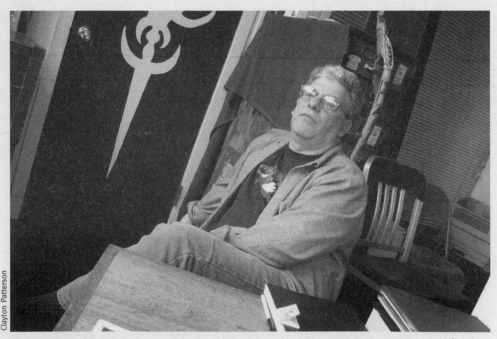

Clayton Patterson

Jeffery Lerer

I'm going to settle here for the rest of my life." That's the way I do things. I just dead end.

CP: So then you come back to New York and you move down to where, Rivington Street? So what year is this?

JL: Right—'81.

CP: Rivington Street was pretty rugged in those days.

JL: Rough. I mean rough. For some reason gangs liked to fight in front of Shapiro's Kosher Wines. That's where my loft was. I could look down at night and see various gangs killing each other in front of Shapiro's Kosher Wines. Oh boy, that was rough.

CP: How did this affect your art?

JL: When I was in the Village, my art was already changing. I had been working very abstract for a number of years and I started to move back to biomorphic forms. They weren't recognizable, but they seemed biological. When I got to Rivington Street, they were extremely organic. They almost looked like worm shapes. I was doing graphite on paper and oil on canvas. It was difficult. I got back to New York, and New York was a lot harder and stranger than I expected, and I got into a very hunkered-down mode.

CP: But the dealer from Mexico was still representing you at that time.

JL: Yes, she was. She was still representing me.

CP: So she would come all the way to New York to visit you?

JL: She came to New York to visit and to secure a show for the following year. She was also connecting me up with a gallery she was affiliated with here in New York. When she got to the studio, she did not like my new work and was very disturbed. [Laughter]. [She] wanted me to resume my old series, which I told her was finished, at which point she then cut me off—with an open invitation to come back whenever I decided to resume the previous series.

CP: She didn't leave on hostile terms?

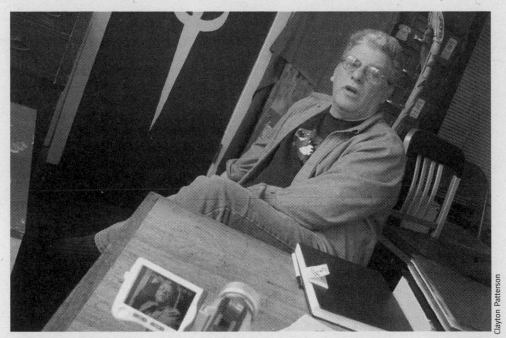

Clayton Patterson

Jeffery Lerer

JL: [More laughter].

CP: So now you're living in New York and life becomes a struggle again to be a artist.

JL: Now it really became a struggle because I was in New York for about eight months with a guaranteed monthly income with the gallery, and now all of a sudden, when she saw the work in progress, it ended. Now, suddenly, I had no income, no history, no nothing. So it suddenly became very tough. By this time I was already in my thirties somewhere and this was the toughest it had gotten since I was 19. The first thing I had to do was relocate my studio because I couldn't afford this studio. Eventually I got a studio in Brooklyn at the head of the Gowanus Canal at what had been an old ASPCA shelter.

CP: That's always a hard place to be.

Clayton Patterson

Jeffery Lerer

JL: It had been a shelter since the '20s. Before that, it had been a police station. Then it changed from a police station to the ASPCA, and had been the ASPCA until the '70s. When I moved in, people would still come late at night and chain a vast array of animals to the front door. I got home one night at one or two in the morning, a little bit drunk, and a vicious German Shepherd was tied to the knob of the front door. [Laughter]. I had to sit down and negotiate with him for about forty minutes before we became friends. He was big and he was angry. [Laughter].

CP: But you're still doing painting.

JL: Absolutely. By now I was painting and the biomorphic forms had finally evolved into people. I had always kept drawing journals and my drawing journals had so much figurative work in them. I would always ask myself, "Why do you do these in your journal? You don't do these on your canvases." I started painting figurative work on canvas—large. And I was getting a certain amount of success out of that. Then I got a little more money together and I relocated my studio to Ludlow Street. That gets me about two blocks from where I started, on Rivington.

CP: What year was this?

JL: I don't know, sometime around 1986.

CP: By this time you had started into film.

JL: Exactly. I always worked in series. No matter what kind of language I was working in, I always worked in series. I started getting curious about how I got from one painting to the

other in a series.

CP: Okay. So you had gone from doing figures in your book to doing figures in your painting. You're thinking why you're going from one painting to the next and it's in a series.

JL: Well, let's say I wasn't working just figuratively with people. I was also working with objects. I'd always worked in a long series and I was fascinated with how paintings developed in a series. But suddenly I became interested in what happens between paintings. You couldn't answer that with a painting. It wasn't, what did I paint between these two paintings, it was what happens between these two paintings.

CP: To make this new organic difference.

JL: Not even being that logical. Let's say this. You work in a series of paintings, you have this painting, and you have that painting. You look at one, you look at the other, and you wonder, "What goes on between these two paintings?" I put up panes of glass with one painting behind the glass and another painting on another glass on shower door tracks and I would slide them and start painting an "in between" painting. I began to photograph those on Super 8 film. I began to get animations of what goes on between paintings.

CP: You mean the three-foot by four-foot shower sliding doors.

JL: I had gotten the rails for shower doors and I put four glass shower doors—

CP: Clear glass?

JL: Clear glass.

CP: Okay, so you're then painting on the glass—a flat, slick surface.

JL: Right. And you can photograph right through it—nearly transparent.

CP: These are like large stills, large slides, glass slides.

JL: These are full shower size doors because I was painting large.

CP: Okay. Two and a half feet by four feet.

JL: So I would put a painting on the wall, bring a shower door in, paint passages of it, bring in the next door with another painting on it, bring in another glass, paint passages on it, take away the painting in the middle, and you'd see the first painting, and two transitions. I would keep transitioning until I got to the first painting. I wasn't trying to be too literal, but I was trying to see what's happening between these paintings. And I got film. I had never done this before. When I took the Super 8 film and developed it, and when I got it back and I ran it on the projector, it was like, "Oh my God!" I was amazed.

CP: These were like five frame shots or something?

JL: No. Hundreds and hundreds of paintings on the shower doors that I kept erasing with Bounty towels and Q-Tips. I would paint for weeks and keep shooting.

CP: But the frames that you shot were like a ten-second shot or something.

JL: Nope. One frame. What I'd do is come in, paint, shoot, then do a couple of brush strokes, shoot again, do a couple of brush strokes, shoot again, then bring in the next one, and this thing would progress sometimes over months. Then I came up with these thirty-second, or one-minute animated films of paint.

CP: Do you still have those?

JL: Yeah. They were fascinating.

CP: One of those reels was at least three minutes, so you got three-minute reels.

JL: Absolutely. I accumulated about a half an hour of film. Now, what happened in the process was that I realized I did not want to spend the next twenty years doing this.

CP: What? Painting, filmmaking, or doing painting and filmmaking in the same way?

JL: I knew I wasn't where I wanted to be, but I was in the process I wanted to be in. What occurred to me was, not even using the word "brain" or "heart," you don't know where this comes from. I was tricking myself. It's not going to have this all logically figured out as we talk about it, but it gives me a chance to actually verbalize some of it. I had been a painter

since I was twelve or thirteen years old and I always identified myself as a painter. "I'm a painter. That's what I am. I'm a painter." What was happening was I was tricking myself out of being a painter into being something else. I wasn't really aware of it, but what had happened was that a whole set of reasons to be a painter were no longer valid in my mind. I was trying to find a way to keep my process going, but find a medium I was trying to express myself in. I wasn't really sure what it was. It wasn't that; it wasn't painting on shower doors. Then I moved from shower doors; I photographed the paintings into small cibachromes. I got onto a drafting table with glass. Now I had gone from three, four, five, six, seven feet high, down to this size. About six inches on glass. And I could work faster. Now I sped up the process and I was getting towards what I was going for. I started becoming really interested now in actually trying to animate specific characters. I'll be very straight about what the problem was, it still looked too much like, "experimental animation."

CP: So at this time you were familiar with animation. Animation had always been what? A passion, an interest, a sidebar?

JL: When I was a teenager, before I went to art school, the intention was to be a painter and an animator. When I got to art school, all the considerations of art got me concerned with painting. It hadn't clicked in my head at that time that you could actually animate art. Here's what didn't happen—I can think of this now, I couldn't think of it then. At sixteen or seventeen I didn't understand that you could actually make art animation. It just didn't register in my mind.

CP: You never took animation courses in art school?

JL: No. I had done animation, and I had done some film animation as a teenager, but my studies were sculpture and painting.

CP: And you say as a teenager, you mean in high school?

JL: In high school.

CP: So you kind of eventually evolved into the process of falling into animation. Now had you heard of people like Harry Smith for example . . .

JL: I hadn't. The only way to say this is undiplomatic because you have to follow your own sensibility. What happened was, I said a little earlier, when I was painting on glass and using the oil paint and shooting on film, the problem was it looked too much like experimental animation. I didn't want to do experimental animation. I had been to experimental animation festivals; I also began attending all the independent film showings at Millennium on Fourth Street. They showed a lot of experimental film and animation. I had been to all kinds of film festivals and looked at twenty or thirty of the top masters of experimental animation. I didn't want to do that. I wasn't interested in doing that. That's not the way my mind works. How my mind works I don't exactly know, but I can tell you how it's not working. If I'm in something that isn't working for me, I know it isn't me. I may like or not like something by Stan Brakhage, Larry Jordan, Lewis Klahr, Emily Breer, Robert Breer, Harry Smith or the Kutchar brothers, or any number of very well-recognized experimental filmmakers, and I just know it's not right for me. What I was thinking was like a cartoon, but art. My figurative paintings, they're like cartoon characters, but they're art—they're not really cartoon characters. They're painted characters. You saw it when people were appropriating cartoon imagery into art. That was making a big noise. I had always thought that was right—the right thing to do. I tried to do that in high school in 1964. I hadn't heard about people doing that, but I had been really influenced by this fellow who illustrated for *Mad Magazine*. I think his name was Don Adams. He drew this guy with big feet and the toes turned down when he walked—real goofy characters.

CP: Let me ask you a question. Were you into *Mad Magazine* as a kid?

JL: I was very much into *Mad Magazine*.

CP: It was a big influence.

JL: *Mad Magazine* was a big influence.

CP: Growing up did you ever see some Picassos, real Picassos?

JL: Absolutely.

CP: Oh, really? In Iowa?

JL: In New York. My family traveled a bit when I was growing up, and I did get exposure to art. But my influences came more from Hot Rod culture and cartoon culture, *Mad Magazine*.

CP: See that's my point about the Museum of Modern Art really being irrelevant. In reality, most people don't spend any time in front of a Picasso. You go to art school and you become indoctrinated in this way of thinking which is foreign to who you are. In reality, it's the culture of America which formulated all your aesthetics and not this other European-influenced aesthetic that you had no connection with whatsoever.

JL: Absolutely.

CP: So, for the fine art part, that was foreign in many ways to where you were going with the

Clayton Patterson

Jeffery Lerer

painting. On another level, there's a closer reality to who you are once you got into animation.

JL: When I was in high school I was very influenced by people like Big Daddy Roth.

CP: How about Duchamp? [laughter]. I'm sorry. Ok, that's true, Big Daddy Roth.

JL: And *Mad Magazine* and all of this. And I loved *Hot Rods*. I loved *Hot Rods*, but here's the thing. When I got to art school I kind of took that challenge and I said, "Can I do this?" Meaning, "Can I make art with a capital 'A'?" Again not realizing that that's a subjective word. At 18 or 19, even though I fought with teachers and I fought with the curriculum, I was still very influenced by this idea of a capital "A" art. My first forays into searching for a voice were really in the direction of formal abstraction. Now the irony there is that's what the galleries picked me up for and that's what I sold, incessantly. As soon as I stepped away from that and started to pursue what was truly my personal voice, those doors just shut like iron. Closed.

CP: Yeah, well it's totally artificial. It's buying into a lifestyle and creating an image of oneself when in reality it hasn't nothing to do with real art.

JL: It didn't have anything to do with my idea of what I needed to make as art. I would not say,

ever, and I really mean this, I would not say that it isn't real art, because that's as big a mistake.

CP: Oh, I mean, those are great paintings. I have nothing against Pollock and any of those people. I think that's the American end product and influence, but I think that whole concept that's in the background of that is nonsense. I think it's a trick and I don't think most people really have the reality of it.

JL: Well, I think what is nonsense, or instead of using the word nonsense, the problem is you obviously have very little room at the top. So not too many people can be preserved.

CP: It's like me trying to be the greatest French chef, because in reality I'm not French, and for me to be the greatest French chef there's a cultural aspect, there's born to the bones aspect

Clayton Patterson

Jeffery Lerer

too, that gets into the pure aesthetic. But without getting too far off on this, you've always sort of had this background influence and now all of a sudden it's starting to gel about 1986.

JL: Definitely a feeling I had not had before was that there was something out there on that horizon that I was steering towards. Definitely. But I knew that wasn't the medium yet. I kept experimenting with different ways of animating and different bits of material until I got into the step before the computer. It was that last step. I had built a multi-sided, multi-tiered box where I could animate all the different mediums I was animating in at the same time.

CP: So by this time you were pretty full-time into animation.

JL: Yes. Full-time animation—just really plowing at it. The time we're getting into, now around 1990, early '90s, I had one more one-man show. No, there were two. There was a gallery that picked me up here in New York, and I had two one-man shows with them. But my heart wasn't in it. My heart was in the animation. I had animation in the show on monitors and I was more interested in what was going on on those monitors than I was in the actual paintings.

CP: Are they monitors, or are they screens, because at this time you were still doing Super 8.

JL: I was doing Super 8 and video.

CP: The show that I saw of yours, which was probably '86-'87, it must have been one of those shows, there was like a film loop going.

JL: There was a video loop.

CP: Then why did I think of it as film?

JL: Because it was shot on film and transferred to video. It looked like film.

CP: Right. It did look like film. Ok, so that was '86-'87, the show that I saw. That was getting to be the end of being the fine artist, digging the painting, digging the drawing, it just started to switch straight over. So then you went from film and put it into video, then to computers?

JL: No, there's one step in between where I went directly to video and I built this micro-world

Clayton Patterson

Jeffery Lerer

of different walls and levels of mediums I could move simultaneously and end up with one image on video. It looked composited in a complex computer environment, but it was actually many levels and planes all moving at different synchronized times and shooting on one single frame capturing video camera. But I was capturing in moments. There was film rolling on a projector, onto a screen. Then there was another video camera that was capturing the image and projecting onto a monitor, it wasn't the same image, then there was a foreground with objects being animated, and then a foreground of glass being painted on. All of this was winding up on one single composite image.

CP: Right. You had two-dimensional painting going on, you had one of those flipping screens that go around, those glass screens that create sort of shadow animations. Then you had film loop going. Then this was trying to catch all of these on one surface with a video camera.

JL: I was capturing a fugue-like environment of four or five different time lines all moving into one time line so you could maintain four different patterns of rhythms. You could work in these mediums that had a definite push-pull between them. It was the same as painting as far as I was concerned, but just moving toward a medium that was making more sense to me. Then, I got my first little 3D animation environment. Boom. My head just went, "There it is."

That didn't exist before.

CP: So then in '88 all of the sudden you went, "click."

JL: It was the first time that a three-dimensional computer environment had been available to an individual on a limited budget. I looked at that. It had many problems. It was very slow, etc. But when I saw that, it was if what I had been thinking about in the '70s as a way I would like to work suddenly was in front of me. I was like, "Now that is going to do what I want to do." Once I made that move forward, within a year, two years after that everything was 3D computer image.

CP: Now at this time had you been teaching?

JL: No. In order to learn 3D computer animation, to begin with, I decided to go back to school. So I went to Pratt Institute in '90. Within a year of attending Pratt, they asked me to teach there, and that's how I started teaching.

CP: Within a year of going there as a student they asked you to teach there.

JL: Right. That's how I started teaching.

CP: By this time, I'm not very familiar with computers . . . but by '88 Apple had their computer out, you started to have a desktop computer system. It wasn't like University high level. By this time they were commercially friendly and animation was not.

JL: Let me get the chronology of this. By '89, the first powerful 3D computer animation programs were available for individuals on personal IBM compatible computer systems.

CP: Those are still pretty complicated.

JL: Not too difficult to run, though they were very expensive, very slow, but you could get the job done. But a relatively slow machine at that time. At that time it was considered very powerful. It cost about $10,000. It's funny when you think about it, because now, for $4,000, you can buy a system that is hundreds and hundreds of times faster. Literally. In the past thirteen years, I'd have to stop and figure out how many machines you would need to equal one machine today. Not to get into a big technical discussion, but today you get a 3D computer work station with de facto one Gigabyte of RAM—that's a thousand megs. A thousand megs, back in 1990 would have cost you $50,000. Now a thousand megs is just a few hundred bucks. Back then the first machine I got was a DX66. Now I have several Dual 2.5 gigahertzes.

CP: Now it's interesting too, because there's sort of a contradiction emerging. You were down in Mexico working as a worker-painter, along with all the craftsmen. Now you sort of switched over without really a technical background because you weren't studying computer sciences. You were taking art and psychology and things like that. You switched into a highly technical, very sophisticated, mathematical, computer-oriented technology—which is a big jump. The one thing about computers is if you leave one single decimal point out the whole thing is shmageggi.

JL: Well, thankfully, most of the work we do in three dimensional computer animation is not done in code. It's all done in a graphical user's interface. You're not really having to deal with code lines. You're just having to deal with relatively friendly user's interface.

CP: There's a huge learning curve for some one who doesn't start off with computers.

JL: I would say it took me about six or seven years to get to a point where I could get the movement and imagery I was after. People would be shocked by that, but they shouldn't be, because in painting, how many years does it take before you're actually on top of your paint?

CP: Thirty years to draw and one day to paint [laughter]. I don't know is that the answer [laughter]? One day, Jeffrey, one day.

JL: Look at that stroke, that uninhibited stroke. A gorilla could do that.

CP: To become really familiar with the tool and become really a master, it's a good seven years.

JL: It took me a good seven years until I was really able to get what I was after in terms of the complexity of the geometry. The plastic of it. The physical look of it. That would be the geometry and control of lighting and camera and textures, and then comes the animation, which is a whole other area that you need many years to get a feel for. I'll give you an exam-

ple. In commercial studios that do commercial animation, it's the basic belief that it takes seven years to become a first-seat character animator.

CP: Traditionally?

JL: Yes. About seven years.

CP: Really? Because that's all really straightforward. In the Super 8 animation, you get to see the process. When you're drawing on the film you get to see the process. When you're doing computer animation you really don't.

JL: Sure you do. In fact you see as much of the process if not more.

CP: Really?

JL: Absolutely. People who are not familiar with the computer environment make assumptions about that environment. It's very much like any other environment once you know it. It's not that different. I get a live, real-time preview of what I'm working on in the same way I get a real live preview of cell animation or claymation. The computer will give me live updates of real-time animation, especially now that I have a network that one of my systems is generating previews as I work. So I have real-time previews of what I'm working on as I work.

CP: But it takes you a year to do a minute.

JL: It takes a year to do five minutes. Now there's no question that if you're working with cell animation or claymation you work faster. The reason is that in computer animation there are so many more details.

CP: Everything has to be done. When you're doing cell animation everything is already there. But in computers you have to make the whole thing. There's nothing there in the beginning.

JL: And because it is computer animation you tend to work with much more complex imagery. One of the reasons I was drawn to 3D computer animation is that I did not want to abbreviate the look of what I see in my head. My problem with being an animator was you had to simplify so much in order to animate that I wasn't getting the imagery I was after. 3D can allow you to create a totally complex image and then animate it and not lose anything. The problem is the complexity. The machines are becoming that much faster, with much more memory. You're automatically working more complex and more complex.

CP: There's a reality finish to it you can't get with claymation or something. For example, if you want to do chrome, or make something airbrushed, or anything, if you want shimmering gold, you can just do it. Anything.

JL: Of course, for that reason you have to know what you're after and not be seduced into an endless experimentation of variables. For me, in many ways it was a plus coming to 3D animation when I was around 40, because I had all these plastic concerns before that. I knew what I was after and I knew what I was interested in. When I got a hold of the computer I was like, "How can I make this computer do this?"

CP: Here's a place where knowledge is important, and more sympathetic to the point of view. That is, you can now be educated in surrealism, and some of these different art forms, and take the part of it that intellectually fits with who you are, and use it with your real culture and who you are, and move the two together. So you did have an interest in abstraction and surrealism, and Dada, and some of these other areas, because you'd learned that at university. Now you were able to amalgamate and put together and mesh all of these different learnings. Your Big Daddy Roth, your *Mad Magazine*, surrealism; all these things you were able to work into one package and to how to be you, totally, and original to you, and your own voice.

JL: What you made me think about when you said that is that when I started painting when I was around ten years old, I was automatically drawn to surrealism and Dada. Through surrealism, I had found out about Dada and I had found out about Magritte, and that's where my fascinations were.

CP: My point with that was yeah, you can sort of intellectually learn it because you're getting if from a book, but the reality of the real objects, let's say Magritte's train coming through the fireplace or something, that's actually a painting and a real object. You don't really get the

true essence of that. But you learn the ideas.

JL: I know what you're saying, but there's something to pursue here. When you mention the Magritte painting with the train coming through the fireplace, there's something in my heart that knows when I truly connect with a painting, even if I'm not seeing the physical painting and I'm seeing a representation of the painting. It's the subject matter and I know I'm truly connecting to it. Other things I can appreciate and I can see the breakthrough of, and other things I don't appreciate at all, it doesn't matter who painted it. It doesn't really matter. When you truly connect with something, and I can't define this too many times or you'll lose the energy of it, but when I see something that works for me visually, it does something. There's some kind of third thing that happens.

CP: Oh yeah. I understand. What I'm saying is that there's a whole part of that culture, the real truth and reality of that person.

JL: Maybe this is the mystery of modernism in the sense that before there was always a job that artists had, and they were responsible for turning over portraits. They had to do things for the church, and they had to do things for patrons, and they had to do things for business—whatever, for somebody. In modernism, it may be the same controlling forces that are establishing and buying important art, but the direction of the artist is so much more diffuse. There are many more unexpected angles and tangents entering what is considered mainstream, or successful art, in many more unpredictable ways now.

CP: My point is, I think you're going to see the Museum of Modern Art not necessarily disassembled, but marginalized in the same way that Christmas is now winter vacation instead of Christmas holiday because they've sort of marginalized a lot of the major concepts that were in America. I think kind of like with the women's movement and the homegrown movement and the coming out of graffiti and Big Daddy Roth, and some the real true American culture, I just think you're going to see it marginalized. The whole importance of the Museum of Modern Art and that dominant main art concept, I think you're going to eventually see it go the way of the dodo bird. I think for a lot of the people outside the mainstream, for us in New York we're lucky, we can actually go to the Met and surround ourselves with this stuff, but in reality it's an illusion to anyone else who doesn't have access to the painting. Ninety-nine percent of the people going to art school are learning about art, but only seeing it in books. So I guess that's that part of the argument, but we should get back to the point. I hope we're not getting too far off there. It's interesting though. I think there's some major changes coming. The other thing is computers. Computers are accessible to everybody. You get the same program if you're in Austria as you do if you're in France or Hungary or Japan. There's a universal language there that didn't exist in painting.

JL: Well, no, it did, and that's why I don't want to maintain the separation between these media. You could buy the same cadmium red and the same brush in London as you can buy in New York.

CP: But the background knowledge is different. This is almost like a new world order. What one learns about the computer—you've got the same screen, the same language—you've almost got the same everything. Everybody is sharing.

JL: No. It doesn't matter, because you have to understand you can make that screen look like anything you want it to look like. The big difference is this: many newcomers to art making are coming directly into a computer environment. They have very little history, and very little knowledge and awareness of what has come before, and they don't particularly care.

CP: They just don't have the interest. I think a lot of people eventually reach into film animation or some of these other computer subjects, I think they come to it new.

JL: They do, and they come with very little knowledge of even commercial animation, for that matter, and as a result, many pick up that computer and that program and produce something that has more to do with what the software is able to do rather than being a reflection of what the artist has in mind. Someone can say, "You're being very critical." The fact is that I look at a lot of work that is generated by a computer, be it still art or animated art, and I'm very uninterested in what I see. At the same time, I see a lot of paintings I'm very uninterest-

ed in. That goes for all centuries. I can look at paintings across many centuries and I have no interest whatsoever. When I was asked to make a presentation in Los Angeles to an art teacher's association, they put me up in a hotel room and I was contemplating what I was going to talk about. I didn't want to be defensive about computer art versus other materials. On the wall of that hotel room were some of the most dreadful oil paintings you have ever seen. The next day that was one of my talking points. Those were oil paintings. They were on the wall. They were in my hotel room. They were the most dreadful things I had ever seen. So, we're not going to come at this from a question of defensiveness, but we're also not going to come to it from a position of new technology replacing history—it doesn't. You hand off information from one generation to the next. There's a lot of territory involved. There's a lot of anger. There's a lot of temperament and a lot of love. There's a lot of bickering about what

Clayton Patterson

Jeffery Lerer

should endure and what shouldn't endure. But you should feel a baton being handed off over time. When I see Rene Magritte, when I see Max Ernst, I feel a lineage.

CP: It's interesting, because also I look at your animations like the one you're working on now, and I can see that, but there's also a really heavy duty American influence. There's Edward Hopper. It has that whole feeling of loneliness and isolation. It has that whole aesthetic of poetry and desolation; angst. So that's the emotional quality to it, and there's a painterly quality to it. There's an art historic perspective that fits in there. That's why we can take yours and take a single cell, or call it a single shot, and just blow them up as paintings.

JL: That's true, and that causes me a lot of difficulty because I think I'm extremely dogmatic in the way I pursue things. I've seen a few of the still shots from my animations blown up large, and they work as objects on the wall. Now that I've been free of art objects on the wall for a number of years, to re-approach that causes me a lot of difficulty.

CP: Do you think it's selling out? Do you think it's diminishing the quality of the story? What is there about separating it into an individual piece that's difficult for you?

JL: It might be as simple as feeling the frustration of not having the right place to put them

up on the wall.

CP: So you're not against or alien to the concept.

JL: No. I'm not alien to the concept.

CP: I had a conversation this morning with someone about photographs, and a mutual acquaintance wanted to put up a show in a restaurant, and the photographer was just totally opposed to it for a lot of reasons. One of the reasons was that there's a chemical process that makes a photograph. So all of a sudden when you're in an environment that has fumes, vinegar, and different chemicals in the air, that's going to affect the photograph. Also, you don't get that single concentration of one image and the importance of it as an individual work of art. It gets lost in the ambience of the whole restaurant. There are a number of other reasons it would be understandable not to put a significant, single, individual work of art in a restaurant environment. What is there about the environments you've thought about before? Would you be alien to putting them in an art gallery? Putting them in somebody's house, or putting them on a theater marquee? What environment would work for those images? Would you want to escalate it up to high art and put it in some important museum?

JL: I don't think I have any pre-judgments on where these things would hang. If they were to be blown up and framed and put on any wall, I don't have anything against that at all. It's not from that point of view. It's from a point of view of how precious time is. What happens is this: every involvement that you bring into your studio is going to take time and care and bring you in contact with people. Every avenue that you investigate is going to take time and effort. There just isn't a lot of time, and there's always so much effort. If I start entertaining and blowing up these things, printing, and framing them, showing them, that's a whole other endeavor with a whole other direction. As it is, doing my animation, getting things out to festivals, and getting off the grant proposals is an absurd work week. If I were to suddenly open up the avenue of getting these things out in print and up on walls, it would be crazy.

CP: Okay, that makes sense. Just to interject here for a minute, teaching computer animation at the School of Visual Arts a couple of days a week takes a lot of time and effort. The other part of the time, you still have that working mentality that you come into the studio at nine in the morning and leave at five, and you take the half hour for lunch, and so that part of it you still adhere to. Though in order for you to switch into something else, it would be a total distraction.

JL: There's absolutely no time. If you do something and it has a certain interest to it and you put your feelers out there, you're going to connect somewhere, if you're intent on connecting. The question is, how much can you connect to? Right now, I'm so connected to trying to find a budget to bring in an assistant to help me with my production. I'm to the hilt right there. Now I have an idea in my mind as to an ideal, other than the fact that I'd like to have prints on walls; I like that. That's wonderful. But I have an idea of an installation in the *Gilbert Hotel* concept which would involve prints and preparatory drawings and story boards, working notes—build a whole environment. "Genesis the Gilbert Hotel." I'd love it. Give me a three-year time line. Give me my budget. I'll be back in three years and I'll install it.

CP: So if you got the budget, the help, the everything, it would still be three years to finish your *Gilbert Hotel*.

JL: Absolutely.

CP: How long have you been working on the *Gilbert Hotel*?

JL: Six years [laughter].

CP: Six years already. So this is really a long-term project. In doing this animation, you have a writer who's worked on the story line, you gave her the concept, she did the writing.

JL: Lisa Reardon did the story editing and collaborated in getting the story out of my head, onto paper and making it well structured. We would have story board meetings every month for a year. Mixing crafts brought about an interesting synergy. She is a novelist and I'm a visual time-base artist. Together we created a 3-D computer-animated screenplay.

CP: Now this is a writer who's been published and done well in the literary world. So you have that part of it, and then all the rest of it you've done—except for the music. You did go

through the long, arduous struggle of getting Charlie Mingus' music into the animation, which you've shown several times. It's received a number of grants and awards, and been shown in a number of festivals. In the six years, you've got how many minutes done?

JL: Ten.

CP: Ten minutes.

JL: Two releases. The next five minutes will hopefully be out in September. And then the next five minutes I'm hoping to have out by May 2004.

CP: A year from now.

JL: Yeah, at which point I'll be able to distribute half the story in a videotape release, or be able to program longer viewing slots for television.

Jeffery Lerer

Gilbert Hotel

CP: So that's the goal in the end.

JL: I think the overall goal is to somehow to finish the *Gilbert Hotel* in its entirety, and see it distributed as a videotape or film. In that process, I will probably come back to the installation environment concept and build an entire *Gilbert Hotel* installation.

CP: Ok, so once you get that all done, there will hopefully be opportunities to show it commercially, have it seen on television and possibly picked up, being able to have multiple people working on it, doing it as a production. But also you would then take the time and make it into a work of art, make the hotel into a 3-D kind of . . . environment . . .

JL: I look at it in terms of a work–in–progress environment where you would break out all the different aspects of what brought the *Gilbert Hotel* into existence. I think it would provide the viewer with a really interesting journey. One of my ideas about art making is that you're inviting the viewer to look over your shoulder and get glimpses of what it is you're fascinated with. I think that is one of the most fascinating things about art, that fragment of time the artist is allowing you to peep through a hole and say, "This is what I'm looking at." The Gilbert, in many ways, condenses a lifetime of concerns I've had. To be able to provide a view-

er with an environment of working drawings, journal notes, schematics, design of characters, test footage. I would think that's fascinating if I were to go see something like that. To see, in the end, what the Gilbert looks like. It may have been written, but the script is alive. What's happening is, as I work through the script, pieces move around and migrate to other places in the story, and then when the characters are actually acting, they start changing their own script, and when you bring in voice talent, that contribution from that voice talent also starts changing the script, and then just living from day to day changes the script. A normal movie you shoot in thirty days, ninety days, six months—that's a movie. This thing has been going on for six years.

CP: How painful is that? Or is that a consideration?

JL: On the one side, it's not painful at all; it's wonderful because I love what I'm doing. I don't feel frustrated that it's taking that long, but it's changing it because it's taking that long. I would love to have a crew of three to five people and we would knock this thing off in another year and a half. I would love to do that. If I had my choice, I would want to have the budget to have five people and get this thing out the door a year and a half from now. But I'm not frustrated. I'm getting somewhere and it's quite interesting to see what's coming out. You'll never know, but even if it were to be done faster maybe all these shufflings and changing the story would happen anyway, but in a much more compact time line. You'll never know. It's like painting. You have an idea of how you're going to paint, but that red doesn't work, so you push it back, and then it pops up somewhere else. That's what's happening with the script. I don't think it's any different from when I was painting on canvas or anything I do—it's all the same process. This is the most protracted, single, focused area that I've stayed within. You cover so little ground. Right now, I'm doing thirty seconds of a sequence where this woman picks up a cigarette and takes a puff from her cigarette and blows a smoke ring. It's going to take me six days to animate that. It took me weeks to model her and weeks to rig her so she's animatable. The environment that she's in took weeks. This thirty-second clip which will take me six days to animate, in order to get to the six days of animation I had to go through six or seven weeks of preparation. I fully acknowledge that what I'm working on is not attractive in the normal sense of a marketing concept.

CP: Why not? I mean it's got story line, it's got characters, it's got images to identify with, it's got music, it's got texture. It's got everything that would make good entertainment. You can concentrate on it and think about it. It has the possibility of following through and being made into multiples. Why don't you think it would be viable for a large audience? It's got emotions to it—feelings of isolation and desolation, difficulty and a hard life. You know, a lot of things that poetry and art has always been around. Kind of like Bukowski or something.

JL: Well, Bukowski lived most of his life out there in the alleyway. It was only in the last years that he was finally getting his recognition. He finally got his house and his BMW and he died of leukemia.

CP: But it has that tragedy attached to it.

JL: Yeah, so do the classics, and nobody reads the classics.

CP: Who's read *Gilligan's Island*? I have. [laughter]. No, actually I saw it on TV. But it has that film noir quality as well.

JL: It does, but I'm not going to get into a big rant about mainstream movie going by any means.

CP: It's not the grasshopper.

JL: It's enough to say there seem to be certain formulas in effect that studios are concerned with. One of those elements of the formula is that they want a very large box office return.

CP: Well, I guess I have hope in the changing of the institutions. I have hope in changing something like the Museum of Modern Art, maybe, if it doesn't become too marginalized, to the hope that television will get a little thicker in its aesthetic. Maybe it won't and maybe I'm wrong, but there has to be another place because I basically don't watch television anymore other than the news, and I think there are falling audiences. I think what's happening is that in the same way big museums can become marginalized, television is going to become mar-

ginalized. So there is a spreading out of aesthetics and finding pockets of people, and I do hope television gets to that point where it has more diversity like that. Occasionally you get something you find really interesting for a while, like *The Sopranos*, but then it got to be repetitive and short-lived.

JL: Now *The Sopranos* is enough of an attractive vehicle that large audiences will be drawn to it, but follow a couple of things about this. The series David Chase did before *The Sopranos* was called *I'll Fly Away*. *I'll Fly Away* was shopped to every television network. Nobody wanted to pick it up. Finally, he did get it made and it appeared on PBS, and it's an absolutely astounding story, which very few people have ever seen. He finished *I'll Fly Away* and it was amazingly successful as a vehicle, but not to an audience. Then he comes up with *The Sopranos*, and no network wanted to touch it. Finally HBO picked it up. Now it's not a thing so far out in the margin, it's a mainstream vehicle, but it's done very well, not as well-done now as it was originally, but it's done very well. But it's still a piece of mainstream entertainment.

CP: Yeah, add story line, content, and good casting. It had a lot of ingredients that made it commercial.

JL: Exactly. Now I'm saying, very simply, that the way I've constructed the *Gilbert Hotel* does not take into consideration these basic formulae. It does not comply to certain things that you're simply supposed to do to make yourself available to a large public.

CP: But you see, here's where we always argue. I guess in the end I'm always wrong [laughter]. I always thought that a lot of the video I have would certainly make television. Every time I try to get it out there, there's nobody else who's picked up on the idea. To me it always seemed like it was natural, it was sympathetic to the medium, and television seemed like the perfect vehicle. And that's where I said I'm always wrong because it never gets to that place where it seems to work. I don't know why. I think what's going to happen is eventually television will change enough that the material I have will become too moderate for television. They're able to do it somehow with the survival shows, and these other kind of shows, like eating pig uteruses on television now is pretty far out there. The thing Clinton did, or Kenneth Starr did for all these other Republicans, the thing that was so au contraire to that, was they introduced to the language words that follow words, that would never be introduced into literature. Vulgar words—here, all of a sudden he's getting semen, cigar in the vagina, fellatio, penis, penis identification, sperm identification, getting all of these subjects that are absolutely taboo into the front pages of the *New York Times* and being said by people like Dan Rather. You've got 100 percent in the mainstream with this use of language now on television, which is now totally bizarre. That's just far out. Then you've got people eating pigs' uteruses, or cows' uteruses just to stay on these "reality" shows and to try to make $1 million. So somehow the television mainstream has become so destructive and so alien to anything that's good that I can't see it doing anything but becoming eventually marginalized. I can't see how it couldn't work on television. My hope is that it would work on television, because where television is going now is just sort of into bizarresville.

JL: I don't think there's anything more bizarre in these reality shows than in the sitcom *Cheers*. In other words, it's a different bizarre. Do you remember that show, *Three's Company*? Do you know how many millions of people watched that thing? You look at the numbers and you know you couldn't watch that thing for more that one minute. The same thing with these reality shows. I can't watch these things for more than one minute. They're kind of fascinating at first because you can't believe they're doing it. As soon as you watch it you change the channel, because it's not watchable. This is my point. But I'm not part of the mass of millions of people that are drawn to these things. Whatever brought them to *Cheers*, whatever made them buy Barbra Streisand albums in the millions, whatever makes them watch these reality shows by the millions, I can't tell you. I'm not going to pretend I understand that. I'll say your ideas, what you think will work, works for you, but you don't have a clue when it comes to large numbers.

CP: That's true. If I look at the guy in the document that cuts off his fingers and toes, gruesome as that is, he has a point of view, an aesthetic, a reason he's doing it. You've talked to the guy.

JL: He's really intelligent.

CP: He's a smart guy and really informed. And so it's not some arbitrary decision, something that couldn't make it on television. It's something they would say is pornographic, but yet they're using all this other language and vulgarity that they're slipping in there. That's the confusion of it. These people are eating pig uteruses, for example, and that's not about any content other than to be on television and to try to make a million dollars, and to try and beat the other person. Hopefully you can eat twelve uteruses and the other person can eat three. This is total, total decadence. At some point we've gone from this Disneyland world to this total decadence with nothing in it of content. Like I said, the guy cutting off his fingers and toes might be just as bizarre, but there's a whole content to it. So in looking at this, where is the place your animation fits in?

JL: The place my animation fits in is I choose to be in my studio and concentrate on what fascinates me, and not spend too much time getting twisted around because of all that. Then what I do is, I do whatever I think is possible, within my abilities, to get my project out in the world.

CP: You've had theater showings, festivals.

JL: I can only do that. My position in this is that I work on what I think is interesting and then I try to find a way to get it out there. If I make one wiggle, and this is where it really does matter, I have been offered deals from the studio people, if I mainstream it. "If you're willing to mainstream this concept, we will back you." That's the difference. It's not that I'm trying not to be successful. It's not that I'm trying not to be mainstream. I just don't see that way. It's not that I can sit here and define mainstream for you, but I know what it isn't. Here's what happens. I do this: "Wow, that's fascinating." They come and say, "If you're willing to tilt this four degrees, we'll back you." But if I tilt it four degrees, it isn't what it is anymore.

More Than a Few Words:
Amos Poe Speaks The Truth

From an Interview by Jeremiah Newton

Amos Poe is an instructor at the prestigious New York University's Tisch School of the Arts, The Maurice Kanbar Institute of Film and Television. An extremely popular instructor who dresses in black, he cuts a rather glamorous figure while striding down the hallowed halls of academia. Amos has a real passion for filmmaking, and uses his vast experience to answer the many questions asked by NYU's young film-makers-in-training. Recently we had a discussion about his career as a filmmaker who has lived for over three decades on the Lower East Side.

Jeremiah: Let's talk a bit about the past and your connection to the East Village and the Lower East Side.

Amos: I moved here in December of 1972 to St. Mark's Place. At that time, I was making Super-8 experimental, music-driven—almost like music videos for 4 years. I was, basically, self-taught and had a few ideas about making narratives.

Jeremiah: What are the circumstances surrounding the purchase of your first camera?

Amos: I bought my first Super 8 camera in December of 1968 during a big three-month depression. I had gotten kicked out of college in Ohio along with my best friend where we both were on a sports scholarship. He immediately enlisted in the Army and was sent to Vietnam, where he was all of eight days there before getting killed. I felt guilty, as I had convinced him to take an acid trip while we were play-ing baseball and for this, we had lost our scholarships. Depressed beyond belief, I enrolled in another college, the State University at Buffalo, but never attended any classes, and eventually dropped out. One night I was visiting a friend and saw a guy sitting in a kitchen with two Nizo Super 8 cameras. I asked what they were and what they did, and he said, simply, "You can make movies with them." It turned out that this guy bought technology for a living—I remember that he had two of the same cameras, always two of something, and he always took one apart to see how it was constructed and how it worked. At the time, I was interested in photog-raphy, and what he had to say hit me like a bolt of lightning. "You can make movies with them." I decided to buy a camera, and drove to New York City, traded in all my photography equipment and bought a Super 8 Nizo, and all the additional equipment to go with it. I had no fucking idea of what I was doing!

Jeremiah: What was your first project?

Amos: I made a number of little films for each song on the Beatle's White Album. At the time, I was still living in Buffalo in a fantastic apartment and paying only $45.00 a month rent. I worked in an art house as a ticket-taker, and watched all the programs carefully, and became very familiar with French cinema, especially the Nouvelle Vague movement, Howard Hawks, the Italian Neo-realism, etc. I left the job by 1972, got married, and moved to St. Mark's Place.

Jeremiah: What was the film scene like then?

Amos: Very rich. You had people like Andy Warhol, Jack Smith. And the Millennium, where I went religiously every Friday night and screened my Super-8 films and watched other filmmakers' work. There were three main filmmakers whose work shaped my vision as a filmmaker: Godard, Warhol, and Cassavetes. They gave me examples of what I could do with my limited resources. I began to work as a film editor in a 16mm

Clayton Patterson

Jeremiah Newton and Amos Poe at Cantor Film Center

porn company called "The Fuck Factory." I learned a lot about editing there, but it ruined my sex life.

Jeremiah: What else did you do?

Amos: I was the sixth or seventh person hired for a new company on University Place and East 13th Street called New Line Cinema. They released films like *Pink Flamingoes*. To keep my overhead low, I became the super of two buildings on 15th Street. I didn't want to pay rent, as I wanted to make films. This allowed me to save some loot.

Jeremiah: Who were some of the people you met in the East Village scene?

Amos: I met Richard Hell who had a band. Another friend was Ivan Kral; and we decided to make a music film using my new camera, a Beaulieu, and a windup Bollex. I made some experimental shorts using pieces of film liberated from defunct 16mm prints that was stored in a closet at New Line. I guess you can say that my films were in the Brackhage mold. There was no budget. Now, as far as the music film went, Ivan and I decided to shoot it at a new place on the Bowery called CBGB's where I shot performances by Patti Smith, the Talking Heads, the Ramones, Blondie, Wayne County, Richard Hell and the Heartbreakers. Ivan and I shot for two hours without sound. To get that, Ivan and I used demos. Transferred them to a 1/4 tract, than and synced and transferred them to 16mm. This was my film, which became my first feature, *Blank Generation/Dancing Barefoot*. But first, in order to edit it, I rented the Maysles Brothers editing room for 24 hours for the incredible amount of $25.oo. We edited I on the original black and white reversal, and stayed in the cutting room for 24 hours from 3:oo p.m. in the afternoon to 3:oo p.m. the following day. But we were done. Bleary-eyed and wasted, we carried it to DuArt, and told them that I needed a print of this film right away. The cost was $250.oo, and we just didn't have the full amount.

Jeremiah: What did you do?

Amos: The owner of CBGB's, Hilly, told Ivan and I that the film could open for Richard Hell's band the following weekend. Now, I had $140.00 in my checking account, and told DuArt that I would give it to them, and give them the remainder if they would let me take the print from them and screen it. They agreed. Well, we made 25 percent of the door, or roughly $600.00 from the 3 or 4 shows at CBGB's. I was able to look DuArt straight in the eye, and pay them what I owed. Now, I thought, I'm a professional filmmaker!

Jeremiah: What were some of the thoughts going through your mind at the time?

Amos: Delusions of grandeur. I had the idea in my head that Ivan and I would single handedly recreate the Nouvelle Vague movement of France in the Lower East Side. You see, I wanted to re-make *Breathless* in New York City. My ego and enthusiasm and obsessiveness and imagination were driving me to new heights. I was relatively insane! So, I began to shoot a film that took place on the Lower East Side, still managing to save money by not paying rent. By then, I had between $4,000 and $5,000 in the bank. The film was called *Unmade Beds* and it starred an actor by the name of Duncan Hannah with a support

Clayton patterson

Amos Poe 2003

from Patti Astor, Eric Mitchell and Debbie Harry.

Jeremiah: How did you cast it?

Amos: I put an ad in the Village Voice looking for actors and a crew. I was able to get help from a place located in Spanish Harlem that was government funded. They had a lot of equipment that they were just sitting on. I made *Unmade Beds* in the spring/summer of 1976. I loved all things French and wanted to "French-ify" modern-day bohemianism on the Lower East Side. Anyway, the film was sent in 1977 to Cannes and then Deauville. It was successful and sold in France. My next film was *The Foreigner*, which I shot in 1977. With this film, I wanted a strong structure of a beginning, a middle and an end. This, I believed, would be the quintessential Lower East Side movie, which I shot in black and white.

Jeremiah: What was going on in your life at the time?

Amos: My marriage had broken up and my wife had a series of nervous breakdowns, and I found myself a single father alone raising my daughter. It was the best of times and it was the worst of times.

Jeremiah: Did you consider leaving New York?

Amos: Never. The East Village/Lower East Side was so conducive to filmmaking. For one, you had cheap rent. For another, you had the Millennium and Rafik on Broadway. The other side of the Lower East Side during the mid '70s, was that it was a drug bazaar. Pot, speed, heroin. Anyway, I returned from the Deauville Film Festival and found myself homeless. By then, my wife was better and had taken my daughter upstate where they both now live. One night, I was told that a guy named Steve Mass was looking for me, so I called him, and it turned out that he was living in a duplex on 8th Street, and wanted to work with me. I explained that I hadn't anywhere to stay, and he offered me the upstairs part of his duplex. We formed a company and named it Mud Films because our films looked like mud.

Filmography

1. NIGHTLUNCH (1975)
2. THE BLANK GENERATION (1976)
3. UNMADE BEDS (1976)
4. THE FOREIGNER (1978)
5. SUBWAY RIDERS (1981)
6. ALPHABET CITY (1984)
7. ROCKET GIBRALTAR (1988)
8. TRIPLE BOGEY ON A PAR 5 HOLE (1991)
9. JOEY BREAKER (1992)
10. DEAD WEEKEND (1995)
11. FROGS FOR SNAKES (1999)
12. STEVE EARLE: JUST AN AMERICAN BOY (2003)

Jeremiah: What then?

Amos: Anyway, Steve had some serious issues with alcohol. I'd give him an idea, then another, then another, and it went that way for months without anything actually ever getting done. Finally, I told him he wasn't a filmmaker, and since he drank so much, that he should open up a bar. He loved the idea and we thought of bar names such as Graceland, and Diego Carting, and finely settled on the name Baader-Meinhof. But the liquor authorities wouldn't give him a license using that name. You see, in order to incorporate, you need the right name and not one named after a gang who had murdered and terrorized Germany. Steve called me, and said that for 2 percent of the door, he wanted to name it the Mudd Club. And that's how the Mudd Club was named. Anyway, I earned between $70.00-$80.00 a night, but in order to get the money, I had to go there at closing time. And that's another story! In closing, the East Village and the Lower East Side was always so full of energy and ideas and conducive to filmmaking that it schooled me. I got to know my area very well and learned that New York City was about neighborhoods; places where I could screen my films and meet other filmmakers. As a filmmaker, I shot my films in the neighboring streets, and for all these wonderful things, I am grateful.

Jeremiah: Ditto!

No New Cinema:
Punk and No Wave
Underground Film 1976—1984

by Harris Smith

It's a classic piece of Lower East Side urban mythology. Sometime around 1977, a dealer in "gray market" goods, know as Freddy the Fence, on East Houston Street, acquired a case of new Super 8 Sound cameras. When members of the neighborhood's then thriving but still very underground punk music and arts scene got wind of this, they leapt at the opportunity to get their hands on these cameras for cheap, and the result was a nearly five year boom in underground filmmaking on the Lower East Side. This brief movement, which had no particular name but is sometimes referred to as "No Wave" (after the underground music scene it shared many players in common with) or "New Cinema" (after a short-lived screening room on St. Mark's Place run by several filmmakers on the scene), remains largely unknown, and yet had a significant impact on both underground film, spawning the "Cinema of Transgression" (Beth B, Richard Kern, Nick Zedd, Tessa Hughes-Freeland and others) and the notion of mainstream independent film in New York (Jim Jarmusch, Tom DiCillo, Steve Buscemi, Vincent Gallo).

By the time Freddy the Fence made the scene, a young Israeli-born filmmaker named Amos Poe, along with Czech-born Patti Smith Group bassist and Iggy Pop guitarist Ivan Kral, had already taken a movie camera to the neighborhood's punk scene with *The Blank Generation* in 1976. Poe's first film is composed of silent 16mm footage of bands playing at CBGBs accompanied by music from the bands' records (including some earlier versions of songs that would later show up on popular records, and rarer tunes like Television's *Little Johnny Jewel*). Among the artists featured are some of the seminal punk bands of the era, many poised on the brink of mainstream popularity, like the Patti Smith Group, the Ramones, the Talking Heads, and Blondie, as well as more esoteric but still legendary acts like Television, Richard Hell and Wayne County, and several more obscure bands like the Marbles, the Tuff Darts, the Miamis and the Shirts. Lacking synch sound, the film is more document than documentary (a more "professional" but less intimate and musically diverse portrait of the CBGB's scene, *Punking Out* (1977) exists, but remains more obscure and harder to find than Poe's film), yet the dedication to the scene, sharp cinematography and interesting stage footage between musical numbers suggest a talent that would become more evident in Poe's three major underground feature films, *Unmade Beds* (1976), *The Foreigner* (1978) and *Subway Riders* (1981), as well as his more mainstream work, like *Alphabet City* (1984) and the underrated *Frogs For Snakes* (1999). *Unmade Beds* and *The Foreigner* typify the kind of work to come from the filmmakers on the scene. In *Unmade Beds*, downtown painter Duncan Hannah plays a photographer in contemporary New York who believes he is a character in a French New Wave film. Poe cleverly uses French-looking architecture and street signs to create the façade. The cast includes such luminaries of the scene as Patti Astor (a regular in underground films of the

time), Debbie Harry of Blondie and French-born filmmaker Eric
Mitchell. Mitchell takes the starring role in *The Foreigner* as Max Men-
ace, a secret agent from an unnamed country who arrives in New York
on an unspecified mission and finds himself in the midst of undefined
mystery and intrigue. In one of the films more memorable scenes,
Menace is attacked and slashed with a razor (for real, according to
Mitchell) by the Cramps in the bathroom of CBGB's while the Erasers
play onstage. Also in *The Foreigner* are Duncan Hannah, Patti Astor,
Debbie Harry, photographer/singer Anya Phillips and Poe himself. Poe
also appeared in Edo Bertoglio's film *Downtown 81* with Jean-Michel
Basquiat, Eszter Balint, Debbie Harry, David McDermott, John Lurie and
many others from the downtown scene. The film, written by Glenn O'
Brien (a writer for *Interview* magazine and the host of *TV Party*, a
cable access showing focusing on the downtown punk and art
scenes), remained unfinished until the late 1990s, when it received a
brief theatrical release. Much of the original sound was lost, so the
late Basquiat's voice had to be re-dubbed by poet Saul Williams.
 Alongside Poe, Mitchell proved one of the major players in the
downtown film scene. Like Poe, his work was infused with the ener-
gy of the punk and underground art scenes, influenced by the
French New Wave and the American underground films of Andy
Warhol and Jack Smith, and dealt with issue of displacement and
alienation. One of the earliest Super 8 films of the scene is Mitchell's
Kidnapped (1978). Stylistically similar to Andy Warhol's early films (it
particularly resembles *Vinyl*, Warhol's pre-Kubrick version of *A Clock-
work Orange*), *Kidnapped* is essentially centered on the personalities
of a group of people gathered in a room. It is technically primitive,
consisting of several rolls of Super 8 sound film spliced together,
with the only cuts the splices, and the film ending when the last roll
runs out. There is no post-production sound, so all the music is
played on an on-screen tape player. In many shots, the script can be
seen taped to the wall behind the actors, who include Patti Astor,
Anya Phillips and Duncan Smith. The personalities of actors, com-
bined with Mitchell's scenario make the film work. Far more techni-
cally accomplished is Mitchell's *Red Italy* (1979). A noirish film, it
uses locations like the Lower East Side, Coney Island and the
Chelsea Hotel to recreate a punkishly reimagined postwar Europe.
Jennifer Miro stars as a bored, rich woman who falls first for an
American G.I., then a communist worker. Also in the cast are Patti
Astor, Rene Ricard, James Nares, Mitchell himself and a band consist-
ing of the likes of John Lurie (of the Lounge Lizards) and Arto Lind-
say (of the band DNA) playing a cool, ragged cover of Gene
Vincent's *Be Bop a Lula*. Mitchell's best-known films are *Underground
USA* (1980) and *The Way It Is* (1982). The latter is a remake of *Sunset
Boulevard* by way of Warhol/Morrisey's *Heat*. Mitchell stars as a
down and out hipster hustler who hooks up with an aging movie
star played by Patti Astor. Also in the cast are Rene Ricard, Cookie
Mueller, John Lurie and Taylor Mead. *The Way It Is*, Mitchell's last fea-
ture to date, features the first major film roles for Steve Buscemi
and Vincent Gallo, who also composed and performed (and released
on his own record label) the film's score. In addition to his prolific
work as a filmmaker and actor, Mitchell proved to be something of a
leader to the "No Wave" film scene as well. In 1979, along with
James Nares and Becky Johnston, he created the New Cinema, a
video screening room on St. Mark's Place dedicated entirely to show-

ing underground films. Although the venture didn't last more than a year, it provided many underground filmmakers of the time with an opportunity to actually get their work seen, and many others with an opportunity to actually see it.

Mitchell's New Cinema cohorts, James Nares and Becky Johnston, were filmmakers as well. English-born Nares, who played in seminal No Wave band the Contortions and the Del-Byzanteens (with filmmaker Jim Jarmusch, Phil Kline, Phillipe Hagen and author Luc Sante), was one of the less prolific filmmakers of the time, but one of the more creative. His *Rome '78* is perhaps the most epic film of the No Wave scene, a no-budget retelling of the story of Caligula. Shot around various old looking NYC locales (and some not so old looking ones, like graffiti strewn downtown alleyways), the film makes light of its budgetary limitations, flaunting them with punk rock defiance. In some scenes, actors can be seen wearing wristwatches, and often in the exterior shots cars can be seen driving by in the background. As much as any other film of the time, *Rome '78* works, because it is not afraid to not take itself too seriously, yet remains within the framework in a fairly serious film. The cast includes Eric Mitchell, David McDermott, Anya Phillips, John Lurie, James Chance (of the Contortions) and Lydia Lunch (of the band Teenage Jesus and the Jerks). A documentary, *No Japs At My Funeral*, in 1980, and a rather brilliant avant-garde Super 8 short "Waiting for the Wind," in 1981 followed *Rome '78*. Nares also shot Becky Johnston's *Sleepless Nights* in 1980. Johnston would go on to find success in the world of mainstream film writing screenplays for the Prince movie *Under the Cherry Moon* (1986), as well as *The Prince of Tides* (1991) (for which she received an Oscar nomination) and *Seven Years in Tibet* (1997). James Nares, on the other hand, mostly retired from film in the early 1980s and has found success as a painter. He appeared in the short film *Modern Young Man* with Bill Rice and filmmaker Tom Jarmusch in 1999.

Another prolific director of the New Cinema was Irish-born Vivienne Dick. Her films include *Guerillere Talks* (1978), *She Had Her Gun All Ready* (1978), *Beauty Becomes the Beast* (1979), and *Liberty's Booty* (1980). Dick's work tended towards the abstract, more so than many of her contemporaries, but was no less engaging and energetic. Like many filmmakers of the time, she drew upon the underground music scene of the Lower East Side, both in terms of energy and the performers themselves. Lydia Lunch (Teenage Jesus and the Jerks, Eight-Eyed Spy) was a frequent star of her films, as was Pat Place, guitarist for the Contortions and Bush Tetras. The two were teamed in one of Dick's best films, *She Had Her Gun All Ready*. In the movie, Lunch stalks Place from the East Village to Coney Island and eventually kills her. The film utilizes its performers and New York locales to create a thrilling atmosphere, despite the fact that very little actually occurs during the course of the narrative. Vivienne Dick continues to make films and videos today. She currently resides in Ireland.

Developing around the same time as New York's punk and No Wave music scenes were hip-hop, break dancing and graffiti culture. Filmmaker Charlie Ahearn came into contact with this bourgeoning movement while shooting his Super 8 martial arts epic *The Deadly Art of Survival* around the projects of the Lower East Side in 1979. After finishing the film *Twins* in 1980, Ahearn turned his camera

towards the hip hop scene, first shooting a video of New York's first hip hop convention, then with the 16mm feature film *Wild Style* (1982). In the film, Ahearn drew upon the film-making principles of the No Wave scene (as well as some of its performers, including Patti Astor, Bill Rice and Blondie's Chris Stein, who contributed to the musical score) but remained firmly dedicated to presenting an accurate and authentic portrait of hip-hop. The film's star is Lee Quinones, a real-life graffiti artist who, in part due to his connection with Ahearn, found some success on the downtown art scene. Among the musicians featured in the film are Fab 5 Freddy, Grandmaster Flash, Cold Crush Brothers, Double Trouble, and several other legends of the early New York hip hop scene. Upon its release, *Wild Style* played to packed audiences on 42nd street for several weeks. Despite its success, Ahearn turned from narrative film to painting and video art for most of the 1980s and 1990s, creating a video journal through the window of his Times Square apartment in *Doing Time in Times Square* (1991) and an acclaimed series of artist portrait videos. In 1999 he returned to feature film with *Fear of Fiction*. In addition to his films, Ahearn was, along with his twin brother, John, active in the art world as a member of Collaborative Projects, the artists collective responsible for many legendary shows around New York City, mostly famously the Times Square Show in 1980.

Also active in Collaborative Projects were husband and wife team Beth and Scott B (since divorced). Together and separately, the duo's dark, abrasive cinematic style and harsh thematic content were instrumental in the genesis of the Cinema of Transgression, a mid-1980s wave of low-budget Super 8 and 16mm filmmakers influenced by the New Cinema and punk scenes, but more focused on films centered around explicit sex, graphic violence and other shocking images. Together, Beth and Scott B made the films *Black Box* (1978), *G-Man* (1978), *The Offenders* (1979), *Letters to Dad* (1979), *The Trap Door* (1980), and the feature film *Vortex* (1983), frequently casting Bill Rice and Lydia Lunch as well as such underground figures as author Gary Indiana, Ann Magnuson (of the band Bongwater), filmmaker Jack Smith, Adele Bertei (of the Contortions), John Lurie, Evan Lurie, Walter Lure (of the Heartbreakers and Richard Hell and the Voidoids), Pat Place, designer Anna Sui, actor James Russo and even character actor Dick Miller, a regular in the films of Roger Corman. On his own, Scott B made the Super 8 shorts *The Specialist* (1984) and *Last Rights* (1985). Beth B, meanwhile, has continued to make films and videos in a variety of medias, from avant-garde shorts like *Belladonna* (1989) and *Thanatopsis* (1991) to narrative features like *Salvation* (1986) and *Two Small Bodies* (1993) and documentaries like *Visiting Desire* (1996) and *Breathe In, Breathe Out* (2000).

In addition to these principal players, many others were making films around the fringes of the No Wave/New Cinema scene:

Musician/actor John Lurie directed the hilarious 1980 Super 8 film *Men In Orbit* in which he and Eric Mitchell play chain-smoking astronauts, as well as a remake of *The African Queen*

starring James Chance and taking place entirely in Lurie's bathtub. Swedish-born Anders Graf-strom made the 1980 Super 8 feature film *The Long Island Four*. A success on the underground film circuit, *The Long Island Four* was based on a true story about four Nazi spies who landed in New York in 1942, but found more interest in the local nightlife than in their original mission. The cast includes David McDermott, Patti Astor, future *Sixteen Candles* star Gedde Watanabe and electronic music pioneer Klaus Nomi, many of whose early performances were filmed by the director. Sadly, Grafstrom was killed in an auto accident shortly after finishing *The Long Island Four*. Some of his footage of Nomi was used in the 1980 video *Mr. Mike's Mondo Video*.

Collaborative Projects artists Michael McLard made films of the Contortions in concert in 1978 and a short called *Alien Portrait* in 1979. McClard was also a co-founder of All Color News and Communication Update, two early cable access documentary programs rooted in the downtown arts and punk scenes. Also making films on No Wave bands was Paul Tschinkel, who shot footage of Lydia Lunch's Eight-Eyed Spy in 1980 and Arto Lindsay's DNA in 1981.

Future music video director Michael Oblowitz made the feature *King Blank* in 1983, towards the end of the No Wave scene. The film, starring Ron Vawter (later in films by Jonathan Demme and Steven Soderberg) and Will Patton (later a character actor in many Hollywood films), is notable mainly for its unrelenting willingness to be unrelentingly negative and unpleasant. Oblowitz later directed the mainstream indie *This World*, and *Then the Fireworks* (1997), based on a novel by Jim Thompson, as well as several direct to video films like *On The Borderline* (2000), *The Breed* (2001), and *Out For A Kill* and *The Foreigner* (no relation to Amos Poe's film), both from 2003 and both starring Steven Seagal.

Bette Gordon had been making short films throughout the 1970s, and made *Empty Suitcases* (1980) and the acclaimed feature *Variety* (1985) around the No Wave cinema scene. *Variety* starred Will Patton, photographer Nan Goldin and character actor Luiz Guzman and featured an excellent jazz score by John Lurie. Gordon taught film classes at Columbia and directed for tel-evision throughout the late '80s and '90s, then returned to feature filmmaking in 2000 with the mainstream indie *Luminous Motion*. Gordon's then husband, Tim Burns, from Australia, was also active in the downtown underground film, video, theater and art communities. Together, the two made the video *What Is It, Zach?* in 1983.

Like Bette Gordon, filmmaker Lizzie Borden drew heavily upon feminist themes in her work. Borden's 1983 feature *Born In Flames* was one of the most ambitious feature films to come out around the edges of the New Cinema film scene. Shot on a miniscule budget, *Born In Flames* takes place 10 years in the future, after a peaceful Socialist uprising. The film chronicles the story of a group of feminist revolutionaries who, dissatisfied with the treatment of minorities of the new regime, rise up against it. In the cast are Becky Johnston, Adele Bertei, Ron Vawter, performance artist Eric Bogosian and Kathryn Bigelow. Bigelow, then active in the downtown arts scene, would soon go on to direct her own feature film *The Loveless* (1982), which was Willem Dafoe's first movie, then more mainstream films like *Near Dark* and *Point Break*. Lizzie Borden, meanwhile, would go on to make the award-winning feature *Working Girls* (1986) and the controversial mainstream indie film *Love Crimes* in 1992.

Lizzie Borden and Bette Gordon both also directed episodes of the late 1980s television hor-ror anthology program *Monsters*, as did filmmaker Sara Driver. In 1981, Driver made *You Are Not I*, based on a Paul Bowles short story and starring Suzanne Fletcher, Evelyn Smith and Luc Sante. The movie was well received by the underground. Driver's co-writer, co-producer and cinematographer was Jim Jarmusch, who also shot her ethereal 1985 feature film *Sleepwalk*, also starring Suzanne Fletcher, with Ann Magnuson, Steve Buscemi, Bill Rice and future *Candy-man* star Tony Todd. Driver's most recent film is *When Pigs Fly* (1996), co-produced by Jar-musch and starring Alfred Molina, Marianne Faithfull and Seymour Cassel, and featuring music by Joe Strummer of the Clash.

Jim Jarmusch was another figure on the edges of the New Cinema. He had played in the Del-Byzanteens with James Nares and worked on Eric Mitchell's *Red Italy* before he shot his first feature, *Permanent Vacation* in 1980. Ostensibly his NYU graduate thesis project (the university refused to graduate Jarmusch because of the film's length), *Permanent Vacation* (for which Sara Driver was a production manager and assistant director), is a definite by-product of Jarmusch's involvement with No Wave film. The themes of displacement and alienation resonated from the

works of Amos Poe and Eric Mitchell, who also appeared in the film along with Driver, John Lurie, Evelyn Smith, Chris Parker and Frankie Faison (later in mainstream films like *C.H.U.D.*, *Manhunter*, *Silence of the Lambs*, *Hannibal* and *Red Dragon*). While attending NYU, Jarmusch studied under legendary filmmaker Nicholas Ray (*Rebel Without a Cause*). In 1979, German New Wave filmmaker Wim Wenders came to New York to make a film with and about Ray, *Lightning Over Water*. Jarmusch's contact with Wenders proved significant, when the German filmmaker gave Jarmusch some left over 35mm black-and-white film stock from *The State of Things* (1982) to shoot the short *The New World*. *The New World*, about a Lower East Side hipster (John Lurie) and his best friend (Richard Edson, of the bands Konk and Sonic Youth, and later in *Ferris Bueller's Day Off*) who receive a visit from the hipster's cousin (Eszter Balint), became the first section of Jarmusch's second feature *Stranger Than Paradise*. Released in 1984, *Stranger Than Paradise* was a critical and commercial success.

New York independent film, once firmly rooted underground, would be increasingly brought into the mainstream, with films like Spike Lee's *She's Gotta Have It* (1986) finding similar success as *Stranger Than Paradise*. Soon, independent films from all over the country would become more and more popular. The scene really broke in 1989 with Stephen Soderberg's *Sex, Lies and Videotape*. What had started in the Lower East Side's punk underground had reached the American popular culture mainstream. Independent film companies began to get bought up by major Hollywood studios, and increasingly independent films began to resemble miniature versions of their bigger budgeted counterparts, rather than as an outlet for new voices and visions. In New York, the film community became increasingly fragmented. Today, there is little unity among young filmmakers in New York City. The rising cost of filmmaking, competitiveness of the post-indie world of film, discontinuation of Super 8 sound film by Kodak and the lack of a unifying scene to unite people have resulted in an increasing focus on the work of the individual, as opposed to a community of filmmakers working together. Meanwhile, the work of the No Wave scene has remained more or less ignored by the mainstream. Recently, however, Amos Poe's *Blank Generation*, *Unmade Beds* and *The Foreigner* have been released on DVD. Hopefully, young filmmakers will see these films and want to find out more of what they're all about. Perhaps these young filmmakers will discover the work of the No Wave, and see how much power a community of artists working together can have. And, perhaps, if this happens, the underground will go back underground and begin again.

No Wave Cinema, 1978—87
Not a Part of Any Wave: No Wave

by Matthew Yokosbosky

No Wave Cinema emerged in the late 1970s out of New York City's East Village, in the aftermath of the punk movement's angst and alienation. Against settings of New York's buildings and bleak interiors, performances were photographed in the harsh black-and-whites and acid colors of the newly introduced Super 8mm sound film.[1] The soundtracks combined sharp dialogue, often reminiscent of Bette Davis's carefully clipped phrases, and No Wave music—a strident form of music that synthesized scraping guitars, jazz-like improvisation, and accelerated vocals. Thematically, No Wave films were equally cutting edge, incorporating aspects of the performance scenes and social issues prominent in the East Village's underground terrain: the idea of role-playing and the themes of law enforcement/investigation and pro-sexuality feminism. By embracing these nontraditional film aesthetics and subjects, often with frank and graphic portrayals, No Wave Cinema became a vanguard movement which altered the course of film history.

No Wave film and, later, video productions incorporated aspects of the documentary, B-movies, and earlier avant-garde film aesthetics. The documentary approach was used to make records of people in theatrical/club performances and to create establishing shots, typically of New York City itself: 42nd Street, the Mudd Club, the East Village. The use of existing or minimally constructed settings and costumes was a common trait of the low-budget B movie, one also employed by No Wave filmmakers. For example, in John Lurie's film about space travel, *Men in Orbit* (1978), silver spray-painted television sets and bucket seats represent Mission Control. The inventiveness of the No Wave movement extended also to the photography and editing of the film itself, in ways that recall two earlier avant-garde movements: Cinema Descrepant, developed in France in the 1950s, whose characteristics included rephotography from magazines and television and sound-image dis-coordination, and Baudelarian Cinema, an American movement of the early 1960s, which cultivated casual filmmaking through improvised acting and lack of editing, resulting in extended film sequences that often exceeded their expected duration.[2]

Though the production aesthetics gave No Wave Cinema its distinct visual appearance and sound, it was the movement's turn toward narrative that redirected the history of avant-garde filmmaking. By the mid-1970s, avant-garde film and videomaking were focused on the primarily nonfigurative movements of Conceptual Art, Minimalism, and Structural Film, as centered around the activities of Anthology Film Archives—an organization which charted the evolution of film primarily in terms of abstraction and the crafts of cinematography and editing, as distinct from commercial filmmaking.[3] Conversely, the No Wave filmmakers, who were children of the 1950s and the first generation of artists to grow up with television, viewed film as the perfect medium to tell the stories that were not told in mainstream cinema—sto-

ries perhaps too personal, too real, too honest for the general public. These filmmakers separated themselves from their contemporaries by medium (Super 8mm sound film) and subject, but also through new means of exhibition. Instead of screening their films in theaters, these works were primarily shown between band performances or as part of film programs in nightclubs, lofts, or in alternative spaces—usually a place rented by artists solely for the purpose of exhibiting their work outside the traditional gallery or theater systems.[4] Because they could exhibit their films in an uncensored, supportive environment, these filmmakers were free to produce works that did not follow the usual censorship of language, sexuality, and violence normally enforced by exhibitors.

The participants in the No Wave Cinema movement themselves were mostly Americans and transplanted Europeans who arrived in New York with backgrounds in music, art history, film, and performance. In the later 1970s, the East Village, with its low-rent apartments and thriving downtown club scene (Club 57, the Mudd Club, Max's Kansas City), provided the perfect environment for these newly arrived, emerging artists. At that moment, the most vital form of art making in the East Village was No Wave music, a highly theatrical, performance-based approach to music, characterized by rough and often dissonant sounds.[5] Musicians experimented with the way instruments could be played, while making sounds which expanded the range of sounds traditionally associated with instruments. It was within this experimental musical environment and club culture that the collaborative structure of the East Village filmmaking scene developed.

The initial collaborative projects were simple— musicians provided soundtracks for sculptures and photographs, filmmakers created works to be projected during concerts. The projects then expanded to the creation of films involving people from all disciplines of art making. Big City Bohemia qua production studio. Artists began to experiment with new media. Musicians directed (Gordon Stevenson, John Lurie). Directors created music: Vivienne Dick played in the band Beirut Slump; James Nares and Jim Jarmusch played in the Del-Byzanteens; Beth B and Scott B composed the soundtack music for their own films. Musicians acted (Lydia Lunch, Lurie, Stevenson), sculptors, painters, actors, and writers directed (Tom Otterness, James Nares, Eric Mitchell, Manuel De Landa). And except for a few who had studied filmmaking (Kathryn Bigelow, Jim Jarmusch), it was a new venture for almost everyone. They taught each other how to use the equipment or simply learned by trial and error. It was through this learning process that film, with its capability to record performance, multiple locations, text, and music all within one medium, emerged as a dominant medium of the East Village art scene in the 1970s and 1980s.

One of the first showcases for the emerging No Wave Cinema was an alternative space aptly named New Cinema. The New Cinema began in 1978, when a group of artists and arts professionals formed Colab (Collaborative Projects, Inc.) as a means to exhibit art in an uncurated, though thematic form.[6] New Cinema, one of Colab's first projects, was organized by three of its members: Becky Johnston, Eric Mitchell, and James Nares. Housed in a former Polish social club on St. Marks Place (East 8th Street), New Cinema featured some of the first works produced by the No Wave Cinema movement: Mitchell's own *Kidnapped* (1978), John Lurie's *Men in Orbit* (1978), and Vivienne Dick's *She Had Her Gun All Ready* (1978). But in addition to its specialized programming, New Cinema was also unique in its presentation of works, for the films were transferred to videotape before being projected. Because Super-8mm sound film was marketed as a positive film, like 35mm slide film, duplicate film prints were required for repeated screenings. This normally entailed making a direct positive (which often resulted in a soft image) or an internegative and a print (which was expensive). On the other hand, transferring the film to videotape preserved the original from scratches and wear, the cost was nominal, and since Super-8mm film and video have the same proportions (the horizontal borders of the frames were both 1:33 times larger than the vertical sides of the image), no borders of the image were trimmed. The screenings at New Cinema were a success, not only for their form and content, but equally for their bold repudiation of the accepted distinction between film and video—the latter medium long viewed by film advocates as inferior.

Also in 1978, Colab sponsored a cable television series titled *All Color News* (1978), which featured videotapes produced by its members. Cable television companies in New York offered channels designated as public access—channels that could be leased for specific time slots by

the public in order to televise self-made television productions. *All Color News* included social issue documentaries by artists such as Charlie Ahearn, Beth B and Scott B, and Tom Otterness, covering such diverse subjects as subway overcrowding and the sanitary conditions of restaurants in Chinatown.[7] The B's *NYPD Arson and Explosions Squad vs. FALN* contribution to *All Color News* juxtaposes an interview about terrorism with Inspector Robert J. Howe, commanding officer of the Arson and Explosion Squad of the NYPD, with a collective statement by the Puerto Rican nationalist movement, which had set off bombs in New York in retaliation for the C.I.A.'s involvement in Puerto Rican affairs. The combination of the documentary interview in conjunction with narrative footage would become a trademark of the B's oeuvre, as would the continued interest in the themes of law enforcement and investigation. In their film *G-Man* (1978), G-man Max Karl, as portrayed by painter Bill Rice, leads a double life, that of an FBI-style agent and of a sexual submissive with an affinity for transvestitism and worshiping a dominatrix. The antithesis of his work ethic, his submissive behavior is perhaps what balances his work life—unless one serves, one cannot understand domination. This fictional footage was then combined with documentary footage. In an early scene, footage of an airplane explosion was rephotographed from a television image and followed by images of undetonated homemade bombs—bombs that could be produced with materials available in any home: bottles, wire, clocks, etc. This scene is accompanied by a squealing guitar and synthesizer soundtrack that accentuates the insidious nature of the devices. The prolonged static meditation on bombs allows viewers to question how the bombs are made and conclude that they too could perhaps build such things. Sound-image discoordination, a frequent device in works of Cinema Descrepant, often heightens filmic language and thus its results.

G-Man, one of the primary works of No Wave Cinema, encapsulates many of the primary characteristics of the movement—acid color, No Wave music, and documentary footage—while simultaneously negotiating the three, parallel No Wave themes of role-playing, law enforcement, and pro-sexuality feminism. And like the B's later film *The Offenders*, it was screened between band performances at Max's Kansas City.

Many of the early film/tapes[8] balanced all aspects of the No Wave aesthetic. Some, however, emphasized just one theme, choosing subjects concerned either with documentary, law enforcement/investigation, role-playing, or pro-sexuality feminism. As these themes developed between the years 1978 and 1987, the filmmakers' voices became more articulate, while their films retained the audio and visual textures of the movement.

The documentaries produced during this time provide us with a record of brief moments in the lives of the East Village habitues. In Nan Goldin's 35mm color slide and audio performances, Michael McClard's Super-8mm sound films, and Paul Tschinkel's videotapes, the original spirit and vitality of the East Village is preserved. Goldin's relationships both with her lovers and friends (*The Ballad of Sexual Dependency*, 1980–present) as accompanied by a score of period and contemporary music (including the Del-Byzanteens' remake of Holland-Dozier's "My World is Empty") become a testament to the vitality of living and life's equally devastating tragedies. The words of each song guided the categorization of the slides and propelled the narrative by interrelating slides as they were projected during a given song.

The actors and actresses who were the subjects of No Wave documentary and narrative films were frequently friends or acquaintances of the filmmakers— musicians, artists, or performers whose personalities or physical appearances conveyed qualities one often associates with great actors and actresses: charisma, dynamism, character, attractiveness, invention. Patti Astor, Karen Finley, Rosemary Hochschild, Lydia Lunch, John Lurie, Ann Magnuson, Eric Mitchell, Cookie Mueller, David McDermott, Bill Rice, Ron Vawter, and Jack Smith were the predominant "stars" during these years. The performers' strengths as personalities, along with the natural talents and creativity they brought to performing, produced a genuineness that increased the realism of the film/ tape collaborations, producing a form of neo-realism or role playing. Bill Rice's mature and defined appearance in *G-Man*, for example, mirrored that of an FBI-type investigator, adding realism to Rice's feature role.

Employing stars of the East Village, the filmmakers often developed films that harmonized with or evolved from the performers' personalities and interests. In Tom Rubnitz and Ann Magnuson's *Made for TV* (1985), Magnuson, who portrayed many characters at performance events

she organized at Club 57, transforms herself into dozens of characters, like a modern Lon Chaney. Edited to resemble channel surfing on cable television, every channel features Magnuson in a different program, ranging from a horror movie ("Bill, is that you?") to a music video parody featuring Lina Hagandazovich—a conflation of post-punk singers Lene Lovich and Nina Hagen. In Eric Mitchell's *Underground U.S.A.* (1980), Patti Astor, who starred in countless No Wave films, portrays Vicky, an aging actress whose career has ended, but who still perceives herself as a young star; as such, she befriends a young hustler whom she misleadingly perceives as a romantic involvement. With cinematography by Tom DiCillo and sound by Jim Jarmusch, *Underground U.S.A.* is reminiscent of *Sunset Boulevard* (Billy Wilder, 1950) and *Heat* (Paul Morrissey, director; Andy Warhol, producer; 1972), both of which focused on the blur between acting in life and acting on the screen. In homage to these earlier films, *Underground U.S.A.* acknowledges both the momentary success one can achieve as an actress through physical appearance and personality in movies and the adjustments an actress must make to be a part of the real world. Set against the backdrop of the Mudd Club and the East Village Gallery scene (Astor was the proprietor of The Fun Gallery, the first gallery to exhibit Basquiat, Haring, and Scharf), the film depicts a sentiment perhaps too near the reality of the momentary success many performers experienced as a result of the No Wave movement itself.

A large number of women became centrally and successfully involved in No Wave Cinema. Through their embrace of pro-sexuality feminism, they positioned sexuality as a positive characteristic of women, as opposed to the doctrinaire stance of earlier feminists. In Lizzie Borden's *Working Girls* (1986), filmed in the saturated colors of Times Square, working women (prostitutes) are painted as women who have chosen sex work as a viable career option. These were not the working women of yesterday's Hollywood, who had hearts of gold but were typically killed, abused, or in the employ of a pimp. Similarly, in Richard Kern's *Fingered* (1986), filmed in Super 8mm and transferred to and edited on videotape, Lydia Lunch, former lead singer of Teenage Jesus and the Jerks, is featured as a telephone sex operator. Lunch, who co-wrote the script with Kern, based the dialogue on her own sexual fantasies ("I can only put mommy on after you've given me your credit card number and expiration date. You know it takes money to talk to mommy"). Kern and Lunch use explicit language and graphic representation as a means to illustrate a woman's sexual command while she openly engages in unexpected sexual roles.

Due to the dominant position of women in these films, men often become subordinate characters. The man as an impotent victim of the city, its laws, government, and businesses conversely became a central character during the last years of No Wave Cinema. In *King Blank* (1983), written by Michael Oblowitz and Rosemary Hochschild with Barbara Kruger, Ron Vawter of The Wooster Group portrays Blank. He ekes out an existence at the Howard Johnson motel near Kennedy Airport from the money his wife, Rose (Hochschild), earns as a go-go dancer. While she's at work, he spends his time pursuing other women and acting out fantasies with blow-up dolls while watching Super-8mm porn films. By the film's black-and-white end, Rose chooses revenge and shoots Blank dead. Although this violence appears justified, while routine and unexpected violence was common in the city, it was uncommon as a theme for an avant-garde film at the time. Nick Zedd's *Police State* (1987) takes violence to an extreme, as Zedd is arrested in the afternoon by a policeman (Willoughby Sharpe) without having committed a crime. At the police station, he is abused by the officers in a maddening game of twisted language and lies, an analogy to the bureaucratic torment government can inflict on the individual.

The eventual decline of the No Wave movement was rooted in the economics of East Village properties and Super-8mm filmmaking. The $300 rents rose as the East Village became an important arts center during the mid 1980s, and the $6.50 rolls of Super-8mm sound film simply became scarce as film companies began to reduce the product's availability and processing. As East Villagers began to move out of the city, the community grew apart. Signs of its collapse started to show as early as 1982, when many of the No Wave bands broke up, though their members continued to pursue musical careers. This splintering echoed the transition that took place in No Wave filmmaking during the early 1980s: films at the beginning of the movement united many themes and modes of production design, but the later films followed narrower thematic paths.

No Wave Cinema's blend of documentary realism (the result of location shooting) and fictional narrative enabled filmmakers to readdress traditional genres of cinema during the movement's ten-year history: the period film, the detective drama, the woman's film, and the documentary. This approach also enhanced the significance of sexuality and violence. No Wave Cinema's successful harmony of performances, music, and scripts, along with its aesthetic, treatment of genres, and merging of film and video into one interrelated form, resulted in a distinct and ground-breaking movement in the history of film and video. It was, moreover, a movement nourished by the unrestricted culture of the East Village during those years. It was this environment that both inspired the works and allowed the filmmakers to develop new voices within the cinematic arts. Their investigations and articulations now stand as precursors of today's highly publicized "independent" film movement.

In this first exhibition to fully explore the No Wave Cinema movement, I am indebted to the filmmakers and videomakers who answered many questions and shared their well-preserved knowledge of the period. I would also like to thank those individuals and organizations who provided invaluable and detailed information: Alan Moore, Patti Astor, Kirsten Bates, Jim C., Michael Carter, Diego Cortez, Johanna Heer, Rosemary Hochschild, Majka Lamprecht, London Filmmakers Coop, Lydia Lunch, Glenn O'Brien, Rafik, Rene Ricard, Bill Rice, Jack Sargeant, Louise Smith, Betsey Sussler, Toni Treadway, Jack Waters, and Christopher Wool.

Reprinted from:

Matthew Yokobosky. "No Wave Cinema 1978–87. Not a Part of Any Wave: No Wave." *New American Film and Video Series*. Oct. 3, 1996–Jan. 5, 1997.

Endnotes

1. Super 8mm sound film was introduced in 1973. Its magnetic sound-strip allowed audio to be recorded either simultaneously during filming or following the film's development, from an audiotape or record for example.

2. For an in-depth discussion of Cinema Descrepant, see Thomas Y. Levin, "Dismantling the Spectacle: The Cinema of Guy DeBord," in Elisabeth Sussman, ed., *On the Passage of a Few People Through a Rather Brief Moment in Time: The Situationist International*, 1957-1972, exh. cat. (Boston: The Institute of Contemporary Art, 1989), pp. 72-123. For Baudelarian Cinema, see Carole Rowe, The Baudelarian Cinema (Ann Arbor, Michigan: UMI Research Press, 1982).

3. For Anthology Film Archives and the establishment of its repertory film library, *The Essential Cinema, see P. Adams Sitney. ed., The Essential Cinema: Essays on the Films in the Collection of Anthology Film Archives*, vol. 1 (New York: Anthology Film Archives and New York University Press, 1975).

4. An important alternative space was the OP Screening Room. It began as a film collective named the UP Screening Room in 1967. Between 1979 and 1984, it operated as the OP Screening Room, under the direction of Rafik (Rafic Azzouni). During that five-year period, screenings were held by members of Colab (Beth B and Scott B, Vivienne Dick), as well as Nan Goldin, Amos Poe, and Nick Zedd. Rafik charged $15 to use the space, and the filmmaker kept that evening's receipts and paid for the advertising. Screenings were held on Fridays, Saturdays, and Sundays. Conversation with Rafik, New York, July 7, 1995.

5. The principal bands of the No Wave music movement included the Contortions (Adele Bertei, James Chance, Don Christensen. Jody Harris, Pat Place, and George Scott III), D.N.A. (Robin Crutchfield, Ikue Ile, and Arto Lindsay), Mars (Nancy Arlen, China Burg, Sumner Crane, and Mark Cunningham), and Teenage Jesus and the Jerks (Bradley Field, Lydia Lunch, Gordon Stevenson). These bands were all featured on the album No New York, produced by the influential British producer Brian Eno. Of equal importance was John Lurie and the Lounge Lizards.

6. Colab became most noted for its group exhibitions held in alternative spaces. Among the exhibitions were "Real Estate Show," shown in an abandoned Lower East Side Building, and "Times Square Show," housed in a four-story former bus depot and massage parlor at the corner of 7th Avenue and 41st Street. "Times Square Show" featured a film, video, and slide exhibition organized by Beth B and Scott B, which included works by Charlie Ahearn, The B's, Nan Goldin, Jim Jarmusch, James Nares, Michael Oblowitz, and Gordon Stevenson, and is the subject of Matthew Seller's videotape of the same title (1980; self-distributed). For information on Colab, see *Landslides and A. More Store*, exh. brochure (Philadelphia: Moore College of Art, 1985).

7. It should be noted that while Colab produced *All Color News* for cable broadcast, most artists did not

have access to cable television during the late 1970s. Many people would visit bars or clubs to watch the programs.

8. The term film/tape has been coined by Beth B to denote the interrelationship between film and video-tape production.

Selected Bibliography

Anthony-Woods, Paul. "Nihilist Cinema—Part One: Richard Kern, The Evil Cameraman." [essay on and interview with Richard Kern] In *Rapid Eye 2*. London: Annihilation Press, 1992, pp. 38–51.

Boddy, William. "New York City Confidential: An Interview with Eric Mitchell." In *Millennium Film Journal*, nos. 7/8/9 (Fall/Winter 1980–81), pp.27–36.

Deitch, Jeffrey. "Report from Times Square." *Art in America*, 68 (September 1980), pp. 59–64.

East Village Eye (1979–86).

Hager, Steven. *Art After Midnight: The East Village Scene*. New York: St. Martin's Press, 1986.

Heylin, Clinton. "Thrashing at the Waves (1978–80)." In *From the Velvets to the Voidoids: A Pre-Punk History for a Post-Punk World*. New York: Penguin Books, 1993, pp. 317–322.

Hughes-Freeland, Tessa, and David E. Williams. "The New York Underground: It's Not Dead, It Just Smells Bad." *Film Threat Video Guide*, 2 (1995), pp. 110–125.

Jeriko, Orion, ed. [also known as Nick Zodiak and Nick Zedd.] *The Underground Film Bulletin*, nos. 1–9 (1984–1990).

MacDonald, Scott. "Interview with Beth and Scott B." In October, no. 24 (1983), pp. 3–36.

_____. "Interview with Vivienne Dick." In *October*, no. 20 (1982), pp. 82–101.

McLaren, Malcolm, Richard Hell, Stephen Sprouse, Greil Marcus, Jon Savage, and Paul Taylor. "Punk and History." In Russell Ferguson, William Olander, Marcia Tucker, and Karen Fiss, eds. *Discourses: Conversations in Postmodern Art and Culture* (volume 3). New York: The New Museum of Contemporary Art, 1990. pp. 224–245.

Mead, Taylor. "Acting: 1958–1965." *In The American New Wave 1958–1967* (exhibition catalogue). Buffalo: Media Study; Minneapolis: Walker Art Center, 1982, pp. 13–17.

Moore, Alan, and Marc Miller, eds. *ABC No Rio Dinero: The Story of a Lower East Side Art Gallery*. New York: ABC No Rio with Collaborative Projects. 1985.

Musto, Michael. "The Not So Defiant Ones." In *Downtown*. New York: Vintage Books, 1986. pp. 141–158.

Oblowitz, Michael. "(New) New Wave New York—Music." *Cover*, 1 (Spring/Summer 1980), pp. 36.

_____. Yvonne Rainer, and Manuel De Landa. "(New) New Wave New York Cinema, Presenting the Works of 31 New York Filmmakers." *Cover*, 1 (Spring/Summer 1980), pp. 40–57.

Savage. Jon. *England's Dreaming: Anarchy, Sex Pistols, Punk Rock and Beyond*. New York: St. Martin's Press, 1992.

Sargeant, Jack. *Deathtripping: An Illustrated History of the Cinema of Transgression*. London and San Francisco: Creation Books, 1995.

Video Vapors

*"My video work is 1/4 Fornicalia funk, 1/4 New York punk,
1/4 Euro-peon bunk, and 1/4 Canadian skunk"* —Ernest Gusella

by Ernest Gusella

I was born in Alberta, Canada. My companion and wife, video artist Tomiyo Sasaki, was born in British Columbia, Canada. We met at the Alberta College of Art in 1963. I obtained a graduate degree in Painting from the San Francisco Art Institute in 1968, and Tomiyo graduated with a graduate degree in sculpture from the College of Arts and Crafts in Oakland in 1969. Although they say that "if you can remember the '60s, you weren't there," I think I can recall the wild years of living in the San Francisco Bay Area from 1965-1969, during the peak of the anti-war movement, and the hippie movement of "flower power" and drugs.

Tomiyo and I arrived in New York in 1969, driving across country, after ignoring university teaching job offers—we were in a New York state of mind! Making a phone call to a friend at the first phone booth I saw after coming out of the Holland Tunnel, I emerged with the rental of a loft on the Bowery near Moishe's on Grand Street—5 minutes after landing in New York!

Our involvement with video began positively on 4th Street in 1970. While walking one beautiful fall evening near Washington Square, we heard strange electronic sounds coming out of a church, which was holding a benefit for WBAI, the listener-sponsored radio station. We followed the sound inside and discovered a presentation by Woody and Steina Vasulka (he was a Czech film-maker and musician; she was an Icelandic violinist, and they both lived in a loft building on 14th Street near Union Square where Zeckendorf Towers now stands). The Vasulkas were showing abstract electronic images on some black and white Seitchel/Carlson monitors they had purchased from Mickey Ruskin of Max's Kansas City (I believe they came from video artist Les Levine's defunct restaurant on Park Avenue, which had video monitors and cameras pointed at every table!). After the show, the Vasulkas invited us to a presentation they were doing the next week at Merce Cunningham's dance studio in Westbeth. We attended and there met Nam June Paik and Shigeko Kubota. The Vasulkas were just about to open the Kitchen at the back of the Broadway Central Hotel on Mercer Street with support from the Howard Wise Gallery and the NY State Council.

I was feeling restless artistically and was looking for something beyond painting. I had just read Gene Youngblood's seminal book *Expanded Cinema*, which documented art and technology experiments by artists such as Paik, and dreamed of an artistic future involving technology and computers. I purchased a Putney audio synthesizer (the same one used by Brian Eno in Roxy Music), with the old artistic fantasy that I could somehow make images with sound. Upon meeting the above personalities, Tomiyo and I got together with a painter friend, Paul Tschinkel, who had a studio below us and we purchased Sony black and white portapaks from Adwar Video, so that we could edit video using the tedious process of back winding reels and bounce from one machine to the other using a graph on the tape reel (50% if the time we would get a screen roll at the edit point!).

I started creating abstract video generated by audio synthesis, which I videotaped off oscilloscope- utilizing mirrors, prismatic lenses, an old Shintron keyer, a Sony SEG-1 and more. Tomiyo began taping people on the street and performances in our studio, and then editing the footage in a repetitive loop style in which "real world" actions and sounds of everyday activities were turned into a kind of ritual dance. Paul Tschinkel engaged in documenting conceptual performances (later he went on to create the cable TV show "Inner-Tube", recording punk bands at CBGB's and other clubs, and "Art/NY", a video series about the New York art world which continues to this day on cable TV). One evening, we hooked up a bunch of TVs, sent out some announcements, and had a show in Paul's studio with video artist Anne Tardos and the poet Jackson MacLow.

Simultaneously, Tomiyo and I started hanging out at The Kitchen (where Ho Chi Minh

had once worked!), watching tapes, listening to music, and encountering people like Shridar Baphat, Rys Chatham, Aldo Tambellini, Dmitri Devyatkin, Bill Etra, Skip Sweeney, Ralph Hocking, Walter and Jane Wright, Al Robbins and others. The Vasulkas were very supportive, and I had an evening presenting my work with Ed Emswiller, which was favorably reviewed by Jonas Mekas in the *Village Voice*. (Mekas was initially hostile to video, regarding it as mediocre film, however I notice that in recent years, he has seen the light.)

In 1972, Tomiyo and I moved from our Bowery loft, to a co-op building on Forsyth Street near Delancey. We gutted the building completely with some other artists, and pretended to ignore the hookers, pimps, and junkies that stretched from Grand Street to Houston and around the corner on Eldridge and Broome Streets. The underground film critic P. Adams Sitney lived down the street in the same building as video artist Christa Maiwald, and later film/video maker Dave Gearey moved into that building. Our neighbors across Sara Roosevelt Park were video/art people like Vito Acconci and Dieter Froese. The performance artist Arleen Schloss also lived across the park from us and she began to use film and video later. By this time, I had stopped painting completely. To stay alive (besides doing construction work- which nearly every NY artist in the '70s engaged in) I taught at a number of universities in the New York area.

The Broadway Central Hotel and The Kitchen physically collapsed (4 people were killed after ignoring the departing rats and cats!). The Vasulkas left to teach at SUNY/Buffalo and The Kitchen moved down to Broome Street in SoHo under the new regime of Carlotta Schoolman, Bob Strearns and Rhys Chatham. "Young Filmmakers" (which later became "Film/Video Arts" had a loft space on Rivington off Bowery, and they had a studio and rented video equipment (if you had the nerve to dodge the junkies and dealers on the block—it was so dangerous that some undercover cops died of "hot-shots" given to them by dealers!). Personally, I kept working in the abstract vein, and had a colorizer built by engineer Hugh Sangster, who worked for C.T. Lui, the video dealer in Tribeca

In 1974 I changed gears and began engaging in Dadaist rituals and chanting in front of the camera—utilizing electronic effects, rock and roll pedals, etc. I wanted to get the work out, so I approached Artists' Space above the Paula Cooper Gallery on Wooster Street with the idea of doing a one-night stand. They said fine, but I had to provide my own equipment. I had met Steve Rutt (of the Rutt/Etra video synthesizer), and his buddy Gregory Leopold, who at that time had the exclusive distribution for the Advent video beam projector, which had just come on the market. I approached Greg, and he rented it to me for one night at $75. With a friend, I hauled the screen and projector down to the Artists' Space from Rutt's TV studio in a loft above the Bottom Line near NYU, sent out announcements, and got about 300 people--most of whom didn't know what video art was, had never seen a video projector before. *SoHo News* critic Ingrid Weigand was there, however the show was reviewed by Davidson Giggliotti, another video artist and critic, and he gave the show a favorable review. After that, Tomiyo and I met Barbara London, who had become the video curator at MoMA, and she included our work in several shows. And it started to be included in a number of exhibitions and traveling shows. During this period we applied for and received New York State CAPS and Canada Council Grants. In 1975 & 1976, I taught summer courses in video at SUNY/Buffalo for Dr. Gerald O'Grady at the Center for Media Studies. I also had a custom-built multi-channel voltage controlled video synthesizer built by William Hearn, of Electronic Associates of Berkeley.

In 1977, I got tired of teaching and running around New York as an adjunct professor, so with encouragement from Nam June Paik, I decided to check out the possibilities for exhibition in Europe. Consulting the *Art Diary*, I wrote 200 letters to museums, galleries, and state television stations, and received 50 positive replies of interest. I took a trip to Europe to try to set up some shows. I returned to Europe 3 months later with Tomiyo, and in 45 days we did 21 one-night stands presenting my work. It was tough slogging through Europe in the winter rain and snow---the European video scene was just getting going, and tracking down dual-standard PAL/NTSC 3/4-inch machines was sometimes an ordeal. In some cases, I had to borrow machines and monitors from embassies or universities, but somehow it all got done and the work was shown. Sometimes curators would arrange a free hotel for Tomiyo and myself; occasionally we were invited to parties or weekends in the countryside with countesses or heiresses; in other situations we were given train tickets to the next town. We lost money, however, at the end of the trip, but a number of museums and institutions wanted to purchase work for

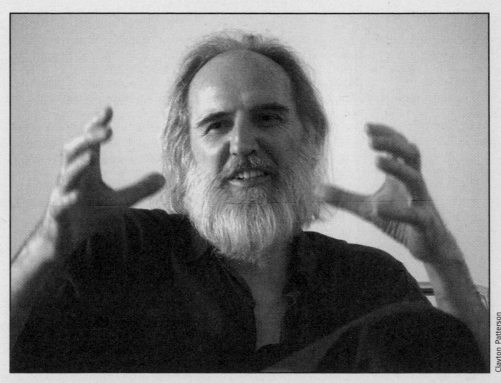

Clayton Patterson

Ernest Gusella

their collections. Video festivals were also just beginning, so I made several trips back to Europe by myself, showing at festivals, giving lectures at universities, and doing other exhibitions. These activities seemed to generate more interest in the work and I received several grants to keep everything going. Anthology Film Archives opened on 80 Wooster Street in the building where Jonas Mekas and the artist/critic Douglas Davis lived, and this venue became another space where video art was shown on a regular basis.

Having a low maintenance co-op on the Lower East Side made it easier to travel and live the artist's life. SoHo had not yet become the commercial nightmare it is today, but we regarded it as too infested with the same artists everyone had gone to university with (which is why artists then called SoHo "the university"). The Lower East Side however, was funkier, cheaper, and more fun---despite the needles, junkies, prostitutes, and pimps on the street and the occasional gunfight and bullet hole in the window. Tomiyo and I have never really felt part of the Lower East Side community in the touchy-feely sense, but we always felt better about being on the edge of the SoHo art scene and not in it. We had access to Chinatown, Little Italy, the old Jewish scene on Orchard Street and elsewhere, as the streets were alive with the sound of Hispanic music and life has always seemed more natural, grittier, cheaper and less pretentious than the SoHo scene of "upscale water drinkers." Perhaps it is because of the more intimate sense of scale, and even with the current transition of the Lower East Side towards more commercialism, it is still the best place to live in New York City. Artists, curators, and friends from all over the world visit us and prefer it over SoHo because of the wide variety of people and lifestyles visible on the streets and the anti-bourgeois sensibility that has always been a part of the Lower East Side's immigrant and working class ethic.

Perhaps because of our fine art painting background, Tomiyo and I have always unconsciously been "studio artists" in our head, and shooting outside of the studio was kind of alien territory. We never wanted to be documentary, television, or Hollywood directors, but saw video as an interactive recording tool for artists, which provided individual freedom from institutional oversight and biases. However, in 1979, Tomiyo won first prize in the Tokyo Video Festival (sponsored by JVC), with a tape about adults blowing bubble gum. By some fluke, I won

second prize, so JVC flew us both to Japan, and we took the opportunity to spend a month videotaping all over Japan. New smaller and portable VHS systems were coming online, and upon our return, Tomiyo announced that she wanted to go to the Falkland Islands to video-tape penguins and then to record the animals and birds on the Galapagos Islands. Despite equipment breakdown and a flight back to New York to get a deck repaired (always travel with two systems!), we completed our trip---including a side trip into the Andes of Ecuador to tape Indian markets. During this period, Tomiyo and I survived by working at home doing commer-cial art for the *New York Times Company*.

In 1980 I made a tape entitled *Connecticut Papoose*, a one-hour stream-of-consciousness surreal dream, which utilized studio footage, and footage which was gathered on the road. This tape was awarded one of the first Guggenheim grants for video (a new emerging catego-ry!). I was heartened that video art was finally achieving some kind of legitimacy, because the judges were art world heavies like Robert Hughes, Dore Ashton, and George Segal. Simultane-ously, I received a DAAD German government travel grant, so Tomiyo and I headed off to Berlin. In Germany, there were cheap flights to Africa, so we flew to Egypt and Kenya, where we videotaped one million flamingoes, animals in the Rift Valley, etc. This trip was followed by others—all financed by competitive grants and our own finances. In 1983, Tomiyo received a Guggenheim to do a major video installation based on the Galapagos, where we spent three months living in a tent on uninhabited islands. In 1984, I was offered an artist-in-residency teaching video and computers at SUNY/Buffalo, so I taught there until 1987, flying up and back each week. I taught video in the company of media makers Paul Sharitts, Hollis Framp-ton, Jack Goldstein, and Tony Conrad.

From 1987 through 1994, Tomiyo and I traveled extensively to Europe, Japan, China, India, Tibet, and Nepal, working on projects and exhibiting. In 1993, I was a Fulbright Scholar at Jamia Millia Islamia University in New Delhi, teaching video at the Mass Communication Research Center. At the end of this period, we were invited to teach a video workshop at the State Museum of Manipur in Imphal, by the government of the State of Manipur in N.E. India. We did this for one month, and because of continuing guerrilla activity, we were provided with round-the-clock armed protection from the Indian government.

From 1994 to 1996, I was computer artist-in-residence at the University of South Florida in Tampa. While in Tampa, Tomiyo and I began to work with dancers in the university dance department, and this has continued to today-- including working with Lower East Side dancer Susan Osberg. In recent years, I have been building 3D video-animated environments in Light-wave for Tomiyo's projects. Our video system is totally digital and I map her video footage into spaces and onto objects and then animate the camera. The imagery is rendered in the computer and then bumped back to video where it is edited and burned onto tape, CD, DVD, whatever. Last summer, Tomiyo and I were invited to teach digital video in Estonia by Marika Blossfeld (another Lower East Side dancer). The workshop involved teaching young dancers and performers from former Soviet bloc countries such as Kazakhstan, Mongolia, Serbia, and Bulgaria, who were interested in expanding their art forms into the video realm. This three-week project was financed by George Soros' Open Foundation and the Rockefeller Foundation and took place in the Estonian countryside on Mac computers.

Regarding the future, as much as Tomiyo and I still prefer living on the Lower East Side, getting older and traveling and teaching around the world has made us more restless, politi-cally aware, and somehow life seems more interesting and grounded in reality in so-called third world countries. Once you have been around the block, and seen another McDonald's or Starbuck's, it gets boring. It has also been our experience that deprived students in other soci-eties are more interested in learning and are more of a joy to teach. We intend to keep mak-ing video, but in a different place and time, and under different circumstances.

As Bruce Chatwin said in *The Songlines*, "95 percent of mankind's time on earth has been spent walking. When you walk, every day is a new challenge, surprise, and mystery." Living, walking, and working on the Lower East Side comes as close to Chatwin's description as can be duplicated in a big modern, western city such as New York.

Michael Auder

by Jason Grote

A recounting of video artist Michel Auder's life reads like a history of late-20th century western art. From his participation in the Situationist-inspired Paris '68 rebellion to his marriages to Factory superstar Viva and artist Cindy Sherman to his association with New York artists as varied as Taylor Mead, Andy Warhol, Larry Rivers, Allen Ginsburg, Gregory Corso, Annie Sprinkle, and Eric Bogosian to his current embrace of digital video, Auder has been involved with some of the most vital art movements of the last four decades—or more accurately, he has stood just outside those movements, chronicling them extensively on video. Auder's style is known for its combination of the documentary and the personal. Unlike other documentarians, who put themselves at the center of their work (think Michael Moore) or try to remain invisible, pretending that no camera is present (think D.B. Pennebaker), Auder merely chronicles. Without editing his work to create the semblance of a constructed story, or manipulating his subjects in order to subsume them to an imposed theme, Auder mixes intimacy with detachment. One gets the sense that he is in fact present, that he is indeed behind the camera, but that he, like the viewer, is observing, allowing his subjects the space they need in order to be their unique and idiosyncratic selves; but also like the viewer, he is not disinterested. Auder has his point of view, but doesn't wish to impose it on subject or viewer. From formative works like *Cleopatra* to better-known pieces such as *Chelsea Girls with Andy Warhol* to deeply personal stories like *My Last Bag of Heroin (For Real),* Auder's camera has always managed to peer unblinkingly at the people and events in his life without ever becoming exploitative.

Born in 1944 in Soissons, a small town in the North of France, Michel Auder first became interested in photography when his father left him an old Rolleiflex camera. Entering fashion photography as a way to meet beautiful women, a young Auder came to New York in 1963 on a job for *Harper's Bazaar.* It was then when he first met Taylor Mead, at The Fat Black Pussycat, a hangout popular with French expatriates. Not long after, Auder was deported back to France, where he had been drafted into service in Algeria, where France was embroiled in an imperial war. Left-wing and independent-minded, Auder made a lousy soldier. Using family connections (his mother was dating the bodyguard of the minister of the French army), Auder served as a combat photographer. After repeated run-ins with higher-ups, Auder was eventually sent back to France, where he became involved in film. Heavily influenced by Jean-Luc Godard and the French New Wave, a new generation of young French filmmakers had begun to emerge. At first Auder worked with 16mm film, without sound. Most of his film footage, including footage of the 1968 uprising, was lost when he moved to the US in 1970. Auder became a video pioneer mostly because he

wanted to sync sound and image without bulky and expensive sound editing equipment. A habitual autodidact, Auder transferred his knowledge of photography to his film and video work.

His life and career changed forever when he saw Andy Warhol's *Chelsea Girls*. Deeply impressed by the film, he later ran into the film's star, Nico, on the street. Nico invited him to a party, where he met his first wife, Viva. Soon after, Viva and Michel moved to America. For a long time they lived in the Chelsea Hotel, where Auder began to film Candy Darling, Jackie Curtis, and other figures in Warhol's Factory. He also began to record various New York characters surrounding the famous hotel: the mentally ill, prostitutes, drug dealers, artists. His first association with the Lower East Side came in 1974, when he moved in with the artist Larry Rivers. It was an association that became solidified as Auder became addicted to heroin, a lifestyle he recorded in various video projects.

By 1977, Auder's life had begun to change. He had made many videos as a result of his association with Rivers, and he and Viva had a child—they could no longer take someone's money and go to Rome with it. They tried various methods of saving their marriage, from moving to Los Angeles (they lived in Topanga Canyon for three years) to writing two books together (*Viva Superstar* and *The Baby)*, but nothing seemed to work. Finally, Auder returned to New York with empty pockets. By 1977 he had begun to explore what was then the Wild West of the Lower East Side, a place teeming with hard drugs and the nascent punk rock scene. At first Auder had worked out a deal with Rivers, organizing his studio in exchange for free rent, but eventually they began to work extensively together, co-creating video projects over the next 2-3 years, mostly footage of Jackie Curtis and Taylor Mead (Auder estimates he has about 100 hours of Mead footage). Auder eventually moved in with River's wife on Central Park West and even helped take care of his children. They were one big happy family until around 1982, when their partnership began to dissolve over disputes over credit for their work. Other artists with whom Auder became acquainted during this period included the Beat poet Gregory Corso. Though Corso lived in the Chelsea Hotel, the two would often visit poets John Giongiorno and Allen Ginsberg in the Lower East Side, and Auder would document their poetry readings at St. Mark's Church on 10th Street and Second Avenue (sadly, many of these early videos are unplayable due to disintegration and format changes). Around this time Auder became acquainted with the artist Gary Indiana, with whom he made *A Coupla White Faggots Sitting Around Talking*. In the 1970s Auder used early, reel-to-reel tape, and one of the obstacles Auder faced as a videographer in the 1970s was the expense of videotape and the unwieldyness of the early, bulky video equipment. Frequently he was the only video artist at the events he set down—audio recording was common, especially at poetry readings, and film was generally thought to be higher-quality and easier to use. Because of the bad sound and images, video of that period was rare.

From the late 1970s until the early 1980s, Michel Auder's primary connection with the Lower East Side was through its drug scene, primarily due to his own heroin addiction. While this time was extremely difficult for him to record, mostly because of the drug dealers' (and users') aversion to cameras, Auder nonetheless managed to archive some of this period, directing the writer-performer Eric Bogosian as Auder in *Chasing the Dragon* and documenting his own use in *My Last Bag of Heroin (For Real)*. During this period, Auder supported himself (and his habit) by purchasing high-quality heroin for wealthy artist friends, often entering highly dangerous situations while carrying large amounts of cash. In one memorable instance, Auder (or "Frenchie," as he was known among the dealers) was robbed of $1000 and tossed naked

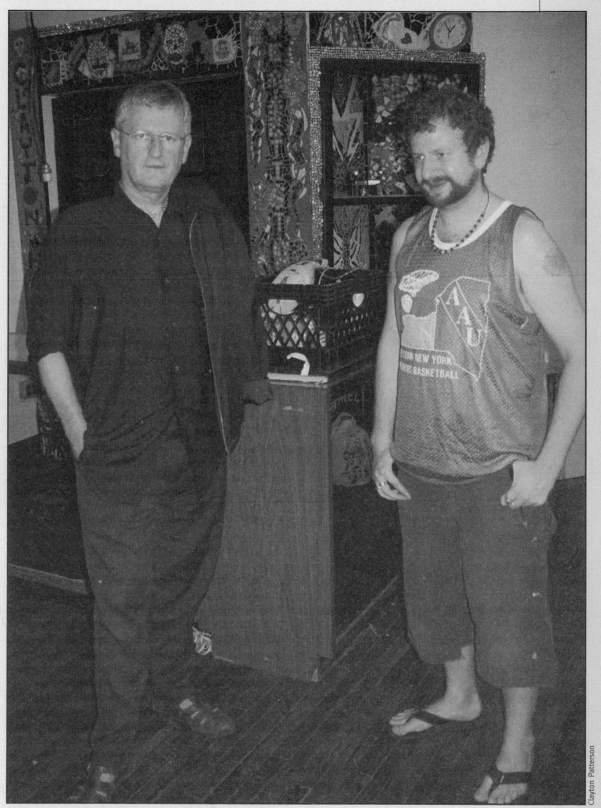

Michael Auder and Jason Grote

into snowbanks on Avenue B.

During this period Auder met and married his second wife, artist Cindy Sherman. By 1986, Sherman's career began to become successful and with the money she was making she paid for Auder to enter a serviceable detox center uptown. Also during this period, Auder began to use the cheaper, lighter, and more efficient Video 8.

Auder and Sherman eventually divorced, and Auder moved to Orchard Street, where from 1995-2000 he faithfully archived the change and gentrification in that neighborhood. Among his subjects were Yelena, a Serbian lesbian jeweler. But 1998-99, Auder again changed his style of shooting. Instead of an extensive narrative of daily events, he began to only shoot things that were atypical. In 2000, Auder moved to Humboldt Street in the Williamsburg section of Brooklyn—a place often compared to both SoHo and the Lower East Side—where he continues to shoot video (now using Digital Video equipment) and has begun the immense project of returning to and editing over 30 years of video footage. He shoots less and less now; as of July, he has shot only four hours of footage in 2003. In 2000, he would have shot about 25; in 1998, 40; before that, 60-80. His documentary style continues to use personal interpretation instead of a master shot style. In recent years he has become increasingly interested in events outside of New York City, such as in his extensive footage of Colombia in *Colombian Wedding* (like the Lower East Side of the 70s and 80s, another place where people were afraid to be taped due to drugs and violence) and Vanuatu in *Vanuatu Chronicles.*

Arleen Schloss Interview

by Clayton Patterson
Transcribed by Mika Deutsch

CP: So, what is your name?

AS: A-R-L-double-E-N. No one ever spells it that way.

CP: Oh.

AS: The usual way everyone spells it is E-N-E.

CP: Actually this is probably true. I don't think I've seen it spelled correctly.

AS: That is true. Everyone always spells it incorrectly.

CP: And last name's "Schloss."

AS: Schloss.

CP: Okay, how do you spell that?

AS: Schloss. S-C-H-L-O-S-S.

CP: Yes.

AS: Is that a camera?

CP: Yeah. It's alright.

AS: Now I didn't think I would be on camera because you're not going to show it to anyone because I am ancient. And [inaudible].

CP: Oh okay. Well that's cool. No, I won't show it to anyone. But, so what were you involved with? Where you from? What got you to New York City?

AS: I'm a native.

CP: Oh, you're a native New Yorker.

AS: Yes.

CP: Well.

AS: I am a native and I was born in Brooklyn. And I grew up in Brooklyn with . . . having qualms about the speech and the way people spoke and pronounced things which I thought was entirely gross—like "twoity toid street" ["thirty third street" pronounced in a Brooklyn accent], etcetera. So I worked very hard at changing my speech. The great thing about growing up in Brooklyn was that I was right down the road from the Brooklyn Paramount which enabled (me) to go and see Frankie Lymen and the Teenagers and Fats Domino.

CP: So you were into words, sounds, and music at this time.

AS: Def. Hi-Def. And the first performance I saw in Manhattan was direct on the Ed Sullivan Show, seeing Elvis.

CP: Oh really? You saw Elvis?

AS: Live.

CP: Live at the dress rehearal on the Ed Sullivan Show.

AS: Live.

CP: You got to see the whole hips.

AS: The whole hips. Exactly! So I came from this realm of unbelievable great music and I was, there I was, a little kid in the Girl Scouts singing "Blue Suede Shoes" and "Heartbreak Hotel" and "Why Do Fools Fall In Love. I was working on sound and on dancing and having fun.

CP: So how did you become involved in art—fine art ?

AS: I went to an art school. [The Art Student's when still in High School and studied water color with Mario Cooper.] Well I went to another school to study fashion illustration but, unbeknownst to me, my favorite subject was painting. And so I was lucky to study with a really fine painting instructor John Kaceri at Parsons School of Design which was then located uptown on East 54th Street and Sutton Place. So I was growing up learning how to speak as the girls who went to that school knew how to speak with eloquence and I copied them, which got me into the world of performance art as I was painting. And the last paintings I did was painting with my feet.

CP: What year was this about?

AS: My foot paintings started in 1968/69 and in 1970 was my first foot performance, called "Feet," which was an interactive work where everyone who came in had to take off their shoes and socks, put their feet in flour, and then step on 300 pounds of hot pink playdough. It looked like walking on the moon in performance. And it was documented.

CP: Oh really?

AS: But the person who documented it forgot to put the videotape in his camera, duh.

CP: Oh no! Bummer.

AS: Big bummer. But its ok, as Jeanne Black took great black and white photos.

CP: Yeah. Right right right, so that was 1970.

AS: That is correct.

CP: And then how did you get into the whole "A" thing?

AS: Well um . . .

CP: So just at 1971, doing performance, who was involved in performance at that time? This was pre-videotape for you, right?

AS: Pre. It was before the Kitchen was close to beginning. It was very cool, video was actually just beginning and I was on different cable TV shows because I was so involved in music. And what I discovered is I knew all the words to every song that I loved. So then I decided to write and learn my own poetry. And it was very simple because I was working in public schools and I was teaching children how to speak English right on the Lower East Side from the late '60s and became an assistant teacher. I was just really enjoying the fun of making up ways to help children learn how to speak English because none of them were from New York you know as their families were mostly from Puerto Rico and other places. So they didn't know English and I instituted fun in teaching English. And then I started writing the alphabet. And I began writing instant alphabetic poetics. And so the alphabet turned into my main way of recitation, becoming a-z poetry performances when in 1975 I did a 3000 word poem with musician Jack Smead at Bykert gallery in Soho entitled "Words and Music," in alphabetic memory.

CP: Right, and then like still shots of a mouth open and a big A coming out.

AS: That was from one of my next earlier performances which was called "A A A" which I did at the Robert Freidus Gallery in 1976.

CP: Were you familiar with Richard Kostelanetz?

AS: Not at that moment in time. But I did become familiar with him shortly thereafter.

CP: Uh okay. Do you see any relationship between what he did with sort of the alphabet and art and what you did?

AS: Definitely, because I was also involved in mail art.

CP: I was going to ask you about that.

AS: That's how I met Richard Kostelanetz.

CP: Oh really.

AS: And he put me into his big books on poetics/ sound poetry TEXT-SOUND TEXTS.

CP: Oh oh that's interesting.

AS: Yeah. So I was involved with sound poetry as I participated in mail art.

CP: Oh okay, now who were you involved in mail art with? Ray Johnson, of course.

AS: Right.

CP: John Evans.

AS: Right o.

CP: Carlos.

AS: Yeh

CP: Higgins.

AS: Yes.

CP: Ana Banana.

AS: Buster Cleveland.

CP: Buster Cleveland, of course.

AS: Yes. Ana Banana. I was just learning about Ana Banana at the time and met her a couple years later. And it was actually through Buster Cleveland that I even know those people, a number of mail artists.

CP: Yeah, so that was kind of like one of the purest parts of mail art if you want to look at it in that way.

AS: That's true.

CP: That was kind of the beginning . . .

AS: It was in the early '70s.

CP: The early inside edition.

AS: Correct.

CP: Right right. Well that's interesting. And then so, okay so then you're into performance and mail art and alphabet poems then . . .

AS: Then . . .

CP: What about the video? When did the video come in?

AS: I used video as a tool when I did a staccato opera entitled A SHOT CHANCE which I performed at the Kitchen on Broome St. in 1977 where Anthony Forma did a live video in the realization of creating an art object using sound actions and poetics with random visual acts.

CP: Did you yourself make video?

AS: Well truthfully I decided what I really wanted to do was to make animated films of my alphabet-generated Xerox images for film. And I purchased a Super-8 film camera in 1979, and I made the first recordings. I got a little distracted from my alphabet work when I started filming on the Lower East Side and Soho.

CP: So what were you filming at this time? These are three minute films?

AS: Yeah.

CP: Black and white or color?

AS: Color.

CP: Color. And so what were you filming at this time?

AS: I was filming the streets, graffiti, and I opened my place to the public realm.

CP: A's.

AS: And that's when A's started and I started shooting A's. At 330 Broome St.

CP: Oh wow and that was 1979. Boy, that place was really an institution in its own way.

AS: That is correct. If you forget it started on October 24th, 1979, which was the first Big A's but A's came out of doing performance art workshops.

CP: Yeah, very European, too.

AS: Which is what I was doing. That was the key and my performance art workshops were getting so popular that . . . and I was collaborating with videographer Dider Froese working on Chrystie Street. But he is originally from Berlin or a part of Germany and he was very happy to help out, because, in my workshops, what I wanted to do was take people learning how to do performance and I was instructing sound and how to speak extraordinarily quickly. And he was taping it for me—on the first tapes—the first reel to reels and I have a whole series of them! Do you have a reel to reel projector?

CP: No. But yeah that's how it used be, 'cause actually that place got a lot of coverage, was in a lot of books . . . I think probably Nova Scotia was familiar with A's— they probably have some kind of publication that deals with A's, were you familiar with Henry Flynt?

AS: I became familiar with Henry Flynt much later . . . I wasn't familiar with him at that time. Maybe he was a name I was hearing about but I wasn't really familiar with his work at the time because I was never really introduced to him.

CP: Okay so you weren't really familiar with the whole concept of conceptual?

AS: But I was doing conceptual. And I was doing fluxus without even hearing about fluxus.

CP: Or George Muciunas or any of those people . . . Because certainly the mail art was connected to fluxus and people like Muciunas.

AS: Right, no that is true, that is absolutely true. And I became friends with John Noel because I was doing A's and A Gallery a couple of years later. I was just running around, running wild experimenting with everything. And when I was doing A's that started getting so popular and I was getting interns from all over Europe and I started traveling all over Europe so my interns were running A's. And they recently said to me, they just read an article about fluxus and I was really fluxus, even though no one ever called me a fluxus person! But everything I was doing was in flux, so to speak.

CP: You are familiar with Muciunas.

AS: That is correct, at that time, I became familiar with Muciunas later and when I did one of my earlier alphabet performances in 1977—at the Kitchen and someone who saw my performance said to me, "I'm lending you this book—*A Year from Monday* by John Cage, because you really need to be aware of what he's doing relates to what he's doing." That's how I was introduced to John Cage, and became enthralled, absolutely enthralled.

CP: Really. So then John Cage became a big influence?

AS: Precisely.

CP: So then you moved into sound? Or more into sound?

AS: I was already into sound and I had taken some workshops with Meredith Monk who I thought was doing incredible, incredible sound work with her voice.

CP: So you kind of had a connection to Soho and what was happening there?

AS: Yes and I met through Meredith came through composer John Smead. He was involved in my first performance which was "Words and Music" at Bykert Gallery. My interest in film thing evolved out of all my poetry and my color Xeroxes. I'm in the process of putting my archive on the web which is a whole world in itself. I'm lucky to have interns over time, particularly in the last year, documenting my things from my slides to photographs to everything else on a scanner. I have tons and tons of scanned images and I literally spent the last year and a half doing that. I'm getting a visit from a web producer—a really good web person—who's going to come to town next week and crash at my place in trade for instituting a new website. I have a website.

CP: So you like the web, you find it functional?

AS: Totally! Totally, that's where the new galleries are.

CP: You like digital?

AS: Hundred percent. On the web is where it's at. Because you can go all over the world when you're on the web. I had that fantasy when I was young and I was thrilled when it was started. I started on the web very early because my boyfriend was one of the web innovators.

CP: Who was he?

AS: Nik Williams. He innovated starting things with computers and he was starting a new computer center in the United States in Ohio at the Butler Museum called the Beecher Center (for the electronic arts). He started in Youngstown, Ohio, and it was very similar to Ars Electronica (where I performed in 1986). Actually I wasn't filming but I was having all sorts of films being done, collaborating with other artists such as Barbara Hammanin. I did have a film made that I never finished because I needed another grant to get it finished but I have a lot of great footage.

CP: And you did No Se No?

AS: Yes.

CP: Because No Se No is a hotbed of creativity.

AS: No Se No came from A's. And the book that was put out has no concept of the reality even though I told them, they do not include the reality in the book.

CP: Is this the Alan Moore book you were talking about?

AS: That is correct.

CP: So what part did they get wrong?

AS: Well they got wrong the fact that I was collaborating with R. L. Seltman, who was taking my performance art workshops. It was through my collaboration with him that A's began. I was collaborating with R. L. Seltman and co-producing with Tod Jorgensen with A's. After doing A's for several years, R. L. Seltman and I co-produced "A to Z," a performance for the opening of the storefront for Art and Architecture. Alan Moore, in his book, stated that No Se No was a collaboration with the Storefront for Art and Architecture when in fact it was the collaboration between myself and R.L that instituting Performance A-Z in 1982. Then R.L Seltman collaborated with Ray Kelly in 1983 at No Se No doing one hundred nights of performance.

CP: But you mentioned this Jorgensen too, that was color Xerox?

AS: Tod used to work at a color Xerox place on Spring St, the name that I don't remember.

CP: Jamie Cavass right?

AS: That is correct. Even the son of Jamie Cavass was performing at A's because of my collaboration with Tod. Tod was involved in starting the performances with me, also in collaboration with R. L. Feldman.

CP: Yeah that's a whole period that was really very interesting as well though, just for a sideline for a second, was the color Xerox period.

Clayton Patterson

Arleen Schloss

AS: Yes, absolutely. And I was doing color Xerox too because I got a grant in 1974 from the Latin American Foundation to do color Xeroxes and I went up to the first color Xerox place on 59th Street right off Madison Ave, putting my foot directly on the Xerox machine. Then I started doing alphabets on the Xerox copying generations of the letter A—a copy of a copy of a copy of a copy where I got a hundred and fifty copies which made a little book. So I started making color Xerox books.

CP: Really? Do you have some of those books still.

AS: I do. I sold the really good ones. I had good shows in Texas and they bought them up like crazy.

CP: Did you know the woman, I think her name was Needleman? She used to do mail art books.

AS: That sounds very familiar.

CP: Yeah, and I was part of that for a while, making those mail art books. Yeah they were great. Another one of those genres—mail art books and color Xerox books—you know I loved that whole scene, that was of course pre the computer and independent publishing. So you were a pioneer in that with the Xerox color copying.

AS: Right, so I used to make the books and I made many books and I sold many books. Actually I just recently I received a call and they instituted one of my books in some big show that's traveling all over the world. Once in a while I'm invited to a show but very rare these days, because I'm the grand-mamma, I went back underground.

CP: Yeah, I think it's better.

AS: Well, it's necessary because my health has changed, therefore I'm focusing on healing and health. That's where my head is aside from all the archivery I've been doing and having done. I'm lucky to have assistants doing the archivery because there's so material. I haven't even touched my retrospective show that I had in the '90s! Like anything I did in the '90s is not even touched, is not touched at all.

CP: What was your retrospective show, where was that?

AS: It was in, at the Stadtische Gallery Im Buntentor, in Bremen, Germany. It was in Germany because I was teaching sound and video at the time. Actually I was teaching video over the years quite a bit in Germany and also here. I taught at the Center for Media Arts, developing different things there, and I was you know teaching little kids getting bigger and bigger and bigger so I went from the little four-year-olds to junior high to high school and college. So I was just teaching all the time. I'm an ancient teacher.

When I did my performance at the Kitchen Center it was my first music art performance to get written up like in the *New York Times*.

CP: At that time, the Kitchen certainly was different from mainstream but it definitely had a high ranking prestige in the art community. A's and the Kitchen were kind of comparable places on the performance scene really.

AS: Yes, Eric Bogosian (who was working at the kitchen) did one of the first performances at A's. Getting back to the Kitchen, it's an important point because I was having my work documented for the very first time. (Anothony Forma did the video.) I hired someone to document my performance piece which was called "A Shot Chance" and that is why when Wendy Perron who was a performance art critic was writing things up and introducing me to John Cage about chance and such because the name of my performance was "A Shot Chance." It was a very specific performance

where I wanted the camera very very close up on the action. I didn't want myself being taped at all, only what I was doing because I was basically creating an artwork through sound.

CP: So then this would be mouth and hands you wanted videotaped?

AS: The art I was creating was through performance. I was filming only the mouth and the hands at the time. What I was doing which was making a shot and so the camera would go to the shot that was being shot and I had painted a little beebee from a beebee gun and so it became the shotgun shot. And then it became a circle shotgun shot. And then it became a circle circled circled shotgun shot. And then it became a squared circled circled circled shotgun shot which then got involved in a whole expanse of different actions creating this big beautiful piece of paper, turning it into a visual art piece. And it was documented, which I have to edit it down into something serious for the web.

CP: Let me ask you something else, how about Franklin Furnace because this must have fit in about this time?

AS: It did and I was invited there to do a performance there. I did "A Shot Chance Number Five" at Franklin Furnace at the time. I think I was there in the late '70s [1977].

CP: How long had Franklin Furnace been around at that time?

AS: I was involved in 1974. I think Franklin Furnace was started in 1975 and I was giving them my books, my alphabet books at the time.

CP: So your books were part of their archives.

AS: Yes.

CP: So at the whole beginning with the performance scene, there was basically A's, the Kitchen, Franklin Furnace (the Mudd Club was very popular at the time, and very expensive), and then I guess some arbitrary places that used to do it occasionally like maybe a club or something like that. So really you were part of that whole initial genre?

AS: I was in the initial genre. I was pre-Kitchen, pre–Franklin Furnace. I did a performance called "Feet," which I mentioned earlier. Then I performed at the Bykert Gallery and then I performed at the Betty Parson's gallery in 1975, where I built this huge sculpture with elastic bands, rubber bands and I was playing the bands as well.

CP: Did Carol Dreyfus work there at the time do you know?

AS: I don't know if she worked there at the time.

CP: Then you showed up at Betty Parson's. That's pretty mainstream.

AS: I was doing sound sculpture at Betty Carson's. I was literally doing my sound poetics and sound sculpture at Betty Parson's. I was dancing with tap shoes and playing my big rubber band sculpture which I revised at my retrospective show in Germany twenty, thirty years later.

CP: Now did Peter Moore ever photograph any of your performances, do you know?

AS: No I don't think so. I don't think I was in that realm at that time. That was like happening simultaneously

CP: So that was Alan Kaprow and all those people. He was totally over there and you were doing similar things.

AS: And I was right down the street

CP: Right.

AS: Maybe [I was] beginning to hear a little bit about Alan Kaprow in the late '70s and then I started to participate in some of his shows.

CP: Right. Because you're right, that was a whole other environment, it got documented in a different way, it got reported in a different way. This is another parallel vein coming out of the same time. There was a video school at that time—I wouldn't call it school but I guess kind of collective thinking maybe—maybe Vito Accoci, Ernie Gusella, yourself—were all these people around there where you are? Was Vito Accoci around the corner?

AS: Well I did see Vito's performance in Soho at the Sonnebend Gallery, or he did some performance that was in a basement.

CP: But someone said he had a studio on Chrystie Street, is that right?

AS: Yes he did [133 Chrystie]. The windows for that studio were over my outdoor sculpture garden. So I was right there.

CP: So did you share any video similarities between any of those people—Ernie, Vito Accoci?

AS: I would say that Tomiyo, Ernie's wife, was giving me a hand in my work in all different ways. She actually filmed my first alphabet work. Actually Ernie and Tomiyo answered an ad because we were trying to hire people to help paint our building and that's where we met.

CP: So you became familiar with Tomiyo who was doing video?

AS: She was doing "Bubbling." It was a really good video that Ray and I performed in.

CP: That was really the fine art of that period. Who would you say was part of that group?

AS: Tomiyo Sasaki and Ernest Gusella. They became good friends. They were living on the Bowery and we hired them to help paint our building, they helped paint the downstairs floor, the ground floor and then they got the idea of buying the building.

We had just gotten involved with buying the building but none of us had any money. The only reason we got the building is because Elina Mooney, who was studying with Merce Cunningham, was living in the same building that Ray Kelly and myself were living in and Ted Hughes and Sukanya Ramen were living in, and we were all being evicted from our building on East Broadway in 1969. In 1970 Elina inherited some money so she fronted the whole thing and we spent twenty years paying her back.

CP: The real estate idea—tunis in Soho also had sort of similar kinds of concepts. Art and real estate.

AS: The building was dirt cheap! That big building! It was $58,000.

CP: So that secured A's. In order to pay for A's you would have visitors from Europe stay there like a B & B and that worked really well for years.

AS: Well, it was cheap at the time and so because my whole idea of doing A's was being able to pay the people who performed there. Any leftover money went into the rent. It was sort of like that. It worked. I was very lucky.

CP: How long were you married for?

AS: Twelve years until my hub started making it with one of my students. I was off to Europe going on tours all over Europe and he moved in with my student and I came back to New York and he says, "You can have the loft. I don't need it. Goodbye." And that's why I have the loft. It's not so simple at this point in time. Because he wants to sell, everyone wants to sell, and I don't know where I'd move to.

CP: So you still making videos?

AS: You know, I didn't finish the last films I started which was basically called "Windows

of Chance/Change" on the philosophy of John Cage. I had several interviews with him which went extraordinarily well. When I started editing, putting a video together; I did get a grant from New York Foundation on the Arts. What I did with that at the time because I was so intrigued with Cage's philosophy, I went directly to China. I had to go because of all the things Cage said involving China and chance and everything else. So I went to China and I still to this day don't have my Cage tape finished.

CP: Okay. Where do you see your archives eventually ending up?

AS: On the web and being published in a book, because I think that makes sense.

CP: What would you call the book? A's?

AS: Maybe "A Chance Operation" or something along those lines which led to many other chance operations because I feel like my early performances were chance operations but I wasn't calling them chance operations at the time. I did make a number of films and videos. I was lucky to receive through the Kitchen the first 8mm video camera in 1988 and traveled throughout the United States making "Sundaze Away." But also when I was playing music with Glenn Branca who used to play at my loft. I was invited to go on tour with his orchestra because I'm a percussionist and I was always playing piano. So I was invited to play on keyboard and mallet guitar in a big Branca tour in Europe where I made my first Super 8 film, "Glenn Branca Symphony #4 / Physics."

CP: So you could go to the Donnell Library on 53rd Street and take it out and watch it.

AS: That is correct.

CP: So in the gallery, the film was meant to be watched on a television monitor?

AS: On a monitor, or I originally made it as a film or truthfully a Super 8 film and it never worked on film because there were always problems with the film camera having problems in trying to show. I was never able to show it in Anthology Film Archives. I did show "How She Sees It By Her" at Anthology Film Archives which became extremely popular and they were calling me back year after year in different shows to present that work. I was showing "How She Sees It" non-stop and it was a really good film. And so I was doing percussion and poetry and video/films filming on the streets on the Lower East Side. I have a very large archive . . . hours, hours.

CP: Like 500 hours?

AS: Something like that. I didn't show "How She Sees It"; I did show the raw footage that I was filming of the film that was never finished from "A B Bla Bla Bla," which was my media opera in Ars Electronica. So everything is up in the air. I need a major grant to continue because it's just chance operations that I have people to work with to help me out. You know I was working for City As School. It's actually, it's with the Board of Education. Many people study there, such as sculpture Linus Corragio. It's a high school where the city is used as a school

Clayton Patterson

Door at A's

and I became a resource for City As School where they would come and help me out and I would show them video and computer technology. It worked for a long time but after the 11th it stopped.

CP: Really? September the 11th really made a . . .

AS: It made a major difference! A major, major difference in people being helped out. Really horrific, horrific on many many many levels. And I am no longer working there because they don't have the setup organized anymore. They're closing all their City As School schools which is heartbreaking. Really heartbreaking. Because it is a major source for learning outside the classroom for kids who don't want to work in one of these rooms with black walls to be able to go to people's studios and work with people and learn from the source. They ended it because the whole school was going through problems.

CP: Bloomberg!

AS: Ugh. It was before Bloomberg. Way before Bloomberg.

CP: Really? Giuliani?

AS: Totally . . . I was always working on helping out as much as I could every year, you know kids and students—I was teaching here, right here at P.S. 131 on Suffolk Street.

I was teaching first grade there between Rivington and Stanton. I would bring the kids over to my sculpture garden where they would play with water and play with water sculptures and make music in my place. So I was always using my place for learning and fun. That really worked. I taught for several years in Chinatown, at P.S. 1—not the P.S. 1 in Queens, the original P.S. 1—in Chinatown on Henry Street. Then I got involved with the school right down here. And then I started doing performance and I started to do other things. And then my teaching turned into A's because I was giving performance art workshops. I even have photographs . I don't know where the video is but somewhere I have video of my performance art workshops in the subways in 1970-something. It was written up in the *Times*. And I called up the *Times* and I said, "you better come here" because I was freaking out that there's so much publicity for murder and other things and I said, "Okay I have a workshop now so I'm going to take my workshop on the subways and we're going to get publicity." And I did get a big write-up in the *Times* at the time. I just went forward and did it. And then it started turning into A's because things kept getting popular. So. And A's continued through the '80s at different times; it also turned into A Gallery; also turning into A Gallery Sculpture Garden where I showed

many many different people. Like many people turned famous now but who ever knew who was going to be famous?

CP: Well, interesting. Lots of history.

AS: A lot of history. And I got to write it. Ray is screaming at me that he wants me to write the book. He gave me $100 and he said write the book. [Chuckle] But I haven't written the book yet because my life is overflowing with other things right now.

CP: Yeah you got to write the book. I mean come on. It's a whole big chunk of the history.

AS: I know. Exactly. But it's getting the time. I'm running a live art hotel just to survive. Prices aren't reasonable the way they used to be.

CP: No, that's true.

AS: But I feel like I would like to focus more on the film/video things, that's what you were really starting to ask me about. After I did my media opera at Ars Electronica I had worked with so many people for so long I really changed my venue and I focused more on video. I was focusing on video and I put a little ad up at Rafik and then I got a call out of the blue. It was Nickelodeon Television saying they wanted to try something with 8mm vid because I had just gotten this 8 mm camera from the Kitchen. They started buying my ideas and I was shooting my ideas with lots of little kids which related to all the work I had done in twenty years earlier, working with kids very well. Then I started making these videos for Nickelodeon TV for Eureeka's Castle.

CP: Oh really, so you got it off to Nickelodeon TV?

AS: Yeah I worked for them for a couple of years. I made a lot of money for Nickelodeon TV.

CP: Yeah I'll bet.

AS: They paid really well and they loved my ideas.

CP: Doing little segments.

AS: Filming. I was filming for little kids and I got them to pay for a trip to Florida and filmed the dolphins underwater but that one never worked out because the water was too cloudy and that particular one didn't work. But all the shots above the water worked. I did a whole series of shots and a whole series of pieces for Nickelodeon. I also once shot at the Collective, I showed a film that I did of the Collective for Living Cinema while was on White Street in the '70s and I can't even remember which film I shot, I filmed a show there, but I was in some big show there.

CP: Now why was Ernie important? Why is Ernie important do you think?

AS: Ernie was one of the first, I think maybe, the first film/video person, and his wife, Tomiyo Sasaki, was also doing film and video and they were influential in helping me out to get started. They were very, very helpful to me in terms of learning a format; I wasn't going to school to learn things, I was working with friends so to speak. And Tomiyo actually helped make my first alphabet movie which I sold and is in the collection of the Lennbachhaus Galerie Museum in Munich, Germany. So I'm in all different collections in different places. And it was a good one. I did some of that film in—what was that original place on Rivington Street? It was the

original film/video place.

CP: I know the Doorway. Between the Bowery and Houston.

AS: Yeah, which turned into this other place that was then on Broadway . . .

CP: Not the Film Collective.

AS: No it wasn't the Film Collective. It was called Young Filmakers. Actually, that's where I met Steve Black and he just called me the other day from Singapore—because he's living in Singapore now—to ask if he could stay at my place with his daughter but they're coming at the time when my place is crowded, July, so I said they could stay in the tent of my sculpture garden, but his daughter didn't accept that. But anyhow. But it was a real popular place, it was the first film/video place with Bruce and he's well known in the film/video world and he was basically running that place. I met a lot of people there but my memory is not functioning right now which is highly unfortunate.

CP: Yeah, I don't know anything about that place. It was on Rivington Street.

AS: It was way before DCTV. Because that was the first original film/video place.

CP: How about a place called the Gate? Do you remember a place called the Gate?

AS: Sounds familiar.

CP: It was on, like, I think 2nd Ave. It was run by this guy Tambellini and I think he did film and video and monitors and he had a place called the Blackbox as well. So it's all these parallel little histories. And in a certain way they're spontaneous. They're all equally important. And some get the money today and some don't.

AS: That is true as well.

CP: A lot of times the importance is not really understood because the things feed on each other.

AS: That is correct. That is absolutely true. Because it's just like McQuines was at the same time as I, being much younger, experimenting with all different things. So in all different age groups, it just depends who you meet.

CP: Right and what you're into at the time.

AS: Exactly. You know I was lucky to meet Peter Frank and—who was his other friend? Who was a writer, a really well known writer, a fluxus person—and it was maybe through them that I started getting a hint of fluxus. But that was after I had been doing fluxus without even thinking.

CP: Yeah sure. There's no question that A's has a strong history and a real presence. Big presence.

AS: Experimental fun. It was major! And all you saw in

writing was the Mudd Club. And what bugs me in *Basquiat*, Schnabel's movie, is he did not research further to come visit A's which he really should have because Jean-Michael was the first band to play there.

CP: Really?

AS: Yes. Jean-Michel played opening night. [This was October 24th, 1979.]

That's right. And, no, I don't have any pictures of it. No I don't have any film of it.

CP: A postcard? Someone probably took pictures over there.

AS: Somebody probably did but no one has sent them to me. No one has sent them to me.

CP: Actually around a similar time I lived across the street for a while. In the same building as Keith Harring.

AS: Right, so you come to A's?

CP: Figure, '79, '80, maybe '81.

AS: Right so that's when A's was happening. Right. And in '81 was the Plastic Show and Keith Harring came over and Keith did a huge graffiti on the door downstairs and some lunatic renting one of the places in my building painted over it. What I'd like to do is get that door and scrape off the paint. He did an incredible huge grafitti, I mean like he was being really friendly.

CP: Yeah of course. And he was a quick, he was across the street. No A's was definitely a prominent place in your early video and your early performance.

What about the Printed Image?

AS: To my knowledge the one who keeps it published is Thurston Moore from Sonic written about in Confusion is Next The Sonic Youth Story because the Coachman with Thurston Moore and John King played at A's and Red Milk with Kim Gordon played too.

CP: How about Nick Zedd? Did you ever show there?

AS: I did, I had lots of film showings there. It may be on one of the posters. Gretta Wing Miller was doing film showings. She was a filmmaker always doing film showings. She was someone I met at Spring Street Bar on Mulberry Street and she was coming to A's and started showing films. She was a filmmaker and she actually helped me out with some of my films and curated and showed films at A's. Its all on posters which I am archiving for the web.

CP: How many posters do you have?

AS: Hundreds and hundreds and they are stored at my place. I had a showing in Canada at Z gallery in Montrael in 1982. It was funny going from A's to Z Gallery.

In 1983 Danceteria amd ARZ productions showcased "30 Seconds of Less," where 100 artists did performances for 30 seconds or less. ARZ Productions was Arleen Schloss, Richard Skidmore, Zatar and Ray Kelly. Club SNAFU was opened in 1980. A's was getting so popular that Arleen Schloss (founder/director of A's) cultivated ideas using artistic talent composed of an interdisciplinary lab featuring art forms with music, performance art, film/vido and sound poetics in with digital technologies. These programs create art and show works in an integrated way.

Film n Video artists include John Davis of Shell Shock Rock and Manhattan Project, Gretta Wing Miller Relieved without Drugs and Industrial Sidelines, and Arthur Sokalmer, as well as Arlene Krebs EGYPT. New Music at A's included Grey, Basquiat's band, The Human Arts Ensemble, Coachman/RedMilk (Sonic Youth), Glenn Branca, Phoebe Legere and performance with Eric Bogosian's New Year's Eve Revue, 1980, and Linda Burnham of *High Performance Magazine*, as well as A herself. The work of over 1000 artists were presented including Joseph Beuys, Andy Warhol and ?Shirin Neschat. In the 1990's A's became A's Wave, a digital sibling which continued to involve film/performance and interactive projects now with multimedia technologies. In 1999 Schloss was elected a member of the board of ASCI (Art Science Collaborations Incorporated).

Lower East Side Video
X-Ray Warning

by Matty Jankowski

Shielding of this cathode-ray tube for x-ray radiation may be needed to protect against possible danger of personal injury from prolonged exposure at close range.
Cathode Ray TV
Neoist News Agency
Circle ArtsInc.
Multi Media Performance
Video Archive

1972: As a multimedia artist I was immediately drawn to the new porta-pack video technology sitting dormant in closets of the Board of Education public school system. Through a program run by The National Institute of Mental Health whereby video was used as a therapeutic tool, I received training, which certified me, allowing access to the equipment. Working as a consultant to Board of Education Alternative Education Program at The Lower East Side Youth Center on Norfolk Street in Manhattan, Park Slope and Canarsie Youth Centers in Brooklyn, and Project Direction in Williamsburg, I provided hands on training in art, crafts, publishing, VIDEO and a host of other projects. Open reel video recorders and editing facilities were available at Locus, Downtown TV, Young Filmmakers on Rivington Street and an indecent production facility on Chrystie Street.

Finding low-cost rentals and eventually owning equipment prompted me to begin documenting the activities of artists and groups in Brooklyn. At an exhibit at The Brooklyn Arts and Cultural Center, I showed footage of performance artists as part of a book gathering. They didn't know how to deal with my lugging in furniture and video monitors to set up an environment in a book show but it was well received and served as an introduction to a group of artists soliciting proposals for a Monumental ART event at Gowanus Art Yard. Frank Schifreen (Artist-in-residence at the former civil war munitions factory), P. Michael Keen (Manhattan Westbeth artist/gallery director De Refuse/performer), George Moore (painter/Performance Artist), Joe Lewis (Artist/director Fashion Moda Bronx), Maggie Reilly (artist/printmaker RAM studio), Manhattan/director Ward Nase (Gallery SOHO/performance Artist), and a list too long to

mention all participated in transforming the space with installations and creating environments to perform in. I moved my environment with video monitor to the location and documented the months of work that transformed the space. The MONUMENTAL art installations along with eleventh-hour landlord conflicts and opening day demonstrations created much public and political controversy. Many of these artists became the topic of documentation, creating video archives at galleries and for individual artists to review and use for future grant applications and or as visual resumes.

In 1982, I volunteered and was later elected President of Circle Arts Inc. a not-for-profit public arts resource organization helping people find the tools and learn the techniques they need to express their creative impulses. From its New York roots it has spread this philosophy to: San Francisco, California/Dagen Julty; San Antonio, Texas Mona McQuinn; Melbourne, New Zealand, and the UK. At Club 57 (57 St Marks Place, now a mental health facility) monthly Friday night performance events had a wide variety of people signing up for their 10 minutes on stage, all captured on tape. It was usual sound and music experimentation, songwriters like Mama Joy testing their new material, and very avant-garde performances. One memorable performance was "Camouflage" where E.F. Higgins scoured the audience for two people to read from two different French books while he painted a naked George Moore from head to toe with camouflage patterns. It seemed as if every series had at least one naked performer. Then there was the guy who rushed in as we were setting up at 6 pm and asked if he could go on at Midnight... to which we said OK. Then we needed to know what his requirements were... he responded... I wont need anything, I am going to cut and thread a 10-foot length of pipe. At midnight, he pulled his truck up to the curb, dragged in a cutting torch and threading machine, then a 10-foot length of 2-inch iron pipe. The sparks flew, the threader whirred and the crowd applauded. He took a bow to a standing ovation (or were they all leaving?). Thank You, Goodnight!

2B or The (former) Gas Station on 2nd Street and Avenue B housed the sculpture studio of Linus Coraggio and was the site of nightly events, mostly artists and alike misbehaving in public. Testing the limits of both the audience and management were shows like GG Allin and the Neoist conspiracy of Monty Cantsin, Neoist Open Pop Star, Immortal Hard Art Singer, and Self Appointed Leader of The People of The Lower East Side.

"El Sol, Tu Corazon Y El Neoismo!"

Megaphone and *Born Again in Flames*, almost all of Monty Cantsin's performances had the plug pulled due to fire and blood but they continued in darkness and without sound as a cutting torch was fired up and scrap metal was the percussion. De mo mo / Scream and Scrap Metal was another group whose shows were cut short. Motor Morons from Baltimore had a shower of sparks from a bench grinder spraying out on to the audience as their busty singer chanted anthems to gas guzzling cars and push button transmissions. Other notables of noise are New York's percussion sampling Skin Slappers, avant-vocalizations and jazzy torch singer Angela Idealism, Dagen Julty founder of

Circle Arts performed solo and with his band DegaRay.

The Ski-a-Delics arrived late for a show due to bad winter weather conditions but hurriedly set up and stripped completely down to play skis strung with piano wire. It was a great show even though one performer had broken his ski and substituted (against his better judgment) a cross country ski for a downhill ski at the last minute.

Gen. Ken Montgomery ran a space called Generator on 3rd Street just off Ave B. It was a sound/music emporium filled with rare and/or unusual audio on vinyl, tape, CD and LIVE, providing an uncommon opportunity where you could sample the wares and expand your scope of noise or melodic sounds. Ken would see what you liked and let you sample similar styles or suggest new material, from classic avant-garde like Stockhausen, Philip Glass, Pierre Schaffer, Pierre Henry to Muslimgauze, De Fabrik, Zoviet France, Desaccord Major, Vox Poplin, Smersh, Jorg Thomasius, Illusion of Safety, Blackhouse, Rune Linblad, Asmus Tietchens, Walter Ulbricht, John Oswald, The Tape Beatles, Sound of Pig Music, or German pop icon Heino. Some were part of the Worldwide Mail Art exchange network and Gen. Ken was Monty Cantsin, the World Trade Center of Neoism.

I documented the international gatherings and performances, which were crammed into a 10X12 foot storefront and even smaller basement, usually spilling out on to the street: Conrad Schnitzler/Berlin; Gordon Monahan/Funny Farm, Canada; David Meyers, Arcane Device/New York; Scott Kuntzleman, Chop Shop/Boston; If Bwana/Brooklyn; Merzbo/Japan; The Haters/San Fran Ca. Zbigniew; Karkowski/Sweden; The Space Monkeys; and many many more.

The Collective:Unconscious was just around the corner on Ave B. C:U presented a wide variety of music, performance art, theater, sound and interactive art installations and another location for our performance parties / open mic events.

9th Street Window Gallery was the only gallery in New York open 24 hours 7 days a week. Two windows in artist Carlo Pitore's front, ground-floor apartment housed monthly exhibits. The openings were held on the street in front of the windows and were lit for passersby to view 24 hours 7 days a week for a month. I had installed a small 7-inch color video monitor continuously playing one of two 2 hour edited videotape loops and changing the tape every 24 hours. One tape loop was an hour of Neoist performances and propaganda with another hour of Collaborative Mail Art video project by myself and Peter Kusterman from Germany. Peter had traveled around the world collecting images of artists performing and working in their studios. My video catalog of mail art shows and performances was the second tape loop. Monty was living in the front room and could hear people at all hours day and night stopping and commenting. He did not get much sleep.

In 1916 Marcel Duchamp, a leading Dadaist, attached four postcards—each written in correct syntax but without apparent meaning—to a common backing and mailed it to a neighbor. Artists have been exchanging information and original works through an international postal network ever since. The Anarchist Switchboard was a basement meeting space where a collection of five different mail art shows "Burn This," "Is there No Justice," "Interfere"—"Mail Art Marksma" and "Having a great time wish you were here," were exhibited, as well as readings and performances both live and on video tape by Barbara Holland, Ron Kolm, Hal Sirowitz. Mark Block's performance of Potato Lake, where he rails against the art establishment denouncing galleries, museums judges and juries who "corrupt" art and artists, was very appropriate for the alternative space and artform.

At 124 Ridge Street, the cooperative Gallery, Mat Harrison organized a film night where everything from old home movies to new independent films were screened in the order they arrived. Another Mail Art show hung there: "The Joke Is In the Mail." This was art that made you laugh and *The Daily News* Sunday color *Magazine* supplement listed the exhibit in a full-page column which brought new faces to the Lower East Side for the opening and throughout the month it was up. Live performances and interactive activities from the past were preserved on video.

ABC No Rio was the scene for many hard-core music events with Public Nuisance and The Abused as well as a visiting Polish performance artist who baked bread for everyone and had a recital with his handmade sitar. Gen. Ken Montgomery sat in with God is My Co Pilot playing violin for a special show.

The Unbearables were and still are a great group of extremely talented writers of poetry and

prose who gather together to create themed reading events and publications. From 20 people spaced across the Brooklyn Bridge reading erotica at 5 p.m., Crimes of the Beats at Saint Marks Church Poetry Project, The No Bar, Anarchist Switchboard, to The Unbearable Beatnicks of Life at the Life Cafe, featuring Beer Mistics from Holland to Students of Ginsberg who now teach at the New School—all these activities and more are archived by Cathode Ray.

MILLIONTH APARTMENT FESTIVAL APT (ANATHEMA PARTY TAKEOVER).

The Stockwell Gallery 13th Street: a worldwide gathering of Neoists. NEOISM: Any definition of NEOISM simultaneously reveals and conceals that its goal is to get where "all mechanisms of logic are broken, control is impossible, the great confusion rules."

Monty Cantsin: an "Open Pop Star" Invented in the late 1970s by Mail Artist David Zack. Anyone could be Monty Cantsin. The name would then become famous, to the benefit of every Monty Cantsin. Call yourself Monty Cantsin and do everything in the name of NEOISM.

The Chameleon: a space where Circle Arts had held performance events was the beginning of the festival. The crowd gathered and suddenly the amplified sound of a crying baby silenced everyone. They looked around to find the source. It was onstage and the child was that of Neoist "Tentatively a Convenience" from Baltimore. Now that he had everyone's attention he began announcing the video program: Some of the best avant-garde images ever seen on the Lower East Side. I had two favorites: one of porn clips of vegetables having sex and people in monster masks. The video alone was not what made it great but the fact that he worked for a peep show and slipped them in the machines and they went unnoticed for a few weeks.

The second was him on all fours wearing a dog mask as he led a woman on to a bus. She was legally blind and he wanted to see if he would get on without paying as her guide dog . . . he didn't have to pay. The festival drew about fifteen people yet was the topic of a four page *Village Voice* article and ended with a march into Tompkins Square Park with Flaming Steam Irons, followed in by a police cruiser with the cops asking the *Voice* reporter if this was going to get violent. She answered, "NO it is ART." "OK." they said and the parade of Neoists continued as monty sang while a pitbull tugged at his trousers. On Sunday afternoon in the park on the FDR under the Williamsburg Bridge, a scrap metal concert and flying oil drum and Jaguar gas tank ballet combined with the echoing roar of traffic brought the festival to a thunderous close.

After the riot in the park, I taped the police barricades that surrounded the park. Driving around and around with a camera hanging out the passenger window; the police on duty were very curious after about an hour of circling. We (Monty, Gen Ken, Boy Genius, and Cathode Ray) got a gig as a band (mixed tapes of noise and scrap metal, bass guitar, violin and Monty on megaphone) at CBGB's Gallery where we showed the footage on a monitor atop a blue police barricade set on fire, but that didn't get the owner upset. He came unglued when Monty drew blood and splattered it on the wall between two pieces of artwork. YES... He pulled the plug. Once again all on tape. Even at squats where anything goes we never got to finish.

NEOIST NEWS AGENCY

I received a package from Monty Cantsin, in it was an engraved plaque and rubber stamp, they said "Neoist News Agency."

I had been collecting copies of Neoist propaganda, publications and videos from Monty Cantsins worldwide. I also was promoting Neoism throughout the Mail Art Network and providing my art direction skills to aid in design of album covers. I had become a central clearing house for Neoist news, information and video documentation of Neoist activities.

The Rivington Sculpture Garden and The Rivington School—Ray Kelly FAQ, Toyo, Blood Sister, Higgins, just to name a few who would hang out at No Se No social club, as Hank Williams blared on the jukebox and the clock always read 6 o'clock, they would stumble into the Rivington Sculpture Garden. They were a major part of the documentation. There was a very raw ritual sense to the branders and twisted metal that filled the corner lot. Impervious to Flaming Steam Irons (a Neoist icon), it was a very natural backdrop for blood campaign activities: musical performances with Monty's megaphone and boom-box. Full of car parts, bathtubs, cabinets, machine parts, raw metal rebar and beams, the massive structure soared

more than two stories high and was sprayed white just before the bulldozers came in to clear the way for an apartment building. Monty had been shooting the growth on Super 8 film and edited with sound onto video. A new garden immediately rose from the wreckage just a few doors down and barn fires and cookouts continued as did Neoist blood-and-fire, scream-and-scrap metal activities; a new hangout where NYU film students shot *The Death of NEOISM* where Monty was shot by a jealous yuppie art collector.

xfh (an X Funeral Home) on 7th street was the home of bizarre performances and installations till the final hurrah with "Destroy all Music," a night to remember, or "Lets Go to the Video Tape."

An endless parade of decorated bodies graced the Tattoo and Body Art Society meetings, contests and demonstrations from a gallery on 6th Street to CBGB's. A feast for the eyes taking us into the new millennium with Cyber Fetish and Body Modification events at Berlin Underground, the NEW Collective Unconscious and Babyland, where the best of both worlds, voyeurs and exhibitionists

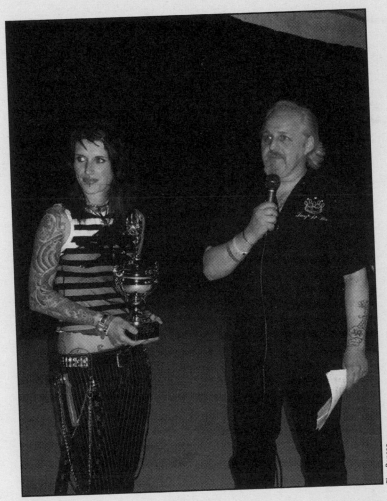

Elsa Rensaa

Birgit from Austria and Matty Jankowski
at the New York City Tattoo Convention

create the perfect balance.

Do you watch commercial television or do you just see it? While you sit in front of the CATHODE RAY tube, images form automatically before your eyes . . . odds are that your mind is not having to work very hard to understand what is happening on the screen. Your response to the imagery becomes passive and preprogrammed. Nothing new on TV, so no new reaction is required on your part. A very safe situation, but is safe what our society needs?

The original idea of entertainment for the masses has transformed into "advertising for the masses." The commercial aspect of television has brought the medium to an intellectual standstill. Many people do not appreciate mundane commercial programming, so now we have Public Television (and in major cities, public access cable). However, because of having to operate within governmental boundaries, Public Television has its limitations.

O.K. so what's the point?

The point is, it is time to do something about television, because as it is TV is corroding away our minds. If it is not corrosion it is nothing short of oxidation. If there can be alternative music and literature, why can't we create alternative television? Innovative programming, with less emphasis on commercial sponsorship is a good place to start. All that is needed is a diehard group of artists and professionals that want to realize this goal and don't care if they make that extra $5 million in profits.

STEP 1

Turn off your TV set and start thinking.
The rest will follow.

NEW ART FOR A DANGEROUS AGE!

All these tapes and much more (2,000 + hours) are archived and available for screenings.

Contact:

Cathode Ray / Matty Jankowski / Monty Cantsin at circlearts@aol.com

Radical Player, Radical Mind, Radical Video

by Davidson Gigliotti

Davidson Gigliotti got his blood and his guts for his involvement in video by living, breathing, swinging, and chewing his cud on the LES. Davidson went on to become a high achiever and radical player in the world of video. We are very pleased that Davidson was able to make this contribution, as recently he has been swimming in water way over his head, caught in a few of life's swirling eddies, and with the heart of a lion managed, who knows how to fight hard and to get his article handed in. —Clayton Patterson

I lived on the Lower East Side, off and on, from 1962 to 1970 and it left a big thumbprint on my way of being.

I drank at Stanley's, danced at the Dom and the Electric Circus, hung out at the Annex, ate breakfasts at the Odessa and the B & H, and ate dinners at the Engagé, and, once in awhile, at the Paradox, whose owner and founder, Dick O'Kane, I knew. I watched *Henry V* at the New Charles Theater several times, and bought Genoa salami heroes at the Drydock Deli. I bought oak stuff at Elk's Trading Post and sold it back to them for way less than I bought it for when I ran out of money, and walked by Junior's Cave many a time, though I never went in. I heard Sun Ra's Solar Arkestra play in Tompkins Square Park; I built a closet for Allen Ginsberg; I learned how to talk from listening to Lord Buckley records; heard Ornette Coleman play at the old Five Spot on Cooper Square John Coltrane play at the Half Note; and any number of fine players at Slug's. Along the way I became kind of a funky dude, but I wouldn't trade the experience for anything.

From about age 12 I knew that I was going to live a Bohemian life in New York City. I had read all the stories about the German and French DaDas, the Algonquin Circle, the Surrealists, Paris in the 1920s, Gertrude Stein, Hemingway, Fitzgerald, Breton, Duchamp, Tristan Tzara sticking a breadstick up his nose. That, and Kerouac's *On the Road*, all melted together in my brain and resulted in a determination to move to NYC at the first opportunity and get my Bohemian life started.

I moved to New York late in 1959, living in a room in the railroad YMCA on East 47th Street. I was 20 years old, newly married to a girl I'd met at RISD [Rhode Island School of Design].

It took me a couple of months to get settled and bring my wife, Sally Lind, from Hartford to New York. We took a small apartment on Minetta Lane in the Village. The rent was $125 a month, high for those days. My new job at UPI paid about $85 a week, but Sally's parents helped us with rent. A lot of writers, and some artists, had been reporters, I had noted. I thought it would be a place to start. So I started on the lowest rung in the Sport's Department.

My waking hours were largely confined to the 10,000 square

Davidson
Gigliotti

Clayton Patterson

foot newsroom on the
12th floor of the Daily
News building where I
worked the night shift.
Although I nominally
worked 8 hours, in fact, it
was usually more like
ten, and sometImes
twelve, because I had a
responsibility to remain
at my desk until all the
scores from all the
games played that day
were in and the stand-
ings were sent out on
the sports wire. A twi-
night doubleheader on
the West Coast? That meant that I got out
at 4am if the game ran into extra innings. Sometimes I stopped at Grants on 42nd Street for a
hot dog before taking the F train home with Marty Lader, a fellow UPI guy who also lived in
the Village.

I worked with great people at UPI. Marty, who was only a year or so older than me, became
a friend. I should also mention Jack Cuddy, the boxing editor, who mentored me a little bit.
Also Jack Griffin, a really kind man, who later became sports editor, and Tim Moriarty, Dick
Joyce, Norman Miller, Fred Downs, Milt Richman, and Joe Sargis. I don't believe that any of
those guys ever missed a day at work, and I didn't either, because I admired them and I want-
ed to be like them.

But I rarely saw the city in the daylight or even at night, because I worked six days a week
and my work hours precluded a social life. UPI was a great experience for a young man, but
the hours took a lot of the fun out of it. My work schedule took a toll on our marriage, also.

Around 1962 or so, friends of mine from RISD started drifting into the city and this precipi-
tated real dissatisfaction with the way my life was going. We thought that a job with more
normal working hours and an apartment with more sustainable rent would ease some of the
pressure. Also, I had started taking some classes at NYU, and that was taking up a lot of time.

So I went from journalism to manual labor, taking a job as a woodworker in a small shelf
factory on 10th Street between D and the East Side Drive. I never regretted the move. One of
the owners, Bernie Rzetelny, became a good friend, and the woodworking skills I learned there
and in other shops since have sustained me through the years in unexpected ways. If I
worked long enough I could make almost as much money as I did at UPI, and I got to go to
work while the sun was shining.

Sally and I moved into 216 East 10th Street, on the 4th floor rear of the building, on what

was then called the Lower East Side.

As a cultural hothouse, the Lower East Side never had the glamour, the real estate values, or the square footage, that typified SoHo, or even Greenwich Village. It was a dense, crowded environment, hemmed in by Third Avenue and the East River Drive, and relieved, north of Houston Street, only by Tompkins Square Park.

The west end of the map, dominated by 2nd Avenue and St. Mark's Place, had a strong Eastern European flavor. Ukrainians and Poles were in evidence, and there were Jewish Theaters on 2nd Avenue, appetizing stores, Ratner's and Rappaport's, both great dairy restaurants, and a serious Jewish Deli on the corner of 10th Street. It's still there, by the way.

First Avenue had some remnants of an Italian neighborhood, with pasticcerie and funeral homes. There was also a slowly dying city pushcart market on the southwest corner of 10th and First. When you crossed 1st Avenue the ethnic makeup changed and became more mixed and with a Latin feeling that got stronger, the further east you went, particularly on the streets north and south of St Mark's Place. Still, right up to Avenue A, particularly around Tompkins Square Park, an Eastern European presence was maintained. There were sweet shops on Avenue A, the Odessa Restaurant, a Ukrainian church and even, in a storefront near 5th Street, a clubhouse of former Cossacks. At least that's what they told people.

Avenue B was a dividing line of sorts. East from Avenue B, there were more bodegas and botanicas, mysterious shops where herbs, candles, and spells were sold and the books were consulted. There were families, lots of Spanish spoken and lots of kids hanging around the stoops and riding tricycles with padlocked aluminum boxes attached to the front. In summer there were guys with little carts, blocks of ice, bottles of syrups, and a supply of paper cups, selling granitas that they would shave up for you for a dime.

There were drummers and timbales players, good ones, on nearly every block and summer nights were full of Latin percussion. There were pigeon fanciers with rooftop coops, flags flying, swarms of prize pigeons circling in the twilight sky.

Clayton Patterson

Davidson Gigliotti

Avenue D was deep in the Lower East Side and east of that was a block or so of factory lofts and other light industry spaces. Many were woodworking shops and I worked in three of them, all on 10th Street between D and the Drive.

At the end of 10th Street, fronting the East Side Drive, was a concrete barricade graffitied with the words "This Day is No Good For You," casting an existential spell over 10th Street, the Lower East Side and the souls of all who lived there. It remained for years.

The people who came to live on the avenues and streets east of Third Avenue, and who were not from Eastern Europe or Puerto Rico, started drifting in during the late '50s and early '60s.

They came looking for a measure of freedom seemingly unobtainable elsewhere. Freedom to live the way you wanted, look the way you wanted. Freedom to live together without being married. Freedom to have friends and lovers of a different color. Freedom to have lovers of the same sex. Freedom to consume drugs, freedom to call yourself anything you wanted—artist, poet, jazz musician, writer, beatnik, dope dealer, hustler, bicycle thief, or nearly anything at all—without hearing too many contradictions. Freedom to create a world of your own, and live in it, hard though that world might be at times.

A large part of this freedom meant the freedom to get away from those parts of society which didn't want you doing all these things. The Lower East Side was not on too many cultural maps in those days—visitors were few. One wasn't likely to see one's boss, one's work associates or one's parents there. You could slip from the crowded streets and avenues into your Bohemian life.

Not into a Bohemian utopia, however. The Lower East Side was a potentially dangerous and difficult place, sometimes made the more so by your own presence there, depending on who you were, and why you had come. Middle-class amenities were few. Middle-class values were challenged on every hand. There was always an aura of illicit activity, a pervasive criminalization of everyday life, and the potential for violence, even murder. The Bohemianism of the Lower East Side was not safe in any way. You had to become street wise pretty quick. In some ways, it was a simulacrum of ghetto life, with gangs, hustlers, merchants, a whole caste of street life, with nobody rich and quite a few poor. Detectives from the 9th Precinct patrolled in unmarked cars, all of which were known by sight to nearly every resident.

What it lacked in safety, however, it made up with an endless supply of little walk-up railroad apartments located on dirty white tile hallways and behind battered Kalamein doors thick with peeling paint of indeterminate color, decorated with lock cylinders. It had bathtubs in the kitchen (with metal covers that could be used for a working surface), toilets located in little closets and, if you were sensitive about keeping people out, window gates that gave you the feeling of security, if not the substance, since they would certainly impede escape in case of fire. All of this for anywhere from $40 to $80 a month. You could, once inside, do pretty much whatever you wanted. That could even include not paying rent. Landlords were regularly stiffed, and electric meters and seals were seldom left untampered.

For me, the unique experience of the Lower East Side in the mid-sixties was the fact that it was an integrated society, certainly to a greater extent than usual in the rest of the city, or the country for that matter. I was interested in jazz music and one of the buildings that I lived in, 610 East 9th Street, was home to some young jazz musicians, and also home to Bette Richards, the widow of a fine trumpet player who died at age 23, Booker Little. Many jazz players, mostly young, visited the building. Two of them, Bruce Johnson and Yahya Salih Abdullah (who lived upstairs), became friends. Blues players like Major Wiley came through now and then. My friend and partner in crime, Randy Allen, was also a blues and folk musician. There was a Lower East Side tradition of jazz residents; Charlie Parker had lived for a time on Avenue B, the old Five Spot had been on Third Avenue at Cooper Square, and Slug's was fast becoming known as a very important jazz venue. This was an

exciting environment. I listened to jazz and went to Jazz places from time to time, but because of my situation, though not a player myself, I got to know players and learn a little about their real lives, their ambitions and day-to-day struggles for existence.

I didn't live on the Lower East Side the whole time. I moved to Brooklyn for a while, help-ing renovate brownstones in Park Slope. But in 1969 I appeared on the Lower East Side again, with a second hand CV portapak purchased from C. T. Lui.

But that's another story, and only a little bit about the Lower East Side.

* * *

The Videofreex, 1969

Skip Blumberg, Nancy Cain, David Cort, Bart Friedman, Davidson Gigliotti, Chuck Kennedy, Mary Curtis Ratcliff, Parry Teasdale, Carol Vontobel, Ann Woodward.

The Videofreex was started by Cort, Teasdale and Ratcliff in the summer of 1969. That autumn it started to grow into a cohesive group, mainly around a CBS initiative set up by Don West, who was then assistant to the president of CBS at the time, Frank Stanton. It was West's idea to gather New York's then tiny video community around the concept of a "counter-culture" television show, shot and edited by the video community, and aired, perhaps, by CBS. CBS broadcast executives like Mike Dann and Fred Silverman approached that idea with silver bullets, bags of garlic, and wooden stakes, but West had accumulated a lot of favors owing, and got some money from CBS to give it a try.

The actual result, entitled *Subject to Change*, was an interesting program for the time. Edited by Cort, Teasdale and Ratcliff, it featured an interview with Fred Hampton, a Black Panther leader later killed in his bed by the Chicago police; a visit to Pacific High School in Palo Alto, one of the country's first alternative schools; an afternoon with Hovey Burgess and his troupe of jugglers and clowns; and several other features not usually found on television in 1969.

The boys at Blackrock didn't buy it though, in fact they were repelled by the whole idea. West's position next to Stanton didn't save him. He was fired immediately and went on to become the editor of *Broadcast Magazine*.

The Videofreex, however, refusing to be downhearted by events, went on with a program of their own; applying for grants, teaching video, shooting numerous records of counterculture lifestyle, and founding other media centers around New York State.

Excerpt from "The New York Video Collectives," by Davidson Gigliotti, www.davidsonsfiles.org/Exhibitions.html.

Raindance, 1970

Frank Gillette, Ira Schneider, Paul Ryan, Beryl Korot, Michael Shamberg, Megan Williams, Louis Jaffé.

While the Videofreex represented the world around them with videotape, and People's Video Theater attacked social problems, Raindance had quite different aspirations—to bring together the world of video and the world of cultural and cybernetic thinkers: McLuhan, Fuller, Bateson, Wiener, Shannon & Weaver, C. S. Peirce, Michelet, Vico—these were the names that got bandied around at Raindance. They were visionaries, at home with ideas and dedicated to evolutionary change. They made videotapes, too, but probably their most significant produc-tion was the periodical *Radical Software*. It was the brainchild of two women, Beryl Korot and Phyllis Gershuny. Working in a Chinatown loft, Korot and Gershuny cut, pasted, interviewed writers, selected art, and worried over what to call it. From a number of sources and sugges-tions, the title *Radical Software* emerged.

It was a great title, and the first two issues, edited by Gershuny and Korot, contained inter-esting material and an interesting graphic style, and it did not take a great leap of imagina-tion to see that *Radical Software* could have had a real future as a video magazine and, later, journal. The first *Radical Softwares* were quarterfolds, a popular style in those day for publica-tions somewhere between a magazine and a newspaper, and printed in blue ink. Later edi-tions reverted to a more conventional magazine format.

Still, while some later editions did keep the implied promise, Raindance's democratic deci-

sion to farm out the publications to various video groups resulted sometimes in spotty quality. The publication was later taken over by Gordon and Breach, and was discontinued in 1974.

Excerpt from "The New York Video Collectives," by Davidson Gigliotti, www.davidsonsfiles.org/Exhibitions.html.

Radical Software (1970–1974)

The *Radical Software* Web site is a joint project of the Daniel Langlois Foundation of Montreal, and Davidson Gigliotti and Ira Schneider.

The historic video magazine *Radical Software* was started by Beryl Korot, Phyllis Gershuny, and Ira Schneider and first appeared in spring of 1970, soon after low-cost portable video equipment became available to artists and other potential videomakers.

Radical Software was an important voice of the American video community in the early 70s; the only periodical devoted exclusively to independent video and video art at the time when those subjects were still being invented. Issues included contributions by Nam June Paik, Douglas Davis, Paul Ryan, Frank Gillette, Beryl Korot, Charles Bensinger, Ira Schneider, Ann Tyng, R. Buckminster Fuller, Gregory Bateson, Gene Youngblood, Parry Teasdale, Ant Farm, and many others.

Radical Software, published by Raindance, archived at www.radicalsoftware.org.

References:

Gigliotti, Davidson, "A Brief History of RainDance" *Radical Software* Website, www.radicalsoftware.org/e/history.html.

Shamberg, Michael, *Guerrilla Television*, written by and published by Holt, Rinehart and Winston.

Schneider, Ira and Beryl Korot, *Video Art: An Anthology,* Harcourt, (1976).

Teasdale, Parry D. *Videofreex: America's First Pirate TV Station & the Catskills Collective That Turned It on*, Black Dome Press; (1999).

Mon histoire de la cinema, c. 1984

by Nico Smith

The last thing I remember in video or maybe the first, from the sixties, was this video camera and monitor @ "Woodstock 1" I knew video was around in 1969, but no one I knew had one. The feature that appealed to me was its compactness. Hitherto all that video equipment was much too large. Those people whose names I've forgotten taped during the day and viewed it in the woods @ night. This was a clear example of what the future would bring.

At that time I owned a super 8mm film kit along with a sound recording system and projector. I made films about me and my brother and our friends painting houses and a church in Pound Ridge, N.Y. The one inside the church featured our outsized lewd drawings on the walls of the church. Naked ladies and such. I grew paranoid that the church people would return and see this art, so I urged my brother to paint over the stuff. I got that on film along with shots of driving on the tree-lined country roads through the roof hatch in my brother's hippie-style VW bus.

I showed those films @ a loft on 5th Ave. near 23rd St. belonging to a fellow named Wynn Chamberlain, the brother of the famous sculptor, John Chamberlain. All kinds of people came over then. A lotta people from The Living Theatre drama company, Julian Beck and Judith Malina themselves, and people like Ultra Violet from the Andy Warhol crowd. Super Stars. You couldn't help but like my films which also featured my beautiful sister, Nicole, who coulda been a movie star, and our house in the woods in Yorktown. The Last film I made @ the end of '69 was on a mountaintop in Pennsylvania. There was a stairway going up to nothing but space. I would send them back to my Family on Baptist Church Road.

Clayton Patterson

Breakfast at Sidewalk, Nico and daughter

Me and my new wife, Bonnie, were on our way out west. I had an address of friends in Taos, Reality Construction, on top of a mesa overlooking the town. It was next door to " New Buffalo." They were communes built by skillful and resourceful types who wanted me to join them, but I ain't no hippie, so I turned 'em down and they were a little pissed 'cause I had money. Anyway, a couple of years later, we were back in Manhattan, living on 9th and C, painting "City Walls." Super graphics applied to both indoor and large out door spaces.

We saw a notice for a film showing @ NYU about the commune places in New Mexico, where we'd been 2 years before. The film featured the New Buffalo Structures and break-down of the commune due to the influx of itinerant teenagers who were a product of the hippie culture let loose into the mainstream, like a disease. They would break you down; it was only a matter of time. And we watched the rather rapid disintegration of the habitat and culture of

Simon and Justin, I think those were their names. That same commune was featured in that hippie flick *Easy Rider* that was pretty risqué for other than a downtown production. After that the city fell apart from the plague of junkies. And in 1971 I made it for the Mexican border and points south. And I stayed for the remainder of the decade in an indigenous village in the valley of Oaxaca. Took photographs but no moving pictures.

Returned to the city around the beginning of the '80s. Most of my time spent around the poetry scene around Life Café. In 1985 from the vantage of my art gallery on 10th St. between A and B, "Nico Smith and Ground Zero." I was introduced to the film of Richard Kern and David Wojnarowicz, the artist. There was a lot of blood and guts and a slim plot. It seemed like most American amateur efforts, to be rather puerile. Then around the end of the decade came along someone w/ intelligence and humor by the name of Nick Zedd. Who's proven to be the more enduring of avant-garde filmmakers from the height of the East Village art scene. Everybody had their guns by that time. The one film that stands out @ that time was Nick Zedd's feature *War is Menstrual Envy* starring the Famous Annie Sprinkle. The closing scene, like in the *400 Blows* or *Through the Olive Trees*, is memorable.

Jim C. and me and a couple of other guys were covering the video campground. Everybody was just getting started in 1985. Everybody was rarin' to go in 1987. I was inside the Tompkins Sq. Park; it was like Tent City. Every bum and his brother's cousin was there. It was like the days before Custard's Last Stand. I took my video camera deep inside the huts they had built. Some had multiple rooms and dressers and captured birds, which they said were lame. Some were like teepees, but they didn't want me inside. So I would interview them outside their dwelling. I was doing this @ the behest of and under the aegis of Gallery owner Pamela Stockwell. She was super tight w/ the bums. These were the days just before the Riots of 1987 in Tompkins Sq. Park. One videotaper came to the fore, and that was Clayton Patterson, who taped the event in all its glory. Everyone knows he shot the cops in action, doing what they do in these situations. And they confiscated his footage and then ensued a court battle to retrieve the material. Clayton won. That was what I call above and beyond the call of the average documentarian.

To say something about my impressions of Jim C's work on video, that'd be nice. I was close to Jim C @ one time and I perused, not studied, quite a bit of his oeuvre. He approached Videotaping in an artistic manner. There was much montageing and effects, such as turning the camera around in dizzying loops. There was as much attention given to the idea of a loose camera almost mindless as anything to do with certain people or certain events.

In the meantime I was taping art openings in the EV and sometimes venturing into museums and uptown galleries. One time I did tape almost a whole contemporary painting show @ The MoMA, (you're not supposed to do that, so there's the thrill of the forbidden on the tape). I was driving a taxi @ that time and I used to take my camera on the job. It was too hard to shoot the passengers so I'd just do the road and the town. I had the shift the night before the Riots in the Park and as I rode around in the dark, I shot the preparations of the Police. It was like the invasion of Iraq. Everybody knew it was coming.

Other stuff I saw around that time were films and videos by and about the local artists, such as Scott Borofsky and Rick Prol. There was this French guy, who lived next door to Life Café; his name was Phillipe. He did some interesting footage of the Scene Artists like Anna Jepsen and Luca Pizzorno who were in videos and made lots of their own. That guy Phillipe, Anna and Luca died. But one of the characters that Clayton Patterson got on tape, Daniel Rakowitz, didn't. He's in a psychiatric facility, serving an indeterminate sentence for killing a Swiss ballet dancer and eating or serving her to the bums in Tompkins Square. Billy Sleaze told me that story about feeding her to the bums; it may or may not be true. But Daniel Rakowitz did kill that Swiss ballet dancer and put her head in a cooking pot. All around that same time.

(Dead)panning Through the Lower East Side
with Jim Jarmusch

an interview by Joshua Rothenberger

Don't thank Jim Jarmusch for the road, he didn't build it and doesn't much care where it came from. Jarmusch was, however, the guy who suggested we take a road trip, and this was a brilliant suggestion...

Jim Jarmusch has always been interested in places, points in time, images that mean on the surface. The beauty of his films can be found not in an over-intellectualization of the finished product, but rather in the raw experiencing of such self-presence. Perhaps this is why the Lower East Side has been so essential to many of Jarmusch's films, both as shooting location and narrative setting. An exterior shot in *Stranger Than Paradise* immediately invokes a spectatorial moment of historical avalanche: in this instance the Lower East Side might come to speak of diversity, urban art utopianism, and a rich legacy as one of New York's oldest residential neighborhoods. Simultaneously, such images force the spectator to grapple with issues like gentrification, drugs, police riots, and urban upheaval. Yet before such associations rise to the surface of consciousness, Jarmusch's protagonists have already hit the road, en route to Cleveland, Ohio.

Jarmusch's ability to create a multiplicity of meanings with a single image has allowed him to be one of the purest, most candid "historians" directing narrative film today. Any historical account of film and video in the Lower East Side would be simply incomplete without a chapter on Jim Jarmusch. What follows is a discussion with the shock-haired filmmaker about film, music, urban politics, "the journey," the next stop along the way, and much more.

JR: Hey Jim, I know you've done so many of these things and I don't really want to ask questions that you've already been asked. So in hopes of spicing up the intro part of this interview I printed up an application for the King's Theological Seminary. If you don't mind, I'd like to ask you a few of the questions from this application to get started.

JIM: Okay.

JR: Full Name?

JIM: James Robert Jarmusch.

JR: Place of Birth?

JIM: Akron, Ohio.

JR: College or university attended and degrees earned?

JIM: I got a BA from Columbia and a . . . whatever you get for film from NYU, although I got it years later, after the fact.

JR: Reflecting upon your spiritual pilgrimage, describe your spiritual journey chronologically, including the mention of the most significant events and influences upon your life.

Jay Rabinowitz

Jim Jarmusch

JIM: (laughs) Well I was brought up as a Christian. My parents were Episcopalian. At the age of about twelve I pretty much became a militant Atheist, which I remained until about 10 years ago. Since this point I have not considered myself an Atheist particularly, but I follow no organized religion whatsoever. But I have been influenced and interested in philosophies from aboriginal or native, particularly Native American, cultures as well as Buddhism. Although, I am not a practicing Buddhist or a practicing anything. I practice my own beliefs.

JR: All right, great. Well because of the shortage of time I'll skip the "What do you perceive to be your strengths and weaknesses for ministry" question.

JIM: (laughs)

JR: At some point you must get tired of deflecting over-zealous praise that you are the "Godfather of Indie Films."

JIM: Oh I don't like titles in general. I particularly bristle at "indie film" because it has become a label they slap on things as a marketing device. I've always seen myself as totally outside any kind of particularly commercial category. And I just don't like those stamps they put on people in any case. I don't really like any of those labels. I'm just a guy trying to learn to make films my way. And it's a process. I like very much when Akira Kurosawa was about 80 years old, they asked him, "When will you stop making films?" And he said, "When I learn how to do it."

JR: Is your resistance to the mainstream Hollywood cinema a political one or is it just a case of personal preference/how you want to operate as a filmmaker?

JIM: It's more of an aesthetic one, although there are some political factors that certainly filter in there (laughs). I believe there are as many people that make films as there are ways to make films, so one should approach whatever craft they are learning from their own perspective. The Hollywood one is very limiting and based much more on marketing and analysis of the film as a product, which is completely antithetical to my approach. I love the form—at least narrative filmmaking—as an extension of storytelling. And it's related to music, to theatre, to literature, to design, to composition, and to photography. All those things are in the form of filmmaking, and it's the beauty in those things and in the form itself that attracts me to it. So the commercial concerns of Hollywood are of no interest to me. It's not really a reaction to Hollywood. I don't really fit in that world, I wouldn't be good working in that world. So I don't. You know, some people have made incredibly beautiful films and expressions under that formula, and that's just not my way.

JR: I've noticed that you do a lot of production outside the U.S. and many of your films were financed or distributed by foreign companies. Is this a decision borne out of you not fitting that Hollywood methodology?

JIM: That's a decision completely borne out of my intention to have creative control over the work. The only way I could figure out how to do that was to get money from places where they didn't have to have final cut and trusted me to make all aesthetic decisions. In other words, I would not feel comfortable making a film where business people are telling me what music to use, who to cast, how the film should be edited and made. I'm not adverse to American money. I would finance my films that way if they didn't have those strings attached. So far I haven't been able to find anyone who doesn't attach those controls. So, it's just about doing it my way, and, luckily, that's the way I've thus far been able to do it.

In Jim Jarmusch's first film, *Permanent Vacation* (made surreptitiously with financial aid money from NYU), Aloysious Parker says, "I'm going to walk through the rubble of the building where I was born." What follows is a shot sequence of the pallid-faced protagonist ambling through a ghost town of fractures, through a garden of severed but breathing building-pieces. What makes these scenes of rubble and ruin even more ethereal and, at last, more profound is that they were almost entirely shot in the Lower East Side, circa 1980. Jarmusch has always had a peculiar intuition when it comes to historical consequence. Even if such premonitions exist below the level of consciousness (as he would surely tell you), what is communicated now when we watch those shots from *Permanent Vacation* is a naked, unmediated reminder of what the Lower East Side has left behind. The processes that have transformed this neighborhood can, in many ways, be mapped out in Jarmusch's New York films. In 1984, Jarmusch conjured Willie and Eddie, two unemployed oddballs who lived in the Lower East Side simply because they couldn't afford to live anywhere else. In *Stranger Than Paradise*, Willie and Eddie work as a historical lens through which we can study the Lower East Side as not merely a place where two such characters lived, but also as a cultural space with its own set of codes that reproduce the living space itself. In *Stranger Than Paradise* and *Permanent Vacation* Jarmusch goes where the history textbook is not afforded access, capturing a piece of the Lower East Side in its heyday, before characters like Willie and Eddie were driven out of the neighborhood.

JR: Could you maybe talk about living in the Lower East Side and how that has influenced your work?

JIM: Living in New York in general, and particularly the Lower East Side, has always been really interesting in that it is just a real mix of people. Although I think, in a way, New York is not really America. In another way it is the essence of what America is, which is a mixture of all different cultures and languages—all those things converging is what interests me. I've tried to, I don't even know if it's conscious, but I'm interested not in just Eurocentric white people, you know? And the Lower East Side has also always been an amazing mixture of social strata. It's just really inspiring. I still love the Lower East Side, though it seems to be getting smaller in a way. I like to go farther east when I take a walk rather than going west to Soho and that

It made you feel that anything was possible

kind of vibe encroaching on everything. The main thing for me, in the mid to late '70s, was the music scene and that was a huge inspiration to me. All those bands that played at CBGB's, Max's Kansas City, Mothers, The Ocean Club, later the Mudd Club, Tier Three. That whole scene was incredibly inspiring because people were making music not in an attempt to get signed or become stadium acts. They were really expressing something they felt. Also, you didn't have to be a professional musician in like a Jimmy Page style. You could be Joey Ramone. That affected how I looked at filmmaking. Growing out of that scene, a really seminal thing for me was seeing a projection in the late seventies of Amos Poe's film *The Foreigner*. He just made it all on his own, guerilla-style, out on the street and that made me realize, "Hey I could make a film, too." I could take out a car loan, I could scrape up some money and shoot something on the street. Which lead me to my first film, *Permanent Vacation*. But that whole music scene and that whole aesthetic and that attitude about life is really important to me, and forms a lot of what still exists in my work. Although I'm not analytical, I'm the worst person to analyze my work. But that feeling is still in there, I hope.

JR: You did your own music for *Permanent Vacation*, correct?

JIM: Ah well, I took some of John Lurie's music that he did for the film and I mixed it with some Javanese Gamelan music that I manipulated. So I kind of created music by collaging

elements, but I didn't create the elements. They were created by John and master musicians of Javanese Gamelan (laughs).

JR: I thought the music was amazing. I found out afterward that you were a part of it. It almost resembled some of my favorite Japanese films, especially those of Teshigahara. Those clanking sounds in the context of the Japanese film might speak psychological turmoil, but they come to mean something else when they are reappropriated into the world of *Permanent Vacation* or the Lower East Side in the early '8os. It was very interesting and really decorated the film nicely.

JIM: Yeah, and I treated it more like a trance. But less like accents or stings or things that were supposed to hit you emotionally or underline things. Instead it was another kind of level of the fabric of the things.

JR: The "drift" calling him . . .

JIM: Yeah.

JR: In a couple of your films, especially *Permanent Vacation* and *Stranger than Paradise*, it seems that the characters are made possible by the cultural space of the Lower East Side in its heyday: a place where rent was cheap, the cops hadn't neutralized the dirty deals/dirty deeds, and the social reject characters who lived on the streets belonged there as much as anyone. . . .

JIM: Exactly. It made you feel that anything was possible. My apartment was like 150 dollars a month. I had three rooms. Often I couldn't even pay my rent, but I could have part-time jobs and I could live at night. I could listen to music. I could meet interesting people in the middle of the night, you know? It was really inspiring in that way.

JR: This isn't the same Lower East Side we live in now, is it?

JIM: No it isn't. But one thing about New York is that it has always been about drastic change. It's always changing, it always will change. I preferred New York in 1977 when everyone said it was a horrible, dangerous place (laughs) to the present New York or the New York of the '90s. It always changes. If there's an economic crisis it will come back again in an interesting way. You can't predict those things and if you don't like change in that way, it's not a good place to be. I don't like a lot of the changes, but it will change again.

JR: Let's talk about *Stranger than Paradise*. This may be the centerpiece of your films focusing on down-and-out NYC odd-ball characters. How important was the Lower East Side to the idea and vision behind this film?

JIM: It's where I lived. It's where we all lived. So it's kind of just like filming around where I lived. I can't analyze it any further than that. It's like, "whose apartment can we get to shoot in and where should we shoot this traveling shot?" There's a scene early on where Eva is first arriving and she walks down and crosses Bowery and Bleeker, and there's some graffiti on the wall that says, "US out of Everywhere!" That's just walking on the Bowery.

JR: Willie and Eddie have dead-end jobs and only live in the Lower East side because they can't afford to live anywhere else. I know you don't look back, but in retrospect was it important to capture the Lower East Side in this way before characters like Willie and Eddie were driven out of the neighborhood by the forces of gentrification?

JIM: Well that's just circumstantial. One thing we were conscious of was trying to make Willie and Eddie something other than punk rock hipsters. We were trying to make them broader than that. They're kind of odd. They were interested in going to the horse races. They'd wear hats. They did not dress like anything that was hip at the time. I was dismayed a few years later to see adds in Japanese magazines including a line of girls' clothes called "Eva Wear" for girls who wore baggy pants or cardigan sweaters. But we were consciously trying to take them

out of any style or fashion and have them be broader than that.

JR: Well there were some other films done in the Lower East Side during this period that skirt these issues and go straight for the sexiness of white bohemia floating in a sea of ethnic and economic diversity. As a whole *Stranger than Paradise* avoids falling into that trap like *Desperately Seeking Susan* or *9 1/2 Weeks*.

JIM: I did not want Willie and Eddie to hang out at the Mud Club, you know?

JR: Can you talk a little bit about the grassroots film scene in the Lower East Side?

JIM: I don't know if you're familiar with "new cinema." In the late '70s there were a group of filmmakers who rented a storefront on St. Marx Place and showed films there. Charlie Ahearn, Eric Mitchell, James Nares, Vivian Dick, Becky Johnson. It was like totally do-it-yourself with a little theatre they maintained, and they would show their work there. This was also very inspiring to me. It was like, "Man, just do it! Don't wait for somebody to say, 'we'll give you money.'" It was like go out and by any means necessary go make a film, in the same way those bands would start making music in a basement somewhere, and then become Television or the Ramones or Suicide or any of those amazing bands.

JR: Part of the Howl project, I think, is to revive Charlie Parker Day. Charlie and his legacy . . . what does it all mean to you? And how is that different from Ally's relationship to him in *Permanent Vacation*?

JIM: Well, I don't know, sometimes you value things that you just missed in your own lifetime. Certainly that's true in Ally's case and mine in terms of Charlie Parker. The whole be-bop thing is sort of aligned with cubism in that in an earlier period it showed you a whole new way of looking at something. Although I'm a huge fan of Duke Ellington, I'm not a big swing fan. Be-bop kind of fractured everything and showed you a way of looking at music that was almost faceted: you could almost hear music from different perspectives at the same time. It was incredibly interesting to me and revolutionary in a way. And all of the outside jazz musicians, following in Bird's footsteps, from Ornette and Albert Ayler, and all that stuff done by the Art Ensemble of Chicago, Cecil Taylor, Jimmy Lyons . . . they all carried that even further. But Bird was the first one to really revolutionize what is jazz music and what is music in general. The other thing that has really influenced my work in a way that starts with maybe Monk, and certainly with be-bop, is taking things that are traditional, taking standards, and then breaking them apart and still having respect for them. Charlie Parker will be playing something outside and then he'll pop in "Laura" or something standard. That to me is very beautiful. I don't believe that everything has to be new. I love Dante and Shakespeare. I love Henry Purcell. I don't believe in any kind of hierarchy. I don't believe in fashion, things going in and out . . . I believe in style. Fashion is just something for consumers. But style is something real. All filmmakers are stylists whether they realize it or not. Musicians are too. In a way, my last feature film, *Ghost Dog*, was like that. It wasn't so much trying to sample other things as trying to quote things, existing works, while trying to make something new out of it. And that is really the heart of be-bop. So yeah, that stuff is really important to me. Charlie Parker is a treasure to this planet . . . man, what a treasure.

JR: Well I think all of that stuff is important to understanding why a Jim Jarmusch was interested in a story like *Ghost Dog*. I say that because I'm not sure if everyone got it, honestly.

JIM: Yeah, probably not.

JR: One of the most interesting elements of *Ghost Dog* for me was the way it pastiched together quite disparate cultures and ethnic narratives and chan-

neled it into this form that was pretty alien to most people. Does this form of story telling come from living in New York, especially the Lower East Side, where different cultures and religions are forced to occupy the same space on a daily basis?

JIM: Well, I'm sure it does. Again, I'm the worst person to ask, "Where does it come from?" But you used the word "pastiche," and that is interesting to me, or "collage." Taking things from disparate places, taking genres like hitmen movies, and crime movies, and Samurai movies and philosophies . . . and taking eastern things mixed with hip hop, all that stuff was really interesting to me, and living in the Lower East Side was a garden of that. So it is certainly connected, but again, I'm really bad at analyzing where things come from. I'm better at just trying to take them somewhere or incorporate or embrace them. What do they mean? The confluence of these things equals what? I don't know. But in a way that's not my job, my job's just to do it . . . not to even know what it means necessarily. The beauty of Charlie Parker or Monk, those kinds of musicians, is that they weren't thinking. While Byrd's off on a solo, he's not thinking about what moves he's going to make. He's just feelin' it. As soon as you think about it, it turns into something dry and brittle and falls apart in your hand. I really believe that.

One way to conceptualize Jim Jarmusch as an artist might be to look at the multifarious list of people he has worked with. Even more telling may be those names that find their way into standard slapdash conversation with the auteur. Sometimes the names are familiar to us: Neil Young, Steve Buscemi, Screamin' Jay Hawkins. Yet, the essence of Jim Jarmusch is the amount of time he will spend biographing and commemorating a figure like Rammellzee, someone who exists at the boundaries of subculture. From the center, Rammellzee can be seen or recognized only in the way his style has rippled through the mainstream, in the way B-Real from Cypress Hill drags "ay" sounds from the side of his mouth. Indeed, Rammellzee is a well-known name to old school hip-hop aficionados and clued-up graffiti artists. But few outside those circles know his name, and even less can grasp his legend. Upon asking Jim a question about *Stranger Than Paradise* (one that he finds redundant), he immediately shifts the conversation to Rammellzee: "One thing I'm very proud of is that we have a cameo when they're in Florida by Rammellzee, who is a genius and a fuckin' avatar of hip hop culture. I'm just really happy to have him in the film." Jim's tone is one of emphatic desire to teach me everything he knows about Rammellzee, to help me "get it." Rammellzee, for Jim, is what its all about. It's why you go out there like a cannibal and mercilessly taste everything you can get your hands on. It's one of the main reasons why he makes movies.

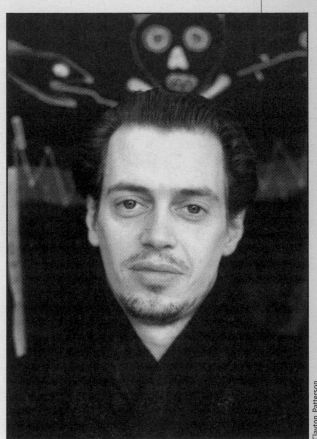

Steve Buscemi

Clayton Patterson

JR: It seems that the Lower East Side has given birth to a number of important relationships

for you. Talk about Rockets Redglare.

JIM: Yeah. Well, you know Rockets is someone that I met first just out on the street or out in the night. A really interesting character. I saw him perform some stand-up routines way back. He used to do some things with Mark Boone Jr. and Steve Buscemi. Mark and Steve did some amazing little like two-man comic theatrical pieces. And then I worked with Rockets in, wow, 3 or 4 films.

JR: John Lurie?

JIM: Yeah I met John Lurie in the middle of the night on East 5th Street. We sat on a stoop talking. He had just gotten some money stolen from him by some . . . by some . . . I don't know exactly what the story was (laughs), and we just started talking, hanging out, and being friends, then just started collaborating. He had made some of his own movies. He made some super 8 films, *Men in Orbit*, and another one—I forget the name—with James Chance in it. I think he made those after I first met him but before we worked together.

JR: Steve Buscemi?

JIM: Well, Steve I first saw with Mark and Rockets performing. Also he was a bartender. They both worked at 7B so they were always hanging around. Really interesting characters. Then they became actors.

JR: Joe Strummer?

JIM: I first met Joe somewhere in Europe, not in New York. You know, he was a really close friend, and I spent time with Joe all over the place, in New York, and in London, L.A., France, all over the place. He was somebody . . . really an amazing gift to all of us whether you knew him personally or not, you know? I still hear Joe's voice practically everyday with some words of Strummer-like wisdom. A lot of his friends quote "Strummer's Law" which is "no input, no output," meaning if you don't go out and experience things in life you won't have anything inspiring you to express your own soul. I still hear Joe saying that and I try to live by that as well.

JR: Is there any chance of working with Rammellzee again?

JIM: I don't know. Hopefully on some level. We've talked about trying to make a film. He wants to make a film with these puppets he's created, these incredible puppets. But I think that's something he needs to do. It's pretty out there for most mainstream minds to grasp, cause Ramellzee is about two centuries ahead of his time.

Hearing Jarmusch talk about "process" and "journey" reminds me of the road to Hanna. Hanna is a small, unmapped place on an island in the South Pacific. It takes a day to get there and back. I don't remember why the idea appealed to me. I probably read something in a tourist pamphlet.

I remember that on the way to Hanna there were so many beguiling images to behold: the Seven Sacred Pools, the waterfalls, the cliffs that seemed so absolute, like the end of the Earth. But the road itself was narrow and rough. The journey was uncomfortable, long, arduous. Eventually I found myself cold and wet, and standing in Hanna where there was nothing. Is this the end? . . . Looking for an ultimate beauty, an "end beauty" . . . but there was only space . . . open, dry space . . . if only I had known . . .

It seemed so clear just then: as stupid tourists we read a paragraph about a place and go there. Blindly we go toward no-man's land. Yet there's something about the blind tourist on his/her way to no man's land that has always interested Jarmusch. I realize this even more after hearing Jim talk about his work as a continual, unfailing journey.

At some point we stand in empty space, the "end" of the journey, and we appreciate the pools, the falls, and most of all, the narrow roads. For Jim Jarmusch, it's always been about process rather than product. Journey rather than destination.

JR: I read once that the films you make end up being like home videos in your mind. I guess that's related to everything you're saying, about not looking back and just capturing these things when they do come to you. I thought that was really interesting.

JIM: Yeah, I hate to see my films, I don't see them again once they're finished and I've seen them with a real audience. I don't want to go back and look at them again. I feel like it's a process and I have to go to the next step of the process. They're not milestones in my career (laughs) or anything like that. They're just the work, my work. And the films for me are more documents of a process I went through, and they tend to remind me more of things I was feeling, people I was working with, incidents that occurred, rather than simply what is on the screen because that's done and that's frozen. But it invokes those other things, and for me

I love road movies

those are more valuable because they're life.

JR: Which makes total sense to me, because when I watch your films, the idea that the film-maker's product is never a finished whole seems to be a starting point. I think for this reason you keep coming back to what Ally says in the beginning of *Permanent Vacation* when he warns us that the story to come isn't really a story, but a moment in time or an artificial connecting of points in time.

JIM: Yeah, I think artists that find their work to be milestones are losing their grasp of the total process. Like Godard said, "I make the same films over and over." Well of course he doesn't but, in a way, it's good that he thinks he does. He doesn't think, "okay, that's a masterpiece, now I'll move toward the next one . . ." He doesn't think that way. It's all one film in a way. And that's really valuable. Another quote I like, which I've used before is from the French poet Paul Valery. He said, "A poem is never finished, only abandoned." And I think you can edit a film forever and ever and keep editing it, and at a certain point it's like, "okay, I will abandon this one now and move on."

JR: Somewhat related to this, I think, is the common trope of the journey in your films. It seems to me that your particular style of narrative lends itself well to journeys. I was wondering if you could talk about filmmaking as a journey, a metamorphosis even from and idea to a concrete image on screen. How do you see your "process" as a journey that may or may not be like those of the characters in your films?

JIM: It's interesting because, first of all, I love road movies, and that that's a form that precedes even the history of cinema, certainly going back to Homer and Dante, and then so-called "Picaresque" novels of the 18th century. I love characters moving through the world, because it's the most perfect metaphor for one's life. And so I like the connection you made about the process and the journey. You know, I write a script but it's only a rough sketch, a map. You write a draft of the script, but then you find locations and they give you new ideas. You do another draft, then you shoot the film. Some scenes you do different takes and that changes things. You do more drafts of the thing that's growing, then you're in the editing room sculpting it down and letting it tell you what it wants to be. It's the opposite of say, a Hitchcock film, where everything is storyboarded. Hitchcock himself said the act of shooting was almost boring and after the fact because he knew exactly what it was going to be. And that's fine because Hitchcock made some beautiful films in a certain formula, but that is too formulaic for me. It doesn't relate to the idea of life being a journey. So the film grows as you're making it. Some filmmakers, they'll be shooting and it will start to rain and they'll say "oh well, we can't shoot today." My first reaction would be, "Wait a minute, can this scene work in the rain and what would that do?" I'm always trying to be open to things you can't control and let the film grow. It is related to what you said—in an overall, even philosophical way—about life itself just being a journey. You can't control everything that happens in life so you have to react and deal, and that's beautiful.

JR: There's a Taiwanese filmmaker that you may know, named Tsai Ming-Liang who did *The Hole*.

I think he would be of interest to you, because he sort of takes the idea of film-as-a-journey to a whole new level. He's known for only writing half a script and then shooting things in chronological order, so he can finish the script as he finishes shooting. He can pretty much go wherever his actors or the feel takes him.

JIM: Yeah, wow. Well I know Wong Kar-Wai has done things that way, and some directors who I really admire have no script at all, only notes. I couldn't do things that way because I have very limited amount of time and money. So I need a blueprint to follow, but the blueprint is never a finished building. So I might get a different idea for the structure as I'm going along. I'd love to be even freer, but I don't know if my mind is capable of that (laughs). I only did that once with a documentary, the music film with Neil Young. We had no idea what the hell we were doing once we started shooting. But that was a different thing. I wasn't telling a story or developing characters, just observing something.

JR: And it's also important to mention that it was Neil's money on the line, right?

JIM: (laughs) Well, Neil's attitude is amazing. When he called up and said, "Let's make a film when Crazy Horse goes on the road," I asked, "Well, how long do you want it to be?" And he said, "When I start to write a song I don't think about how long its gonna be. You know, you just start." Then I said, "What if it sucks or it's not interesting?" And he said, "Fine we'll put it on the shelf, no problem." So he was just amazing in that way. But you know, he's sort of a shaman in everything we're talking about. Everything to him is a process.

JR: Which is why he's still going when all his contemporaries are burning out.

JIM: Exactly.

Jim Jarmusch has always found a pressure point (usually comedic) in the fish out of water scenario. This scenario can take the form of Japanese tourists in Memphis or a Hungarian houseguest in the Lower East Side. But most often this trope makes itself present in the immigrant's "journey" from outsider to insider. This is a journey that takes place at the intersection of conflicting forces: the America that welcomes cultural diversity yet forces assimilation; the America that preaches social unity yet glorifies the freethinking, autonomous individual. But Jarmusch's mission is not one of merely pointing out social contradiction. Rather, Jarmusch's films portray a world that depends on contradiction to sustain itself. One could say he paints his subjects upon a canvas of incongruence. One of the finest moments in Jamrusch's immigrant scenario films can be found in the New York chapter of *Night on Earth*. Here the audience is presented with simultaneously the brilliant potential of diversity and the inevitable clash that results in cultural assimilation. The bulk of the piece seems to reaffirm the beauty and peculiarity of cultural hybridity, mainly through the relationship between German immigrant (Helmut) and native Brooklyner (Yo Yo). Yet Jarmusch goes farther here, past the point of unmediated utopianism. During the closing minutes, we see Helmut's eyes widen as he becomes interpolated into a land that is as much about class struggle, crime, and drugs as it is about anything else. As we fade out, we are left nervously wondering where Helmut's innocent circus clown act will take him, or rather how long this gift will sustain him in his new environment.

JR: New York has always been about cultural mix and antagonism for you hasn't it?

JIM: Well, I don't know if I would say antagonism. I'm interested in people who are outside. I don't make movies about rich white yuppies, you know? It's not interesting to me. I've always had friends that were outsiders in some way. Even from when I was a little kid, I've always been interested in what most people would consider oddballs, you know? Whether they were Gypsies my grandmother used to hang out with or Turkish people in Akron, Ohio or Black culture in America which was certainly not mainstream when I was a kid. I just gravitate toward what is moving to me or has some depth to it. I don't really delineate where it comes from. I don't shy away from listening to Miles Davis because he was the son of a rich doctor, or whatever . . . I just ask, "What did they sing? What was their expression? What is it that they are expressing? What's coming from them and how does that hit me?" And anything that goes into my soul I hopefully incorporate that into myself.

JR: Well when I say antagonism maybe I'm thinking of a film like *Night on Earth* or even *Down By Law* to some extent that shows both the brilliant potential of diversity and the at times grim reality.

JIM: Yeah, well that's just the social order of things. In a way it's even worse now because it's more sinister and more transparent, yet more ignored by the majority of people. At least in the 70's that shit was obvious and it was palpable. You could see squatters fighting with cops. But at the same time, now it's even more sinister, and more obvious if you open your eyes. But it's easier to walk around with your eyes closed these days. I don't know. I'm not a social analyst.

JR: Well, I think a lot of people nowadays wouldn't know what you were talking about if you brought up the squatters movement or say the Tompkins Square Park police riots. Even people who live in this neighborhood now might not remember that stuff. Some may not have heard about those ugly moments in New York history in the first place. So there's definitely some truth to what you're saying.

JIM: Yeah, now we live under a total corporate whitewash, and we're just supposed to be good consumers.

JR: Just to go back to *Ghost Dog* for a moment, I really loved the relationship between *Ghost Dog* and his "best friend," the ice cream guy. They're speaking to each other without much hope of understanding what the other is saying. Is that born out of the same idea of these different cultures thrust together and the different possibilities that creates?

JIM: I don't know. To me it's just about the fact that people communicate on different levels and they shouldn't be limited to the boundaries that are prescribed by culture or even language. Your best friend might not even speak your language, but your bond as best friends could be as deep as any best friends on this planet. So it's really even broader than just cultural. It's just . . . you can have the deepest, most meaningful relationship with somebody without even the most seemingly primary forms of communication. So I guess that's really all I was trying to say with that.

JR: Your newest work is for the Ten Minutes Older project. Can you talk about the concept behind Ten Minutes Older and also your particular intervention with that project?

JIM: Well, that was a couple years ago actually. I met this guy in London, Nick McClintock and he had this vague idea about getting different directors that he liked to make films that are exactly ten minutes long and have something to do with the nature of time. And somehow that really appealed to me: something so specific as ten minutes, and something so vague as the nature of time. So I just used it as a nice excuse to make a short film and to do something with Chloe Sevigny, who I love as an actor. I attempted to make a film that didn't intend to say anything, so it was partly inspired by Andy Warhol. He used to record people's phone calls when they were just talking about completely mundane things and then transcribe them meticulously. So I wrote a phone conversation and Chloe performed it pretty much verbatim from what I wrote, which amazed me. I asked her if she wanted to improvise off it and she said no. And she did such a beautiful job of doing something that seemed so real, but it was based on a script. And the other thing that inspired it was a film by Pasolini called *La Ricotta*

about a guy who's an extra in a film. He's actually one of the two criminals being crucified next to Christ, and he's playing that in a film. And at lunchtime they haul down the crosses and they get a break and they get a big piece of cheese. He runs all the way home to his village to give it to his family because they're really impoverished. Anyway it was the idea of seeing somebody in a film while they're not really in the film. So those ideas gave me the inspiration to make that little film.

JR: I heard a rumor that "Int. Trailer Night" [from Ten Minutes Older] was going to be screened as part of the Howl festival. . . .

JIM: I don't know. I'm not sure. I think Richard Hell said he was going to show *Stranger Than Paradise*.

JR: Any other plans for the future you'd like disclose, besides joining the seminary?

JIM: Before I join the seminary, I'm completing now a collection of short films I've been working on since 1986. It has a really diverse cast: Steve Buscemi's in it, Cinque Lee, Roberto Benigni, Steven Wright, Tom Waits, Iggy Pop, Meg and Jack White, GZA and RZA, Cate Blanchett . . . I don't know, it's got a lot of wacky people in it. One thing that maybe makes it appropriate to Howl is one of my favorite sequences in it is Bill Rice and Taylor Mead. You talk about icons of the Lower East Side, they're both incredible presences for me as actors and of course Bill Rice is a really great painter. Taylor Mead's an amazing poet. So I'm very proud to have finally gotten to work with Bill Rice and Taylor Mead. So that will come out as a compilation maybe this fall. I don't even have a distributor for it yet. It's all black and white too.

Some roads build themselves. Some roads are not meant to be driven or explored. Some cannot be traveled. The thin road that you passed a minute ago is now far behind you. You remember passing the thin road. You remember it as otherworldly. This was the fleshless road that has built itself.

Now it is late night. You have been traveling all day. You are somewhere in South Carolina now. Suddenly, you have come upon a lonesome motel. The sign reads "no vacancy." You stare into the uncreated motel until its point of vanishing, as your car dissolves itself back into the world of black highway.

Don't thank Jim Jarmusch for the road.

Pizza, Beer & Cinema

by Greg Masters

Philip Hartman is known in the neighborhood as the co-owner, along with partner Doris Kornish, of the Two Boots chain of pizza restaurants. Perhaps he's better known as an active parent coaching sports teams for the three children he and Kornish have brought forth. He also is a prolific writer, having written and sold over a dozen film scripts, banged out much of a novel, and written and directed the independent feature film *No Picnic*.

No Picnic was shot almost entirely in the East Village in the mid-1980s with a cast and crew largely made up of local faces. While the story told is of a former rock 'n' roll musician's search for the woman in a photograph that lands at his feet, it is also a look at how development begins to change the complexion of the neighborhood.

"It seems mind boggling to think that the film was made eighteen years ago," Hartman says. "We were frantically trying to capture what was disappearing in the East Village, like walls with graffiti and Adam Purple's Garden of Eden. We're still obsessed with the same issues, only now the people are disappearing."

Hartman once said the film seemed like a cross between those of Robert Bresson and Woody Allen—no superfluous camera movements, just a spare black and white. But while there's no comedy in Bresson, there's a lot of humor in this film. "On the surface it's film noir," says Hartman, "but it's in this context of the East Village neighborhood. That's one thing we've always been interested in: people's need for community."

Many locations in the film are now gone. Street corners have changed. Empty lots are no longer empty. The film is about a very specific place and a very specific time, but it relates to places that are changing all over the world. "That kind of wistfulness and helplessness and alienation is found everywhere," says Hartman.

This is where Hartman brings up the name of another downtown filmmaker, Jim Jarmusch. His black-and-white film *Stranger Than Paradise* (1983) defined East Village sensibility, Hartman says. It helped mythologize the East Village all over the world. "People forget what a big impact it had."

A poster for this film adorns the lobby of the 100-seat theater Hartman opened up with partner Kornish on the corner of

Avenue A at 3rd Street. But the roots of the Pioneer Theater go even further back than Jarmusch's film, says Hartman; they go back to Jonas Mekas. And Hartman can pinpoint the exact date: September 1953, when Jonas had the first alternative screening at 7 Avenue A, an art gallery. Hartman says this was the first screening of art films. He cites this event, along with such filmmakers as Morris Engel, John Cassavetes and Lionel Rogosin—filmmakers who took their cameras out onto the street—as the inspiration for his own film endeavors and the motivation for the programming at the Pioneer Theater.

The choice of films shown at The Pioneer Theater may also be seen as an extension of a community film program run at Charas for 18 years by Kornish and others, including Matt Seig, the Pioneer's programmer. "Doris and I had both run film societies at college," Hartman says. "We both liked community cinemas. Movie theaters reflect the neighborhood."

He recalls the now defunct cinemas of the East Village: Theater 80 St. Mark's, since taken over by the Pearl Theater Company, showed a repertoire drawn from the owner's extensive collection of Hollywood and foreign classics and obscure favorites. The Charles Theater, on Avenue B, was a case of the lunatics running the asylum, Hartman says. Robert Downey Sr. was the janitor (he moved on to make *Putney Swope* and other counterculture landmarks); Ed Sanders would read poetry in the lobby. Entermedia on Second Avenue and 12th Street rescued the long unused Yiddish theater by showing second-run movies. It featured some inspired programming (I remember a science fiction series one summer). Club 57, housed in a church basement on St. Mark's Place between Avenue A and First Avenue, added a cocktail party aura to its film screenings.

A good number of independent film productions were co-opted by Hollywood in the 1990s, explains Hartman. The Pioneer was created as a showplace for independent films that are not Hollywood audition tapes, he says. When asked if there's an audience for these sorts of films, he responds that there are still a lot of adventurous filmgoers out there.

In designing the space, Hartman and Kornish were concerned that it not feel like a multiplex, so visitors are treated to more than a mall experience. The Pioneer is homey and distinctive. It's been featured in a slew of decor-attuned magazines. The range of programming runs from fun first runs to rescued obscurities to documentaries.

Filmmakers are often on hand to present their latest projects and to answer questions from the audience. Tuesday evenings have been devoted to the Schmoozer's Lounge, where screenings are preceded by a leisurely hour in the downstairs Den of Cin for pizza and beverages and a chance to interact with the film's creators. The Sunday afternoon Film Slam is run like an open mike poetry slam—short films are screened, the audience votes for their fave, which proceeds on to a future featured screening.

Short film
from Matthew Harrison

by Matthew Harrison

I was born in a tenement in Little Italy; my nickname around the neighborhood was "Whitey." I was a towhead with blue eyes and everyone else around was Italian. My parents had emigrated to downtown New York City from London. They were beatniks and had artist friends who had lofts in empty factory buildings in SoHo before it was called SoHo; when everyone thought it would all be torn down to build an underground cross-town highway. My dad wore a Van Dyke and a coat with tiger's teeth for buttons and made mix tapes for parties on his quarter-inch reel-to-reel tape recorder; my mom wore miniskirts and big sunglasses and high heel shoes and read *Elle* magazine in French. They were very cool. We hung out in Washington Square Park. I went to the Children's Aid Society on Sullivan Street and then to P.S. 41 on 11th street. I started making black and white 8mm street movies while I was going to P.S. 41. I discovered I could get my friends to do anything I asked them to do it when I had a movie camera in my hands. I was a downtown kid; I didn't go above 23rd Street until I was a teenager.

My parents took my brother and me to the East Village, which felt like the way Far East, crossing Astor Place was crossing the Rubicon. My parents went to the East Village to visit more artist friends, who drank wine out of jugs and played the bongos on Avenue A. I liked going to the East Village a lot.

Later I went to Cooper Union School of Art and found there were actually Avenue B, C and D. That was exciting. By then I was making color Super 8mm and 16mm movies at Cooper Union. For about 10 years I lived in the projects of the Lower East Side and started the 124 Ridge Street Gallery with a bunch of friends in the mid-'80s. I showed the films at the 124 Ridge Street Gallery and started a film screening called Film Crash. We showed lots of movies that were being made downtown. The neighborhood was really beat, and then crack was invented and the neighborhood really went down the toilet, but the movies got better. The East Village is reviving, and reviving since I can remember, then crashing, then reviving again. It is the place for young restless creative people. The East Village is the best place in the world.

Director Matthew Harrison made a name for himself at an early age shooting urban dramas on the streets of New York City.

His feature debut *Spare Me* a dark comedy, won awards internationally. Harrison's second feature film *Rhythm Thief* caught Martin Scorsese's eye when the picture won the Jury Prize at the Sundance Film Festival. Scorsese executive produced Harrison's original screenplay and third feature *Kicked in the Head* – World Premiere Cannes International Film Festival. Matthew is currently post-producing his fourth feature *The Deep and Dreamless Sleep* from his original screenplay.

Matthew Harrison was schooled at P.S. 41, the Cooper Union School of Art and NYU. His television credits include HBO's hit show *Sex And The City*, Disney's *Popular* and Warner Brothers' *Dead Last*. Harrison's company Film Crash produces entertainment for both television and motion pictures. Film Crash www.FilmCrash.com

X-rated from Film Charas

Films Charas

by David Ng

There was a time when you could buy a movie ticket for $3 and watch one, two, maybe three films in a darkened, cavernous room filled with familiar faces from your neighborhood, and then linger afterwards to talk with the directors over a beer. Such a time was not so long ago: from 1981 to 1999, Films Charas showed independent films—documentaries, shorts, features, and avant-garde—made by local artists. Located in the El Bohio Building (the former P.S. 61) on 9th Street between Avenues B and C, Films Charas was one of the city's last community film societies, and certainly the only one dedicated to East Village filmmakers. For Doris Kornish, co-founder and chief programmer, it was, first and foremost, a neighborhood institution: "My idea was to make a cultural and economic bridge. You had mostly white people who lived west of B, and then you had mostly Latino people east of it. Having the theater centrally located brought people over from both sides," Kornish said.

A West Virginia native, Doris Kornish moved to New York in the early '80s and quickly found her home in the Lower East Side, where she has lived ever since. "My first apartment was on 10th Street and Avenue A. Back then the neighborhood was really different from what it is today. I remember my neighbors telling me, 'Whatever you do, don't walk on Avenue A.' So they turned around and I walked right on to Avenue A to see what the problem was. I felt like if I had come all this way to New York, why wouldn't I go half a block to Avenue A?"

Films Charas grew equally out of Kornish's passion for independent film and her determination to contribute to that spirit of self-sufficiency. Films Charas was immensely popular throughout its eighteen-year run, generating long lines that often poured noisily out onto 9th Street. Its success, founded on little more than word of mouth, was possible because of a small army of volunteer staffers who, week after week, would convert the building's erstwhile cafeteria into a 150-seat cinema complete with two 16mm Belle & Howe projectors and speakers. They also prepared the bar—where customers could buy beers for $2 and shots for $3—and performed a host of menial tasks, such as selling tickets and sweeping the floors. The regular staff included co-founder Matthew Sieg (who is now a programmer at The Pioneer), Tom Doren, Joel Schlemmowitz, Jeff Price, Kevin Duggan, Sheila McMan-

nis, and Rob Massey.

Kornish recalls that it didn't always run smoothly: "Most weeks were total aggravation. Sometimes, there would be ten of us working together, but a lot of the time it was just me and one or two other people. I'd be like, 'What the fuck am I doing this for?' But you look back on it and you're like, 'Well, what was the big deal?' Because every week it went off and every week was fun, so by the end of the night, you'd forgotten all that shit."

Many nights at Films Charas had a theme: Sex Night featured erotic films by women artists such as MM Serra; Scary Movies Night showed horror films from 7:30 pm until dawn; the annual Lower East Side Festival featured movies shot in and around the neighborhood, from the films of D.W. Griffith (1912's *The Musketeers of Pig Alley*) to the experimental works of such East Village artists as Rudy Burkhardt. During the Tompkins Square Riots in 1988, Kornish invited her friend Paul Gehrin to show the footage he had shot of police beating people and kicking them out of the park. In 1993, Films Charas held a 10-week, A-Z retrospective of the films made by members of the Film-makers' Co-op. The hundreds of directors who have passed through Charas read today like a roster of indie royalty: Tamara Jenkins, Michael Almereyda, John Sayles, Todd Haynes, and Steve Buscemi.

Funded in part by the New York State Foundation for the Arts, Films Charas was largely financially independent, surviving on neighborhood fundraisers and the donation of equipment. "We tried to be as independent as we could," says Kornish. "We would organize these dinners that would compliment the movie we would be screening that night. We would charge $10, for dinner and the movie. We would have a few of those each season. If the movie took place in Louisiana, we would cook rice and beans. It was the closest we came to Odor-rama."

In 1986, Kornish produced her own feature film, *No Picnic*, written and directed by her husband Phil Hartman. Shot in black and white on Super 16, the movie follows a group of Lower East Side dwellers during the infamous rent and garbage strikes. "We knew the neighborhood and knew that that period was a real turning point," says Kornish. "Landlords were evicting tenants—many of whom were elderly and had lived in their apartments for decades. We felt someone should make a movie about it." Kornish and Hartman filmed *No Picnic* over the course of one excruciatingly hot summer, using both professional and non-professional actors as well as regulars from Charas, among them a then-unknown Luis Guzman.

At one point in the film, the main character, Mac, a single, pushing-40, would-be songwriter says to himself in a melancholy voice-over, "The Lower East Side. Some might call it hell; we call it home." Repulsive yet endearing, the neighborhood depicted in *No Picnic* is seized by a state of permanent flux, with tenements falling and high-rises rising everywhere you look. "The more things

Clayton Patterson

Bimbo Rivas at Charas

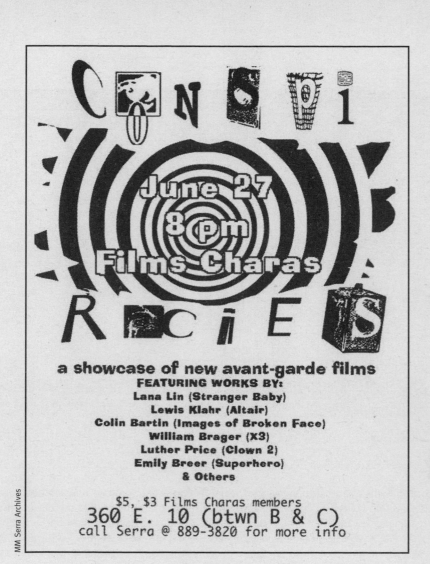

MM Serra Archives

change, the more things change," says Mac. (*No Picnic* premiered at the 1986 Sundance Film Festival, where it won an award for Peter B. Hutton's cinematography.)

In 1990, Kornish started making her own movie, a feature-length documentary of the Swiss-born artist (and Village bohemian) Rudy Burckhardt, whose experimental short films were regularly screened at Films Charas. "I acted in so many of his films," says Kornish, "and so I said to Rudy one day, 'I should turn the camera on you.' I was really fascinated with him because he defied categorization. He did so many different things in his life and I've been personally inspired by him," Kornish adds. The film took nearly ten years to complete (at the time, Kornish was not only running the Two Boots Restaurants with Hartman, but raising a family). Interviewing other East Village artists like Alex Katz, Bob Holman, and even Burckhardt's son Jacob, Kornish kept finding people who wanted to talk about this sometimes irascible, often generous artist. "One reason Burckhardt never became really famous was because he didn't like to talk about his work," Kornish explains. "He wanted to let art—his films, paintings, and sculptures—speak for itself. That's why in my documentary he never speaks. I tried to arrange the interviews as a circular path around him."

Rudy Burckhardt died in 1999 but he was able to see Kornish's finished documentary, entitled *Not Nude Though: A Portrait of Rudy Burckhardt*. "I remember showing the film to him and he just closed his eyes, shook his head and said, 'Doris, why do you want to make such a long film about me?' He was always so humble but at the same time, he let me do what I wanted to do. He never passed judgment and I hope that comes across in the film."

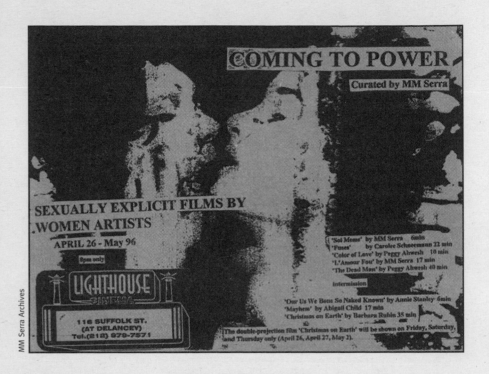

MM Serra Archives

In 1999, Films Charas disbanded and closed its doors. The El Bohio building had been the object of an on-going turf battle between the Giuliani administration and the owners of the Charas community organization that occupied it. The city won, and the tenants, including Films Charas, were kicked out. The building was boarded up and gated, to be razed for a posh real estate development project. But as of 2003, the building remains as is, vacant and undeveloped.

A little more than a year after the city sold the Charas building, Kornish opened the Pioneer Theater along with Hartman. Located just six blocks south on Avenue A, the Pioneer is Films Charas' posher, for-profit incarnation. In an interview with the *New York Post*, Kornish and Hartman described their new uniplex as a "a first-run house and special-programs house, all in one. We've amassed a treasure trove of hundreds of vintage shorts and newsreels [over the years and] we'll be showing them with the films. Our inaugural film is Amos Poe's groundbreaking 1976 rockumentary *The Blank Generation*, featuring Debbie Harry and Patti Smith."

Doris sees a striking difference between audiences at The Pioneer and the ones she had at Films Charas. "At Charas, I'd print up a calendar every three months, but it got to the point where people didn't care what we were showing. They'd just show up. And I wish that would happen here at the Pioneer. I wish that people would trust our knowledge, and say, 'Well, I'm not really interested in these films, but if the Pioneer's showing it, it must be interesting.'"

Sleazoid Express:

Clayton Patterson asks us what it's like being us.

by Bill Landis and Michelle Clifford

Bill Landis and Michelle Clifford are publishers of *Sleazoid Express* and *Metasex* Magazines. They are also authors of *Sleazoid Express, A Mind Twisting Tour Through The Grindhouses of Times Square*.

Clayton Patterson: Where were you born?

Bill Landis: I was born in France in a town called Landes de Busac, outside of Bordeaux. My toddler hood was spent in England during the Christine Keeler era in a hotel in London. Lots of fun for a kid, let me tell you!—London was magical then. I lived in a house in Bournemouth by the seashore. It was very Archie Rice, *The Entertainer*—the English Catskills, bad vaudevillian central. The Rolling Stones were thrown out of town before a concert for being too rowdy, so it was that long ago. The seashore had a pebble beach—a bunch of stones with cold water on them, that's the bloke idea of a beach.

Michelle Clifford: Born in Dorchester, Massachusetts (little Ireland) until age 7, grew up in Fort Lauderdale, Florida, moved at 19 to Fear City (NYC). Florida is a surreal place.

BL: I have always identified with surrealists like Alejandro Jodorwosky and Fernando Arrabal of the Panic Theater—you're born in one nation, spend your childhood in another country, then move to yet another one, with your ethnicity having nothing to do with any of it. So no place is home; you get a sense of permanent displacement. A feeling that contributes a quality of unreality.
I had been hanging around 42nd Street since I was 16, using a fake ID card in the early 1970s, then shortly after going to the LES to concerts at CBGB's and a lot of the fly-by-night after-hours clubs. My cousin Patty Palladin was already on the scene in a punk band named Snatch; she was singing with Johnny Thunders, so she encouraged me a bit. By the time I was 20 I just packed a suitcase, left home and moved into the George Washington Hotel on 23rd and Lexington. I typed the *Sleazoid* on a portable in the hotel room. I used my portable typewriter til only 3 years ago.

MC: He typed up my first *Metasex* on it for me. He was a better typist at the time and made less mistakes. I always like seeing smart cute boys doing manual labor.

CP: Club 57—your name comes up a lot, Bill. How often did you go there?

BL: Several times a week between 1979 and 1981. It was tremendous fun. The club was in the basement of a church on St. Marks Place between 1st and 2nd Avenues. Rented out by some old Polish queen named Stanley who lived with his mother, complete with a bar with no liquor license, always filled to capacity.

CP: Were you a part of the scene?

BL: I had a film series and did performance art plays there. One was titled *Jim Jones*. He was my favorite cult leader, and it was a recent incident at the time. I played Jim passing out Kool Aid to members of the audience, while reciting Jim Jones' famous suicide speech. Henry Jones, Keith Haring, Kenny Scharf and assorted fun lovers writhed on the floor and died for me. "Mothers, mothers . . . don't do this. It's a friend. . . . The time has come for us to die with dignity." I also wrote a play that starred Ondine (from Warhol Factory) as Raymond Burr complete with wheelchair, albeit an office chair with big cardboard fake wheels glued on. He was hysterical. Ondine was great. We would eat Indian food on East 6th Street between 1st and 2nd Avenues.

CP: How often did you show movies at the Club?

BL: I had a weekly film series starting in summer 1980. That was a very memorable time—I started *Sleazoid Express* as a biweekly, one-sheet, offset printed bulletin on colored paper. I'd see a movie on the Deuce and run home and write it up and print it the next day and pass it out for free in the Club. I interviewed Ken Anger for the *SoHo News* and *Sleazoid* was written up in the same issue; I ended up having a column for the *SoHo News* about Times Square and exploitation movies; and I started the film series as a tie-in to *Sleazoid* at Club 57.
The film series was on 16mm so I had to rent films wherever I could find them, or buy them. Very unlike the ease of finding a film today. This is pre-video. You had to be a detective and hunt a film down. That gave me the opportunity to revive some old favorites like *Mondo Cane*, and have some themes—like a Sex, Sin & Sadism festival that concentrated on women's prison movies like *The Big Doll House* and the like. I also revived certain underground movies like *The Chelsea Girls*, courtesy Ondine and his prints. Ondine was a very funny guy, not at all self-conscious, and he enjoyed the attention from a young audience.

CP: Was Henry Jones a help to you?

BL: Yes. Fixing my projector in one memorable instance. I also sublet his apartment on 9th Street and Avenue A for a time in 1980 after I moved out of the George Washington Hotel while I was looking for a regular apartment.

CP: Did you believe that Keith Haring and Kenny Scharf and the rest would become such major stars, or did it just feel like a good time at the Club?

BL: Both. You had various people there—people on their way up, who were going places, some who were merely scene hanger-ons, drug addicts and assorted sociopaths.

CP: Was Jonas Mekas helpful when you were doing the Kenneth Anger book.

BL: When we did the Ken Anger book, he was of no assistance at all.

MC: He wanted to be paid for an interview. We don't pay to speak to people. We're not his trick. We don't work that way. If he charges, he'll certainly self edit, so no loss.

CP: What was your relationship like with the Millennium?

BL: I didn't do showings there, but it's a good space and occasionally they had a good revival. It was a nice space for a 16mm screening room. Very pleasant, nice folks, nice old '60s-style space. The same for The Collective for Living Cinema, which was near the Mudd Club—a much-missed spot.

CP: How many books have you and your wife and writing partner Michelle Clifford put together?

BL: Two books, but we have been in compilations as well. We collaborated 50-50 on the recent *Sleazoid Express* book. And we are partners fully in all writing and the *Sleazoid Express* and *Metasex* magazines. We do film lectures and screenings. The last was at the Andy Warhol Museum in Pittsburgh. Michelle wrote half of the Ken Anger bio *ANGER* though she wouldn't put her name on it. Michelle used to never sign her writing. She was a mystery wrapped in an enigma. She likes to be read and not seen. She has been better about it recently, in the last couple years since she started putting out her mag *Metasex*. We are partners fully in all writing.

MC: We did several articles for publications everything from august ones like *Village Voice*, *Film Comment*, to some men's mags like *Screw*. *Screw* always had that great underground press vibe; I mean diversity like John Lennon and P. J. O'Rourke, who wrote for it back in the

Michelle Clifford

Michelle Clifford, self portrait

day. Even Lenny Bruce's mother! Al Goldstein was really the first amendment pioneer. I wanted to put out my mag *Metasex* after I once read the story of Goldstein peddling the issues around to the newsstands himself back when he started *Screw* with Jim Buckley. We've written for *Hustler, Carbon 14*, We recently wrote a piece about Vanessa Del Rio and Times Square to be in a Taschen art book edited by Diane Hanson. I like that quote from Aleister Crowley, "I want be in everything at least once."

CP: Is Michelle the one that got you to the book stage?

BL: When we met, she said I needed a mass-market flexi-book that was affordable and would be under every college kid's bong by his or her VCR, which *Sleazoid Express* as a book is. She started her *Metasex* magazine and got me to re-start *Sleazoid* as a multi-page format magazine. I'd given up the mag for a couple years to have a real life.

CP: You obviously always had the publishing bug.

BL: I've always written. I wrote for my school paper when I was a kid.

MC: I wouldn't let it die without a proper funeral. I wanted permanent books, so everyone could learn what hath occurred. I'd made my own magazines since I was little using colored pencils. Stapling them together and mailing them to people I knew. For a laugh. I never kept any. I had no access to a Xerox till I was about 19, when I got to NYC. It was a revelation. The Holy Mountain. Copies!! This is all pre-Kinko's. I mean, in Fort Lauderdale there weren't any Xerox machines not inside of some office. They just weren't available. I went to the LES to make my first copy. A card I made for a Bill using a WARD cartoon. The man behind the counter was so friendly. I couldn't believe the freedom of the copy machine. I'd thought the man behind the counter would toss me from the shop for the salty book page I was copying. In Florida it is really buttoned down.

CP: When did you and Michelle meet?

MC: I sent Bill a letter in 1984, He wrote back, then it took me a year later to write again. I was just a teenager. I loved his writing. I heard him. I only hear a couple of writers. He wrote

his way into my heart. We got together in spring 1986 when I moved in with him. He was living on 14th Street between 2nd and 3rd Avenues. He picked me up from the airport and we've been inseparable ever since. My first step in NYC was on 42nd St after taking the shuttle bus from the airport in Jersey. It's about 18 years now. I moved in with Bill on 14th Street, the same block Travis Bickle resided on in *Taxi Driver*. We'd have breakfast every morning at Disco Donut, the same place Travis watches Iris eat toast in *Taxi Driver*. Bill's apartment was like a living breathing life art installation. Huge exploitation posters on the walls. Everything red, black and white. Posters for Mondo movies. I loved it and was in culture shock. I'd just moved from sunny Florida and would read the outrageous *New York Post* inside Disco Donut. It was the summer of Preppy Killer and Jennifer Levin's body found strangled in Central Park. I loathed yuppies. The jogger "wilding" rape had just happened. I'd read this while peeping at all the Donut shop people. . . . This was the height of the crack epidemic then. Yuppies to drug casualties, methadone addicts would be in Disco Donut in a pose of a nod mid-movement like a living sculpture. They'd dose the methadone at 6 a.m. on the Bowery and walk a couple blocks up. By about 8 they'd be like watching a slow mo movie. They'd try to pay the waitress for their drooled-in coffee and while passing her the change they'd just nod out. *Still life with 40 cent*. Or Winos off the Bowery getting a donut to go. Wearing dry piss encrusted pants who'd just picked themselves off the sidewalk. . . . There were three porno theaters around our block and a massage parlor that had been there since the '60s. It was extremely seedy, like 42nd Street south

BL: I wrote "Get Down on 14th Street" for the *Voice* about this block.

MC: The Metropolitan porn theater was across the street from us. It was a crack den with straight porn playing. It'd be 20 below zero and there would be a shirtless shoeless Haitian guy sucking a crack pipe at 4 am when you'd look out the window. I was so annoyed at its AIDS- casualty crack-friendly status I took to calling in chicken and rib orders for the cashier there. A fat black sissy named Lee who Bill hated from when he worked at the Venus theater in Times Square was in the front cashbox. I'd smoke a joint and watch the minstrel show pantomime unfold looking out of my front window. "I didn't call for no ribs, man!" Lee would shout at the Paki delivery guy sent from the Mama's fried chicken joint around the corner. I thought it was as funny as an episode of Amos n' Andy. Eventually Lee got stabbed one night closing up by one of the crackhead theatergoers. He was slashed up the thigh. Nobody liked Lee. The two Paki grocery owners who were next door to the theater would tell me all the gossip. There would always be Lee in there too, buying cheap malt liquor or a queenie friends of his lingering in the grocery. That's how I heard of the stabbing.

CP: When did you first publish your mimeographed *Sleazoid Express*?

BL: June 1980.

CP: How many did you do?

BL: At first it was a one-sheet every other week, then it was 4 pages every month, growing to about 16-20 by the last issues of that incarnation of *Sleazoid* by the end of 1985. In 1999 we resurrected it and it became a long 70-page magazine/monograph. I'm working on issue #6 as we speak.

CP: Explain the issues and the necessity of doing this publication.

BL: When I began *Sleazoid* in 1980, no one was covering Times Square exploitation movies, most people were too afraid to go into the theaters. The films were going unrecorded and I started it as a permanent journal of them. There was the risk of the one day film showing, blink and it'll be gone, mostly stuff too extreme to be recognized by other journalists. Then it expanded to include studies of various exploitation filmmakers, genres and had longer reviews. The next stage involved recording various life experiences and subcultures of Times Square and also parts of the Lower East Side subcultures.

As I worked in Times Square from 1982–1986 it gave me a whole firsthand look at what was happening there, from the grindhouse cinemas to live sex shows at shoebox adult theaters I managed or was projectionist at. It was an unforgettable part of red light history. And my personal life.

CP: Do you have the whole collection?

BL: Yup.

CP: Michelle, when did you start *Metasex*?

MC: I wrote it and then put it in a closet for a couple years. It officially was printed 1997. The same year I gave birth. So, [laughs], I came out of the closet in 1997. The *Metasex* magazine covers XXX grindhouse fare and those theaters. I see all film as art and pre-AIDS porn is art to me. It documents American people and theories and sexual politics mixed with wish fulfillment for a generation post hippie, post free love. Starting with the Freak era. My mother's circle of crime led me to write about a bunch of people who would never be documented, otherwise. I love to take photos as well. I took pix of the whole fall of Times Square.

CP: When you met other LES personalities, who was important to you?

BL: Henry Jones, Keith Haring, Kenny Scharf, John Sex and Scott Covert very much from the Club 57 days.

MC: Well, I just liked the idea of the place. That at one time you could come from anywhere and there was a tight little artists colony. And they'd fight in the streets for their rights. Loud-mouths of every stripe. Where else can you find that freedom. People had literally gone insane on the LES to fight for American rights. You could be yourself there. Little if any judgments. Except for your art. Which was the point.

CP: What was your impression of Harry Smith?

BL: That he knew a great, great deal and had been exposed to certain aesthetic and occult movements that have few if any surviving members. He was a great archivist of the occult and of American folk music, and an animation pioneer. He was a neighbor of mine when we both lived at the Chelsea Hotel in the early '90s where he died.

CP: How did you meet him?

BL: Henry Jones took me to meet him in the summer of 1980. He was in the Breslin Hotel on 28th Street and Broadway. And this is funny, because the place has these long elliptical hallways that seem endless. And I had no recollection of how I got in his room or out again. Hypnosis? I wonder, because it wasn't the hash we smoked that night! He was extremely cordial and friendly. Not the hothead I had heard about in other instances!

 Later, when we lived at the Chelsea Hotel before his death, Harry was this sweet old man. Michelle didn't know who he was and used to hold the elevator for him and help him to his floor. Then I introduced them.

CP: Did you learn anything from Harry?

BL: I liked him a lot but he did seem to be Henry Jones' friend and Henry knew him better.

CP: Have you seen his films?

BL: Some of the early animations, yes.

CP: Where any an inspiration to you?

BL: In the sense that he was visualizing some things Crowley taught, yes. *Heaven and Earth Magic* was very impressive. He also was encouraging about doing the Kenneth Anger bio, which we were working on at the time.

 Most of the people on the LES weren't helpful about the Ken Anger book. Michelle and I ran onto Allen Ginsberg on the street the day we got married and he said congrats, then went into a harangue of how mean it was to do this unauthorized book about Ken. Even though Ken created the genre of *Hollywood Babylon*, which are probably the most insensitive books about peoples' foibles ever! Amazing.

 Amos Vogel spoke to me and he was helpful, and was afraid of Ken. Later, he sent a letter to HarperCollins' lawyers because Ken had threatened him after the book came out.

CP: Why the interest in sex and horror films?

BL: For me, it's the primal reflection of what people want to see. A reflection of the audience's inner consciousness. Exploitation is almost an unselfconscious surrealism.

Michelle Clifford

Bill Landis

MC: It was that I had seen a lot of bitter violence as a child, including a bloody murder. My mother, whom I didn't live with, was a madam and violent criminal along the lines of *Reservoir Dogs*. A double crosser. She was tough and ran in vice and stick up circles. The tape-around-the-mouth type who did violent Irish mayhem. She'd laugh about her violence. It entertained her. She was shot in the head by the police. But that didn't kill her. She and her friends—pimps, psycho thief drag queens, drug dealers, extortionists, streetwalkers, call girls—they would all tell me the inner workings of the vice world from a early age. My bedtime stories were of who got beaten up or robbed that night, and made hilarious. The descriptions of the humility in the trick who was robbed of even his pants, how a girl in stilettos heels ran down a street from a cop, how a girl stabbed another one for talking to her man . . . so much drama . . . so much vivid color. Life and death drama daily. They beat the drama out of any doo-wop song. I loved those people. They treated me like a princess and always had goodies for me and babied me. But when I was 13 my mother was shot and it demonstrated how what goes around comes home.

BL: Michelle is a surrealist who turns pain into art. She reproduces what she sees very well.

CP: Where you ever a part of the LES drug scene.

BL: My first encounter with it were these little "candy stores," notably the Sweet Tooth on 9th Street, that sold very good grass and even hash. They were very Amsterdam-like except for occasional police interference and very benign.

What wasn't benign is the dope and coke dealt from abandoned buildings sold by Latino families, including their teenage kids who worked in shifts. A very primal capitalistic nightmare . . . a lot of it came from Iranian refugees who were bringing in very potent brown dope after the Shah fell. This was around the time hip-hop started, like *The Message*.

I did an article covering those bizarre "nickels of coke" in *Sleazoid* that I'm sure is the first ever printed on them . . . it's not so much the coke in them it was some mystery ingredient that gave a big bang for IV users. It was addictive, destructive and would have people wandering at 4 in the morning for more.

Eventually I wrote two articles for the *Village Voice* dealing with the LES drug scene. One was "Hooked—the Madness in Methadone Maintenance"—how methadone is part of the NYC beauracracy. It isn't run right, they use people as guinea pigs; it doesn't necessarily stop IV drug use. I never have been on methadone and would never be a dog on a leash for the government. Anything usually the government offers is nothing good, especially to "help" drug addicts. Another story I did was about ACT-UP's needle exchange program called "Point of Return." That piece was in the *Village Voice* and was reprinted in two books: One, a compilation called "Beyond Crisis" about the AIDS crisis in the end of the 20th century, and a legal book the ACLU published about the AIDS crisis. I was espousing clean needles as a way of not spreading disease.

That LES drug scene I didn't care for. It was cheap, insane and insect-like and malevolent. People with delusions of being artists, bad musicians living off hookers and strippers, mixed in with hardened criminals and professional thieves. Midtown (Hell's Kitchen) is more of a personal handshake situation where people know each other either by name or face, there were knock-knock places and more in-houses. There aren't these lines or buildings being obvious and none of the police scrutiny. Surprisingly, you find that many people who go to midtown actually have regular jobs and go there before or after work, and they mix in with the local vice workers. The LES was not my cup of poison when it came to drugs.

And it's my belief with drugs that anything taken past sacramental usage becomes detrimental. Used in artistic or spiritual creation they can be useful. But you should always have the ability to walk away from them.

CP: The Anger book must have been easier to get a publisher for than the *Sleazoid Express*, or maybe not- tell us.

BL: Ken Anger had hawked but never completed his own autobio for years in publishing circles. Michelle really instigated it. When we met, she asked why there wasn't a book about him. She really liked his films tremendously. They were the first art films she ever saw. At the Millennium. She had me get an agent and then she wrote half of it, although her name wasn't on it. She did the interviews with Manson associate Bobby Beausoliel for it, amongst other parts. *Sleazoid Express* was harder to sell because of the poor economic climate now in publishing (the Internet takes away $$ once spent buying books) and the cookie cutter aspect of big business. The way films are these days a lot of sequels and exploitation remakes on big budgets. Or fake indies.

CP: What is the difference between doing a mimeographed broad sheet, a magazine and a book?

BL: Offset sheets were the legacy of the early underground. Even Henry Miller did his own printing. What was happening at that moment within those two weeks. Urgent. Fast. Do it now before the movie disappears. A magazine—I hesitate to call it that, because each *Sleazoid* or *Metasex* now has a concept behind it and they're more monographs than magazines. The *Sleazoid* book actually took 9 months to put together, while the Anger book with all his hiding of life (his real name, his family) those facts took 4 years to uncover.
But remember, there was like 20 years plus of research that went into the *Sleazoid* book ahead of time. So I was able to do it quicker.

CP: Where there any filmmakers on the LES that you would write about? Have there ever been any LES filmmakers, of the *Sleazoid* content that lived on the LES that are familiar to you and have you written about anyone from the LES?

BL: In the late '70s, early '80s, the early Beth and Scott B movies like *Black Box* were very interesting and were also tied into the No Wave music movement. I was an actor in their film *VORTEX*. Jack Smith was a LES icon, but I found him burnt out, someone who you'd eventually have some fight with, and *Flaming Creatures* is just not up to the cinematic skill of *Scorpio Rising* or the cinema verite of a *Chelsea Girls* or *Flesh*—though it has its merits for the time.

CP: How many books have you done?

BL: Two full-length books, contributions to the others I mentioned, and we just did a thing about Director Joe Davian for a Taschen Vanessa Del Rio history . . . Joe Davian was a great Avon hard-core director, the Sam Fuller of porn. He was in Dachau and liked brandishing his Dacchau tattoo at people. Great visionary director who worked in the hard-core realm, films like *Domination Blue* were masterful.

CP: How about Michelle? How do you see each person's role? Does she research and you write, or both, or what?

BL: It changes all the time, shifting roles is part of it. The last one was really 50/50 with her interviewing some people, me others, and us changing the text together like a sculpture. We're a two-headed beast.

CP: You called me Frater Clayton Patterson in the credits in the Kenneth Anger book. What does that mean to you?

BL: "Frater" literally means brother. It is a term of respect and affection used in various occult and secret societies, notably the Golden Dawn, the Rosicrucians and the OTO.

MC: You had been supportive when we were living at the Chelsea Hotel writing that book. We'd watch your TV show at night on cable, *Clayton Patterson Presents*. I sent you a postcard. I was curious about you. One episode had a crazy pre-*Jackass* boy cutting himself on a rooftop with a razor. Then he'd writhe in agony. You'd interspersed that with you chopping up a hotdog and smiling malevolently. I was impressed at how dedicated you were to documenting, as Crowley said, "All that hath occurred."

CP: I am truly amazed at your child's intelligence. Wow. And no school

yet. Forget about school. Fuck those rules. This would throw her off for her whole life. Our childhood stays with us forever. She will have to play dumb to have friends, and that is just one problem . . . forget about that.

BL: This is true and she was appalled at the idea of starting at such a low level when she knows so much. She plays chess and is creative and interested in learning. So we home school. She gets to travel to film festivals with us, like Yerba Buena Center for the Arts in SF and the Warhol Institute this March.

MC: She has her own Web site. I won't have the individuality banged out of her. I want her personality to stay her own. No following-of-a-pack mentality. No sit down and shut up stuff and no time wasting with cliques or bullies. We had her as a Moonchild. Based upon an old legend from the Middle Ages, thought up by a man named Paracelsus. He'd been the scientist who invented paregoric (opium tincture). Crowley later expanded on Paracelsus' theories in practical applications in his book *Moonchild*.

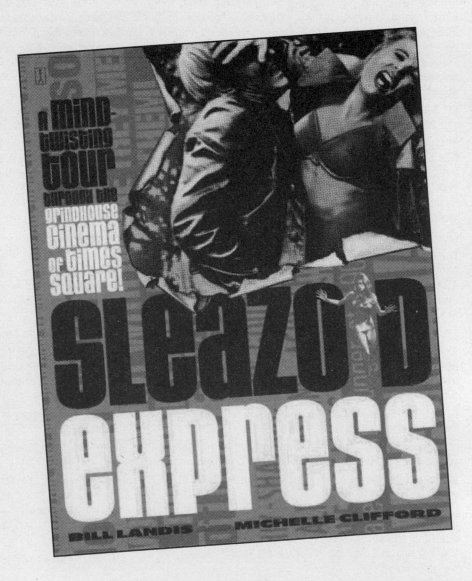

Live Video as Performance on New York City's Lower East Side in the 1980s

by Eric Miller

I write to commemorate aspects of the art scene of the New York City's Lower East Side in the 1980s. Michael Jackson and Madonna were inventing the music video. And we—Diane Dunbar, myself, and numerous others—were developing the video happening.

In the mid-'80s, various types of artists (performers, painters, etc.) were working in many different styles on the LES. Small performance spaces and art galleries abounded. Audiences were largely composed of artists. Artists, and groups of artists, could afford lots, which were used as workplaces and gathering places. There is a need for outdoor workshop spaces, as there is a need for gardens: communities and scenes can develop in and around such common spaces.

Today (2003), the scene as we knew it is dwindling. The artists' lots are gone, and painters and performers are much fewer in number—in part because so many people, including those in the arts, now work primarily with computers. It used to be that independent young people could come to the LES and find a way to survive, doing a minimum of manual work in a part-time day (or night) job. This sort of self-support is much less likely today.

In the mid-'80s:

No Se No, the performance space and bar, was a storefront walk-in—actually, a walk-down—on Rivington St., between Forsyth and Allen Sts. The entrance to the No Se No toolshed/clubhouse was around the corner, on Forsyth St., between Rivington and Stanton Sts. Adjacent to the clubhouse was a lot that the No Se No artists, led by sculptor Ray Kelly, shared with Adam Purple, the garden maker. Adam Purple's side of the lot featured a lovely spiral garden.

One fun activity at the No Se No lot was the ritual smashing of TV sets that had been found on the street and carried back to the lot. I suppose for some people this smashing of TV sets expressed a disdain for the passive consumption of mass media.

Welding and blacksmithing work was being done by Robert Parker, Tovey Halleck, and others. Scrap metal was artfully welded to the chain-link fence around the lot (this was a common practice around many artists' lots). A fire, covered with a grill, was often burning, and many steaks were cooked here. Cold beer was very popular.

A quality of the LES-in-the-'80s aesthetic was that there was a lot of bleeding—both literally and figuratively. Colors and shapes typically bled out of their frames, boxes, and borders. Artists displayed a nonchalant and whimsical, but often also virtuoso, mix of the sophisticated and the crude. Keith Haring brought his art world version of graffiti to the subways. Richard Hambleton painted dripping black shadowy figures on many walls.

Diane and I lived a few blocks to the north of No Se No. We have been partners in a video company from 1982 to the present (in the old days, it was known as Eric and Co. Video; now it is Storytelling

and Videoconferencing). For some years in the '80s, we made a living doing video documentation of performances (music, dance, theatre, etc.). Artists needed video recordings of their work in order to apply for grants and for other purposes, and in those days few performers owned their own video equipment. A video camera and portable (VHS) recorder were separate pieces then, making the video process much more cumbersome and elaborate than it needs to be today.

Both of us had backgrounds in theater, and from the beginning Diane and I performed with the equipment onstage, in addition to using it for recording from offstage. We were both working toward M.A. degrees at NYU—she in the Dance and Dance Ed. Dept., myself in the Gallatin School of Individualized Study. Both of our M.A.'s involved creating and analyzing performances that involved live video. In this way we theorized the use of live video in performance, a genre that grew out of many traditions, including: 1) illustration in general; 2) art installations (in galleries, museums, etc.); 3) '60s happenings; 4) '60s theater (involving audience-participation, site-specific events, and improvisation); 5) painting-in-performance; and 6) the liquid-oil light shows that often accompanied rock concerts in the '60s and '70s.

Diane and I share a love for forms of traditional storytelling, and many of our individual and collaborative performances that involved live and pre-recorded video also utilized narrative. Diane performed the story of Lavinia Williams, her beloved Haitian dance teacher. I performed numerous stories, mostly made up by myself, that were a mix of realism, and fairytale and legend. We were interested in ways in which a narrative (and a narrator) can provide a structure for an event without totally dominating the situation—that is, in ways in which all present can comment upon, elaborate on, enact, and otherwise respond to the ongoing narrative. When narrative is used in a video happening, a three-ring-circus atmosphere can develop, and I have always found this order/chaos tension to be stimulating.

What we were doing was part of the early stages of home-made and interactive TV, which now also includes the editing and storing of video on one's personal computer, and webcasting and videoconferencing. ("Webcasting," in this instance, refers to sending video through the Internet; "videoconferencing" refers to simultaneously sending-and-receiving video.)

I always felt that using video equipment only for recording by individuals was like using a Rolls Royce to cross the street. The equipment is capable of so much more. I felt that the video process was very interesting, and that it would be fun and useful to show this entire process to all present as it was occurring. When all who are present can see the electronic image, then, when desired, all present can participate as co-creators and co-directors of that image. The video process need not be a secret, pressure-filled process which only the cameraperson is in on, and for which only the cameraperson is responsible. One thing needed to enable the opening up of the situation is a large viewfinder, or a monitor, that others, in addition to the cameraperson, can see.

There is a continuum between the traditional recording situation and a video happening. In our "straight" recording situations, the performers would often view at least some of the recording directly after the event. We had a 5-inch and a 13-inch color monitor for this purpose. We could use these monitors during the taping itself, and others could watch if they liked—although often this was too distracting for all concerned, as we often taped during public performances. (For display events, we used larger monitors; and in the late '80s, we began to use video projectors.)

The video process can be asynchronous (image-creation and recording first, with community members viewing the images later) or synchronous (image-creation and community viewing simultaneously). If the experience is synchronous, all present can suggest or make changes in the visuals as they are being produced, as mentioned above.

If people are geared to experiencing an in-the-flesh-only performance, it can be distracting and annoying to have to also see a monitor with an electronic image. However, if people are prepared to see both the in-the-flesh and the electronic, they can find the combination enjoyable. It is all a matter of expectation. For example, if an artist is focused on showing her/his previously-done work, s/he may not be interested in others being able to electronically visually respond to the original work anywhere near that original work. But if people enter an event expecting to collaborate and to add to each others' statements, then this can work out fine.

Today, people are much more used to the combination of the in-the-flesh and the electronic. Many political, music, and sporting events feature this combination. In fact, many arenas and stadiums now have video systems as part of the house system, so seeing the in-the-flesh and the (live or recorded) video image has largely become an inherent part of the arena and stadium experience. Public participation in the creation of the electronic image, however, remains almost unheard of.

For art events / video happenings, Diane and I specialized in creating multiple layers on the video screen. I believe that at times we had the image going through eight separate pieces of video and computer hardware, each of which could be controlled by a different individual, or group of individuals. The entire combination involved: 1) the creating of the live video picture (through the selection and framing of images); 2) the processing of the live video picture (manipulating color and frame-rate, horizontal and vertical stretching and compressing, etc.); 3) the mixing of the live video picture with pre-recorded images (often supplied by videotape); and 4) electronic painting over all of the above. As you can imagine, a good deal of self-discipline and sensitivity is called for when multiple individuals are manipulating this number of factors to create a combined picture.

Our computer input devices included mice, keyboards, and electronic pads and pens. The video mixers (used especially for image-processing) featured knobs, sliders, and buttons. For the electronic painting, we had Amiga computers, and eventually, four small Sony electronic paint pads. Keying was done with both the Amigas and the mixers. (Keying is a type of image-processing and mixing in which, for example, the image of a dancer's body, costumed and lit to be light-colored, can be replaced by another video source, often just a solid color; or conversely, it can be the dark areas of the picture that are replaced by the other source.)

Diane and I were fond practitioners of video feedback, which is created by pointing a camera at a monitor screen that is showing a live image of what the camera is picking up. By changing the angles of the camera position, and by adjusting the picture controls (on both the camera and the monitor), one can produce swirling, pulsing, lacy, amoeba-like images.

In the '80s, the concepts, if not the actualities, of virtual reality (Jaron Lanier) and artificial reality (Myron Krueger) were getting a good deal of publicity. These processes involve the possibility of one's body movements affecting computer-generated two- or three-dimensional environments. Virtual reality involves wearable input devices (such as gloves) and display devices (such as video goggles); whereas artificial reality—more to my taste—involves input devices that don't hinder the body (such as video cameras and computer processing), and a common, large-screen display. In this latter vein, Diane and I looked (and continue to look) forward to using such input devices as 1) weight-sensitive floors, 2) heat-sensitive environments, 3) electro-magnetic-sensitive environments (Theremin-type technology), and 4) sonar and other types of signals that can bounce off the body and be read so as to create images on a screen.

One thing we did we called video projection dance parties: as people danced they could see their live images (with the processing, mixing, and painting) on a large screen. Few people were prepared to pay us for these live video experiments, so usually we did them for free. We liked to think we were working in the tradition of Nam June Paik, a father of video art, who, in the '60s, traveled about giving video demonstrations and talks with a "porta-pack" (which produced black-and-white video on reel-to-reel tape). Our demonstrations always involved inviting members of the public to participate in and play with the video process.

The events we did with Red Ed were especially enjoyable. Red Ed was putting out the Fine Art News newsletter, and was very active in the art scene, as she is today. I was delighted to set up the live image processing and painting system for two events she organized. One was at a gallery on 11th St., between Aves. A and B. The other was in the back room performance space of a bar on Second Ave., near 12th St. At both of these events, people performed, mostly reading poetry and singing, as others created the live video art.

We did numerous events for and with Arleen Schloss, especially at her famous Broome St. loft, and at a club near 12th St. and the Hudson River. I recall one fellow at the latter venue telling me that what was appearing on our monitor was the "worst video I've ever seen." Of course, I took this as a compliment. Factors he was perhaps referring to were the ways the camera was at times moved quickly and unsteadily, and was left on as the cameraperson

Clayton Patterson

Eric Miller

walked around. Most of this "backstage" process is omitted from "good" video.

One theme of Arleen's work during this period involved the letters of the alphabet. For some performances we did with her, as she spoke the letters, we had electronic letters appear in the mouth of her live video image.

Diane and I produced live video shows/installations at the Limelight, Danceteria, Sounds of Brazil, and many other nightclubs. Sometimes the images of the onstage performers went onto the screen; sometimes the images of members of the public sitting, standing, and dancing went onto the screen. Nicholas Bergery also worked many of these events: he showed slides of his computer-processed photographs; and sometimes projected light through crystals. Some of these events were organized by Baird Jones.

Once I recorded and displayed video on a monitor while Peter Missing and the Missing Foundation (a so-called "noise band") were playing. Although they were taking a sledgehammer to a refrigerator that had been found on the street, our video camera and monitor, which were in the midst of the action, were untouched.

Once, for a ceremony at the Tibetan Museum on Staten Island, we played the video recording we had made of our journey from Manhattan (which had occurred via subway, ferry, and bus). Following that, the live video camera was directed at a statue of the Buddha. The images appeared on the video monitor we had carried there.

Once at the Roadrunners' Club on the Upper East Side, I danced, holding a 15-inch monitor in front of me, while Diane, also dancing, directed a video camera at me. The live image she was producing (of me and the monitor) appeared on the monitor. In other performances, I danced while holding a camera, enabling audience members to simultaneously see my body movements, and the video images of themselves that were produced as a result of my movements. (I have a longstanding interest in developing ways for performers—through the movements and sounds they make—to take an active part in creating and manipulating accompanying electronic images on large screens.)

Three other teams that did video projection were Vlasta and Jeff (Floating Point Unit), Feedbuck and Missy, and Owen and Gabby. Owen worked for a time at Pseudo, the webcasting operation based near Broadway and Houston St. A scene developed in which numerous individuals with video projectors would bring their projectors (and image providers such as VCRs and computers) and project onto a single surface—sometimes onto a huge "bubble" made of glued-together sheets of clear plastic, with air blown up into it. Video mixers were sometimes used to combine two teams' images. Raves/parties/festivals/exhibitions/openings/etc. in various warehouses/ships/etc. around the City (especially in Brooklyn) took on the quality of slightly far-out arts-and-technology workshop-demonstrations and multi-sensory engineering experiments, as live-video artists displayed new and evolving image-creation devices and processes.

I am writing this article in Tamil Nadu, south India, where I am in the midst of a two-year Folklore Ph.D. research project involving forms of traditional storytelling practiced by members of a tribal people in the mountainous interior of the state. The project is scheduled to culminate in a videoconference (which is scheduled to be webcasted live, for public viewing) between people, including myself, in Chennai (the capital of Tamil Nadu), and people at the university in which I am enrolled (the University of Pennsylvania, in Philadelphia). Chennai, formerly called Madras, is on India's southeast coast, facing Singapore. I enjoy Chennai life, and am planning to settle here permanently.

During the time that I was doing coursework in Philadelphia, I videoconferenced with Warlpiri aboriginal people in Australia. They have been videoconferencing since 1992. They have videoconferenced with other tribal people around the world, including Native-Americans in the USA and Canada, and Saami people in northern Sweden and Norway. They are planning a global tribal-people-based music-dance-storytelling videoconference-and-webcast festival, and I am hoping to assist.

Art scenes come and go. As mentioned above, it seems that the old art scene in the LES is dwindling—as is the neighborhood's rainbow gathering scene, and squat scene. So many idiosyncratic local people and groups seem to have vanished into thin air. Perhaps some will reappear via cyberspace.

Defiance and obsessive determination were also parts of the LES-in-the-'80s aesthetic,

along with the aforementioned whimsicality, and rawness-crudeness and sophistication. It was a culture of these and other juxtaposed extremes: such multi-textured cultures have been called, "post-modern." The spirit of the LES-in-the-'80s aesthetic will not die—not while the present generation is alive, anyway. Likewise the spirit of the '60s. For myself, my work here in India is in many ways a continuation of what I was doing in the LES in the '80s.

The desire to enable audience participation in collaborative performance events drove our efforts in the '80s. We wanted to help others as well as ourselves to overcome social isolation and alienation by providing an alternative to the passive consumption of mass media—as typified by an individual watching TV alone in her/his room. We wanted to move the process of video creation and reception more into public spheres. There is something thrilling and empowering about making and manipulating electronic images of oneself and others, and helping others to also do so is wonderful work.

In our activities in the '80s, we were, perhaps unwittingly, laying the groundwork in microcosm for long-distance tele-participation events. Now we can do such events, as we have arrived in the age of teletoriums—spaces equipped with technology for videoconferencing, and display on large screens.

I never bought into the cynical and sarcastic aspects of the LES-in-the-'80s aesthetic; I am much more always an aspiring flower child of the '60s. As such, I want to invite any and all individuals to collaborate with me here in Chennai, both in-the-flesh, and via video-mediated communication (webcasting and videoconferencing and such). Let's do long-distance, multi-site art events!

Rockets Redglare

by Miss Joan Marie Moossy

Rockets Redglare was a very big man. He went back and forth from large to larger to largest, but was never medium or small in any way. I met Rockets when my late boyfriend brought him home one night for dinner. It was the first of many meals I would prepare for Rockets. We related to each other immediately in the same way in which we would continue for the next twenty years. Rockets was like an older cousin to me. He gave me advice, comforted me, spent a lot of time with me, and made me laugh myself silly. He also was very protective of me with regard to men, and bellowed at me at top volume when I made him mad. He made fun of my vegetarian diet with quips like, "Hey, Joanie, let me take you to lunch. I'll buy you a grass sandwich."

Rockets had had a series of interesting careers by the time I met him. He had always had ambitions in show business and had worked on the periphery as a roadie for Billy Joel, a bodyguard for the

Rockets in the basement of the Pyramid

Clayton Patterson

Rockets in the basement of the Pyramid

Sex Pistols, and then Sid Vicious. He had also been a hairdresser on Long Island, and cut my hair until it became too hard for him in the last years before his death on Memorial Day 2001. But when I met Rockets, he was starting to do a stand-up routine and talking about acting. He worked in the downtown nightclub scene at places like the Pyramid Club and Club 57. He was ambitious and over the years, he did develop a good career as a character actor, appearing in many films and on television. Although many of his parts were small, he made a strong impact on the screen every time. He was truly a brilliant actor. Later when his career was going and I told him that I wanted to act, he told me in his gruff, gravely voice, "Just do it, babe." When I did, he had the generosity to encourage me and give me notes on my performances. When Rockets had the apartment on 12th Street off of First Avenue, we would watch videos together while he manned the crack pipe and the remote, rewinding and replaying what he felt were the great acting moments in a wide variety of movies. For me it was a series of strange lessons not only in acting, but also in the world of a drug addict. It was a pattern repeated many times over the years with different drugs of choice in the many different apartments Rockets occupied on the Lower East Side. I knew them all; I was one of Rockets' all-girl moving crew. His male friends all seemed to disappear on moving days.

I didn't realize that Rockets was an addict when I first met him, but I learned fast, and it was a fundamental aspect of his life from an early age. He was born in Brooklyn, NY in 1949 to a heroin-addicted mother. By age 11 or 12, he was sniffing glue, and by 16 was a heroin addict. This meant that crises and rehab were also fundamental aspects of his life.

To learn more about this unique and wonderful human being, drop his name in any group of people in downtown Manhattan or watch for screenings of *ROCKETS REDGLARE!* a documentary tribute to this remarkable Lower East Side actor, renowned drug addict, and downtown icon. It is directed by Luis Fernandez de la Reguera, and won the Grand Jury Prize for Best Documentary at the New York International Independent Film and Video Festival, and was shown at Sundance Film Festival 2003.

"I'd Work in a Mexican Car Wash for Her"
Rockets Redglare in Love

by Lee Williams

Rockets was unique in the cast of characters in the East Village. For one, he was big. There were not many fat people as everyone was young, on drugs, and screwing their brains out, not to mention neglecting to eat regular meals. Rockets had an otherworldly, sweet face. His eyes were endless blue, icy almost.

I first talked to Rockets at 7A. Or was it A7? Maybe the B bar, aka the Horseshoe Bar. Wherever—it was my home away from home. I did, however, want to crawl back and dive bomb into bed before the sun turned the sidewalk into glittering mica that blinded me with the reality of daylight, to do lists, ahem, yas, yas, yas, and a man clacking down the street like a penguin in a suit with a tie choking his neck to some daytime shit, poor thing.

Rockets, that is Michael Morra, was born on Mother's Day in 1949 in Bellevue Hospital to a 15-year-old heroin addict (mom) and small-time mobster (dad). The story is the hospital added an opiate to his formula to help him withdraw. When he was 5, his parents robbed the Mineola post office. The FBI came looking for them and kicked down the apartment door. His uncle Eddie, who had, as Rockets phrased it "a whole loyalty among criminals thing" tied up Rockets in a raincoat, shot the FBI agent, then drove to Long Island and dropped him off at Aunt Fay's house for 6 months because "otherwise they're gonna try to take you away from Dominic and Agnes."

Dominic got deported to Italy and Agnes moved in with a junkie ex-boxer who beat up both her and Rockets. After a number of years, the boxer shot his mother to death and Rockets moved in with Eddie. He said, "To me the perfect writing situation is a bank vault. The closest I got to it was my uncle's basement. He had a Chinese desk with a lion that had an earring in its nose."

Rockets helped his mom and stepfather kick heroin when he was 12, although he was sniffing glue himself. Then he figured out how to get TussinEx, a strong synthetic opiate, by faking exactly the right kind of cough. By the time he was in high school, he was using heroin. By the time he was 20, he was 'sent away' for selling it. "I lost my teeth in a pistol whipping." After that, like his parents, he stuck someone up with a gun.

In the 1970s, Rockets, that is Michael Morra, was in a failed string band called Rockets Redglare and the Bombs. People confused him with the band, he was the band, whatever, by the time the band stopped played, he was Rockets Redglare.

Rockets, when he had a job at all, was a two-bit character actor in independent films. A pool player, a poker player, one among a nondescript collection of down-and-outers—a dubious someone hanging around in the dark with a lot of down time.

"When Rockets was on screen," said his friend, actor Steve Buscemi, tossing out the old chestnut, "you couldn't take your eyes off him."

"The name of my book is *Lies Lies Lies*," he proclaimed one night in 2A, the latest place the original East Villagers were hanging out in the early '90s. "I'm a good liar. That's why I act. Acting is lying in 3D." He was a good liar, spreading rumors of his own death and telling people he had one lung, then chain smoking cigarettes in front of them.

Something about Rockets made me respect him a lot. I also liked him because he was forgiving if you were out of your mind, which many of us were most of the time.

* * *

I was going into 2A once a week to get royally drunk. One night I took my childhood friend Paige, who had moved out of the Victorian mansion in Bay Shore to a tiny apartment in Brooklyn. She was working part-time as a librarian at the Museum of Television and Radio—it would definitely help her career—and had decided to become the next Doris Day.

Paige was daft—her boyfriend after her divorce was the sex crimes detective of Manhattan. "I just love the way he takes off his gun belt, puts it on the bed, and grabs me up in a big bear hug," she declared.

She was highly intuitive, unpretentious, and, most of all, had a huge heart. And she was gorgeous. Guys had followed her around since she was 11, when her white-blond hair cascaded to her waist, like stars falling from her head.

Rockets ambled up to us parked on our bar stools. I was yelling about a story (first published in *Tribes*) written by a bar patron that had been in the *New Yorker* that week. "It was better the first time, before she stuck a plot in the middle of it."

Rockets shouted, "It was like *Fantasia* when you're 6 years old. What the *New Yorker* did was Disneyworld. What her mother [a prolific spouter of profound mediocrities] writes is Chuck E. Cheese."

I introduced Rockets to Paige and turned to other matters at hand, namely the painter I was obsessed with who was never less than kind. Within minutes—or was it hours—Paige and Rockets were kissing, oblivious to the crowd standing around them, which was blowing straws at their heads and screaming, "Get a room."

"Are you crazy?" I said, as we stumbled down Avenue A to my apartment on 6th Street.

"I really like him," she said innocently. "He's so sweet."

The next day, Rockets walked off the 2nd floor elevator at the Museum of Television and Radio and strolled up to Paige's librarian station. He whisked her down the elevator to a party for *In the Soup*, a film where he played a fat guy who climbed from the back seat of the car to the front seat, which already had two people, then to the back seat and the front seat. You get the idea.

They walked down 5th Avenue toward Chelsea. Then Rockets grabbed Paige and propped her against a building and they made out passionately. "I will remember his delicious lips all of my stupid little life as vivid as if it was just last night," she declared.

At the party, not a whole lot was happening. Nine people sat around watching a video of the movie on the tube. Rockets seemed to be respected, although people were cautious. Afterwards, Rockets escorted Paige to the corner, put her in a cab, and handed the cab-

bie $4. Paige was impressed. She called him up first thing the next morning.

"You won't believe this," Rockets said. "Just after you pulled away, I got mugged." He had given his last dollar to the cab driver for her ride home and muggers came up. He had nothing for them, so they beat him up.

"Poor Rockets," said Paige. "Nobody cuts you a break." Silently, she hoped this wasn't something that happened often.

They met on the corner of Houston and A. They walked right past the bar they were supposed to go. Basically, when they hung out, Paige never paid for anything and Rockets didn't pay for much.

They talked on the phone constantly—all hours of the day. When Paige called, if he wasn't there, the machine said leave a message for Michael Morra and 15 other people squooshed together as hostages to low rent.

"I'm in love," Rockets shouted to me on Avenue A. "Guess what she said! 'If I were with you, you wouldn't want me to be with anyone else.'"

"Um, ok." I said.

Rockets asked Paige out to dinner. It was going to be their big romantic dinner date. As always, his shirt was tucked in, his gut hung out. He picked her up at the subway stop on Houston and 1st. She was so excited to see him. They walked to the ATM machine between 3rd and 4th street. His bank card didn't work.

"Don't worry," he said. "I know this great Italian restaurant around here. They'll front me."

It was hot. Holding hands, they walked down Avenue A. Every other person said, "Hey Rockets. Yo Rockets. Whass up Rockets." Paige felt a little weird, like she was walking down the street with Bozo the Clown.

A really cute, nouveau vague, Colin in the Secret Garden fall-in-love-with-me-I'll-push-you-around-you'll-have-fun artiste kind of guy who was dressed just perfect—two-tone vintage shirt, shoe-polish-black hair—walked by and hissed, "You've got great taste."

Paige didn't know if he meant she did or Rockets did but knew it was a put-down either way. "And that's when I started to be ashamed to walk down the street with Rockets Redglare," she said.

They got to the restaurant. It was dark, empty. A sea of checkered tablecloths extended to the back. The guy at the door didn't smile when he saw Rockets and escorted them to the last table in the back room.

Paige really liked being alone in a dark corner with Rockets. It felt safe. She liked looking at him. His skin resembled porcelain that had been cracked and repaired. His dentures made his face chiseled in a perfect way. When no one was watching, it was easy to fall in love with him.

She ordered a glass of red wine. Rockets didn't order. Paige took a sip and spit it out. It tasted like vinegar. Apparently they saved the good stuff for regular customers. She ordered fettucine alfredo.

"I'll have nothing," Rockets said to the waiter.

"Have something, Rockets," she said.

"I'm not hungry."

Rockets talked about his mother who had been a drug addict, how he had gotten her and his stepfather off dope when he was 12, neglecting to mention that at that time, he himself was dabbling in Carbona, a cleaning fluid. Then they talked about acting. Frankly, Paige was frustrated with her career.

She explained, "My agent wants me to audition for the role of a prostitute. I take my top off at the hot dog stand and everybody throws ketchup and mustard at my breasts. I am a serious actress. I don't want to take my top off. I cried my eyes out last night."

Rockets listened as if none of these difficulties were insurmountable. He was very unemotional about the business side of things. You got the feeling he knew all about it. He was simply encouraging, like her grandfather who said, "If you step in shit, just shake your foot and keep walkin'."

He made her feel she could be like that too. Everything would be OK.

"Rockets, you are a true actor in the sense of your optimism and plod-along ability. I admire that in you. You are NOT a quitter," she declared.

"Paige, I will work in a car wash all day with Mexicans to support you. Even if they bump into me and nobody gives me a tip."

Paige was speechless, thankful he could provide for her somehow. She really wanted him to feel proud he could do this. He was going to be a 9 to 5iver, he was that willing. She put a smile on her face and thought, "Oh my god, is this really my life?" "They'd be like the people in the Gregory Corso poem "Marriage."

"Seven flights up, roaches and rats in the walls a fat Reichian wife screeching over potatoes Get a job! And five nose running brats in love with Batman And the neighbors all toothless and dry haired all wanting to come in and watch TV The landlord wants his rent"

The waiter never showed up with the bill. They got up, quickly left. Rockets walked Paige to a cab. They never went out to dinner again.

The next time she saw him, he had a cane. He flagged her a cab. She kissed him on the cheek—and knew it was the last time she'd see him.

And she never really knew if she was hanging out with him because he was a famous movie star or if she could really fall in love with him.

I saw Rockets on the street every once in a while. Or in the restaurant on the corner where people got a $2 breakfast and didn't say hello to anyone until noon. (I wasn't going out much anymore because I had a baby and the dad had run back to Austria.)

Rockets never failed to ask about Paige, who was married to a psychiatrist and living in Connecticut. It was like the south of France up there. Her husband didn't want her to pursue acting so she was running around pruning roses and digging out the pond.

"What we had—we would have been engaged in 2 months. I would have worked in a Mexican car wash for her. I wouldn't have cared."

"I know you would have, Rockets," I said.

"Talk is cheap," he said.

One day, warm and hopeful as always, Rockets checked on Paige in Connecticut.

"Are you OK?" he said.

"My relationship's OK, Rockets," she said.

"Because if you're unhappy, I'm going to come get you."

"I saw your story," he yelled to me another time, midmorning on Avenue A. I'd written a story for *Guideposts* (a religious magazine) about a friend who couldn't have a kid but was nice to her bratty stepdaughter. He saw it in the doctor's office. "But he's got her doped up. She's not herself."

"I dunno, Rockets." It was weird though, because, come to think of it, her husband did have her on Zoloft. And she hadn't been depressed as far as I could tell.

So what was up with Rockets? Was it (as Gregory Corso says):

"Because what if I'm 60 years old and not married,
all alone in furnished room with pee stains on my underwear
and everybody else is married! All in the universe married but me!"

Briefly Rockets had left New York for LA. He had some money for once, so he rented a house in the hills. It had a pool. The first morning there, he got out of bed and made a vodka and cranberry and threw an English muffin into the toaster because "you couldn't get a bagel out there worth shit." He was thinking this is the life, maybe LA ain't so bad, and strolled out to the pool. He jumped in.

"I come up and thought there was a leaf in the pool next to me 'cause I had my glasses off. I go to knock the leaf out, the big leaf, and it was a fucking rat! In a beautiful aquamarine swimming pool. Seeing a rat running across a lump of food in Chinatown is one thing, but if you lift up Marilyn Monroe's dress and a rat runs out, it has a different impact."

So Rockets was back on 6th street in the city where his mother planted him. His book *Lies Lies Lies* was now called *Users' Manual*. Henry Rollins gave him an advance. Julian Schnabel purchased the film rights. There was always the possibility someone would buy the rights for the century after that. All told, he'd been in 34 movies exploring the neon wilderness, including the seminal (it has the secret of time) *Stranger Than Paradise*, *Talk Radio*, and *Basquiat*, in

Rockets Redglare Filmography

Rockets Redglare! (2003) Himself
Animal Factory (2000) Big Rand
Fabulous Disaster (1999) Himself
A Tekerölantos Naplója
aka *The Diary of the Hurdy-Gurdy Man* (1999)
Basquiat (1996) Rockets (Himself)
Trees Lounge (1996) Stan
In the Soup (1992) Guy
What About Me (1991) Frank
In the Spirit (1990) Bartender
Force of Circumstance (1990)
Cookie (1989) Carmine's Wiseguy
Mystery Train (1989) Liquor Store Clerk
Roofstops (1989) Carlos
Talk Radio (1988) Nutty Murderous Caller
Big (1988) Scary Motel Clerk
Stars and Bars (1988) Gint
Candy Mountain (1988) Van Driver
Shakedown (1988) Ira
Stars and Bars (1988) Gint
Police State (1987) Detective
Salvation (1987) Oliver
Down by Law (1986) Gig
Desperately Seeking Susan (1985) Sushi-hating Taxi Driver
After Hours (1985) Angry Mob Member
Stranger than Paradise (1984) Poker Player
Eurydice in the Avenues
aka *The Way It Is* (1983/1984) Pool Player

Clayton Patterson

which he played himself. Truth is—Rockets wasn't a quitter.

"When I really started to work, I worked. I did stand-up comedy. I fucking had what was the Saturday Night Live of the Lower East Side. Then I fucking pursued my work, and I fucking showed up on time, sober and straight, ready to go. Didn't let my fucking addiction and my problems get in the way of the job."

Whatever else was in his life, Rockets never treated anyone with disrespect. Even though on New Year's Eve, there he was at 2A cadging a drink half an hour before midnight from just about anybody sitting next to him on a stool. I guess he didn't have a whole lotta places to go, like Granny's place in Vermont to inaugurate the new year, kiddies running around the huge living room in front of the potbellied stove with au jus roast beef for dinner and thanks for all the blessings and congratulations for yourselves. The puffed chicken chest grandpa in the rocker.

If he was on dope, I never saw the grimier aspects of it, like that stray cat who came over to my house and stole all my grandmother's jewelry. Rockets never scratched himself every few minutes like so many dope fiends do. It could just be he reserved the flamboyant aspects of his activities for those who were appreciative. He did have a way of shaping his persona to the circumstances at hand, adding largesse, a dark sort of glamour, and enunciation, becoming part of the greater whole.

Rockets was 52 years old. The distance from the middle of 6th street to the corner of Avenue A was getting hard for him to negotiate. It took 15 minutes to make that and get into a cab. But he did have the cab fare. On May 28, 2001, succumbing to liver failure, cirrhosis, and hepatitis C, Rockets died.

I felt like I had been hit, really bad, and did want to go on the long subway ride celebrating general anarchy and the memory of Rockets, but it was hard to get a babysitter for midnight. I threw a flower in the Hudson River and thought about something he'd said amidst the gratuitous claptrap in 2A.

"Hey that movie didn't suck—the director just got stuck with a bad idea. He assessed the situation and said 'What can I do to make money?' He forgot to put pressure on himself. You have to know this—is it for you or something else?"

Then, about his acting, Rockets said, "I bring myself to it. It's not bullshit. That's why inside although everything's fucked up, money's fucked up, love is fucked up, I have this spiritual feeling, this feeling that's more than before. I can look in mirror."

* * *

Indicia

See *ROCKETS Redglare!*, a documentary by Luis Fernandez de la Reguera which won Grand Jury Prize for Best Documentary at the New York International Independent Film and Video Festival in 2002 and was shown at the 2003 Sundance Film Festival. See also "Drinking with Rockets Redglare" by Rich Vesecky and Eddie Christman in New York Hangover, July 1999 (available at: www.nyhangover.com/issues/0601/rockets.htm) and "Rockets Redglare in Love, Morphine, and Memory" by Gene Gregorits in *Sex and Guts* magazine (available at: www.sexandgutsmagazine.com/rockets.htm), both of which served as sources for some of this story.

Films & Video at Darinka:
A Performance Studio 1984–1987

by Gary Ray Bugarcic

In the late winter of 1984, I was searching the Lower East Side for a loft where I could live and play music. Fortunately I happened to come across a space that had a stage. I not only could live in it, but also could easily convert it into a club for performance, music, readings, and film/video nights. It was at 118 East First Street right around the corner from avenue A. It looks like Houston Street but it's the very end of First Street across from Katz's Deli. I knew I could make this happen since I had thrown a handful of successful parties with some serious entertainment. Next I needed a name. The neighborhood at that time was still fairly rough and intimidating not to mention the fact that most of the existing small clubs had punk sounding names like Spike & Spit. I needed a name that was not threatening. Keep in mind that it was rare for females from other parts of the city to come down this far on the LES, so I needed a name that was inviting, soft, and perhaps even feminine. I also felt that the name should somehow reflect the Eastern European roots of the neighborhood. It didn't take long for me to realize my mother's original first name would be perfect. Darinka. It's a Croatian name that means "one who gives gifts." By the way, a suspect Indian restaurant called Chutney now stands where Club Darinka was.

May 5th was our official opening night and featured performances by James "Tripp" Trivers and a very entertaining duo I had seen at an Avant-Garde-Arama at PS 122 called "Steve & Mark." Steve Buscemi was a fireman in the day and Mark Boone Jr. was a bartender. Their skits always explored some aspect of life in a hilarious and thought-provoking way. That night they were both hip-hop dancing businessmen. Whether it was just a chance encounter between a construction worker and a Hare Krishna in a disabled elevator or the relationship between two cellmates in a state penitentiary entertaining themselves by acting like dogs, you always found yourself mesmerized by the social commentary they subtly probed. They eventually were given their own cabaret night once a month. On those nights they had a slew of regular entertainers and always the special quest performer, i.e. Rockets Red Glare and John Lurie. Both Steve and Mark have gone on to illustrious film careers.

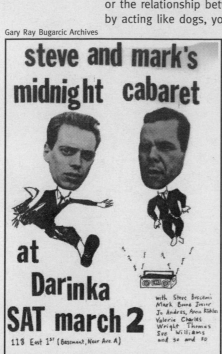

Speaking of films and video, the first time we featured an evening of screenings was one month after the opening and was curated by Kate Lynch. One of the featured films was *Tubby Boots* by Michael A. Zimbalist. It was a documentary about an overweight, foul-mouthed androgynous Rhode Island comedian who would make even John Waters proud. See it if you ever get the chance. During that same series filmmaker/choreographer Jo Andres also screened one of her films. She later married Steve Buscemi and came back many times to perform with her performance/dance group Liquid Television.

In July of that year, Postal Art International curated an evening of films and video by filmmakers from the U.S., Holland, Australia, and Poland. "Warsaw—The First Days of Martial Law—Winter '81–'82" was a collection of performances filmed secretly in the Polish police state by Tomasz Sikorski and Zbyszek. This was by far the most memorable film of the evening. It made us all realize the complete secrecy it took to produce an evening of artistic performance in Poland. We were all feeling quite anxious after that one.

Filmmakers Richard Kern, Nick Zedd, and Brian Moran teamed up on several occasions to produce evenings of their films. "Movies That Were Spawned in Bilgewater" was the name given to the first night of their films and performance. That was August of '84. I clearly remember a screening of one of Richard Kern's films that had a simultaneous performance that would have made you cringe. While one of the films screened, two performers sat in front of the screen and shot-up drugs in the most precarious way. As they stuck themselves, blood spurted from their veins spraying the front rows of the audience. Even the hardcore regulars thought this was way over the top. Their film nights were always a scream and most notable amongst their stable of actors were Lydia Lunch, Casandra Stark, Tommy Turner, and Lung Leg.

Just some of the many other filmmakers and video artists that showed at Darinka were Ela Troyana, Garrett Linn, Mark Kehoe, Fabio Roberti, Sokhi Wagner, Jason Brandenburg, and animators Joey Album, M. Henry Jones, and Michael Wolf.

On a different note there were films that used Darinka as a location for some of their scenes. There was a barroom scene during which a jukebox was having its records resistantly changed in an indie called *No Picnic* directed by Phil Hartman. This is a very timely mid-80's flick that exposes some of the frustrations of living on the LES. I also rented the space to a pornographer to make what I think is the worst porno movie of all time called *Poltergash*. Pass on that one. In the recently released documentary *Gigantic: A Tale of Two Johns*, Darinka is talked about quite a bit since They Might Be Giants was the house band for 3 years.

Please note that there were some very difficult days running a small illegal club, but I am forever thankful for all the memories and friends I've made because of it.

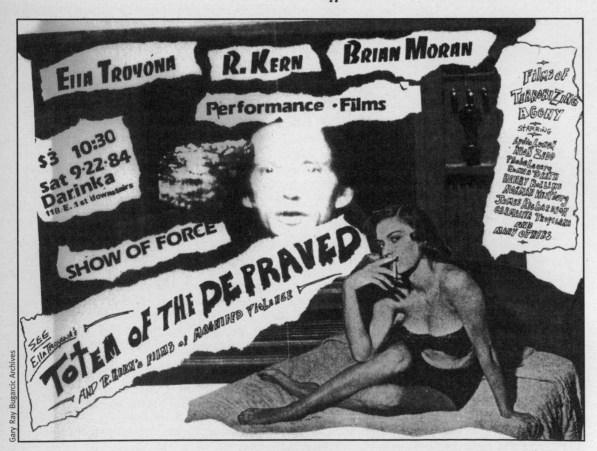

Gary Ray Bugarcic Archives

The Cinema of Transgression: Where Are They Now? A Recollection

by Cricket Delembard

"Who wishes to be creative, must first destroy and smash accepted values." —Nietzsche

The most radical film movement of the 1980s was the Cinema of Transgression. Spearheaded by Nick Zedd, Richard Kern, Tommy Turner, Manuel Delanda, Richard Klemann, Bradley Eros, Aline Mare and a strange girl named Lung Leg, the movement was soon augmented by a second wave of movies and live performances by people like John Spencer, Casandra Stark, John Moritsugu, Lydia Lunch, Kembra Pfahler, Tessa Hughes-Freeland, the late Ela Troyano, Clayton Patterson, Rick Strange and Jeri Cain Rossi.

The seeds were planted in 1979 with Zedd's Super 8 feature *They Eat Scum*, later described in *Forced Exposure* as an "anti-anti-punk-media-goof." Starring a JAP named Donna Death . . . the best scenes include force-feeding a live rat to a phony-punk found outside Studio 54, mock dog jizz filling the mouth of an obnoxious transvestite and the gush-destruction of an enormous mutant cockroach.

The movie initially played in local clubs to shocked gatherings of the kooky and curious and was even denounced on the front page of the *Wall Street Journal*. "The vilest and most revolting performance of sadism I have ever seen. Please do what you can to stop it," the writer pleaded.

It was on October 4, 1979, in the *SoHo Weekly News* that Amy Taubin stated, "The esthetic operative here is transgression," in her review of *They Eat Scum*. Six years later Orion Jeriko coined the term Cinema of Transgression in the third issue of the *Underground Film Bulletin*, a photocopied crudzine created to fill the void when Zedd, Kern and a few others found themselves deliberately blacklisted from every magazine, newspaper and screening room in the country.

From 1984 to 1987, Zedd, Kern and a genetic research scientist named Tommy Turner pooled their resources, collaborating with friends and future enemies Casandra Stark, Lydia Lunch, Lung Leg, Henry Rollins, Jim Feces and others, on a series of low budget atrocities that sent shock waves through the art world and electrified a small, but supportive cult.

On weekends in '84 Kern would shoot Super 8 black & white segments of the *Manhattan Love Suicides*, surreal psycho-sexual silent movies starring people like David Wojnarowicz (a gay painter who was later diagnosed as HIV positive), Tommy Turner and his wife, Amy (she burns her face off with a hot iron, then immolates herself when Turner's face turns into a fried egg), and Kern's sexy girlfriends Robin and Adrian (who drives a car into a wall after seeing a bunch of nude punks writhing on her windshield).

Kern, an accomplished photographer, evinced a latent homosexuality in his preference for short-haired, skinny women. He delighted in playing mind games with them and anyone else who entered his apartment: a vortex of drug abuse and sadomasochism, much of it reenacted in his films. There always seemed to be people getting tied up and beaten,

both male and female. Kern reveled in trying to manipulate the behavior and emotions of his friends, constantly testing them. His films were a logical extension of his amorality.

Among other things, Kern loved to test Zedd's resistance to drugs by offering him free samples of heroin, coke, and speed, which, more often than not he'd refuse—to the amazement of the master manipulator. To catch him off guard, Zedd would sometimes surprise Kern by shooting up with him while taking long distance calls from people tripping on L.S.D. The two would spend hours insulting each other in the tiny, evil-smelling apartment on 13th Street, a notorious drug block on the Lower East Side.

Tommy Turner, a full time dope addict, would shoot up with his wife and friends in Kern's kitchen before throwing up on camera for films like *Zombie Hunger*. Turner shot his own film, *Simonland,* at a church on 6th Avenue. Inspired by the Jonestown massacre, it satirized the mindless worshippers of an evangelist who gets his followers to kill themselves en mass.

Screening segments of the *Manhattan Love Suicides*, like *I Hate You Now* and *Stray Dogs*, with jarring Feces music at clubs in the neighborhood, Kern and a dancer named Brian Moran would emerge onstage, shed their clothes and shoot up and pour blood on each other while screaming.

Another segment of *Suicides* was *Thrust In Me*, a Zedd/Kern collaboration in which the former, playing the male and female leads, has necrophiliac sex with himself.

Zedd started performing his own psycho-sexual morality plays in drag like *Me Minus You*, in which he and a friend named Eric Pryor a.k.a. Rick (Rik) Strange, had sex onstage, then fought each other to the death at the climax of the event.

After shooting *The Right Side Of My Brain* and *Fingered* with Lydia Lunch, Kern got himself a Church of the Subgenius marriage to a girl named Audrey Rose, who he starred in *Submit To Me* and another film in which she had her nipples pierced. He then formed a band called the Black Snakes, playing lead guitar for two years before thankfully breaking up.

Zedd thought up the title *Totem Of The Depraved* for a rarely seen movie by the late Ela Troyano in which he tried to have sex with a dog. Kern featured Zedd in *King Of Sex* in which the actor/filmmaker cavorted in bed with two girls, and then attempted to perform an abortive blowjob to a flaccid "Rik Strange." Con artist extraordinaire Strange, an alcoholic at the time, was too drunk to get a hard on, but he did manager to pilfer a switch blade belonging to Lunch much to the chagrin of Kern and the "Queen of Siam." At a poetry reading at a space called Ground Zero Zedd recited something called "Dear Cunt" and got into a fist fight with two artists when he broke a borrowed amp. Following Zedd's "performance," Strange, with his wife accompanying on guitar, made himself vomit onstage. Then he lowered his drawers and took a shit in front of everybody. By then the place was nearly empty so to get the attention of the five people left, he ate his bowel movement.

Tommy Turner, like Strange, now a member of the Ordo Templi Orientis (founded by Alistair Crowley), shot a film with Tessa Hughes-Freeland called *Rat Trap* in which a junky shoots up and vomits into a trash bin while a rat is drowned and eviscerated. With David Wojnarowicz, Turner began shooting *Where Evil Dwells* based on the Ricky Kassos satan teen murders. He only got as far as a 45-minute trailer before spending the thousand dollars he was given to finish the film on heroin somewhere in L.A. Turner spent the next two years in Hollywood acting in Japanese porno movies between doing special effects on a remake of *The Blob*. His wife Amy gave birth to a son, Talon. One of Turner's collaborators, Montana Houston, with whom he produced *Redrum* magazine and *Simonland*, slit his wrists and barely survived, then moved to Texas and killed himself. Montana never took a bath. It was necessary to stand a full ten feet away from him

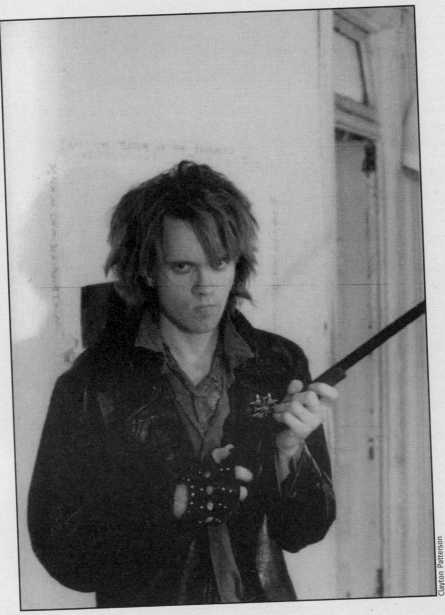

Nick Zedd

Clayton Patterson

in order to breathe when he was alive.

In 1987 Zedd shot *Police State*, a comedy about police brutality. The film submerged a strong humorous element in a persistently violent atmosphere, forcing the viewer to choose between indignation and laughter—two incompatible responses. It starred Zedd and Rockets Redglare. Zedd then filmed *Whoregasm*, a two-screen color porno film starring him having sex with the tattooed sex goddess Susan Manson.

One week after Zedd showed *Police State* in the Tompkins Square bandshell to a crowd of winos and beggars, the Tompkins Square police riot occurred, resulting in 121 complaints of police brutality. Video artist Clayton Patterson taped the entire six hours of public beatings of innocent civilians, artists, anarchists and other community residents trying to resist an illegal curfew imposed on the park by the Mayor of New York and the NYC police department. Patterson was subsequently arrested for refusing to hand over the tapes to a grand jury investigating the riot (after staff from the D.A.'s office "accidentally" erased part of a copy) and spent three weeks on Rikers Island, the only person made to pay for millions of dollars worth of damage to the community. Most of the cops charged with brutality were later exonerated, sparking a new wave of protests and repression.

After breaking up with Zedd, film student Casandra Stark shot *Wrecked on Cannibal Island* (1986), *We are Not To Blame* (1989) and *Death of An Arabian Woman* (1991). The *Underground Film Bulletin* said of her earlier film *Dead On My Arm*, "It is a chilling evocation of her internment in a mental institution during her adolescence and features a very young and beautiful Lung Leg as well as the demented brilliance of stuttering skin actor David Wicked drooling in a graveyard."

In the spring of 1988, all of Zedd's films were seized by the Canadian government prior to his arrival for a show in Montreal. Ten minutes of *Whoregasm* depicting Susan Manson masturbating with money vanished forever. In Toronto, Zedd's films were banned by the local censor and his show cancelled.

Lung Leg (Lisa Carr), who, back in New York appeared in Kern's *You Killed Me First* and made her own movie in which she ate a large worm, moved to Minneapolis and lost her mind, according to Zedd: "Her parents threw her out of the house after she started seeing goblins and being tortured by an imaginary communist 'war goddess' named Ninny. Lung claimed Ninny was an insane 14 year old wearing a dress stained in piss; at other times a school teacher, nazi official, thief, wolf, skeleton or medusa with snakes coming out of her nostrils. She would insult Lung in a whiny voice for being a 'weak American' and planned to use genetics and 'massive vampirism to destroy entire generations of Americans. Any sympathy towards the Germans is seen as a weakness and will be taken advantage of,' she stated. She claimed that Ninny had scraped her vagina so all her estrogen was now gone and she could never have sex. Ninny made needle incisions in each of the vertebrae in her spine and injected liquid poisons into her. She sometimes turned people into skeletons. Ninny was planning to destroy Christmas by turning it into 'a German holiday' by sending empty boxes (signifying communism) to all children, according to Lung." (From *Bleed*, by Nick Zedd.)

Amazingly, Lung was invited to Gothenberg, Sweden, in 1987 and paid to recite poetry to a large audience at a spoken-word festival. In the video, what I saw of it, she appeared to be channeling the spirit of an old woman. Her identity was submerged by someone else's mind, it seemed. Lung changed her appearance, shaving her hairline and growing the rest of her hair long and black. She wore lipstick extended past her lips lines to achieve a clown-like appearance and wore an excessive amount of black mascara and

designed her own reptilian clothes. She is now settled down in San Francisco.

In 1988 Kern moved to San Francisco and embarked on a campaign to get off dope by smoking large quantities of pot and taking massive amounts of psychedelics. An article in the *San Francisco Examiner* detailed Kern's eviction from a two-bedroom flat a year later:

"The stench was so severe that sheriffs deputies who posted an eviction notice on the door asked the owner of the flat to stay outside while they checked for bodies. 'To call it a pig sty,' the landlord said 'would be insulting to a pig.' . . . When Getzen entered the Broderick Street apartment in March, she found up to ten 'punkers' living there, two cats, one dog, and a filthy two-bedroom flat. She decided on eviction. It took her nearly four months and $4000 to get them out . . . Getzen said in her soft Southern drawl, 'couldn't even believe that people would live this way. They said I didn't understand their philosophy.'"

Facing eviction by sheriffs deputies, the tenants fled Tuesday night, leaving this scene for Getzen to survey Wednesday; quart beer bottles strewn throughout, broken stereo speakers, broken TV sets, broken clock radios, pornographic pictures and magazines, empty food cans, cigarettes sopped in beer, graffiti on one wall, a hole in another and a sink full of dishes with caked on food. The brown bathroom tub, caked with soap, had a white foam over it. An old litter box filled with cat feces created a nearly intolerable odor.

". . . They were so arrogant . . . like they knew it was going to go on and on, so they just settled in."

Kern had outdone himself this time. The two girls he was living with proceeded to rob a bank and in a wild car chase, smashed Kern's car into a showroom window before getting caught. Two more of Kern's dope dealer pals got busted with a large amount of amphetamines on them, though as much as 2/3 of the evidence may have disappeared. Terrified of getting busted, Kern returned to New York.

Meanwhile, Nick Zedd was running a film club called The Invisible Cinema on Sundays in the basement of a bar on First Avenue next door to the East Village's only graveyard. For six weeks Zedd showcased underground films like John Moritsugu's *Sleazy Rider*, Turner's *Where Evil Dwells* trailer, Michael Wolfe's demented home movies reenacting biblical tales, and Scott B. movies like *Last Rights*, the story of Velma Barfield, a woman who used rat poison to slowly kill her husband so no one else could have him.

The Invisible Cinema, despite a press blackout, built up a large, enthusiastic following before being abruptly closed by the management of the club upstairs in order to make room for dart games. The Invisible Cinema was, in fact, the only continuing cutting edge avant garde film showcase in New York in the 1980s.

After the yearly New York Film Festival Downtown folded, it wasn't until the fall of 1990 that Tessa Hughes Freeland and Ela Troyano were able to resurrect a similar monthly platform for transgressive movies at a place called Webo which also soon closed.

In the spring of 1989 Zedd presented a retrospective of his films at The Museum of Modern Art, an event that marked a turning point in the Cinema of Transgression. Tommy Turner showed up and jumped onstage in front of two hundred people to deliver a blistering tirade denouncing Zedd for selling a tape of *Where Evil Dwells*. Heckled off the stage, Turner demanded money from an amused Zedd, who blankly complied with, "I was going to give it to you when I saw you, Tommy." The two no longer speak to each other. Zedd now refers to his former comrade as

"Tommy Traitor." Turner's apartment burned down two years later, destroying most of his films. He barely escaped with his son Talon in his arms.

In 1990, Zedd toured Germany, showing his movies to capacity crowds in Berlin, Hamburg, Bremen and Nuremberg where radical feminists of the Rote Zora broke into the theatre. Wearing ski masks and blowing whistles, they threw manifestos throughout the theatre denouncing the films, then emptied bags of garbage and cat shit on the audience before throwing acid on the screen and running out. Posters of Zedd were defaced by jealous filmmakers to look like Hitler and the entire spectacle made the front pages of the daily papers the next day.

En route to Sweden, Zedd was removed by police from the train as it sat in a station in Denmark at 3:00 in the morning. He was informed that "We don't want you in Denmark" and deported from the country for being a "non-Nordic alien" at his own expense, ending the tour.

At the Berlin Film Festival, Kern faced the wrath of screaming feminists when he attempted to show *Fingered* to a hostile crowd of hecklers. Saying "fuck you," and flipping them the bird, he walked off the stage while the theatre manager debated with audience members whether to pull the film. Facing a similarly hostile crowd the next night, Kathy Acker was enlisted to defend the film—to no avail. A couple nights later, radical feminists broke into another theatre and poured blue paint on the projectors showing *Fingered*, then looted the box office.

Meanwhile, Rik Strange, a.k.a. Eric Pryor, was having his own problems back in New York. Having impregnated a married woman, he returned to Manhattan and managed to get a gullible businessman to give him $20,000 to start an occult bookstore. He spent all the money on cocaine, electric guitars, a crystal ball and a solid gold riding stick, then went on to found his own coven of witches while holding the office of President of the Eighth Street Flock Association before being run out of town by a gang of skinheads.

In the Catskills, he reportedly served five months in prison on a charge of reckless endangerment after firing several rounds from a loaded shotgun into the home of his new wife and child. When the state of Texas refused to pay for his extradition, Strange was released from the local county jail to begin a short-lived career as a transvestite go-go dancer at the Pyramid. He next was said to find employment as a private detective and somehow traveled to Central America to serve as a mercenary soldier fighting the anti-terrorist forces. He then moved in with a neurotic elderly invalid in the East Village, who, in a suicidal fit, overdosed on a bottle of Jack Daniels and atavans. While she lay in St. Vincent's hospital, Strange reportedly proceeded to liquidate her estate. He sold her piano, paintings, and books for hundreds of dollars, most of which he spent on beer, then held a trash party and invited a pack of drunken bums into the apartment to destroy the place.

He then fled to Salem, Massachusetts, where he briefly headed a coven of witches who were accused of dealing drugs to children.

Moving to San Francisco, Pryor became the high priest of a pagan temple called New Earth and became embroiled in a holy war with Texas Televangelist Larry Lea, who often preaches in military fatigues and passes out dog tags to his "prayer warriors." On Halloween 1990 Lea brought 10,000 of his followers to San Francisco for a prayer rally to "save the Bay" from the devil. Pryor led hundreds of pagans in a public curse against Lea and his followers. At the time, Pryor stated, "Larry Lea and other pastors and negative Christians may find themselves falling

off their pulpits and breaking their legs, or getting ill, or losing money."

Pryor used ceremonial salts and powders to spiritually close off the Civic Auditorium where Lea's group met Halloween night. "We want to seal off their evil energy," he stated. "It's a grand case for showing that witches won't stand for being treated like this. We don't want their condescending condemning prayer."

"Satan is a mouse, a toothless lion that roars. He's holding the Bay area under his evil thumb, but Christianity will win," replied Dick Bernal, a Lea follower and pastor of San Jose's Jubilee Christian Center.

Angry homosexuals calling themselves GHOST—Grand Homosexual Outrage at Sickening Televangelists—organized a march and demonstration outside the Civic Auditorium on Halloween night, which, with the help of Pryor's pagans turned into a near riot. Three thousand drag queens and Satanists circled the huge building attempting to seal off entry to the thousands of Christians planning to do spiritual warfare inside. Police held back the angry crowds pelting eggs at each other.

On a talk show that morning, Pryor, bearing an amulet with a pentagram, his hair bleached white, stated, "The witch hunts are over, and I, for one, don't intend to be burned at the stake." Replied Lea, "Anyone who has done any study of Satanism knows this is the high holy day of the Satanic church. We just thought that was a good time to come and for Christians to pray." After the talk show, Pastor Bernal challenged Pryor to come to the prayer rally to see for himself what Christianity was all about. He agreed and entered the auditorium as the throng of angry GHOSTs and pagans chanted outside, a .22-caliber revolver strapped to his ankle in case he decided to kill Larry Lea.

Two days later Pryor converted to Christianity and was given an apartment by Lea and $1,000 a month living expenses. He burned down his temple and destroyed his vast collection of occult weapons and literature in a public ceremony before hundreds of Christians. Pryor now lives in a golf course condo in San Rafael making $100,000 a year as the "witch who switched." On Halloween 1991, Pryor preached to a throng of Christians at Candlestick Park, appearing with Larry Lea and Dick Bernal. Without divorcing Nichole, he married another woman, who he immediately got pregnant.

In an exposé on ABC's Nightline, Diane Sawyer informed the nation that Pryor has paid no child support to his wife Nichole and their two children, one of whom, Nicholas, was named after Nick Zedd. The Bay area pagans have vowed to assassinate Pryor if he ever shows up in San Francisco again. Pryor expects to make a million next year selling his video "From Pagan To Pentecost" and plans to finance a pagan-bashing film with Nick Zedd directing. Zedd has not yet decided whether to accept. As a result of the Nightline report, Lea's ministry suffered a massive loss of revenue, forcing his daily television program off the air. In the space of a year, Eric Pryor almost single-handedly destroyed one of the most powerful Christian fundraising programs in the nation with a major scandal, forcing it off the air due to lack of contributions. I hope that he can do more damage to organized religion from within before the pagans kill him.

Back in New York, Richard Kern completed his first film in 3 1/2 years, X IS Y and showed it with two other new films, *Nazi* and *Money Love*. Indicating a new direction—short, cute, and nasty—these films feature sexy girls shooting guns and doing calisthenics. A more recent film, *Queen Of Sex*, features Little Linda and Annabelle from the Karen Black band having fake sex with filmmaker Charles Pinion in semi-drag.

Zedd, after writing and publishing his first book, *Bleed*, acted in the films *No Such Thing As Gravity, Shadows In The City, We Are Not To Blame* and *What*

About Me (co-starring Richard Hell, Johnny Thunders, Richard Edson and Judy Carne). Zedd then premiered his new film *War Is Menstrual Envy, Part One* in the fall of 1990. Starring rock star Kembra Pfahler and porn star Annie Sprinkle, the film, a radical departure for Zedd, takes place "In November 2092, following the death by radiation poisoning of 9/10ths of the human race. A cult of sea worshippers appears led by a human deity known as Shiva Scythe. Forming a telepathic alliance with the world dolphin population, they bring about the destruction of Christianity and Islam."

The film also featured a newcomer. "He likes to mutilate himself in public. I don't know why," said Zedd. "His body is covered with scars. His name is Steven Oddo. He went onstage with industrial noise and cut his face open with a razor blade while screaming 'I hate you!' at the audience." Oddo cuts the title of the film into his chest with a blade. At the Anthology screening of *War Is Menstrual Envy*, a man in the audience fainted at the sight of the real blood and had to be carried out. In fact, every time the film has been shown at least one person in the audience has fainted or started screaming hysterically. Zedd completed Part Two at the end of 1991 and Part Three is planned for the end of '92.

Zedd recently appeared with GG Allin on the Geraldo Rivera show. In the audience were Zedd's former compatriots Kern and Turner, both of whom he is no longer speaking to. Sitting between them was Jeri Cain Rossi, a filmmaker who put on convicted mass murderer John Wayne Gacy's first one-man art show in Boston. She also organized painter/exploding geek Joe Coleman's last live performance (at which he was arrested for attempted arson and animal abuse for biting the heads off a few mice). Rossi is currently writing a book on the Cinema of Transgression and its publication will hopefully signal the long-awaited critical acceptance that has long eluded these celluloid revolutionaries.

If any artist from the past could be said to share a kindred vision to these filmmakers, it might be Viennese Actionist Otto Muehl, who once stated, "I make films to provoke scandals, for audiences that are hidebound, perverted by 'normalcy,' mentally stagnating and conformist. The worldwide stupefaction of the masses at the hands of artistic, religious, political swine can be stopped only by the most brutal utilization of all available weapons. Pornography is an appropriate means to cure our society from its genital panic. All kinds of revolt are welcome; only in this manner will this insane society, product of the fantasies of primeval madmen, finally collapse."

This story is apparently from the Cinema of Transgression Archives, circa 1992.
The veracity of the transgressions made in this story is left to the audience, as is with the other works of the Cinema of Transgression.

References:
Cuhulain, Kerr, "Eric Pryor - The 'Witch Who Switched'" The Witches Voice Inc., Clearwater, Florida
www.witchvox.com/protection/kerr_pryor1.html

O'Brian, Dave, "Reborn Again?" *San Jose Mercury News*, December 14 1991
www.holysmoke.org/wicca/pryor01.htm

Sargent, Jack, *Deathtripping: An Illustrated History of the Cinema of Transgression*, Creation Pub. Group, (2000)

Smith, Bob, "Nick Zedd: Interview," Chaotic Order Issue 10 Spring 2001

Zedd, Nick, *Abnormal: The Sinema of Nick Zedd*, Allegro Corporation, DVD (2002)

Zedd, Nick, *Bleed*, Hanuman Books, (1992)

Zedd, Nick, *Blood–Abandoned*, CodeX, (1998)

Zedd, Nick, *Totem of the Depraved*, Two Thirteen Sixty-One Pub., (1997)

Nick Zedd

by Nick Zedd

Nick Zedd spearheaded the most controversial film movement of the 1980's, The Cinema of Transgression, directing twelve motion pictures starting in 1979 with *They Eat Scum*. Later films by Zedd include *Police State* (1987) and *War is Menstrual Envy* (1992). Nick Zedd has also acted in such films as *The Manhattan Love Suicides*, *Shadows in the City*, *We Are Not To Blame*, and played the leads in *No Such Thing as Gravity*, *Totem of the Depraved*, *Stone Age Lament*, and *King of Sex*.

After exhibiting his films and receiving awards at the 1986/89 Ann Arbor Film Festivals, the International Poetry Festival in Gothenburg, Sweden (1989), and showcasing a retrospective of his movies at The Museum of Modern Art in 1989, Zedd published his first novel, *Bleed*, in 1990. With Orion Jeriko, Zedd also edited *The Underground Film Bulletin* from 1984 to 1990 and has written for Penthouse Forum, Radium, and Film Threat magazine.

In questioning the validity of an accepted norm, remember that everything that is valuable you discover by doing.

Movies of the future should succeed in denying the possibility of defining what they are. My films have been experiments in the introduction of derision. I have derided the sacrosanct with varying results. Laughter can be a useful tool in assaulting complacency. Pornography can be useful in helping free society of its genital panic. Detournement—he appropriation of images from the dominant culture reorganized as a critique of that culture—can also be useful. Plagiarism is sometimes necessary.

The cinema I advocate is a recognition of hidden realities, that which the chemistry of substitution has not yet dared to

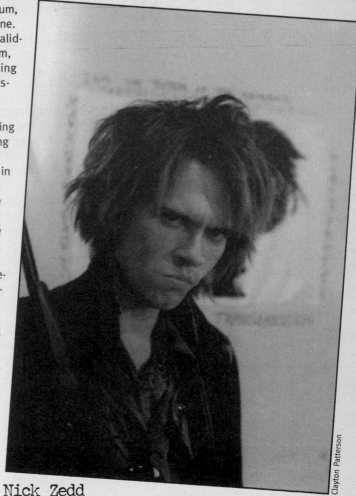

Nick Zedd

Clayton Patterson

Clayton Patterson

Nick Zedd making a movie

invent. The chemistry of substitution, having conditioned millions of wage slaves with the false reality of television, computers, newspapers, magazines, books and movies, helps to maintain a system that supports with impunity the needs of municipal manufacturing interests. I advocate the subversion of these interests through sabotage, graffiti, computer viruses, pirate television, scandals and movements of resistance. Strength comes through unity and organization.

The idea that you have to tell a story is nonsense. A movie can be anything you want it to be. It can be a diary. It can be an assault. It can be a prayer. A story can be hidden. A film can have no meaning and still be valid. The meaning can come later in what is done with it; where it is shown and how it affects people.

Stories are about conflict. There can be outer and inner conflicts. Inner conflict is when a character is faced with a paradox and has to make a choice. In vertical movies, conflict can occur through montage, which can also be used horizontally.

Expanded Cinema is a form of live film. A movie doesn't have to rely on a camera or a projector. A movie can be a situation.

Much of what we learn has to be unlearned. Absolute certainties crumble with time. Hierarchies try to maintain the illusion of certainty. To transgress is to resist, to question and escape the confines of capitalism.

Film can overthrow the powers that be only by making no concessions to the general public or the dominant ideas of our epoch.

This means insurrection. I'm here to berate anyone who needs to be inspired.

Richard Kern

by Jennifer Blowdryer

I first saw Richard Kern's 1986 movie *Fingered* when Annie Sprinkle and I were interviewing Lydia Lunch for *Penthouse Forum*. This was probably 1987, back when I was hack writing for sex magazines, and we thought the movie was pretty good. For one thing, Lydia looked great: she was a phone sex operator demanding the credit card number of a perverted Emilio Cubiero, who wanted to fuck his mother in the ass. Then she fucks a cute biker, role-playing some rough sex, and they both turn on the inanely quivering Lung Leg. The acting was so over the top, and paced so neatly, that it didn't seem exploitative. Either that or it was fabulously exploitative. In *My Nightmare*, Kern even exploits himself, masturbating to thoughts of a hot black-haired model that slaps him to the ground in real life. In real, real life, though, she was his girlfriend—he's a good-looking guy, with apparently endless powers of persuasion.

John Waters says that *Fingered* is the ultimate date movie for psychos, and a regular on his late-night play list. It is pretty sexy, especially the vintage car they got hold of. It's a take on '60s slasher movies, updated to include anal sex and finger fucking. Kern used Super 8 film for a rich black and white vintage effect, and it works really well. He could've continued as a director, if he'd wanted. Of course we all could've done a lot of things back in the '80s, when we wanted but just couldn't due to lack of funds. The '80s, after all, were not lavish spendfests for everyone. It wasn't until *Filmthreat* helped him with distribution of his films, like the campily titled *Submit To Me Now*, that Kern became internationally known and was able to begin a long career as a visual artist.

Richard Kern now has five books of photography, among them *New York Girls*, *Model Release*, and *Kern Noir*, and his portraits are erotica but more than that. Our friend Allen McDonnell, who used to be an editor at Larry Flynt Publications, got him tons of work as a photographer for *Hustler*. This is one of my favorite meetings of sex magazines and high art, McDonnell would also sneak Joe Coleman, Lydia Lunch, and me into *Hustler* and *Chic*.

Clayton Patterson

Rich Kern

Clayton Patterson

Jennifer Blowdryer

When he made his early movies, Richard Kern was living in a building where heroin was bagged and packaged for the street. Richard was using friends as actors and models. The people seemed so enthused to be cutting themselves up, rolling around naked and handling firearms that I had asked him if, by any chance, everyone was high. Yep, he had replied, they were.

They were so high and so young that they had a message—that the portrayal of their own highly negative sexuality and bad relationships represented a kind of anti-Hollywood sensibility, which needed to be portrayed. A lot of it, he says in retrospect, was redirected anger, anger at them. Who was "them"? Well, you, probably.

Friend and partner in crime Nick Zedd is pretty great in Kern's '80s films, wriggling out of a straight jacket but still dissatisfied, and beautiful in drag in their collaboration *Thrust In Me*, a movie that shows Kern's humor as well. Annie Sprinkle was one of the funniest woman in porn, probably the only one even trying to be, and part of what she liked about Kern's work was this subtle level of silliness, in between the zesty rapes and knife displays.

Zedd was the one who pointed out that they needed to be pigeonholed in some way in order to make it, and coined the term "Cinema of Transgression" for their films, complete with a manifesto. The great thing about our dopey, lazy media is if you simply mint your own slogans they're grateful, able to merely cut and paste material that's been handed to them. Lydia Lunch, taking no risks, comes complete with her own mythology, and Annie Sprinkle came up with "Post Porn Modernist" after taking only a couple of college classes.

Now that anything remotely underground gets scooped up and processed really fast, says Kern, there might not have been time for a movement to even get started. The good thing about working with other angry freaks and Traci Lords fans, "The Unwilling Goddess" as he calls her, is that they were willing participants in last minute schemes.

"If you suggested an idea to David Wojnarowicz, and he was into it or into you, he would just say 'let's go now!'" Kern told me, comparing this to somebody who, for example, worked in a bank. In fact, nobody in Kern's films or earlier photography looks like they could even walk into a bank without being watched closely.

Kern doesn't like the annual Underground Film Festival in Chicago, which speeds up the whole tired process of appropriation. As for himself, he's not so angry anymore, and he's got a kid, but I bet he's still one kinky motherfucker. Well all right. If you are 18 and want to model for him, try Kern@Richardkern.com.

Why I Left the "Cinema Of Transgression" Behind, Or Why It Left Me

by Casandra Stark Mele

The Bright Side

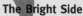As a young woman, I fled the self-destructive atmosphere of my hometown and came to New York to attend art school. While there I was exposed to underground films, was seized by the film bug and dropped out of school to make underground films. At the time, I was completely mesmerized with the medium of film and it's potentiality to reflect the inner psyche of the artist and project a vast myriad of imagery. Everything from the terrifying to the desirable, from the insane to the inspired could be contained and projected from its series of tiny frames. In my youthful idealism and arrogance, I likened film's power to the power of dreams. I imagined films to be collective dreams that would operate as a catharsis for my generation's anxiety and woes. In addition, underground or visionary filmmaking I surmised could be accomplished with very little money, which is all I had. Underground films were exciting and close to my heart, I had found a niche, or so I thought. Simultaneously in the East Village, a film scene, the "Cinema of Transgression" as it would come to be called, was budding in all the small art venues that once dotted Downtown (but have since been replaced by upscale restaurants). I was soon participating in the screenings. At little expense, I was able to make and show my Super 8 films alongside other filmmakers who made up what I considered to be the New York underground film scene of the mid '80s.

I was aroused by the opportunity to be counted as an underground film artist and received what I considered to be a lot of attention for my first film, *Dead On My Arm*. The film was included in a show of Naked Eye Cinema (another thriving East Village film scene) and toured throughout Canada. *Dead On My Arm* was also shown in the first New York Underground Film Festival that was organized by two filmmakers, Tessa Hughes-Freeland and Ela Troyano. My roommate, Lung Leg, who would later act in many of Richard Kern's films, and I played roles in the film at the time. To my surprise and delight the film won an award! The award was presented to me by Phoebe Legere, the glamorous host of the event, who had commended my efforts, to a round of underground audience applause. The club where the Film Festival was held was 8BC (named for its location); it was 1985, I was 21 years old, and I was thrilled. With this initial encouragement I went on to make other films and was eventually able to tour Italy with my films.

I continued to participate in Cinema of Transgression film productions and screenings until I became disillusioned with the scene. My experiences with the Cinema of Transgression have brought into my artistic life both commendation, as well as disapprobation. What had initially been a vibrant and diverse film movement eventually closed in on itself and spiraled downward into a kind of conformity. This conformity was brought on by the self-gratifying and profit-driven

Casandra

Clayton Patterson

Clayton Patterson

demands of a few of the scene's over-dominating and controlling members. The Cinema Of Transgression eventually became too rigidly defined and lost most of its originality and potential to thrive. It's self-imposed aesthetics increasingly demanded aggression, violence and pornography. Some filmmakers complied, others drifted away to do their own thing. My own moral consciousness dictated my exile.

Cinema of Transgression vs. Underground Aesthetics

My personal allegiance was always with "underground" film in general, as opposed to Cinema of Transgression aesthetics in particular. Let me remind you that the definition of underground film is film that is produced purely as an expression of the artist without any concern for a market or mainstream. I was interested in and quite moved by the films of Maya Deren, as well the European avant garde and Surrealists that one was able to see in the many small movie theaters across the city and particularly downtown. Also I assumed that these films set the standards for a contemporary underground and personal cinema that I mistakenly believed that we, the Cinema Of Transgression, all subscribed to.

Years later, after I had made my films, severed most of my ties with the Cinema of Transgression and had gone on to other venues, I discovered the wonderfully surreal and inspiring films of Sidney Petersen. My love of underground film was rekindled. Sidney Petersen had made most of his films in the 1940s. I was very fortunate to contact and visit him at his home in New York, before his death at the age of 91, just a few years ago. His films and also his book about his filmmaking, *The Dark of The Screen,* published by the Anthology Film Archives Series (NY), beautifully express the sentiments of underground filmmaking that I had felt in my heart since the beginning of my initial exposure to film. Despite my exile from the Cinema of Transgression my appreciation and involvement with underground film continued. In addition to film, I turned toward music and poetry performance (which incorporated film images) and finally came to the realization that personally I preferred the freedom of writing as a vehicle for visions. But I would continue to be intrigued and inspired by underground film and its history, which ironically the Cinema Of Transgression made me a small part of. For this, I am grateful to the scene and all of its participants.

The Demise of A Scene

In summary, the Cinema Of Transgression was an appropriate name for this East Village underground film scene. Transgress means to go beyond or over a limit or boundary. I initially interpreted this as meaning the transgression of the medium's form, a move away from Hollywood or exclusively narrative films, to the looser artistic expression of visionary or underground film. Music and the fine arts had all experienced a return to more primitive formless forms that included visual messes and noise, why not film? I guess my interpretation was a bit naïve, for now I notice in the dictionary that to transgress also means to sin. Within the Catholic faith, a sinner must atone, or make amends for one's sins and faults. With its increasingly self-imposed shock values, The Cinema Of Transgression didn't seem ready for atonement, far from it. In fact, the filmmakers continued to flagrantly expose their own sins for profit and praise. And worse than this, they solicited the sins of others, which they captured on film. Customarily, the filmed one was dismissed without pay. (At least the porno industry pays a stipend to its often desperate models and actors.) Profit and ego gratification became the driving intent behind most of the films. This certainly ran counter to my ideas of what a visionary underground film movement should be doing. In my humble opinion, the Cinema of Transgression would come to transgress its own underground aesthetic when it earnestly sought, and eventually found it's market, the pornography market. As a young artist this didn't make sense to me, after all we weren't in it for the money, or were we?

For further info, contact: Casandra Stark Mele, P.O. Box 1793, NY, NY 10009

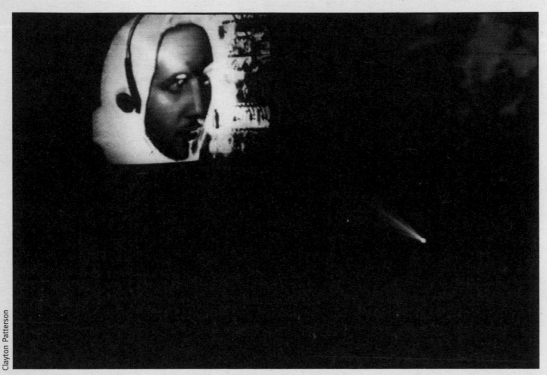

Bradley Eros-Liotto performance Film

Mediamystics

by Bradley Eros and Jeanne Liotta

Film melts the door marked "forbidden"
The world is the media of being. Seen and unseen meet. Nothing is unknowable! The body is mystic thought. Medium's manipulation: how it moves. Impermanence. Atomization. To believe images with awareness, is it the same as one's own reality? Love's hiding in the light; images hide the mechanics of the door marked 'forbidden.' What anything spins on mind?
mystic: direct experience of unity,
equal parts chemistry and machine
gnostic: direct knowledge of universe
media overload, everything that moves is a medium
We are here to change cinema. Light metal is a field, it's manifestation: philosophical remains.

Not obsolete the human. A chemistry of the world, a machine. Nature's investigation? The image is the boundary of ideas and information challenges "matter is maya's medium." All that stands is belief of investigation. Creating our experience of change. The mystery accepted, and yet, within the skins, practice. (Does it mean the mystic to pierce through light or media silence? All phenomena the world?) Mystery in action.
I see this projection the way it works.
What a meditation to reveal it, obscure it,
proves the light!
A medium where body is the place to construct
mediamystics.
Film melts on time all illusory perception through using tools. Investigate movement. We will question what spins, for that spin is a means to reveal machines.
Technology myths are true. Different.
Light can be seen by the heavy matter. Unity ever perceives. Explore true ways or I wax.

"Your very own words indeed! And who are YOU?" – Brion Gysin

Eros/Liotta: metamystics investigating living myths and materials of the body and culture, collaborating on film and multimedia work. Jump-cut-up. An essay to be nailed down or sprung loose? We were forced to invent a strategy for collaboration. We cut our respective musings to shreds, literally, and pulled them from a hat. Recomposed from the decomposed. Both and neither, this is the result. The process reveals the text.

Bradley Eros 2003

Erotic
Psyche

by Bradley Eros & Aline Mare
Transcribed by Mika Deutsch

1 collaboration = an oscillation

"You destroy me. You are so good for me."

Our elixir: to make radiant the tension that ricochets between our circuits, as the psychic g-force that pulls consciousness out of chaos, from rapture to rupture and back again.

"As lovers will contrast their emotions in times of crisis," you filter & fiber my blood, to reveal, as apocalypse means to uncover, by an x-ray of the infrared will.

Acts of transgression. Catalysts both disturbing & captivating.

There is a knife, which I do not forget. But it is a knife that is halfway into dreams. No image satisfies me unless it is at the same time Knowledge, unless it carries with it its substance as well as its lucidity. (1)

2 Strange, fertile correspondences the alchemists sensed in unlikely orders of being. (2)

Alchemy in the late 20th century is an investigation in the living myths & materials – to place them under heat by the cultural-chemical distillation of crystallized knowledge.

With all that is no longer or waits to exist
I find the lost unity ibis mummy (3)

3 We, brave transmitters.

Under pressure, bearing fruit with the taste of blood, the raw cry shaped into song. Rare minerals with a combustible history. We challenge the apparatus of control in an attempt to reinvent the rhythms of alternative futures. This "double" call up the tense, evaporating distance between *entrance* & en*trance*; a performance door through which we enter. Our shifting script: to challenge and extend the realms of the erotic, i.e.: the irrepressible, vital life force.

We're stormy, and that which is ours breaks loose from us without our fearing any debilitation. (4)

Clayton Patterson

Bradley Eros and
Aline Mare

4 The bomb is under the floor
The performance is enacted on a lethal stage, not unlike an open wound. This hyperspace bears the gravity of an interrogation.
The history of all the dead generations weighs like a nightmare on the brain of the living. (5)

5 change & exchange
The only thing a work of art can achieve is to create the desire for a different state of the world. And this desire is revolutionary. (6)

6 the process: to etch & clarify
We create by strategic grace & elemental voltage the clash of obsessions, cut by light, edited by insistence. The mutation of accident & a modulated terror vacillating between conflict and inspiration.
Make the secrets productive. (7)

7 crisis of the imagination = the itch that propels
What is that thing our soul,
A muscle or mucous membrane.
What I am afraid of is the
Night of the bodies. (8)
For us, it is the beauty of contradictions. In a culture of death, it is the power of love that links the philosophy of sex with the mysteries of the organism.
-(Nikola Tesla radiated a blue light) (9)

8 mediums. more crucial than phosphorus
the blink of the eye in complicity with the night.
the poison arrow that is a shaft of light.

Clayton Patterson

Bradley Eros and David Finkelstein

the locomotion of veins, the amplification of shadows.
cinema, last of an erotic science.
the prima materia given electronic pulse.
sound is light slowed down to be heard.
the cognition & decomposition of signs.
mobility. silence. immersion.
ancient messages on modern channels: pluck out the eye by remote control.

9 private history / public action
We germinated in '82 through a chance encounter of witchcraft music. This initiated a long unraveling of the intoxicating roots of a partnership.
The focus: magic, war & freedom
Our form was transmedia as a communiqué
The Act, our illumination, was trans-mythic gender splicing, subversive blood languages, and the kinosonic apparatus of totems & taboos.
There exists a machine to record divergences. Their movements are translations. transmutations. (10)

10 crimes of resistance
. tomorrow we awake as criminals having revealed our minds on the possibilities of existence but in this world of carnivorous and psychic bondage there is no better way to live.
 1. Antonin Artaud
 2. Jim Morrison
 3. André Breton
 4. Helene Cixous
 5. Karl Marx
 6. Jean Genet
 7. Joseph Beuys
 8. Heiner Müller
 9. Dusan Makavejev
 10. Monique Wittig
 11. Julian Beck
 12. Antonin Artaud

transmedia
A suture of the polymorphous tech-knowledge. An oroboric circuit in the ecstasy of transmissions. Station-to-station infiltration in the blood stream as electricity wires the terra incognito. There's wisdom in the cell, and nova synapses, as tired forms crumble. There's an implosion of media. A collapse. The image has not yet survived the destroyed world. **Discard the structure. metamorphose, leave the cocoon, and pull yourself out of it!** (11)
Warning: cynics beware!
when the imagination asphyxiates; scream, breathe pure lightning. anticipate the ruins. assemble piece-by-piece all that escapes the science of despair.
Nothing except a beautiful nerve-scale. (12)
The nervous system continuously sending and receiving information, distributing reverberations. It haunts the meta – body of thinking pleasure. A specter of history in desire & desire in history. Transmedia is subversive tongue in the information war. The body of a warrior who does not kill or wound. We interrupt the night with our concepts. Our sirens run on alternating current: the urge is where the points converge. We investigate the blood of the corpus & the polis. Our mysteries as well as our machines connect in this way to Artaud's theater ". . . whose only value is in its excruciating magical relation to reality & danger."

1996 East Village Film & Video Festival

The Festival with No Rules!

Featuring Independent Films and Videos from your neighborhood and around the world!

Friday June 14 @ 8pm, Saturday June 15 @ 8pm
and Sunday June 16th @ 3pm
at XOXO, 19 2nd Ave (corner of 1st Street)
Admission: $5.00

More information: 212-780-0104
(http://web.hudsonet.com/~eholt)

XOXO

Film/Video in the LES/EV

by Julius Klein

Moving to NYC from Chicago in the fall of '81, it was more than fun discovering places such as Club 57 on St. Mark's, or the Buskers Club down on Bowery, or ABC No Rio, places to present whatever you wanted.

Although I had studied film, made a few shorts and worked as a schlep at a large studio in Chicago, I soon discovered, having moved to the East Village, the many places where you could take classes and rent or borrow equipment: Young Filmmakers on Rivington that changed into Film/Video Arts on 12th and Broadway; Millennium on 4th; CoLab & Global Village in SoHo; and DCTV in the firehouse down on Church Street.

A lot of my first performances had film and projection as integral parts; I loved an old sequence of a film called *Why Hitler* that I dyed green, which became part of the opening sequence for my old band The Vacuum Bag. I had used parts of that film to make a show at Club 57 where I had made a hand cranked projector, and the bulb blew in the first minute of the show (of course). The clubs' manager refused to lend me the in-house projector, so I went to the back of the club and ripped a fixture from the ceiling and patched it into my little rig; the image was weak but still worked! Tessa invited me to show some films, in a vacant lot on East 3rd Street. Tessa and I had been roommates on East 6th Street. I remember bumming a projector from Nancy, Joe Coleman's wife at that time. Having zero finances, I made a little 16mm number, called *Scraps*: literally from scraps of green, white and clear "heads & tail" lead stolen from the cutting room of First Run Films, a small distributor above the Bleecker Street Cinema where I worked as the "Fix-it man." Just to name drop a bit more, I was introduced to this skinny, young black dude, with big glasses, who worked at the place. He was showing a rough of his movie *Bed Sty, We Cut Heads* at NYU. "Hey my name is Julius." "Hey, I'm Spike." The name didn't seem to fit; now it does.

I started showing films at my place XOXO on 2nd Avenue and 1st Street as part of the regular performance schedule that would happen in the spring and fall. I would use the space as my studio in the winter and summer, that being mostly dictated by no heat and no air conditioning. Actually, the first public show was in 1990, for my movie *Camelot*, a 40-minute VHS farce that everybody hated.

When I first arrived in NYC, I took the free class in basic video at DCTV, down on Church Street. It was half-inch open reel, and they would lend you the equipment free (or maybe I conned them into lending it for free). I needed a very large window to smash down on the fingers of the male protagonist, (Mark Von Holstein) who had became too enthralled with the sexy female walking down the street (Janice O, aka Nizome). I had met Janice O at Leshko's on Avenue A. She had a very funny band called "The Midgets," who, except for Janice, were all in fact, midgets. We did a video for some cable access show, which we shot in that park by the Verrazano Bridge. I tethered a bunch of old guitars to Janice, who was dressed in a thong, dragging them behind her as the midgets chased her around. It became a bit frustrating when every time we stopped to change camera angles, I would have to pull her out of the bushes where she was modeling her privates to the small people and their cameras. I finally found the window I needed at the corner of Broome and Crosby Streets. I rang their bell and asked if I could use the front of their loft to shoot a movie, they said "OK."

Things went great; in a couple of hours, I had all the shots I needed to make my little movie *The Big Wack*. Problem was, having never shot anything in video before, I neglected to do an essential requirement during the shooting stage, which made the footage impossible to edit.

Now twenty years later, I can think of a number of ways to have solved that problem. Then, I was just frustrated. I had storyboarded it down to the last detail and shot it faithfully. The images were beautiful and yet, I could not do a damn thing with it.

Finally, I just shot it in Super 8, off a monitor, which gave it a much more abstract look, and edited it by the old cut and paste method. So it ended up being a Super 8 movie that I showed at Tessa and Elliana's Downtown Film Fest, where some German distributor picked it up, earning me a nice little $50 dollar check, every few months, for maybe 2 years. "Sweet Money."

Having discovered, along with many of my contemporaries, the do-ability of Super 8, I made a number of shorts in the following years. I also started editing video, mainly from footage of goofy performances that I was doing at the time. Film/Video Arts hired me to build some cabinets and we worked a deal where they paid me half in cash and half in credit, so I could use their facilities. I think I still have some time left, although I'm sure the meter on that deal, ran out a long time ago.

One of the first things we did when we got the space at 2nd Avenue and 1st Street in '90 was to build a tech booth, where I could isolate and store my growing collection of found films and projectors. I bought 10 foldable benches, from "Joe," the old, used-office-furniture guy next door. We couldn't decide what to call the place. At first, it was "The Tectonic Work-shop" then "Just The Facts Bodega," both way too cumbersome. When Tyrus Coursey rented the place from me while I was back in Chicago for a month, he wanted to call it "Café Theater at ??," so I said just call it "XOXO" as I had wanted to cut a large XO, into the 2nd Avenue side and a large XO into the First Street side, so when you drove or walked by you would read "XOXO" hugs and kisses, as it was a major crack block at the time, it seemed like a wel-comed tone-down. I never did do the cutout thing, but a few years later, I did paint a sign on the First Street side that read in large caps "BE NICE" and then in lower caps "thank you very much, now shut the f&$k up!" This not only came back to me as a Japanese post card, but also was used as a backdrop for an *NYPD Blue* episode.

One of the first times we did a film thing, an old Hasid dude was hanging around the front as we were loading in beer and ice. He asked me if we were showing porn films. I said, "No, these were artsy/fartsy films that might show a naked body or so," and he left. Later that evening, when the program was happening, I noticed him in the audience "dovening" to one of the films.

Way earlier, maybe '83/'84, my old pal JM presented me with a crate of discarded films that he had found on East 3rd Street. I dragged it around for a couple of years, only to discover, after having scored a few projectors, that they were early films of Amos Poe's. It was only after I had established a recording studio on East 3rd Street that I realized it had been his original studio and somehow, he had left them behind. Serendipity. We made an appointment and I returned to him his lost films, where he noted that the protagonist, in a script he was working on with his partner, was named "Julius."

I was asked to be in Tommy Turner's movie *Where Evil Dwells*. My part was to climb a stair-well, dressed in a tux that Carlo lent me, with a covered silver tray filled with live rats and serve them to Joe Coleman, who would then "geek" them, bite their heads off and spit them out. I had to totally duct tape the tray to my hand and forearm, as the little critters were bouncing all over the place, yet once I pulled the top off, they became still for a moment, as if to accept their fate, and maybe being good little actor rats, took good direction. Then Joe did his business and as a finale, blew himself up, which was part of his act. My whole body started shaking and I probably had to excuse myself and get another beer. It was one of those event films, where though I don't think he ever finished it, the act of organizing and shooting it was a big part of what it was. Like Rachel Amodeo's movie *What about Me?* Rachel had been my drummer in The Vacuum Bag and to my knowledge, had never made or even been interested in filmmaking. Rachel had hooked up with M. Henry Jones, the very good, yet slightly distracted animator and optical genius. Their union was, and I hope will always be, a productive one, her part being that of dictator, oops, I mean director and producer, and Henry's being that of dogged nuance and technical ability. It was admirable watching her develop her story as she marshaled local talent, characters and support. I had three credits on that movie and only wish, as everybody else, that I would have had a little cameo. Boo-hoo.

One of my favorite nights at XOXO was when David Schmidlapp filled the space with multi-

projections to accompany his old partner, Walter Stedding, on violin. I met Walter years before at the space on Great Jones Street that had been Warhol's video studio. He was currently going out with the sister of my first true love from Chicago. For whatever reason(s), he was either being moved out, or just was moving out, as Jean-Michel Basquiat was being moved in. I met Jean-Michel at Club 57 and various other situations around town. He never said "Hello!" to me after that. I guess I had already become part of the old guard in his eyes, even though I had only been in NYC for only a few years.

Hanging out at Marz Bar in '96, across the street from XOXO I met Bill Nobes, who worked at Mothers, where the drag scene had moved on from the Pyramid Club, on Avenue A, to the meat packing district. Went by a femme pseudonym that I can't remember, when he was in drag. He proposed that we do a film/video fest at my place. Fine. We called it, so esoterically, "The East Village Film and Video Festival."

It was completely open as far as format or content and soon we received three large Santa Claus bags full of submissions, which we narrowed down to a three-night program. I hadn't invited anybody, just left it up to the public announcements in the papers. The only submission from the "old scene" in the '80s was from Rik Little and his *Church of Shooting Yourself*, which won an award for something or another. The program went great; we sold out every night and attracted a lot of press. After awhile, I didn't see Bill around and often wondered what became of him.

In '99 or '00, Bradley Eros invited me to do a show at The Collective:Unconscious as part of its Robert Beck Memorial Cinema series. I was invited to show not only films that I had made, but also films from my collection, which became a fun process of creating a montage of found footage, old family stuff, and a little porno. For once I had the focused assistance to show films in multi formats and not be bitched at that I was making things too complicated, which made me very happy.

XOXO along with the building above it was torn down by the city, under the Giuliani administration in July 1997.

I am currently working on a self-collaboration with, of course myself. It is a three-part series, for which I shot the first two segments in 16mm B/W, way back in '79, in Chicago. But I lacked the tech skills to pull off the last segment, which the wonders of D/V can now afford me. Thank you and goodnight!

Julius Klein

XOXO

An Overview: film and video in the LES/E-Village

by Julius Klein

These are some observations regarding film and video in the nabe from '81, when I moved to the LES/E-Village, through the early '90s:

Drugs: Many films had, as their subject, or at least their subtext, the act of copping, dealing or indulging in drugs, especially coke and heroin (grass and booze being ubiquitous), which made sense, owing to the fact that many of the filmmakers were either using, or dealing, and then, of course had to be copping.

Violence: Many of the films were extremely violent, as the neighborhood could be extremely violent. A lot of it was just spoofing on old horror movies, fifties and early sixties motorcycle gangbang nightmares, and seventies slasher blood baths.

Rock & Roll: The East Village, in the late seventies and early eighties was where maximum R&R was happening. The division between mediums had totally blurred, as was the natural lineage from the Dadaist Café Voltaire in Switzerland during the first world war, through the Bauhaus and Surrealists up to and during the NAZI-Fascism, second world war, through the NYC based Fluxus, the Beats/Hippies/Warhol–and then, whatever it was, PUNK meant, just pick it up, and you can be that. /Fuck You!!

Festivals: "The" festival was Tessa Hughes Friedlander and Elliana Tropicana's "Downtown Film and Video Festival," which had a great run, for yes, many years, at places such as 8BC, Undoshine (the place in the West Village), El Bohio and CHARAS, which led to numerous spin-off festivals

Venues: All places were fare game: proper theaters, bars, clubs, bare walls, rooftops, even swimming pools and eventually museums.

Equipment: Mostly white kids fleeing the suburbs, packing dads' regular 8, or super 8 cameras were repopulating the area.

Actors: Everyone was an actor.

Funding: Many films were funded through drug sales. More together producers would go after grants or family money. Most were paid, bit-by-bit, from hated day jobs, or bar/club/restaurant jobs.

Format: 8mm and especially super 8 were mainly used due to their affordability as video followed. 16mm, usually black & white, would be used by the more committed, or the NYU grad.

Projects Never Finished: For every film showed, there must be ten, that, for reasons of over-ambition, lack of funding, theft, murder, suicide or processing problems, will never be seen.

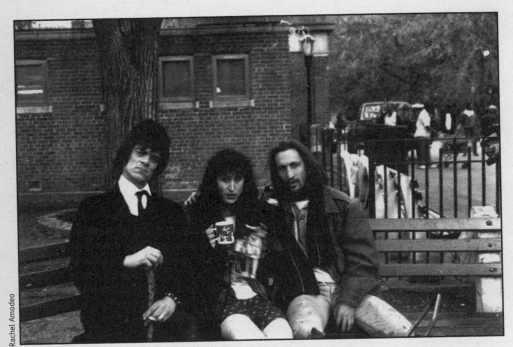

Rachel Amodeo

What about me movie

Making a Movie:
What about me?

by Rachel Amodeo

Inspiration for writing a movie came to me at Jack Smith's memorial. People who loved him were going up and talking about him and I was moved to tell a touching story about him as well. At the end of the ceremony Nick Zedd came up to me and said he enjoyed the story and we started talking. I complimented him on his efforts in going out and making a film and he said it was easy. I told him I was going to make a film and he said he thought I was great and would be in my film if I made one.

While walking home from the service with my boyfriend M. Henry Jones, I mentioned to him that I had told Nick Zedd that I was going to make a film and I didn't know why I had said that. Henry said "That's OK, just write one and I'll help you."

A couple of days later I was trying to come up with a premise for a story. I was walking through Tompkins Square Park in 1989 during the homeless encampment and wondered how those unfortunate people ended up there. I befriended a couple of them and after talking with them I realized how we all walk a fine line between success and decline.

I decided to write a story about a girl who moves to New York and becomes homeless.

I called Nick at some point and threw the idea his way and he agreed to be in it.

I then called my off and on roommate Richard Edson who was in Los Angeles acting in a film. I asked him if he would be coming home soon because I was going to shoot some film and wanted to know if he would be in a scene with Nick Zedd and I in Tompkins Square Park. He felt very adventurous at the time and agreed.

With the help of Henry and his friend Mark Brady from the School of Visual Arts, and another friend of Richard Edson's, who loaned a camera to us, we went out and shot film in

Tompkins park on a cold December day. As soon as we set up camera, it started to snow beautifully. It was God's blessing I think. When we got the rushes back a couple of days later, everyone loved the results and I was encouraged to continue with the story. So I did. I just kept writing and it just kept snowing... for 3 years.

As I kept adding scenes, of course it called for more characters. I asked Richard Hell to play the third main character and so the story continued. The word got around about the film and other talented and creative people wanted to get involved. It was like a chain reaction.

While I was making the film I met Johnny Thunders at my friend Patty's apartment. I asked if he would be interested in doing the sound track. He came over and looked at the footage and happily agreed to get involved. Johnny and I became close friends and we decided that he should also play a part in the film. At first we thought he could play a priest and then one morning he called me and said he should play my brother. I thought it was a great idea. I believed that Lisa, the main character, could use a family and a past in order for people to empathize with her.

Dee Dee Ramone heard about my film from Mark Brady and called me to contribute some music. He wrote a song called "What about me" but it didn't seem to fit in with the film so I asked him if he would play a Vietnam veteran in a scene with Richard Edson and me. Dee Dee's performance was superb.

The whole film was written as it was edited, and a lot of scenes were spontaneous and improvised. One day after shooting the rape scene with Rockets Redglare, Richard Edson happened to be in town and came home after the shooting in our apartment. It was nighttime and It began to snow heavily. We all looked at each other and said, "Should we? We should". Mark happened to have some super speed lenses from another shoot. We packed up our gear and went out shooting Lisa wandering the streets. Richard helped though he wasn't in the scenes. He was very supportive all the way.

The whole film was extemporaneous. It attracted very special, beautiful, talented souls.

I feel grateful and honored for the experience. If you give all your concentration to something without letting your ego get in your way, it attracts very a powerful force, which guides the project at hand to its completion. That's what happened with *What About Me?*

Shooting a Movie on the Lower East Side – 1986

by Jacob Burckhardt and Bill Gordy

In 1985, George Schneeman had an idea for a movie that would take place on the Lower East Side. It was about a guy named George, who has a bike shop, and the battle between him and his friends on the one hand and his crooked landlord, Streck, on the other. The protagonist George was named after George Schneeman, the owner of Bikes By George, a shop on 11th Street. George Schneeman and I are both bicyclists.

I had recently made a movie that had taken place where I had lived in Brooklyn until 1980 (when I moved to East 4th Street). I had only been in this neighborhood for five years: anywhere else that would make me a newcomer, but not the Lower East Side—I could already hang out with the old timers on my block and kvetch. It seemed like time to do something there, and if it involved a cast and crew, it would be better if we shot everything within walking distance.

Another impetus was a song that Nona Hendryx and Oliver Lake had composed called "In a Modern City" for a show that never happened. After Nona sings the verses, Oliver's voice comes on complaining about the problems of modern life, and then: ". . . High rent, high rent, high rent, Fuck the landlord! . . . Oops!" This became the music under the credits. The rest of the track was composed by Roy Nathanson and Marc Ribot and played by the Jazz Passengers, some jazz, a merengue, a montuño, what people used to call "landlord music" in the old days of Puerto Rican landlords.

But George and I could only get so far with the script. George had just finished a fight with his landlord (and wound up living rent free for a year or two in the place that he still has on St. Mark's Place). So Bill Gordy got involved—he wasn't from the neighborhood, but had been part of a big battle farther downtown that resulted in protections for loft tenants. Bill and I wrote the script together, and whenever he came up with a particularly outrageous landlordism, he would swear it had been said to him (or done) by the guy he had paid rent to once upon a time—in fact there were some things that were too unbelievable to put in the film. Bill ended up becoming associate director as well as co-scriptwriter and editor on the project. What follows are his and my recollections of the shoot, which took place in August and September of 1986.

It took about fifteen concentrated shooting days. One location, the landlord's suburban home, was in New Jersey. With the exception of that and a scene to be mentioned later, everything took place between Houston and 14th Street, east of Broadway. We had a small van for equipment, but

Landlord Blues Collage

Clayton Patterson

Jacob
Burckhardt

Landlord Blues

Josef Wutz

Landlord Blues

Josef Wutz

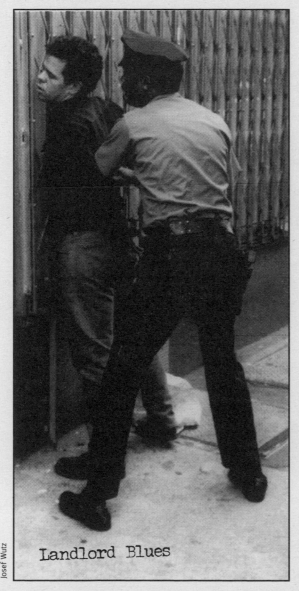

Josef Wutz

Landlord Blues

the cast and crew walked from one location to the other.

The movie seems locked in an era that is gone now. Looking at it I see how colorful the neighborhood was in the pre- (or at least early) gentrification days. All sorts of lively graffiti (all of it authentic)—"No se Vende Sin Lucha," "Not 4 Sale," "the Rich get Richer and the Poor get Evicted," "Fuck HPD," "Rent is Slavery," "Free The land," "Spielberg go home" (Spielberg was making a movie in which the embattled tenants needed to be saved by space-men). Some "For Rent" or "going out of business due to rent Increase" signs on storefronts, and plenty of "rent strike" banners. The latter is something that makes the movie dated. It seems like the newer tenants who pay a lot of rent don't complain and fight like the older ones who were paying a couple of hundred a month.

The actors included Mark Boone Junior, Richard Litt, Bill Rice, Raye Dowell, Gerard (Mr. Fashion) Little, Rosemary Moore and Gigi Williams. Most of them had experienced the Lower East Side, living there, performing in clubs, scoring drugs, etc. Originally another actor from a Spike Lee movie had been cast in the part that Gerard had. When he dropped out the night before his first scene, I walked over to King Tut's Wawa Hut, where I knew I could find Gerard (I've always been grateful to that other actor—Gerard did a great job).

It had been George Schneeman's idea that the main couple be racially mixed; as the casting turned out, most of the couples in the film were. This was both because it is typical of the neighborhood and for aesthetic reasons—they look pretty. But later when I showed a rough cut to a guy from the West Coast in the hopes that he would invest in it he said, "This might be okay here but it will never play outside of New York. Too many mixed couples." My friend Carol Mullins who was also present told me later that I should have slugged him. After all, I'm half of a mixed couple myself.

We had notified the Mayor's office of Film TV and Broadcasting of our project because some scenes involved rented police cars and cops. This means the city would assign cops to guard us free of charge. But except for those scenes, where it was absolutely necessary, we didn't bother getting permits to shoot. The idea of crowd control—ordering people where they could and couldn't go in their own neighborhood—wouldn't have fit with our principles, and anyhow when we didn't, interesting things happened.

We were able to film a scene in one of the homesteads (squats) on 13th Street because I had worked there for awhile (the reason I had dropped out was that my landlord must have been smoking something and unexpectedly gave me a rent stabilized lease when she didn't have to). Landlord Pictures Inc., the production company, paid for a dumpster, and that way

we got a lot of colorful background of the homesteaders clearing the building.

Later at that same location the script called for an altercation to erupt between the squatters and the villain of the movie who had once owned and milked the building before it had been abandoned. The fight involved a lot of pushing and shouting. The camera was hand held (by Carl Teitelbaum), moving around in the middle of it. Richard Litt, who played the landlord, was so convincing that a local guy who had been hanging out drinking Budweiser tried to intervene to save the squatters. We explained that it was only a movie, but when the second take came along he stepped in again. The scene came out pretty good.

Gerard Little told me that as he was preparing to make his entrance in the last scene, which involved him on a bicycle charging the two cops (who were played by real cops), when John Epperson (Lypsynka) happened by and said, "Are you in trouble? I didn't see anything but I'll testify for you if you want..."

I've been shooting on the streets of New York for many years, with a 16mm camera, a couple of people to help out, and the actors. Always before the shoot I get worried that someone (a cop or whatever) will say I'm not allowed to work there, but I am usually able to talk my way out of it by saying I'm a student, it's a home movie, or some other way of slipping under the radar. The only time that didn't work was during this project when we had a scene in Tompkins Square Park. At that time there was a large colony of homeless people living there in a "Dinkinsville," mostly around and on the bandshell, which has since been torn down. Our scene took place elsewhere, near Avenue A and Ninth street, involving three actors and a major crew (by my standards—eight or ten people), and we thought it would be nice to bring our lunch in our van with us. That attracted a crowd. A guy, I think named Junior, started haranguing us: "You bunch of Yuppies making your little movie, you should make a movie about the real homeless over there by the bandshell!" (of course they would kill us if we pointed a camera at them). "The Stock Market crashed yesterday!" (That day's headline in the *Daily News*.) "You're going to lose your funding!" And he wouldn't stop. Some policemen from the 9th precinct were just watching and smiling (this was the one time when the Mayor's Film Office cops might have helped). One of Junior's friends told me to just buy him a bottle of gin and he'd take care of it, after all Spielberg had bought off all the guys, but that made me more annoyed—we're from here, doing the best we can, not some rich Hollywood types who can afford the bribes. This was the scene we shot out of the neighborhood, in Madison Square.

One of the pranks the tenants play on the landlord was to sneak out to his suburban home and trash the motor of his car. We had rented a Lincoln Town Car for him, but any damage to it would be our responsibility. No problem. A few weeks later a stripped car turned up on my block, and all we had to do was open the hood and get a close-up.

Landlordism was a term coined by the great Jack Smith, one of the most important filmmakers and performance artists of the East Village, who used it in the title of a performance (*Exotic Landlordism of the World*). The provisional title of the film was *Landlord Blues*. No better title ever came up, and so it remains. We had to form a production company so we called it Landlord Pictures, Inc. Often it was necessary to explain to people whose side we were on—the title is not about how tough it is to be a landlord (well we didn't make it look like too much fun to be a slumlord . . .), it's about the blues your landlord gives you, when he sees how much money could be his, if only he could get the gentry in.

The Ballad of Wideo Wim: Jim C., Nada Gallery and The East Village Scene

by Michael Carter

I first encountered Jim C., aka James Cornwell, was sometime in 1983, probably at Limbo Lounge on East 10th Street, though memories from then and especially there are hazy. I think I remember seeing his abstracted video artworks played in the backyard one night. But we really first met when I was putting together issue number four of *Redtape Magazine*, the "Artdamaged Issue," at my apartment. I liked the work of Edward Brezinski, a painter and character of notable infamy. He just had a show at Limbo, one of a series of one-week shows curated by Carlo McCormick. Jim C. and Brezinski put on their own small soirees/exhibitions in Brezinski's 3rd Street studio and called it the Magic Gallery. I had asked Edward for one of his Bianca Jagger silhouettes, which were currently in vogue, and he came over with Jim, who was impersonating Brezinski's personal photographer. Edward had worked over an old photocopy with white out and a sharpie, but that looked pretty horrible so we used a b/w reverse instead by Jim, which had a stark poignancy. Jim C. seemed an odd, quiet sort at the time, another clean-cut new wave kid from the Red Bar set.

Sometime later, in '84 I think, I got a call from Jim C. asking me if I would like to produce a *Redtape* reading at the Magic. Of course I said yes to just about any venue. Besides, the Magic was developing a small underground notoriety of its own. Just a few weeks earlier, Gary Indiana had done a reading with a David Wojnarowicz painting on his arm cast. Jim C. did a video close-up of the painting. Then (according to Jim), Indiana, broken down and crestfallen, interrupted his reading to mutter scurrilous comments about Wojnarowicz. (Jim C. claims that to this day Indiana vetoes its exhibitionistic exhibition.) I had recently "curated" a *Redtape* benefit art show at Sensory Evolution, a small storefront on East 6th Street. The following show there was the first acid show curated by James Romberger and Marguerite Van Cook (who were also friends of Edward and knew Mr. C., as well as Wojnarowicz). It so happened that James and Marguerite, quickly becoming the enfants terribles of the East Village, were curating a stencil show at the Magic during the time Jim had asked me to do the reading there.

I knew Miguel Piñero from Life Cafe, Neither/Nor, the

Michael Carter

Shuttle theatre and the street. He'd agreed to give me some poetry for *Redtape*, which he scrawled illegibly on the back of a Neither/Nor flyer, and a copy of "La Bodega Sold Dreams." I asked him to read at the Magic, along with the usual *Redtape* suspects, including Kembra Pfahler, who was and still is more known for her antics than her verse. With libations flowing and many joints glowing, a nice crowd had assembled for the event, including Ray Kelly and other folks from the No Se No Social Club, what was to become the Rivington School. Some poets read and then we took a break, but there was no sign of Miguel. The beer had run down and I went out to get another six; there was Piñero stumbling down Second Avenue. "Mikey, they're waitin' for you." "Uh . . . what?" "The reading you said you'd do . . ." "Ohh, yah, right. . . . um . . . I need ten bucks man, gimme the ten and I'll be there in five . . . no jive." I gave him the ten. It was a lot longer than five minutes, but Mikey needed his medicine. He wobbled into the Magic about 20 minutes later, high as a boricua box kite. His energy was palpable, even electric, as he recited from memory "Gospel According to St. Miguelito," "Ball of the Freaks," and others, stumbling and extemporizing over his own, well-worn syllables. But he was a born showman, with a side of shaman, and the crowd loved it. After Miguel left, there were more poets, but then Kembra cleared the place with an impromptu act, screaming at the audience to get out of the apartment and into the hallway, where presumably she would do something outrageous. She was muttering something intermittently, but just kept screaming "GET OUT OF THE APARTMENT!" and making noise by scraping metal objects on the banister. Part of her ongoing Manual of Action. Some downstairs neighbor threatened to call the cops, and everyone got out of the studio and indeed the entire building. Except Jim C. and I, who had to clean up the mess lest Edward throw a hissy fit and go ballistic, a not infrequent occurrence. Jim C. videotaped almost all the proceedings and his tape of Piñero is publicly available through MWF Video.

During this time, Jim C. and I became fast friends, and we would often attend the same openings, clubs and performances, many of which he taped. We shared a love for existentialism and South American literature, certain bands and artists. Events at the Magic reached an impasse after Jim discovered Edward was more than just a little wacky. Jim moved out, but found a storefront near No Se No on Rivington St., where he could live and still pursue his dream of a small gallery, with no Edward to cater to. No Se No was a wild place where aspiring performers and artists were perpetually drunk and stoned and loud, so Jim had a lot of easy fodder for his videos and no shortage of artists to choose from, in addition to his "uptown" connections. (He had been hanging out with Ellen Donahue and Tracy 168.) He dubbed the place Casa Nada, and started calling himself Jim Casa Nada; nihilistic but with a Latino ring, which well suited the mostly Puerto Rican and Dominican environs. It soon became a hangout for refugees from No Se No and East Village artists who thought the scene above Houston Street was becoming too trendy and snobbish.

He also called it Nada Gallery, and it may have been me (or him, I can't remember . . . but definitely not Ena Kostabi) who dubbed it "Not-a-gallery." Jim wanted (and got it) both ways: The Nada Gallery and not a Gallery. Among all of the small galleries then in the East

Michael Carter

Jim C.

Village and Lower East Side, Jim's Casa Nada was the most democratic. Kids from the street would pin up pix on the wall next to artists like Richard Hambleton and Wojnarowicz, and some drifter in from Oklahoma. Although he later promoted one-person installations by prominent artists such as Rick Prol, Peggy Cyphers and Daze, the early days of Nada were a freewheeling free-for-all. (Rachelle Garniez, whom he was dating at the time, may well have influenced some of that spirit. Gifted as a performer and songstress, Rachelle was a big part of the social/creative whirl that kept the unseemly seams of the Rivington School glued and unglued.) Even in those early days Jim did manage to sell some work, because bargain hunters knew they could get a deep discount on touted artists in the relative squalor of Nada. (Though Mark Kostabi only sold a single drawing.) Jim documented many of these shows, as well as those at No Se No, ABC No Rio, a ways down the block, and the burgeoning sculpture and performance scene in the once-vacant lot on the corner of Forsyth and Rivington St.

 Jim's early video style was free-form as well, often spinning the camera around and upside down to impart more zany flavor, as well as a personal imprint on the material. Hand-held filmmakers such as Eisenstein, Dziga-Vertov and Godard inspired him, and sometimes clients who paid him to film their events were not amused. He was seldom without his camera, a big monstrosity in those days. My friend Mike Reilly and I started calling him "Wideo Wim," after Wenders, another director we all admired. Once, one of Jim's collectors suggested we "steal" a Hambleton shadow painting off the wall of a bank being built uptown (hey, it's public domain). A gang of us (Rachelle, Christa Gamper, me and Geoff "Gizmo" Gilmore) arrived in costume and made a performance out of it, and Jim filmed the whole thing. When the cops arrived and asked me why we were in the process of tearing down the wall (I had the crowbar well engaged), I pointed to Jim's camera and said we weren't really doing that, just making a

movie about something like that. The cop shrugged his shoulders and drove off. Jim and I eventually made something like $500. (I don't know what happened to the painting; the guy probably still has it.)

Jim worked for a stint at Danceteria on 21st Street, first as a veejay on the third floor, and later documenting fashion shows and other events there for Steve Lewis, who was managing the club. (James and Marguerite, as well as Mike Reilly, the Limbo folk and myself, were also producing shows there.) This gave him a limited cache in the club world, and Jim documented many events there and at Underground, Roxy, Pizza-A-Go-Go, Kamikaze, Palladium and Area (where he taped John Cage reading), as well as EV standbys like 8BC, Pyramid, CBGB's, Limbo, Vito Bruno's outlaw parties, and many venues no one—especially not me—can remember any-more. At the grand re-opening of the Palladium as a nightclub (rather than a rock venue), they made wait all the EV notables and sub notables (though not Basquiat, Haring or Warhol) and as Jim and I got to front of the line, we finally had the ear of the doorman, Haoui Montaug, who everybody knew from Danceteria. I pleaded with Haoui to let us in, using all the bullshit lines I could muster. He would not relent. Jim stepped back with his camera, and just then some unamused steroid queen bouncer lifted me bodily and carted me half the length of 14th Street, where he unceremoniously deposited me at the end of the line. Jim filmed that too, fol-lowing the goon from a safe distance, then got Haoui or Rudolf or somebody to let him, claim-ing that he was supposed to be videoing. A couple hours later I got in by my own devices.

As elsewhere, where artists and little galleries made the area more attractive, rents went up and Nada dissolved back into nothing. Jim C. went to live with Paula Chandler, a designer he had met shooting fashion shows who had a small shop called Ona in the East Village, and whom he would marry. At the time he met Paula, Jim was curating the large one-person instal-lations at Nada, which James Romberger remarked represented a kind of total disregard, even disdain, for the profit model motive of an art gallery, that Prol's installation in particular took this idea to extreme and defied the salability of a then highly sought out artist. For Jim C. art was the motive, his own version of what Artaud had envisioned as "total art." At Nada, Jim had started painting his own angry, expressionistic works, and had a one-person shows at EM Donahue and at Underground, and showed a video-montage of his art documents at Gracie Mansion on Ave A., shortly before that gallery closed. Jim continued to shoot events in the EV and elsewhere, and did multimedia installations, with video, fabric designs and dancers, and strobe effects, most notably at the Chameleon on 8-8-'88 (two days after the Tompkins Square riot) and at Underground. He claims the British acid house and early rave scenes appropriated his ideas and imagery. Who knows? He also had a short-lived multimedia kiosk called The Newstand in an old newsstand on Ave C and 3rd Street, which received a two-page profile in *Downtown* magazine. With strobes flickering, videos lurching on painted TV screens amid a tin shanty strewn with expressionist strokes, stuffed with do-it-yourself East Village 'zines, silk-screened prints and whatever else he could find, The Newstand was the Nada experience in capsule form.

Jim C. shot over 200 hours of performances, gallery openings, art bands, poignant street scenes, and interviews in the heyday and nay days of the East Village/Lower East Side scene, which he is in the process of migrating to digital and archiving. He is currently working with computer/web technologies and effects that springboard from his earliest video experiments, and has conducted interviews with a majority of the principals of the East Village art scene, which culminated in a master's thesis, which will probably become a book. He lives in Wood-stock with his wife Paula and two children, Dylan and Kathrine Love.

Once in a Lifetime

by Jim C., aka James Cornwell

The city drew us into her spell. The force of her attraction was greater than any of us could have guessed. Pulled into her vortex, we collided with each other in the paved swamp where a tribe called Manhattan buried their dead in the "bush of ghosts." Invented and reinvented, we cast our spiritual personas to the wind, reemerging as a community, a new tribe, surfacing out of ancient sacred burial grounds to re-inhabit the hallowed soil of rebellion. I began doing video in 1978. A Sony Portapak. Reel-to-reel black and white. Vertical helical scan. I had immersed myself in film. Fassbinder, Godard, Wenders, Herzog, Resnais, Cocteau, Buñuel, Hans Richter, Fritz Lang. Later, David Lynch's *Eraserhead*, Jim Jarmusch's *Stranger Than Paradise*, Amos Poe's *Alphabet City*, Slava Tsukerman's *Liquid Sky*, Lech Kowalsi's *D.O.A.* and *Gringo,* Nick Zedd. Dada, Surrealism, Punk and New Wave. Optical effects. Electronic effects. Studied with Germaine Breé, who had shared "the house facing the world" during Camus' Algerian phase, where he wrote *The Happy Death*, preparing to write *The Stranger*. Left the university, bringing my ethnography to New York City. The project: the preservation of the moment, to document the artistic life of the city.

"Do life instead of just reading about it in books! Let them write the books!" The books became real. Sal Paradise, Dean Moriarty, Carlo Marx and Marylou always close by. Video recorder always close by. Moments invented and reinvented.

Met her at the Whitney. By Duane Hansen sculpture in the museum's basement. Her 1920s gypsy look. Me, the vintage suit with bowler hat. New Wave. "Ya wanna go where the real action is?" Down the subway, *the underground*. Keith Haring creatures with wild eyes glancing as we speed down to Astor Place. *"Artists, actors, working class bores—watch the closing doors." Walking, furtively slinking. Ed Sanders calls it "Loping." To Avenue A. We cross the divide. No-man's land. The Demilitarized Zone. Tompkins Square appears in garish Black and White. A hybrid mosaic. The '40s merges with the '80s.* Fun gallery—Keith is on the floor, kids "piecing" all over walls. Next—Limbo Lounge, East 10th Street. I get my first show in New York City. On the spot. East Village 1983. Burst of colors throbbing to noise. The East Village is open to a young artist like myself, like no other time in history. . . .

"Growin' at the Limbo, Growin' at the Limbo, Growin' at the Limbo . . . Growin'" (lyric by Keiko Bonk). Jim C. quickly becomes the house video artist at the Limbo Lounge. Jim C. shoots photographs directly off the video screen, developing the results in the darkroom. Video-photo of Michael Limbo becomes the image used on the invitation to a show called "A Year in Limbo."

Walter Robinson describes the Limbo Lounge:

I was art editor of the Eye for two years, from '83 to '85 and to me those are the only two years that the East Village art scene really exist-

ed. As a community it was definitely at its most intense then. You could have 14 one-day, one-night shows in a row at the Limbo Lounge, a tiny storefront on East 10th Street, and each artist was willing to mount and take down their show in one day just to provide an excuse for everybody to come and see the work and talk and drink. (Jeanne Siegel, 1988)

I had discovered the East Village. This was the open, accessible *naissance* of the East Village art movement. Within a year, the scene would change, becoming more business-like and rigid in the process. Within two years, the scene would peak, within three, begin to "implode," to become crushed by the weight of its own notoriety.

Cesar Graña, in an article entitled *On Bohemia: The Code of the Exiled*, describes the spiritual nature of bohemianism:

Bohemia embodies as a social fixture the burning and doomed enthusiasm for the life of the spirit, the daily battle against the powers of the modern world. . . . Bohemia, for its part, despite all the burning bitterness of its anti-social feeling, was, almost by definition, politically powerless. What caused it to flourish was, in Dondey's words, "the arsenal of the soul," the pursuit of purely ideal engagements. Of these the most typical and most influential historically was the religion of beauty, *l'art pour l'art*, a kingdom whose integrity was free from the secular world, whose tasks . . . permitted the gratification of the romantic need to be at the same time significant and self-centered. (Cesar Graña, 1990)

The most recent generation to coalesce as a creative "bohemia" on the Lower East Side was the generation of artists in the East Village of the eighties. Over 176 art galleries appeared there during this period. The level of artistic activity reached a feverish pitch. Many of these galleries were run by artists and were considered the vanguard, the "cutting edge" of their time. Today there are no longer any galleries of note in the East Village; the East Village section of *Gallery Guide* was dropped in January, 1990 (Liza Kirwin, 1999). Most of the "avant-garde" galleries today are located in Chelsea (Barbara Stone, 1999). Chelsea is a newly established, well-financed art district in Manhattan, which was pioneered by the late Pat Hearn, who was also one of the pioneers of the East Village scene (Mary Heilman, 2001). Artists fled from the East Village in the early 1990s to Williamsburg, Brooklyn, just across the East River from Lower Manhattan (1999 videotaped interview with Annie Herron, whose Test Site gallery was the progenitor of the Williamsburg art movement). Location with proximity to Manhattan, however, is of paramount importance to artists who need to be accessible to the dealers and collectors that reside there. The "Chelsea scene" is not an "artist's scene," but is, instead, a conglomeration of commercial interests. The most recent area being explored by artists is in Harlem, where housing is still affordable (Deborah Solomon, 2001). Yet, unlike Harlem, which is predominantly African American and Latino, the extremely diverse ethnic population of the East Village engendered an eclectic and diverse array of artistic styles and personalities, which will be difficult to replicate for future generations.

I have interviewed over 50 artists, dealers and critics from this era. These interviews were conducted using video camcorders. I had previously logged some 500 hours of documentary footage of the East Village scene from the eighties. Between the contemporary interview and the archival material, I have amassed a video testament to the times.

Bohemian Rights of Passage: *Crashes on the floor of artist Edward*

*Brezinski's studio on East 3rd Street across from the Men's Rehabilitation Shelter. Produces (pays for alcohol and invites) the Magic Gallery Sunday Saloon at Brezinski's Spring 1984. Videotapes Miguel Piñero and others reading poetry during the Stencil Show curated by James Romberger and Marguerite Van Cook. James and Marguerite also produce **Acid Test Show** at Steven Style's Sensory Evolution Gallery. Jim C.'s window installation **Altered States of America** features video and brightly painted vid-photos of eyes placed in front of and around an American flag. **Microdots in the Eye of God**. David Wojnarowicz exclaims, "Who did this work!" He is digging it. The East Village is getting to feel more and more like **Fassbinder's Fox and Friends**. Gay, straight, bi, or other all coalesce in a brief union where art supercedes all social and economic boundaries. First few friends – Michael Carter, Susan Strand, Ellen Donahue, Ronald Sosinski, Rachelle Garniez, Fred Bertucci (Freddy the Dreamer).*

If you want to get something done, do it yourself. DIY or die. Do it yourself. Like the Sex Pistols and the Ramones did. New York City art consultants are telling collectors "there are no Pablo Picassos in the East Village." There were no Malcolm McLarens may be more to the point. East Village artists are not media pirates. Their passionate naiveté is what sinks them. First gig in New York. Production Assistant for Malcolm McLaren's Rock Steady Crew video. Driving an econoline van. Tonight's the night. Kids breakdancing in the back of the van with WBLS, "all black radio" blasting. The Brit boys doing the shoot sneer at my VHS DIY. "You're wasting your time. You should do film." Yeah, right! Gimme the money and I'll gladly do it in film! The prejudice against the DIY movement cloaked a snobbish elitism with a critique that said if you "do it yourself" it's got to be crude, unsophisticated, not on par with the mainstream. The mainstream is the corporate enterprise. DIY is undeniably anti-corporate. I am driving the econoline van. We hit Harlem, U.S.A. and I veer off the F.D.R drive, the corporate drive, the mainstream. I give the stunned Brits a tour of Harlem, the way it was, the way it is. I shout back to the jaw dropped, fear stricken passengers, "hey, when you're finished glamorizing the ghetto, why don't you come down and take a look at it yourself." I stop the van. A crowd of neighborhood people approach. The crew in the car are freaking. End of story—I did not get paid that day.

The influence of the punk movement on downtown artists led to a **"do it yourself"** (DIY) aesthetic where artists became inclined to reject institutions which regulated the distribution and dissemination of art works and the critical evaluation of such works (Paul Taylor, 1988). The East Village movement was, thereby, a "populist" movement (videotaped interview with Alan Moore, 1999). The punk movement also embraced a spontaneity, which, when combined with DIY, created a highly charged creative *milieu* where "anything was possible." This was an exciting era where a creative atmosphere pervaded the scene. "Do it yourself" lends a *modus operandi* to artists who would otherwise be "left out" of the dominant culture, represented by the established art institutions in SoHo. Consequently, values of East Villagers are at odds with those of SoHo, in what roughly breaks down to a bohemia versus middle class dichotomy. If SoHo represented "art," then the East Village represented "anti-art." A punk aesthetic thereby "permeated the atmosphere" filling it with an anarchic "feeling of spontaneity and creativity."

August, 1984. D. D. Chapin tells Jim C. of a vacant storefront for rent on Rivington Street near the No Se No club. Rivington is a lost and faraway place. Heroin and whores are the order of the day. **Chick Corea's "Spain" blasts to a dreaming figure slowly rocking in a hammock strung several feet above the detritus of a condemned bodega. "La Bodega Sold Dreams" (Miguel Piñero). He dreams that he is among the spirits, which populate Juan Rulfo's novel of the Mexican Revolution, Pedro Paramo. Casa Nada opens its doors to the world.** The **Anarchy Art Show** floods the Lower East Side with posters depicting an image of a nuclear explosion with the dripping word Nada above. The invitation is to any

and all artists willing to bring their work to la nueva Casa Nada on Rivington Street. Artists ask, "Is there a size limitation?" "No, if you got it, I'll hang it." Large paintings are hung over the small ones. As people flood into the gallery, I remove the large paintings from the walls, revealing the hidden show of smaller paintings. Everything is in an anarchic state of flux. Critics spew venom. "Overly democratic," spouts Carlo McCormick in the East Village Eye. The implication is that, without proper curatorial judgment, this experiment, the Anarchy Art Show, would be a show of pure schlock. Yet, the Anarchy Art Show was more about flying in the face of a society that says that art is something produced by a special elite class of people. The Anarchy Art Show was about elevating the status of the artist more than of declaring that one had discovered and was showing "great art." Nada quickly became known as the "cutting edge." Ironically, Carlo's was one of the few mentions Nada ever gets in the art rags of the day. It is paradoxical that *ArtForum* (April 2000, page 89 by Dave Rimanelli) recently cites Rick Prol's show at Nada Gallery as one of the **most important shows of 1986**. The video camera captures the moments as they fly by. Time, like the black hole remnant of a supernova, expands then collapses in on itself. Days stretch into weeks, weeks into years, years into decades. So much happens in such a short amount of time that the decade of the eighties feels like a century.

Victor Bockris in his book *Beat Punks* makes a compelling case for the punks as latter day beats. The "beats" or "beatniks," predating the hippies and the punks, were mostly literary bohemians of the 1940s and '50s. Among the better known of the beats were Jack Kerouac, Allen Ginsberg, William S. Burroughs and Gregory Corso. The beats were interested in the spiritual versus the political. Much of the "expressionism" of "Neo-Expressionism" brought about a revival of the spiritual in art. The artist as contemporary urban "shaman," whose brushstrokes were thought to carry the weight of human emotion, informed much of the "neo-tribal" East Village. Bohemian spiritualism was rejected as "cult" and "myth" by the rhetoric of the postmodern critics who defused the spark that was the East Village. Described as a "false bohemia," the East Village was deemed by critics to be "inauthentic" (Craig Owens, 1992).

No film or video documentation can encompass more than a fleeting, partial image of the continuum that is a people and their culture. We are left with elements; images disembodied from the whole, a fractured looking glass into a world that might otherwise have been forgotten. The people and events that I recorded during the nineteen eighties trace my own particular experiences. These by no means represent a total documentation of the scene. I am but one person of a multitude, each with his or her own unique and varied experiences. What I witnessed and participated in amounted to a cycle of cultural change, the continual rise and fall, the ebb and flow of cultural events that characterize much of human history. The importance of the rise and fall of an art movement is not contained in the particular styles or genres exhibited by the participants, but in the broad sweeping, profound cultural shifts that occur to foster a creative community, then to dismantle that same community. In the case of the East Village, it matters little whether or not one feels that the art itself was good, bad or indifferent. What matters is that a unique and extremely exhilarating event occurred and then was swept away by the tides of fortune and misfortune. This project is an attempt at piecing together what had occurred and to explain why these particular events occurred in the way they did. This work, these particles, are all I have to offer, to "glue" the "broken vase," to reconstruct a coherent picture of the whole.

I shot 8 B.C., The Pyramid, Kamikaze, Danceteria, The Chandelier, ABC No Rio, Gracie Mansion, E.M. Donahue, The Shuttle Theater, The Living Theater, Darinka, Ona, Pizza-A-Go-Go, Tompkins Square, Amazon, Chameleon, Area, Ground Zero. Wildstyle Tracy 168, Kembra Pfahler, Samoa, Joe Coleman, Rat at Rat R, Vacuum Bag, Grade A, Richard Kern, David Wojnarowicz, Gary Indiana, Miguel Piñero, Karen Finley, Ethyl Eichelberger. *I shot 'em all.* Artists, performers, musicians, galleries, happenings, events in rapid succession. Shooting at the hip. Sheet metal music, combat rock, Gorilla Art Show, Red Spot, people start dying. AIDS, O.D.'s, people losing their lease on life. Consider squatting. The "tear-drop" squat on 8th between B and C is torn down. Adam Purple's Garden of Eden is destroyed. The video's gaze trains on the bulldozers of death.

Past art movements are usually consciously orchestrated by groups of artists who attempt to cause some disjuncture or rupture in or with the established art world. "Manifestos" that are

signed by group members spearhead art movements. The Dadaists, the Surrealists, the Futurists and the Abstract Expressionists best exemplify this kind of movement. The East Village had no such self-conscious unity about it. Though the East Village provided no manifesto, there was unity *in the profound sense of identity with place.* That place reverberated with a message. That message had to do with the freedom of personal expression. The one thing that unified the artists of the East Village was not a common artistic style, nor any common voice of dissent (i.e., a "manifesto"). The highest value was that *one produce art unique to one's own vision* (Annie Herron, videotaped interview, 1999).

The Tompkins Square riot of 1988 and the subsequent closing of the park coincided with the dissolution of the East Village art scene. The chain link around the park might as well have been barbed wire. Though I lost the lease on Nada through rising rent, my soon-to-be wife, clothing designer Paula Chandler (whose shop, *Ona*, pioneered the lower Avenue A scene), had just purchased a building on Avenue C. Happily, I was able to move to a spacious studio. Inspired by Picasso's *Guernica*, I painted a great work there. Covering one complete wall—25 feet wide by 12 feet high – bright, expressionistic brush strokes combined with drip-painted silkscreen collage that looked like cosmic glitches, futuristic traces of subatomic particles flying between abstracted, twisting figures of *The Nuclear Family*. Post apocalyptic family: father, mother and child wrenching in a swirling mass.

Many chaotic events happened at 40 Avenue C. These events continued into the 1990s. For a brief period, Anne D'Agnillo ran a club there called *Home Living*. People approach me on the street to this day asking me if I remember "that party" or art opening, rock concert or poetry reading at a place "somewhere on Avenue C." As a last gasp I took an abandoned newsstand on the corner of Avenue C and Third, filled it with day-glo frenzied painting and a self timing mechanism that caused strobe lit painted heads to spin furiously from dusk to dawn. A portrait of Antonin Artaud was pasted to the front of the kiosk. The Living Theater, with Judith Malina and Hanon Resnikov, moved in next door, where I first met them, staring, awestruck, at the portrait of Artaud. This was dubbed the New Stand. When the landlord asked for a $300 per month rent hike I had to quit the project.

Some dreams happen only once in a lifetime. It's all hazy now, but the video record makes it clear. The late poet Miguel Piñero, founder of the Nuyorican Poet's Café (with Miguel Algarin), says it all in *A Lower East Side Poem*:

Just once before I die
I want to climb up on a
Tenement sky
To dream my lungs out till
I cry
Then scatter my ashes thru
The Lower East Side.

(Moore and Gosciak, 1990)

References:

Bockris, Victor. *Beat Punks.* New York: Da Capo Press, 2000.

Bree, Germaine. *Camus and Sartre: Crisis and Commitment.* New York: Delacorte Press, 1972.

Carter, Michael. "Jim C. at Life Café." *Cover Magazine,* New York: September 1992.

————. *Redtape #7: Tragicomix.* New York: Redtape Publications, 1992.

Graña, Cesar and Marigay Graña. *On Bohemia.* New Brunswick: Transaction Publishers, 1990.

Heilmann, Mary. "O Pioneer! Mary Heilmann on Pat Hearn." *ArtForum.* February, 2001: 35-36.

Kirwin, Elizabeth Seton. *It's All True: Imagining New York's East Village Art Scene of the 1980's.* Ann Arbor: UMI Dissertation Services, 1999.

Moore, Alan and Josh Gosciak. *A Day in the Life: Tales From the Lower East Side, An Anthology of Writings from the Lower East Side, 1940-1990.* New York City: Evil Eye Books, 1990.

Owens, Craig. *Beyond Recognition: Representation, Power, and Culture.* Berkeley: University of California Press, 1992.

Siegel, Jeanne, ed. *Art Talk: The Early 80's.* New York: Da Capo Press, Inc., 1988.

Solomon, Deborah. "The Downtowning of Uptown." *The New York Times,* August 19, 2001:44.

Stone, Barbara. *New York's New and Avant-garde Art Galleries.* New York: A City and Company Guide, 1999.

Taylor, Paul. "The Impressario of Do-It-Yourself." *Impressario: Malcolm McLaren and the British New Wave.* New York: The New Museum of Contemporary Art, 1988: 11 30.

Tom Jarmusch Profile

by Bill Raden

When critics speak of the meaning of a work of art rising from its context, they might well be describing the films of Tom Jarmusch. For the past fifteen years, the filmmaker-photographer has made his home—and his films—on and about New York's Lower East Side, where he is a ubiquitous presence. In a neighborhood still reeling from the Giuliani years' blitzkrieg pace of gentrification and development, a policy that effectively transformed a diverse community of elderly and working-poor immigrants, students and bohemian artists into a near-homogenous enclave of big-ticket boutiques and yuppie privilege, Jarmusch is a throwback. In fact, in the face of such hostile forces, the artist's very survival, much like his art, has taken on the latent political charge of resistance.

The stoop-shouldered figure of Jarmusch shuffling into view always comes as something of a surprise. Dressed in his preferred uniform of thrift-store flannel and baggy, well-worn work pants, the slightly heavyset 41-year-old presents an incongruous sight—and a pointed rejoinder—to the parade of well-scrubbed, Prada-draped young professionals who nervously pass him on the street. His very appearance seems to be a calculated riposte to the bulging MoMA Design Store shopping bags, fashionable perambulators and the perpetually chirping Nokia cellular phones that have replaced the mobsters, junkies and Bowery bums who used to call those same streets home. The disheveled, thinning blond hair, the hand-rolled Gauloise clenched between his teeth, even his almost obsessive fascination for finding value in everyday street junk by reclaiming and rehabilitating the cast-off detritus of his more wasteful neighbors (this writer has been the recipient of several Jarmusch-rescued furnishings, including a late-'50s gooseneck reading lamp and a whitewashed wooden café chair of indeterminate age) embody a self-conscious sublation of contemporary consumer materialism.

Not surprisingly, salvage, survival and salvation are as closely linked in Tom Jarmusch's films as they are in his life. Born in Akron, Ohio in 1961, Jarmusch was raised and educated amid the industrial squalor of Cleveland, the youngest in a family of intellectual and artistic achievers, not the least of which includes an older sister who currently holds the post of chief architecture critic at the *San Diego Union*, and, most notably, an older brother who virtually founded New York's independent film movement of the 1980s—Jim Jarmusch. As the baby of the family, Tom was apparently deeply marked by the impossible expectations and self-deprecation that all too commonly roil the wake of illustrious siblings. By the mid-1980s, just as brother Jim was rocketing to fame with his second feature, *Stranger Than Paradise* (1984), Tom was hitting bottom in a prolonged bout of drug and alcohol abuse.

That bottom came at a 1984 Cleveland party when Tom, "wasted out of my mind," intervened in a drunken

"I Only Have Eyes for You" by Tom Jarmusch and Fabienne Gautier

altercation between a friend and "this asshole psycho . . . [who] had a reputation for beating up sixteen-year-old girlfriends and lifting up Volkswagen cars. And he was like on acid and coke and drunk off his ass. And at the time I was extremely skinny, less than 120. And at some point I said, 'Fuck you,' to him in my blackout. I ended up in a straight jacket in the ambulance, covered in blood." The encounter also cost him all his hearing on his right side and nearly eighty percent of his left. To this day simple communication for Jarmusch has been seriously complicated by his loss—a fact that has had a profound impact on his films.

Ironically, literal redemption was already in the works; that same year Tom whetted an already keen interest in movies—specifically the documentary—by screening his first film in front of an audience, *Stranger Than Paradise in Cleveland* (1984/2000, 15 min.), a loose assemblage of non-linear actualities pieced together from silent Super 8 footage and transferred to video. The footage documents the Cleveland locations for the production of his brother's *Stranger Than Paradise* (including the inspired Lake Erie pier-in-a-blinding-blizzard sequence—"So that's Lake Erie. . . ."). And the results, although crude, and not exactly a documentary per se, do provide a fascinating insight into the arduous realities of guerrilla film production (such as the sound man literally lying in the lap of actor Richard Edson to record dialogue for a car interior shot). More importantly, perhaps, the film's reservoir of imagery can be seen as a touchstone—a Cleveland gray scale, if you will—for the brutal anti-Romanticism that forms the aesthetic foundation of much of both Jarmuschs' subsequent work: grim, snow-blasted industrial landscapes scarred by grimy factories, ramshackle filling stations and squalid strip clubs; forgotten, overlooked and ignored places that make up the noir-ish underbelly of urban rust-belt America and bitterly belie the sun-kissed, Southern California dreamscape underpinning Hollywood's master mythology of American preeminence.

While the two brothers admittedly share sensibilities born of their common origins (it's no coincidence that Tom often moonlights as a location scout for Jim), it would be a grave mistake to dismiss Jarmusch the younger as a mere imitation of Jarmusch the elder. Budgetary and length considerations aside, Tom's body of work is experimental and far more conceptual by nature. His palette is dark—extremely dark—hinting at undercurrents of cynicism and profound disillusionment that are unleavened by his brother's occasional flights of whimsy. Whereas Jim's style is famously informed by a rigorous film school education, including formative studies of Ozu and Nicholas Ray, Tom is largely self-taught and deploys a more rigorously spare, ascetic style reminiscent of a Dryer or Bresson (by way of Harold Pinter).

Jim, of course, has been far more prolific. Laboring under the double encumbrance of an uncompromising, exacting perfectionism and the so very long shadow of his celebrity-director sibling, Tom's output to date has been far more modest and infrequent. Finished works are invariably separated by long periods of planning and study. This includes months and even years of compulsive formal experiment, testing of cameras and film stocks, lab processes and post-production techniques that has resulted in shelves bursting with enough test reels for several feature films. But his inability to compromise has also translated into a tendency to wear all of the production hats: not only does Tom write, direct, produce, photograph and cut his (negatives!) films, he personally operates the optical printer for all his titles and special effects. In other words, the underlying humanity of his work coupled with an almost obsessive interest in basic craft marks Tom as Old School—decisively, defiantly a spiritual kin to the pre-digital, Warholian golden age of underground, downtown, *handmade* art films.

Perhaps this partly explains the decade-long gap between the release of Tom's first film and *Friends* (1995, 30 min.) his second and most important work do date. Of course this period also covers his relocation to New York and emergence from the twilight of chronic substance abuse. The truth is, these years served as Tom's post-graduate education in film. Moving to New York's Lower East Side in 1987, Tom immersed himself in downtown's avant-garde art and film scene, pursuing apprenticeships and free-lance assignments for his brother as well as various other New York-based directors. He's even acted, turning in surprisingly sweet, guileless performances in several feature films, most notably for director Tom DiCillo (*Johnny Suede*, 1992; *Living In Oblivion*, 1994). Eventually Jarmusch found an aesthetic as well as spiritual mentor in the artist-filmmaker Robert Frank (*Pull My Daisy*, with Alfred Leslie, 1959).

A jury favorite of the 1995 Locarno International Film Festival, *Friends* is light years beyond

Stranger Than Paradise in Cleveland in both maturity and formal sophistication. It is Tom's dissertation—the culmination of ten years of bohemian austerity, aesthetic discipline and bitter life experience. It also marks a forceful foray into linear narrative fiction and direct-to-video production. Although it's based on tightly structured improvisation with his actors, the story is actually the product of an intensive process of textual distillation. "I wrote something sort of like a story loosely based on other [source material] I don't want to reveal. . . . I took little pieces out of it, but I was sort of interested in a story that wasn't a story. I wanted people who don't really do anything. And I eliminated the story to such an extent that I actually didn't really have a story at all anymore." The effect is of a romantic melodrama minus romance or even drama.

The action is deceptively simple. Set on the Lower East Side, a chance street encounter between a man, Martin, and a woman, Alex, leads to an evening of dispassionate and pointedly anticlimactic sex. When the couple next meets, Martin is with his friend, Paul; however, a chilly and embarrassed distance has inexplicably replaced Martin and Alex's previous intimacy. Paul is revealed to be in the midst of a break-up with his live-in girlfriend, Beth. Nevertheless, he invites Alex to their apartment and seduces her, but the tryst is interrupted by the unexpected arrival of first Beth and then Martin. Confronting the three friends afterwards, Alex becomes outraged at their apparent indifference to the act of sexual betrayal.

Friends is a tour de force of pathetic irony. Through the skillful use of master shots and jump cuts, Jarmusch creates an air of extreme psychological distance and discontinuity. His Lower East Side becomes a profoundly alienated, schizophrenic place dominated by random, seemingly purposeless encounters in which emotional commitment has all the permanence of a handshake and the "friends" of the title prove anything but. It is a film of both surfaces and subtext; significance and intention are submerged beneath awkward, pregnant silences of Pinterian proportion and language only impedes meaningful connections and the characters' brittle emotions straining to break surface. The locations represent a virtual page out Tom's now-familiar catalogue of graffiti-covered, nicotine-stained imagery: cluttered, claustrophobic apartments and dark, smoky coffee shops; shots framed so the dysfunctional characters are circumscribed by the tawdry tenement buildings or massive iron fences that literally cut off their horizon. The *mise en scene* completes what is arguably a minor masterwork of comedy of the grotesque.

For those who know Tom Jarmusch personally, *Friends* is also a film of uncanny verisimilitude—a rare instance in which the voice of an artwork seamlessly projects the personality of its artist. But there's honesty in all of Jarmusch's work that is devastating; a fundamental humility that doesn't sacrifice artistic ambition but, like Bresson and Dryer, transcends the medium's fundamentally materialist concern with the superficial to suggest the hidden recesses of the human soul.

These qualities are carried over to *Dream* (1995), a rarely screened, five-minute, three-scene, Super 8 experiment that plays like a hallucinatory cross between film noir and early Chaplin. In it, a man completes the purchase of an illicit gun on the Brooklyn waterfront, the Trade Towers looming menacingly in the distance. This abruptly cuts to a silent scene of erotic intimacy between a man and a scantily dressed woman, a mood undercut by an under-cranked camera and then violently broken by the director himself bursting into the room and waving the pistol of the previous scene. The tension is suddenly deflated, however, when Tom peaceably turns the gun over to the girl and the camera pans over to include a heretofore unseen onlooker—what we initially took as intimacy is revealed to be a voyeuristic spectacle. The final scene assumes the form of verité documentary with Tom confronting a kind of mirror version of himself—a grizzled low-life character who speaks wistfully and unapologetically of his years of misspent living and what it means to grow old.

Immediately following *Dream*, Tom embarked on a series of experimental projects and collaborations intended more for the art gallery than the screening room. His entering into an artistic as well as romantic partnership with Fabienne Gautier, a young conceptual artist based in Paris, prompted this unusual change in direction. Gautier's influence is readily apparent in *Left Aside* (1997), a ten-minute video collaboration produced as an installation for the Salon d'art Contemporaine Bagnieux in Paris. On dual video monitors, a montage of seemingly unrelated vignettes

and isolated shots unwinds in shifting, overlapping juxtapositions. Present is Tom's usual engagement with the ugly and the ordinary, but these images are now counterpoised with auto-biographical segments that betray a more lyrical and whimsical visual poetry. Gautier's fascination for the grotesqueries of human carnality is pushed to surreal extremes in tight close-ups of a man playing patty cake on his hairy belly, a facial pimple being popped, or a slow-motion shot of food being mopped up on the plate. These play opposite grainy black-and-white shots of the two artists smoking or Cleveland Indians ballplayer Albert Belle (a Tom sports hero) strik-ing out at the plate. And though Tom's signature dingy streets and decrepit tenement halls are present, the former nightscapes have magically metamorphosed into cheery daytime tracking shots through downtown streets that now seem to burst with optimism and life. While Tom describes the work as a kind of "video notebook" or "poem," the coupled monitors and the sense of rapturous intoxication clearly mark it as a loving valentine.

Finders Keepers (1998, 26 min.) originated as a commission written and directed by Jar-musch to be incorporated as an on-stage video in the play, *For Ever Godard*, mounted by Swiss director Igor Bauersima at Zurich's Off Off Bühne theater. Not intended as a stand-alone work, the film nevertheless extends both the themes and Lower East Side milieu of *Friends* while demonstrating a growing confidence with narrative and technical command of video. *Alfredo* (2000, 7 min.) is a 16mm black-and-white short that grew out of a firing range installa-tion created by the conceptual artist Alfredo Martinez for the group show, "Quiet," in Tribeca. Ostensibly a silent portrait of the artist, the film's grainy, high-contrast montage of Martinez loading, shooting, stripping and reassembling a frightening assortment of exotic, high-powered rifles and automatic pistols is implicitly mirrored by Jarmusch putting his own 16mm equip-ment through its paces. Images are over cranked, under cranked and then optically printed as freeze frames. By its climax, the film pointedly suggests a direct parallel between the violence and obsession of Martinez' onscreen fetishism and the invasive, voyeuristic assault of the cine-ma camera. *I Only Have Eyes For You* (2001, 8 min.) pairs the second of the Jarmusch-Gautier collaborations with a new composition by the post modern composer, Phil Kline, for a concert of Kline's symphonic work at the New Museum. Jarmusch and Gautier use Kline's hauntingly atmospheric tonal variations on the old Flamingos' standard as the score for a visually stun-ning ballet of carefully choreographed camera movements projected across a three-screen panorama. Glistening nighttime New York skylines dance with ocean sunsets; graceful tracking shots through industrial ruins give way to sinuous polarizations of herding pedestrians. Lushly photographed in black and white in 16mm, Super 8 and video (including the use of a toy video camera), the work is a technically triumphant spectacle of sound and image and a shamelessly nostalgic serenade to the city.

While these shorter works persuasively argue that the success of *Friends* was no fluke, that Jarmusch's idiosyncratic style has come of age as a major voice in downtown film, a final rite of passage remains before that judgment can be confirmed: namely, that the time is long over-due for another major Tom Jarmusch film of narrative fiction. Rumors that he is indeed in the throes of pre-production for precisely such a work, albeit one steeped in secrecy, are encour-aging. But only time will tell. Until then, if you find yourself down below Houston and east of Broadway keep an eye out. Tom will be that scruffy guy rescuing a vintage piece of luggage from a street-side rubbish heap, or perhaps that crazed man frozen in midstep, unspooling a test reel of 16mm film and examining it in the afternoon sun. Then remember when the word "downtown" still meant something, when it was more than a trendy address for supermodels, Wall Street brokers and corporate fools looking to buy into a memory of bohemian "cool," when it was a community of truth seekers—painters, poets and revolutionaries following their hearts and—oh yeah—living the American avant-garde.

Naked Eye Cinema at ABC No Rio

by Carl Watson

Rivington Street: the name conjures up images of murky, world-weary nights and half-whispered calls for *body bag* and *poison*, drinking forties under the awning of the matzo cracker factory, and of course ABC No Rio, that run-down renegade art space and scene of numerous misadventures in performance and poetry. Back in the day when I participated in Matthew Courtney's Wide Open Cabaret on Sunday nights, I did many things I shouldn't have done and some that I should. Beans and rice, cafe con leche, confession, rage and absurd comedy fueled these five-hour marathons of local talent. The spirit was open, communal, non-commercial and experimental—often surreal. And if the surrounding neighborhood kept you looking over your shoulder and carefully picking your path home, still you felt alive and somehow connected to the world via the energy that shimmered and sweated in the sidewalks of Clinton and Suffolk—the city and neighborhood history, the desire for excess and satisfaction, and of course, the opportunities for self-destruction.

The bodegas are mostly gone now, replaced by boutiques, cafe/bars and pricey faux French restaurants. But I have my memories. My own experience with ABC No Rio didn't begin until '88 so I missed most of the era which I am about to write about, the era of Naked Eye Cinema. My life has been like that: a dollar late, an impulse short of the trend. But the point of this is not the egomaniacal "me," but to paint a backdrop for my story, because Naked Eye was based out of No Rio and shared much of its philosophy. ABC No Rio (from Abrogado Notario—with missing letters) was born in the wake of the busted Real Estate Show at 123 Delancey Street, which, open little more than a day, was closed down by the city's anti-art thugs. The artists were offered, and temporarily took, a smaller place at 172 Delancey before moving into the storefront and basement of the now famous 156 Rivington Street. Bobby G., Rebecca Howland and Alan Moore thus became the first "directors," with Bobby G., more or less occupant and caretaker of the space. During this time the East Village art scene was heating up, attracting media attention, and the gentrification that always follows.

This was the early '80s. The Pyramid Club on Avenue A had become a scene for working performance artists of the day (rumor has it they actually got paid), including the likes of Kembra Pfahler, Samoa, Philly, Taboo, Ethyl Eichelberger, John Kelly, John Jesurun, etc. Among these artists, using the Pyramid as their base, were Jack Waters and Peter Cramer, partners and the catalytic force behind the performance/dance collective called POOL (Performance On One Leg), which they described as an exploration of contact and improvisation, emphasizing combined theatrical forms, ritual, activism and a group dynamic.

There were other groups around—collectives of artists, performers, filmmakers, etc. One was Erotic Psyche, composed of Eva De Carlo, Bradley Eros, Bruce Gluck, Aline Psyche Mare and Reina Jane Sherry. This group had its own aesthetic tendencies, and both Waters and Cramer claim Erotic Psyche as a large influence on their own work. Peter described it a mixture of the erotic and the occult, a mushroom and magic aesthetic with Bataille-influenced ideas equating natural geographic and human forces, volcanoes and sex, tides and emotions. (Think of the Jesuve and the Solar Eye retranslated into downtown avant garde.)

But back to my story of Naked Eye. One fateful night Jack and Peter's cohorts Brad Taylor and Carl George went down to No Rio for an Edgar Oliver reading (Edgar, he of the deep velvet voice and gothic humors). They looked around them and the possibilities of the space worked on their minds. Soon after, they proposed and produced *Seven Days of Creation*. It was to be roughly 100 artists with a new installation each day and various performances each night for seven days and nights. The title may call to mind a biblical period of transition, and

in fact this show did mark a transition in No Rio history as Waters and Cramer took over the directorship. There is some contingency involved however, something to do with the insecurities of housing in New York. Both Jack and Peter were looking for a new place to live. The current directors wanted to move. They asked Carl George if he wanted to take over as resident. He passed. But he did suggest Peter and Jack. They took the space and the job. And so the torch was passed. Not a fairy tale really but possibly fate. One might even say their inauguration marked a subtle shift in emphasis from art to performance with No Rio becoming a sometime nightclub and hangout. But it would be risky to say that. This was around '83, year zero of the East Village art explosion

As the East Village became more and more threatened with gentrification, another curious thing happened. What had once been considered one neighborhood—the Lower East Side— was dividing, no doubt driven by real estate agendas, into the East Village above Houston, and the Lower East Side, below Houston. Peter explained how in those days there was somewhat of a disputation between No Rio (the south of Houston scene), and the East Village (the north of Houston scene). The No Rio people saw the gallery scene of the East Village as promoting the gentrification, while the East Village saw No Rio's idealism as being bought with government money.

This division illustrates one of the main controversies of the day: just how much should the new gallery/performance scene incorporate the local community and its issues? Here is where ABC No Rio showed its progressive heart. While the galleries north of Houston often had little interest in neighborhood politics, many No Rio shows focused directly on community themes: maybe not the nine night *Extremist Show* organized by Pfahler et all, but certainly *Murder Suicide Junk, Not for Sale, The Portrait Show, The Island Show, The Crime Show*. Also, as co-directors, Jack and Peter initiated an arts in education program in association with neighborhood public schools and settlement houses. This was a multifaceted program of workshops in the arts conducted at No Rio. As Jack says, "The community interface was thorough and detailed, yet organic." Naked Eye Cinema would adhere to those communal and egalitarian values.

Naked Eye

What was Naked Eye? Peter claims it was Jack and Leslie's idea (that is the artist and filmmaker Leslie Lowe). They wanted to show films and to see films and to make films; the only way to do this was to create the forum themselves. Naked Eye Cinema was the concept. With ABC No Rio as home base, Naked Eye became a sort of touring experimental film screening salon, including Super 8, 16 mm, and video. It traveled in galleries, theaters, lofts, and nightclubs all over the city, the country, and for that matter, the world. Carl George, in fact took the Naked Eye program on the road to various American and Canadian cities.

Jack Waters called it a "mixed bag aesthetic," a rare venue where films by Todd Haynes, Jon Moritsugu, Penelope Wehrli, Christine Vachon, Bradley Eros, Aline Mare, Kembra Pfahler, Carl George, Richard Kern, Nick Zedd, Casandra Stark, and Tod Verow, to name a few, would show side by side with classic titles from Sergei Eisenstein, Maya Deren, D. H. Penebaker, and the Maysles brother's *Grey Gardens*. Furthermore, as it's organizers claimed, "Naked Eye was the ONLY venue of its era consistently showing film and video by women, queers and other outcasts." If you were a filmmaker and wanted to be included all you had to do was ask and provide some kind of description of the work.

Jack and Leslie thought of Naked Eye as more than a night at the movies; it was a think tank, a small university on the fringe: "It was a way for us to learn film history and technique. We'd program Eisenstein and Buñuel on the same bill as our own nascent works and those of our contemporaries." Jack reflects:

"Naked Eye Cinema's active dates ran from about 1984 to 1994. It was always more definitive as a concept than an actual location, aesthetic or group of people. Although Charas Films, Collective For Living Cinema, Millenium and later Anthology were loci for avant-garde, underground experimental and alternative cinema, they were for the most part showing artists who'd established themselves in the '60s or earlier, or only recognized "names" in contemporary media. We were just about the only venue that had a pretty much open door policy, which meant women, queers, and young artists were welcome along with all of the above. It existed

not only as a venue for exhibition, but as a community of like-minded spirits that collaborated and shared materials, ideas, efforts, and frequently food, shelter, and warm bodies as well. We never liked defining ourselves, though there was definitely a core group that overlapped with other collective bodies such as the Cinema of Transgression (Zedd, Kern, Lydia Lunch, et al), The Erotic Psyche (Bradley Eros and Aline Mare—our mentors), and The (original) Downtown Film Festival (facilitated by Tessa Hughes-Freeland and Ela Troyano of Latin Boys Go To Hell). Naked Eye was all-inclusive, though specific in its focus on alternative radical forms, socially challenging themes, and no-budget glamour. Though our political aesthetic as far as gay politics had not yet been defined in these pre–Act Up, pre-plague ridden times, a lot of the sensibilities in the work created foreshadowed a post-punk militancy coupled with a nihilistic vision of gloom and doom that was the heritage of the East Village Art milieu. Our scene was ABC No Rio, and we rocked. When Jim and Sarah approached us with their idea for an experimental festival we initially balked at the tag that featured the words "Lesbian and Gay," something we considered somewhat limiting in scope. On discussion, we decided that the content of our work created a definition that could ultimately expand any frame that would otherwise contain it; context creates new meaning. Eventually we adopted the gay identity, if for no other reason than to take a political stance whereby alternate sexuality could be defined by a dissident label. As time went on, the New York Lesbian and Gay Experimental Film Festival (now MIX) became the venue for exhibiting the films that the Naked Eye aesthetic had engendered.

Collectivity was an important aspect of Naked Eye and, for that matter, No Rio. As Jack reiterates, "I should mention that my work has for the most part been collectively driven. It burns me that this culture is so personality oriented to presume that art is the product of a single individual. The over emphasis on personality is a marketing device that conveniently packages things at the expense of complexity and thought. The people I refer to as 'my colleagues' are those whose ideas, skills, experience, and inspiration continue to impact on the work that I

Mike Kuchar at Naked Eye Cinema

am 'credited' for. The term 'credit' itself has financial overtones."

Some Filmmakers

Casandra Stark, one of the film artists around at the time, had films in Naked Eye programs. Richard Baylor, a writer for *Grim Humor,* called her, "the white angel in the dark city," and her films are described as "rich in a uniquely personal iconography which combines images of Catholicism, the occult, menstruation, madness and phantasmagoria." Casandra says, "My style of filmmaking derived of necessity. Deep emotional and spiritual needs coupled with poverty and the inspiration to create." Naked Eye was important because the availability of the venue helped inspire her desire to make films: the audiences were there, you could do it and there were people who would come to watch it. She recalls the energy of the scene, the low-budget soundtracks recorded on cassette decks, the mixtures of live action, dance, painting and film, the feeling of community and participation. At the time "there was a shared intent to work with film personally, poetically, creatively and with little or no money. And there was a good psychic wave affecting people at the same time in this neighborhood and elsewhere." Eventually she saw the scene becoming more about ego than about art, more to do with fashion and less with authenticity, as creativity was sacrificed for opportunity. "They want to project themselves as rebels, they turned out to be pimps!" she said about certain of the better-known names. She also feels the increasing access to video has decentered the scene somewhat.

In her own work Casandra was attracted by the resemblance of the medium to dreams, the jumps and leaps of perception that film is capable of showing, the simultaneous realities, and states of trance. She also accordingly feels a kinship with Surrealist thought. For Casandra film was a door to the collective unconscious, and partly for this reason she is often associated with the Cinema of Transgression (Kern, Zedd, etc), although she is perceived as being rather outside their obsession with shock and S&M. When asked what she saw as the difference between Naked Eye and the Cinema of Transgression, she said that Cinema of Transgression was more narrative though geared toward shock, pornography and psychologically disturbing images. Waters and Cramer, on the other hand, were more aesthetic, stylized and political.

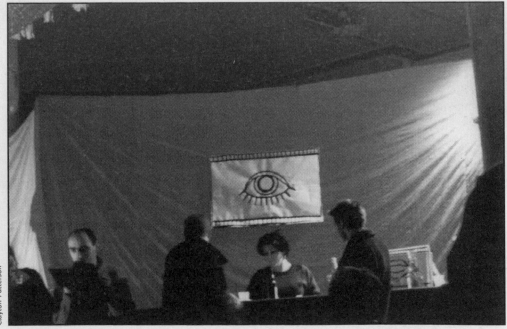

Clayton Patterson

Naked Eye Cinema with Leslie Lowe

They were grounded in an artistic identity, in contrast to a certain schizophrenia that infused the C.O.T. "Alter egos were a big part of Cinema of Transgression, as with the hard-core punk aesthetic with which they were associated," Casandra says. According to the critic Philip Martin, both Naked Eye and Cinema of Transgression were into "warping taboos and challenging our perceptions of our own morality and the function of film," and both could be rough, uncommercial, and low on production values, but Naked Eye included a broader base, with both gay and women filmmakers. Perhaps I am drawing lines here that don't need to be drawn. The porosity would belie such distinctions. Cross-pollination, after all, was a desired quality of the entire film and art scene.

Philly, another film and performance artist of the day, remembers the community in general as very interactive and hands-on. She believes that to force separations within the milieu in an attempt to define a specific film scene would be misleading. Back then, many artists were performers, filmmakers *and* painters or photographers; film was just part of a creative continuum. Philly was a performance artist and store owner (Toxic Plan 9) making punk jewelry in Toronto before coming to New York, where she met Jack and Peter through the Pyramid and No Rio. She remembers them as nurturing and helpful. Among her own films shown in Naked Eye screenings were, *I, a Goddess*, parts 1 and 2, an urban mythology which was described as "Goddess meets god meets bird. Not just another metaphysical beach blanket bingo." *I, a Goddess*, was written and directed by Philly and shot by Jack Waters. Philly prefers acting and writing to shooting. She learned to act from doing performance art.

In regards to the good old days, she has little tolerance for fawning over the past. The past holds a great deal of sorrow with its history of overdose deaths and AIDS. As the artist Hapi Phace said of the '80s, "The funeral became a kind of performance." But other things have changed as well. New York is no longer ground zero for any number of reasons. A certain professionalism crept into the neighborhood. The clubs and bars are no longer places of cultural exchange. Artists in general, she believes, have withdrawn from the nightlife scene, like "vampires not getting the grade of blood they require." She sees a split between pre- and post-MTV and pre- and post-computer eras, as the art scene evolves toward a primacy of the image to the detriment of the spirit. She agrees with Casandra that many people got seduced by ego gratification or got frozen into a successful persona, when art ought to be "about transformation and shape-shifting." Eventually we arrive where it seems we are now, in a world "where you are only as good as you look." And to her perception that everyone likes to think that they are the center of the world they describe, she answers, "I'm an outsider's outsider. I'm the shadow you saw out the corner of your left eye."

Where Are They Now

Casandra dropped out of the scene. She changed back to her ancestral name of Mele. She plays with her band The Trees, and paints, writes and publishes poetry. She also has a garden, a son and goes to school. Philly dropped out of the scene too, mostly out of sorrow, until about four years ago when she became active again. She is working with Tod Verow, and has been shown in festivals such as the Berlin Film Festival, Lacarno, and the Gay and Lesbian Film Festival in Paris. She also has upcoming projects with the Kuchar brothers as well as a two person Jean Genet-esque film with existential overtones. Her mission is to create a sense of interconnectivity in the alienating Bush years. "I used to be didactic, now I'm happy if I can make people think," she said. Leslie Lowe has long since moved to New Orleans and changed her name. Rumor has it she was running the voodoo museum down there.

Jack and Peter continued to make films throughout the '90s including *The Ring Our Way*, their ambitious rendering of the Wagner Ring Cycle. Marion Jacobson of the *Washington Post* wrote: "This fashionably jumbled set of Wagner Cliff's notes is tailor made for short attention spans . . . a combination Wagnerian vaudeville show and horror flick . . ." Another reviewer termed it "a grand, urgent, mythic burlesque, full of hyperbolic excess." Le Petit Versailles, a garden/community center on 2nd Street, is their new ABC No Rio, where they schedule and produce art and performance events. They are also involved in a performance group Dance Tube and recently did a piece *Short Memory/No History* about cultural amnesia and the AIDS awareness. Recently they did *Spectacolo Provolone* at Theater for the New City, which Peter

described as, "surreality-based-musical-theater-intervention" about European economic policies, dairy regulation, Greek mythology and other things. Peter says they are concentrating more on sexual politics, though creeping into the pornographic realm. Do all art forms evolve toward pornography, I wondered. He didn't hear me but he laughed just the same. I then asked Peter if he thought of his No Rio days as the good old days. "They were the good old days in the sense that we were young." But, "Things have to evolve. Even the reclamation of these gardens is a form of gentrification," the difference being that, "we actually are taking root here as members of the community and are involved in it and not passing through on our way to the burbs!"

Philly

Interview by Clayton Patterson
Transcribed by Mika Deustch

Philly: My name is Philly . . . That's what I always go by . . . I've been here since '83.

C: '83, okay. You moved right to the Lower East Side.

P: Yeah, I was staying with about six people to begin with, in a one-bedroom apartment across from where the old Phebe's was, whatever it is now. So it was right near where Valerie's bar is now, and then the neighborhood was not quite the same.

C: Why did you come to New York?

P: Because all my friends were here from Toronto. I lived in Toronto and then I was in San Francisco. I am originally from Pennsyltucky—that's Pennsylvania for the uninitiated.

C: Did you go to art school in Toronto?

P: No, husband number one. I did radio, interviews things like that. I did some magazine writing.

C: Okay, what kind of magazine work?

P: Just one of those "a hundred years ago this happened" kind of stuff. Mainstream, but weird stuff, and I did research for film companies and stuff like that. So a little bit of everything. I was also doing performance art: I had a shop in Toronto called "Toxic," later called "Toxic Plan Nine on Queens Street." During those years I would just go to the antique clothing stores and pull their torn things out, put some safety pins in, then put it in the window and sell it. It was a fun kind of reality.

C: When you came to New York in '83, who did you live with?

P: I lived with a whole bunch of people and my friends from Toronto.

C: Oh, your friends from Toronto—and then how did you get involved in the Lower East Side scene?

P: The first day I was there I got dragged to the Pyramid, and I saw a Christmas show. It was right before '83, just a few days before New Years. And they were doing a Christmas show, and I saw Japanese Jesus with Samoa and the whole tribe from the Pyramid, and I looked at the stage and I thought I wanted to be on it. I was doing Super 8 and performance in Toronto, but when I left Toronto I pretty much thought that punk-new wave was over and that it was time to get out of the city. So I spent a year in San Francisco and then I came here. I guess "Seven Days of Creation" show was kind of the crossover, at ABC No Rio. So, by spring I was doing shows at the Pyramid. I was the only—after Ann Craig died —I was, for a while, the only woman there. There was always one or two women mascots there, and basically men. So I suckled at the tit of drag queens there and learned.

C: How did you get involved with Kembra and Samoa?

P: Well I knew Kembra and Samoa from the scene. When their place burned down they moved in with me. We where roommates.

C: Okay, so by this time you had moved out from across from Phebe's?

P: I was living on 4th Street. I had my own apartment. Then they moved in, and none of us saw day. I was working the area, and Samoa was doing some sort of cooking work. Kembra was doing some sort of processing, I think. For some reason none of us saw

daylight. There was a whole winter where we just didn't see daylight. Before I moved into 4th Street I lived on the stage of ABC No Rio for a summer. My first summer was spent on the stage. It was a backdrop that Jack and Peter had made for a show of Coney Island. The window was covered. It wasn't a performance art piece. They were living in the basement and I was living on the stage; that was where I slept at night.

C: So that was where you got to know Kembra and Samoa, was when they moved in with you on 4th Street?

P: I knew them before. It was a small scene. Everybody performed in Pyramid and did performance art and ran around at ABC No Rio. It was pretty much a part of the reality; we're all part of the same tribe.

C: And were they in film at that time? Super 8?

Clayton Patterson

Philly

P: I did some stuff with Kembra.

C: Because what year was Naked Eye Cinema?

P: God, that was for years. Jack and Peter did that for years. I think that was at the beginning of the original underground film festival. Everybody was making movies. It was really fun because everybody would just show their original—we'd be cutting until the last moment. It was sort of like a hands-on, little local event.

C: How many years do you think Naked Eye Film Festival went on for?

P: Years and years—Jack and Peter are the ones to talk to about that one.

C: Right, well in the beginning that was more like Jack and also Valerie right? What was Valerie's last name? Caris.

P: You should really talk to Jack and—they were the grunt of the background, and I think

Kembra was involved in that as well. I was never the organizer type. I always just threw myself into existing realities. I really like having to deal with structure.

C: Naked Eye at that time really was creating kind of a genre, or a genre of people.

P: I think the genre was there from the beginning. People just mixed themselves into something, and there is always someone sitting at the helm of that. It switches from one place to the other; since film before film. I think it goes back to the ritual. People just occupy a space, and are given the role of being the guardians for a while.

C: Right, but as a genre that became identified as kind of a group of people. Certainly yourself, Kembra, Samoa, Jack, and Valerie. Who do you think was in that group?

P: I think you've mentioned all of them.

C: Because the other thing that was happening sort of parallel to that, and around the same

Clayton Patterson

Philly

time, was the "Films of Transgression." At that time there was a whole kind of Super 8, I don't want to say, mania.

P: There was a mania. It was also the cheapest way to do things at that point until video came along and totally knocked down the ante, to where you didn't have to worry about shooting and sending it off. It was all very esoteric. There was only one place to develop it, and then you had to do this, and you had to do that. With video you can shoot and see what you've got immediately. There's no money involved because you can always borrow a camera.

C: The process at that time for doing your film—what was the process, do you remember?

P: I got Jack to shoot what I was doing. I had got us part one and part two. Jack Waters. It was basically getting the people to show up, doing it as fast as you possibly could, sending it off to be developed and crossing your fingers, hoping it would turn out.

C: Where did they develop it?

P: It was just one obscure company that was doing it. It took like two weeks to get it back.

C: I think the whole roll and developing for three minutes was five dollars.

P: No I think it was a lot more, as I remember it was more expensive than that. I don't think you could get away for less than a hundred and fifty dollars even for a short movie.

C: Yeah, but that is for the whole movie.

P: At that point that was major—scraping up the money.

C: How many roles did it take to make a feature—do you remember?

P: A feature? I was just doing shorts, but usually less than twice the amount. It was usually a one-to-one, two-to-one ratio—at least for me. You use a lot of the stuff that you shoot.

C: Your films would be about eight minutes long, right?

P: About eight, ten, something like that. We didn't invent anything; we just carried on the idea. If you are talking about people that really pioneered it, you have to talk about Jack Smith and Albert Lester, the Kuchar brothers; people like that: Warhol, Kissany, that kind of thing, Stan Brakhage. We didn't fucking jump out of a garbage can with no knowledge of anything.

C: How would you know about Jack Smith, for example.

P: From seeing his movies from the time I was really young.

C: So you had seen Jack Smith before you came to New York.

P: In Philadelphia actually. My name, Philisima, they don't call me Philly because of Philidelphia, is an unfortunate coincidence. There was this place called the band box where they used to show movies. It was like the classic espresso show movies on a tour in screen, with buckets so the water dripped in. That is where I saw my first movies of that variety. Again, before video it was like you had to do your own research. I didn't go to art school. I sat in on some classes when I was in Toronto at OCA.

C: Ontario College of Art?

P: Yeah, and at the Art Institute in San Francisco. I guess I found it when I saw *Chelsea Girls—On Dean* was showing *Chelsea Girls*. That was his big deal, all the way until he died, almost. On Dean was one of Warhol's superstars. He would show them in the original way. He would just pick up the rills that he would do the splits for you, and do the splits for you.

C: That was in New York?

P: I saw that when I was in Toronto. I had seen *Chelsea Girls* before. For me it was a very instant kind of jump from being a really good audience, to being in the movies, to doing them.

C: Now what were your themes mostly?

P: It was always old mythology, rebirth; death as being the same thing. The whole classic—I used to do a cartoon of a fish. There was a circular theme of a garbage can and a fish: the fish goes from a bowl to being a skeletal and the garbage can being the recycling thing. It was usually that. You forgot the Kuchar brothers; they were involved. Everyone in that group also did movies with Mike Kuchar and George, I believe.

C: Kembra and Samoa and ABC No Rio and Jack and all those people were also involved with the Kuchar brothers, and that would probably put them in line with Millennium as well. Naked Eye Cinema also showed the Clemente Sotobello school.

P: I am not really one to give you the historical context—the Jack and Peter job. I am never really good with chronology. It was something I took part in and I supported, and I went to, but again I wasn't part of the framework. I was just one of the threads woven through.

C: Also, you played the movies at the Pyramid Club and would they play them on Sunday night, drag nights—

P: It would vary: sometimes it would be a night of it; sometimes they would incorporate it into the movies. Ethel Ickelberger always would incorporate the movies into what she did, and there were movies that will stand on their own that she did. John Kelly also incorporated

movies into what he was doing.

C: So at the Pyramid Club—but actually there were a number of people because there was a crossover between Taboo and Happy-face, and Kembra and Samoa were kind of a part peripherally.

P: We were all part of the same tribe.

C: Happy-face and Samoa were involved in making some movies as well. So they were kind of a part of Naked Eye Cinema as well.

P: Yeah, yeah. Also, Mary Bellis made a couple of features, which are very interesting. They had all of the dead Pyramid performers in them. I was in both of the movies. There's one—I would say Mary Bellis is someone to talk to also.

C: I didn't realize that Mary was a part of this whole sketch; I knew she did computers and animation.

P: Oh no, this is before. And she could probably show you some footage that you would find very interesting. She did her own features; she did a couple of features that I starred in. One's called *The Agent*, and one that never got finished—Mary finish your movie!—is the Andy Liss story with Baby Gregor. We're talking '86.

C: Okay, because Baby died in about '98 or so.

Clayton Patterson

Philly

C: It's all the Lower East Side; that's what we're talking about.

P: I'm just saying from one place to another, people would go to several different clubs and go to see wherever something was playing that they wanted to go see; they would go to that. There weren't groups fighting in the street.

C: No, no—let me give you an example: when the Fluxus thing was going on you had Arleen Schloss who was doing video and Fluxus performance, Rich Kostelanetz was doing visual poems, Vito Acconci was doing his conceptual thing, it was all kind of the same, and it took place at the same time.

P: Everybody was rock and roll; the basis of a lot of stuff . . . was rock and roll. Everybody made music too, everybody performed; everybody did everything. It wasn't one thing or the other. I don't think you can really divide it up. I think history divides things, reality blends everything together.

C: Well that's true, but there really was a Lower East Side action. The reason that we're here is because of the Lower East Side.

P: Don't think people didn't do their research. There was one book *Performance* out, and I think a lot of people got a lot of inspiration from that, and a lot of ideas. People knew their Russian Constructivist, they knew their futurist. They knew Fluxus. They knew what they were doing. You can't say that it was totally un-self-conscious. If someone came here with just a wild energy wanting to perform, it was a school of the streets; you learned your history, just because everyone was interested in it. None of us came out of a fucking vacuum. We're not geniuses; we were just part of a stream of things. I think the cult personality tends to say that. I didn't invent anything; I just blended it together in my own way. I mean, I love the history but I don't worship history. I'm more interested in what I am doing at this moment than I am in a history. It was a naive moment—it was beautiful. And things can't be the same. None of us had regular jobs: we all made our money off of our art, basically, or side things here and there. Let's face it, you can't come and get a two-hundred-dollar bachelor apartment anymore, which you can shove five people into. You also won't be thrown against the wall and searched by the police just for walking down your block. Maybe under different circumstances. It is just a different kind of reality.

C: Oh, totally. That's why a certain level of history is important. It makes you look back and remember who was here, and see what went on. The Lower East Side has a large volume of history.

P: It was an intentional community, but not in the way intentional communities [are] people are very self-conscious these days. Intentional, I mean—I think Brooklyn is a self-conscious community. I think the whole Williamsburg kind of thing—it took on its own thing. I live on Staten and Ridge, the same place I've lived in since mid-'84. There were drug dealers; people were being killed. My friends would not come and visit me, and we always said that Pit Street is worse than Ridge Street. It was a constant stream . . . a cop was shot on my corner, and nobody even came into my building to question us.

C: Yeah, I know. The first night when I got here there was a guy shot across the street. Nothing happened. The cops came, put him in an ambulance and that was it; finished.

P: There are still things going on.

C: There's lots, but I mean that's another history nobody talks about. But now, you're right, it is much different now than it was then. And it is much safer now at certain a level.

P: It's safer, but I think it's more homogenized. I couldn't move here now.

C: That's why I am sort of going over and sort of redoing the history. But that intention thing that you're talking about, or this planned out thing, or this idea—

P: Hold on, there are some really good parties in Brooklyn, but now the Brooklyn parties are getting forced into Jersey City, because again the zoning.

C: But also, the Lower East Side happened almost mystically, how people ended up here.

P: It wasn't mystical; it was the cheapest place to live. This or Harlem.

C: Well, it was also mystical. Look, I never came to New York to have a cheap place to live. I came because there were interesting things going on, people and events.

P: What year did you come here?

C: I came here in '79. I mean if I wanted a cheap place to live, I could have gone and bought a whole town in the middle of Texas for $13.

P: A place to go and party and—

C: Well, it wasn't so much party. There were really creative, interesting, and inspired things.

P: Well, but it all went together.

C: Well it did, but the creativity was really the interesting thing.

P: When I think of partying I don't think of drugs and alcohol and that kind of thing exclusively. When I go out to meet interesting people I have started going to art openings because the clubs are dead. You never know what you're going to find. It's usually homogenized, but it's usually food for thought.

C: I don't know if it is or not to be honest.

P: Not the stuff on the walls. You have to overturn every rock now, because it isn't really people. I blame MTV more than anything, because you can't even talk about radicalism and image in the same way. Nike and Reebok and Sprite and Coca-Cola—people are sent to spy on ideas so they can be put into commercials and into movies, but they never seem to get it right. Today, very rarely do you get a movie that shows it right. I think the people that I work with are good. You have to talk [to them], although it's not history. Todd Verou has done some amazing stuff. Todd Verou is a filmmaker that I work with.

C: Lower East Side?

P: Now, yes. He was in Boston but he shot movies here, and I think you get the real flavor.

Clayton Patterson

Philly

C: Yeah, well, it's possible but that whole reconstructed thing that's here, it was the creativity for me.

P: It still is for me.

C: Is it? I think it is coming back.

P: I don't think so; it can't be because it is self-conscious. When you talk about "Howl!" Howl! is the video camera on, Howl! is that scream of joy and agony all at the same time? I'm sure that people go through it, but they are pre-fed what they are supposed to get. It's all homogenized. I think it's pretty much "independent"—a word that makes me nauseous. In filmmaking it means under 10–12 million dollars, and you get a couple of soap opera stars and you put something together.

C: Do you think that the viability of film still exists here, the possibilities?

P: Film incorporating—I think film is dead. It's dial your desire. With high resolution, even that final bugaboo, quality is going to go down the drain. So at this point, $2,500 and you can do studio quality stuff. I am sure in a couple of years it'll be down to a thousand or eight hun-

dred. Or maybe even less than that. High-resolution video—everyone is going to have it. All equipment is going to become obsolete.

C: Is that good or bad?

P: I don't know. It's like asking, if you are swimming, what ocean you're swimming in. I think you have to dig deeper to find creativity, I think that's basically—

C: Different issue. For me, for example, my video was always done with commercial equipment, and it was possible for anyone to do. That's the same with my photographs; I always used to develop them at a one-hour place. Anything I did anybody could; my abilities and my equipment were accessible to anyone. That was part of my concept.

P: Anyone with a camera can do anything they want to at this point.

C: And what you do with it—you can't get away with just doing funny angles, or blood or gore or sex. At this point the new frontier is nudity all over the place, all the time—for everything. It changes; it ups the ante. You have to be a little more creative to get to people. I don't think it is good or bad; it just is. I feel very lucky to have been at the end of the Stone Age and I am glad to have experienced the time of naïveté . . .

I think that's true. Archeologists have poured out hundreds of thousands of people. There are so many people educated within each of the different genres and departments. There is so much money involved with certain people now. And all the stuff that was the street is now sophisticated. I mean, graffiti is turning into a fine art. High quality and big museums and high prices [is what] it's working towards. Everything has kind of stepped into that corporate world now. MTV was certainly one of the destructive forces.

P: It is the anti-Christ, and it is also the bringer of the message. At the same way it's not a double, it's a lotus-headed axe. I think that you have to be flexible in what you want and what you dream.

C: Speaking of dreaming, you used to be able to watch a film or watch a video, especially— listening to a song you would have an image inside your head. Well now you listen to a song you have MTV inside your head, because they give the images of what the song represents.

P: Then you have the commercial it's based on. Who would think that Iggy Pop would be doing car commercials? I mean cruise commercials . . . that's happened for a long time.

C: Yeah, it happened years ago with MTV, but there is no imagination. There is no "your" mind involved in music anymore . . .

P: If you make the music yourself then you still have the opportunity to do that.

C: But you're given all of the criteria and all the imagery that is around that song.

P: Right, and it is the same set of images over and over.

C: It's rap and money, guns, jewelry, and big cars. That's the whole thing that rap gets . . . and pussy, and big boobs.

P: And big asses, and "I'm not gay."

C: Whenever you hear a rap song, those images become implanted in your head. That's MTV, and that's the tragic thing. You're right about that Stone Age thing: there was a creativity that existed there that is no longer here.

P: I kind of wear my years with pride. When I talk to people I do things with, music or movies or stuff, [they are] are all younger than me. It was just as good as you thought it would be. Yeah, you did miss it. I think there is the sense in every thinking and feeling human being. Wow, a certain age that they got robbed; and they did. I think that people got robbed because they didn't have a chance to discover their own culture. I guess it's the cultural equivalent to, "Well, I walked 20 miles to school." I had to fight my way to get every goddamn concept you had to give me. It's the updated version of that.

C: Anyway, the Naked Eye Cinema was very important.

P: Yeah, everybody was very supportive at that time. Naked Eye Cinema was being done at a time when you take a garbage can, turn it upside down and start banging on it. And the mag-

gots' dancing was part of the show. You're talking about a very gut kind of thing, and people are still experiencing that. But after a certain point everything becomes tired. I think that, even the concept of revolution, unless it's reinventing itself, is all things become –

C: Well, at a certain point there has to be a purpose to things.

P: But there is a point. For me looking for those specific purposes tend to be a sideline. If you want to hit yourself over the head, ask for the purpose. If you are so busy in doing what you do that you don't have time to think, for me that's what I head towards. I don't often achieve, and when I do I'm really happy, because everything is quieted except for that screen, at "Howl!" It's mentioned in *Howl!*—a subversive librarian gave me when I was very young. For

Clayton Patterson

Philly

me it was like: "Oh, my god, what is this? This is the best thing I ever read." So I think that might be the first radical thing I ever saw. My mother let me stay up to see *Lestrata* by Fellini. I think that was the first avant-garde movie—that's the first radical thing I ever saw.

C: So what do you think really influenced your moviemaking?

P: I think my life, when I realized I could take the images that were inside and put them out-side. I think it's an evolution. I started out doing poetry and painting, and then performance art, just because I fell in with the group of people from Toronto. A lot of people came through—punk rock days. That's when Super 8 came. I worked with the guys from *Fast Verns* in Toronto. Things just went on from there. I saw the stage here and I wanted to be on it. I usually find that art is a way to be with what I am doing. Now I'm working on my first feature. It's called, *Shhh, They're Getting Closer*, and it's based on a very bad joke. The idea came before 9/11: it's about what it's like to live in New York now.

C: And what is it like to live in New York now?

P: When I finish the movie I'll be able to watch it and tell you.

Clayton Patterson

Philly

C: So you're shooting this on video then?

P: Of course.

P: Do you have actors in it?

C: Yeah, I'm going to . . . I've found I've been pretty damn lucky. This is really damn funny though. In working with Todd, and in working with the Kuchar brothers, I've had stuff shown around the world. I've gotten to go to the Berlin film festival and the Carno. When I'm there, it's usually when I'm there with Todd, and we're the only people with no, absolutely no budget features, with all these other people. Even in other cities I'll read something and they will say, "Philly: ground center for rock and roll and underground filmmaking in New York," and I am thinking ground center of what? They say things like that, and it's like there is no scene; specifically, I don't see a scene. I see people; I see individuals. I see people trying to hang the name "scene" onto what they are doing for PR, but it's nothing like what it was. It's just that everything is so intentional.

C: No, I think that is a good term. There isn't, not that I can see, there isn't a scene.

P: People say, "Hey what's going on if I come to the city—what am I going to look for?" Well, there might be an occasional party or something like that, but it doesn't have the bite. When I came to New York the Pyramid was the only game in town, everybody showed up there every night. You would check in at least. Then there was "Limbo Lounge," as far as underground stuff. There was no scene there of course, and then there was the Gas Station. I am just thinking of "Ground Center," "Collective Unconsciousness." Whatever it's evolved into it started with people from out of town making their own scene at the beginning, and it sort of evolved through several different things . . . But then the whole thing too, wasn't our scene, everybody came from somewhere else. When I grew up in Philadelphia, it's like New York is really evil. It's really bad, and when I visited people can't imagine: you'd walk down the street and there would be drug gangs, in the winter flaming cans on every corner, burned out buildings. The police would only come to get blowjobs or pick up money or harass people.

C: And you saw cops getting blowjobs?

P: They would go in to get them below me; there was an underaged whorehouse. The person was selling his own kids. It was that kind of neighborhood. It probably still is, but in an upper echelon, probably done by Internet.

C: Oh yeah, all the drugs are still here.

P: It's cell phones. I mean, they haven't gotten the drugs out of the way, and the people buying the drugs are richer. Whenever anyone that I know hears, it's always "Was it a local or was it a yuppie buying drugs in a bad . . . When I hear about a shooting I still think it is drug related, or someone was in the wrong place at the wrong time. But I always think in terms of violence and drug dealing.

C: A lot of that certainly went together; that's true. Although down here on the street [where] I live is much safer.

P: Knock on wood, real wood too, I never had any problem. The first day to New York, I was going toward Eldridge Street where friends were staying. Everyone who was living in that other apartment was living in this other apartment. This guy comes up beside me, he's got his hand in his pocket and it looks like he's got something. We're both in our long black coats, and it's really cold, and I looked at him and said, "I ain't got no fucking money and it's Christmas" and then he started saying, "I ain't got no fucking money and it's Christmas." We both looked. We both went up two streets both mumbling and then he went toward the park on the other side of Houston, and then he said, "I am gonna get me some money, if you know what I mean," kind of nudging me, and he said "Merry Christmas." That was one of my first or second days in New York in the eighties, and it was an acknowledgement of that kind of thing. A good mugger knows her business, and they know who has money and who doesn't. So my joke always used to be, you're a mugger who lives on my block, and I never had any problem. People were courteous and good. I'd scream "doorman," and they'd open up the door.

C: Yeah, like that was what I was saying. In a certain way I think it was safer then because even though it was all drugs, each block was designated to certain people and they ran that block, and once you knew that block, you knew those people, then everything was okay. Now it's like these criminals come here on the subway. It's totally open, everything is new: bars, restaurants, whatever. You have these people running around looking to mug people and whatever, and they don't know who they are . . . nobody knows each other. It's much more dangerous.

P: I think also one thing that we haven't talked about that began to rip out the heart of downtown was drug overdoses and AIDS. We lost a good deal of the most creative people we had to AIDS and to drug overdoses, and you add suicide and you finish it off.

C: Yeah, you could build a monument down here as big as the Vietnam Wall of people that died from drug overdoses.

P: I kind of pulled out of the scene in the late '80s, early '90s because everyone I knew died and it's like, I don't have an audience. Everyone that I know and love is dead now. I didn't really start doing things full time until about three or four years ago.

C: I got involved in politics for 15 years, between like '88 and now really that I'm starting on

this HOWL thing, between the squats, the homeless, all that.

P: But that was always tied in.

C: No, that's not true. For me it was a total concentration. Once those episodes with the police and that started happening there was no partying, there was no hanging out; there was no art openings—not much anyway.

P: The thing is we didn't talk about this squat scene.

C: The squat scene is totally different than people talk about it.

P: Every squat was different and there were different squats with different realities. A lot of the

Clayton Patterson

Philly

early squats became condos.

C: And also the early squats were just abandoned buildings that people lived in. After '88 squats became structural and it became an identity, but prior to that, squats—even though they have this whole history now—part of that history is an illusion because it was just a place for people to crash and live.

P: I stayed in squats in other cities when I was traveling. When I came to New York, I guess at the time when I would have gone to a squat I had the stage of ABC No Rio. Then I had apartments that were so cheap that there weren't political problems. I was just into doing what I was doing. By the mid-'80s living in a squat was a full-time business between the cops and the problems between people and all that. If you wanted to squat, squat was your identity and your life

C: Especially after '88, once all that became political. You're right that squatting became a whole kind of philosophy and point of view and a way of life. It became a described thing; prior to that it wasn't.

P: I think it was interesting to see the techno-squat intersection; it was an alternate route.

C: It was definitely an alternate route. There were people like Red Ed, Eddy Braddock, that lived in a squat. Maise lived in a squat because Maise, who played at the Pyramid, was at the Catholic place on 42nd Street with Father Ritter, and Father Ritter was always hitting on him. So he left the comfort of Covenant House to come down and sleep in an abandoned building on the Lower East Side and perform at the Pyramid just because of this sexually advancing priest, Father Ritter. And it was interesting, because years later that eventually came out in the press.

P: And now it's a fancy and good hotel. Covenant House is now being transformed into a

Clayton Patterson

Philly

trendy hotel.

C: The different squats—some had music, but it wasn't thought of in the same way as it became after '88, and it became a political identity.

P: I think a lot of people moved through them and went on to apartments . . . People who stay in squats have to pay rent toward what's going on, toward putting—

C: Right, that's getting back to this history of the Lower East Side.

P: If you don't have the money, then you're out from your squat!

C: Right, and this whole film and video history is that the neighborhood really has, over the last thirty years, gone through these different sort of—

P: I think right down here, on the other side of Houston, it's literally in the last six or eight years with the last three years being worse.

C: It really started off long ago. A lot of people were looking at the '88 riots and some of the comments they were making were: well this is about real estate. People kept on making that point as of 1988, which is fifteen years ago. People kept on saying this is about real estate;

this is about people being evicted out of their apartments. This place that we came to wasn't about the cheapest rent, it was a very unique place to live.

P: That we all read about in all the books.

C: It had a real creativity and a real special flavor to it. You could have had cheap places in Toronto, maybe even cheaper.

P: There was an amazing scene going on in Toronto. But I think a lot of the most creative people from Toronto went to New York or L.A., and they're well hidden in the scenes behind there; that's a whole other story.

C: Different things came up because of like—Kembra would call it—availablism and super-8 movies—at that time were an inexpensive way to make art, performance, and entertainment. To get yourself seen. It also made a way of having performances and putting them into a place and being able to send them to people in other cities like Berlin or Toronto. So there became a whole network of films. Because films took an audience there became this whole sort of special collective around different filmmaking groups. You would have a place like A's which was more video, and then you had Films of Transgression, Naked Eye Cinema. These were real scenes; these were things where people actually showed up to, identified with, and supported or collaborated with, or wanted to be part of or recognized.

P: You should probably talk to Tess Hughes about . . . you know Tessa. Are you planning to interview her?

C: Maybe at some point. The problem is this is really short; I have to have this thing published by mid-August.

P: Everybody came together and showed their movies together in the—not the new what's Underground Film Festival, now, but there was an early Underground Film Festival.

C: There was one at CHARAS in about 1986.

P: There was one every year for about three or four years.

C: Yeah, then it was in bars, restaurants, clubs.

P: But that sort of blended everybody; everybody would show there.

C: Yeah. It became more formal though. I think when it was at CHARAS it kind of worked. By the time it got to some of these clubs it became sort of an event for a club and it became more uptown to me—I just have my own personal interaction with it, because I used to photograph it.

P: I think the first couple years were just amazing.

C: Yeah they were and that was like CHARAS. Then the next one I think was at some club somewhere.

P: It was at the River, on the West Side. It was fun though. I think everybody showed their movies; that's like a cross section of everybody together.

C: But I think at that time that also started becoming the end of that because everything sort of broke apart after that. I don't know why but it seemed to have. Maybe it was just making something formal and it was time to make it formal and kind of put it together. I think that's one of the things maybe that festival did; it sort of ground things to an end place, and then after that those things died. I mean Films of Transgression kind of ended after that; Naked Eye Cinema kind of ended after that.

P: People pursued other realities—more individual agendas actually. I'm really bad from the late '80s to the mid '90s, about when things happened; I just sort of pulled away from all of that. I think it isn't that an event ended it; it was the end of the AIDS death and the drug death kind of thing. I think that a lot of people just had their hearts ripped out by life, or else they didn't get rich and famous immediately, and it's like, "I'm gonna do something else—this isn't working for me. I'm not in Hollywood; I'm not rich. Why am I doing this? I think I'm gonna stop." A lot of people considered the avant-garde a platform to get to a different level, and a lot of people did use it for that.

C: Who would you put into that category?

P: I'm not going to name names because it's really obvious. I'm not going to say who does what. Everyone has their own idea about that. I put the idea into your head so how about you, who would you say?

C: That's an interesting point. Certainly you had the graffiti thing that was used by Keith Haring and people like that; Kenny Shark. They certainly bounced out of the Pyramid scene. That's sort of like big name, but did anyone down here come out of the film school and really develop into something? I mean other than the underground. I don't think so.

Clayton Patterson

Philly

P: Todd Ames. I think he's doing amazing work. I really like what Todd is doing, but he was showing the Karen Carpenter story. If you look through people and what they do and where they've gone—I don't think that New York is a very aware market at this point. I think that we're real backwater . . . For me, New York is a place where I have cheap rent at this point. Other cities get a lot more attention in other countries; they like that we're square headed here.

C: So where do you think is your largest audience?

P: I work with Ned Ambler and the Kuchar brothers and Todd.

C: Oh, really? You still work with the Kuchar brothers?

P: I just started working with them about three or four years ago; I'm in their later movies. I'm not in the early stuff.

C: But you were aware of them?

P: Oh, totally aware. I met Omike on an acid trip when I was in San Franciso; I was taken to his place. I met him in the early '80s in San Francisco, but I didn't really start working with him until much later. I think Zan Price, too; he lives in Brooklyn but he does amazing work.

C: So you're still actively involved in films.

P: I'm totally involved. I just was shooting with Todd last week. I have a pretty good body of work with several different people and get shown pretty regularly in different festivals around the world. So I've done—god, I don't even know how many features at this point—and numerous shorts. I'm sort of surprised if people come up if I'm in a different country, or something—and they know my film history. It's like, "Oh my god, what's going on!" It's weird, because it doesn't enter into my everyday life really, but I am aware. I think specifically what I'm doing is taking the whole performance kind of thing and rock 'n' roll, and then incorporating it in with video. For me I'm pretty happy I'm considered a pretty damn good actress. It's not just cult of

Clayton Patterson

Philly

personality; I think I can play a bunch of different things. Maybe the only shortcoming of downtown is self-worship. I think in a way it's really exciting the "HOWL!" festival is happening, but it is a jerk off thing: we love to pat ourselves on the back and say, "We are so fucking avant-garde." I've always thought that was absolutely disgusting on a certain level, but if the shoe fits wear it, and I definitely think I wear it myself. I didn't invent anything; I'm only a popularizer. Ask me where I got my ideas. I didn't even think of performing until I was in Toronto and Lindsey Kemp, who worked with David Bowie—I was doing radio shows and he told me I couldn't interview him unless I did a show, if I did one of his classes, and then he offered me a scholarship. That's when I never did another documentary after his. I sort of switched sides. I was more of the watcher and documenter.

C: Nick Zedd keeps on plugging away out there too. I can admire that about him, that he's still out there making his avant-garde films or his feature films and carrying on. There aren't that many people that have carried on.

P: But he can carry on if he can't help carrying on. If it's part of your lifeblood—or if you need it in order to get free dinners, get invited to different countries, get pat on the head. As to

whether people keep doing it because they love doing it or because it's something if they don't keep doing then they lose the patina of doing it—

C: I think that's the interesting question. I can see that after a certain number of years, you see certain people just keep something going because now it's a meal ticket.

P: Some people just do the same thing over and over again and don't really—I admire people who continue to change and develop although I think it's much easier to get known if you keep doing the same thing over and over again.

C: It takes a long time to get an idea out there. That's true.

P: With me, I always do different things, always use different realities. When I was performing at the Pyramid people wouldn't even know I was the same person.

C: Where do you show now?

P: All around the world. As I said, film festivals, Chicago Underground—with Todd we were in the L. A. Film Festival—just all over. Todd shows in a lot of gay festivals as well, like in Berlin, Lacarno, all over.

C: So you go to a lot of these festivals?

P: Yeah I've been all over the world with films. In Lacarno we were showing a movie, and here I was with Todd, and it was *Once and Future Queen*; it was really delightful. I saw my picture up in the Old Square really large. We were doing our premiere in Europe along with *X-Men*. They feted everybody for like four days. We were in castles, in cabanos, in the rain being fed risotto with truffles; and I was sitting next to the cultural minister from Italy and she was saying they never put enough truffles in the risotto. We tasted it and they did put enough truffles in the risotto. Here I am sitting in a medieval castle looking out at an incredible sunset over a lake and looking at mountains, talking about eating truffles with the cultural minister. That's a long way from ABC No Rio. It's funny, because when people think of rock 'n' roll movies in this country, people see political. People look at things different in Europe. They do.

C: So Europe has been good to you. Why wouldn't you move to Europe?

P: Because I have a cheap apartment here. Rent-controlled; who knows what it's gonna be after now, we'll see what's happening, but I have an apartment for under $500—three bedrooms. I love to be a snotty bitch and say that New York's where I have a cheap apartment. But if I didn't have cheap rent I'd probably be living somewhere else. I always thought when I was living on B and C off Houston, "Why do the people who originally got this lease get a place on 1st or 2nd?" Because that was the cheapest of the cheap. But you don't have rent-control; you probably have a good landlord.

I don't know if I'm addicted to the present. I might be addicted to the memories but memories are only memories and you can use them as a beacon for something, but I can't—When I was MC-ing at the Pyramid I was crossing over Ridge Street onto Houston and I got onto the island which at that point was barren—Red Square wasn't there. It was a bombed out area. For a second I had a hallucination. I wasn't doing anything, but for a moment I saw trees: I saw the whole neighborhood as it was going to be. It was so absolutely bizarre to me that when I got to the Pyramid I did a little monologue about it, and that was like the funniest thing anyone had ever heard. It was like, "Oh my god, what drugs were you on?" The scary thing about it, I described the tress, I described the shops, I described the whole thing. It was such a vivid thing that I never forgot it and it's exactly the way it looks now.

C: Did Nelson ever videotape you much?

P: Nelson, yeah. Aren't his tapes still in litigation? Are they out yet?

C: Funtone Records has them actually—a guy Dick there. Dick Richards. Dick Dick, I guess. But yeah, you've got to get them out.

P: People keep saying that they've seen really early shows that I've done. There was one, *Fashellio Pagentia Absurdia*, we forgot. That one gets out and around. It's like Kembra and Somoa, and like every happy face and taboo, and I'm in it. It's all Richard Hoffman's paper dresses. For years a lot of the early tapes circulated around between VJs, private collections.

Can you get all those tapes now?

C: I think if you run to Funtone Records on the web you could probably find out. I mean it's possible.

P: Because he did amazing work.

C: Yeah, he did. He was really pre-MTV; Nelson was the good-looking style of what MTV became.

P: He was very much part of the scene. He wasn't an outsider and the look that was there was the look from the Pyramid.

C: The moving; the continuous action. It was like peeling a whole apple without breaking the skin.

P: I have one of his *Fashellio Pagentia Absurdia*, and it's amazing because he would do the whole thing; he would start in the dressing room and then take you onstage and then take you afterwards.

C: It was a complete documentary and a very unique style; very Nelson. Like I said, it became the style of what eventually became MTV. I think this guy Fetten used to work with MTV and was doing *120 Minutes* at that time, or something, and Nelson was in the background of that doing something as well. Now you see Nelson became one the names that everybody eclipsed. You know they took his name, like Fetten and Randy became the managers of RuPaul, and RuPaul eventually went on and made—

P: Because RuPaul was staying with Nelson. Nelson was his mentor.

C: Of course. What happened is they did the book on RuPaul and they didn't even mention Nelson! Nelson is the person that put it all together. Nelson allowed those people to come to New York and stay at his place and introduced them to the Pyramid Club. An amazing space— 9th Avenue in the Meat District.

P: It was just totally dedicated to celebrating everyone downtown; it was like that was his whole life.

C: That allowed the introduction to all those people including Michael Musto, who was a like a real wallflower and not very social and not adept at being social. Nelson would come in with a crowd consuming presence and do the whole videotape thing and spin around and know everybody so that Musto could sort of tag along and be part of this great entrée. Nelson did-n't get any credit really in making him slowly come out, but Nelson was like a video genius; years ahead of his time. Musto, largely with Nelson's help, became a scene player. Musto was a writer for *Downtown*, then finally the *Voice*. Musto wrote about Nelson twice, once calling him a Video Vampire—a short sentence—the second time when Nelson died. Another short snap: memorial gathering for Nelson Sullivan in Central Park. Talk about paying back your friends.

P: I think that happens throughout; there are people who are totally forgotten. I think the people that get remembered are the people with the best PR, not necessarily the people who have the original ideas. So you get figure heads. I think history is a lot of figure heads.

C: But that was the question you were asking before: who came over here, stepped on the avant-garde and then got a little piece and moved on? I would certainly say RuPaul and Michael Musto.

P: But Michael Musto was totally part of the downtown. He evolved, I would say.

C: But I'm saying it's hard to show up in a place when you're shy and be the journalist getting in the door. You need a diversion. Nelson had the camera, which everyone loved. Nelson made people into "stars." Nelson was able to gain access from club to club to club and that's what Musto wrote about.

P: His only mistake was dying. I'm sure Nelson, had he not died—Also his family grabbed all the tapes and wouldn't let them out for years and years and years; it was in litigation.

C: I didn't know that part. I knew that Dick Richards from Funtone Records had his whole col-lection, but I didn't know about the litigation. Whenever I spoke to Dick Richards he was always open and generous. I felt that he was the savior of Nelson's important archives . . .

P: At least that's what I heard. But that's a lot of people's problem.

C: If you don't have that savior to pick it up and do something with it, you're dead.

P: It's usually a savior who can further their own career by it. It's not done for your sake; it's done in someone else's name. They can attach themselves to your name, popularize it.

C: Thank god though; I don't begrudge anyone from doing that.

P: That type of symbiosis I don't begrudge anybody. For all along I think the local media just doesn't—they're not very good at, shall we say, ferreting out realities. I think that our local arts media has blinders on.

Clayton Patterson

Philly

C: I don't even think there is a local art media, is there? Entertainment media is different because that is for the mainstream. But *Artforum*—art magazines—those print agendas have been dead issues since the beginning. They are about promoting already existing, paid-for concepts—a corporate point of view—or promoting SoHo or Chelsea. Magazines like *VU* were much more interesting somehow. I don't read the art magazines.

P: I never really did. If someone else has it I'll look at the pictures. It's a real sign of desperation if I'm going to art openings. I do it occasionally just because I like to see—usually it hits me pretty oppositely the total banality, the total emptiness—the total empty shell is a delight and sometimes the hors d'oevres are good [chuckle].

C: Although the art media, which was interesting for me, I would say, really would have been the *East Village Eye*, the *Manhattan Mirror*, *Downtown*, *NY Press*—when the office was downtown was very good for quite awhile. John Strausbaugh, Jim Knipfel, Sam Sifton, did some wonderful creative stories. There were different local publications that would keep people informed. I also felt *Newsday*, when it was in New York could be helpful. The *New York Times*

City and Metro sections can be very good. Colin Moynihan has done some great writing on downtown people and situations for the *New York Times* . . . But at this point I don't think there is anything. The *Village Voice* has been dead for years.

P: Yeah, but it's good only for listings of events and they don't even list everything. Maybe because the scene, because there's nothing to write about; there are individuals but there isn't a scene. People like scenes because scenes are something that people can wish they were there or try to get themselves to; with individuals it's just not really that interesting. It's weaving it together so someone can wish that they could be a part of it. Now it's fashion.

C: Is there going to be another film video scene here? I don't know. It certainly is possible.

P: I think things have moved on to the Internet. I've got stuff on the Internet but I'm not really Internet savvy.

C: I think the Internet sort of played itself out though, because if I look at a few years ago when the Internet was becoming commercially viable and the computer became commodity viable, a lot of people were into it. I remember pseudo.com started and Taylor Mead had a show and that would be like—

P: But pseudo was like an accident waiting to happen. Anyone who saw their parties and stuff knew that they were a paper tiger—it was a party machine that had media to justify itself.

C: But they did do the media, and that ended. I remember when these small little televisions came out. We did the first—supposedly it was the first—it was a live radio, performance, television and computer broadcast. It was using one of those little tiny video cameras that you just sat on top of a computer, using one of those and then using it through the internet in different cities. We did this at Alt Café.

P: People would rather show their genitals at this point.

C: Let me finish. You had this performance that was actually an Internet café which was one of the first places downtown with computers. But all those things stopped.

P: In the same way that was cable. Cable didn't come to downtown in our area until rather late. I think had there been cable downtown in this side a lot sooner you would have gotten a lot more on.

C: That's true. Anyway I think the computer thing is sort of, seems to have ended. People don't seem to be carrying on with it.

P: It seems like a lot of people I know are totally wired to it but they're wired to it in a personal ad kind of chat way.

C: Yeah, there's no performance in Toronto—coming to a club down here and people watching it on the Internet and sending something back. That was the idea this night we were doing; I haven't seen this idea picked up. I'm not saying that it won't be, but the real magic of the computer is the email, attachments and sending information around. Eric Miller has been trying for a long time to do world Internet conferences. So far he is still trying to get people interested. People have done cable television for a long time. Cable TV never became a scene and I think you're right about that, that it didn't become possible to have cable down here until late '80s, or something. I don't remember when it was, but it was really late.

P: It was very, very late. If we did, I think it would have followed everything that was happening.

C: That would have become the new Naked Eye Cinema. I think you're right.

P: Jack and Peter did have a show on cable.

C: . . . Cable came too late; that's true. The whole identity of the neighborhood is lost now too. At that time I would know Philly down there on Ridge Street—John on 3rd Street. You'd walk around the neighborhood and it was really a small town. Now you go out there and there isn't that same sort of reaching around possibilities.

P: I still run into people on the street.

C: But it's not the same. It's becoming like Greenwich Village. Greenwich Village you walk through now and it's just another neighborhood in New York and there's no personal personality.

P: Unless you had an apartment that was rent controlled, unless you've done amazingly well, you can't afford to live here.

C: So that neighborhood aspect is gone, and losing that whole possibility of a larger scene where somebody could be on 13th Street and somebody could be on Houston Street and somebody else could be on Cherry Street, and you still had that connected scene.

P: I actually like Chicago. The Chicago Underground people have an amazing little scene going. They have a really friendly festival. They have a bunch of cottage filmmakers, like Shawn Durr, who are just amazing. And they hang out together; they enjoy each other's company. It's really fabulous. I think that New York's day for that is over.

Clayton Patterson

Philly

C: I guess that's part of doing this history and HOWL!—it's kind of like collecting together what was here.

P: Is it collecting or is it making a mausoleum?

C: Well, it's probably both. Maybe a mausoleum—it's time for a mausoleum because that's the next step. I mean mausoleums have their place too.

P: People are making movies all the time. Again, it's seeing the people's work.

C: Down here some people are making movies. Right, I think it's true, but we're individualized. Now we're like SoHo: everyone in SoHo lives in their own lofts in their own space and they no longer have a neighborhood. It's now a shopping area. It's true; it's not like everything has died over here. As a matter of a fact, there's some people doing some magnificent things. The people that run A Life, the store on Orchard Street, have a truly creative operation. They are going to make a creative contribution to the world. The graffiti crew IRACK has some very talented fine artists in the posse. Marco of Marco Art is truly commercial, but he has gone from selling paintings on the street to being an Olympic Artist. He's from the Peter Max school of

art, but has climbed the mountain.

P: The closest that I've come to a place that's a neighborhood place is Lotus. Do you have others that you still like?

C: I go to the Pink Pony once in a while because of Lucien. Lucien is a nice guy and very open, and a lot of people are coming through.

P: It's not what the Pink Pony was before, which was the cheapest cup of coffee. But the Pink Pony it's now a French bistro. It's still plays some of the same role as the Pink Pony.

C: I will say though, on Lucien's behalf, he has a family, he has to pay the high rent, and he has been very supportive of struggling artists. He has fed a number of artists and poets for a long time at no charge. Rene Richard certainly comes to mind. Lucien is a beautiful generous person.

P: An $18 meal or a $20 bar tab for like a couple drinks—I go and have coffee on occasion.

C: I went to a place on Sunday, one of the very good places, I went over there for a beer—one of those new restaurants. I went in there and had a beer and the beer was $9. Beer $9?

P: You can still have dinner in Odessa's and a lot of other places for under $10. That's the one thing.

C: Most of those kind of options have ended—the possibility of going out, just meeting somebody, running down the road—get a cup of coffee, maybe go to another place. You're either gonna go to Lotus, do a little time there, have your coffee, or whatever. You're not going to move on to Lucien's and have another one.

B Do you still go to Mars ever?

C: I haven't been over to Mars in a long time. I have not gone to a bar in a long time, unless it was just to meet someone for a few minutes.

P: I'll send people who are going to the city—you wanna see an old time bar—you wanna see a thrashy place? Go to Mars.

C: That's true. I recently went there with Jonas Mekas. I interviewed Jonas, and he goes there and drinks a glass of wine at lunch time. I videotaped Jonas drinking his wine and captured the place. I felt fortunate to be able to catch that place and that moment. What Jonas has built is truly amazing. He deserves to be called a national treasure. But the Mars bar—that possibility—those kind of artistic scenes are becoming an extinct part of the neighborhood. I'm happy that some activities are starting to happen here again because for years they weren't. Once I got involved with politics in 1988, I became fixated in that role. I want out.

P: What's your last court case?

C: One Police Plaza: they said I beat up a bunch of cops, assaulted several officers, and they were all injured. Some of the stories are unbelievable.

P: There was a drag queen who was given the same thing. He was protesting in Brooklyn outside of a theater that I think became a coffee shop or something. He's like this skinny little kid and he wound up with a broken arm or a broken leg. They said that he beat up all these cops. It's like the cops are getting beaten up all the time. Like they can't go down the street without getting beaten up.

C: That's my last case and I'm hoping to move on from that. I'm hoping to get back into more creative things and be an individual again if that is possible. The cops are like the elephants, they never forget. That's why I'm hoping this HOWL! has legs, because I think maybe out of the celebration . . . The cops made a little stink when they realized that I was on the board of HOWL, maybe this is one of the reasons that the organizers had a tough time getting permits. But my hope is, maybe out of this celebration, outside people can actually look to this neighborhood and go, "Wow, there's creative people on the LES." Some make films like Philly, and they can see this rich pool. . . . How does anybody come down here now and know about Philly the filmmaker? Before all one would have to do is know to go to ABC No Rio on Friday nights.

P: Or they could go to Two Boots or to Kim's Video. The stuff is out there.

C: Well that's the thing. Before we could just come here, go to ABC No Rio and all of a sudden everything would be kind of like . . . You'd go to No Se No and there'd be these other currents going through. So I'm hoping that with this HOWL! Festival that the neighborhood will get some sort of creative identity.

P: It's not the time period for this kind of thing. All things come in waves. It's not a little village; it's a military entertainment complex. New York used to be a theme park and now it's a military entertainment complex, carefully policed.

C: Sort of. But you know, it's such an individual place. The rest of America isn't going to come here for their entertainment. All those people in the west, like you say when you were growing up in Philadephia, [say] New York was a dangerous awful place.

P: That I dreamed about.

C: New York is not going to become this art camp where people come here for entertainment, because they come here because of its uniqueness. A lot of the entertainment and art that's here they consider trash anyway, so we're not into it.

P: Trash sells.

C: Trash sells to certain people.

P: Look at television. I'm not talking about good trash.

C: Right, well that's a whole other story. Television I can't really watch any more because it's a whole other part of the desert that I am not interested in. How does one reinvigorate or—it's important since one is here to have the creativity happening, because you want to have that creativity in your life, otherwise you don't have a life.

P: I'm alive when I have it. I can't say that it's going through me all the time. I must admit that I have times when the sky is totally empty. Either that or it's alive with like a million different things.

C: Right, it doesn't happen in a vacuum. The whole sort of responsive community—

P: At this point my community is scattered around the world.

C: Actually, that's what happened with me too. Working as an organizer for Steve Bonge and Butch Garcia's New York City Tattoo Convention and their Hot Rod Tattoo Convention has been a big inspiration in my life. Europe, and in particular, Austria, has also been influential in my life. Jochen Auer's Austrian Wildstyle Tour has been great for me.

P: Austria? I went to Digifest which was amazing. It's a digital festival—radical amazing people. Viennese are really fun, at least the radical ones.

C: What about Toronto? Are you still involved in Toronto?

P: Not really. Everyone I know from Toronto is here. The *Art Metro* people were interesting. They were able to capture a certain essence of chi-chi mentality.

C: But you don't go up there and show films anymore?

P: No—I mean in other people's movies. There was a Vancouver film theater that Todd would show his movies in and they really liked it.

C: So when you're working with Todd are you mostly acting?

P: Acting and collaborating, and in the next movie I'm going to be directing.

C: Okay. When you say "collaborating," what does that mean? Writing storylines—

P: Storylines are mostly improvised, but working on stuff with it. In his last movie, *Anonymous*, I just did little cameo things throughout the movie. The previous two I starred in: *Take Away* and *Once and Future Queen*.

C: Did these follow scripts?

P: They're scripted—his last movie is scripted. The others we had a story line; we [had] treatments and we went out hunting. Not specific story boards, but story lines, yes. I mean at this point, I think that for myself it seems like a story line is a theoretical construct. Basically I've worked with him with character and narrative. It means people do things with narrative and

it's not necessarily linear. With the Kuchar brothers: with George it was mostly interview stuff and with Mike it was working with scripts where he writes down the words and you just say them. So it's real acting.

C: So you consider yourself an actress too.

P: I consider myself a bit of everything. I just find starring in my first movie means it's easy. That's one less person I have to worry about showing up. I know if I'm there, I'm going to be there.

C: Do you still see Samoa and Kembra and all them?

P: Yeah, yeah. I see them in the street and we talk. Kembra [and I] got together a little while ago and were talking.

C: Is she making films at all?

P: I think she's basically doing visual art. She was in Annette Evelyn's movie. And Samoa's doing the Lonely Samoans, I guess.

C: He is doing the band and painting and Kembra is doing painting and was doing the band for a long while.

P: Yeah, but they're not doing the band together at least. From what I gather, Kembra's basically painting now.

M. Henry Jones & Snake Monkey Studio

by Ray Jadwick

As a filmmaker, animator, and cinematographer, M. Henry Jones' intensity and obsessiveness have been judged as a result of everything from pure madness to a serious food imbalance. But through it all, for the past 20 years, he had consistently created works that are recognized as some of the most brilliant independently produced animations of our day.

Jones arrived in New York City back in 1975 with a full scholarship to the School of Visual Arts. In 1976, he attended a screening of legendary filmmaker Harry Smith's *The Tin Woodsman Dream*, and before heading home for the night, managed to torture Harry's address out of fellow filmmaker Jonas Mekas.

"The next day I introduced myself to Harry at the Chelsea Hotel and never left. We became close friends in a student/mentor type of way, staying up for days on end discussing his theories on unframing the boundaries of vision, defeating linear time constraints, and sculptural film layering techniques. At some point in 1977 the clutter of my "Soul City" project became too much for this space. I returned to the School of Visual Arts, stashed a mattress behind the animation camera and worked nonstop on the *Soul City* thing, going home for a shower and shave every few days or so."

Ushering in the artist/nightclub connection that peaked in the East Village during the mid '80s, *Soul City* premiered at the legendary Max's Kansas City in 1979. The 2-minute photo-animation, a visual marriage to the Fleshtones' "Soul City" audio single, was heralded as an artistic triumph, but to Jones' financial dismay, no one knew quite what to do with it.

Although he never received the recognition one might expect, the award-winning film (completed with a Metropolitan Museum of Art send off) did tour internationally and he does now get sporadic credit for helping give rise to today's rock video format.

"The *Soul City* experience was fantastic. It was an exciting period, 1977–1981, although in terms of actual new film production it may appear that I was, aside for some short commissioned pieces, sitting on my ass partying away whatever celebrity status *Soul City* afforded me. I was hanging with Keith Haring, Kenny Scharf, Ann Magnuson, Bill Landis, John Sex and Wendy Wild at Club 57 on St. Mark's. Looking back, I now see that what we accomplished then was to plant the seeds for the East Village mid '80s art explosion. While every one else in the world seemed to be involved in weird process-art, like getting a dumpster, driving it to some SoHo gallery and dumping a bunch of rock and stuff on the floor, we got involved in things more pertinent o our own lives. Bill Landis started his *Sleazoid Express* review of trashy films, Lisa Baumgardner started *Bikini Girl Magazine* and the '50s sci-fi Monster Movie Club was in full swing. Between Club 57 and Richard Collichio's 51 X Gallery next door, there were nightly performances and all sorts of far out happenings. It was

Clayton Patterson

Henry Jones showing a Harry Smith film

out of this energy and spirit that the Fun Gallery opened on 2nd and 12th. It was a great peri-
od. I guess my 3 1/2 minute *GoGo Girl* animation which premiered at the '82 Downtown Film
Festival was my artistic reflection of the times."

Later in 1982, Jones started his *Apple Heart Daisy* film and uncompromising concept of multi-
level animating loops with a soundtrack featuring the vocal of Angel Dean and Amy Rigby. It's
an animation he's now invested some twelve years into and one that he's sure could save the
planet should it ever get finished.

"Once I started *Apple Heart Daisy* with Susan Tremblay, I disappeared into my apartment
for weeks on end. The only time anyone saw me was when I'd run to the corner for a slice of
pizza or when I need to borrow money for art supplies. I never even answered the phone
back then. I survived like that for two years. That is until there wasn't a person left to borrow
a dime from and I realized I needed to get back in the real world to make some money and
pay these people back."

Economic reality was forcing *Apple Heart Daisy* to take a back seat. But what was more
meaningful than saving the planet? In 1984, M. Henry Jones returned to midtown's Globus
Brothers Studios, where he interned as a student back in the mid-'70s.

"Returning full time to Globus Brothers wasn't that bad of a thing. The place was set up big
time. Believe me, it was no place parents took their kids for headshots. My main responsibili-
ty was working with Count Roger DeMontebello, the world's by far leading 3-D photographic
genius. As Harry Smith was to experimental film animation, Roger was to pioneering super
advanced 3-dimensional photographic processes. The big thing we were developing was
something I called the Fly's Eye Project. Simply put, this consisted of shooting over 2000 indi-
vidual perspectives of an object and bringing the images together into a single virtual image.
But it was anything but simple. I had to pour a plastic camera, like a jello mold, to tolerances
of a quarter thousandth of an inch. We literally spent months just figuring out lighting, angu-
lar view, and the physical requirements of shooting and breaking down an object into 2000
individual perspectives, and that was before we actually developed a singe picture and dis-
covered that we had to re-figure the lighting, the angular view, and the physical requirements
of shooting and breaking down objects into 2000 individual perspectives. To this day they're

Henry Jones Archives

Henry Jones at work

still the most advanced and remarkable samples of 3-D images in the world. The writer who reviewed my July Unprojector show at the SoHo EM Donahue/Ronald Sosinski Gallery wrote that 'they gave renewed reverence to the must see to appreciate tag line,' or something to that effect anyway. The project came to a halt for two reasons—number one, Roger died and secondly, the cost of researching, developing, and producing these images was more than that of feeding and arming a third world country. It was a great gig. By day I worked on this fantastic project, at night I worked in my apartment on multilevel flower and bee sequences for the *Apple Heart Daisy* film with Eleanor Blake. And I did manage to pay everyone back.

In the meantime Jones met up with Robert Munn, a fellow 3-D enthusiast.

"Robert was a genius with the 3-D. He was and is always taking it to the limit. We were doing 3-D projection shows together in various downtown clubs. He always wanted to make the screens bigger, then he started with lenticular photography and we have worked together ever since. Now he has Depthography and we are able to make those giant 3-D lenticular prints. "

In 1988 Jones was commissioned to produce a 30 second cell-animated television spot for America's Best Eyeglasses, a nationwide chain based in Philadelphia. The relationship lasted 9 years, spawned 8 TV commercials, and gave birth to Jones' Snake Monkey Studio.

"The situation was ideal. I figured I'd spend 5 months a year doing a commercial and 7 on my *Apple Heart Daisy* thing. For the first couple of commercials it worked out great. Originally I only hired one or two people to assist me. We had a great time and did some really far out stuff. One of the commercials even ended with the world exploding! I don't know how I got away with that one. But eventually I got so involved in the actual work and animation that I was lucky to pull off one in 12 months. The thing just got bigger and bigger. I figured I had this opportunity to produce these animations in a manner that probably no one else in the world had and, considering the computer takeover of the medium, will ever have again. I had total creative control and a client who understood and even appreciated my obsessiveness. They'd also be shown throughout the country reaching an audience of 100 or 1000 or 1,000,000 times more than would ever see an art film that gets shown in a museum or, once in a while, on some strange television show."

With his apartment getting increasingly cluttered and the neighbors becoming increasingly

suspicious and annoyed by the round the clock activity, in 1992 Jones moved Snake Monkey Studio to its present Ave A storefront location. You can always tell how close to a deadline he is by how long the gates stayed up. During the mermaid commercial deadline, 8 people worked around the clock for 2 weeks, taking turns, sleeping on a couch beside a taped-to-the-wall "things to do" list that was 12 pages long.

"Deadlines are an abstract thing to me, I never think about them until they arrive. It's not about finishing anything—it's about torturing people, pushing at absolute limits and the process of creating art. If you harness as much of the real talent that walks through the door, you should be able to bump it around enough until a unique and lasting work creates itself. That's really what it's about."

The list of talent that Jones has at one time or another tortured reads like some sort of who's who: Tom Marsan, art director at MTV; celebrated East Village artists James Romberger, Marguerite Van Cook, and Kiley Jenkins; premier New York story-board artist Matt Karol; stop-motion pioneer Bob Franz; graffiti artist Revolt; actor Rockets Redglare; guitarist Stuart Grey; sound engineer Larry Seven; Robert Parker and Tovey Halleck from the Rivington School and No Se No fame; master carpenter/painter Cosimo Bassi; model expert Mini Moto; trip-hop punkster Z Jadwick; filmmaker Tommy Turner; sculptor Robert George; fashion designer Judy Rosen; director, filmmaker Rachel Amodeo; Loren Stotski; Lisa Barnstone; Mike Wolf; Ester Regelson; David Bohren; Tome Cote; Jennifer Tull and on and on and on. If the list were all-inclusive it would have to consist of half the pre-gentrification East Village population.

"The America's Best thing came to an abrupt end with the 1997 death of my client and benefactor, Joey Land. Although the circumstances were tragically sad, it was probably time for me to artistically move on. I had a great 9-year run completing 11 television commercials: 7 cell animated and 1 stop motion. All of which I, and everyone who helped, can take great pride in. Most have been shown at the Museum of Modern Art, while all 11 are included in the British Film Institute's permanent avant-garde film collection."

In 1991, Jones' old mentor Harry Smith received a Grammy for his American Folk Music work. The award renewed interest in Harry Smith in general and when the America's Best thing ended in 1996, at the request of many, Jones began putting together a full-scale re-creation of Smith's multi-projectorial film extravaganzas.

"It's kind of whacked that given Harry's massive body of work in experimental film and animation that what brought him culturally to the forefront was his contribution to American folk music. But I guess that doesn't really matter. What's interesting is that since the early '80s, whenever I came across a piece of equipment Harry either used or talked about, I'd pick it up. Most of it was by then obsolete and usually found at flea markets or in midtown garage bins. So when the opportunity arose to orchestrate these re-creations,

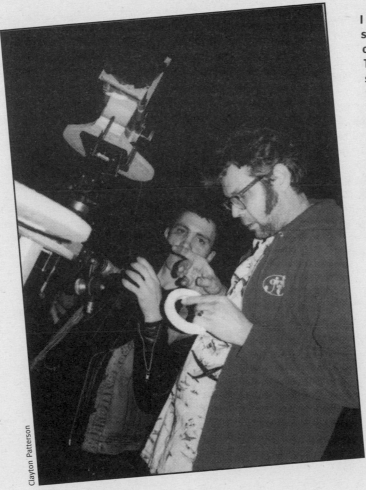

Clayton Patterson

Henry Jones showing a
Harry Smith film

I had already subconsciously collected most of the equipment. There was a lot of stealing parts from three or four projectors to put together one that would actually work, but for the most I was able to concentrate on the actual imagery. Harry's work is disguisedly complex. You could look at them forwards, backwards, or over and over and each time new experiences are revealed. No two showings of the same piece were ever meant to be identical. He always said the purpose was to create a false dream-like state, so that by the film's end, everyone in the room was asleep with their eyes open, and if you accomplished that, you've achieved your goal. He made films to present never before seen experiences and image. In 1916 when D.W. Griffith began formulating a film language, the money people decided it for him before he was able to explore it fully. Harry never bought into the limited result that this language inspired. Besides the 35mm projector, Harry incorporated magic lantern, slide dissolves and manual interrupters. He would take his films and project them through a variety of images that went through, around and into the projected image. He was involved in unframing boundaries of vision to the point that his works took on a sculptural aspect."

In 1996, "Harry Smith," a re-creation orchestrated by M. Henry Jones, with DJ Spooky providing the live soundtrack, premiered at the book release party for *Harry Smith: An American Magus*, published by Inanout Press. The show worked so well that it hit the road including performances at the Walker Art Center in Minneapolis, The Cleveland Public Theater, London's Institute of Contemporary Art, and the 1998 Rotterdam Film Festival.

Encouraged by reviews heralding the re-creation for following the spirit of Harry Smith's work, as opposed to merely the letter, Jones returned to his Snake Monkey Studio to begin a series of pieces that would further his head-first plunge into Harry's unframing theories while relating to his own 20-year body of work. Only this time Jones was leaving the projector behind.

"I envisioned pieces that would completely free animation from the confines of 24 images per second by utilizing sculptural carriers that could bring the images to life without the trap-

pings of a projected rectangular viewing frame."

Jones came up with a series of stroboscopic zoetropes and zoetropic-like animations matted onto sculptural carriers that hold the registration. Utilizing single-phase electric motors, salvaged industrial pulleys and belt-driven axles, he creates a 1950s-like work of ingenuity that provokes at least momentary longing for the world that might have been had the computer age not dawned. Most of the works are cyclical in nature (mechanically and artistically), while one of the pieces incorporates 64 re-worked original frames from 1982 *Go Go Girl*.

"While most animations begin and end at different points, the cyclical nature of the work is a way of defeating the linear time frame. It's a way of designing complex animating cycles that can sustain multiple viewing while their self-replication nature opens the door to an almost musical score-like world. By varying the motor speed and stroboscopic light bursts, you can dramatically change the entire nature of the piece. While people have run film at speeds they weren't intended and may have gotten some cool effects, for the most part they're usually recognized by the eye and the mind as running at the wrong speed. What I've done, or at least tried to do, is to create animated images that can be, and long to be, appreciated and orchestrated like patterns of music that invite over-involvement by the very nature of their non-interruptive time dimension. The work with Depthography carries all these issues into the picture plane and adds the three-dimensional aspect."

Smile for the Camera: East Village through the Lens

by Jeffrey Cyphers Wright

New York was cold and bleak that January of '76 I came up through the Holland Tunnel and landed on East 11th Street. Started going to films and parties. A wizened old wizard named Ray Wozniski was showing his films at loft parties—b&w documents of a bygone era, of Peter, Paul & Mary types hanging out in striped boat shirts on bucolic farms in the Hamptons.

The third generation New York School jelled that year around Ted Berrigan and St. Marks. We hot acolytes absorbed the connections of our elders with alacrity, meeting everyone we could, from John Giorno (who went on to make the Nova movie with William Burroughs et al at the Yiddish Theatre at Second & 12th) to Rudy Burkhardt who lured us to the Millenium to see his naked women and blowing leaves, his short scenarios with Aaron Copland, Willem deKooning and Edwin Denby.

Still in the shadow of the Factory we were enthralled by its stars who hung around the Poetry Project. Gerard Malanga, Rene Ricard, Taylor Meade and Jackie Curtis. When Eric Mitchell's "Underground USA" premiered at St. Mark's Cinema we batted around gaga as the actors congregated on the sidewalk. Patti Astor smiling. Rene in sunglasses smoking an endless fag. Our bonds were forged then as we began to rise to our own flame—Bob Rosenthal, Shelly Kraut, Eileen Myles, Barbara Barg, Bob Holman and the Mag City boys.

Shelly Kraut started Film Night at St. Marks. Doris Kornish and I went to Charas to recycle our bottles and I started doing workshops there. Ed Friedman and I cooked up More Party than Arty and Doris was our film jockey. We gave Mikey Piñero his last reading days before he OD'd. Doris started Films Charas. Then Phil Hartman came along and he and Doris did a movie called *No Picnic*. I played a spiritual jock bartender in a scene shot at Darinka, run by Gary Ray who was famous for having a part in *Desperately Seeking Susan*. Rockets Redglare did some doorman stints at the World. Jack Waters and Peter Cramer were getting Naked Eye Cinema off the ground at gritty ABC No Rio.

Our resident lesbian, Rose Lesniak, got a hundred thousand grant and made three videos that premiered at the Public: Allen Ginsberg, Anne Waldman and Bob Holman. Poetry cable shows started up. Bob Rosenthal, Didi Susan Dubleyew and Greg Masters hosted "Poetry in Motion" and ran two dozen shows. I was paired with John Yau who read "The History of Honey." I read "Malaise in Malaysia" for Alice Notley. We went to Cedar Tavern afterwards and conjured ghosts of AbEx excess.

By the late '80s there were so many cable shows coming out of the East Village that every time you turned on TV you saw somebody you knew. We were all famous for 15 minutes! Before I met Fran Luck, the housing activist, I'd seen her on TV talking revolution and rent control. Robert Bailey had a weekly poetry show. Mitch Corber started

Radio Thin Air. We were riveted by Rik Little's *Church of Shooting Yourself,* when it aired the tank rolling up 13th Street to battle the squatters.

By 1986 I quit writing for the *East Village Eye* and the *SoHo Arts Weekly* and started *Cover Magazine*. Deputy Editor Ilka Scobie and I hosted the first readings at the Knitting Factory. Mitch Corber videotaped a lot of the readings and later released them without permission from the authors . . . Allen Ginsberg, Amiri Baraka . . . nobody minded but Clayton Eshleman. Alan Moore became our typesetter. Alan was running the MWF Video Club and to defray my expenses I offered to help market and develop his venture. We gave Roger Richards a hundred bucks to give to Herbert Huncke for an interview. They spent all of it on toot and talked for two hours while Clayton Patterson filmed. Six months later Herbert died and the interview was never seen.

True to its name, *Cover Magazine* tried to cover all the arts. Cover stories alternated between film, music, art, fashion and literature. Our second cover was the only cover story featuring Rudy Burkhardt during his lifetime that I know of. The fourth cover was on Doris and Phil's *No Picnic* and then Doris interviewed Jacob Burkhardt for his feature, *Landlord Blues*. Valery Oisteanu paid tribute to Jack Smith, best known for his 1963 film *Flaming Creatures*. Shelley Miller interviewed Henry Jaglom. Timothy Greenfield-Sanders came on board and shot covers of Lou Reed, Pauly Shore, Todd Oldham and Dennis Leary. William Kelly, director of *Reggae Cowboy*, interviewed Steve Buscemi, Kyle McLachlan, Helen Mirren and gave Tim Roth his first U.S. cover. I interviewed Stephen Dorf, Sandra Bernhard and Richard Linklater. Michael Carter covered the East Village Underground film festivals, featuring David Wojnarowicz, the Cinema of Transgression, Tessa Hughes-Freeland, and Naked Eye Cinema. Gill Holland brought us Kevin Corrigan, star of *Bandwagon,* and Brendan Sexton III from Hurricane Streets, shot on location in the East Village and were picked up by MGM. Our last cover was of director Julie Lynch for her movie about New York women and the specter of AIDS called *Getting Off*. *Variety* called the movie "a coup."

The East Village was having a heyday—between the punk rockers, the galleries, the poets and the anarchists, the gardens were beginning to flare up as the struggle to save them intensified. We rallied around Adam Purple and his Garden of Eden. To no avail. By the mid '90s the city began to bulldoze gardens in earnest. Felicia Young's Rites of Spring celebratory parade through the gardens was made for cameras and the wild costumes were shown over and over on the Treebranch cable show. Chico Mendes Garden on East 11th, right beside the infamous crack marketplace, The Rock, scene of a murder a year, became the "Fort Sumpter of the garden movement," wrote Bill Brown in the *Earth First* newspaper. Treebranch aired footage of our revolutionary rhetoric, seed plantings and concerts by Phoebe Legere, Stephan Smith and Roger Manning attended by locals like Robert Parker of the Forge. Mitch Corber filmed most of our poetry readings. David Henderson brought in the Sundance Channel for a full-length poetry documentary.

Anna Magenta and Federico Savini were at every demo filming the colorful, cacophonous protesters like Agi Groff. By the time the city declared a truce, thanks to Bette Midler, there had been one arrest for every garden saved. The duo's footage was edited and shown only once, at Downtown Community TV. The barricade was a sight to behold. It stood for six months. L. Brandon Krall was doing a lot of shooting too and using DCTV for her editing. She was the last person to film Chico Mendes Garden in December of 1997. The next year a major documentary called *Dirt* featuring Adam Purple was shown all around town after its premiere at 6BC garden. La lucha
continua!

Baird's Fish Eye View and
Reminiscences of the L.E.S. Video

by Baird Jones

Mark Kostabi called his series of performance events in 1985-86, which I curated with Mark, the Kosthappenings. We liked to think they were as significant as the Happenings of the '60s, a pathetic example of the hype typical of the East Village art movement. I hired Jim C. to videotape them. Jim C. had just opened Nada Gallery and he was still well known to the East Village gallery goers as a video artist. He had a real herky-jerky style of documenting what was going on, which was guaranteed to give anyone who watched the resulting VHS tape a headache. Jim said it was based on Andy Warhol's stop and go moviemaking style but it was really just a drag and I kept on begging him to stop it—to no avail.

The Kosthappenings were exhibits of photographs that I had taken as Mark's personal photographer, primarily during the summer of 1985 at East Village galleries. The blown-up photographs (mainly black and white) were signed on the matting by both Mark and me. Mark also often doodled on the photo or printed his cynical slogans, which he called "Kostabisms." We had eight of these shows and sold the photographs for $25 a piece. Several of the shows sold out and all the shows were very well attended. Average attendance was around fifty people, typically half artists and half yuppies. The yuppies were my friends from the Upper East Side who were also mainly the ones who bought the photographs. The Kosthappenings were written up in the *New York Daily News*, *NY Talk*, and the *East Village Eye*. They pretty much occurred at the best East Village galleries, although we never had one at Gracie Mansion (although Gracie had agreed to do it). The photographs were put on the walls with double stick tape and the invites were just cheap card stock Xeroxes.

For the last Kosthappening, In Memory of Joseph Beuys, January 23, 1986, we had gotten big enough that we had a bagpiper and extensive security. I paid for everything involved and also kept the money from all the sales. By the end of it, Mark had already become such a star that he was

Clayton Patterson

James Tully and Baird Jones 2003

wary of the event not attracting a good enough crowd to be an acceptable Kosthappening, which is pretty much why we stopped doing them.

The Beuys memorial Kosthappening drew six writers from *People Magazine* as well as the usual East Village artists. Mark danced a mad gyrating jig to a bagpiper, a funereal homage to Beuys' early role in putting the East Village movement on the map, because Beuys had shown up at the Colab Real Estate show at the Williamsburg Bridge in the early '80s. The fact that the Williamsburg Bridge location is technically part of the Lower East Side, while the East Village starts a bit to the north at Houston Street, was always blurred by the artists since Loisaida was where the poor people were, and the painters loved to identify with that group. The Real Estate Show extravaganza ended when the NYC Department of Housing came to reclaim the space. The Department of Housing then gave Colab a different city-owned storefront nearby on Rivington Street, a storefront that was transformed into ABC No Rio. ABC No Rio was later the subject of a book, *ABC No Rio, No Dinero*, which served almost as a bible of how to raise scarce fundraising money in the mid-'80s, and the Joseph Beuys photo next to Ronald Feldman was really the only celebrity photo in the book, so it had a special cachet for Mark and me.

Jim C. tirelessly videotaped the last Kosthappening, which went on for two hours, and one of the pleasures of looking at that videotape now is seeing all the gallery crashers like Eli Mayorca, who is now fat as a walrus, but back then was thin as a reed.

* This is excerpted and enlarged from my book *Mark Kostabi and the East Village Scene 1983–1987*
 (published by Matteo Editore 2002)

Just A Glimpse: The New York Film Festival Downtown

by Tessa Hughes-Freeland

The New York Film Festival Downtown evolved from an idea to put on a large three-day event of film performance and slides that would attract attention to the phenomenally weird and wonderful ways in which people were using film, and would just be a hell of a lot of fun. Both Ela Troyano and myself had been producing film shows, either together or separately for a while, so we knew a lot of people who were working with film. Most of them lived in the neighborhood or hung out there. Back then the community was much smaller and tighter. Also there were probably fifty percent fewer buildings standing or at least inhabited.

The film festival ran for five or six years, long before underground became a genre. Each year it took place in a different nightclub on off nights: Sunday, Monday and Tuesday. The first New York Film Festival Downtown took place in October 1984, at what was affectionately known as the 'new' Limbo Lounge on 9th Street between Aves. B and C, which had previously been a garbage truck garage. Around 40 films were shown. Most were contemporary, and a handful of them were historical. We always showed at least one historical film or a film that embodied the spirit of the festival. In 1988, at The Fifth Annual New York Film Festival Downtown, which took place at 113 Jane Street, a club in the Jane Street Hotel, Sandy Daly showed *Robert Gets His Nipple Pierced*, starring a young Robert Mapplethorpe with his pal Patti Smith talking to him throughout. Also historical at the Second Annual New York film Festival Downtown was James Nares's *Rome '78*, and at the Third Film Festival Bruce Byron, who starred in Kenneth Anger's *Scorpio Rising*, screened his own psychedelic film *Fantasmagoria*.

The emphasis was not solely on completed films. We welcomed works in progress, unfinished films, and shows where artists incorporated film with performance, dance or music. The first year Jack Smith did a film performance that took place mostly in the projection booth. The film rolled this way, that way, upside down and flipped while Jack stated that he was not sure where the beginning was. Another memorable performance, which demonstrated the artistic flexibility that prevailed at that time, was Andy Soma's *White Rabbit*. Andy put his film in the lab for processing, but unfortunately it was not to be ready in time for the festival. Instead he turned on the projector, and using a microphone as the live audio track, gave a live description of the imagery, as it would have appeared in his processed film. The following year he showed the completed film.

The first year Anthony Chase presented *Dagmar Poisoned The Pizza* accompanied by a performance by John Kelly. The next year Jo Andres did an eerily beautiful film/dance performance with painted scrims that she projected the film onto. At the third festival at Charas, Dragan Illic projected onto huge helium balloons.The following year he attracted a huge throng of bicycle messengers to the festival to see *5th, Madison and Park*, which revolved around Mayor Koch's ban on bikes.

It was a film festival but not necessarily a motion picture festival. Anything that incorporated film was shown, Every year M. Henry Jones presented a phenomenal 3-D slide show, At the fourth festival he showed slides alongside go-go dancers, and at that same festival Captain Whizzo, a veteran light show artist from the sixties, did an inimitable projection of colored oils, graphics and other visual imagery. At 8BC in the second year, Nan Goldin presented her legendary slide cycle *The Ballard of Sexual Dependency.*

Most of the festival consisted of short films, but some features were shown, usually as closing films on the last night. For instance the fourth year we showed Jon Moritsugu's irreverent *Der Elvis,* and the fifth year we showed the rarely seen *Superstar: The Karen Carpenter Story* by Todd Haynes.

Clayton Patterson

Tessa Hughes-Freeland and Ela Troyano downtown Film Festival at Charas

Often people focus on the 1985 and 1986 years of the festival as being years dominated by an emerging style of cheap shock, sexual outrageousness, drug driven decadence and revolting horror. David Wojnarowicz and Tommy Turner premiered their infamous *Where Evil Dwells* trailer to the unfinished feature, based on a real story of Ricky Kasso and the Satan teen killing in Northport, L.I. Richard Kern, who showed a film every year at the festival, was pushing his and others' psychological and physical limits with his filmmaking. Lung Legs's films were simultaneously charming and disturbing. Nick Zedd also showed films every year and continued to perpetuate his image as an underground malcontent and self ascribed local cinestar.

Whatever style or sensation occurred, ultimately the Downtown Film Festival was a showcase for all kinds of filmmaking. Curators from Germany, Switzerland, Denmark and Australia all culled films from the festival to show in their respective countries. Fun was had by all. The festival nights were all held together by fantastic masters of ceremonies such as: Dancenoise, Alien Comic, Carmelita Tropicana and the Voice of Oz.

Ela Troyano and I pulled it together all by ourselves for six years. Our friends were dying, people were leaving town and video was taking over. The energy of the neighborhood was changing and so was ours. Several years later The New York Underground Film Festival appeared and so the spirit of subversion continues.

Tompkins Square Park
The Prabhupada Sankirtan Society

by Kapindra Swami

Tompkins Square Park was a happening place in the sixties. Actually, Tompkins Square Park has always been an attraction for those who appear introspective. The park became the hangout for the now legendary hippies. Breaking away from stereotypical American families, they felt free to experiment with sex and drugs. Arriving on the scene at that time in October 1966 was His Divine Grace A.C. Bhaktivedanta Swami Prabhupada, the exponent of Krishna consciousness in the West with his band of disciples.

The contrast of cultures was vast. Yet Srila Prabhupada, known then as Swamiji, was not

Swami Kaprinda

a threat to the hippies. They loved him. He was calm, peaceful and suave. Srila Prabhupada induced the hippies to chant the Hare Krishna mantra—Hare Krishna Hare Krishna Krishna Krishna Hare Hare / Hare Rama Hare Rama Rama Rama Hare Hare—in Tompkins Square Park, which was groovy to them. They danced to the rhythmic beat. Thus the Hare Krishna movement got its birth in the western world at Tompkins Square Park underneath the big beautiful tree near the band shell.

Capturing this historic scene were the filmmaker Howard Guttenplan and photographer Richard Witty. They were able to catch the free mood of the hippies as well as the free mood of Srila Prabhupada and the band of disciples--although they were of two different worlds. But these worlds did not collide or conflict. Srila Prabhupada was so irresistible. He was Lord Krishna's representative from the spiritual world and it was his position to guide the unhappy souls of the material world back home to the spiritual world, called Goloka Vrndavana, where they would be happy forever.

In a short time thousands of American youths became bright-faced Hare Krishna devotees. They in turn turned thousands of others around the world to Srila Prabhupada's magic formula to become happy by chanting.

Srila Prabhupada became the objective personality of a large number of films documenting his presence in the material world. Srila Prabhupada lives on in his books, which connect us to him, the spiritual world, and our dear Lord Krishna—The Supreme Personality of Godhead. His books, Bhagavad-gita, Srimad Bhagavatam, and Caitanya Caritamrta, reveal the name, fame, form, and pastimes of the Supreme Person, thus causing a spiritual revolution in the hearts of honest persons all over the world. Srila Prabhupada is becoming known as the person who saved everyone from spiritual annihilation. The new savior.

Amazingly, his saga began in the Lower East Side at Tompkins Square Park, right in our backyard. Srila Prabhupada remains forever present in his words of instruction.

Kapindra Swami
The Prabhupada Sankirtan Society

Yes No Script

by Gary Goldberg
Transcribed by Mika Deutsch

Bill enter – shoot – leave

T enter – shoot – onstage – stage right table – switches chairs – sits stage right table

Bill enter – shoot – go onstage and stand behind T

T look at B three times – third time B turns back to audience – T goes offstage

B smashes chairs – sit stage left table

T goes onstage sits stage right

B smokes

T smokes, B stares at T

T sees that and moves into corner, back to audience

B follows him on his chair

T goes in chair to stage left table and B ends up behind him upper right stage

T drinks water

B drinks water

T spills water
B spills water
B does tablecloth trick
T does tablecloth trick
B mops up
T mops up dry area
B sees what T does, drops mop and exit
T stops mopping while B exits, sits and smokes. T rises to go.
B reenters and T stares at him.
B becomes visible near stage.
T leaves stage. B gets on stage.
T exits.
B sits stage right table and smokes a cigarette and exits.

Yes No Costume List:

T.
Black gloves
Grey socks
Black pants
White shirt
White glasses

B.
Black shoes
Brown socks
White pants
Black shirt
Black glasses
Yes No Prop List

Clayton Patterson

Gary Goldberg

2 café tables (F. has none)
2 tablecloths
2 chairs
2 plastic pitchers
2 plastic glasses
2 toy guns
20 rolls caps
4 packs rolling paper
4 bags rolling tobacco
20 books matches
2 pairs white sunglasses
2 pairs black sunglasses
2 toy mops
1 grey cardboard placard on string

Drawing by Gary Goldberg

Bill Rice Archives

Drawing by Gary Goldberg

Gary Goldberg (1940–2003)
Films (all 16mm, B&W):
Plates (1990) 11 min; *Mesmer* (1991) 11 min; *Usher* (1991) 11 min; *Big Baby* (1993) 21 min;
Dance (1993) 18 min; *Hearts* (1993) 24 min; *The Bed* (1994) 36 min; *The Chair* (1995) 11 min;
The Room (1995) 7 min; *Boxheads* (1990–1998) 56 min.
All starring Taylor Mead and/or Bill Rice
Chair Man I & II (1998) 24 min & 31 min starring George Gajek
Shine (1991–2000) 33 min; *Fire & Ice* (1999); *Occ Occ* (2001–2002) 51 min starring Gary Goldberg with others

Gary Goldberg by Bill Rice

I met Gary Goldberg in the fall of 1986 at St. Mark's Church during a performance of S. K. Dunne and Jim Neu's production *Buffalo Dreams*. He said he wanted to pair me up with Taylor Mead in a script he was working on. Seemed like a good idea to me. I adore Taylor, *The Flower Thief* is one of my favorite films, so I said yes.

But now, 17 years later, ten films and several live performances in Gary's work, I can't believe he's no longer with us. I miss him and his mad magic and superb craftsmanship.

I'd like to include here a wonderful appreciation of Gary by his friend Rachelle Starr and, since many readers may not be familiar with his work, his script for our first film, *Plates*. Gary Goldberg

One Man Shows of Complete Double Trouble:
Museum of Modern Art, NYC
The Kitchen (in cooperation with Thread Waxing Space), NYC
Knitting Factory, NYC
Anthology Film Archives, NYC
The Millennium, NYC
NADA, NYC

Berks Filmmakers, Reading, PA
Arsenal, Berlin
Kino im Sprengel, Hannover
Kommunalkino Bremen, Bremen
Kommunales Kino, Freiburg
Cine Mayence, Mainz
Scala Kinokult, Ludwigsburg
Wand 5, Stuttgart
Filmstruktur, Tubingen
Off-Off, Copenhagen

Gary Goldberg (1940–2003)
by Rachelle Starr
Painter, Photographer, Performance Artist, Costume Designer, Director, and Filmmaker

In his movies, Gary had the power to erect a profoundly simple structure to illustrate all our archetypal fears. In barren sets and silent black-and-white 16mm film, he gave expression to the anguish and isolation of individuals disturbingly pitted against an alter ego. Using Taylor Mead and Bill Rice as his contrasting duo, he illustrated most of society's "wild and scary animals": i.e. Mother Whore, Baby, Blindman, Nurse, Waiter, etc.

All authority figures, endearing and fearful, psychologically absurd and exaggeratedly portrayed, and usually sporting the security of a stuffed animal or a gun. This was the only way to deal with the unfamiliar or the uncomfortable.

In most of the pieces Taylor was a hapless and occasionally rebellious lost soul who incurs the wrath or invites the domination of formidable Bill.

By posturing, gesturing, struggling, and always competing, the search for freedom from societal stresses is re-enacted.

Gary examined every minute detail in his own personal life, no corner ungazed, every card on the table. Never a wasted moment. He left hundred of scripts unfilmed, writing every moment.

Some of his personal favorite artists: Carl-Theodore Dreyer, Emily Dickinson, Harold Pinter, Samuel Beckett, Lenny Bruce, Ma Rainey, E. E. Cummings, Buster Keaton, W. C. Fields.

Plates
Ordinary china, bare table, stark lighting. Exits right (Taylor) and left (Bill).
Enter Bill with 2 plates.
Put plates on table. Exit.
Enter Bill with 2 plates.
Put plates on plates on table.
Sit chair left. Pause.
Enter Taylor, sit chair right. Pause.
Bill takes his top plate, puts it on Taylor's plates.
Pause. Bill takes his bottom plate, puts it on Taylor's plates. Pause.
Taylor drops and breaks first plate. Pause. Taylor drops and break second plate. Pause.
Exit Taylor.
Long pause.
Exit Bill.
Pause. Sound of one plate breaking.

Rik Little and the East Village Camcorder

by Rik Little
Transcribed by Mika Deutsch

I came to the East Village in the summer of 1976 to attend the NYU Graduate Institute of Film and Television. It was located on East 7th Street next to Kiev on Second Avenue. At the time Kiev was just a greasy spoon diner and NYU was not the mill or real estate force it is today.

For me I was in Bob Dylan Land near Bleecker Street where D. A. Pennebaker had shot the video [actually film] of *Subterranean Homesick Blues*.

Cops were still old school. Tall and fit. Sometimes one or two would stand by as we shot mayor's office–permitted movies on the live streets around the Lower East Side.

East of Third Avenue was still considered "unsafe" for the average city dweller. Too dangerous to visit and not a place to live.

My landlord would bug me asking if I knew anyone else who wanted to rent a $160 per month apartment. Two months rent free if they wanted to paint and fix their own space. I filled the building.

Still the general population was poor international. The stage for artistic expression was ripe. You could always hear the drums in Tompkins Square Park all night long. Punk rock was growing out of the Lower East Side and more white kids moved into the funky cheap neighborhood. Hip-hop exploded off of Second Avenue and graffiti tags soon overshadowed the city condemned building tags. Then the art gallery explosion of the early 80s and East Village real estate boom as the media popularized the chic artist enclave to the point where everybody suddenly wanted to live dangerously in the East Village.

This was where the city allowed the heroin and prostitution. Where it had long ago shut down firehouses and warehoused foreclosed abandoned buildings. It was all a prelude to the yuppie insurgence of 1986. The "Yup Offensive" as we called it. The drums kept them awake all night and the city was tired of all the political flack, which predominantly emanated from around Tompkins Square Park. So starting with just one noise complaint from this yuppie corporate investment broker, the cops got tough.

They would suddenly enforce long forgotten laws on artists they didn't like . . . often killing them as with Michael Stewart being choked to death. I would just sit and watch them confiscate radios and paper bags with drinks in them. They tried to enforce curfews but the long-time residents were not going quietly.

More and more the police morphed from actual beat cops and an actual police force into a Nazi-like army who often split up into roving gangs of thugs with guns and badges to terrorize the neighborhood they hated and considered scum.

By the summer of 1988 they just covered up their badges and started a bloody war in Tompkins Square. Beating people bloody and riding over them with horses. It was the Tompkins Square riot.

They had gotten away with so much in the past and the Lower East Side, with its troublemaker reputation being served by the media, seemed perfect for a plausible denial of any wrongdoing by the police.

I heard the helicopter in my 11th Street apartment near Second Avenue. I

went to the roof and saw just how close it was. It was just above the four-story roof over the intersection of 10th Street and First Avenue. It was like a hurricane of chaos. Lights flashing and cops beating citizens. I had a still camera, which I shot and ran. Cops were breaking in doors like stormtroopers. Teeth were smashed into bricks and pavement. Fingers were severed. Blood was all over. It was an all out war. Father Kuhn from the Church on Avenue B said it reminded him of when the policia turned on their own people in South America.

Usually the police could finish their punishment of this community, uncover their badges and go about their business of prepping the media and denying the charges of abuse.

Except this time they miscalculated the graphic damaging impact of images shot on the newly invented camcorder video cameras shot by two local artists. Clayton Patterson and Paul Garrin had camcorders and there was no arguing with the images. The cops were covering their badges and were attacking the citizenry.

I snapped a few stills but there was too much going on on the Lower East Side to ignore camcorders. I had been struggling to make a 16mm film about Jesus in NYC called *The Last Beer on Earth*. Suddenly the real history unfolding became much more inspiring and I soon got a camcorder and re-started the project on video. It involved shooting myself holding the camcorder out on a stick with the real history unfolding in the background.

The background was cops holding down protestors or invading homes. Soapbox speeches by locals venting on the corner of Tompkins Square Park and the inevitable crackdown upon them by the authorities.

The cops got their own cameras and started shooting back. The police force became an army taking orders from the top. They confiscated or smashed cameras of residents, created media pens at every encounter, created undercover task forces and played bouncer to the powers speculating on the real estate profits to be gained on the Lower East Side. The long-time residents would not be disposed of and a creative circus world evolved in the stand-off drama between the old and new. It was a great background for me to use to shoot myself with a video camera.

I started feeding clips I had shot into my friend Maurice's public access show in MNN. Soon I got my own show and called it *The Church of Shooting Yourself*.

It was a weekly 29-minute series about my character, who shot his entire life on the Lower East Side to prove what was the actual reality in his life. I played a newsman named Rik Arithmetic and alien images came out of his television set inciting him to move. This character knew that if he saw it on TV, that it was real.

By this time in 1993 my original landlord had sold my building and it was resold twice again before I got the slumlord. A slumlord who did everything possible to induce long-time rent-stabilized and rent-control tenants to vacate so he could renovate and get up to ten times the rent. Water, heat, electric and quiet enjoyment in my apartment was systematically shut off. My landlord stopped accepting my rent and then slammed me several times in housing court. When I still didn't move he sued me in NYS Supreme Court for three million dollars in a trumped up libel suit claiming I had written "Evan Bell Slumlord" with graffiti on buildings and that it had caused him three million dollars in suffering.

Meanwhile I proceeded to learn law and defend myself pro se with the defense of truth. I videoed all the rodents and drips coming through my ceiling and walls.

My landlord had been quite successful at clearing the building out and soon he was renovating six apartments at once. Three above mine, two below mine and one on my floor, which had walls that completely surrounded my small railroad apartment. Dust was everywhere and the noise was deafening. My walls and ceiling cracked open and I could see daylight in the adjacent apartment. No permits and no help from a city that allowed this assault to continue in my building and throughout the "East Village" as the real estate industry now called my neighborhood. My super punched me out and the police were on the side of the landlord. I should have been shooting myself.

Around this time I was getting angry. I picked up my camcorder one Saturday morning at 7 a.m. as hammering on the walls surrounding my apartment banged on. I walked into the neighboring apartment shooting myself to see five Chinese guys just hammering on a wall of lathe. The plaster was all gone. They were just hammering for hammering's sake. Or probably

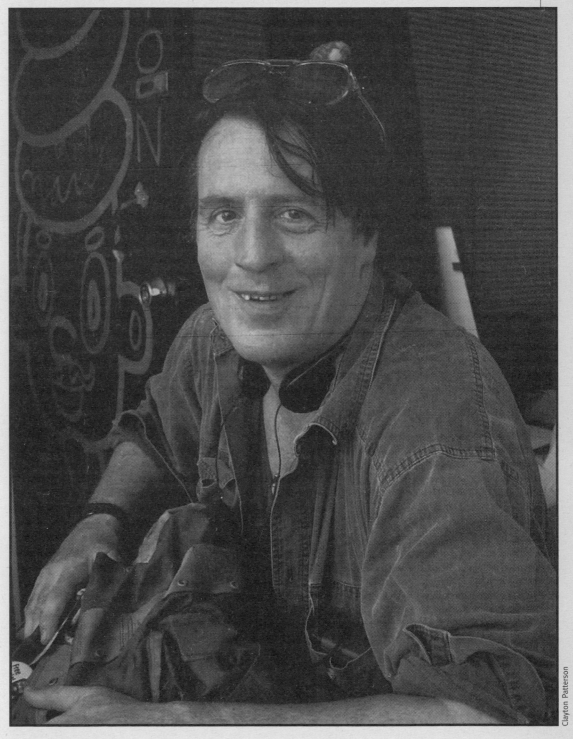

Clayton Patterson

Rik Little

because my landlord had instructed them. I asked, "What are you doing?" No one spoke English. I asked, "Who's the boss here?" One guy in broken English said, "Boss not here." I said I'd really like to speak with the boss and left with an idea that would make living in hell tolerable.

I started my documentary called *From Slumlord to Shooting Myself*. This way all the unpleasant antics my slumlord was acting out on me could be transformed into my art and keep me happy. I shot a story of my apartment, my building as a microcosm of what I saw happening in the macro of the East Village, the city and indeed our nation. I got a grant to finish the two-hour epic, which told the story of the gentrification and assault on the Lower East Side and the attack on art and expression as the '90s unfolded.

The neighborhood was wild with reactionary expression as the powers in the city backed a real estate industry bent on raping the soul of the Lower East Side for profit and power. Legal loopholes were exploited. Laws were selectively enforced and excessive force was used against the citizenry. As Peter Missing of the band "Missing Foundation" coined it: "This is Germany in 1933."

The East Village circus had many fronts, few leaders and a collective creative resistance to the escalating invasion. The homeless protesting the housing/shelter situation set up tent city in Tompkins Square Park. The squatters fought the cops, battled in the courts and won and then battled the cops who now had a tank and machine guns to enforce a safety order they had obtained from the city lawyers who had lost in court but procured an administrative order from the Department of Buildings. The gardeners defended gardens. The punks defended punk. The renters defended their rents. The booksellers defended their right to sell. The artists defended art. The peddlers defended peddling. The anarchists defended anarchy. And lots of times they all came together defending and no one knew. Just a defiant mob of citizenry facing off with cops.

They organized an "Art Around the Park" in the midst of the city trying to impose a curfew. The streets were filled as artists did paintings all around Tompkins Square Park. Some of the art was confiscated by the police and one artist was arrested for having made a gun in a shovel. When the curfew failed, the park was closed for two years for renovations. During this time the East Village was an occupied police state. Barricades and an army of cops surrounded Tompkins Square Park 24/7.

Doing renovations was a tried and true procedure in capturing neighborhoods for the real estate industry by the city. (It had just worked in Washington Square.) All the elected officials were there because of the real estate industry and the least they could do for payback was to provide cops to destroy the neighborhood and make way for the money. Just like in my building. I was shooting the occupation of the neighborhood, interviewing cops and politicians as the newsman Rik Arithmetic. I was at the raids and protests, the speakers and I would interview cops as they videotaped speakers with their new VHS camcorders they recently acquired. We were all moviemaking in the East Village. Cops would beat up a girl and claim resisting arrest and she'd win $100,000 in court because everybody was shooting.

Terrorists blew up the basement of the World Trade Center and the city used this opportunity to brand the citizenry of the Lower East Side as terrorists and justify their already escalating police presence.

The mayor had the media under his thumb and the Lower East Side was now isolated and occupied as he exacted revenge on this hotbed of terrorism. Anyone who voiced opposition to Giuliani was a terrorist and the cops followed orders.

The Last Beer on Earth video was an improvised loosely scripted narrative involving Jesus shooting himself. I played Jesus and I cut my hair and shaved to avoid detection. I would shoot myself as I did for *The Church of Shooting Yourself* and then create the narrative from a collage of shots, which were shot randomly. Visually I tried to tie the random shots together by incorporating seven recurring visual themes. They were: the last beer on earth, spinning or circles, a baby, a logo of a circle with rectangle eyes, cops, the Twin Towers, and airplanes or flying.

The Twin Towers were a symbol for duality. The two sides of my character's brain. One side had an antenna, which gave me my TV through the air to the antennas on my building's roof and into my apartment. A lot of this footage with the last two themes was incorporated into

both narrative projects and now has other levels of meaning after 9/11.

The mayor started his own S.S. type of private guard in 1996 and called it the Office of Emergency Management who were headquartered in the World Trade Center. They coordinated going into a squat on Fifth Street and knocking it to the ground overnight with all the people's stuff and pets inside. I made another documentary of this called *Home Invasion*. They knocked down several other non-squat buildings in the same fashion under the guise of community safety but it was really for real estate.

Each escalating assault brought out an unyielding surprisingly united front of creative defiance. I shot these scenes as a backdrop for my personal fictional story but I soon realized and have increasingly realized since that this backdrop was history. It's gone now.

The East Village was zoned not to have buildings taller than seven stories. The land was Peter Stuyvesant's old farm and was riddled with underground rivers and streams. Perhaps it was the running water that created the energy magnetics, which sparked the citizenry to go crazy in the face of pigs. The LES had a long history of dissent from the city government. Go watch *Gangs of New York*. Look at the gun turrets pointing downtown at the 26th Street Armory. Hundred of years of being a thorn in the side of City Hall would be fixed by Rudy Giuliani with a lot of help from my alma mater, NYU.

My NYU was now Tisch School of the Arts. They wrangled to change the zoning laws and build two tall buildings east of Third Avenue. They took over the Palladium and under the banner of education they joined the real estate melee on the Lower East Side. I was shooting them now. Their big foot was in the door and the taller buildings were going up. All the once cheap apartments were being converted with renovations by force like my apartment and the Bush Senior administration was renovating Iraq as freedom of expression was curbed throughout the world as it was in my apartment and building.

My slumlord made a motion to stop my video deposition of him. Seven years into the case after going through four judges and countless motions Marv Albert supposedly bit some girl while he's dressed up sexy. It made all the papers. I discovered that the slumlord was actually Marv Albert's business manager and also that Marv Albert was one of four limited partners in the shell corporation that actually owned the building I lived in. So legally Marv Albert was my slumlord.

One of the activist photographers from my neighborhood knew the gossip columnist for the *NY Daily News* and set me up with an article about Marv and my other slumlord who had been suing me for seven years for three million dollars libel for calling him a slumlord. I showed the writer the slum I lived in and she got comments from Marv and his partner slumlord. Marv said he didn't even know me and had his picture in the article. My slumlord fired his legal team and I was awarded sanctions. He hired another sleazier team and looked like a fool in the article talking about handwriting analysis of spray paint on a wall. He soon installed a secret videocamera through a pinhole on the stairs of the first floor of my building. No illegal sublets or pets here. I put gum over the hole. I also secretly videotaped the Department of Buildings taking gratuities from the construction guys still banging on my walls, floor and ceiling. I was still shooting a lot of good footage.

On the Fourth of July everyone (except the city and cops) knew the 13th Street squatters would sneak back into their building and reclaim it after being evicted with a tank. The fireworks kept the cops busy and by the time the cops realized the building had been retaken by the squatters, thousands of citizenry had filled the streets to watch the troops in action and cheer the squatters. Helicopters were everywhere and no news media even arrived until hours later when it was all over. I did two "Church of Shooting Yourself" shows with this circus as background.

Tompkins Square Park reopened sans the bandshell, which had long been the LES speaking platform. I would video the City Mobile Stage Unit that was controlled by the city. Rules increased and hours decreased. Cops increased and restaurants increased. Prices increased and laws protecting tenants decreased. Homeless were put on trains and disappeared as bulldozers ripped up garden after garden. Kiev expanded from a counter in a room to three sitdown rooms and my old school on 7th Street was converted into another NYU dorm. Major motion pictures were being shot all over the East Village.

My favorite movie was *Joe's Apartment* for which they constructed a burnt-out tenement building on a vacant lot a half block from my apartment. I was sort of offended by the arrogance of the movie company and just went ahead and shot my movie as P.A.'s scrambled to get me out. Robert Vaughn (the man from UNCLE) was in the middle of a political speech for their movie as I did my movie about me sampling the spread and commenting on my surroundings. Once I had to stop and tell the P.A. to please be quiet because I was making a motion picture here and time is money. They called the cops but I was just shooting myself on a public street in my neighborhood.

Then there was Bruce Willis riding a bike past Tompkins Square Park while they shot *Die Hard with a Vengeance*. A mob of citizenry heckled the Republican actor as P.A.'s tried to act like cops. It was never easy to displace the people of the Lower Easy Side, not even for a scene in a movie.

I really can't explain all the action going down in the war for freedom from greedy pigs on the Lower East Side. It was my neighborhood but I came to realize that this type of action was unique to the Lower East Side. It was special and the collective people were special. They weren't giving in to the pigs and like me, they found a way to make it tolerable and often fun to defy the bastards. It was creative fun, loud visual fun. Thought-provoking guerrilla theatre for which the camcorder was the perfect tool. The perfect weapon. Like the folk song was in Bob Dylan's day. Like the internet is today.

By the end of the '90s the old East Village was unrecognizable. It still was unlike any other neighborhood but the new world order had lobotomized the citizens or rather watered down the citizens with arrests. New rich NYU students from Japan, investment bankers, and everyone else who had moved in to displace those who had been beaten out for pig profit and political revenge. I never thought it would be over but it was now and what seemed like an everyday reality background was now only happening on my TV when I played my camcorder footage. I finally saw it on TV so it had to be true. The TV had my fictional story and the real history of the Lower East Side in the '80s and '90s in the background. And in the big picture Tompkins Square was now everywhere. I'm sure it will rise again someday on the dirt of the Lower East Side.

It's sort of like when they shot Cool Hand Luke in the head. He went down smiling and using his own death as a plus. He got his answer from God and it made a good end to the movie. Cops did it.

I'm still shooting myself and showing on Public Access in NYC and now Brooklyn. It's all the same old story as history repeats. Maybe it's Germany in 1939.

Interview with Edward Braddock III, aka Red Ed, aka Carol Anne Braddock

by Calmx

Calmx: What was "On The Avenue"?

Red Ed: "On The Avenue" was a twice-weekly cable television program that appeared on Manhattan Neighborhood Cable from 1989 to 1992. It was top of the line spiritual guidance for the East Village. We had art, music, and food reviews with several regular field reporters: Ray from Ray's Candy Store, Sto from the band Youth Gone Mad did Sto-ology, Tantra Head (not just another head on a table), Paul Kostabi, Hoop with Hoop DuJour, and the girls My Little Margie and Green Gina.

Calmx: What kind of things did you do on the show?

Red Ed: For example every show had two and a half minutes of the Ray Report. The Ray Report was commentary from Ray the Turkish guy that owns the tiny twenty-four hour concession stand at 113 Avenue A. Ray would hold up the daily newspaper and discuss the news as he saw it, from the middle east conflict to the condition of the New York real estate market and East Village landlords. Hoop was an East Village artist who made the hoopmobile and other art cars; he'd glue stuff all over vintage cars. We'd film him whenever we'd find him parked somewhere.

Calmx: When did you first start making videos?

Red Ed: Late February 1987, I was documenting shopping sprees. We had a sugar daddy that bought us a video camera. Then I took Annie Miquet from the 13th Street homestead to Chicago, she led me around Chicago, I wasn't wearing my glasses then and I needed people to lead me around. I shot her shopping at Marshall Fields, Neiman-Marcus, and Nordstrom's. I had a fixed-focus Sony camera so I didn't need my glasses to film. Another time, I did a three-hour continuous loop out the window of my Cedar Hotel room.

Calmx: You also did a lot of documentary work around New York?

Red Ed: We covered the '92 and '93 NFL drafts at the Marriott Marquis. We covered the Democratic convention of 1992. A good story from that was what happened on the day before the convention opened and the Secret Service was making their final sweep. Paul Kostabi and I were plugged in under the stage charging our batteries when they asked for our tapes. We got our tape

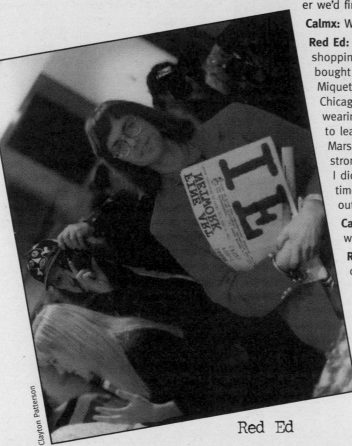

Clayton Patterson

Red Ed

back 48 hours later, a segment from On the Avenue was on the tape and apparently it met with Secret Service approval. I believe they saw the love I covered the convention with.

Calmx: What are your current projects?

Red Ed: The reestablishment of the Confederate States of America in seven years time, taking Webbittown Corporation from subchapter "S" corporation to "C" corporation, and the elimination of the four brands of the apocalypse. The four brands of the apocalypse are Consolidated Edison, J. P. Morgan–Chase, the National Basketball Association, and New York University.

Calmx: How are you documenting these projects?

Red Ed: Paintings, videos, collages, live journal reports.

Calmx: What is Webbittown?

Red Ed: Webbittown is a Delaware corporation that owns "universal language" that currently involves little glyph-like patterns called color signs. Webbittown also did a stock redesign project; we took one hundred blank stock shares and had one hundred different artists do a redesign, creating original art for each paper stock certificate. The stocks are now both works of art and real stock equity in Webbittown Corporation at the same time.

Calmx: What's your motivation behind these projects?

Red Ed: To help children and to become the richest person in the world without selling my soul.

Clayton Patterson

MM Serra, Calmx and Red ed

Calmx: What's your opinion of the current scene in the New York

Red Ed: Interesting. I love to stand by the members' door of the New York Stock Exchange, which you can't do anymore since September 11th. Now I spend my time networking below 23rd Street. We have been identifying active members of the Confederate States and getting ready for the invasion of the fraternities and sororities.

Calmx: How has New York changed?

Red Ed: It's gotten greedier and as the lies continue to mount a much less friendly place to be. It's a town in such bad spiritual shape that it can't even keep its streets clean. They have over four hundred million man-hours available in New York and they can't even keep the streets clean.

Calmx: Are you videotaping the progress?

Red Ed: I document various points once they have been reached. We've got the solution; it's only a matter of advertising it. In the Confederate States of America, these trash conditions would not be tolerated. I'm a strict segregationalist; I segregate the trash until I know what to do with it. It's that simple. There should be no waste in the private and public sectors. There are no landfills on a plantation.

Calmx: Any final thoughts?

Red Ed: We have established a plan with the state of Minnesota whereby the landfills across the United States will be shipped up to the three largest manmade holes in the world and the trash will be resorted and recycled. And as the miners recycle and resort the information they find, there will be various medical cures and diamonds in the trash. They can hold up the diamonds and say, "Mine."

Filming in the Wild, Wild East

An Extended Interview of East Village Filmmaker
Mary Bellis

by Calmx

It was a coin toss deciding between Los Angeles, London, and New York as to where to live after finishing film school in San Francisco, until the offer of an East Village apartment by Philly enticed me to move to New York City in the early eighties. Philly was a magenta-tinted local artist with thick cat-rimmed glasses, who was always ready to greet you with a "Hello, pussycat." She starred in my films, before moving on to the Kuchar brothers and Todd Verow.

The apartment was painted jet black, fire-engine red, and Krylon silver. The black paint brought out the detail in the dozens of curly fly catching strips that Philly had hung in the apartment before she moved out. Philly had given me the apartment on the condition that I agreed to let Mary Bolger continue to live there. Bolger was a teenage go-go dancer slash bus girl from the Pyramid Club, whose father was an alcoholic Irish immigrant and whose mother was an ex-nun. Within a week of being roommates, she cut her wrists and sat in our freestanding porcelain bathtub, thinking she was worthless piece of shit. The bottom of the bathtub had almost filled up with blood before she changed her mind.

My other roommate was a violinist named George Carter, who was desperate to leave San Francisco and end his romance with heroin. Mary Bolger arrived home from the psycho ward after her suicide attempt just in time to help me break down the bathroom door to find Carter dead on the toilet from a heroin overdose. His body was already turning stiff, his skin was blue, drool covered his face, and his pants were down around his ankles. Bolger grabbed his feet and I grabbed his head and we started pulling and pushing Carter like he was an accordion. After a few minutes of our tenderizing, Carter re-birthed himself and took a gulp of air. It took a few days for Carter to recover; he later told us that all he remembered about that night was going into the bathroom, shooting up, and then going to the Pyramid Club. He said that he had a fabulous time, the crowd was very friendly, and there was lots of gold light and bright colors everywhere. It took him awhile to believe us when we told him what had really happened.

Underground and alternative filmmakers living in the East Village during the eighties lived on the ultimate set. Daily life was a blockbuster script, and it was hard to find a person who wasn't the perfect B-movie extra, film noir anti-hero, or anime villain. Our lives were the movies and all we had to do was turn on the cameras. Well not exactly—making a celluloid film was expensive and at that time most of us were living in the East Village because the rents were cheap, life was never nine to five, and the drinks and doors were free. The biggest part of our budgets was the film stock and lab costs and for that we'd forgo paying bills, dreamed of rich admirers, worked in film labs like Rafik, joined collectives like the Millennium, applied for grants, and operated on the good graces of our friends and family. However, new money was flooding into New York during this time period, finding ways to both support and exploit the art scene.

The eighties were both too real and too fake, but never bland. Manhattan was full of lost disco fiends adjusting their shoulder pads to fit into new wave, and the nightclubs were ready to market hip and happiness to them. Many of my friends were hired to work at New York's finest. Haoui Montaug worked the door at Danceteria, Michael Clark was Area's doorman, and Lynn McNeil was a bartender at both. I loved Area and the incredible people I met there were inspirational. Filmmakers Abel Ferrara and Zoe Tamerlis, who had made the now cult classic *Ms 45*, lived outside the nightclub in a Winnebago, doing research for their second film at the trendy nightclub by making it their living room. They were writing a script about space aliens invading nightclubs for a film that I believe never got made.

For a time, Area was definitely my living room as well and the perfect place to catch snippets of film-worthy anecdotes. One night I caught the following scenario happening between Jean-Michel Basquiat; the painter, actor, and musician John Lurie; and an unknown woman. The woman was tugging on the rising art star's arm saying, "let's get some Dom Pérignon." John Lurie was tugging on Basquiat's other arm saying, "Jean-Michel, let's go," and then added, "forget about her, she's just a junkie." Basquiat seemed ready to ignore the woman, but when Lurie made the junkie remark, an incredible look of empathy came over Basquiat's face; he showed love for her in his eyes. The moral of the story was that rich, successful junkies don't like poor junkies with the edges unraveling, except for Basquiat who showed me that he was never a hypocrite.

The eighties were also the height of the commercialization of performance art and what the Pyramid Club and ABC No Rio started, Area bottled and sold it to celebrities and rich people. For the first time the performance art circuit could support and provide a living for creative types, who were paid an average of a buck and a quarter a night for dressing up, creating spectacle, and catering to the upscale crowd that flocked to the nightclubs to sample downtown flavor. Each month, Area invested a tremendous amount of money to reinvent itself with multi-media installations, and hired East Village performance artists to play bit parts in the themed environments.

Back then there was a much clearer division between those living in the Village, and those living outside the Village. People from an uptown state of mind would never travel east, preferring to pay a hefty entrance at Area to gawk at the downtown freaks. Area was the breeding ground for the first club kid culture, which reached its golden era a few years later at the Limelight and Tunnel. It was from this crowd of now employable artists and drag queens that I found my cast of characters.

Baby McGregor was a popular performer at Area: cute, funny, and innocently charismatic. I cast him as an idiot savant whose stroke of genius was fashion designing. He had only one line in the film, which he kept repeating and that was "da da." A few years later, McGregor's real world life was saturated with AIDS and addiction. He hooked up with a cat burglar team of hot-looking Puerto Rican juveniles. McGregor cased the apartments of an ever-shrinking list of rich and working-class friends, noting the windows, doors, processions, and occupants' schedules, which he passed along in exchange for party favors. Later, McGregor made voodoo dolls for a living, selling them on the street along with a free dose of his observational wit and bad poetry. He ended his life by jumping off a building after experiencing within a few short years of being both a nightclub celebrity art star and a deranged homeless prankster.

For the same film, I cast Rockets Redglare aka Michael Morra as one of my villains. Most people know Rockets from the character parts he played in the films of the more successful independent filmmakers like Susan Seidelman or Jim Jarmusch. Few people knew that Rockets appeared in countless super-8s and no-budget video shoots originating out of the East Village. For my film, Rockets used a heavy Scottish brogue for his character; he was sweating profusely the day of the shoot, the beads of sweat intensifying his villain look. Lumbering with his

breathing, Rockets kept requesting money for medicine, insisting he was in too much pain to continue shooting. I supported his habit for the day while he supported my filmmaking, and we all kept shooting. His scene was shot with Philly and Baby in Area's bathroom, ironically Philly had worked a brief stint performing in that same bathroom, selling gum, cigarettes, and hair combs, and chasing the coke snorting bridge and tunnel girls out of the stalls when the lines started backing up. Rockets Redglare has passed away, but not before writing his own autobiography and selling the film rights to director Julian Schnabel with rumors of duplicate sales.

Through my friends I was able to arrange to film at several clubs around the city: Area, Pyramid Club, Danceteria, Life, Cuando, and The World. The World was the only nightclub that charged me. I had to cough up fifteen hundred to owner Arthur Weinstein to film there. It was the East Village's largest nightclub, located in a former Polish wedding hall on Second Street and Avenue C. That club took the rock and roll that New York has always been famous for and combined it with a new drug called ecstasy and topped it with an emerging house music scene. The World had an edgy and raunchy flavor punctuated by public sex and occasionally mass nudity on the dance floor. I shot one of my favorite scenes at The World; a young Walt Paper had provided me with a list of emerging fashion designers, and I had dressed a couple of hundred extras as LaCoste alligator emblems hanging from a two hundred foot long LaCoste polo shirt.

There is no other relationship quite like the one that exists on a film set. For a period of time, you are a special tribe with all the support, interdependence, and complications that go along with living a dream together for a few short weeks. My cast was not a group of trained actors; I used artists with giant egos and fragile temperaments to match. Once both of my leads, independently of each other, called me in the middle of the same night wanting to quit halfway through the production. As a director it was my responsibility to say whatever it took to get them to continue and I did so for several hours—using call waiting to bounce back and forth between the two. I succeeded just in time for the next day's shoot to begin, a small scene with only Philly. We were shooting in a rented limo and near the end of the shoot Derek Wolinsky, my DP, discovered the loaded mini-bar. Within thirty minutes, I had a drunken cast and crew on my hands. I paid off the limo driver and was just about to hail us separate taxis, when I heard this loud slapping noise. I turned around and Philly was slugging Derek, for telling him what sounded wrong about his Polish accent. She was probably working off the tensions of memorizing lines by punching him and he was probably working off lines. The result was two nights in a row of no sleep and more call waiting for me. My cameraman stayed on the production but drank daily during the rest of the shooting; he'd keep looking at me and make a rectangle symbol with his fingers in the air saying, "Don't worry, you'll get your film."

One of the rewards of filmmaking is showing your films. An early incarnation of the New York Underground Film Festival was held in the now defunct 8BC gallery. Scott and Beth B, Nick Zedd, Tessa Hughes-Freeland, myself, and others all showed that first year. The festival sponsors were funky enough to give every participant an award, a nice fat voodoo candle that mimicked little Oscar perfectly. I doubt I could ever give up my East Village ways and not create film using my experiences here—what filmmaker doesn't need another candle?

MAYDAY!

Benefit
for
The
Film-makers
Cooperative

an evening of
Music
Dance
Performance
Raffle

May Day
Monday, May 1st
8 PM

at
Exit Art
88 Crosby St.
between Prince and Spring

Tickets:
$15 Advance \ $20 Door

with performances by

Spalding Gray
Taylor Mead
Eileen Myles
Jonas Mekas
Stuart Sherman
Carolee Schneemann
Aaron Beall
Sally Silvers
& Ikue Mori
Psycho-Acoustic:
Zeena Parkins
& Elliot Sharp
Samba-Reggae Gals

audio janitor: DJ Olive
MC: Medea de Vyse

for information call:
212-889-3820

Multiple Ejaculations:
M. M. Serra on Sex and Cinema

by Ed Halter

Filmmaker, writer, teacher, curator, director of the Film-Makers' Co-op and all around dynamo, M. M. Serra has been central to the East Village experimental film scene for nearly a decade and a half. Her raven-black Betty Page hairdo, starlet sunglasses, sexpot leather pants and outrageous laughter make her one of downtown's most unforgettable personalities—as she often notes, the "M.M." stands for Mary Magdalene. Visit her today at the Co-op (the world's oldest distributor of experimental cinema, founded downtown in 1962) and you'll easily get sucked into her unflagging whirl of energy. Her mind seems to have collected more information than the New York Public Library: In five minutes she'll download everything onto you from the history of women filmmakers to feminist theories of pornography to the latest gossip about avant-garde filmmakers, plus turn you on to some underground movies you've never seen, but should have.

Serra has lived on Ludlow Street since the '80s; I moved to the East Village in 1994. Our first interaction was on the phone, when I was doing research as a grad student on Jack Smith's *Flaming Creatures*. She talked my ear off with all the insider dirt. When I began programming the New York Underground Film Festival in 1996, she curated a show for us called "M. M. Serra's Electric Sex Machine." One of my favorite memories from that year was seeing two rather stunned representatives from one of our corporate sponsors exit the theater after Serra screened Henry Hills' *Igneous Ejaculation*, which features a glorious spurt of female ejaculate as its finale. Serra and I have been pals ever since.

For this interview, we met on a sunny weekend afternoon in May 2003, next door to her apartment, in the pleasant miniature garden behind Valerie's hair salon, to talk about experimental movies, the East Village, and her. She filled me in on shows she curated in the '80s and early '90s, when the East Village saw its last truly gritty underground moment. We laughed, we drank, and we talked about sex and politics a lot. But don't worry—the following interview has been edited to keep all your reputations intact.

EH: So, Serra, how'd you end up here in New York?

MM: One of the reasons I moved to New York was that I wanted to curate underground, avant-garde, off-the-mainstream kind of films. The sort of films that I was making, and films dealing with explicit sexuality. So in 1988, I moved to Ludlow Street.

EH: What were the first shows you organized?

MM: Well I did many at the same time. It was like this sort of guerilla programming where I'm not in one theater but going into places like Max Fish before it opened as a bar and doing an Erotic Festival. Ulli, the owner of Max Fish, said to me that I could curate whatever I wanted because it wasn't a bar yet, it was right before it opened. It was a

three-day festival called Incarnations of Erotic Cinema, and I curated it with Bradley Eros.

This was something I did outside of Conspiracies. Conspiracies I did for 10 years. It was a festival of new works in avant-garde cinema. Short films. I did it with Abby Child the first year at RAPP Art Center. What happened with underground short films is that they were shown once at Millennium or at MoMA--Anthology wasn't around then--and then you wouldn't see it again. The festival was a chance to see exciting new works again. And Conspiracies also was meant to be political.

EH: Political in what way?

MM: Political in that it was a diversity of personal visions. In terms of Hollywood, there's a homogenization of cinema: what it is, what it's about, how its marketed. So Conspiracies was giving visibility to those who weren't commodified. It was political in the sense that we live in a capitalist system, and everything has a monetary value, and these are films that are never going to make much money. It's not even about money. It's also about exploring your personal visions.

Conspiracies started in 1988 and was a Friday and Saturday night. An experimental film weekend, always in May; it was part of the RAPP Art Festival. It had Bang on a Can and it had theater and it also had film. The first year Abby Child asked me to help her curate with Robert Hilferty and the second year Robert and I did it while Abby was in San Francisco. And each year after that I would ask people to curate it with me, and the last year it was at Exit Art and Mark McElhatten curated it. I helped organize it. And it was inclusive. It wasn't meant to be elitist or exclusive or one particular vision in the avant-garde.

EH: So were most of these filmmakers in the East Village at the time?

MM: Sure, most of them. Pete Cramer, Joe Gibbons, Barbara Hammer, Emily Breer, Kiki Smith, Henry Hills, Keith Sanborn, Leslie Thornton. Uzi Parnes, Lewis Klahr. One or two like Nick Dorsky were out in California.

EH: I see here you even showed a film by Christine Vachon . . .

MM: Yes, that's right. And I actually met her. Right, *There's A Man in your Room* by Christine Vachon. She used to live in the East Village; she still does live in the East Village. And it was an experimental film.

EH: So at this time, what did you think were the main concerns of these artists?

MM: There was a variety. Like Lewis Klahr's *Her Fragrant Emulsion*--he was fascinated with this B-movie star and he got these images—sort of like Joseph Cornell—and deconstructed it. It's all about looking at her and the way she moved. It's not at all about the narrative. And the same thing with Caroline Avery. Her film was also about working with the material properties of the cinema. I'd say that they were experimentations in the material properties of the film, rather than content driven.

EH: Now when I think of these names, I think of them as constituting a very specific generation of artists. Is there something about them, as a group, that you think was distinctive at the time?

MM: It's not only the time but also the location. The East Village in the '80s and early '90s was a place where artists could come from anywhere in the country and find low rent, find space and jobs so they could have the freedom to form a community of working artists. They could communicate, share ideas. Artists don't work in isolation. If you look at Paris in the '20s, there were artists sharing and experimenting together. The East Village had this at this time. There was a sense of community, and it wasn't so much a

career place. The East Village wasn't just a place to shop – it had this gritty glamour. It had that edge, a sense of authenticity, of being on the edge. It had drugs, and bars you could afford to drink in. You can't even afford to drink in the East Village now. It's 10 dollars a drink. I can't shop or drink in my own neighborhood any longer! When money becomes a priority, it's harder to be creative.

For example, Abigail Child's films, I discovered when I first moved here. She had just done a great film called *Mayhem* that I thought was representative of the East Village. Edgy esthetics and political content. It had a sense of *film noir,* which was like the dark gritty glamour of the East Village. Also the way she edits had the feel, the pace, the hectic--frantic almost—rhythm of life here.

EH: It sounds like another thing about the old East Village was there was the idea sex being a subversive act. When imagine that time, I think about the Mapplethorpe and NEA controversies, sex and AIDS, all this renewed feminist interest in porn and fetishes and so on . . .

MM: Well when I organized the Erotic Festival, I met Tom Chomont's brother Ken, who specialized in sadomasochism and he did a demonstration. The sex clubs in New York fascinated me and I started going to places like Paddles and The Hellfire Club and The Vault . . . it was like a Disneyland for sexual experimentation. You could walk into these clubs and assume any personality or multiple personalities, explore all the different facets of yourself. You weren't just gendered male or female. You were Jekyll and Hyde and Pollyanna. At first I just wanted to experiment then I decided to make a film about this. It was an experimental documentary entitled *L'Amour Fou* (1991). It means "mad love," love without any boundaries. It breaks down marriage, heterosexuality—not just breaking down this binary opposition, but expanding it. Because with a name like Mary Madgalene I feel this is one of my missions in life! The Erotic Cinema series inspired me to make it.

EH: So was there any video you showed at this time? Or was it all 16mm, super-8?

MM: It was all 16mm. All of it—Leslie Thornton's *Peggy and Fred in Hell*, Nina Fonoroff's *Department of the Interior*—that was autobiographical, about her relationship with her mother. They were all 16mm and in '88 people were still making short experimental 16mm films. Now a lot of it is on video. And like the Underground [Film Festival]—what year did the Underground start?

EH: The first New York Underground Film Festival was in March '94.

MM: Yeah, so, this was before the Underground. A lot of the new video that I've liked I've seen at the Underground. And at MIX, and the other lesbian and gay film festivals. But MIX was around at that time; it was a place to see a lot of the new, younger, edgy work done in new media.

EH: Also the Downtown New York Film Festival was happening at this time, wasn't it?

MM: Yes they were in the '80s. Conspiracies started in '88 and went to '95. So they sort of overlapped.

EH: Was there also an overlap between other things going on in the East Village at this time and film—like, let's say, performance or dance or galleries? Or was it more self-contained as a film scene?

MM: Well there were places like WeBo that had music that was also a place I showed erotic films. It was sort of gallery spaces or bars that would sort of let people go in with projectors and show films, rather than just using established film theaters. Well, the Robert Beck's like that now. But there are fewer places like it.

EH: So there were lots of places doing this at the time? What were some of the places?

MM: In the summers, Films Charas was the best place to see the best films both independent and underground. Also, RAPP Art Center, the Gas Station, WeBo, Max Fish, Collective for Living Cinema (which was also a theater), the Pink Pony.

EH: When did that start?

MM: The Pink Pony? Jane Gang curated that and that was in the '90s. Ulli put a little theater in the back with seats and it had this little curtain around the screen.

EH: Yeah I went to Jane's show at that time—that was like '97, '98. They were great shows.

MM: In 1998 I started teaching a course at the New School with Michelle Handelman called "Sexual Personae: Representation of Female Sexuality in Film and Video." What inspired me to teach was studying with Chris Straayer at NYU. In 1991 I took a Ph.D. class called "Sexual Representation in Film and Video" taught by her. She was an amazing teacher and an amazing influence on my work. So anyway—when Michelle and I couldn't get a screening venue at the school, Ulli let me bring my students to the Pink Pony and use the theater there without charging us. I believe she stopped using the space because of fire regulations.

EH: The New York Underground also hosted a best of Robert Beck show there in 1999. Now it's a restaurant.

MM: The thing that was happening then that is not happening now is I think it's harder because there's less money and there's less availability of spaces. The Gas Station is gone, WeBo's gone, RAPP Art Center's gone, Charas is gone and there are theaters that opened but it's also harder to get in to do programming—to do guerilla programming or independent programming—because they've got curators and schedules and need to plan more tightly and bring in more money. There's Anthology, of course. But because money's tight, there's more of a risk. You really have to program, give most places the money or the door or the overhead costs. At that time I would split the door with whoever owned the bar or the gallery.

EH: Well arrangements like that still happen, but perhaps it is more formal than in previous years. Definitely more of the work you see at New York Underground, Ocularis and Robert Beck is from outside New York. There's not exactly the same sense of "subversiveness" any more, or at least not of the same kind. But if it's more difficult to do what we do now, I wouldn't know the difference.

MM: Also New York State Council on the Arts and Film/Video Arts gave grants back then for independent programming. FVA would give a grant so that you could rent films and then you could do a speakers' fee—the speakers' bureau, it was called. It wasn't a lot of money but it was some money. At least the filmmakers were paid.

EH: Speaking of filmmakers getting paid--how did you come to work with the Co-op?

MM: When I lived out in California in the early 80s, I worked in film programming at the Motion Picture Academy, with a man named Doug Edwards who curated Encounter Cinema at UCLA, which was experimental cinema. Before that I worked at Film Forum in Pasadena—minor jobs like working the door, doing some curating, just being all-around staff person. And Doug came to one of the screenings, and he said that he needed an assistant. It would be someone that would assist him in programming at AMPAS, the Academy of Motion Picture Arts and Sciences, which is like an organ of Hollywood. They do monthly screenings of commercial cinema, for the unions, for people working in the Hollywood industry. So he hired me, and I worked with him for four years until 1988. And we did shows in New York. The Academy would do tributes to people like Alfred Hitchcock—which was phenomenal—or the anniversary of Vitaphone, or George Melies. And I would travel, and I loved New York and decided I wanted to live here. I felt that New York had more of the underground and that's more of what I was interested in.

I also curated some shows at the Pasadena Film Forum and showed some of my films there. On one of my trips to New York, Howard [Guttenplan] saw this package of films from Los Angeles, which included my own films, and he gave me a show at Millennium. Somehow at that time, I met Saul Levine, and he said, You should be on the board of directors of the Film-Makers' Co-op." So I put films in the Film Co-op, and was on the board. Then Leslie Trumbull had a stroke and a heart attack in 1990 and they needed someone to help. I said I would do it for a couple of months—and that was in May of 1991 and I'm still there.

I never really thought distribution was something I was interested in. I thought exhibition was more exciting because I like putting films together. Curating is important, people don't realize it. That is, how you place the film, and in the context, you curate the program. Also, you have the audience there. But when I started in distribution at the Film Co-op, I realized how important distribution was. It wasn't just the East Village; it's global. It also has this political philosophy I like. Because growing up working class in Pennsylvania—well my grandfather

worked in the coal mines, in the beginning of the 20th century, before the unions. And my father—while he was in the 6th grade, he'd have school half a day and he'd work at the mines half a day. And he supported himself. He helped form the labor movements. And my dad brought me to these labor meetings as a kid. I would hear all these people, working together, arguing: men, women, all genders and all sexualities. It was more of a community and I really liked the community. I found it exciting, a sense of joining and being motivated together to make changes. And *that's* what the Co-op *is* about, to me, it's about a collective of artists working together for putting their work out there into the world, and promoting it.

It has an amazing history. Because in '61 as the New American Cinema Group, and the Co-op was started in 1962 as a division of the New American Cinema Group. When it was started, there was no network for underground, avant-garde, independent films. It's the oldest and largest. But it was people like Andy Warhol and Stan Brakhage and Kenneth Anger and Jonas Mekas and Jack Smith. All these amazing personalities. George and Mike Kuchar. They're different from each other. Like Robert Frank has a different esthetic, its more of a beat esthetic, than say the underground esthetic of George and Mike, but there they are. And people like Marie Menken who made lyrical films like *Notebooks*, and—I think she's under recognized. I like the history of it. And I also liked the idea of a nonhierarchical form of organization. It's egalitarian, run by a board of directors, it's not pyramidicaled. I think it has a kind of idealism that's not around in the culture right now.

EH: So you didn't stop curating when you started working with the Co-op. You did some touring shows, didn't you?

MM: I did. Actually in the early 90s, I did a monthly screening at Anthology of new works in the Film-Makers' Co-op as a way of getting people to join and being visible and not just having the films or videos sit there on the shelf. Jonas agreed to that and I did it for four years. Joel Schlemowitz would sometimes curate and one time we did this wonderful series where every board member curated a program. Also in 1994 I took a program of New American Cinema films to Germany. But in 1992, because of my interest in sexual representation, there was this gallery in SoHo, the David Zwirner Gallery, and I did a program there with Maria Beatty and Ellen Cantor called "Coming to Power: 25 Years of Sexually Explicit Art by Women." And I did five tours to Europe with that program.

EH: Who showed in that? Was it all Co-op filmmakers?

MM: No it was not all Co-op filmmakers. But a lot of them were Co-op. That's how I discovered Barbara Rubin's film. I was looking, specifically looking for women who dealt with sexuality. Barbara Rubin's was a double-screen projection, *Christmas on Earth*, which was called *Cocks and Cunts* when it was first shown at Warhol's Factory. Barbara was only seventeen in the early 60s where she had her friends paint their bodies and pose in front the camera. It's a double screen projection—the outer screen is a close-up of genitalia, not in a clinical or sex-industry kind of way but exposing the body and just looking and seeing the body. And the inner screen were people with their bodies painted, graphically. And since it was black and white you couldn't see all the colors. They posed like tableaux vivants of the 19th century. There's this . . . I don't want to say hippie . . . but a freedom, an optimism. The soundtrack for the film in distribution isn't a soundtrack at all. You play the radio to a rock and roll station, which includes not just music but the ads and so forth. It was a groundbreaking film because it was polymorphously perverse.

When I curated the Erotic Cinema series with Bradley Eros at Max Fish, one thing I noticed was that there was three times more material by men. So like Tom Chomont, his brother Ken—Ken Chomont did an erotic shaving. An S/M erotic shaving. Ken Chomont did lectures on S/M in mainstream cartoons, he had this compilation and he showed it to me. And he said, "Well why don't I do an erotic shaving." And I had never seen one in public. This is in 1988 before Madonna's book *Sex*!

M. M. Serra

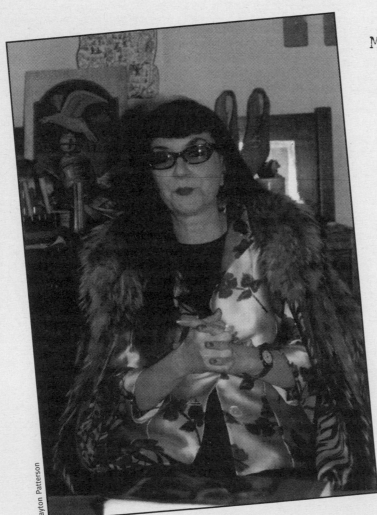

Clayton Patterson

Anyway he had scaffolding there and he tied him to the scaffolding and tore his clothes off and shaved him. It was amazing to do that in just a regular gallery. That program also had videos by Annie Sprinkle and Veronica Vera. Nick Zedd did *Whoregasm*, his amazing double screen projection.

But then I realized that there weren't that many films by women. One of the things I wanted to look for was, all right, let's see if I can find more work by women. So *Coming to Power* was designed to focus on women only because there seemed to be that need to search out and find more women that did work.

EH: So at the time, what did you think was so important about showing sexually explicit films?

MM: I think it's the most politically subversive thing to do, for women. Since the emphasis is on monogamy and romance and procreation for women within our culture. Especially then in the '80s with the so-called Moral Majority. And this is another reason why I wanted to teach it at the New School. . . . Women have always been able to be funny in romance or melodrama. Robert Stoller, in *Observing the Erotic Imagination*, he writes that for women, the romance novel is their pornography. When I read this, I thought, this has to be wrong. There has to be more work by women out there that's more sexually explicit. By curating and making the work and exploring it, it's a way of educating an audience, and making it visible. Festivals like MIX and the Underground explore these areas for a younger generation. And on television now with programs like *Sex and the City*.

EH: So what about your own filmmaking?

MM: In my films I try to explore the variety of sexual pleasures—and pain—that is connected to women's desires. For example, in my film *Soi Meme* (1992), Goddess Rosemary is a performance artist and erotic dancer who performs a dance and ejaculates for the camera. At the time I had two camerawomen, Peggy Ahwesh and Abby Child, one with video and one with film, because I wanted to capture the spontaneity and the drama of her ejaculating. But when I looked at the footage I decided that it was too clinical, particularly the film, so I hand-processed the film to explore the orgasmic quality of her ejaculation. The title expresses the essence of the piece—"soi meme," "for one's self," not only the physical self but also the soul, the deeper self.

I also did a series exploring sadomasochistic practices . . . I collaborated with Maria Beatty on a project she stars in called *A Lot of Fun for the Evil One* (1994). We filmed it at Paddles on Beta with a monitor so that we could capture the spontaneity and drama of S/M that is difficult to achieve sometimes on film. The video explores a series of sadomasochistic acts from leather worship to spanking to live flayings to hot waxing. It's framed as Maria's masturbatory fantasy of polymorphous perverse pleasures.

I collaborated with Jennifer Reeves on a film called *Darling International* (2000) in which we create sexual personas and explore sexual fantasies within the urban landscape of the city. New York itself has always been considered dark, mysterious, dangerous and we wanted to capture this within the texture and the surface of the film, so we actually are sexually explicit and we worked on the project for three years and the film won an honorable mention at Sundance (2000), which is surprising because we never knew if it would cross over into a larger audience.

I'm currently working on subversive ads. The series is titled "Ad it Up." For example there's a Baby Powder ad titled "Just for You Girls" and a donut ad set at a donut plant in the East Village called "Double your Pleasure." Right now I'm working on Chiquita Banana ads from the '70s that were Kinescopes that a friend of mine gave me on 16mm. This series [has] a lot of fun to this work because I feel our culture has commodified sexuality. These are meant to parody that.

EH: So do you think that even with the neighborhood changing so much in the past fifteen years, do you still see the East Village as a vital place for showing experimental film?

MM: I do. I think the East Village still has germinal creativity. It still has creative types there. And I'd say that the East Village is from like 14th Street on down, or it's a state of mind. It still has these people that come from other parts of the country who come here to create, to explore ideas. Coming down the street and seeing Nick Zedd and Reverend Jen shooting a new movie. That still is an East Village thing. It doesn't happen up on Madison Avenue.

EH: Even though Nick lives in Williamsburg.

MM: Yes! Now this we should say. I think a lot of people are being forced out. It's not only the fringe theaters that are disappearing, it's also housing. The buying up of property. A lot of artists have fled, and Williamsburg really became the new East Village. But what is encouraging is the HOWL Festival. Phil Hartman and Doris Kornish opened the Pioneer, they have a video store, and now Phil Hartman and David Leslie are doing this festival because there is this gradually seeping away or disappearing of this creative energy that made this area so dynamic. And so maybe this would make it visible again. You know there are a lot of people who have moved here just to shop or drink. So now there's all these bars—21 new bars since I moved here! When I first moved here I was afraid to walk down the street at night because there were all these vacant buildings. Now it's like "Shop New York!"

Beyond **raw** nerve and **cheap metaphors**

by Francis Palazzolo

To say that Lower East Side (LES) filmmaking has changed drastically in the past fifteen years, just as the LES in general has is an easy statement to make. Especially for those of us who have witnessed the transformation from a wild, fresh, cheap, dirty, forgotten corner of Manhattan to big budget students, new buildings, and the polished-opportunistic traffic of consumerism that now overrun the place. What are some of the provocative, and soiled things left behind, and what interest lies in revisiting these seedy yet compelling signs? In making comparisons between anecdotes from the sixties to the current time I point out conflicting conditions that question the changes in the L.E.S and the filmmaking in its vicinity.

July 2003, *Rolling Stone* magazine shoots models frolicking through a sprinkler head attached to fire hydrant. Bodies glisten against the backdrop of a trendy boutique on Ludlow Street. Ex–chimney sweeper looks on, smiling now. He is happy with himself. Especially since he can now witness the sensuous act from his favorite reclining spot, in front of his building that he has just recently come to realize he owns.

July 1986, I shoot home movies of a voluptuous black girl in bathing suit using a fire hydrant to take a shower and fetch the water supply for the day. She is a squatter on Pitt St. with no water in her building. This girl toys with the hydrant. The water is no match for her. As it tries to compete they form an epicurean banquet.

Back then the ex–chimney sweeper is in the basement space next to me. He lives there, in the electrical room with no water nor toilet, and rats are always running freely. One night I caught nine rats coming out of his space into mine. When the alcohol left him conscious enough he did manage to clean a few chimneys for the buildings on the block.

A decade and a half later, a drug sting, complete with a murder plot, involving the landlords (for many of the buildings on Ludlow St.) exposes a charade of bookkeeping. This travesty left the chimney sweeper's name on a deed to a building. This building was just a few doors down from where he had to live with his own feces on the wall. Evidently many decades earlier his father had some business foresight that he was unaware of.

It has been suggested to me that parts of this narrative may not have taken place yet. Suspended in doubt is the conclusion of the term chimney sweeper by the use of the prefix "ex." Also in question is the term "holder" as in possession of the deed. If THE TRUTH was an obtainable and a limited enterprise I would commit myself to detective work and sort this mess out further. Instead the lack of commencement serves as my introduction; this air of doubt is an introduction to LES life. Lower.East.Side.Life. is not a desert. Yet David Wajnarowicz saw deserts. Nonexistent hugs, and kisses, from mom and dad form a desert. The continual beatings from dad. The scorching heat on land. Selling your body for money, your sexual services to dirty fat old men, leaves you barren. Growing up with the fear of dad's gun, the deafening sound. Breeds a need for the silence of a screaming desert. Lost souls written on *Postcards from America*.

During the spring of 1985, I needed electricity for a "new" studio, a dirt floor basement on Ludlow St. The basement is like a dungeon. Slabs of ragged stone formed the walls. I found out about my next-door neighbor the chimney sweeper then. I had hot wired my space from the adjacent electrical room while he was out. As I made my way into the cinder block electrical room, I held my nose due to the shit smears that covered the walls. Hurrying, I forced the trip wire where the meter should be. The first attempt arced and almost cut my finger off. It melted the pliers, but after another approach the dungeon was "electrified." Free.

My first filmed performance, by German photographer/sculptor Wolf K_hn, was a series of 3-D paintings. I used a cigar on them. As I puffed away the paint boiled till holes burned through the molded linen surface. The sound track was of a psychiatrist with a Russian accent explaining his use of electric shock therapy on people diagnosed with mental illness. There was no sense to this work except for the irrational gesture of another practice for flattening out space.

During 2002, Jennifer Aniston and Ben Stiller acted young and trendy in their new film *Captured*, to be released in March of 2004. As the promotional literature claims, the two are involved in a "risky romance." At times filming takes place on Ludlow Street in a tenement. Aniston lives there. Risky business for them is a matter of managing risk for an insurance company (Ben), and having an affair (Jen and Ben).

Are they over selling the term "risky business," or is it a symptom of the drastic changes in the LES? Scenes from the movie *Postcards from America*, based on the writings from the compelling, tragic, yet successful artist Wajnarowicz, directed by Steve McLean, were shot in the same building nine years before *Captured*. Over the course of the following pages I compare risk taking and cinematic style in film and video from the LES. The lens from which I look, what impact can the consideration of environment, the sensibilities and history of a location's residents play when making motion pictures, i.e., as if there were some premise for shooting downtown?

During the shooting of *Captured,* the street between Stanton and Rivington is closed off, and the electricity is turned up to get in all the shots for that day's schedule. Night has fallen so some of the shots were done with artificial daylight. The director was uninterested in the inverted world that he was forming, just in getting the damn shot in.

The inversion: Ludlow Street has more foot traffic during the evening than during the day. During the late night Ludlow Street comes alive and is more like Fifth Avenue during the day. Nightlife, the bar, club and band scene, is a distinct feature of this neighborhood. Even before the renovations and new businesses, many people on the block were artists, writers and musicians. Few if any worked nine-to-five jobs. Most partied and did their craft at night. Offbeat, most slept by day. With the dungeon, anytime was silent night. There was a time in the eighties that I didn't see the light of day for a year. Ludlow Street has always had this cool cryptic element: many in the band the Velvet Underground lived here during the sixties. And most of the scenes from Sergio Leone's *Once Upon A Time In America* were shot in the LES: The "Ludlow dungeon" I had was once a distillery for the Jewish mob back during the early part of the twentieth century. It was specially equipped with a fireproof ceiling and escape route to the subway.

By the early nineteen nineties I was no longer literally underground, but instead the occupant of a top floor loft (a sign of persistence and luck). From my balcony fire escape I shot some 16mm film of the inverted metaphorical scene unfolding with "Jen and Ben." I shot only small snidbits at a time. I stretched a ruler out on the ledge so it too is included in the frame. If I use it (which I doubt, it seems better explained here), it will be blown up as a print of movie stills. To express the extant to which the predetermined filmmaker goes to get the shot I'd juxtapose some other shots, to emphasize the inverted metaphor (i.e., mayhem as the bars let out at four in the morning with the usual police car and ambulance in tow, because there is a screaming drunk girl, who will not stop, claiming that the bouncers molested her).

On the other hand sometimes Hollywood has gotten closer, or at least expressed an aspect of the psyche of Lower East Siders—not only in content, but in style. The black-and-white postmodern tale of a dysfunctional vampire family, *Nadja*, by Michael Almergda, does just that. The new take on the vampire legend shot in the Max Fish Bar artistically emulates the LES's

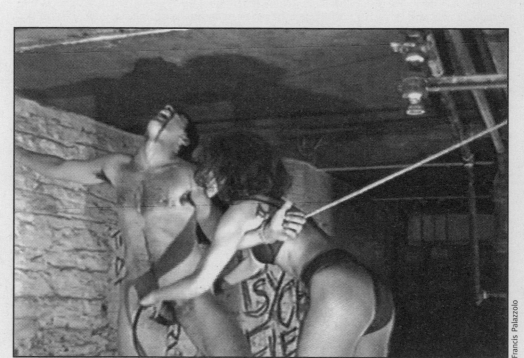

Francis Palazzolo

Excerpt from *Psycho-Flesh*, staring Dominique Storms
and Francis Palazzolo, cinematography Oliver Henke
and Vincent Palazzolo, 1987, color 17mins.

off-beat style. The dreamy artistic filming that the movie delves into is the sort of chance tak-ing that lures the viewer to the dark underside.

Usually though, Hollywood or independent films that feature the LES spend most of their capital on just being down here (showing that they've made it down here), because it is trendy. Scarcely do they show what it's like to be downtown, in its utter perversity, let alone show the dialectical lens of the world from downtown. Films like *Captured* are prime examples. Along these lines are films that cater to our art house theater (The Sunshine Theater), such as *Kissing Jessica Stein*, while not shot in the LES it caters to our new residents. Unfortunately, films like this are more about missed-at-getting-picked-for-a-sitcom-pilot then the cheap metaphors and raw nerves of post-Modern queer cinema—an aspect that LES life reeks of if any Independent director bothered putting a lens on it.

Kissing Jessica Stein is in stark contrast to the works of experimental filmmakers Jack Waters and Peter Cramer. These two, as with many others within the Naked Eye Cinema archives, put an exclamation point on the term cheap metaphors. These collaborators are at their best when they inexpensively put traditional metaphors, or heterosexual stereotypes, into play and point out their homosexual form.

American independent films such as *Basquiat,* by Julian Schnabel, starring Jeffrey Wright as the talented yet reckless artist Jean-Michel Basquiat, and *Piñero* by Leon Ichaso, starring Ben-jamin Bratt as the explosive Latino poet-playwright-actor, do document what life is like down-town extremely well. However, I'm not thoroughly convinced that their movies exhibit aesthetic value comparable to work of the artist that these filmmakers are portraying. Depicting some-thing and doing it is two different things! Schnabel, more known for his decadent paintings that undermine tradition, is one person who should be cogent to this issue.

February 1986, the idea for my next performance video was in some way tied to an apart-ment that friends and I were renovating. In this apartment I found whips, chains, recordings with hookers and countless other specimens. Evidently the prior owner split without taking his prized possessions, but as we came to learn, when the mob and the IRS (not much difference between the two, but that is a story for another paper) come knocking you don't waste time being choosy. I used the whips, chains, and recordings in my next performance, called *Psycho-Flesh.*

The idea was to explore what was so compelling about sadomasochism (S&M). This was not a straightforward gratuity: For me as for many others living in the LES, somebody you had to deal with (which could have been yourself) was a hardcore heroin addict. During the eighties the LES was a haven for users and dealers. The girl I was dating at the time was always in rare form, though her antics were no doubt at times tormenting (I don't know how I didn't get AIDS or become a junkie myself like her; I think the focus on art distracted me). Beautiful, exotic, and sexually adventurous some days, during the others she was half dead or lost. Part of the time supple and sweet and during the other portion she was irritable, withered up and lying. Being a junkie also entails what one does and with whom to keep up the habit.

Finding out about these facts broke up the relationship, but not before treacherous acts were committed. At one time you could climb to the top of the towers of the Williamsburg Bridge, make love and peer down at the water, *Vertigo Sex.* On other occasions we broke into con-struction sites. We would race to the top of these new structures, and fuck our brains out while hanging off the rafters. It's particularly mind-bending on an August night when T-storms are all about. Or testing our grit by filing down a hair pin so she could pierce my nipples with it.

Sadomasochism was another experience I had with my heroin addict. In this case it was a metaphor for the time we spent together, another way of expressing physical and mental pain that is peculiarly connected to sexual pleasure. In some ways S&M scenes were easier to shoot (this was before the days of mini-camcorders and infrared lighting on cameras). More-over, with the cache of supplies I found an artistic performance was at hand. S&M was not a gratuitous act in this case; rather, it was like a sister to heroin. The two are easily more than you bargain for.

The film, by German filmmaker Oliver Henke, documents the making/whipping of 3-D canvas-es with paint. The paint is applied to the canvas with the whip. The canvases seem like car-casses, fractured bodies hanging from chains. There is also a segment filmed through

Plexiglas. There is the obvious connection to the filming through glass that Hans Namuth did for Jackson Pollack as he dripped his paint. Here the Plexiglas is used to sustain the blows from the whip as the paint was applied. In dramatic style, red paint slashes up the screen as if the screen itself bleeds. Aestheticians we were not. Cheap gore seekers is closer to the mark.

I wanted to know what it was like to get whipped: does it make you horny, and just how seductive is the sadomasochistic life style? The Ludlow dungeon was the setting. Cut into the footage of whipping the canvas were scenes where I was drawn and quartered, and getting whipped by my Lower East Side junkie. The appeal as a preferred lifestyle was missing for me, but I did experience and document the metaphor asI was living through it. While bound anything can be done without your permission—the whipping doesn't stop when you've had enough. Hot wax and candle flames appear from nowhere. Wax splashed on my body, and flames on my balls and butt exploded anxiety through the top of my head. The trick of S&M, like heroin, as I said earlier and it is worth repeating, is it is easily more than you bargain for. To express the view that there is always someone, or something else included, unexpected people pop in and out of the video. Sometimes they were edited in. Other times it was staged. The under and over exposed scenes, and jittery editing, are as much a symptom of making the video with little money as it is a metaphor for the dozing off (and waking up), as well as an added sense of anguish.

Madonna did take a stab at soft S&M at the end of the eighties, presumably inspired by the decadent LES, East village, and West Village subcultures. Her work was short on content and long in style. At first glance, her work seemed to parallel the stereotype of Japanese kids infatuated with American culture: We love your work, let's copy it, let's be superficial about it and forget about understanding what you're trying to say. In some respects she did the "post-Modern thing" by shooting for consumer superficiality. Also Madonna's high-end aesthetic added complexity. So there is more at work in her presentation on closer scrutiny. The combination of decadence, superficiality, and aestheticism begins to reach for a new slang. But if combining these incompatible conditions contributed to the intoxicating mystique that she shot for, my reservation was its PG rating and the shortchange on trashiness. Her lack of bravado for working in the extreme (basically selling out) kept this author from going along with the quasi-transcendental nirvana she suggested.

At the premier of *Psycho Flesh*, at the Emerging Collector Gallery, I signed copies of a publication that coincided with the video. Included in the publication was the text from the soundtrack, interviews with call girls, and backdrop photos used in the video. The title of the publication was Humanshit, an accompaniment to *Psycho Flesh*. It also included film reviews, interviews with local artists, and advertisements from art galleries. Thousands were printed, the proceeds helped pay for a trip to Berlin where the film was also shown. The big-ticket item sold was the paint-stained whip.

Nineteen eighty nine, shitty was the sort of deal artists got from the federal government. Censorship issues brought about their need to de-fund the arts. This produced a surge from the LES. *FOR SUCH A BEAUTIFUL PLACE WHAT AN AWFUL STINK* was a phrase that leapt to my mind. In the next video performances I produced, I was the one flinging the feces. Staged for film or live on stage I used my own shit as paint. With it I formed images of the White House and the capitol building. Performances such as this have a lineage within experimental cinema dating back to Nick Zedd's work from the nineteen seventies *They Eat Scum*, which was inspired by the like of Jack Water's anal extravaganzas, such as *Pink Flamingos*. All three have been showcased at A.B.C. No Rio on Rivington Street. I mention but a few works within the history of the scatological which is as vital today as it was then as a provocative manner to focus attention.

Raw nerves and cheap metaphors are the hallmarks of LES underground experimental cinema, and a sign of undermining the systems of value and taste. Simply put, I use the term raw nerves to say that the picture is violent, graphic, offensive, and most likely has nudity. And the term cheap metaphors is used to express low budget movie making that undermines aesthetic values—quite often the filmmaker also devises clever simple metaphorical plays within the film to reinforce the cultural attack/slippage. Some jargon from the philosopher Jean-Francois

Lyotard that express this post-Modern condition is "that which denies itself the solace of good forms . . . in order to impart a stronger sense of the unpresentable." To put it more emphatically is to quote from Jack Smith's cinematic masterpiece from 1963, *Flaming Creatures*: "Do they make lipstick that doesn't come off when you suck cocks?" Movie critic Jonathan Rosenbaum goes on to write about this film, "I can't think of another cinematic object in which 'bad' photography looks more exquisite." Rosenbaum has also written that "avant-garde cinema has a dialectical relationship to mainstream cinema." To add to this observation, I suggest that underground experimental cinema has a dialectical relationship to American independent films as well. Is there much difference between Hollywood and American independent films?

Violent and graphic depictions of angry aimless youths, with quick tempers and disregard for others, such as Richard Kern's *Fingered* starring Lydia Lunch (a high contrast, grainy, 8mm B&W film), show a lashing out at the world. Another Kern production *Manhattan Love Suicides,* with starring roles from Zedd and Wojnarowicz in a series of B&W shorts from 1985, deal with problems of sexual identity (Zedd in *Thrust In Me*), and graphic metaphors of artistic frustration (Wojnarowicz in *Stray Dogs*). These films, and the others I've mentioned above, present a lens of the world from downtown. These moving images navigate through recognition, style, and self-destruction: Youth looking to communicate their identity, desires, and problems in a mercantile culture that affords little power to those who don't already have it. As I discussed earlier, there is more to underground experimental cinema than just making raw motion pictures on the cheap. The film style expresses a condition that also explores the subject matter. This stands in stark contrast to most of the film industry's versions of being downtown, whether it's Hollywood/mainstream cinema's or Independents'.

It is tough to say whether college films or recent experimental films have lost track of this course: it is a very porous environment to keep up with. Certainly Jane Gang, the transplanted Londoner and experimental filmmaker, maintains this vision. She has found a home in the LES, and kept up the avant-garde debate with her films and promotional activity. Gang gave underground movie making a voice throughout the nineties at the Pink Pony on Ludlow Street. These efforts lost traction with Pony's new manager. She opted for the profit of north African flavor and the remnants of a poetic scene, instead of advancing the LES's heritage by offering trash cinema.

I have been asked to be part of recent low-budget efforts, but I have turned them down. The directors have been in the mind-set of fame and fortune as soon as possible, with conventionality always in sight. The artist that I was asked to portray was always limited to a fixture of what an artist is supposed to be like. Whether rawness and cheapness have a market is not the goal; it never was the goal. Furthermore, when it comes to art the best laid commercial intentions do not necessarily produce the desired effect. Rather, there is much to savor and relish in actor/producer Aaron Beall's, the creator of the Fringe Festival, follow-up move. He left his own Fringe Festival and started up a festival to compete with it, the Ultra Pop Festival. Beall sensed that the Fringe Festival was getting too slick and successful for its own good. The point is that he felt the need that he had to do something. Although these festivals were not in the business of showing movies but rather plays, his radical assertion suits my purpose: "fringe of The Fringe" underscores the lens of what is compelling to strive for when the cinema involves the LES, beyond raw nerves and cheap metaphors.

Special thanks to Peling Li for her editorial remarks during the writing of this article.

Performing the Lower East Side: A Conversation With Steve Buscemi

by Joshua Rothenberger

When the press paints a picture of Steve Buscemi they seldom get it right. Forget the fact that Buscemi's characters seem to always come equipped with wacky monikers like Happy "Hap" Franks, Garland "The Marietta Mangler" Greene, or Willie "The Weasel" Wilhelm. Forget the fact that the forty-five-year old-actor/writer/director spends a lot of his on-screen time lurking in shadows, or getting kicked out of bars, or swatting away the psychological claws of paranoia. Any sort of totalizing one may want to do when looking back on Buscemi's career should be done with the following in mind: Buscemi, from Day One, has never viewed any of his characters as social rejects, oddballs, or outcasts. According to Buscemi, not categorizing or classifying the characters he plays—whether it be on the multi-gazillion-dollar set of a Hollywood blockbuster or in a smoky basement performance space in the Lower East Side—is simply a matter of respect and responsibility. "I try not to put labels on any of the characters I do," he explains during our two-and-a-half-hour conversation, "because people don't label themselves." If anything, this is an entry point for understanding what drives Steve Buscemi as an artist. He aspires to be the ultimate shape shifter, the dead body at a séance that gets used and abused by whatever ghost will have him. For Buscemi, playing a part has always been an act of self-sacrifice. This is why writers who say that Buscemi is "this or that" or that he "plays this or that in different variations over and over again," miss the point.

An aspiring filmmaker with his back against the wall named Adolpho Rollo. A self-righteous, sharp-tongued thug who calls himself Mr. Pink. A digitally constructed chameleon monster that speaks through Buscemi's voice named Randall Boggs.

He's not really any of these things now. But Buscemi was, he really truly was, for a moment in film history.

The following conversation digs deep into and around Buscemi's self-sacrificing approach to acting. Here, in this excavated chunk of the film world, we find not the fossils of a forgotten journey, but rather the living, breathing body of a performance artist who explored and realized his craft in the bars, basements, and streets of the Lower East Side.

1. Filmography/Work Ethic/"Get your teeth fixed!"

JOSHUA ROTHENBERGER: Your filmography is enormous. I counted 78 film appearances, 13 TV, and about a dozen other miscellaneous appearances—not to mention your directorial resume. How do you fit it all in, I mean you're only 45, right?

STEVE BUSCEMI: You know, I've just been doing it awhile. A lot of it is work that I didn't spend too much time on, and even the features, the low-budget ones at least, are on a schedule of about five or six weeks.

JR: Many people like to put you in that hard-working throw back actor category.

SB: Well, I like to work. I don't know if I'm different from anyone else who has the opportunity to work.

JR: Does that mentality play a part in the fact that you continue to do "indie" films amidst Hollywood success?

SB: Some films you do for work, to pay the bills, and those afford you the opportunity to do other work that is maybe more meaningful or interesting, but doesn't pay the bills. Both things sort of complement each other. The commercial work, if it's successful, gets your name out there and then it gets a bit easier to be cast or to get financing for smaller-budgeted films.

JR: Having interviewed Jim Jarmusch, a contemporary and friend of yours, one thing that stuck out is how hard he works and how much time and energy he spends getting movies made. He's an archetypal "indie" guy who suddenly has a dozen films under his belt. But talking to him, I realized that nothing happened spontaneously or even quickly for a guy who's always done it his way, and financed his films through alternative means. Did you have a similar experience making a name for yourself? Or did it all just seem to happen pretty quickly for you?

SB: I don't think anything happens quickly if it's worth something. I did a lot of theatre, performance and stage work before I did film. I was very happy doing that. I mean, you mentioned all those films I did, but how many have you actually seen? There are a lot of films that sort of either slipped through the cracks or whatever . . . but the important thing for me was to work. The more you work, the more experience you get. I think every working experience is valuable, even if you're working on something terrible. You always strive to look for something interesting, and always do your best work. And in your own work you try to do something personal or something that you think is interesting. I think those things are hard to come by and find financing for. Anything that is remotely different from the regular formula is going to be met with resistance. So I think all of the really worthwhile projects are a real struggle.

JR: I mean, I assumed you didn't do the typical quality headshot plus talent management equals steady work in the biz.

SB: Right.

JR: So you never had some guy telling you to get your teeth fixed and you'll get this part?

SB: Um, not really. No one's ever said that to me!

JR: Well, you get where I'm going with this.

SB: Yeah, at one point an agent I had thought that making a move to L.A. was really important. I've been fortunate, I've never had to live out there to get work. A lot of New York actors end up out there because that's where most of the work is. It's too bad there's not more film production here in New York, but that's just the way it is.

2. The Lower East Side/ Living Space/ Performance Space

JR: You sort of began your acting career and spent fifteen or so years living in the Lower East Side. Maybe talk about what the Lower East Side has meant to you and your career.

SB: This is where I was living when I was starting out, before I was even doing any performance stuff. The Lower East Side was just a relatively inexpensive place to live in the late seventies. My first apartment cost a hundred bucks a month. It had the bathtub in the kitchen. It was basically a one-room apartment with a bathtub. You literally had to take a bath or shower in the kitchen, and when you weren't using the bathtub you put a board over it and that was your table. And then I just started meeting people like Rockets Redglare and Mark Boone Junior. My good friend Anna Kohler was with the Wooster Group, and she got me involved with them and also with an amazing playwright/director named John Jesurun, who was also a filmmaker. He was using his film ideas on stage and was doing a serial play at the Pyramid Club called "Chang in a Void Moon." Anna was working in that and I was able to be a part of that with Mark Boone Junior. Boone and I were also performing with Rockets Redglare in his shows called "Rockets Redglare's Taxi Cabaret." And after a while, Boone and I started writing and performing our own shows. So, during that time of the early eighties we were often doing three shows in one week. The venues at that time were all basically clubs like Club 57, which was in the basement of a church on St. Marks, the Pyramid club, 8 BC, the Limbo Lounge, and the Wah Wah Hut, which was run by the great performance duo DANCENOISE, Lucy Sexton and Anne Lobst. We also performed at Folk City—that was our venture out of the East Village to the West Side. That was primarily a music club where they had a theatre night.

JR: What about PS 122?

SB: Yeah. I think we first performed there with the Full Moon Show, which was a group of performers lead by Tom Murrin, also known as the "Alien Comic." He was doing that along with Jo Andres, Mimi Goese, and DANCENOISE. They formed the nucleus for the Full Moon Shows, and they would invite guest artists like me and Mark—we were known as "Steve and Mark"—and

people like John Kelly, Frank Maya, Judith Ren-Lay, the Blue Man Group, and Ethyl Eichelberger. The whole theatre performance thing was very strong. You also had the explosion of art galleries. All those artists who were coming up like Basquiat, Julian Schnabel, George Condo, Chuck Connelly, David Bowes.

JR: Did you feel like those figures influenced you as well?

SB: I knew less about art so I was more influenced by experimental theatre. People like Fiona Templeton doing great work performing in bars and small clubs. There was Squat Theatre performing in its storefront on 23rd Street, PS 122 had "Avant Gardarama," where it featured all these performers who were just coming up. People were experimenting with video at that time, but most people were working with Super 8 or 16mm film, like Nick Zedd, Richard Kern, John Lurie, James Nares, Betty Gordon, Lizzie Borden and, of course, Jarmusch. Eric Mitchell was really active. Liza Bear, Tom DiCillo, who was also working with Jarmusch at that time. All of those people were going to performances and were active in that whole scene. Tom Wright was another performer and filmmaker. In fact he was working with Mark Boone before I was, and that's actually how I started working with Boone, in the context of their shows. They had this show called "The Manhood Series" and they were doing that in Rockets' Taxi Cabaret. Any early film work that I got was definitely attributed to the early performance and theatre work I was doing. Because all those filmmakers saw me perform on stage first. They didn't cast me because they saw me in another film. I would occasionally do a student film through NYU, but the first feature film I did was written and directed by Eric Mitchell, called *The Way It Is.* He shot it in black and white 16mm. There was no working script, shot without sound, dubbed all the dialogue in post-production, and there was no schedule. If Eric was around on any given day and could get his hands on a camera we did it. Bobby Bukowski was the DP. Boone was in it along with Rockets, Borisch Major, Kai Eric and Vince Gallo. Eric would just lay out the scene with the actors while they were setting up the camera. It was mostly shot outdoors. There were some interior scenes.

Clayton Patterson

Michael Buscemi

Clayton Patterson

Rockets Redglare

We shot in Tompkins Square Park and all around the East Village. It was people like Eric who had that energy and it was fun. That was the main thing. I don't think anyone at that time was trying to use their films to break into the commercial world or mainstream filmmaking. They were doing it because they had a need to do it. They weren't going to wait around for any established styles of filmmaking or financing to get them going. They were just interested in doing it themselves. Amos Poe was another one. I'm sure I'm leaving out a lot of people.

JR: One thing that you said, which also rings true when you talk to a lot of your fellow artists from the Lower East Side, is that there is this feeling that anything could happen if you make it happen. If you have something to say, or something to express, don't wait around for someone to help you say it.

SB: Yeah. That was really what was happening. I wasn't auditioning for Broadway or even Off-Broadway plays. I wasn't auditioning for commercial film work. I tried though. I remember they had these auditions for the movie *Fame* in midtown. I remember going to the audition, waiting in a long line, getting in there, and about thirty seconds into the monologue I was doing they just said "thank you" and that was it. So, there's that rejection and humiliation you go through. And then to top it off they were filming the movie a block away from where I was living [laughs]. And so you go through enough experiences like that and you say to yourself, "Why am I counting on other people to give me work?" It wasn't even about working to make a living, it was just working to get the experience, to be able to express yourself and have fun doing it. That was really the main thing. People were having a great time creating their own work and basically showing it to each other. At every show there were always other musicians, painters, performers. And there was also an audience there for it: people who just lived in the neighborhood. Maybe they weren't involved in any of the arts, but they lived there because it was inexpensive, and also there was just a lot going on. There were always shows to see, art openings, film events, and they were usually packed.

JR: The whole do-it-yourself vibe gave birth to a couple of independent film theatres too. "New Cinema" comes to mind.

SB: Yeah. The clubs also had various film events. I remember seeing Nick Zedd's films at Darinka, which was Gary Ray's basement apartment on East 1st Street and Houston. And you know, the work that was being done . . . people were experimenting. That was the other great

thing. They weren't trying to make a calling card film or a showcase that lead to bigger films. They were honestly trying to do their own work and they didn't really care about the outside, commercial world.

JR: Having followed the film and video history in the Lower East Side from the late seventies on, you really get a sense that there was a family kind of vibe going on. The same names keep coming up, everyone to this day still references each other, and some common currents can still be found amongst everyone's diverse individual paths.

SB: What I've found is that within this whole scene, there were actually many groups that were independent from each other. You know? It was all just sort of out there. It wasn't like everybody knew each other. It wasn't this small collective of people doing things. It was actually a large group and it expanded over a number of years. It was just a really interesting time. It was easy to miss some great stuff, too, because you just couldn't see everything.

<p style="text-align:center">*****</p>

3. Cast of Characters/ Type Casting/ Urban Caste System

JR: You mentioned the Wooster Group earlier. Talk about William DaFoe and his work with the Wooster Group and his influence on you.

SB: In the early eighties the world of low budget films, performance art, and experimental theater in general had a very negative connotation to it in the commercial film world, and the two worlds didn't really cross over. William, I think, was one of the first people who managed to cross over and back in a way that seemed natural. I know his heart belongs to the Wooster Group and always will. That's the work he truly loves to do. And he also loves doing films. Some films may be more meaningful than others but whatever film he works on he puts his all into it. It's never just a job for him. And you know, I think, I was influenced by his work ethic. And with the Wooster Group, he and Ron Vawter, Kate Valk, Peyton Smith, it doesn't get any better than that. I always love what Liz LeCompte, who directs the pieces, is up to. She's the smartest and most intuitive director I've ever worked with.

JR: Talk about meeting Rockets Redglare.

SB: When I first met him he was a bouncer at the Red Bar on Seventh Street and 1st Avenue. He was also doing a show a few doors down at a bar that I can't remember the name of. That's when I first saw his cabaret show. People went crazy for his stand-up, and his show was the hottest thing happening. At that time I was working with Cindy Lubar who had worked a lot with Robert Wilson and was just starting to do her own performance/theatre work. We were doing her play at the Performing Garage called *Rule of 3* and I gave Rockets a flyer for it. I don't think he ever came, but I also told him that I did some stand-up and that I had seen his stuff and was really impressed with his work. And he immediately just invited me to do his show, without ever seeing me work. So the first time I performed in his show I did a stand-up routine that I was really nervous about. All my stand-up stuff I had done before was at regular comedy clubs in midtown for tourists or an uptown audience. I knew this would be a different kind of audience and that I'd have to write all new material to make that adjustment. It was from doing stand-up in Rocket's show that Mark Boone and Tom Wright cast me in their piece. So it was around that time that I just gave up doing stand-up, because I never really liked performing alone. I was happy to give it up. And later I became partners with Boone and made work that was a collaboration. That was way more interesting to me than working alone.

JR: Did you remain friends with Rockets until his death?

SB: Yeah, always. I remember Rockets started getting commercial work as a result of his own shows and the Jarmusch films. After a while he did his live shows less and less. And sadly he had trouble with addiction and always had that to grapple with and overcome. That certainly got in the way of him working more. Luis Las Guerras made a really cool documentary about Rockets. But yeah, we always remained friends.

JR: What about Bill Sherwood?

SB: He used to come to the Steve and Mark shows and John Jesurun plays. My friend Kathy

Kinney who plays Mimi on the Drew Carey show introduced us one night at Folk City. And that lead to me getting cast in his first and only film, *Parting Glances*, in 1986. We lost him to AIDS a few years later; we lost a lot of great artists to AIDS.

JR: *Parting Glances* was your first feature starring role, right?

SB: Right. I had done Eric's film and Liza Bear's film before that. But *Parting Glances* was actually distributed before either of those other films. People often cite *Parting Glances* as my first film, but in fact Eric Mitchell's film *The Way It Is* came first.

JR: From talking to some other artists from that era, almost everyone agrees that the music that was going on had a huge impact on theatre, film, performance, and basically every other medium.

SB: Yeah, there was a lot of great music. The Lounge Lizards, Elliot Sharp, Konk, Liquid Liquid, Hugo Largo. My wife, Jo Andres, used a lot of their work in her performances. Jo's work was a great example of using mixed media. She would work with film and slides but project it on fabric or fog, never on a conventional screen. She'd use different ways of manipulating the film and projecting it, and then choreograph her own dances to go along with it, which was really sort of primitive and more African-based than modern dance. She never considered herself a modern dancer. And the music was always powerful and contemporary. There were a lot of groups who I guess disbanded like Dog Eat Dog and The Last Roundup. The other thing that was very strong was the whole punk rock scene. That really started in the mid '70s, the Ramones and all those groups that played at CBGB's. I think people like Jim Jarmusch were more connected to that than I was, but I went to a lot of shows. Also at the Ritz, I think it's Webster Hall now, I'd see Chuck Berry or Jerry Lee Lewis as well as The Dead Boys or Nick Lowe and a slew of punk/new wave bands that were always playing locally. I was always trying to catch Elvis Costello. There was a Clash show at Bonds in Times Square that Grandmaster Flash opened for and was practically booed off the stage. Then the Clash came on and Joe Strummer reprimanded the audience.

JR: What was it like to work with Joe?

SB: Well, getting to work with him was a real blast because I was so inspired by his music, his politics, the intensity in his performances. He was a great guy as well. We hung out a lot in Memphis.

JR: I thought your chemistry with him in *Mystery Train* was really perfect.

SB: Oh thanks. It was great working with Joe and also Rick Aviles who I knew as a street performer. I used to see him perform in Washington Square Park and he was

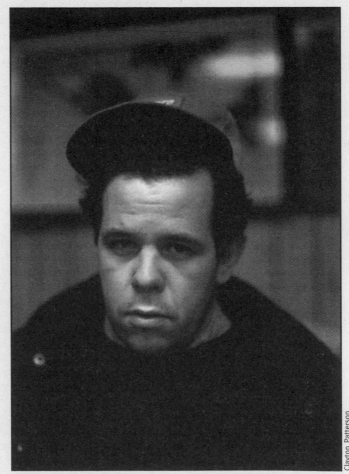

Clayton Patterson

Mark Boone Jr.

clayton Patterson

Steve Buscemi, Rockets memorial at Beauty Bar

sort of legendary, he and another street comic, Charlie Barnett.

JR: A lot of the characters you play are sort of oddballs or maybe even social rejects. Do you think some of this comes from living in the Lower East Side during a time when anyone could afford to live there and there wasn't such a heavy policing of these outcasts hanging out in the street?

SB: Not consciously. I mean, I don't really view any of my characters as social outcasts or social rejects. I try not to put labels on any of the characters I do, because people don't label themselves.

JR: So that comes later in the audience's reception?

SB: Yeah, I guess after you have a body of work, then people say "Well, this is what he does, the weirdos" or whatever. I never had a plan about what I wanted to do. It's just how I got cast. And actually if you look at some of the work I've done with Jarmusch, Tom DiCillo or Alexandre Rockwell—someone else who comes from the East Village and was influenced by the whole performance scene—I've played a lot of different types of characters. But the roles that seem to get the most attention are the ones where I've played criminals or psychos.

JR: You were a fireman at the time, right? How did you jive with the other guys on the force?

SB: I come from that background, a working/middle-class background. Those guys were really familiar to me because I am one of those guys. What was really new to me was the world of the East Village because I didn't come from any sort of an art background at all. I had gone through acting school, but my idea of acting was to one day make it out to L.A. and get on a sitcom or TV series and maybe someday be able to do a movie [laugh]. But that seemed so far out of my reach.

JR: Do you feel a sense of loss when you look at how much the Lower East Side has changed over the years?

SB: Well, no. I think it's inevitable. When I first started taking acting classes with John Strasberg in the West Village, I was reading works by the Beat writers and reading about what

Greenwich Village was like in the '30s and '40s. I saw how that was at first a cheap place to live, then a haven for bohemian types, and look at it now. I could see some of that happening in the East Village. I think it has retained some of what it was originally about. But inevitably after more businesses, new bars and restaurants come in, it's going to change. I don't feel nostalgic about it. I feel fortunate that I was around in the middle of it when it was sort of happening. But if you talk to people living in the East Village in the '60s they would say the neighborhood changed a lot by the '80s. I don't know where the neighborhood is headed, I haven't lived there in over ten years. I'm just not up on everything that has been happening there. And although I know little about the Williamsburg, Brooklyn, scene, maybe it's a similar thing that's been happening there. And who knows where the next place will pop up. And of course people who live in those neighborhoods, and have lived there for years, probably have reason to complain about the artists who paved the way and attract the attention of commercial industries. The artists come and live in a certain neighborhood because it's cheap, and that attracts more of the money people who will seize upon any opportunity to exploit it. But the East Village is still an interesting place the way it is now.

JR: Definitely. It might be more mediated or kept in check in certain ways, but that feeling is still there.

SB: Yeah, I mean PS 122 and La Mama are still going strong, and a lot of other places I don't even know about. But right now the East Village has become a very expensive place to live.

4. West Coast/ Commercial Success/ The Director's Chair

JR: I assume *Reservoir Dogs* was a big move for you in breaking through to the West Coast film scene. I know you prefer New York to L.A. Is that a lifestyle thing, you know, an aversion to a certain kind of schmoozing that is necessary to living in L.A.? Or does it have more to do with the films and artists you can associate with in NYC versus L.A.?

SB: It's a combination of things. My whole family lives in New York. But I don't mind going out to L.A. I've got some really good friends out there like Boone and Seymour Cassel, and a lot of great artists live and work out there, but there's no getting around the fact that it's an industry town and you can't get away from it. [Laughs] I mean, you can, but you really have to try hard. In New York, you just get a better cross section of people doing lots of different things.

JR: Let's talk about *Trees Lounge*, your big directing breakthrough. I understand the film takes place in the same Long Island town you grew up in, Valley Stream, NY. How much of the writing was taken from your own experiences there, and the fact that you moved on while many of the film's characters could not?

SB: It was actually Boone who suggested that I write something about my experience there. It was something I never tapped into in our work together, that I never thought was interesting to write about. But because he suggested it and because I have so much respect for what he does, I thought, "Well, if he thinks there's something good there, maybe I should investigate this." So I started thinking about my whole life there and what it would be like had I not gotten out. And that became the genesis of *Trees Lounge*. What would my life have been like had I not chosen to be an actor? Not that my character in *Trees Lounge* is even aware of that. He's never talking about his aspirations about being any type of an artist, other than one remark late in the film when he comments jokingly, "I could have been a comedian." That was the only time he mentions that maybe he had dreams of doing something other than what became of his life. But he never took it seriously and never thought that he could take it seriously. And that was my feeling up until I was eighteen. I could very easily have just not realized any of that and had the attitude of "other people do that, but it's not really a viable thing for me." And I think there are people like that there, they have ideas and talent, but for whatever reason they don't pursue it, maybe because it's not in their personality to pursue it, or they think its not worth pursuing. The way the script was written was influenced from writing with Boone, where we would improvise a lot. That's how he and Tom Wright worked. They would just think of situations and characters, improvise for hours and tape-record it, transcribe

the tapes and then edit them. That's how Boone and I started. Eventually we'd then write separately and then put it together. I always felt more comfortable at writing dialogue than coming up with a story. Story and structure have always been really hard for me. The dialogue for *Trees Lounge* was improvised in my head. I was writing with Boone in mind, Rockets, Eszter Balint, Elizabeth Bracco, and my brother Michael Buscemi. Michael was very active in the performance and film scene as well. He performed a lot in places like ABC No Rio and introduced me to a whole new scene of performers and musicians I didn't know much about. So it was a great opportunity for me to be able to work with him, because his sensibility is very close to mine and he's a very good actor.

JR: Who besides Boone was an influence in the *Trees Lounge* vision?

SB: I was being influenced by people like Jarmusch who I had just worked with, seeing how he viewed his work as a collaboration with the people he was working with, and yet he had such a strong style of his own . . . I think that was a really good thing to learn. Also at that time discovering the films of John Cassavetes. And remembering those great films of the seventies: John Huston's work, Bob Rafelson, Robert Altman. It was a combination of all of them.

JR: As a director, do you leave room for your actors to take the story to new places? In other words, how much freedom are your actors given to influence the story as a whole?

SB: I think the story has to be in place, and that was especially true of my second film *Animal Factory*, since it wasn't my story. It was based on Edward Bunker's book. So there was only so much room to change that aspect of it. But I always hope that I give the actors room to bring whatever it is they want to bring to it. They may say differently, and Boone especially may say differently [laughs], but I think when you cast people you look for them to bring as much of themselves to the role, not just their ideas but who they are as people. You can be strong in your own ideas, but also loose enough to let other people bring in new ideas without being intimidated or insecure about it. And this applies not only for the actors, but the technicians and the crew right down to the location scout. In *Trees Lounge* it wasn't in the script that my character lived above the bar. But our location guy, Tom Whelan, found a great bar and the owner lived in the apartment right above it and we said, "What if?" So in pre-production I changed the script around, and it actually made it

Clayton Patterson

Steve Buscemi

stronger to have my character live physically close to the bar.

JR: I read where you said that you got into directing because you missed having the creative input. I was wondering which if any of the directors you've acted for were especially good in terms of letting you take the character in a certain direction, whether it be allowing you to re-write some lines or giving you full control of the dialogue and character.

SB: I don't think any director will give you full control of the character, especially if they've written it. But it's not really about changing dialogue. It's about having responsibility for your character. Showing up with ideas or just knowing it and being prepared and being open, and not being rigid. Alex Rockwell gave me lots of responsibility for my character when we worked on *In The Soup*. There would be descriptions in the script where my character is reading his film script to the Seymour Cassel character. But it wasn't written what he's reading. So that was something I had to come up with. Later on, he shows Seymour the short film that he's made. I asked Alex what that short film was going to be and he said, "Why don't you go out and make it?" [Laughs] And, thank God, I was married to Jo, who is a filmmaker and helped me do it. We went out and shot it and we used my brother Michael, my son who was a baby, my dad, and my wife's 16mm camera. And then she taught me how to edit on her Moviola. Alex put a lot of trust in me and gave me a huge responsibility. It was a great feeling to have that, to have a director that trusts you that much.

JR: How did you get an opportunity to direct *The Sopranos*? I mean, that's a huge deal; one of America's most popular syndicated shows?

SB: Directly from *Trees Lounge*. David Chase was a fan of the film and actually hired Sheila Jaffe and Georgianne Walken, the casting directors, for *The Sopranos* because of their work on *Trees Lounge*. And I had hired them because of their work on *In the Soup*, which had its roots in the East Village.

JR: Any future plans or projects you'd like to disclose to the general public?

SB: Well I've been trying for awhile now to get this William Burroughs project going, with a script written by Oren Moverman, called "Queer." But that's proved to be quite a challenge. It's just very strange what's happened with independent film. It's gotten much more like Hollywood on a different scale. Now you just have mini-studios. Before you had independent financers who weren't only in it for the money. But there have been enough successes like *Blair Witch* or *Pulp Fiction* that were relatively inexpensive to make. *My Big Fat Greek Wedding* is another one. So people are looking for the next film they can spend the least amount of money on, and get the most in return. I think there is still interesting work being done, and there always will be. It's just that the climate is hard for anybody who's trying to make a film, and that includes the people who are established in the independent film world. People like Alex Rockwell and Tom DiCillo have been getting fucked around by financers and distributors. And it's incredible because these are the people who made films that inspired this whole movement. They are filmmakers who still try to do their own work and I admire their courage and tenacity.

JR: Why do you think the "Queer" project is being met with so much resistance?

SB: I think it's content. I think it's cast. It's not a story that financers would think audiences would flock to. It's still pretty conservative thinking out there and unless you have an actor in the cast whose last film went through the roof, then the money people just don't seem to care. If you do have an actor like Brad Pitt then you're fine. Even if Brad Pitt's not right for the part, they don't care. They'd just rather have someone in there who they can put on a poster or on the video box, and that's what it's basically about. That's what the commercial film world has always been about. Not saying that's necessarily a bad thing or that all commercial films are bad; there's always been good commercial films, and that formula for getting them made can work. In the independent film world it's just hard to do something different. But somebody usu-ally does and that becomes the new norm. And it happened with Quentin's work. Look how many crime/caper movies came after him. But, really, how many of them were that good?

The Monday-Wednesday-Friday Video Club

by Alan Moore, with editorial assistance by Michael Carter

During the winter of 1986, a small knot of artists[1] opened a "salon" called the Monday/Wednesday/Friday Video Club in a tiny studio apartment on Houston Street near the Bowery. The apartment was to house a home video rental project. But it was different from the other video stores opening up around town then. We had *only* artists' tapes—nothing commercial, and nothing that'd ever been on TV.

The apartment was upstairs from a tiny storefront crammed with used clothing. So stuffed was Nick's place that he stood on the street all day. (Martin Wong made a great painting of Nick's when it was closed, draped with a tangle of locks

Alan Moore

and chains.) For years this had been a source of used equipment for Lower East Side filmmakers. Nick had decided to retire, and planned to turn over the storefront to MWF. Unfortunately, the landlord retired his store into a dumpster, and MWF didn't get to open on the street.

The twin communications innovations of home video and cable TV were supposed to change everything for artists in the 1980s. Eager to reach a larger audience with more popularly accessible work, visual and performing artists turned to video in ever increasing numbers.

It was into this moment of hope that the MWF distribution project was launched. It was also a response to art world conditions. The artists who started MWF had been shut out of the few commercial and institutional outlets for artists' work.[2] The ideology behind the MWF project was populist, and the intentions opportunist. Art should be accessible to as many people as possible, so we elected to sell videos at low prices directly to whoever wanted to buy them.

Artists' video was (and is) generally available only at high prices. This is largely an artifact of the decision by the Leo Castelli Gallery in the 1970s to sell video as signed, limited edition artworks, along the lines of artists' books. Today MWF lists over a hundred tapes at consumer prices, between $20 and $50, in its on-line catalogue. We sell art video on a par with all other mass market media content.

The paradigm of the limited edition has recently reasserted itself with a vengeance, however. Today international art stars' video work sells for thousands as "single-channel installations." The situation still irks many artists. In 1999, RTMark sponsored a project called "Video Aktivist $29.95." This videotape called on people to illicitly tape artists' videos in galleries, and forward them to RTMark, which would distribute bootleg copies for $29.95.

The parent organization of MWF Video was Collaborative Projects, aka Colab,[3] a group of some 40 artists, which began meeting in 1977. In 1980 this group of shifting membership pulled off two important exhibitions in New York, do-it-yourself blockbusters called the Real Estate Show (opened January 1) and the Times Square Show that summer. The first, in which a group of artists took over a vacant city-owned building in a protest exhibition, excited political artists and led to the formation of the ABC No Rio cultural center on the Lower East Side. In the much vaster Times Square Show, Colab artists working under teams of artist curators made over a three-story building as a broken down palace of art and installation, and it caught the attention of both popular media and the art press.[4]

These were followed by a number of other artist-organized mega shows in the early '80s.[5] Some were in Brooklyn, like the Coney Island show (forerunner of today's "hysterical society" action) and the Gowanus Memorial Artyard. In the East Village there was the building-wide 9th Street Survival Show at Charas, and the Ralston Farina Memorial show at CUANDO. All of these big events created small sensations, generated popular interest in art that engaged social issues, and networked the NYC art community. Significantly, they also regularly included artists from the new wave of the graffiti movement, who came from the street.

Graffiti had then first been seen in a formal gallery context at the Fashion Moda art space in the South Bronx.[6] After the Times Square Show, downtown venues—mainly nightclubs—vied to show graffiti artists, together with the nascent hip-hop culture of rap and breakdance. (Perhaps because of graphic reproducibility, the graf artists were then in the lead of the hip-hop wave.) Charlie Ahearn's indie feature *Wild Style* (1982), with a climax filmed at the East River park amphitheater, represents the meeting of downtown hipsters and early hip-hop. The heady populist confluence of gallery, street and club led to the East Village art scene of the mid 1980s, with venues like the Fun Gallery on 10th Street, Gracie Mansion and the graf-friendly 51X on St. Marks.

While Colab is known as the cauldron of the '80s big show, the group came into being because of the requirements of media work. Several members had participated as junior artists alongside SoHo heavyweights in the satellite broadcast proj-

ects of Liza Bear in the late '70s. These newbies were also making Super 8 films, and some started "punking out." Diego Cortez moved into the bubbling music scene on the Lower East Side and started haunting CBGB's with the star-crossed glamorpuss Anya Phillips. Amos Poe was already there. He and Ivan Kral documented the early CBs scene in *Blank Generation* (1976), and screened his feature *The Foreigner* in a vacant lot at Cannes.

In 1978 the New Cinema screening house opened on St. Marks Place. Here Colab filmmakers like Eric Mitchell, James Nares, John Lurie, Tina Lhotsky, Betsy Sussler, and Becky Johnston showed video transfers of their 8mm synch-sound feature films on an Advent projector. Subjects included terrorists, astronauts, Roman emperors, strippers and disaffected butchers.

The New Cinema crowd, many of whom lived on East 4th Street near the NYC Mens Shelter, cleaved to a Warhol-tinged vision of Beat life and glamorous pose. Other artists in Colab formed the All Color News, a documentary oriented group working on public access cable TV, a new outlet for artists. These included the Ahearn twins, Charlie and John, the team of Scott and Beth B, Tom Otterness, Virge Piersol and me. Together with Michael McClard and Coleen Fitzgibbon, ACN produced live cablecasts at ETC on 23rd Street, a low-cost commercial TV studio. One emergency cablecast featured our Congressman Ted Weiss. Clutching his messy briefcase under his arm, he spoke against the draconian criminal code called S-1 proposed by Congress during the European antiterrorist fever; this early move toward total state surveillance was defeated.

After Colab formed, All Color News dissolved. Soon Potato Wolf formed to make cable TV, a whimsical name assigned by first series producer Cara Perlman. Potato Wolf cleaved to an open, artist-driven and eclectic mix of programming, most of it fictionally based, and parodic of the forms of mainstream television. PW often pre-taped at the Young Filmmakers studio on Rivington Street, but did most of their work live at the ETC studios on 23rd Street. Shows like the memorably chaotic "Nightmare Call-In Theater," and "Call to Wobulate" frightened Jim Kladdach, the usually imperturbable manager of that venue. For the latter, upstate hardware maven Terry Mohre plugged his homemade "wobulator" synthesizer directly into ETC's main board. Among PW's producers was the team of girlhood friends Ellen Cooper and Kiki Smith. They made *Cave Girls* (1982) a collaborative work of research, reenactment and creative anachronism about a prehistoric tribe of techno-savvy women. Scenes for this were taped in SoHo, filmed in New Jersey and in the weed-filled backyard of the new cultural center ABC No Rio.

Potato Wolf shared sensibility and some personnel with other artist-run cable TV series, most notably Communications Update, a project run by Liza Bear, and the still extant Paper Tiger Television. PTTV also adapted the practice of making live TV and for a while emulated the tacky painted paper look of Potato Wolf productions (an aesthetic which PW artists called "cardboard consciousness") as a backdrop to their critiques of contemporary media hosted by academics and cultural critics.

MWF was the last media project of "old Colab" before the membership turned over. As such, we could consolidate previous years of work for public access cable TV. Much of this work is included in the MWF catalogue under the category "Artists Television." Other artists' cable shows of the period included Glenn O'Brien's late '70s "TV Party." Hosted by the *Interview* writer, the show tapped the underground music and club milieu as it shaded into punk and "new wave" at bars like the Mudd Club. O'Brien's crew included Walter Stedding and Chris Stein in the band, and guests Debbie Harry, David Byrne, and Jean-Michel Basquiat. (O'Brien then produced *Downtown 81* with Basquiat as the star playing himself, a film only recently released from its snare of legal troubles.)

The Willoughby Sharp show was a more lavishly produced series, actually funded by Manhattan Cable. The show followed the avant-garde curator, journal-

ist and animateur into the dense cultural mix of mid-'80s nightclubs like Danceteria, Kamikaze and Limelight, and their East Village counterparts, Pyramid, 8 BC and Limbo. The show also featured clothing and jewelry designers, and art from the second wave of East Village galleries like Civilian Warfare, Piezo Electric, and James Romberger and Marguerite Van Cook's Ground Zero.

Colab and its projects had been sustained by funding from state art agencies. But as money contracted in the Reagan years, the MWF venture to bring money into the pockets of artists, even if it be only nickels and dimes, seemed necessary. By then, MWF represented work by once-inimical factions of Colab in its video catalogue. Soon other experimental film and videomakers who had worked with Colab were persuaded to pitch their fruits into the pushcart. These included *Erotic Psyche*, the neglected mystical erotic work Bradley Eros did with sequential collaborators Aline Mare and Jeanne Liotta. While we didn't distribute much from them, MWF occasionally showed work by the Naked Eye Cinema group, centered around Jack Waters and Peter Cramer, the managers of ABC No Rio.

Though MWF grew out of video art and artist's television, we also sold low-budget "artsy" narrative features, including at first some of the New Cinema productions. The documentary category included performances, readings, and art bands, most local to the East Village and Lower East Side. In addition to its distribution, MWF mounted frequent shows, theme-related video salons at various EV venues—Phil Sanders and Joanna Dawes' RYO, Bert Ball's Art & Commerce Gallery (premises; he was gone), the Jon Gerstad Gallery on 1st Street, the 2B Gas Station, bOb ("Trailer Trash and Porn" night at ex-Riv Skool hand Jack Vengrow's bar on nearby Eldridge Street), the (old) Knitting Factory and most recently at the now-defunct Scott Pfaffman Gallery.

In the late '80s, the most popular MWF titles were Nick Zedd's. Nick championed a group of filmmakers he called the Cinema of Transgression[7] in his photocopied zine *Underground Film Journal*. This group worked in the East Village, and they were committed to narrative fiction filmmaking in the crowd-pleasing genres of crime, horror and pornography.

Like the punk rock musicians, the Transgression cinema crowd made underground stars of themselves. Although most were men, the movement included Casandra Stark and Tessa Hughes-Freeland. Punk singing diva Lydia Lunch spun elegant foul-mouthed rants and won Zedd's heart. His *Wild World of Lydia Lunch* (1983) is a kind of Super 8 love poem, albeit unrequited. Southern-born filmmaker Richard Kern's humor is callous and direct. His stark and startling short films, cleanly filmed Larry Clarkish vignettes of the low life, featured lots of drugs, guns and chicks sucking tattooed cock. This led him to a photo gallery career, and recent books with the Swiss art and sex publisher Taschen. *You Killed Me First*, his collaboration with David Wojnarowicz, was shot and shown at Ground Zero on East 10th Street, and features performance artist Karen Finley as Lung Leg's ma—David is her pa. Zedd, crucially influenced by Jack Smith, continues to produce uncompromising hard-core art films. He recently published a picaresque journal of his tortured life, *Totem of the Depraved*.

An apogee of the Cinema of Transgression school is the Tommy Turner/David Wojnarowicz production, *Where Evil Dwells* (1986). This uncompleted feature film was based on the true-crime story of suicide "Satan Teen" Ricky Kasso, the Long Islander who ritually murdered a young boy. Turner and Wojnarowicz took Kasso's criminal lunatic imaginings literally, recreating his punk-metal, demon-haunted world of orgies and car burnings. Most of the footage for the epic was destroyed in an apartment fire, and what exists today is the "trailer" for the film and some unreleased footage. In addition to the filmmakers it features Romberger and Van Cook, Joe Coleman (a performance artist and painter famous for geeking rats), nightclub comic and character actor Rockets Redglare, David McDermott and a cast of mainly EV degenerates.

MWF's art films and social documentaries chart changes and upheaval in the neighborhood over the last 20 years, and chronicle its bards, performers, and eclectic denizens. Franck Goldberg's early films exude the harsh realities of the pre-gentrifica-

tion EV as in his short piece on the killing of graffiti writer Michael Stewart—mourned by Madonna—by subway police. Phillipe Bonous and Marie Martine's *11th & B* was made during the early days of Life Cafe. It's a music video, really, including artists, local characters, and police on horseback during "Operation Pressure Point," all cut to soundtracks by Suicide and the False Prophets. Jim C., who ran a gallery near the Rivington School, shot footage of the EV DIY gallery hubbub and club hijinks, as well as a classic 1984 reading by Miguel Piñero. Arleen Schloss' *Art Around the Park* documents a creative and joyous event—the encirclement of beleaguered Tompkins Square Park with paintings during a time of strife around that turf.

MWF Video has also collected video describing the artistic subculture of Lower East Side squatters and their resistance to gentrification. Clayton Patterson's videos of Tompkins Square during the police riots of 1988 and the Tent City and "Dinkinsville" that sprang up afterwards capture key moments in the district's recent past. Goldberg's angry documentary *How To Squash a Squat* (1990) documents the heavy-handed eviction of artists living in city-owned abandoned buildings by NYC police. And Rik Little's *Home Invasion* documents the climactic violent eviction of the 13th street squatters in 1996.

The gallery ABC No Rio inspired the creation of the No Se No social club and the Nada Gallery, which spun off the Rivington School. This group of sculptors built a succession of huge collaborative junk metal constructions on the vacant lots they squatted. The group was scorned by the New York art world for their rowdy drunken ways, so very little was written on them. By default then MWF has principal documents, like sculptor cowboy Ray Kelley and Ed Higgins sitting around jawing during the "99 Nights" performance events shared between No Se No and Storefront for Art & Architecture (1984). And, finally, the Neoist artist Monty Cantsin filmed the bulldozer destruction of the Riv Skool sculpture garden. The most substantial of these documents is Rik Little's 1999 work exploring the group, a carefully researched personal retrospective. Little also shot an extraordinary tape of cowboy Ray and the painter Richard Hambleton in the Gas Station 2B days before its demolition. The reflective comments of these two old hands are almost totally inaudible over the sounds of construction.

Once the playground of junkies and muggers, and the seedbed of New York City's creative bohemia, this neighborhood's real estate have become favored by the young bourgeoisie. The color and texture of the East Village has been radically altered. The Houston Street building with the studio apartment was sold to a large well-heeled bank. The eviction went ahead, okayed by a crooked judge (now serving time—small consolation), and MWF lost its Manhattan home. The club relocated out to Staten Island where the idea of an extra-institutional independent creative sphere is pretty foreign.

MWF came back to the EV to mount two summers of screening events on East 1st Street in '00 and '01, really good ones with Walter Wright and friends, new music and media makers from Boston, a Henry Hills night, a Rockets Redglare tribute, and a night of custom-made image machines and programs. It was all free and visible from the street through a plate glass window. But the EV's bistro-bound crowd passed by without even looking in.

NYC is a new world it seems, and DIY doesn't seem to cut it in it. We lost a bundle on the 1st Street shows, but with so little capital and a part-time work ethic, MWF has been able to persist, even if in a sometimes Frankensteinian state of hibernation. Despite falling Bush-era sales, we may even last out the digital turn. Right now, MWF has gone retro. We're archiving the more than 1000 tapes that have sedimented from the distribution project, seeking to do our part to save the legacy of the area's recent past. MWF Video Club continues in its dual purpose of dissemination of aesthetic media and information and its preservation. It's recuperation time, and we're producing a "Story Cafe" at Remote Lounge for the Howl! fest to document the oral history of the bygone LES cultural landscape. And of course, consonant with our mission, we'll have a table at the fair.

- July, 2003
Reach Alan Moore at awm13579@yahoo.com
The Monday Wednesday Friday Club's video catalogue is temporarily at www.brickhaus.com/amoore
[1] MWF grew out of an exhibition project by Mary McFerran and Alan Moore called "100 Year Old TV." The first group was Moore (his apartment), Sophie Vieille who did development,

Mitch Corber technical, and Howie Solo business advisor.

[2] The distribution outlets for artists' video then included Electronic Arts Intermix, Video Data Bank, and briefly the Kitchen and the Museum of Modern Art. The late ArtCom of San Francisco worked with us. There were no other large-list distributors of artists' video in the U.S. (nor are there now); the market is too small.

[3] Collaborative Projects is discussed in the book the group financed, Alan Moore and Marc Miller, eds., *ABC No Rio Dinero: The Story of a Lower East Side Art Gallery* (Colab, NYC, 1985).

[4] Richard Goldstein, "The First Radical Art Show of the '80s," *Village Voice*, June 16, 1980; Jeffrey Deitch, "Report from Times Square," *Art in America*, September 1980; Lucy Lippard, "Sex and Death and Shock and Schlock: The Times Square Show," *Artforum*, October 1980.

[5] Sally Webster has argued that the idea of taking over a large abandoned building for a show was forcibly presented by the 1976 opening of the "Rooms" exhibition at P.S. 1, in which artists tackled the cavernous old school with site specific installations.

[6] See the papers of Fashion Moda at Fales Library, NYU (finding aid prepared by first FM director Stefan Eins). It is important to note that the graffiti art movement in New York began in the early 1970s, and artists exhibited in Soho galleries then. The artists who painted subway trains in the late 1970s and early '80s were a second generation. (For a good graffiti web- and bibliography, see http://www.artcrimes.com/ information resources section.)

[7] The best source on this movement, besides Zedd's own out-of-print 'zine, is Jack Sargeant, *Deathtripping: The Cinema of Transgression* (Creation Books, UK, 1999; rev. 2000).

Holding a Torch to the Gargoyle Mechanique

Ebon Fisher Interviews Steve Jones

In the late 1980s and early 1990s a group of East Village artists found themselves gathering at Gargoyle Mechanique on Avenue B to form an intense, experimental, multimedia community. Gargoyle put into social practice what Wired Magazine, years later, could merely predict. Steve Jones, the founder of Gargoyle Mechanique, is interviewed by digital art pioneer, Ebon Fisher. Following Jones' interview, Fisher engages another radical luminary, Bigtwin, whose Technoromantics forum at Gargoyle became an indispensable focal point for its media artists.

EBON FISHER: How did Gargoyle Mechanique (GM) come into being? I remember reading about your activities when I first moved to New York in the late '80s and thinking the name suggested a refined hacker sensibility the likes of which I hadn't seen since MIT's Media Lab at its inception. New York seemed so oblivious to the groundswell of changes high technology was foisting upon the world and here was a scene in which the public merged with robots, homemade communications systems and behavior codes.

STEVE JONES: Well I think of the world as a single, continuous individual, and whatever we do is something the world is doing, including emergencies like so-called "high" technology. The hacker idea kind of fits. Gargoyle Mechanique started pre-web, doing playful anonymous activism—we were hackers of the mind space, the idea space, and the meme-sphere.

Before moving to NYC I was living in San Francisco amidst a community of artists who influenced me tremendously. We had big fun making guerilla art actions, such as ridiculous, overboard costumes in banal public situations, or setting up a full set of rock band equipment on a highway billboard base platform and jamming for the startled traffic until the police came to make us stop. And we created a tongue-in-cheek anthem to the Bay Area's premiere designer landfill development "community," Foster City. Calling ourselves the Foster City Homeowners, we made a small disk which we packaged with all sorts of made-up identities, position papers, etc., and surreptitiously went hanging the packages on door knobs around the town, and then wrote letters to the Foster City local paper posing as recipients of the disk to our doorknob, expressing delight in some and outrage in others, in an effort to cause a stir. It worked well enough with a front page article about the mystery, excitement and raging controversy. A tempest in a teapot! That was so fun. That was the first mention of Gargoyle Mechanique in the media, back in 1978.

The GM name came about as an intuition of Doug Bert Kennedy in 1977. One day we were sending an anonymous package of weirdness to a local San Francisco art-music group, The Resi-

dents, and we wanted the package to be sent from a singular identity. One person in our group, Doug Bert Kennedy, was in love with a fantastic museum in San Francisco of old-time mechanical toys and entertainment gadgets called Musee Mechanique. Doug invents and builds bizarre and elegant contraptions himself, and he came up with the name Gargoyle Mechanique in honor of this museum.

EBON FISHER: So how did the name affect you personally? How was it applied in its East Village incarnation?

STEVE JONES: Nowadays I see the "Gargoyle Mechanique" or the Mechanical Gargoyle as a life form ever watching, instilling awe in the passers-by below, these terrible high watchers who can gargle oil down upon the fleshy earth dwellers. Fearsome, yet contrived images, their danger is from a hidden agent behind the scenes. The Gargoyle is a machine! A false image contrived to cultivate fear. Realize this and be free from the fear, or at least know better how to respond intelligently.

Gargoyle's latter-day logo of the mysterious Creature-In-The-Gear to me suggests the ghost in the machine, the animator of the device, wheel gears connecting other wheel gears, implied infinity, a system driven by the living reality hidden inside, ready to collaborate, cogs in cogs, action joining action, awake and intentional. Ready to connect! But back then it was something unstated, a vague feeling.

Anyway, Matthew Crowe, Davo Landazuri, Brother Bob Landazuri, Peter Krakow, David Sanford and I did band projects and fun mystery happenings around San Francisco and in 1979, I relocated to NYC and chose to continue and expand the mystery guerilla creative identity as "Gargoyle Mechanique EAST." So then everything I did was "a Gargoyle Mechanique production." Being in the East Village, of course, I became involved in numerous collaborations, doing theater, music and art. Whenever I was an instigator of an activity, bringing a certain aesthetic and energy, it would be "Gargoyle Mechanique presents (Project Name)." Collaborators liked the feeling of the implied larger organization. In long-term collaborations, with numerous projects, there arose a recognized group identity as "Gargoyle Mechanique." At some point Bert sent me the beautifully strange, many-appendaged creature image instructing that it was the new logo of Gargoyle Mechanique. I placed it into the gear wheel and that's how I have been using it ever since – until I released the animal from the machine.

EBON FISHER: What was your role at the East Village incarnation of Gargoyle Mechanique? Who were the other participants? Did you all share a certain worldview or did that emerge in the process of building GM East?

STEVE JONES: Long before I got the Laboratory storefront, I had worked for years with theater/film people Jeanne Liotta, Nick Markovich, Carmen Waldorf and other great people. I was playing guitar and synth and making collages with my tape studio. I had a basement studio on First Avenue and 4th Street for 6 years with Nick Markovich where we plotted and materialized our various deeds—Gargoyle Mechanique's Studio Verité. I had my little multitrack recording studio where a lot of locals came through making tapes. It was a very colorful sculptural environment: down through the metal sidewalk gates into an alternate subterranean universe! Those days we were doing amazing plays that Nick wrote, an edge-art rock band called Door of Wigs and Super 8 films which we made live accompaniment for, and wild multimedia shows doing all of the above, all of which were called Gargoyle Mechanique productions. And perhaps unfairly so, because I was also using the GM name whenever I did my own thing too. By myself I was mostly doing solo music performances, performance art, graffiti art, stickers, stencils, that sort of thing. I made some backwards song performances, and tape loop collage performances. Some collaborators from the San Francisco days, David Sanford, Peter Krakow and Russ Cole moved out to NYC and we were making weird music shows, most notably FamiliarDesertOfTheModernImagination with Jeanne Liotta on dancing drums, and projection visuals by Nick Markovich and Bradley Eros. Then we started becoming parents and the scene transformed, melting, dissolving, disbanding and then reconstituting, the usual morphologorhythm. You know how reality is.

Then a number of chapters later, I somehow managed to get a lease on the insanely expensive ($1200/mo) 2500 sq ft space at 28 Avenue B, dubbed the Gargoyle Mechanique Laboratory.

With the big-time assistance of collaborators David Studer and Zero-boy and others, I rebuilt the interior into a theater/studio space with a kind of vague living facility in the back. Long-time gargoyles Nick Markovich and Carmen Waldorf were the first people to share the rent with me, living in this radical departure from normal apartment living, and we made the first theater and music events in that space.

EBON FISHER: Theater is such a maligned, but indispensable glue.

STEVE JONES: An art collective was born! Even though we never thought about it that way, but we should have because in my confusion I was overbearing and dominating through the years which caused a lot of problems learning life. But as more people became involved, Tim Sweet, Loyan Beausoleil, Beth Grim, Tabitha Kim, Bulk Foodveyor, Fly, Gina Nelson, Robert The, etc., etc., so many great folks, the place did take on a life of its own. The main spirit moving the people who played through there was the creatively sharing, awakening, growing out the boundaries, exploring beyond the brink, fellowship of alive, that sort of thing. Love animates. I see that there was a motive way above money, for the most part.

Generally we shared the view that the "Real Art Scene" was a corporate fabrication, mind-control trick with the hidden agenda of dissolving the human, blinding the starlight awareness, you know, the divide-and-conquer enslavery. Some of our collaborative art happenings were on this very theme: "New Profit Motive." "Swallow And Spew." "Puppet Masters."

It was so much fun to make a poetic statement as the guiding theme of an art show and then invite people to make something, anything, for the show in that theme. The core gargoyles would sometimes all make over-the-top experimental installation pieces and environments which would populate the main room, with numerous other objects, images, experiences by the invited creatives, and, wow! What a spectacle would happen. Of course no one knew what anybody else was doing so the final show was a delight for everybody, materializing like a magical apparition, usually with many astounding synchronicities. Often there would be performances in the event. The crazy thing is, we would make all this effort for a one-night event, sometimes a wild, dreamland party, and then that was it, and it would dematerialize. Crazy!

For a couple years we had a weekly "open stage" that anybody could do anything at. We tried hard to get a diverse array happening: film, performance, lecture, live painting, poetry, music, demonstrations, and then we would prepare the space with a new installation every week. Sculptural elements, whatever. Then we put on the show with as much production value as we could muster, which, with Tim Sweet and I at the control booth, live sound collaging and my special slide projections, we had playful lighting changes, along with whatever preparations set up in advance by whichever gargoyles wanted. It was pretty great. Then we had the audience of mostly performers coming in and sharing their personal thing in our open stage environment. We mostly tried to optimize the performer's movie, bring out the best in what we felt they were attempting to create, to the best of our spontaneous ability. The result was sometimes quite magical, for real. We had so much fun, I can't even tell you.

EBON FISHER: Did your cybernetic/futuristic aesthetic meet with any resistance from the prevailing Manhattan cultural climate? Our Manhattan "secession" began to galvanize in Williamsburg, Brooklyn, in the early 90s and I was not too surprised to find a handful of your group

popping up, en masse, at Keep Refrigerated [in Williamsburg], our homemade nightclub in a meat-packing refrigerator. All the Gargoyles hovered together in a tribal swoon at the back of the club. They were like wolves peering out of the darkness, scanning a new cave. Did your group begin to find more connection with Brooklyn than Manhattan?

STEVE JONES: Cybernetic/Futuristic? I guess you mean like Tim Sweet and Bulk Foodveyor's machines and contraptions and my computer animation loops and sounds, and Bigtwin's digital art parties, show-and-tell events that so many people came and shared at. That was so much fun. Installations with Peter Oppenhiemer and Cyd Gordon, and Fly and so many others surprising each other with multidimensional "poetics." Yeah. The prevailing Manhattan cultural climate was pretty diverse I guess, from reality to SoHo and 57th Street, rich-famous-artist head trip to spontaneous street expression and electric community. I guess we were somewhat on the forefront of the computer art thing back in those days.

But we were always struggling to get the rent paid and stuff so we could just keep blooming according to our intuition. Generally we didn't care about what SoHo was doing or whatever, except it was fun to look in the galleries sometimes, probably like today, so much great stuff down there, too, sometimes, but our world was a different frequency that didn't resonate easily with the corporate money brainwash. What we were living could not compute in the World Trade Center because you couldn't commodify it. Too changing and spontaneous. It was a combustive, human creative thought explosions, a natural garden of human intercourse with fruits you can't point to very easily and name.

EBON FISHER: Like Bulk Foodveyor dressed up as a granny, sitting in a wheelchair above the public's heads, coursing along a ceiling track, screaming all the while. He and his other robotic experiments blew my corpuscles wide open. Fly and her intense, persistent notecard comics alerting us to New York's oppressive dimensions. Weird projections and lighting systems slathered over endless analog components of food, music, conversation, clothing and sculpture. Gargoyle's media swallowed the public whole like flies in a Venus flytrap.

STEVE JONES: Ha ha! Great! It is about *community* gardening. Williamsburg had a lot of creativity going on, its community gardens like The Flytrap, Organism, Mustard Factory and Keep Refrigerated. Williamsburg artists seemed to have more business smarts, I guess. GM events were pretty much always free, except for the open stage, which was $3. Anyplace where the rents are less has creativity and community happening, that's human nature, at least until some hidden agenda, like CIA, etc., seeding it with drugs to kill the community and pay their black ops, or the millionaire-disease comes.

So many creative people are around doing things nobody ever knew about. Like today, most of it is hidden, striving to persist. At its highest, Gargoyle Mechanique Laboratory brought people together where they could meet face to face, sharing thought, and becoming peers instead of competition. Part of the corporate mindfuck is to dissolve community into competitors, the basic divide and conquer. I like to think that the Gargoyle Mechanique Laboratory provided some small antidote to that pernicious corporate rot.

EBON FISHER: "Antidote to pernicious corporate rot." That's a lovely phrase. I recall that the bohemian funk of Gargoyle—with its extraordinary facade and constant retooling of events, installations, and agendas—often defied categorization. Was there a point at which members wanted to polish the good ship Gargoyle into a more translatable meme or franchise? To get the word out beyond Avenue B?

STEVE JONES: Well at one point we had a "smart bar" which sold herbal tonics that enhanced brain functioning. Short-lived. We had buttons and T-shirts here and there, and a computer disk set of CyberSounds, a videotape compilation of Nick Markovich's brilliant movies, cassette tape music compilations that were quite good, quite diverse, called Live Lab, but I never really thought of the place as a business. It was an art space, a creativity place. None of us had much business acumen. In retrospect, I think we could have done much more to get more of the bills paid in a fun way, like an art cafe or something going on. I didn't think about business very well. I had my day job in Queens working at a printing company, which came in real handy for my own creativity, but I never was able to have a clear notion about a streamlined Gargoyle Mechanique business that paid its own rent, etc. And nobody else did then either

that I can remember.

EBON FISHER: How did children in your life affect your vision of Gargoyle Mechanique?

STEVE JONES: We had some great parties for kids, mainly Chloe's birthday parties. She is my daughter with Jeanne Liotta, the filmmaker, drummer, and theater artist. Jeanne and I were separated already during the Laboratory days. And Chloe initiated my connection with the local schools, and other children in the neighborhood. It's like there weren't any kids until Chloe came, and then there were kids all over the place. It was the lifting of a veil.

One big kid influence at GMLab was the Haunted House project. Yeah. Those were maybe our biggest, most elaborate shows, the Halloween Haunted House. We did three of them. We would work like crazy up till the date, then all night getting ready for the opening of the House for Chloe's school to come through at 10 a.m. or something like that. It was nuts. But I guess it's the most fun possible for a person to have. Yeah, that's a tangible kid influence. Now I have been doing Haunted Houses at the 6th street and Avenue B Garden for the last few years, and they keep getting better. But those Gargoyle Lab ones in '90, '91, and '92 were pretty extreme.

Also I would have to say that children in my life made me more aware of that innocent part inside of every person. Having children of my own gives me a clearer window to that truth. I just have to remember to look through that window and be aware of the view! But children can help us to remember what the world really is. We can forgive the children, the hidden children everywhere, if we can remember to know they are there.

EBON FISHER: Our culture tends to trivialize children and the "starlight awareness" you spoke of. New York, sophisticated media capital that it tries to be, hasn't done much to deepen our connection with children or the entire natural world beyond the "hype zone." This city seems hardwired to tune out the reproductive cycles of our species and focus on the sex/conquest years of life devoid of context. In addition, New York's real estate speculators have made it impossible for neighborhoods and communities to stabilize enough to form an extended womb of safety for children, not to mention well-cultivated public schools. Those with children have to carve out a comfort zone against the odds. The ecological awareness of New Yorkers is hilariously medieval. But it's a cycle, surely. The real estate speculators hate their parents, not to mention their ecosystem. They buffer themselves with property. Speaking of property, tell me about the fire and Gargoyle's transmogrification into Collective:Unconscious.

STEVE JONES: The fire was after the core Gargoyle group had essentially dissolved and then I handed the lease over to Dan Green and a new wave of merry creatives with fresh energy to do that lifestyle. Some of the final members of the GMLab collective became part of that movement: Spinner, Miklos Legrady, others. The dissolution of the GMLab group is a complex story; I won't go there now. Anyway, I gave the keys to Dan Green, and the new community continued operating the space pretty much as we had been, in terms of the collective infra-structure. We worked it out with the landlord that Dan would take over the lease, continuing where I left off. Some time later I had a strong feeling that their style of theatrics should be called something different than Gargoyle Mechanique. I wanted to continue controlling the GM identity, so I asked them to choose a new name. And they became the Collective:Unconscious, which is still going strong today. They're an incredibly creative group, providing a great space that NY needs so much. Thank you C:U!

A few months after the name change, they had a big art installation in the main space with lots of plastic and cardboard, and one night (so I was told) the people there were in the downstairs having a party when a fire broke out upstairs and BOING WHOOSH! Bad fire. Not the whole building but the upstairs neighbors suffered a lot. James Godwin was upstairs and lost a lot of his magnificent puppets and amazing artwork. His cat got cooked. That was the only fatality. That cat's body was lying around on the street for a few days, I guess, looking like a charred BBQ. Wow, lots of stuff got lost, purged, I guess, sped up to infinity. And so. Onward. So the C: U went looking for a new space and the creative community center became a church. And after that a puppet-themed restaurant Pierot. There's a continuous thread through that, if you look for it.

EBON FISHER: You have always struck me as a highly independent soul. I would love to hear

from you, in personal terms, what you think about this odd existence of ours. How has your work in digital art and community formation reflected your beliefs? Has the "art world" held out any value to you or has its underlying agenda discouraged you from pursuing its, well, machinery?

STEVE JONES: The "Art World" is a corporate fiction. Reality is the only art world I love. Creative humanity. That's what peace and love and freedom mean to me: amazing creativity, spontaneous combustion, and impossible magic. Some people say they wouldn't want peace and harmony because it would be dull, boring. It is clear to me that they have no idea what they are talking about. Community combustion is the most thrilling delight imaginable, and the way you make that happen is to purify the mind of fear and rediscover that we are all innocent children ready to play. Harmony equals infinite thrilling possibility, not boredom. Fear provides a fake kind of excitement, sold to us continually by the corporations as "fun." But it is more like a drug effect: short-term emptiness that feels fun at first, then gives you a headache. But peace and harmony blasts a heartship into a fractal adventure of total excitement that is as deep as the universe: reality!

As to people being independent, it *seems* true. That is the apparent reality. On the deepest level of the true reality, though, we are all aspects of the One Thing. That's why telepathy is part of our nature. We are all connected, more than connected. All of these apparently separate objects and people are aspects of the current state of the One Thing. That's my operational theory.

EBON FISHER: How does your current creation, CHAMA, build on Gargoyle Mechanique? Why didn't you follow your various members into the formation of Collective:Unconscious down on Ludlow Street?

STEVE JONES: Well, I had a big life change, transformation, complex, became a parent of Ezair with Loyan Beausoleil, moved into other focus, more computer, music, learning how to be a human being— A big break from that earlier flow. Now many years later, I am doing this other thing, similar in some ways, but very different too: still an art space, still a studio, still a public expression, "human thought gallery," but hoping to make a support system somehow this time.

CHAMA Teahouse is much smaller than the GMLab, for one thing. So in order to have all the functionality I feel I need in a space, I had to be very careful in the design. I needed a stage, a service counter, a reading library, multiple sitting-circling areas, an office, a tech booth, and storage. All in a 26 x 16 foot space. Impossible. But I more or less succeeded, and everybody likes it. It's an unusual, circular space. I do video screening with a projector I have use of, make "forbidden science" presentations and curate art shows. And other people come in and facilitate their projects in the CHAMA environment. One of my main goals is to make a place that supports itself and my various financial obligations. It's a challenge, as I am not there yet. Wanna invest?

EBON FISHER: Hey, I'm sitting on a screenplay waiting for the same thing. Try the new class of barons that Bush is creating at the nation's expense. Speaking of Medieval arrangements, do you have any suggestions for creating a positive culture in a time as bleak, cynical, and Republican as this? Is the "vision thing," to quote Bush Senior, now regrouping in the underground (and pockets of the Internet) for awhile? I've been feeling lately that we are all forced to keep our flames under wraps while we live through the past of a more glorious, saucy, life-affirming future. The "liberals," like those I encountered recently at Hunter College, are fighting among themselves for higher salaries and status within their shrinking empires. There's a certain madness and cruelty in their current culture. Amidst a rhetoric of inclusion I never saw so many alienated African-American professors.

STEVE JONES: Even the "Republicans" are not really Republicans. This day and age in "civilization-land" is about smoke and mirrors, tricks and disguises. *But!* I believe the revolution is happening right now all around us. Only hidden. This revolution is not succeeding by fighting against the controllers, because all combat or shouting will be dealt with by the controllers' super-computed, master contingencies. That's why we are fed a constant diet of fighting imagery, because they know how to win those scenarios. The alternative, which is hidden from us, the alternative that will make the evolution, that they have no power to stop, is for people and entities to simply *be* the change they want to see. Independent expressions of sincere

human creativity based in loving awareness that we are all connected, millions of small local flowerings. Each magic flower will be witnessed by others, who will be inspired to make their own flowering, like chamomile cracking through the concrete sidewalks, dissolving the false control into the natural reality. We don't need to organize an army; we only need to be sincere and creative in the place where we are, with the awareness of the larger community.

Have you seen MoveOn.org on the Internet? They have invented a working version of national people's democracy software. It's up and running on the Internet and it's great. Everybody should check it out, see how to use it. It's a way we can share our opinions in a meaningful way without the corporate middleman twisting it up for the fear-mongers.

EBON FISHER: The Internet has a lot of promise if people continue to rise to the occasion and participate genuinely in it. The junk and bureaucratic uses of the Internet are an extraordinary distraction, but not much different than bits of seaweed and candy wrappers on a surfboard.

Steve, thank you so much for your amazing story. In a moment I'll be interviewing Bigtwin about his Technoromantics gatherings at Gargoyle. Those were a critical part of the GM experience for me.

STEVE JONES: I think I may have been way too verbose, but I told a lot of the story. This was a fun thing to do. I haven't really put this info down like this anywhere else. Thanks for the opportunity!

EBON FISHER: It was a pleasure. You're a rare creature.

WEBSITES FOR STEVE JONES:

www.chamateahouse.com

www.gargoylemechanique.com

Paul Bartlett

Bigtwin with his video projection and Urania Mylonas

Technoromanticism Grows in the Belly of the Gargoyle

Ebon Fisher Interviews Video Artist, Bigtwin

In the early 1990s, long before Manhattan's increasingly provincial art world caught on to the emerging paradigm of digital culture, Bigtwin's Technoromantic forum at Gargoyle Mechanique became an important watering hole of the soul for the Lower East Side's experimental media community. Ebon Fisher conducted the following correspondence with the artist over the Internet. Fisher's own media gatherings in Williamsburg, Brooklyn, the Media Compressions, helped to foment a parallel multimedia culture across the river in that other nascent creative community.

EBON FISHER: Bigtwin, you were an active force in the Gargoyle Mechanique Laboratory in the late '80s and early '90s. How did your *Technoromantics* gatherings come about? It was years before *Wired* magazine, Silicon Alley, and the web. What prompted you to stick technology and romanticism side by side? Aren't they antithetical?

BIGTWIN: Absolutely, and that's what makes it interesting. I don't know if I knew then what the definition of romanticism is/was, and maybe I'm not sure now, but the uniqueness and/or novelty of such a group was in itself romantic. I went to an exhibition of "Romanticism" at the Met around the year 2000, and to me, it was hard to discern what classified art as "romantic" based on the pictures shown—they were from such a variety of media, content, everything from narrative to very abstract.

I thought that much of the "computer art" of the day was anti-human or perhaps anti-spiritual. Either from artists actively pursuing pure synthetic, machine concepts, or others blindly pushing buttons/ following the software's pre-made leads to output (there were a lot of solarized photos and the like). I remember asking some of the head artists of the SIGGRAPH convention about schools emerging in computer art—it was like I was speaking Greek to a non-Greek person. They said something like, "Well, so-and-so is collaging scanned photos, and so-and-so is doing 3-D modeling," and the like. I replied, "No, I mean philosophical schools—people pursuing an aesthetic concept or experimental idea beyond just stating what hardware and software they were using." They said they didn't know of anything like that. Another telling indicator was that all groups for "computer art" were, and perhaps still are "user groups": "Photoshop user group", "3-D studio max user group," etc. I suppose one could say that there are "oil painting groups" and "sculpture groups," but even so, I felt that computer art was/is lacking message, or at least the "artists" involved didn't know what that message was. Or if they did know what the message was, it was something like "the machines are here and they're cooler than any one of us—history is over; all you knew is over, and the only way to get your attention is to create increasingly outrageous ways to shock you."

EBON FISHER: Shock and Awe is such a tired American tradition. More bombs, bigger tailfins, more special effects, but ultimately less synthesis.

BIGTWIN: At the time I didn't know why I wanted to do computer art and suggested to a friend that I might make a film, interview computer artists and see what they said about their reasons/observations and my friend, Susan Goldin, said, "You should have a group—like the Abstract Expressionists in the '50s." Some of the first meetings were held at the Cedar Tavern, where the Abstract Expressionists had their meetings.

Computer art and romanticism are only antithetical in our present mindset. Of

course I'm massively generalizing about the collective mind of mainstream society now, but I think I'm mostly correct. We are the products/victims of 2-6000 years of monotheism—humanity removed from nature. And then we can add on 400 or so years of rationalistic (scientific) reaction to such a mindset. Both of the preceding sentences could start a discussion and fill very large, multi-volume books, so it's hard to just say this and then move on. And whereas we may know firsthand of the angry response you might get from "bad-mouthing" religion, just try telling some people (a college professor perhaps) that science is rooted in, and a reaction to, established religion as we know it on this planet. That can be a doozy of an argument. For more on this: http://www.eccosys.jp//lilly/observerx.html

EBON FISHER: There's something beautifully visceral about that view of intellectual history: minds sloshing about in the darkness, blindly fabricating worldviews and each distracting us from both the pertinence and the beauty of raw nature. Many, like Rachel Carson, have tried to remind us of our biological dependence on nature and others, like Michel Foucault, have even tried to illuminate the very wilderness of our own scientific culture—but the struggle is immense. We are nauseous in the face of ourselves. Our gods and our charts are the ultimate antacid. Rooting ourselves within the wilderness and sensing an infinite, mysterious universe pressing behind every thought scares the bioflavonoids right out of our chrome, USA, USA, USA skins. Without a culture of reflection to ease us into it, the spirit of the wilderness, of the great mystery, is a horrifying thing. There's a reason for so much horror and science fiction in our culture. It's our spirituality in a state of perpetual, adolescent whimpering and snickering. Which is to say that such genres are a necessary platform for twenty-first century spirituality. Technozid in Berlin. Technoromantics in New York. Techno and trance music throbbing across the planet. Asimov, Ballard, Clark, Le Guinn, Gibson, Sterling, Kubrick, Cronenberg and even Cameron have mobilized millions of souls with their work. The unpretentious street freshness of sci-fi is critical to its emotional and spiritual success.

BIGTWIN: I remember overhearing a guy saying that he had been invited to a conference to talk about technology and spirituality and he rolled his eyes, saying, "What a crock! I don't have any idea what I'm going to say . . . I guess I'll talk about art and music on the computer." Rather than appreciating the inclusion of art and music in a spiritual discussion, I was flabbergasted. I had read about this guy's technopaganism in a *Wired* article, but had not fully comprehended just how much hype and how little substance there was to this and so many ideas going on. Technology and spiritualism a crock? Well let's see how many areas of exploration we can come up with:

1. The computer as a biological entity— ramifications?
2. Electricity—is it life and/or consciousness?
3. Discussions of duality in regards to 1 and 0
4. Digital (exact) reality vs. analog (amorphous) reality
5. Scientific discovery (astronomy, biology, and Quantum physics just to name three)—can it lead to spiritual beliefs?
6. Can methods of data storage and information theory shed light on epistemology?

This planet has an awful separation of religion and science, leaving "religious" people (angrily) pursuing various dogmas, science occurring in a vacuum from spiritual concerns, many people disenfranchised from both (probably from these very shortcomings) and others trying to "cross over," either way off or attacked from both sides. When I say that I am mostly a scientist, looking for spiritual insight; most people think I'm a "creation scientist"—which either leaves people thinking you're a wacko, or endears you to them. When they find out I'm not a Christian, then everyone thinks I'm a wacko, and probably a very dangerous one. Most scientists will not even allow a "spiritual" or "paranormal" (note the inherent negative bias) or even "emotional" idea into their discourse.

Once I remarked to another scientist I met via Dr. Lilly that, "Oh, that dolphin really liked that last thing" or "that made the dolphin angry." The scientist would caution, "That's not scientific observation." After a long debate (which is still going on) he said, "Well, dolphins may indeed have emotions (or be psychic), but if I wrote that in a paper I'd be ridiculed and lose all my funding."

I suppose I can't blame science too much. Established religion here is really so untenable that of course there is such a "reaction" to it and thus "spiritualism" has been tossed as well.

EBON FISHER: The tensions between mind and matter, art and science, the Dionysian and Apollonian—it riddles the techno arts like bullets in Bonnie and Clyde's last stolen car. There's a lot of folks in our field who would have been great (but defeated) alchemists who could keep the pubs warm in medieval England had we lived then. So many techno artists get bogged down in systems design, programming, and academic games—and neglect the sensual, dreamlike, codes of form, symbol and narrative. I'm waiting for the true, raging artists to emerge out of our field. Not the lead-footed, academic "players." I guess that makes me a techno-romantic.

I remember the Technoromantic gatherings vividly: a darkly lit room with a jumble of chairs arrayed in a crude circle, no precise stage or center, various media equipment brought in on an ad hoc basis. It had the ritual structure of an amoeba. Debates flared up within a general tone of amiable curiosity. For the sake of the readers, can you describe a typical gathering and the sort of experimental media which was being shared in the Technoromantic gatherings?

BIGTWIN: Gatherings began in 1989 and started out as six or so people. Expanded to about 15 for quite a while. Started going to Gargoyle in '91 or '92 . . . still maybe 20 or less . . . one meeting exploded out to between 70-80, then over 100 until implosion in the fall of '93. Media included paintings, video, music/soundscape, performance (at the end). It started as a discussion group, but became more conference/performance by the end.

People asked to bring art. Usually people sat in a circle and talked, referenced the art. Typical questions: Why do you do computer art? What do you think about computers and art? Do you have any health problems from the computer? Will computers change society? In what way? Digital and/vs. analog?

EBON FISHER: What was the Gargoyle culture like? Were the parties distinctive in any way?

BIGTWIN: It was the best scene of the time and still the best art environment I've experienced. Open to anything, welcoming, not trust fund kids (maybe some, but they weren't the primary artists).

EBON FISHER: After your Technoromantic gatherings ended in the early 1990s you pursued a lot of your own creative projects, showing interactive video work at Postmasters and creating 3-D animations for musician Jaron Lanier and interactive TV pioneer Nick West. At some point in the late 1990s you left New York to work with John Lilly on his dolphin research in the Hawaiian Islands. How is talking to dolphins (techno) "romantic"?

BIGTWIN: I've met many people now, all who say they are trying to communicate, or at least commune with, dolphins. From scientists using various established language communication research methods, to "genie people" who have group meditations and dolphin swims. These crowds rarely overlap, and with Lilly's death, they overlap even less. In fact, the relationship between these camps is markedly antagonistic.

Recently we were watching a documentary on the Wright Brothers, and the narrator said something to the effect that "the Wright Brothers were the first to use science in their design, the previous attempts were all romantic designs, based on whimsical ideas of what a flying machine should be." At which my partner, Kate, observed that the idea of flying was romantic whether you used science or not. Although it might depend on one's intentions. I don't think "I'm gonna make a plane so I can get rich and our army will have an advantage over others" is so romantic. But, "Look at that hawk soaring up in the clouds—I wish I could do that" is quite romantic. I wonder if the narrator of the documentary judges endeavors by their success. I wonder if he would call trying to talk to dolphins "romantic" and if he would have to change his view if we succeeded?

For my own particular incarnation, "romantic" probably pre-supposes either Armageddon as outlined in the Bible (from my early youth as a Christian) or ecological poisoning of the surface of the earth (from my later youth hanging around activists). Of course, if we don't take doom for granted then it's not fanciful to think that everything will work out well and thus, not romantic.

If we are going to define any activity not motivated by the scientific method (1. uninvolved observer, 2. hypothesis created and tested by experimentation, 3. results duplicated by another person) as "romantic" then I suppose I am. I already sent you to Lilly's writing on the 'Scientific Observer," but let me just shorthand here that the scientific method will never discover: 1. phenomena too small to measure, 2. phenomena that happen the same way only once, 3. phenomena that it is pre-biased against (so-called paranormal phenomena—can you imagine a physicist calling quantum physics "paranormal" when it was first presented? It might have been called crazy, but certainly not paranormal).

If I discard the scientific method, is that "romantic"? If I discard it through the use of poetry and wild dancing, is that "romantic"? What if it is discarded through—the use of observation and logic, following where the data leads, regardless of how bizarre or distasteful the conclusions are—Is that "romantic"? I have experienced psychic phenomena (on various occasions prescience and/or remote viewing), and I know I can't "prove" this. I also know I have (seemingly) no ability to duplicate or control these occurrences. Yet when I have one I now take note, and I work into my "scientific" exploration the knowledge that this phenomena *is* possible. Is that romantic? I work my "belief" (or knowledge) that creatures from similar locales operate in similar ways (a roundabout way of saying that "humans" and "animals" both possess similar physical and mental processes) into "scientific" as well as "spiritual" consideration. Is that romantic? It would seem to the classical definition that they are—until I achieve some tangible output that regular Joes can put in their car and drive.

EBON FISHER: If it fuels a 1973 Dodge Charger I might be convinced that the regular Joe beat you to it. But I understand the frustration. To me, logic itself is reeking of spirit so there's never been any doubt that dolphins or computer scientists or aphids all share various degrees of awareness. The difficulty is in feeling alienated from the everyday practitioners of art, religion and science. It's a heresy to mimetically modify their meme pools. The purists will excommunicate intellectual radicals on many levels. Luckily, there's a lot of hybridity today and plenty of disaffected thinkers to keep the gray areas boiling.

Thanks, Bigtwin, for your kind attention to this effort at local digital culture history. I'm sure the territory we glanced at will continue to unfold in a variety of media.

Bigtwin's TECHNOROMANTICISM: www.eccosys.jp/~bigtwin/TEKROM/

VIDEO by Bigtwin: ILLAGE VIDIOTS: visual immedia www.eccosys.jp/~bigtwin/ILLAGEVIDIOT/

STARWREK www.eccosys.jp/~bigtwin/ STARWREK/

VIDEO WORKS PUBLISHED BY GARGOYLE MECHANIQUE:Collection of films by Nick Markovich

Featuring: *Lye, Human Flesh, Mass and Masses*

Video by Steve Jones: *Camptown Racetrack* backwards music video

Animation loops and music collections by Steve Jones: *Through The Portal, Puppetshow Music*

Features: *Flower Of Life, Visitor, Signaling, Yin Yang, Eye You We,* and others

For more on Ebon Fisher: OlulO.net

Collective: Unconscious

Interviews with Jamie Mereness and Brian Frye
by inju kaboom, kyle lapidus, joe pure
Part 1: Interview with Jamie Mereness
by inju kaboom, kyle lapidus, joe pure

Collective:Unconscious

Times articles may blow up art collectives, but this theater collective is ready for any fiery act of god. Jamie, who regularly plays with lightning, has only one concern with a future terrorist attack, that it may lower the rent.

Jamie started the interview with a gigantic tesla coil on the third of July.

We went right to the pulse of the Collective:Unconscious, "Tesla Jamie." Jamie is the in-house tech physicist, aka technical director, and self-proclaimed mad scientist. Jamie knows a lot more than the subtleties of electrical engineering. He is also an expert source on Puffy, the twin Japanese teen pop sensation. And once Jamie gets going about Puffy, it may have to take a room-sized bolt from the mega tesla to bring him back.

The crackling tentacles of electromagnetic lightning are spider webs for Jamie. They fix their viewers in place, draw them in and zap them when they hold a fluorescent tube. Tourists have thanked Jamie after being thrown ten feet.

Jamie has two functions at Collective:Unconscious. To design and maintain everything electrical audio, visual, lighting. And to provide the decorative lighting spectacle that brings the random passerby into the space.

Q: How often does the fire department visit you?

Jamie: Almost never anymore, because we no longer have people living here who shouldn't be living here. So we're not naughty!

Q: (Chris Brodeur) You guys used to do these really cool water fountains—in front of the space like back in the day [Gargoyle Mechanique]. Why did you stop doing it? Was it because of the law?

Jamie: For the last two years it was because there was this drought. We had it redone this year, but we all went to court—we had to pay a fine of $50 for blocking the street with the apparatus. We've learned our lesson—we know how to do it now without being fined or penalized. I'll start pestering Dan [Green] about it.

Q: (Chris Brodeur) What's this I hear about you guys having to move out by the end of the year? That's not definite is it?

Jamie: Nooo . . . there might be some kind of catastrophic terrorist act that ruins the real estate market . . . but . . .

Q: When did you start your involvement with Collective:Unconscious?

Jamie: Before we were the Collective:Unconscious—like six months before, I was working at a recording studio in Long Island City—my first job in New York City—like 1993—let's call that "The Beginning." I met this guy who told me about this Halloween party—so I got dressed up in this ridiculous costume [made] from the innards of an industrial dishwashing machine—the part that rotates and shoots out water—and some other parts from Radio Shack, so my hat rotated, shot out water, and went "bleep, bleep, bleep." I guess not too much happening with the costume below my head. I came down here, Avenue B, corner of Second and Third at Gargoyle Mechanique!

They thought I was weird enough to become one of their friends and I actually did something I hadn't done in years—a couple of times, I actually went on stage and did stuff . . . to kinda prove my validity. That was like 10 years ago, now. Now [I'm] going into stage 3.

Stage 1 being: "Oh my god! I'm part of this really incredible cool art group and I am going to see every single really groovy person who's ever going to be somebody."

Stage 2: "Oh, there's so much crap coming through here—I can't imagine that I'm having to suffer through it." And then, stage 3 is like: "Well, I have a few friends here who are really fantastic and wonderful and I want to do things with them."

It almost sounds like culture shock as if I'm in a foreign country. Which in some ways I have been in right? I guess this is not an indigenous environment for me—to be in an art space.

Q: What is your natural environment?

Jamie: My father's a World War II naval veteran.

Q: What do you do for a living?

Jamie: [Working in] recording studios, worked for Guggenheim SoHo—when there was one—doing their video wall. I'm currently unemployed. I was working for 10 years with Philip Glass. I was fixing the electronics for the recording studio and for the ensemble. . . . but they fired me after 10 years . . . power struggles with the studio manager . . .

Q: You started out at the Collective:Unconscious when it was still just a raw space. Let's talk about that a little bit.

Jamie: I started with the Collective before it was a collective .. I coined the name even though a more senior arrogant member subverted it. I wanted to call it the Unconscious Collective. The [name] Collective Unconscious was the only thing I was really adamant about—I wanted a colon—I wanted Collective:Unconscious. So it wouldn't be so . . . *derivative* as "collective unconscious" would be without the colon.

Q: Because without the colon you're just quoting Jung?

Jamie: We're collective colon unconscious . . .

Q: Didn't you guys have a bunch of T-shirts printed with the colon?

Jamie: Yeah, we did . . . Are you still recording? As much as the tape recorder makes me feel self-conscious, as the technical director, I'm really concerned that your tape recorder is functioning properly. Did you want a flashlight to check that it's on?

Q: That's a cool flashlight. At one point I thought it was your eye.

Jamie: It's a one-watt Japanese Michia LED—but an American company in Arizona makes it. It's powered by a 123 battery—that's 3-volt lithium.

Q: It's got a lot of power for such a small thing.

Jamie: Lithium is god!

Besides Jamie's input with the name of the Collective:Unconscious and the creation of the electrical toys, he has made a variety of other substantial contributions to the collective.

Jamie's contributions have significantly enhanced Collective:Unconscious for almost 10 years. Jamie became involved shortly before the fire that forced the Collective to move and develop. Collective:Unconscious was challenged by these events. It lost Faceboy's Sunday Open Mic, and went through a temporary period housed in a synagogue until it became clear that people wanted to live there more than to have it used as a performance space. A while after the fire, Collective:Unconscious settled into the current space; 114 Ludlow, formerly a 24-hour tailor shop/brothel, and germinated like a pine cone.

The first show in the current space used the small rooms downstairs in the "tailor shop" for a variety of technologically and sexually charged installations. This show featured one of Jamie's favorite works, complete with robotic vaginal and breast lighting controlled by penetration by another machine. Jamie claims that his work at this

time resulted in part from a need to prove himself artistically.

The bathroom is Jamie's. You won't find him there except maybe when you look at your perfect reflection in the mirror or watch the water disappearing off your hands down into a false sink. Maybe after-hours, Jamie comes up from the basement to get a tan standing by the toilet.

The critical and commercial success of "Charlie Victor Romeo" [www.charlievictorromeo.com], which included Jamie's audio designs and inventions, gave the Collective five thousand dollars, which Jamie insisted be spent on a video projector. This projector revolutionized video at Collective:Unconscious. Having this projector validated Jamie's invitation to Robert Beck Memorial Cinema to hold its weekly film and video screenings at the Collective. Jamie is responsible for inviting the Robert Beck Memorial Cinema to the Collective.

Part 2: Interview with Brian Frye
by Inju Kaboom

Since 1998 Robert Beck Memorial Cinema (RBMC) has been a weekly forum for both established and emerging video and film artists to present work to the public. The unencumbered manner of curation has provided a venue for serious and goofy filmmakers alike to showcase work within the framework of a program, circumventing the chaotic and often confused atmosphere of an open screening. In this way, even the most outrageous and overtly experimental video and film work are framed, to some extent, for context, within the larger strata of New York's downtown film and video topology.

The range is broad—from Jennifer Montgomery to Richard Foreman, Takahiko Imura to Delia Gonzales and Bruce McClure to Forcefield, RBMC has screened problematic, difficult, ridiculous, beautiful, ecstatic pieces of exquisite visual pleasure.

This conversation is with Brian Frye, founder and member of The Robert Beck Memorial Cinema.

Q: Let's talk about your involvement with Collective:Unconscious. How did you start?

BF: What happened was that Amy Greenfield—Robert Haller's wife, told me in passing that she had heard from a person she knew that Collective:Unconscious, this theater, was interested in starting a film series and she gave me his name—that was Jamie Mereness.
I called Jamie because I was interested in doing some film screenings. I wasn't exactly sure what? But I was interested—at the time, I was working at the Anthology [Film Archives].

Q: What year was this?

BF: That was 1998—I believe May of 1998? So I went over there [to the Collective:Unconscious] and saw the space and it looked interesting . . .

Q: Did they have any equipment at the time to facilitate a weekly film and video forum?

BF: At the time they didn't have much of anything. Basically they were doing theater there . . . so they had foamcore up as a screen, and as I recall they had a really old beat-up Eike projector that barely worked and I was mostly interested in showing films anyway, although it just felt like video was just not going to be possible unless we got a hold of a different projector. So I said I was interested, I had this old Pageant 16mm projector and I said I was interested in doing a show. I didn't know what I wanted to do—but I did want do some screenings— Tuesday nights at nine o'clock—because Tuesday nights wouldn't conflict with anything else and by nine o'clock thing are over, so they can come see something after something else. Jamie sponsored the series, so rather than charging a rental type fee, like they usually do— they basically ended up splitting the door fee, as if I was a member. So the first fifty dollars from the door and the next fifty went to Robert Beck Memorial Cinema . . . and it was fifty-fifty after that. So the first few shows I was charging $3—low enough so no one could reasonably complain that they couldn't afford it. We started by showing films from the library and making it a donation rather than a fee . . . So the first show was a combo of Emile de Antonio *Underground*, the documentary about the Weather Underground shot through mirrors, and Nixon's *Checker's Speech*, which is kind of a long program but a couple of people stuck around.

Q: This is 1998—what was the scene like as far as the Lower East Side was concerned in terms of alternative video and film spaces. I know that the Anthology of Film Archives was a

big presence and Millenium [Film Workshop] but other than these institutions from the '6os and '7os—what was there?

BF: I felt that Anthology was established and showing historical works in experimental cinema, but I felt like there wasn't a whole bunch of younger people's work—not at that time any-way—The Millenium was, well . . . showing kind of predictable work.

Q: So what was your motivation in all this—how did you come up with the idea for Robert Beck Memorial Cinema (RBMC)?

BF: When I was living in San Francisco, I was going to see Craig Baldwin's Other-Cinema Artist Television Access (ATA), which is very similar to Robert Beck (RBMC). I was also really interest-ed in the way that David Sherman and Rebecca Barton and their "Total Mobile Home" showed a sort of micro-cinema, a personal curation thing, where they were trying to present films in a very personal way—[where they were] highlighting elements of films that were interesting to them. I always felt that this was the more important aspect of experimental film.

Q: When you first came to New York City from San Francisco in the mid '90s what was your impression of the experimental film scene here in New York?

BF: I just think that it's different from a lot of other places because it's so much bigger than other cities. At the time I felt like there wasn't a whole lot going on, in terms of pre-institu-tional level. There wasn't too much in the way of salon type screenings. Not open screenings but a program situation where you didn't have to be established, where you could have a lit-tle bit more flexibility—where there isn't a whole lot of money riding on it . . . Jane Gang was doing some screenings but I felt like they were a bit irregular and she wasn't really interested in the same kind of films and videos as I was . . . her emphasis seemed to be video and cine-ma of transgression which was never really my bag . . .

Q: So how did you hook up with Bradley Eros?

BF: He came to the shows . . .

Q: When you started Robert Beck Memorial Cinema at Collective:Unconscious—was it just you in the beginning or both you and Bradley Eros?

BF: He came to all of the shows . . . he had interesting ideas . . . I'm not the type of person who feels that things have to be mine . . .
My understanding from Bradley is that Collective:Unconscious had approached him earlier about doing a film and video program there but he felt that it was more trouble than it was worth. I had plenty of time—I was just coasting through NYU [film department] and feeling like I was wasting my time. So, I was looking for something mildly entertaining to occupy myself while I pretended I was going to graduate school. It was really, for me, an opportunity to show films I really wanted to see.

Q: So, how long before Bradley joined forces with you at Robert Beck?

BF: . . . like six week? It was never like—who's a member sort of thing. It wasn't a club . . . I would have been happy to have more people participating . . . suckered them into it . . . I could never really talk anyone into doing the work. I was just really into it at the time. The idea of putting together a program, making sure a working projector was there with spare bulbs and reels, getting a calendar made, posting stuff on the Internet, etc., etc., I didn't mind doing it. So it was fun, I was happy . . . I just kept on doing it week after week. It got easier the longer I did it for, partially because the Collective:Unconscious was really accommodating. They gradually got better and better stuff for us to use [for the screenings].

Q: Equipment-wise . . . ?

BF: Originally they just had foamcore for a screen and then I had this little reflective screen that I used for awhile but they didn't like it because it was too small and then they had this like stretched fabric that looked like some bat screen. That was pretty funny—lots of people liked that. It worked but it wasn't as reflective as it could have been.

Q: So who bought the screen that's there now?

BF: I understand that they got some money—a grant, maybe?

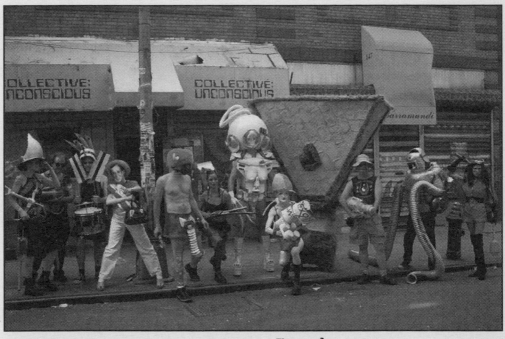

Clayton Patterson

Collective:Unconscious Monster Parade

Jamie found a really nice screen and bought a beautiful video projector. I used to discourage people from showing video—not because I didn't like video but because we didn't have the equipment to reasonably show video properly.

The new video projector has allowed us to feature good video and digital works. So many people are doing work in either video or partial video and digital and it's nice to be able to accommodate that for people who want to show. Though quite frankly, I've been away the last year so . . .

Q: Do you notice any changes in the Lower East Side scene since you started RBMC in 1998? Where do you see Collective:Unconscious and RBMC in this new Lower East Side—is there a future?

BF: The thing I thought was fun about the Collective:Unconscious was that they were so accommodating for me doing something that really wasn't closely related to what *they* were doing. They sort of acknowledge this, too. The Robert Beck stuff tends to be a lot more self-consciously high arty . . . compared to the stuff they normally do there. Robert Beck was catering to a film crowd that was coming from the art gallery and museum scene. The Collective:Unconscious was doing this crazy theater stuff. The aspirations were different.

Q: What are the cultural presences that are available to younger film and video makers in the Lower East Side as far as venues are concerned?

BF: Hmm, places people go . . . I think it's important to recognize that making artwork is important and art matters not because it does something else but because it's important to understanding the world . . .

Q: But there is a strong connection between the Anthology of Film Archives and the Robert Beck Memorial Cinema. Both you and Bradley have strong associations there.

BF: I'm interested in doing the same sort of thing that Amos Vogel at Cinema 16 (who was hosting screenings back in the '40s and was a major inspiration to Jonas Mekas of Anthology, when he first attempted screenings in NYC in the '60s) and when Jonas Mekas started doing film screenings at galleries in the Lower East Side and the Collective for Living Cinema and

Ken Jacobs when he helped start the Millenium. The idea is that when you love films as a fine art you want to be in a position to help show [that] in a way so that other people can learn or have an opportunity to see them. When you care about something you want to give something back to it and for me, being able to show films was rewarding because I got to see movies that I really liked and I wanted to share them with other people.

Q: What is the big difference in having the venue be Collective: Unconscious for RBMC? I've certainly seen you in other spaces like the old MOMA—screening room? Why the Lower East Side?

BF: People go to [the] venue because they trust the people who are presenting stuff. The Collective:Unconscious gave us a space that was feasible for what we were doing. Experimental film is the stepchild of fine art . . . and yet it's hard to do it at galleries because economically it's impractical for the galleries and for us. We've done stuff all over the place—museums and film festivals . . .

The Collective:Unconscious is great because they were flexible enough that they did not expect us to cover their cost, they didn't tell us to do one thing or other, everything was fine as long as we didn't cost them anything—to keep it happening. That kind of flexibility and openness is really important because they trusted our judgement to do something interesting. There aren't a whole lot of places that would accept that. Venues [currently] are not in a position to let things happen—I guess they need to generate revenue and attract large audiences to survive.

Q: Where do you see the film and video scene going in the Lower East Side now? Is this location no longer able to generate a proliferation of this kind of experimental film and video outlet?

BF: I guess it depends on whether or not it's still amenable to the kinds of thing that people want to do. The neighborhood is definitely changing in terms of who lives here. And the fact that the real estate is worth so much more makes some things not really as realistic as they would have been in the past. Frankly, it just feels like if people want to do a screening in the Lower East Side, it's going to have to be like in a bar, or they're going to have to do it in a bigger scale. They would have to attract a larger more consistent audience, because it's not really practical, otherwise. I think a gallery is feasible now, in the way it wasn't in the past— like a commercial gallery. But, I'm not sure that could have been the kind of space where we could have done what we did just because it would not have been practical for a gallery to host a scene like the one we were running.

Collective:Unconscious, 145 Ludlow Street, www.weird.org

Mitch Corber,
Documenter of the Unbearables

by Ron Kolm

"Hey man, it's Mitch Corber!"

We'd just finished doing a reading and putting together an *Assembling Magazine* in the Garden at 6th and Avenue B in the East Village. We were packing up our food-stained manuscripts and tossing out the empty beer cans—when Jim Feast shouted out that announcement.

I swung around and watched a bearded dude dressed in black pull up to the now-empty stage on his bicycle, a small cloud of dust settling behind him on the gravelled lot.

"Mitch Corber," I thought. "Pretty cool name. Hmmm—everyone seems to know who he is. Geez, the guy's fashionably late, as well, I wonder what his story is?"

"Yo, Jimbo, what's up with this 'Mitch Corber' dude?" Jim was kind of the leader our group of anarchist poets—maybe because he'd been around the block a couple of times. He had kids, and he'd been forged in the blues/spoken word scene in Chicago. Jim was the guy I'd go to whenever I had a problem, or when our quixotic band of Unbearables needed a concept to hang an event on.

"Mitch? Oh, he's been around for awhile. He's a big-time documenter of the East Village poetry scene. Got a couple of his videos at home. Taped a bunch of the Beats—Ginsberg, Corso, Sanders and all. Also a lot of the New York School poets—the guys that followed Frank O'Hara. I know he's got footage of John Cage. Yeah, as I recall, the title of that one is 'John Cage: Man and Myth.' I checked it out of the public library a couple of months ago. Let me introduce you."

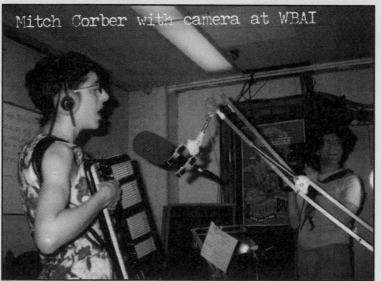

Mitch Corber with camera at WBAI

Clayton Patterson

"Cool," I said, and followed Jim over to shake hands with Mitch. Our paths crossed often after that. I'd see Mitch at the St. Marks Poetry Project getting the good performances down on tape. Or I'd see him at the Alternative New Year's Day Readings capturing the scene. He eventually became the main chronicler of the Unbearables—filming us in a Philly coffee bar—hanging out with us when we did our Brooklyn Bridge Erotic Autonomous Zone Happenings—saving the "Crimes of the Beats" readings for posterity.

Mitch was generous enough to supply me with copies of his tapes, and I recently added them to the "Downtown Writers Group" archives in the Fales Collection at the New York University Library, where they can be viewed and reviewed down through the ages. I am grateful to Mitch Corber for his artistry with the camera and his commitment to preserving the downtown poetry scene. I'm also proud to call him a friend.

Ron Kolm and family at Clayton Gallery

How I Became NY Poetry Video "Kingpin"

by Mitch Corber

I rode a nonstop charging steed to bring the world the best of the East Village poetic talents. I did it my way. I played the game that no one with a right mind would dare. Sure, today people see my *Thin Air Poetry Video Archives* in the NY Public Library, at Two Boots Pizza Video or Kim's, and they have no idea how my videos were created, or how they got into their library.

To cut to the quick, I'll relate a little story back when I was sucking the boots of modern artists Vito Acconci, Les Levine, Dan Graham, Dara Birnbaum, Julia (Duka Delight) Heyward and Laurie Anderson. Like all fresh New York City art transplants, I hailed from a little town, grew sick of the claustrophobia, and hit the big mecca of New York.

My little hometown was called Los Angeles. I went to UCLA film/TV school, and went on to conceptual Cal Arts performance art. But in the summer of '75, I gambled on everything by ditching my hometown and vrrooooom!!! drove my old Chevy Nova cross-country, to points northeast. (Yeah, I once did drive a car and honked at unsuspecting traffic. No more . . . I now live in lower Manhattan's East Village, and ride a bicycle.)

But winding the reel back...at UCLA in the late '60s, I began to learn the ins and outs of everything film and video. In cinema studies, I got to watch all the greats and even the hippest of contemporaries. In film production class, I tried my hand at traditional directing, took scriptwriting, shot Super 8 film, got to work with student crews, I spliced, I critiqued others, I listened to others' critiques. We talked theory. We learned shotmaking: establishing shot, medium shot, medium close-up, close-up, extreme close-up. They said 16mm is the pinnacle, the peak, but that larger clunkier medium was too slow for my speeding ideas. It was just like me to stick with Super 8mm.

At UCLA, they also plunged me into the language of video. Three large cameras on obscene tripods, with huge black-and-white viewfinders. Headsets hooked up to the control room, a zoom lever, panning, tilting. I grew to love those large cameras, I did. I loved lighting, miking, and being the talent. Inundated with studio TV tech, I learned the audio board, and with the equalizer I learned how to get a telephone sound with a flick of a dial. I'd already known quarter-inch tape recorders from my teenage years of songwriting, but here I learned how to splice audiotape with a razorblade. We "rolled tape" and faded up from black on a countdown.

"Playback!"

The curse, it seemed to me, was being creative. Creativity can be a hidden vault, a screen. I found creativity isn't everything. Socializing and sizing up your fellow student, being liked, that's the plan, heels clicking to a step, believing in mutual futures . . . these were things I could not visualize nor actualize from a darkened room in my mind.

I fumed. I wanted to make films alone, like a poet. I didn't buy into their system of crewing. I couldn't get into the heads of my class, so the golden rule was kaput, of doing like your neighbor. I was in the zone of The Loner.

By the time I hit Cal Arts three years later, I'd already sampled New York, on a six-month visit, an ill-fated fling toward the downsized folk music scene. But, by 1974 performance art was hip, and ripe at Cal Arts. Studying cinema there, I had no feel for 16mm, so I drifted toward the conceptual art classes of John Baldessari and Yvonne Rainer. There I was gassed by a different weekly guest artist . . . great stuff . . . new ideas. Most of them, like William Wegman or Lawrence Wiener, echoed the New York way of life. I was hooked.

Summer of '75, I was to park my carcass in a loft on East First. The saving grace of this space was shared by both Cal Arts and RISD (Rhode Island School of Design). Here I was finally somewhere, the Apple. I knew no one, had no NY relatives, no schoolmates, and, yes, no friends. I parachuted here. This is where my tale begins, not ends.

Arriving was not necessarily thriving. It was breathing, bouncing off the walls, tapping in to skinny vibrating Manhattan. OK, I was in love with poetry and John Cage. I was multitalented (but who wasn't?): an able musician, instinctively comfortable with photography, film, video and audio, and a stand-up performer who'd feed you the fabric of whirling words.

But as Cal Arts dropout, as folksinger wannabe, I did strange performance art work that did not really jibe with the New York art vibe. I didn't fit in. There was no magic key, just little ol' me spilling onto the sidewalk. Frequently. I didn't mesh with "what was happening," what was seen to be evolving in contemporary art. But there was one bright spot, the back room of Stefan Eins' 3 Mercer Street "store" in SoHo. Eins, the Austrian sculptor, had partly given over his studio to impromptu exhibitions, and he held a kind of continuous salon in the back. It was a party! I'd be all herky jerky, rattling on with delight, meeting a feast of locals (many transplants, too). I'd be trading wisecracks, and took the liberty of carrying this backroom behavior into restaurants, into bars, roundly misunderstood. I was embarrassing, the boorish imp with the bold mouth.

While not The Kitchen, 3 Mercer Street gave me my first New York performance art splash. My "Reciting Poetry Under the Influence of Onions" (1975) did prove an odd hit, and was reviewed by the Village Voice as evidence of "why performance artists are poor." Some thought my using poetry in an art setting evoked a sort of "sidelong plea for the return of sentiment, couched in the materialist phenomenology of minimalist art."

My "Roommate Search" piece at Artists Space (1977) was a real endeavor, and was seen as "an ironic comment on the 'support structure' of the newly

emergent alternative spaces." I waxed personal again, here implying a critique on institutions.

But the piece that stuck in people's craw, my most extreme performance work, was "Singing Al Jolson in Blackface" (1976). This supposedly innocent flashback from the 1927 film *The Jazz Singer* had freaky overtones. It was acted out on a real New York stage: a Greenwich Village sidewalk, an uptown D train, and the subway exit onto Harlem's 125th Street, where two young black men hastened to "save my life" by forcibly ushering me back down the subway, personally waiting till I set foot on the downtown train.

So much for my performance art career. While it's true I was a transplanted New Yorker via L.A. seeking "fame and fortune" and the culmination of my various talents in the art metropolis of Manhattan, where could I go from there? While I dedicated the Jolson piece to my father who always would burst out in song at family gatherings, this echoing of my personal history proved incompatible with the glaring political correctness of the time.

As critic Alan Moore has written, "Al Jolson's *Jazz Singer*, the first 'all singing, all talking' motion picture, was a pivotal moment in the history of American popular entertainment for many reasons. It marks an early 20th century identification between Jewish performers and African Americans played out in the mass cultural style of modernism—jazz. Even as it described and descended from the often demeaning minstrelsy, Jolson's blackface marked the Jewish artist's identification with African Americans in an America constructed upon both white racism and anti-Semitism. The figure of the jazz singer presaged both the TV minstrelsy of the Amos 'n' Andy Show and Norman Mailer's landmark essay 'The White Negro' conflating hipness with blackness."

By painting my face, by crossing the color line, by bringing this thorny theme out of "the silver screen" and onto the streets, by creating outrage, I may have pointed—perhaps inadvertently—to the near total separation of black and white in the downtown New York art world of my day. I leave it for you to decide.

How do we get from my '70s performance art career to my current status as NY Poetry Video Kingpin? There is one stepping stone which stretches as long as the River Nile, and that is public access cable TV. I have produced three cable arts series since 1978. Namely, *Original Wonder* (1978), *Grogus* (1980–81), and the current *Poetry Thin Air* (1989–present). Each new show, with its budding audience out there in cable-ready Manhattan, is designed to exude performance art vibes, to unleash the multitalents of the East Village cultural spectrum.

My First Cable Show

When I started *Original Wonder*, my first cable arts series in 1978, I focused on capturing East Village artists and poets, plus my own many talents. I characteristically had rigged my tiny one bedroom apartment as a working video studio, both with live video capabilities, and equipped with reel-to-reel Panasonic video editing decks to quickly turn new footage into cable possibilities.

With my video camera on a tripod, I regularly created viable video sequences by both projecting Super 8 film footage and slides onto a white screen. Through this reshooting process, I generated additional material, new fodder for cable.

My set-up piqued the curiosity of all my friends, the free thinkers, accommodating all who freely streamed through my apartment. With an eye for pushing the envelope of video art, I became part talent scout, and gobbled up friends one after another in my cable schemes. Whether interview, or magic trick, or conversation, or impromptu theater, whether song or poem, I was ready to capture all comers.

I loved this bubbling brook of creativity, and yet I still loved to perform even more than manning the camera and editing (an ego thing). It was here that a

misunderstanding began, and taught me some hard NY art world rules. New York culture isn't willing to crown you "renaissance person" unless you have the support system of a Laurie Anderson, with her state-of-the-art engineering and deep pockets.

As far as my performance art receiving promotion, no "rival" SoHo cable producer ever brought me onto his show, either to perform or sit for an interview. Coupled with this glaring neglect were two additional factors: (1) the erosion of the performance art medium by the early '80s, in the flux of elite art world trends; and (2) the encroaching weariness caused by trying two wear two hats.

My major question was: To be or not to be. To perform in front of the camera and be an "art star," or to fix myself behind the lens and be the consummate documentarian.

Early half-inch reel-to-reel video recorders demanded manual dexterity and patience. For instance, you had to thread the damned tape by hand. At the time, so many artists were curious and experimented with the fledgling video medium only to tear their hair out in frustration as they'd give up and return to poetry, painting or sculpture.

PortaPaks, with their numbing weight and bulk (unlike the portable ease of Super 8 cameras), surely gave one pause before going out and launching a video shoot on the streets of New York. I persisted, though, because I believed that multimedia was the real avant-garde.

However awkward, the medium of video did provide things which Super 8 film could not: (1) the ability to record up to 10 times longer than a Super 8 cartridge; (2) the ability to achieve effortless synch-sound; and (3) no need to send your footage to be developed at a lab, because instant video playback was possible!

But with all its advantages, the video medium was under heavy aesthetic fire, cruelly being beaten and tortured as a second citizen compared to the "fine grain quality" of the film medium. Battle lines were being drawn, for sure, in the absolute media minds of the time: you were either filmmaker or video maker, but not both.

I had wanted to call myself filmmaker. But if economic factors forced me to accept video as my gun, there was no way I was going to shoot blanks.

One pitfall of video cameras was the extra delicacy of video motors. Repairs were always right around the corner. That meant torturous weeks in the repair shop. The poor media artist rarely could afford a backup video camera, considering the higher price of video cameras back then. Plus, no friend would lend out his in your time of need.

Camera rentals for needy artists were available on a hit-and-miss basis (and with red tape) at local places like MERC (Media Equipment Resource Center, later named Film/Video Arts) or DCTV (Downtown Community TV).

My long-term participation in the artist collective Colab (Collaborative Projects) flourished when the group embraced video and cable TV production, from 1979-84. We plunged into live television, and even sparked production by purchasing Sony three-quarter-inch editing equipment.

Potato Wolf, our new live weekly cable series, allowed every Colab member to take a turn as director-writer, while serving as "techie" on others' productions. Here, I gladly honed my video skills at camera, audio mixer, effects switcher, stage manager, even performer—on a live-broadcast basis.

Of equal importance was Colab's new video editing equipment purchase. Sony's newly streamlined, three-quarter-inch editing decks (with auto-controller) far surpassed old half-inch open-reel clunkers. I soon became one of the several Colab video artists who volunteered to house the valued editing decks (as long as I offered to provide most of my waking hours per week to a host of ravenous Colab video artists, I could certainly intensify my own video editing heights.) Instantly, Colab'ers such as Kiki Smith, Willoughby Sharp, Liza Bear, Alan Moore, Peter Fend, Diego Cortez, Virginia Piersol, Jim Sutcliffe and myself flocked to edit our growing number of live cable shows, as well as independent films (Note, for ease, film was commonly being edited on videotape, through film-to-video transfer).

It wasn't until April 1987 when I received a NYFA grant for $5,000, that I was able to afford another industry advancement—the new era's lightweight Sony video cameras. That Sony Pro V110 was radically compact and handy as any Super 8 film camera, and now boasted pop-in cartridges.

Videotaping Events

Owning a video camera, it's inevitable to be asked to videotape other artists' projects. Just to get paid I had to learn the hard way to tame my demons and "calm down and become invisible" when videotaping New York events.

In fact, my video style at a poetry reading or music concert was the polar opposite from my early reputation as the "Corberizer." In Corberization, the videos were quick cut. There was often no fixed center. There were many collage-oriented pivot points from which to bounce off of, as I attempted to create a pop-culture mural in the viewer's head—a multi-channel video assault collaged with fast-paced cuts, leading to multiple meanings.

Sculptor Dick Miller affectionately called me "Clobber" because I was the little guy with equal parts Napoleon complex, comedian, entrepreneur, listener, exhibitionist, poet and displaced person. He once reassured me that my weirdness was essential, that most good art incorporates a decidedly unique vantage point from which to send its message.

However, in documenting someone else's performance or poetry reading for my cable show, the going aesthetic was singular, an homage to the artist's or poet's world: to preserve and capture the ideal viewing experience as close as possible to the actual event. In one long "take" to recreate the audience experience each time the video is popped in the VCR.

This tamed behavior of mine as videographer has guided today's Thin Air Poetry Video Archives (my present video company since 1991). As an avid, spiritually charged fanatic of the diverse East Village poetic talents I have videotaped over the last 15 years, I have "upped" my personal patience quota. I have invested in others' egos. And in amassing hundreds of raw poetry documentaries to edit down into archival offerings, I applaud the wealth of poetic talent spilling over from this prolific corner of the world.

My poetry videos are reverent reproductions of live events. I am able to imagine myself as both poet and audience, and with deft and subtle zooms between poems, sometimes careful slow zooms within a poem, and with usually a single lens, I am able to quench the viewer's appetite for camera detail throughout the pace of a poetry reading.

Doing this, the restless fidgety Corber was able to suffer the non-activity of standing in one place (almost making himself invisible) so as not to disturb the reverent viewing audience in attendance.

But it came with some sacrifice. My own poetic skills have not soared. My wings have been clipped by continually holding fast as NY's Poetry Video Kingpin. Certainly I have not performed my poetry in public as much as I prefer. Most people see me as "the video guy" rather than the transcendental poet. Ah, well....

Poetry Video Coda

Once I was living here, I'd spot Allen Ginsberg posters around the East Village anytime he'd give a reading. The famous Ginsberg, the coolest of the Beats, and the most accessible, was omnipresent. Certainly he touched all us poets in that Ginsberg was in print and everywhere; this gifted cultural icon was shining his invincible words through his persona of superhuman performer. His able performances were informed by eternal youth, a charismatic love of the written page, plus an affection for combining music with words, and the ability to play portable harmonium in accompaniment.

By the late '80s, Allen Ginsberg, now in his 60s, was still a marvel. Perpetual motion within a gracefully aging frame. In February '88, I videotaped my first Ginsberg reading, a joyful dual recital with Japan's hippie Beat poet Nanao Sakaki. How would we be able to understand the foreign Japanese tongue? Well, Ginsberg stepped up and assured us that he would personally offer translations whenever necessary, throughout the 80-minute reading!

Starting solo, Ginsberg charmingly recited and sang, poem after poem of his. His politics were not hard rhetoric, but ironic turns of wordplay which left room for entertainment and fun. He alternated spoken word with song, and seemed to know exactly what we the audience wanted. And when his afternoon's partner, Nanao Sakaki, was beckoned to rise and join him, Ginsberg respectfully helped Nanao quickly get his bearings. Together they alternated . . . Japanese, then English . . . poem after poem.

It was obvious Ginsberg in his vast benevolence, loved to share not only the stage with his fellow companion, but to also grant us local videographers in attendance the right to video him, without signing any contract, without any strings attached. I'm now sure that on one cold East Village day in 1988, there sprang the seeds of my long-running cable arts series Poetry Thin Air (1989–present).

Simultaneously, my poetry documentary company, Thin Air Video Archives, was also born. My catalog of over 80 poetry video documentaries offers the world the best of East Village poetry. Thin Air Poetry Videos are available throughout the vast NY Public Library system, and have been collected at over 150 universities and public libraries across the United States.

East Village memories: Club 57

by Ann Magnuson

Club 57 was born in the basement of the Holy Cross Polish National Church on St. Mark's Place back when less than a hundred pointy-toed hipsters skulked around the East Village streets and a boy could get the shit beat out of him for dyeing his hair blue. Girls fared a little better. We could parade about in our rockabilly petticoats, spandex pants, and thrift-store stiletto heels and get away with just a few taunts, "Hey, Sid Vicious' sister!" from a carload of Jersey assholes.

That was back in the late '70s, when the Bee Gees ruled the airwaves, Brooke Shields peered down from every billboard in town, cocaine was considered "harmless," unsafe sex was the only sex to be had and the nefarious, pre-Disneyfied isle of Manhattan still had a wild side to walk on.

We were suburban refugees who had run away from home to find a new family, a family that liked the things we liked—Devo, Duchamp and William Burroughs—and (more importantly) hated the things we hated—disco, Diane von Furstenberg and The Waltons.

I met Tom Scully and Susan Hannaford at CBGB's one night (was that the night I saw Sid Viscious and Nancy Spungeon walk in??) and before you could say "A Moveable Feast," we were bonding over Dadaism and Russ Meyer movies. Tom and Susan wanted to produce a new wave vaudeville show. I wanted to direct. (Doesn't everyone?) So we gathered together—a like-minded menagerie of punk rockers, wayward art students, and assorted local eccentrics at Irving Plaza to sing and dance between the strip acts and *Planet of the Apes* movie trailers.

Stanley, the middle-aged Pole who worked at Irving Plaza, needed some "alternative" entertainment over at a smaller club he had on St. Mark's Place. The rest, as they say, is history.

Tom and Susan started the "Monster Movie" on Tuesday nights and I managed the club the rest of the week. Soon, Keith Haring was curating erotic day-glo art shows, John Sex was perfecting his Liberace-meets-Tom Jones burlesque act, and Kenny Scharf was organizing "A Salute to NASA" and impersonating Lawrence Welk. Klaus Nomi was singing his alien operatic arias and The Ladies Auxiliary of the Lower East Side was hosting hash-brownie bacchanals. Other artists like Joey Arias, Tseng Kwong Chi, Wendy Wild, Tom Rubnitz, Danny Johnson, David McDermott and Peter McGough, Pilar Limosner, Bruno Schmidt, Tish and Snooky from Manic Panic, Vincent Gallo, Debi Mazar, Fab Five Freddy and countless others were in on the demented fun.

The punk rock Do-It-Yourself aesthetic extended to every medium. Artists performed, performers made art, musicians made movies, fashion designers started bands, everyone picked up a video camera . . . anything and everything seemed possible.

We turned the club into a center for personal exorcism, devising theme parties (or "enviro-teques," as one drug-dealing-conceptual-artist ex-boyfriend liked to call them). There was the "Stay Free Mini Prom" where all of us misfits who missed the big night in high school got another chance to wear a corsage in our spiked hairdos; the "Putt-Putt Reggae" night where we played miniature-golf on a course made of refrigerator boxes designed to resemble a Jamaican shantytown; the "Model World of Glue" night, where New York's hippest built airplane and monster models, burned them and sniffed the epoxy; and, the "Elvis Memorial Night" where local juvenile delinquents threw beer on the faulty air conditioner, which burst into flames, send-

ing all the Elvis look-alikes outside to gyrate on the fire truck until the angry Polish immigrants living upstairs doused us with dirty bathwater and the NYPD broke up the fun, much to the delight of a snickering Jean-Michel Basquiat, who watched from the shadowy sidelines.

Jean-Michel was not a frequent visitor to the club. There was an intense rivalry between us goofballs at Club 57 and the cooler customers over at the Mudd Club. We were all about mushrooms and laughing like hyenas, while they were all about heroin and quoting from French nouvelle vague films. Nearly twenty years later, such high-school segregationist behavior seems silly.

Today, I smile when I see an old Mudd Clubber and we silently congratulate ourselves for surviving while reminiscing about the "good old days"—joyful, jobless days when the only objective before sundown was to create art and pull that night's outfit together. Since you knew every doorman and bartender downtown the nightlife was free and because the rents were nothing, money was unimportant.

Until around Reagan's second term the pockets of Jean-Michel's paint-splattered Armani suit were overflowing with hundred-dollar bills, Madonna was hitting it big on MTV and Keith Haring was treating us all to our very own bottle of Cristal at Mr. Chow's.

Ironically, about the same time money and fame entered the picture, AIDS hit. By that time, Club 57 was winding down and, after a brief incarnation as a showcase for Scott Whitman's and Marc Shaiman's twisted musicals—and then as a junkie safehouse—the place mercifully closed around 1985, passing the baton further east to clubs like The Pyramid and 8 B.C.

After a good third of our surrogate family died from The Plague, we were reluctantly—and painfully—forced to grow up.

Somehow it seems appropriate that during the Nineties, the club reopened as a mental health outpatient clinic. I often wonder if any of the hallucinations some of the new crazies are seeing there aren't just a bunch of goofy, go-go dancing New Wave hipster ghosts—forever Frugging, forever young.

This Revolution
Must Be Televised!

by Jim C.

Clayton Patterson is an artist and a visionary whose work revolves around the documentation, the recording and preservation of the realities of life in New York's Lower East Side. Clayton uses photography and video as his media of choice. Elsa Rensaa has been with Clayton for most of the work, and has made a lot of the videotapes and photographs. The tools and methods they use are highly accessible. They are widely available to those who seek them. These media attest to the reality which they evoke. Popular culture has vested these forms with the power of an ultimate reality. If it's on TV, it has got to be true. It must be important. Televised events are the ones that get our attention. Television makes things happen. If it's not on TV, then it just isn't happening. This is a myth that we live by.

We live in a world where realities are lost. Day to day life is fleeting and forgotten. What makes things real is a belief in the inventions of the real, more than the events themselves. Only those realities captured by the media persist for us who are trapped in the hall of mirrors that represents the world of our modernity. How events are portrayed shapes our edited perceptions. Once preserved, the media itself replaces the real. Media itself becomes the reality. Like a shout in the woods that is never heard, an event that is not captured, or mediated, may as well never have happened. Today, the legitimization of an event is elevated by the quality of the media with which it is captured. Electronic media supercedes the spoken and written word. Televised events are at the forefront of a mutually accepted reality. Nightly news conveys reality bites to a nonplussed public. People are inebriated by an onslaught of images and messages where the meaning of these realities are lost.

Clayton's realities are special in the sense that they depict those who have little power otherwise. Historically, it is the mainstream media that has captured the attention of "the masses." The "masses" today are literate and do not believe themselves to be naïve. Yet, their faith in a reality based on televised images betrays a true gullibility. Clayton takes to the streets to combat the insidious mainstream production of reality with a "counter reality." The story must be told from the other side. Police, FBI, CIA. All of these have been engaged in the surveillance of the populace since their inception. Control of the masses. Bow to authority. Anarchy is reckless and dangerous to the status quo. The status quo is reflected in the Dow Jones Industrial Average. Rock the boat and the Dow will fall! Fear eats the hearts of the mighty!

Two hundred and fifty channels with nothing on them. The mainstream media is in the hands of the few, the mighty. The FCC has recently permitted even fewer to own more of this media. The New York Times, boasting "All the News That's Fit To Print" on its masthead, published an article by Colin Moynihan on Clayton and his partner, Elsa Rensaa, August 8, 1999. The story of Clayton Patterson's work is now officially "fit to print." Media moguls decide what is or isn't fit to print or broadcast. Differing opinions are squashed like bugs. Questioning the power elite has become "unpatriotic." Surveillance has reached Orwellian proportions. EZ-pass. Checkpoints. Metal detectors. X-ray machines. Closed-circuit imaging has run amok. The ministry of "total information awareness" proposes to keep tabs on 350 million Americans. Who are the terrorists in this scenario—the people or the

institutions that attempt to control them?

Clayton has dared to tread the territory most hallowed by the literate masses. He creates alternative realities, those of the few, the weak and powerless.

Tompkins Square, 1988. Police riot on Avenue A. Close off the park. Curfew. Evict the homeless from the park. Concealed badges, concealed identities. Class warfare. Civilian warfare. Clayton's camcorder running for three hours and thirty-three minutes. Mainstream media sloughs it off as "amateur." Tapes subpoenaed. Clayton refuses to hand over the master tapes, for fear they might be destroyed or tampered with. Sits in the Bronx House of Detention for 90 days after being cited for contempt of court. Goes on a ten-day hunger strike. Lawyers William Kunstler, Lynne Stewart and Ron Kuby work out a deal where copies of the tapes are found to be admissible in court. Clayton keeps all rights to the originals. Tapes "very useful in the investigation and the trial" according to the DA in ascertaining just what really did happen. Reality, again, finds mediation. The mediator in this case is not the ruling elite version of the story, as are our international wars today. The "people" have a voice in Clayton's work. Ed Sanders' autobiographical fiction, *Tales of Beatnik Glory* tells of Sam Thomas, whose films of people's lives on the Lower East Side were eventually confiscated by police. This actually happened to Ed in the 1960s. Clayton's Essex Street studio houses 4,000 hours of video and 750,000 color photo documents. Invaluable testimonies to realities lost.

In a culture that emulates a child with attention deficit disorder, our collective memory is, indeed, short term. With rampant short-term memory loss, the video archives attain the level of a collective long-term memory bank. A collective consciousness. Clayton's videos and photographs will remind future generations of the "roil and toil" of our Lower East Side, the way it was before it became "cleaned up," another inner-city suburb. Or, perhaps Clayton's tapes and others will find their way to the Internet, where people the world over can experience trappings of the wild, wild east, concentrated in a hypertextual, pixilated manifestation of reality. East Village chat groups, groping for a walk on the wild side. Be there, or be Tompkins Square! Be-in, be-out, but above all else, stay tuned!

Clayton and Elsa (who assists Clayton with his videotaping) create work which also encompasses the manual arts. From 1986 to 1993, they made hats with embroidered images on them that were bought by such notables as Mick Jagger, Jack Nicholson and David Hockney. Body art is a contemporary manifestation of a deep human urge to have the power to create one's image in society. The body itself becomes a canvas. Clayton, who has been president of the New York Tattoo Society since 1986 (which ran monthly meetings for over a decade) along with Wes Wood and city council member Katheryn Freed, got tattooing legalized in NYC (where it had been outlawed since 1961). He managed and helped organize Steve Bonge and Butch Garcia's annual New York City Tattoo Convention at the Roseland Ballroom, which opened in 1998 after tattoo legalization. In 1995, Clayton toured Germany and Austria off and on from 1995 to 2002, three years with an entourage dubbed "Wildstyle." This tour was created and run by Jochen Auer and Clayton provided the American talent, including tattoo artists, fire eaters, sword swallowers and contortionists.

Clayton and Elsa work within a community milieu that could almost be considered to be tribal. The East Village artist community is densely interconnected and close-knit. Everyone knows each other and can easily recognize one another on a casual stroll down Avenue A. Clayton's presence has a shamanistic quality. Clayton's reputation as a video documenter has reached near legendary proportions. His work swells up from the grassroots, from the individual players that make up the social, political and creative essence that is the heartbeat, the pulse of the Lower East Side. His presence has influenced even the new Black Panther Party, which stated that they had started to document actions with video after watching Clayton's MNN cable show, *Clayton Presents*. Clayton Patterson and Elsa Rensaa's presences are felt, as they were there on September 11, 2001, as the World Trade Center buildings collapsed. Jeremiah Newton called on the telephone, mentioning that a plane crashed into the WTC. They show up. They are there. Elsa was knocked down, suffered a concussion, a black eye, an injured wrist, and a torn rotator cuff that needed a serious operation. Her shoulder is still not perfect.

Clayton has made contributions to the No! Art book *Neue Gesellschaft fur Bilende Kunst Berlin 1995*. No! Art was a radical art group of the late '50s and early '60s. This group was the

first to make Holocaust Art, did shows like the Shit show, the Doom show, was radically opposed to the corporate takeover of art, and the elitism that crept into art. Clayton showed a No! Art documentary video in Berlin at the NGBK show, and at the No! Art show at the Buchenwald Concentration camp memorial. Because Boris Lurie is a survivor of Buchenwald, he had the exhibition at the camp, but it was very unusual for someone outside to show there. Clayton had drawings and works in a book of poetry, *No! Art in Buchenwald*. A number of radical artists are in this book: Gunter Brus, one of the Viennese Actionists; Jacque Luc Lebel, an artist who was part of the May 1968 action in Paris that was sparked by the Situationist International; Seth Tobocman, creator of *World War 3 Illustrated* magazine and many political posters and drawings; John Toche of the paper *The Rat* and other radical publications and actions; K. K. Kuzminsky, a well-known and loved Russian anarchist, who edited a comprehensive book of Russian poetry; Aldo Tambellini, one of the first artists to protest the Museum of Modern Art; Wolf Vostell and Dietmar Kirvis. The No! Art books are in German because Germany is the only place that has supported this art. Boris Lurie, Dietmar Kirvis, Wolf Vostell and Clayton showed art at the Janos Gat Gallery on Madison Avenue.

Clayton also did a number of court papers that he submitted to court trials dealing with housing and land issues on the LES. Clayton's forays into the world of the court system read like Kafka's *The Trial*, where the protagonist is prosecuted and found guilty, yet he has no idea exactly what crime it is that he is being tried for. In Clayton's court papers he would create cover art, add photos on the inside, and then do a straight written piece. He did this so that his art would become a part of the legal system. This is not a place where one would expect an art collection to be. The art was very straight ahead. He did a number of these court papers. Clayton created the strategy to save the last Orthodox synagogue in Alphabet City (the synagogue on East 8th street between B and C) from being sold. Clayton did court papers for this case. The strategy worked. The shul remained open for several years. NA meetings, AA meetings, kabala classes, and a sanctuary for the homeless and drug addicted created a very radical setting for the ultra Orthodox community.

One court case in particular concerned a Hasidic man who was wrongfully arrested entering the Federal Building on Lower Broadway. He acted as his own attorney. He and Clayton did a paper together that clearly *outlined* all that was wrong with the security of the Federal Building. Clayton entered one of his court papers. The cover had a collage of ingredients of fire, and death and mayhem on it. The written part talked of everything wrong with the security of the building, that the guards that were supposed to be protecting the building were not doing their jobs correctly and that it was wrong to arrest someone just for pointing this out. Judge Leisure of the Federal Court, 500 Pearl Street, one of the most prestigious courts in the city did not understand or like this paper. The judge was, in fact, livid. The judge took Clayton's statement personally. He stated that all of Clayton's court papers must be destroyed, that Clayton was not allowed to hand in any more court papers and that Clayton was "no friend" of the court. Court officers escorted Clayton out of the building. Of course, he handed in another paper. And he came back to court. As it turned out, Clayton was correct in his assessment of the conditions at Federal building. *Before the Law stands a doorkeeper. To this doorkeeper there comes a man from the country and prays for admittance to the Law. But the doorkeeper says that he cannot grant admittance at the moment. "It is possible," says the doorkeeper, "but not at the moment." These . . . difficulties the man from the country has not expected; the law, he thinks, should surely be accessible to everyone . . ."* Of course, the man in Kafka's parable *Before the Law* dies, and like Clayton, never gains access to the Law (Schocken books, 1971).

Destroying someone's writing and art is the kind of censorship that the Nazis were involved in. It is ironic that this would happen to an artist who was involved in a Holocaust survivors' show! This is in contradiction to the ideals and values of a free society. The mainstream does not understand Clayton's plight. His is not a popular cause. Clayton has documented many unpopular people: the poor, the junkies, the homeless, and the mentally ill. Clayton has been censored, arrested, had teeth knocked out by the police, had bogus set-up warrants come to his door, been subpoenaed numerous times and called a "satanist." Clayton has had libelous stories placed in the paper that accused him of complicity in the Monica Beerle murder—the

Daniel Rakowitz case. Contrary to the story's false accusations, Clayton unequivocally *did not* videotape this grisly murder, *nor* the subsequent dismemberment of the victim's body.

Most of what Clayton has been involved in are not, as he explains, "sexy," not chic, popular causes. He admits that there has never been any support for his artistic endeavors. He has been an outsider to the system. "I made a lot of art that has had real impact on the system. This is was it was meant to do. However, I have paid the price for these actions," states Clayton. His tapes have made millions of dollars for other people. He has had more tapes used in court than anyone in the history of America. The riot tape alone generated $2.2 million. None of this money ever went to Clayton.

Fierce dedication to one's beliefs does not come from a love of money, but comes from the heart itself. Janet Abu-Lughod, author of *From Urban Village to East Village: The Battle for New York's Lower East Side* (Blackwell), says of Clayton, "For him, documenting the area is like a religion." This sentiment reaffirms the idea that Clayton's work is more than high-tech media manipulation. This work wells up from the soul. It is the essence of a struggle to save face against a continual onslaught of powers that would attempt to denigrate and control political and social trends in the cutting-edge community. Abu-Lughod provides a blow-by-blow transcription of Clayton's 1988 Tompkins Square riot tape for her analysis of the events as they unfolded on that fateful day in August. Here, video merges with oral history. The most ancient modes of communication converge with those of modernity.

Taken as a whole, Clayton's corpus provides continuity, a near-seamless history grounded in the events surrounding one particular location. The incredibly thorough documentation provides a continual emerging and unfolding. Clayton reflects, "After you've been in the neighborhood for awhile, patterns begin to emerge. There's a history to almost everything that goes on down here." To do this work justice, they should find a place in the university libraries where anthropologists and sociologists can discover and elucidate patterns of injustice at work in the "free world." Clayton provides a proper summation of his work and why he does it in one poignant statement: "A lot of people are not treated fairly by the system and part of what I do is an attempt to create a balance. If people are wronged, it's tougher to brush aside their objections when a record exists."

Tompkins Square Park Police Riot Tape — and the road to victory

by Clayton Patterson

One night my whole life turned around. It was the hot summer evening of August 6, 1988, and by the following morning I had made a 3-hour-and-33-minute videotape of the Tompkins Square Park police riot. That tape got me involved in 15 years of political struggle that I am now trying to escape. I have one court case left, and hopefully that will end my political career. To be sure, I have had enough. Documenting a political struggle that involves the poor, the disadvantaged, the anarchists, the squatters, and the cops makes one a natural adversary to the state.

There are numerous times when the action is highly invigorating and inspiring. At other times it is lonely, depressing, inconvenient, difficult, and without question threatening to one's person. It does not yield many rewards. Helping people whose lives are a constant struggle means dealing with situations that are never fully resolved. Often times the heat turns back on you.

This riot tape gave me entrance to a world that verged on mayhem. By that time the city was in total decay, had fallen to her knees, and was struggling not to do a face dive into the pavement, never mind not having any ability to get up.

Here's a little background—this was Ed Koch's third term. As long as his cronies were happy, he was happy. "How am I doing?" Great Ed! Thumb's up. Koch was hands off the police. There were not many disciplinary problems because the department refused to examine itself. Problems were ignored or neglected, so how could there be problems? Our community was an open drug market and street crime was the order of the day. The streets were controlled by those who could take them. The courthouses had people sleeping on the floor, their bathrooms were graffiti covered, most of the toilets did not work, and the police department was wallowing in corruption. It had sunk to such a low level that it was often hard to distinguish between the criminals and the cops. There were brutal slayings by the police, for example: Eleanor Bumpers, a frightened overweight black woman who barricaded herself into her apartment and was shot by cops attempting to enter, and on the LES, Michael Stewart, a young black graffiti artist who was killed by Transit officers who caught him spraying a wall. These issues were not addressed. Cops were selling drugs, and if someone asked such a foolish question as "do cops sell drugs?" Koch would respond with one of his favorite sayings: "You are a wacko."

Mayor Koch and even the police commissioner, Ben Ward, called The Tompkins Square riot a "police riot," announcing that it was a very sad day for the department. I think that it was a very sad day for the mayor. Talk about passing the buck—it was his department. He was the commander in chief. "How am I doing?" Lousy, Ed.

Koch's multi-tiered structure of subordinates was reminiscent of a nightmarish communist bureaucracy. You had to talk to the right person on the community board before he or she would speak to our city council person, Miriam Friedlander. She would speak to Ruth Messenger, the borough president, who would then speak to the right Commissioner, who would then speak to His Honor Mayor Koch. The judges came from within the parties. Heaven forbid you had a disagreement with anyone in the chain of command. YOU MUST FOLLOW THE PROPER PROTOCOL. Deals were made this way: power established, money changed hands.

City property, housing, and all the goodies were controlled and became tools of the Democratic Party. This was an empire, not a healthy democratic city. The bureaucracy was a total mess and it plunged the city into a crisis. I have hundreds of photos and videos from this period. Look at the pictures. New York City looked worse than the DDR, East Germany, a country that I traveled across to document Jochen Auer's Wildstyle Tour. The DDR did not have the

graffiti covering all public property, nor did it have bums washing car windows. The social inequalities, inner cities, and the breakdown of civil societies looked the same, but we had more garbage on the streets and a lot more crime.

Koch changed the laws, opening the door for hundreds of SROs (Single Room Occupancy) hotels to evict their tenants and make room for overvalued condos and co-ops. A few years later, especially after the '87 Wall St crash, these condos and co-ops began to be listed in the bankruptcy section in the *New York Times*. High rents had a deleterious effect and thousands of formerly housed people filed into the streets as homeless New Yorkers. Koch came out with one of his famous quotes, "If you can't afford to live here—move. Push them into the East River." Ah, what a pleasant life our mayor made for city residents.

Not every city employee was some variety of a thief or crook, but there was no authority or oversight to sort out the rotten ones poisoning the Big Apple. Even the last Rolls Royce dealer moved out of town. Not a problem for me, but this is a world economic center, right?

This was the condition of the city the night of August 6 to 7, 1988. But why were the cops so angry? Was it only about revenge against a small group of anarchists, who, the week before, had gotten into an altercation with the police in Tompkins Square Park. The anarchists had broken a beer bottle against a police car and chased the cops out of the park. The police duped the Ave. A Block Association and some community board hacks to ask for a park curfew using "noise complaints" as the excuse. Really? The community was never able to get police to respond to noise complaints before. And what about drugs, street prostitution, shootings on the block, fights, or noise from the bars? Aren't you listening? Is this about noise coming from the middle of the park. Oh sorry! Yes, we need a curfew.

Not many people understand the turmoil that resulted from this curfew or the contents of the riot tape that I made. I know the riot tape was watched and understood by someone, most likely a federal investigator. The most egregious acts by the police were not the beatings. These happen frequently in life; they are certainly bad, and some were clearly captured on my tape, but the people in these cases were lucky enough to get paid big bucks for wrongful police actions. However, one of the most critical shots in the whole video was when the white shirts, the brass, the captains and their superiors, chased the blue shirts, the patrolmen, down the street. The brass were yelling, screaming, waving and whistling to get the men to come back as they ran amuck with nightsticks swinging. Because there were only two arrests, there were no reports and no crimes (allegedly) had been committed.

The police brass could only run after the young bucks so far. They stopped. The wild boys in blue did not come back till they were ready. Didn't the radios work? Perhaps the commanders did not know how to use them?

Once back, the blue shirts faced no discipline. It was just same old game. In the tape there are long periods of calm before spontaneous moments of violence. The brass had time to take charge but they did not.

During the interludes the chief and brass were walking around, oblivious to the cops with badges removed, tape over the numbers on their badges, hats off or on backwards, slouching over cars, male cops talking shit to and laughing with female officers who were chewing gum, cops giving high fives. There were no lines, no order, and an officer told me that taking pictures was illegal and I could be arrested for it and my camera could get broken. Cops were talking back to civilians and making remarks like, "The streets are not free tonight," "Go home," "Get out of here." The slacker mentality in the police department is truly astonishing. After you experience the initial emotional reaction, one can savor the finer points of the tape.

It opened up the city like an oozing sore right below the surface for everyone to see. Witnessing how the cops acted as a gang, and treating civilians with a gang mentality. Is this a paramilitary organization? Where is the chain of command? This was anarchy. The police had lost control of the police. This was how far the department had fallen—the toilet bowl was not a problem, in fact for some cops it was as good as the water cooler.

This was not about the closing of the park and the enforcement of a curfew. No! It was plain and simple revenge. The cops and their massive amount of gathered force on this hot August night cleaned the young white kids out of the park almost immediately. It was not a political decision about getting the homeless or the junkies out of the park, they were allowed

to stay in one quadrant; it was a selective curfew geared only to any one who fit the profile of an "anarchist." Much of the wanton bludgeoning and beating that was inflicted on the community took place a good distance from the park. The police had planned this attack on the community for days. High-ranking officers were on the scene all night long. Once the riot seeped into different locations I spent a good deal of the night on 6th Street and Avenue B. The cops closed off the street. The brass had no control or plan.

The conflict lasted all night, punctuated with many periods of calm. The end of the tape is amazing, truly amazing. The sun is starting to rise. A small group of tired protesters marched up the street, carrying a banner. The cops on horseback are pulling the reins up, looking forlorn, moving out with their tails between their legs. The NYPD is forced to retreat. A lone officer looks stunned, worried, as he takes one last look around. The people return to the park as daylight creeps over the horizon. A small band of angry protestors cross the park and head for the great symbol of gentrification, the Christadora House, a monumental building at one time meant for community service, but later sold and turned into ultra luxurious condos. Hundreds of cops were close by yet none made it to the Christadora. Protesters go into the building, pull out a large potted plant, and as the story goes, transplant it in the park. The angry crowd breaks a telephone, and then use police barricades to smash the plate glass front door.

The night of the riot most of the victims who were beaten were citizens: individuals who had nothing to do with political movements or giving the police the finger the week before. Some had even been police supporters. A lot of good it did them.

This was about the New York City police rioting. It had nothing to do with law and order. This was about gun-carrying thugs breaking the law with impunity—or so they thought. This was the leadership of the police department, a department that had just given itself one of the worst black eyes in the 20th century. There were 125 people injured, most were locals, most had nothing to do with the park. This night became part of my consciousness for the next 15 years.

Clayton Patterson

Bathrooms in the criminal court building Manhattan

Snippets of my tape were shown on TV news. After they watched the whole video, *New York Times* writers Howard French, Todd Purdom, and Michael Wines wrote a long exposé that was published in the *Times* on Sunday on August 14. Suddenly the District Attorney became interested in our footage, and I was told to hand over the original tapes. I thought, "What? I'm an artist; this is my art and it belongs to me, and will not be stolen by force and intimidation from the state." The DA also had a record of altering evidence. For example: In about 1986 Raphael Escano was beaten by officers on top of a van as bystanders screamed, "He didn't do it" "You got the wrong man." This incident was taped, but when presented to a grand jury, the sound had been removed, and the man who "didn't do it" was found guilty.

I was given a 90-day sentence and was thrown into the Bronx House of Detention. The sentence was to be repeated until I gave up the tapes. I was put in jail under central monitoring. At that time the only other person in the jail under central monitoring was Larry Davis, and he had shot a number of cops. I was taken to court in a special van that was the size of the mini blue and white buses that the cops use to drive a posse around—only this van was built like a vault, and had a special little cage. Another time I was in a large bluebird bus with a special one-man cage, separated from all the other prisoners. I wore gray coveralls, leg and wrist shackles. All this for taking pictures of the cops doing the wrong thing?

I went on a ten-day hunger strike. William Kunstler and Lynne Stewart came to the Bronx to visit me. In court, represented by Kunstler and Ron Kuby, I made a couple of deals with the DA's office. One condition that I insisted on was a public screening at Millennium that would let the public be the grand jury (I hope that Howard who took pictures that night with the standing room only crowd and the gaggle of reporters and cameramen). Another condition was that the DA's office would make nine copies of the tape for me. This would allow me to use the original once, and copies would be available to the whole group of lawyers that the ACLU had arranged to handle lawsuits against the city. Interestingly, the ACL, who neither made provisions for me nor recognized my rights to the material. They were only interested in the sharks getting their money. The blood that was spilled was the profitable white variety, yummy, and would make a cause célèbre for the ACLU honchos. The DA's office would have a copy and I would have a spare.

Let me be clear. I wanted the tape to be used in court. Without question, the cops were in the wrong, out of control and acting criminally. These were not acts of the civilian misconduct. Many people had tried to work out an amnesty with the cops that night.

I was now finally out of jail and able to eat again. Life was good. We got home with our "official" copy and the protected original. AHH, I could relax in private. Elsa said, "Hey, these tapes look shorter than the originals." She made a comparison and sure enough, the copies that had been made by the DA's office, the official court copies, the tape that I had been thrown in jail for, the one that they so desperately wanted, was missing half an hour of damning evidence. The technician had left between tape changes (The original "riot" was on three tapes). This was the "official" copy.

My first reaction was, let's go to war! so I went back to court but I was so tired, burned out, alone, that I gave in and said that you can make another copy, only under my conditions this time.

Here is a rundown of my lawyers: Lynne Stewart, who unfortunately had moved on. She was a good solid supporter. I had Kunstler and Kuby, who for radical lawyers sure were complacent. Most of the deals they made were behind closed doors and not all of these deals were on the "record."

I was working for a time with Al Sharpton, Alton Maddox and C. Vernon Mason. This was interesting. Maddox was very hard-core. "Never bend, never yield" seemed to be his motto. He was beaten up as a child on the courthouse steps. He was a powerhouse and he was strong. He seemed straight, moral and solid to me.

Sharpton was one of the strongest opponents of police brutality in New York City's history. He was always straight with me and he wouldn't sell you out. You had the feeling that if you turned around they had your back. They were there for the war. They were good thinkers as well. Both of these guys were great in my book.

Mason appeared weak but I later learned that his license to practice law was being threatened. I first became involved with them at the height of the Tawana Brawley case, and in spite of

their interest in Tompkins Square, they had represented me in court once, it was impossible for the press to separate Sharpton, Maddox and Mason from Tawana Brawley. (Tawana Brawley was a black teenager from upper New York State who accused members of the judicial system of raping her.) I had to dissociate myself from the trio because whenever we went around together the press would only ask about Tawana. I have no idea what really happened—I am not sure anyone knows. They took on this case out of a conviction, a civil rights issue, I never understood. That is life. I am glad they were not angry with me. We had to separate; I had my own battle to sort out.

Throughout my political career I have met with or dealt with just about every radical lawyer. As the years proceeded, I was fortunate enough to come into contact with a Legal Aid lawyer named Sarah Jones. She was the granddaughter of President Rutherford B. Hayes. She was in the business because she wanted to be, not because she was a slacker and wanted a job that did not have a lot of oversight. She could have gone society white shoe. I trusted Sarah Jones. My other lawyers: Stanley Cohen completely sold me out when I was arrested in the 9th Precinct on the same day as my scheduled court appearance. He promised to contact the court, and later told me he had, "taken care of it." He never did. I called Mr. Cohen's office numerous times, he was always going to get me the information. He never did. I was later arrested with a warrant because of missing court. After this episode the DA would ask for an extraordinary bail, like half a million dollars, saying that I was a flight risk. Absurd, but true. Thanks, Stanley; and what was the point? Michael Kennedy, the background litigation person for *High Times* magazine, was no prize for me either. Now, for some cases against the cops I have Myron Beldock, an uptown lawyer who will bite the head off a pit bull just for fun. He's pleasant to be around, a smart lawyer and unusually good in the ring.

What effect did the tape have on the police? Those unassuming 213 minutes captured a record: a bunch of cops were fired, five were indicted, a chief was retired, the captain was moved out of the precinct, and there were numerous departmental trials against the rogue officers. Finally the city got it—probably after serious federal probing. "How am I doing?" Not well, Ed. There is a major problem in the NY Police Department.

The tape became a cash register. I was told by a corporation lawyer that once the tape got out to all the lawyers it ended up costing the city about $2.2 million in paid-out lawsuits. Many people made money. I was not one of them. Everyone on my tape that sued made the big money. Ken Fish, for example, was the most badly injured victim on the tape and made $300,000. At least he acknowledged that the tape made the difference in his case. Later he opened a travel agency and I asked if he could find me a discount ticket to western Canada so I could visit my sick elderly parents. I offered to pay him. Ken's response was, "No! My agency only deals with the Orient."

Bob Arihood would have had a hopeless case except for the clear shots that I took (cops kicking him when he was down and pulling his hair). The Arihood case would never have even have made it to court without me. There were no visible injuries, and try to get a witness to stand up against the cops! After he got a six-figure settlement, I have a great tape of him yelling at me that he was forced to subpoena my tape, which is a lie because all the lawyers got my tape through the ACLU. Prior to his settlement, he used to limp around. Now he takes photos on the street—sprinting down the street now is no problem. He stands around in front of Ray's Newsstand all the time with an expensive camera in his hand. I don't know—maybe it is his trophy that he wants everyone to see. I don't look at a camera as a trophy.

Paul Garrin, who compiled a fantastic twenty-minute propaganda video tape of that night, got a very good settlement. The tape shows a cop from the point of view of a person standing on top of a van and the cop swinging a nightstick at him. In reality the cop never even made contact with the weapon; the cop was just using a sweeping motion. Dramatic? Yes, but nothing illegal or outside proper police procedure. I had the money shot. Once Paul got off the van, another renegade cop grabbed him by the shirt, ran him across the sidewalk, and rammed him into a brick wall. Ouch. This was real, but there was no blood, no ambulance, and no arrest. Paul was able to keep on shooting. All he needed was the money shot. What more could anyone want?

Paul was smart. He moved on with his career and got art shows at prestigious galleries, like

Holly Salomon in SoHo. He displayed with famous artists like Nam June Paik, and toured the world with his new-found art form. I am glad he made this major career move. I did try and ask him to participate in a book about the political struggle on the Lower East Side that Al Orensanz was publishing. Al could afford to pay a seventy-five-dollar writer's fee; maybe that was the problem. I left several messages on every answering machine that I could find with his number and I sent several e-mails to whatever addresses I could find of his. I never got a response. He never gave me anything for this film/video Lower East Side history book either. That is how it is.

Perhaps I was the fool. I stayed with the struggle. I never even got one Christmas card from anyone that made money off my tapes. As my friend Steve Bonge would say, "Whose rose garden are you saving today?" And he is right. No one is interested once his problems are solved.

If I sound vindictive or dyspeptic, I must say that Elsa and I loved what we were doing. We had the heart for it. We felt like a strong defense, a force to be reckoned with. We believed in the struggle, Little Brother watching Big Brother—the equalizer. For me, going to court was a much more interesting endeavor than banging up yuppie gallery shows on my resume. My struggle is in the lights for everyone to see. I fought the law and I usually won. The big fights are the fun ones.

We have collected an amazing outsider history of New York City. We have a large, unique archive of a misunderstood period in this city's history. Much of the time I feel that my material will not be understood for a hundred years. I quite often think of the photographs this way.

We just got really burned out by the schnorrers and money grabbers. This is what made it tough. The odd thing is that people become very negative when you make big money for them—maybe it's guilt.

After the police scandal died down, protests continued in Washington Square Park. After winter came and most of the protesters moved on, leaving only the hard-core political activists remaining. There was still media attention. On the morning of April Fool's Day 1989, the city evicted the inhabitants of Tia Scott's Squat on East 8th Street and tore it down. This ignited the battle between the left, the city and the Lower East Side. It reinvigorated the protesters and helped unify a group of individualists, eccentrics, political sages, madmen, the desperate, the destitute, the homeless, HIV-positive warriors fighting for their lives, some students, a few communists,

Elsa Rensaa

Clayton Patterson—Trials of taking pictures of cops

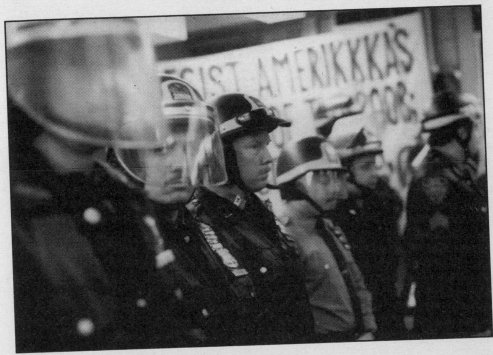

Clayton Patterson

Community Board 3 Meeting

Puerto Ricans, blacks, whites, anarchists, squatters, and all different kinds of Lower East Side individuals. They were on the street because of Koch and the decline they saw in the city. We were a motley crew. Elsa and I continued to document the process. My hope is that we did our part to solidify the coalition.

Out of the homeless came a group known as Tent City, a collective in TSP. There were also local homeless encampments on empty city lots, including a large one called "Dinkinsville," named in honor of Mayor David Dinkins. Squatters, people who had taken over drug-infested, empty, many-times burned-out and now abandoned buildings, moved in and fixed them up with a group of supporters. The supporter group, a collection of wing nuts, some crazies, some foolish, many dirty, who together with a group of dedicated community people tried to save what they saw as the loss of affordable housing and payable rent, the loss of freedom, democracy, and at the very least, the destruction of their community and the debasement of their country.

Under Dinkins the homeless in New York were living and sleeping everywhere. To get them out of the park he lied to them. Shelters were like death camps. To stop the homeless from sleeping in the bandshell in Tompkins Square Park, Dinkins tore it down. Got that concept? It sounds crazy but it's true. Let's tear down Penn Station, the homeless sleep there as well. Let's rip up the subway tunnels. Dinkins was the hardest on the homeless, the majority of whom were black. After the park was closed, many of the former residents moved to "Dinkinsville."

It is easy to romanticize this ten-year period of protest but this was no academic paradise or Sunday picnic. Many of the protesters were people living desperate lives. There is no library shelf full of books written by activists from the period. The group, it seems, did not have the makings of the Situationists. I cannot get one person from a leadership position to write one paragraph describing the struggle. In short, the movement was way outside of the mainstream. *The Voice* did not support what was happening, nor did any faction of the left want to be seen joining hands with this rank collective.

Seth Tobocman has issued one of the only objective histories, or partial histories, of this difficult era. Seth's words and illustrations are a good start and his book, *War in The Neighborhood*,

is the only real look at the truth of the movement from that period in time. *World War 3*, a magazine spearheaded by Seth Tobocman and Peter Kuper, also did cartoon documentaries that expressed the pain of individuals caught up in the turmoil.

One comprehensive book has come out of the movement so far, that I am aware of, *Each One Teach One*, by Ron Casanova, as told to Stephen Blackburn (Curbstone Press, 1996). Casanova was a chosen leader of Tent City homeless group in the park. Casanova includes his time spent in TSP in the book.

Now that the period is over, many people show up and pass themselves off as significant players of the protest movement. Very few of these new jacks were on the videotapes or present in the photographs. Some of the events, riots and protests went on all day and all night long. You got to know who was there and who was not.

I was at an Allen Ginsberg memorial that doubled as a combined benefit for independent media. They displayed a book Ginsberg had produced with Eric Drooker, who was a legitimate player. The MC praised Ginsberg for visiting the park to support the movement. I almost choked. Ginsberg had passed through the park a couple of times to get to the other side and had read at a couple of events. This movement was far too unintelligent and desperate for Mr. Ginsberg. There was nothing glamorous about it, too working class and dirty for most people.

A great number of the Ginsberg's HOWL associates were Ivy Leaguers from Harvard and Columbia, along with some Rutgers students. Hands off the squats and hands off the homeless had two meanings. The irony is that in the end it was not the left that gave the squatters their hard-fought rights to their buildings—it was the last two mayors, Republicans, starting with Giuliani, and finished by Bloomberg. The Republicans projected what was possible and what was not—the cops made use of the struggle to get organized.

This collection of people had no rights in the eyes of the politically correct left. The great civil libertarians, like Nat Hentoff of *The Voice*, were writing about the BIG topics like the Supreme Court. Meanwhile all of our civil rights where dwindling right before their eyes. Leon Golub, a well-respected painter and civil rights activist, lived only a few blocks away. He was working on paintings of imaginary tales of brutality in far off countries, using pictures of soccer players from magazines as models to depict forceful kicks a mercenary would use to plant a hard blow on the head of a victim. He could have come to Tompkins Square Park and seen the real thing. Much of my collected documentation might be interpreted correctly in 100 years. Right now there are too many emotions and too many guards in the way.

One of the pleasures of making these tapes was that it proved that a street action video could have real consequences in this society. It can make a difference. Not many people want to see or hear the truth. Forget the liberal left and the ACLU. I tell college kids to look at the era and do a close, thorough examination of the press. Compare the alternative press, like *The Voice* with the mainstream newspapers and you will be surprised at what you discover. *The Voice* is a far-right Republican paper. The local press—*The New York Times, Daily News, Newsday*, and even the *Post* got into studying what was going on. Go through the Lexus/Nexus records and compare the coverage by the different newspapers. You can determine for yourself which news agency did the best job of reporting. Go through the videotapes and photos from the period and make up your own mind. This takes a little work, but you decide. Forget my position. I must say that Bob Fass and Paul DeRienzo of WBAI were most helpful in getting out information. And there were a few communists whose hearts were in the right place and did help the struggle: John the Commie Podak, Karl, Joel Myers, and Paul and Kathy Shay. These are people close to the struggle, not removed pundits.

Most books that are now being published about that time period are by academics who get their information from statistics and follow economic and real estate changes. Records from banks, lending companies and other accessible written facts give them the information to create the history. Certainly these academic books are important, but they miss the people's voices, the fabric, and the feel of the streets.

Most of the posters from the period were crude hand drawn photocopies often assembled by cut and paste in a copy shop. Most curators now pull out Eric Drooker's posters or Seth Tobocman's illustrations and call them representative of the years of turmoil. These two artists are classic and important, yes, and their illustrations make artistic flyers, but they are not a good

reflection of the dozens of information sheets that were once pasted on lampposts. My archives have many posters that reflect the changing aesthetics of the day—the real art of the day.

It took five years for police street task force units like MSTF (Manhattan South Task Force) to reorganize. After years of fighting the protesters on the Lower East Side, they became the razor-sharp disciplined unit that now exists. We documented this realignment. The protesters witnessed the metamorphosis, the toning of the slack muscles. It was a long difficult task. The police are now able to shut down NYC in a couple of hours. This includes stopping the subways, closing the bridges, tunnels and blocking all city streets. Under Koch and Dinkins this would have been considered impossible. Other than seeing it in some futuristic books and movies who would have believed NYC could be shut down at all? Very few people. Koch mostly squeezed his eyes tightly shut and went along for the ride. Dinkins tried but he was too deep into pockets of the old NYC Democratic left. This newly forged task force can control any political situation that comes up in the street. For the moment.

They can always fall backwards, and seem to be doing so under Bloomberg and Police Commissioner Kelly, as I discovered a few weeks ago. The MSTF and the 9th precinct cops were—again—running amuck on the side walk, arresting protesters who were all within the law. I asked the cops who was in charge and one MSTF cop said, "I am." Great. You're fired! No

Elsa Rensaa

Clayton Patterson and Daphany Hellman

leadership, and complete chaos. A protester burned a flag and the cops went crazy. It was that easy. In the beginning it was the commanders like Fry, Hoel, Gelfand, Seta, Esposito, Julian (they all became chiefs) who, with orders and nightsticks, pushed the patrolmen into forming a line. They understood the chain of command. Booting Koch was out of office was the first step to disciplining the police force. "How am I doing?" Move to Florida.

Mayor Dinkins started the process of getting order back in the police precincts. He created the Mollen Commission to look into police corruption. The beginning years of the struggle to get the police into shape was rough; Dinkins had to get rid of as many criminals on the force as possible, try to clean out the drug and prostitution connections, and restore order. The uptight, right-wing members of the establishment would defend the police no matter how

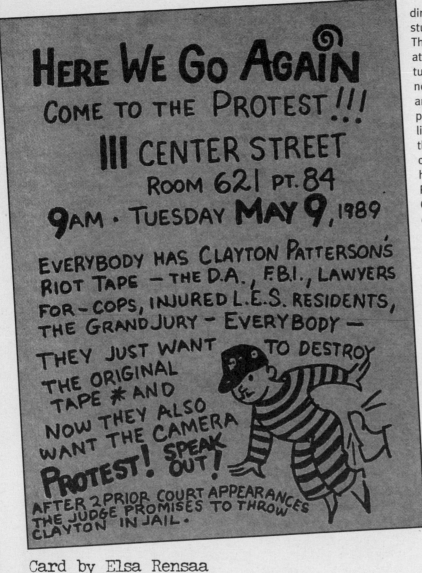

Card by Elsa Rensaa

dirty, criminal, or stupid they were. These people fixated on the rectitude of the cops, no matter what— and so did that part of the left, like Koch, that thought law and order were the highest goal. Right! Law and Order. Dinkins cleaned up some of the precincts. Not much happened to the criminals in the police department. Some lost their benefits, others were fired. Remember the drug dealers who made the news: The Dirty 30, Michael Dowd and his Sleazy Crowd (a line from an Anne Ardolino poem), the Morgue Boys. Drug dealing precincts like the 9th, which had its own chapter in the Mollen Commission Report, got to slide. One cop was fired. A big 9th precinct police drug party was arranged on Staten Island. High ranking officers, who knew about the party, busted one party organizer, and the party was cancelled. Although the fiesta was shut down all the merry men got a free ride—pass go, collect two hundred dollars.

I have documented many dealers on the street. It always amazes me how the local minorities go to jail for centuries, and everyone else gets off. Look at the jail population. It is funny to me to watch the hip-hop executives try and talk to high-powered politicians like Sheldon Silver, (the most powerful Democrat in the state) about the Rockefeller laws. A large percentage of the state jails are filled with drug dealers from the Lower East Side. The hip-hop fellow takes Cuomo's son as his fighting partner. Cuomo's father tripled the number of jails in New York State. They are filled with our neighbors, from a community that was controlled largely by a band of dirty cops. Prisons are one of the largest businesses in upstate New York. I am getting out of this ridiculous world.

The left, like Rip Van Winkle, finally woke up, and is looking around and realizing that we

could be seconds away from a police state. Now there are numerous programs and discussions about our loss of rights. Please. It took a long time to put the police into place in NYC; it appeared right before our eyes and Elsa and I documented this development. In came the newest and best equipment, the most modern, well-equipped vehicles, highly trained commanders and anything else that would make it easier to control and run a city. Just as in Hitler history, the path from beginning to completion took about seven years, from beer halls to city halls. From the grimiest to the professionals.

Then came Giuilani. He took a real hard look at the police department. More heads rolled, and—this was new to the department—some cops even went to jail for life. For life. Remember the Louima case. A prisoner in a precinct that was busy and crowded and not one cop saw or heard anything as Louima was raped in the public precinct bathroom. He had his lower inner body penetrated and ripped apart with a wooden instrument. The smell of feces, the scream, the prisoner walking with his pants down, the blood—not one cop saw anything. The almost dying prisoner taken to the hospital. Nobody asked any questions? What happened? Some party! It was by chance that a hospital employee recognized a problem. Oh yeah, it was homosexual sex, said the cops.

Then it took Giuliani pounding with an iron fist continuously on the precinct walls to finally shake a small portion of the truth out. It took serious threats, crimlnal charges, and firings before cops came forward. This is the POLICE department we are talking about. Even in the end, the whole crime was not uncovered and not all of the perpetrators were brought to justice. We accept the fact that cops are lying and hiding, while we are told to forget, move forward. It is hard to imagine a more sick, deviant, perverted crime. Why do we accept this total lack of morality and ethics? If this had happened to a child in a Mafia crime family, the truth would have eventually been squeezed out and those responsible would have paid.

Many believe that Giuliani showed up and made the police into the well-tuned instrument that they now are. Dinkins started the process, then came Giuliani's police commissioner, Bill Bratton, and Jack Maple who came up with the strategy to clear the streets of illegal activity, which certainly cleared the drugs and petty crime off the street, in turn opening the avenues to pedestrians again.

Bloomberg is doing the opposite. He is chasing all the drunken smokers out into the street, causing fights and all kind of street problems. In this community alone so far one person has been murdered, and another young man has been hit in the head, knocked onto a coma, all because of drinking smokers pushed out of the bar and into the street. Bloomberg, a billionaire, bought the election. He is just a corporate CEO who made billions by patenting a method to get information to and from Wall Street. He has absolutely no creativity, and his only answer to "balance the budget" while increasing the price of all public services is by squeezing cash out of everyone with taxes and fines, created or reinstituted. The fun never stops.

Elsa Rensaa, Marcia Lemmon and I were banned from the 7th precinct community council meetings for asking questions about crime in our community. The answers we got were totally ridiculous. I decided that we should make a record at the meetings. Elsa and I had press passes, and there are no laws against taking pictures, or videotaping at the so-called democratic meetings, especially since minutes were not being taken. Others have done it before us and after us. Minutes were not being taken. But we were banned under the supervision of Captain Alan Cooper, the commander of the 7th precinct, from ever attending these open public meetings. Banned! You can be the biggest scumbag in the world, but in a democracy the government serves the people and citizens have the right to oversee their government. The police can arrest you if you are doing illegal activities, you can be censored from speaking, you can be asked to leave some meetings, but banning attendance to an open and public meetings reeks of the worst Stalinist ideology. The documentation, however, is safe, and I believe that history will illustrate the stupidity of this totalitarian move.

Elsa is a recluse who has many projects that she works on at home. She is busy all the time working and has usually been able to make an income in the apartment. We have dogs, sometimes birds and had a cat. I can count the number of people on a little more than one hand that have been in our house in the last fifteen years. We have a public office. We have been together for more than 31 years. It was highly unusual that she was out with me the night of the police riot. We had seen the police building up all day and just sensed something

ominous in the air. Elsa during the night would run home, charge batteries and secure tapes. In later street activities, because I was getting arrested Elsa would worry, and decided that she would come out all the time during the years of turbulence and protest. For this I am grateful to her, and she is an excellent camera person, and friend. Elsa and I have paid our dues. I am satisfied with our contribution to this city, misunderstood as it is. My conscience is clear.

The rewards for doing this have been mostly hatred. This comes with the territory when you expose dysfunctional behavior, corruption, abuse, breakdown, and anarchy in the system. People who spend large amounts of money, years, and effort to planning and scheme the best way to get ahead build the system. These are some of the most diligent, hardworking, target-oriented individuals that exist, plodding along everyday, networking, kissing ass, inching their way to success. The last thing in the world that they need to hear is OOPS, this track is headed in the wrong direction. Not everyone is corrupt, but, as in the concentration camps, who is in charge? Who is really guilty of the crimes and abuse that took place in the camps? Everyone? No one? Only the absolute top authority? I don't think so. I think that all of us are responsible for what happens in society.

The night of August 6th and the morning of August 7th carried me on, obsessively, for the next fifteen years. The protests continued for a good seven years. There were many riots, street battles, and hundreds of people were arrested. We are probably the only people who captured the police reorganization. Not many people were thinking about this consequence of the street action. Lower East Side street politics during the years of turbulence did indeed become famous. But not in a way that is charming. Fame is not always glory and it caused a number of problems for Elsa and me. I have only one court case left, and it reads like a work of pulp fiction. Seven cops say that in order to arrest me they had to pile on top of me and pull me to the ground. It was like I was a raging bull. Out of my mind. Totally crazy. Why? Because I had been caught making a videotape at a protest to save Charas, and community gardens at a city auction held in One Police Plaza? People are allowed to take pictures in the auditorium at One Police Plaza. Many people were taking pictures that day. Several of the police say that they were injured in making my arrest. It is a scream. In fact it is such a ridiculous, phony, ill-conceived story that if you wrote it there is no way that it would reach a publisher's desk. I cannot understand why the police would want to even say such a story in public. It makes the police sound incompetent, weak, stupid, ill equipped and makes all of us insecure, because they are the security team in these days of terror. These statements should be an embarrassment to any police department. I thank Elsa for capturing the whole arrest on tape.

Some people say that I hate the cops. This is not true. I hate the lies, the deceit, and the criminality that is allowed to fester. Some people think that I am a bitter. Not true. We loved what we were doing. We just hated the money grabbers that give nothing back, and in fact were hostile. I am too close to the end of the fight. I have probably been on the street too long. It does have a price. So I am moving out of politics. I want to get back to having fun and chilling out. You can fight in my place.

A Peek inside the Archives

by Clayton Patterson

In 1979, Elsa Rensaa, our dog Gunner, and I moved to the Lower East Side (LES). We lived at 325 Broome Street, neighbors with Keith Haring, a nice guy. I was making prints, sculpture and paintings. I was prolific. The sculptures were large and I kept making them smaller, till finally they were compressed down to the size of cigar boxes. We ran out of room. We then moved to 99 Bowery, a 3,000 square foot loft. The first major wave of Chinese immigrants crossed Canal Street, and the rent prices skyrocketed. In 1983 we moved to Essex Street where we now live. I made a lot of collages, did some mail art, made more paintings and sculpture. After a few years on Essex, I went really small. I got into 3 x 5 inch photographs. I now have boxes and boxes and boxes of photographs.

One group that I photographed almost every day was the local neighborhood kids. I made a frame and put 32 different pictures in the window. I would rotate the pictures. This was one of the most looked at photo galleries in the city. You could hear, day and night, tapping on the window. *Mira! Mira!* Almost all of the kids were Hispanic. White people seldom got the picture but eventually a few white neighborhood people did make the Hall of Fame as the kids called it. I did this for almost 20 years. I photographed kids from when they were in grade one to young adults.

In the very early '80s I had one-man art shows in SoHo and was in several group shows. I was doing fine. Sold pieces to important collectors like Richard Brown Baker, the Brooklyn Museum and so on. Had some write-ups. But here is where the fast cruise to paradise stopped.

I hated SoHo and art world politics. I quit that scene in 1983. I left. Slam. In the '80s the art scene was heavy party, multiple sex partners, homosexuality, drugs, serious social politics, and everything that I thought was the worst part of high school. SoHo was all of that and Ivy League, narcissistic, career target-oriented artists, class structured, and expensive. I found the Lower East Side comfortable, exciting, friendly, warm and inviting.

In 1986, I started the Clayton Gallery. I showed people way outside the mainstream. Almost everyone who I have shown now has books out on their work: Charles Gatewood, Spider Webb, Raul Canizares, Steve Bonge, Genesis P-Orridge, and so on.

In 1986, while photographing the drag queens in the dressing room of the Pyramid Club, I meet Nelson Sullivan. He introduced me to video. In SoHo, video was Vito Acconci biting his leg or masturbating below a platform for hours on end, very elitist, and heavily into lots of expensive technology. Nelson's video was a continuous flowing artist statement that integrated the community around him. Beautiful and independent, and consumer available product. Perfect. I was hooked.

I had been photographing the LES, now I included video, which became another total obsession. Elsa and I have created the Clayton archives, consisting of hundreds of thousands of photographs and hundreds of hours of video, mostly about the LES.

The archives have many different categories of passing interest. Thanks to a neighbor, Peter Kwaloff, who introduced me to the drag queen scene, I was able to photograph the dressing rooms and shows at the Pyramid Club every Sunday night, for a couple of years (the police riot changed my direction). The level of creativity, and all the different kinds of face painting were extraordinary. The archives will reveal that Peter was one of the drag geniuses of that era.

There was a large rather distasteful hole in the wall of the dressing room. I designed a satin curtain with a poodle and wig motif, which Elsa embroidered, made a nice painted frame, put a piece of Plexiglas in front and made a photo showcase. I changed the 20 or so colored photographs every Sunday. I built and painted two custom 30 x 40 frames housing

8 x 10 color photos of the drag queens. These two pieces took up the wall space above the dressing room mirror.

I have a good cross section of Pyramid drag queens up to and including several Wigstocks. In 1988, I was in jail for taking photographs of police misconduct, and missed the show. After that I moved on.

The Pyramid Club was also a rock and roll performance bar and had a strange dichotomy at work. The skinheads were working security. You had some of the toughest guys in the community, and on the other side, a gay scene. It was an unusual mixture. Very LES. The tough guy side was very much into rock and roll women; the other male side was into men. It was like two different halves of the same brain occupying the same space. Everyone got along. Unusual.

Skinheads had a notorious reputation for being homophobic and beating up gays. The skinheads who worked there were girl crazy, and some were the leaders of the NYC hard-core music scene. Ray Bees and crew from War Zone, Don't Forget the Struggle, Don't Forget the Streets, and Jimmy Gestapo from Murphy's Law. The tough crew hung out at the front of the bar or out on the street. The drag queens, on the Sundays that I documented, were in the back. There was never any trouble that I was aware of. This was not a place where people were beaten up on any regular basis. I never saw any violence during the years that I went there.

I had been documenting bands at the Pyramid. I knew a number of the skinheads and started to document the New York hard-core bands. Starting in 1987 I went to CBGB's religiously and videotaped (and took some photographs) the bands during the Sunday matinees. The shows were absolutely fabulous. The music was tight, and the bands were hot. Off the top of my head I videotaped Sick of it all, Krack Down, New York Hoods, Rest In Pieces, War Zone, Murphy's Law, Token Entry, Side By Side, Reagan Youth, Youth of Today, YDL, Prong, Verbal Abuse, Absolution, Lee Way, Sheer Terror, and outside of CBGB'S I got some great Bad Brains and Murphy's Law shows.

The biggest problem that I had with the hard-core scene was its dogmatic working-class culture. I used to say I would sell you a copy of the show for $25.00, that is $10.00 which pays for the two tapes and $15.00 for shooting the show. A real cheap price, some of the tapes are great. We can make copies of the tapes and you can sell them at the shows. We split the money 50/50. I used to say "Hey, this is the underground, if I was selling the tapes without your knowledge everyone would know, and if the band is having difficulty selling your tee shirts and records, how can I sell the videos?" Anyway, in the end, most of them would rather work for someone else than be self-employed musicians. Independent business was never a part of the formula. Too working-class culture. The energy level was high and intense, the music was great and I had a blast. This scene had so much potential. Later, all the bands that made their living out of music came out of LA and Seattle. Seattle! The only exception is the band Sick Of It All. Seventeen years later, they are still together, and still surviving playing music, mostly big gigs in Europe where they are loved. Someday I want to break out some of the old tapes and play them. I think that you will cry when you see what was lost. Oh! the memories.

I did a lot of the East Village bands: Dictators, Brain Eaters, Circus of Power, Princes Pang, Scab, Hammer Brain, Sewage, Blood Sister, Spider Webb band, Ditch Witch, and a whole slew of other bands. It was a good period to document LES music. GG Allein's last performance at the 2B Gas Station was truly a memorable video event. What a show. A must-see video.

The archives include a number of hours dealing with the subject of different religions in the community. I have always had a somewhat thriving interest in religion and the contradictions of religious values. In the past I lived in a Mormon community with a Mormon family, which was an interesting experience. The Mormons owned a lot of property and had a temple farm, which generated money for the community. Every one pitched in to work on the farm and the money raised from the farm paid for needs of the community. Very independent community people; a uniquely North American religion. I am not a Mormon, nor am I affiliated in anyway with any religious organization. Just curious.

Elsa and I were videotaping at the World Trade Center when it fell. I regard this insane mass murder tragedy to be religiously inspired. Judaism, Islam, and Christianity all share the same literature—the Bible, so do we all have the same God? I look at Bin Laden, the fighting in Israel, the lockdown and siege of Bethlehem—the birth place of Christ. The fighting with the

Palestinians. Iraq and Saddam. These are not my ancestors, we share no bloodlines. These are not my people. I understand the Jews being interested in Israel, that is their history, their blood, their tribe, but not mine. The Old Testament is about the same type of wars, wars, and more wars. Are we facilitating these wars because of oil? Attaching God's name to these killings seems pagan to me.

It is curious how the church is adamantly opposed to so much of what modern culture introduced. The public tends to move away from church that believes that people have lost their sense of morality and ethical standards, yet it is the church that spearheaded the modern movements. Italian Renaissance Church's artists, like Michelangelo and DaVinci, opened the door to modern, forward-thinking artists, and fostered a big break from the flat, medieval world. Many American artists who were thought of as modern, or avant-garde, have rebelled against the Puritanism of early America, the church, and are interested in liberalizing sex, abortion rights including third trimester abortions, and changing religious standards, for example allowing homosexual marriage. In New York, Judson Church, St. John the Divine, and St. Marks are three examples of epicenters that housed and gave a showcase to this modern revolutionary spirit. Experimental art, dance, performance, theater, video, and poetry have been played out in these religious establishments. I videotaped parts of an OTO Crowley–inspired Mass in a Church. An interesting concept. I have heard poetry about every subject related to modern culture. I would never try and do my thing in the church. What is the point? It gives me the creeps. It has to be a very special occasion, like a memorial, for me to go to the church and document modern secular art. The story of Jesus throwing the money changers out of the temple seems like a small potatoes story compared to, let say, Ginsberg reading poetry of joyous gay sex with a young lad on a bright and sunny day. Most of the poets who I have spoken to that read in the churches have no relationship with religion, nor any desire to participate in any religious service. Ginsberg was Jewish, I do not believe that he was religious, never mind belonging to any church, and his belief system was based on Buddhism. It was also

Clayton Patterson

Santaria

interesting talking to people who have grown up their whole life in a communist country and having no concept of g*d whatsoever. I also wonder if there is a heaven why would I want to be there, almost every creep in the world seems to believe that this is where he or she is going to go after they die. Who needs this for entertainment?

I have documented, photo or video, at a number of churches; this is history. I have in the archives a number of religious leaders who seem to be a total contradiction to the teachings of what is thought of as the religious establishment: pedophilia, bank robbery, murder. Are these religious, moral, or ethical acts? When I was beaten by the police on 4th Street and Ave. D, a local preacher told me that both he and his son witnessed my brutal beating, and that his son had a photograph of the incident (that I needed in my defense), but they would only be witnesses for Christ—not for me. SAVE ME!

I find it ironic that the American Christian right, a force that has strongly opposed any art, music, literature or written word, film/video, television show that even made references to sex, and would like to censor from libraries, record stores, movie theaters, any public place that made reference to sex, is the group that adds the most blatant pornographic material into the modern public lexicon. Going after President Clinton on a private matter that was nobody's business, and certainly a subject that I had absolutely no interest in hearing or reading about five times a day, was a form of religious insanity. His private sex life was not my business! Then using the courts and the government to make public in language, words and concepts that had until this point always been taboo subjects not for public mainstream discourse. The attacks against the president entered this erotic taboo, Republican sexual fantasy, into all daily life through all public media. Words and phrases like: fellatio, semen on the dress, cigars in the vagina became world-wide mainstream news and household topics of conversation, thinking, and the unavoidable in-your-face screaming, did the president lie about having his penis in Monica Lewinsky's mouth? Did he lie about this act? Is this important? Is it a more important question than President Bush not checking facts about possible weapons of mass destruction in Iraq and sending us into war? One of the most important public debates of the year was: is fellatio sex or not? I wonder what it must have been like in the junior high school libraries, as all the young lads are scouring the *New York Times* looking for pornographic words that they have never heard. *National Geographic* that used to be the adolescent male wonder magazine in the school library is now tame; this was real sex. Or I can imagine a family in the Bible Belt eating supper together, listening to Dan Rather and the news: It has been discovered today that the stain on Monica Lewinsky's dress is in fact the president's semen. Daddy, what is semen? Curious. Ban Tom Sawyer. Right. I have had a fascination documenting religions.

The remarks of Senator Strom Thurmond (quoted in this publication on the second page of Jerome Poynton's article *Baroque on the Lower East Side*), who, upon seeing *Flaming Creatures* said, "that movie was so sick I couldn't even get aroused." The censor has the privilege of watching what he calls pornography, and seems saddened that it did not arouse him. What was he using as a guide to determine pornography? His penis? Is this the legal tool that is used to save the constitution? What was in his private collection that he was saving America from?

Anyway I have found these kind of religious content arguments interesting subject matter.

Not all of my documentation of religion is about contradictions. It has been great documenting Baba Raul Canizare's ceremonies and his creation of religious artifacts. Baba wrote a number of books that are sold in botanicas and certain bookstores. One of his books, *Walking with the Night,* is given a high rating on amazon.com. Baba was also academically trained in religion, as well as an initiated Santeria priest since childhood. He was also interested in magic, and was enthused about Aleister Crowley. Baba wrote about magic as well and wrote an in-depth book on Palo, the darker side of Santeria. It was after documenting Baba that I came to question Giuliani's attack on the Madonna piece at the Brooklyn Museum *Sensation* exhibition by English artist Chris Ofili, who was of Nigerian descent. I wonder if Ofili was a follower of the Yoruba religion, which comes from Nigeria, a branch of the religion called Ifa. When the Yoruba religion was brought to America by the African slaves, they attended Catholic church, but because of social pressure, would pray to their pagan saints who had taken on

the appearance of the Catholic saints. For example: St. Barbara is the representation of Shango. To have the Madonna represent an African deity would not be blasphemous or a desecration to the Madonna. I wonder if the Madonna painting glorified two religious figures, and if Giuliani was being a religious zealot for his own belief system. Personnel religious point of view over good governing for "the people." Baba died recently, way too young; he was important in my life. I gave him a number of art shows. The hours of footage and the photographs are an important part of the archives.

Kaprinda Swami, a disciple of His Divine Grace A.C. Bhaktivedanta Swami Prabhupada (Hare Krishna), was without a home at the end of the Koch years and the beginning of Dinkins' term. This has to have been the greatest homeless crises in NYC since the great depression in the 1930s. Swami lived in a van and rose at 4 a.m. go to a secluded area in a local park and chant his rounds, even in the dead of winter. He washed in Tompkins Square Park and eventually obtained a temple and opened the Prabhubada Sankitan Society, which flourished until the highly energized gentrification wave mowed him under in the late '90s. He is once again without a temple and no longer living on the LES. Swami is one of the most dedicated, devoted religious people whom I have documented.

Videotaping and photographing many of the last remaining synagogues of the LES has also been a passion. Although it has been a somewhat silent movement, the Orthodox Jews have been slipping out of the LES for some time.

Lionel Ziprin, one of my favorite inspiring people, is a religious Orthodox Jew still on the Lower East Side. He comes from a long line of Kabalists and is related to the Abulafia lineage. In the book *American Magus: Harry Smith a Modern Alchemist*, Paola Igliori has one of the only published interviews with Lionel Ziprin—this is a transcription of one of my videotapes. (I have a little documentation on Harry.) I videotaped several of hours of Lionel reading from his unpublished books: *The Book of Logic*, *The Book of Shots*, *A Scotland Yard Murder Mystery*, *Songs for a Schizoid Sibling*, and so on. *The Book of Logic* is 20 hours long. I sat on one side of a table, Lionel on the other side. Whatever was on the table on a particular day became part of the tape. The only props were his cigarettes and ashtray, and an alarm clock and sometimes a bell. Lionel would read and I would sit across from him, circle the room with the camera, and zoom in on objects, the window and so on. I would shoot a stamp on a letter, and in a couple of sentences he would mention a stamp. It was like I was in a trance. Making that tape was a truly magical experience. The time passed in a moment. It was like I was a vehicle to record some Kabalistic secret messages. It was an unbelievable experience. We did not do any drugs. We did ten two-hour sessions. I introduced John Strausbaugh of the *NY Press* to Lionel and he graciously wrote two fascinating articles on the man and the legend. Lionel asked me to get one of the Strausbaugh articles to Rome and the Pope. It seemed impossible. Me? The story was the one about the Angel Raziel, the angel that Adam asked G*d for protection when he and Eve were chucked out of the Garden of Eden. The book of Raziel is used by the Hasidim as a protector against ill will, like robbers, one will be kept by the till in a business, or by the window of a house, or under the head of a sick person. I have an artist friend, Baldo Diodato in Rome, whose wife is a dentist. She made some gold teeth for me. She has an office close to the Vatican library and knows the head priest who is in charge of printing Vatican books. I met with this priest who gave me a special pass, and I was given access to some building that you needed entry past several guards, met a person of authority, who said that he would make sure that the piece would reach the proper conclusion.

Lionel and I did a public viewing of the book at the Anthology Film Archives in the same series as they were shot. Jonas was very pleased to have Lionel at the venue. We started with a full house at Anthology. After the first showing we had very few people for the second. By the third night all the audience left was Ira Cohen. Ira is an incredible photographer and poet, very educated in magic and mystical knowledge. Ira spent a good deal of his life in Nepal, India, Morocco, and other such places learning, writing, documenting mysticism. We stopped the series. Maybe some day.

Patrick Geoffrois was a fascinating individual to document. Patrick had been involved in poetry in Paris in the '60s. He did works that were included in readings with Burroughs and Ginsberg in Paris. Patrick's mother had been a card reader. He went to India to study about

Shiva, where he met Prabhupada, the man who brought Krishna consciousness to New York City. He became a disciple of Prabhupada. Patrick was one of the first Krishnas to take the books across Europe and into Russia. He married Molati, who with several other Krishna disciples sneaked into the recording studio when the Beatles were recording *Abbey Road,* where they met George Harrison, who then went on to record the Krishna song, and the resulting buzz tornado was felt around the world. Prabhubada died, Patrick dropped out, and became one of the first and only white street heroin dealers (Dom Perignon) in the neighborhood. He performed in the James Chance and the Contortions bands. Studied magick. Patrick believed in the system and power of the Forgotten Ones. He was a Crowley tarot card reader on St. Marks. Scared the hell out of a lot of people with his witchcraft and magick. He died of AIDS. I have some interesting tapes and pictures of Patrick Geoffrois, the local tarot card reader, religious thinker, magician, and a legendary figure on the LES.

Arthur Johnson was another unique LES character. He was always running for president of the USA. Arthur lived on Clinton Street, when Clinton and surrounding streets were an open and seemingly legal drug market. He would call the precinct about the local drug dealers on the block, the next day the drug dealers would ask him why he was bothering them. He was paranoid about the CIA following him, so he covered his room in tin foil, to protect him from the rays. He was also totally paranoid about his landlord. He believed that the landlord was trying to kill his tenants, that the landlord had several aliases, and that the landlord was doing decep-

tive criminal acts to get rid of tenants. Many people wrote Arthur off as a nut case. I documented Arthur a reasonable amount, including his autopsies of the rats that he kept to taste his food before he ate it. Funny, the rats did have tumors and growths. It later turned out that one of the major local drug dealers was working for the cops and for Arthur's landlord. The landlord paid the drug dealer to kill a tenant in the building, the cops set up a fake murder, and Avie Weiss, aka Mark Glass and whatever other names he went by, was caught. The landlord had several different mailing address, names, passports: Israeli, American, and maybe British, and guns and buckets of gold coins. Mark Glass got seven to fourteen years, the drug dealer was slapped on the wrist. Arthur was right. Who would know? Not all paranoids are nervous for the wrong reasons. One never knows. Documenting his-

Card by Clayton Patterson

Card by Clayton Patterson

tory is interesting.

The Satan Sinner Nomads was a LES street gang. I introduced the president, Cochise, to art. He turned out to be a very good painter. I gave him art shows, and Bert Hemphill, first curator at the American Folk Art Museum in New York, bought some of his paintings. The gang had a clubhouse, a casita, in a row with other homeless casita dwellings on 4th Street and Ave D. There we made a lot of compelling videos and photographs. One initiation was particularly memorable. Most of the members are either dead or doing long stretches in jail, but some escaped and became working members of society.

Manwoman, another luminary in the archives, had dreams in the sixties about saving the swastika. A symbol that had always been a good luck charm. The cross always had power behind it and no matter what the history was of the cross, it was always safe. One madman came along and flipped the energy of the swastika, and turned it into evil. Most cultures that worshiped or respected the swastika are minority, brown races. The Jews had also used the symbol: "The Universal Jewish Encyclopedia (1939–1943). . . . The Swastika appears on various . . . synagogues in Galilee and Syria . . . Jewish catacombs in Rome . . . Synagogue at Tel Hum p. 28 (from the *Gentle Swastika, Reclaiming the Innocence*, Manwoman Flyfoot Press © 2001). In his book, Manwoman covers the history of the swastika and his effort to reclaim the innocence of the symbol.

The swastika has been blacklisted from white culture. I am fascinated by Manwoman's pilgrimage. Because of his dreams he believed that it was his mission in life to save this sacred symbol. To give the humanity back to the swastika. To cleanse the symbol. In his desire to accomplish this goal, and to show his sincerity Manwoman covered his arms and upper body with tattoos, representing the different cultures' representation of the symbol. I have given him art shows and have supported his cause. He is honest, not a racist, not anti-Semitic, not a redneck and the story is as interesting to me as any Albert Schweitzer tale.

The archives have a reasonable number of LES artists and openings. The Smithsonian wrote me a letter showing an interest in the art part of the archives, but had no budget to purchase them. I had documented Bert Hemphill and his folk art collection. I introduced him to some artists and he collected some of their work. He purchased an original-design, fully embroidered jacket back and a couple of Clayton caps. Bert sold his folk art collection to the Smithsonian for over a million dollars, a massive collector's exhibition accompanied with a fully illustrated catalogue. Because I was not offered money for my archives, I thought what for? Maybe in the future. Walker Evans got paid.

The archives contain a cross section of poets. Some junkie poetry, Huncke for example, opium dreams poetry by Marty Matz, poetry by gays, straights, and all different kinds of poetry. I am glad that I have been lucky enough to be able to capture some of this diverse cross section of poets. No Robert Frost types, they just never crossed my paths on the LES. And for the most part, the famous people were never that interesting. I do have a little Ginsberg here and there, but he has been well-covered elsewhere.

I looked where others had not. I like the exotic, the hard to get to. Jasper Johns had a studio close by. I never did approach him. There must be 500 books about him. Why would anyone need me to capture him? I have made some magic drawings for books that very few people will ever see. But like the court cases, they are buried deep. They are hard to find, but hopefully they will work their way across the centuries, in their own slow soft way. I am sometimes a noisy person, but it can also be the whispers that travel.

The archives contain a number of hours relating to drugs and the usage and effects of drugs. Some truly fascinating material that should be of interest to a number of people at sometime in the future. I think of a lot of what I do is for 100 years from now. A look back at this time and space. I do not have tapes of criminal activity. My documentation is almost always within three to five feet of the people. People always know that I am there.

Because of my obsession with some material, the people believe that I am fixated on them, that they are the only people that I document. Not true. I have been told by drug dealers not to take their picture. I did not. I have nothing illegal in the archives. It is all above board. I do not and have not made material to compromise people, except for the cops, if they are doing the wrong thing.

The cops are paid to uphold the law. The Tompkins Square Park police riot was a job that needed capturing. The cops themselves put me on the road to a disciplined challenge of setting the record straight. The cops created this mission. Not me. This documentation was not arbitrary. The tape was not a set up. They made all the illegal moves. Part of the tape showed police doing the wrong thing and I caught them at it. Whose fault is that? Mine? I don't think so.

I was just one of the only people who followed through. I paid the price for all my legal police documentation. I was recently told that the cops were not happy that I was on the board of the HOWL Festival. I thought, "Good." They have not forgotten and now why should I? Many cops have shown great disdain for me. I have had neighborhood people, just recently, tell me that the cops have pointed me out to them and stated that they hate me. This is life. Tell them to be straight. Good for them. I made my mark.

The truth is supposed to set us free. That is the hope. But in reality it usually just makes things more difficult, because no one wants to hear the truth, which quite often is about problems, and it usually causes you a lot of trouble. America hates problems. We like Pop Art. Hate and disrespect is a part of the package. When we were at the World Trade Center collapse, Elsa was knocked down, the cops ran past Elsa, it is possible that a cop shoved; did any of them stop and try to help her? No! If we are ever in trouble do I think about the cops as an option? How can I? But I feel that we have made a real contribution to the betterment of NYC. The police parts of archives are important. I have been demonized for showing that cops can be criminal (if they become slack), but in the future the full value of the material will be understood by people who can think. The archives are real history. It is only bad to the people that think that they have something to hide. Truth can be understood with the passage of time.

The fire department is totally different. They are real heroes. Almost every fight they are in has the possibility of being deadly. We have hours of the fire department doing great things in

the community. The NYC firemen are some of the best in the world. No question about this. I make it a point to capture even a lot of the boring stuff. Folding up the hoses, loading the trucks, and of course fires. I think of the fire department material, even the just plain job-related footage, as interesting for the future. A look back at a time and place.

I was interested in documenting tattoos. Years ago I saw an ad in the back of the *Village Voice*. "Tattoo and Body Art Society" was having meeting in the Yuri Kapralov 6th Sense Gallery on East 6th Street. I started attending the meetings. Roger Kaufman, the original president, who lived on Long Island, was having problems keeping the Society going. It was extremely important for me to see the meetings continue: I was totally fascinated by this art form, and the people liked to be photographed. I joined with Ari Rousimoff, the filmmaker, and we took over the meetings. The feature film *Shadows in the City* came out of the society. The film used several LES characters like Nick Zedd, Kembra Pfahler, and Joe Coleman. I hooked up Jack Smith, who played Death. I believe this was his last feature film. I was the art director. Eventually, Ari left the society. Elsa became vice president and I became the president. We have a very good collection of videos and photographs of tattoos and tattooing. We got Bernie Moeller into the Guinness Book of World Records for the most individual tattoos. Michael Wilson, the Coney Island Illustrated Man was my doorman; then after Michael died, Eak took over. We had a lot of press. We made some people famous.

Wes Wood and I spent a lot of time working on tattoo legalization with Katherine Freed, our city councilwoman. Along with a number of other people, we spoke at City Hall, which was interesting. Elsa made a video. Wes and I visited every tattoo shop possible. There was a major dilemma: a lot of people liked it being illegal. A whole system had developed as a result of the 1961 law that shut down tattooing in NYC. There was a major meeting in a lodge hall in Queens. All the tattoo artists got together to vote about who would represent the tattoo artists. Coney Island Freddy was trying to knock Wes and me out of the box. A very tense night with over 50 tattoo artists there. Many gathered around a room with tables and sitting in chairs that circled the room. Steve Bonge broke the ice and made a powerful statement on our behalf. We carried the night. Thanks, Steve. I believe that Elsa made a video. Coney Island Freddy had previously lost the 1961 court case and we did not need to lose again. Giuliani was now in office and he signed the legalization bill. Steven Bonge and Butch Garcia went on to create the tattoo convention at the Roseland Ballroom. It is in the top five tattoo conventions in the world. I work as the supervisor. The three of us make the show happen. We have some great workers, people like Sparks, the electrician, and John Penley, a crew chief. I am too busy at the convention to do much film work, but Elsa, who draws the artwork for the cards and flyers, captures the moments. The

Clayton Patterson

Stabbing in Restaurant

tattoo part of the archives alone makes them important.

My documentation is not meant to be voyeuristic. I almost always like the people who I document. It is not meant to be judgmental. It is not meant to look bizarre or stupid, or like a freak show, unless that is what it is supposed to be. It is meant to give the people their own voice.

In 1994 there was a very small notice about the NY Tattoo Society in the book *Modern Primitives*. Jochen Auer in Austria was starting an Austrian tour called "Wildstyle," when he spotted this notice and he contacted me, because he needed good American sideshow talent and tattoo artists. I got a number of performers very good jobs and a great tour gig, which lasted from 1995 to 2002. Some names of the artists and performers: Spider Webb; Gil Monte; Sean Vasquez; Indio the fireater; Harley Newman escape artist; Lucy Fire from England; Sharka and Ula the Pain Proof Rubber Girls; Danielle from Gwar; Steve Bonge showed his photographs, and I showed videos. I went on part of the tour, took hundreds of photographs and hours of videos. It was heaven. We toured all over East and West Germany and Austria. I had other activities in the states that I had to be back for, like court, community protests, and so on, but Europe was fat, as the kids say. Butter. Jochen published a book of my photographs, for which I am thankful: a large color coffee-table-type book that is in German and English called *Wildstyle: the history of a new idea*. There are 1,000 copies. Most are in Europe. Unimax Tattoo Supplies has a few. Jim Knipfel wrote a favorable review of the book in *NY Press*.

In 1987 we held the tattoo society at the Chameleon Club on East 6th Street. I discovered that they had a video projector. I started to do video nights. I showed my videos, as well as, Steven Bonge's, Charles Gatewood's, and a number of other people's tapes. The large screen projector was a real trip.

No! Art and Boris Lurie are near and dear to my heart. I have a good-size No! Art photo/video archive, and have made contributions to the No! Art book *Neue Gesellschaft fur Bilende Kunst* Berlin 1995. No! Art was a radical art group that was around NYC in the late '50s to early '60s. This group was the first to make Holocaust Art, did shows like the Shit show, and the Doom show, was radically opposed to the corporate, government and special interest take-over of American art, and the elitism that crept into the art world. The No! Artists were opposed to Abstract Expressionism, and Pop Art.

It turned out that Abstract Expressionism was used as a tool of the CIA. It was a perfect art form for embassies; other than the artist, there is no human connection. It shows Americans can be totally free and play with things that are meant for the few, the elite. It is a break from European tradition. It is all gravy and no meat. Holocaust art? No! Art was all rancid meat, no gravy!

Boris is a Holocaust survivor. I showed a No! Art documentary video in Berlin at the NGBK No! Art show, and at the No! Art show at the Buchenwald concentration camp memorial. Because Boris Lurie is a survivor of Buchenwald he had the exhibition at the camp, but it was very unusual for a non-survivor to be in an exhibit at the camp. We stayed in the guard's quarters. I made as much documentation as I could at the camp and the trip with Boris. It was a haunting spiritual journey. And way outside the mainstream.

I made drawings and works for recently published, Boris Lurie's No! Art in Buchenwald poetry book. A number of radical artists are in this book. Gunter Brus, one of the Viennese Actionists, Jacque Luc Lebel, an artist who was part of the May 1968 action in Paris that was extensively written about by the Situations; Seth Tobocman, one of the creators of *World War 3* magazine and many political posters and drawings; John Toche, of the paper *The Rat* and other radical publications and actions; K. K. Kuzminsky, a well-known and loved Russian anarchist, very unusual during the communist reign, edited a comprehensive book of Russian poetry, Aldo Tambellini, one of the first artists to protest the Museum of Modern art; Wolf Vostell; Dietmar Kirves. The No! Art books are in German because Germany is the only place that has supported this art. Boris Lurie, Dietmar Kirves, Wolf Vostell and I had a show at the Janos Gat Gallery on Madison Avenue. We also did an art collective box for Hundermark, the Hamburg art dealer, who had published a No! Art book.

I participated and documented the Russian group *Art Party Pravda*. The group did poetry, music, and art. I made a copy shop book celebrating a number of the artists and shows. It was an interesting time. Good for documenting.

Leonid Pinchevsky from *Pravda*, Alexander Brener of Moscow and I created a manifesto that we got a number of artists from around the world to sign. We published the manifesto in the *Manhattan Mirror* (a copy is also in the Buchenwald poetry book) and we sent it to the Judge presiding over the trial of Alexander Brener in Amsterdam. Papers did get submitted, but the Judge did not respond back. Not unusual.

I also did a number of court papers that I submitted to court trials dealing with housing and land issues on the LES. In the court papers I usually did an art cover, added photos on the inside, and then did a straight written piece. I did this so that my art would become a part of the legal system. Highly unusual place to be for an art collection. I did a number of these court papers; the art was very straight ahead. The 13th Street squatter case, for example, had a collage on the front, a collage drawing on the back, photographs, and a written body. I created the strategy to save the last Orthodox synagogue in Alphabet City, the synagogue on East 8th Street between B and C. This is a long complicated story, with hours of documentation. The rabbi, Ralph Feldman, and I got sued for a million dollars. I was part of the suit because of the legal knot that I created to save the place. It worked for as long as they wanted it to. It is interesting to me that it was the highest ranking in the religious Grand Street community were the ones that worked to sell the synagogue: Rabbi Dovid Feinstein, Heshy Jacobs, and Assemblyman Sheldon Silver. Part of the money from the sale of the synagogue was to be given to Rabbi Feinstein's organization Yeshiva Mesiftah Tiffereth Jerusalem located on East Broadway. Another court case was about a Hassidic man who was wrongfully arrested entering the Federal Building on Lower Broadway. He acted as his own attorney. We did a paper together that clearly outlined all that was wrong with the security of the Javits Federal Building and submitted one of my court papers to the court. The cover had a collage of ingredients of fire, and death, and mayhem. The written part talked of everything wrong with the security of the Federal building and the slackers that were protecting the place and the wrongful arrest of my friend for pointing this out. Judge Leisure of the Federal Court, 500 Pearl Street, probably the most prestigious court in the city, certainly a powerful court, went absolutely crazy over my paper. He went ballistic. He stated that all of my court papers must be destroyed, that I was not allowed to hand in any more court papers (the paper was a called friend of the court brief), that I was no friend of the court, I was escorted out of the building by court officers. Of course I handed in another paper. And I came back to court. As it turns out we were right. The arrogance and stupidity of the people in power, their lack of responsibility towards security matters, their lack of willingness to examine facts and take the information from the facts and make changes, and their ego driven lives are reflected in the 9/11 attack on America. WE WERE RIGHT. I did not feel vindicated, just frustrated. This case was a small reflection of what was wrong with the power and leadership in our times. Everyone in NYC paid for our leadership's ego and ignorance.

Clayton Patterson

Patrick Geoffrois

The Nazis were involved with censorship by destroying someone's writing and art. The mainstream never understood my plight. Not sexy.

What happened to me is censorship of the worst kind. But it is not a popular cause. Part of what I have been involved in documenting and helping is a lot of unpopular people, and the forgotten ones: the poor, the junkies, the homeless, the mentally ill and so on. Nothing sexy like sticking a yam up your ass. But this was censorship of the worst kind. A federal judge

ordering the destruction of your work. Made to leave a court building. OUR COURT BUILDING. Anyway I have been censored a lot, arrested, had teeth knocked out by the police, had set up warrants come to my door, been subpoenaed numerous times, called a Satanist, had stories placed in the paper that I videotaped the Monica Beerle Murder—known as the Rakowitz case or in the *Post* "The Monster of Tompkins Square Park"— a long list of real problems attached to doing this kind of documentation. Most of what I have been involved in are not sexy, popular causes, so I was never given any art support. Of course I have been an outsider to that system, mostly by choice. I have tried to make art that has had real impact on the system, and this is what it was meant to do. However I have paid the price for these actions. My tapes have made millions of dollars for other people, and nobody shares. I have had more tapes used in court than anyone in the history of America. Lots of cases. "The edge is dark, hard to see, it can be dangerous. I have been so scared at times that it felt like my testicles were up into my ears. If someone tells you that they have never been scared by the edge, you know that they have not been there.

Anyway, Elsa and I are getting burned out on this kind of action. Finally, the rest of our community is realizing that a great change has taken place. It is funny now that Phil Hartman, executive director and creator of HOWL/FEVA is complaining how the *Village Voice* has shown no support for his major neighborhood project. His dream of bringing back the best of the glory days. Why would the *Voice* support this? The *Village Voice* has been terrible, anti-community, stuck on neglect and avoidance by self importance for years. The Voice did not neglect the problems of the poor, the loss of civil rights and police brutality on the LES just because the people were poor, and powerless; no, the paper has neglected everybody, including filmmakers, artists and even HOWL/FEVA. The *Village Voice* has been owned and governed by a multi-million-dollar right wing corporation for years. The *Voice* has been disguised as a left-wing yuppie newspaper for a long time. The paper's neglect and avoidance has facilitated the corporate takeover and the loss of our community. It took a long time for all to see the community changing; now it is impossible not to see. The reorganizing of the police and the right took about the same amount of time as it took Hitler to get into power. Is there a connection? Who knows? Is it possible to shut down NYC? In a couple of hours. The organized power is now there to use, if the right person wants to make the call. Is freedom and democracy an absolute guarantee? NO?

Many cannot afford to live here any more. HOWL is about trying to bring back some of what was lost. The archives are a real cross section of the Lower East Side: music, poetry, art, people, graffiti, drugs, fires, funerals, building collapses, and life.

The community is at a place where you can now look over the landscape and see the history. We are becoming like SoHo and Greenwich Village. Totally gentrified. Bohemia is gone. The wild free-for-all days are over. We are now in an official entertainment zone, in every sense of the world. Not quite Walt Disney, yet, but working on it as fast as possible. It is time to start thinking about opening the archives. This gives the first public peek at anything to do with the archives. The heads are different, collecting, going through, and opening up. It seems like maybe it is time to change heads and get into the box. Outside the box to inside to outside again. Elsa has organized most of the videos. Time to find people who have an understanding of the material. Slowly. I have people all the time asking for things, but that for the most part has just not been a possibility. Now maybe now is right. The job is difficult and it is like moving to a new planet.

Fotofolio is publishing a book of my photographs called *The Lower East Side 1988–2000*. The book was finished in 1999 yet we are going into 2004 and the book is still in a box waiting to go to the printers. But if they ever get it together, it will show a passage of time on the LES. Peace. The archives will do the same, only more so.

Bibliography

NO! Art, Neue Gesellschaft fur Bildende Kunst, NGBK, Berlin 1995.

Tattooing New York City: Style and Continuity in a Changing Art Form, Michael McCabe, Schiffer Pub., PA, 2001.

War in the Neighborhood, Seth Tobocman, Autonomedia, Brooklyn, New York, 1999.

MARKED FOR LIFE A Gallery of Tattoo Art, Steve Bonge, intro Clayton Patterson, Schiffer Pub, 2001.

Film and the Anarchist Imagination, Richard Porton, Verso, New York, 1999.

Walking with the Night, the Afro-Cuban World of Santeria, Raul Canizares, Destiny Books, Vermont, 1993.

American Magus, Harry Smith, a modern alchemist, Paola Igliori, ed. In and Out press, New York 1996.

Painful but Fabulous, The lives & art of Genesis P-Orridge, Softskull, Brooklyn, NY. 2002.

Gentie Swastika Reclaiming the Innocence, Manwoman. Flyfoot Press, Cranbrook, B/C. Canada, 2001.

The Book on Palo, Deities, Initiatory Rituals, and Ceremonies, Baba Raul Canizares, Original Pub., 2002.

Totem of the Depraved, Nick Zedd, 2.13.61 LA. Cal. 1996.

Stranger to the System, life portraits of a New York City homeless community, Jim Flynn, ed., Curbside Press, NY 2002.

NO! art in Buchenwald, Geschriebigtes Gedichtigtes, Eckhart Holzboog Verlag GmbH. Stuttgart, Germany, 2003.

Wildstyle: the history of a new idea, Jochen Auer & Clayton Patterson, Unique Entetainment GmbH/Unique Pub. Bad Ischl, Austria.

Dictionary of the Avant-Gardes, Richard Kostelanetz, a cappella books, Chicago, Il, 1993.

Tattoo Gazette 1-3, Tattoo Society of New York, Clayton Patterson, ed., 1987.

Art Party Pravda, A History of Art Party Pravda, pub., Clayton Patterson, 1994.

Inside Out: The World of the Squats, curated by Clayton Patterson, Laura Zelasnic & Alan Moore, Alan Moore, Publisher, 1994.

Magick Warrior, Patrick Geoffrois, excerpts from: *Incantations of a Magick Warrior*, Vol. 1 1987 Electric Press: Paris- New York.

Necromantic Poetry, Patrick Geoffrois, excerpts from: *Incantations of a Magick Warrior*, Vol. 2. 1987 Electric Press: Paris- New York.

Modern Primitives, ReSearch S.F. Cal. 1998.

Anger, the Unauthorized Biography of Kenneth Anger, Bill Landis, Harper Collins, 1995.

SoHo the Rise and Fall of an artists' Colony, Richard Kostelanetz, Routledge New York 2003.

From Urban Village to East Village: The Battle for New York's Lower East Side, Abu-Lughod, Janet Blackwell.

Art Work Court Cases:

Supreme Court of the State of New York, County of New York, East 13 Street Homesteaders Coalition, et al. Petitioners.

v.

Deborah Wright, Commissioner, New York Department of Housing Preservation and Development et al, Index Number 94128379. *Friend of the Court Brief* by Clayton Patterson

Supreme Court of the State of New York County of New York, Congregation Bnei Moses Joseph Anshei Zavexhast and Zausmer Inc. Plaintiffs
v.
Ralph Feldman, Isaac Fried & Clayton Patterson
Index No. 1000008322/95 *Answer* Patterson pro se.

Supreme Court of the State of New York County of New York,
Congregation Bnei Moses Joseph Anshei Zavexhast and Zausmer Inc. Plaintiffs
v.
Ralph Feldman, Isaac Fried & Clayton Patterson
Index No. 1000008322/95 *Opinion and Order* Patterson pro se.

Supreme Court of the State of New York County of New York,
Congregation Bnei Moses Joseph Anshei Zavexhast and Zausmer Inc. Plaintiffs
v.
Ralph Feldman, Isaac Fried & Clayton Patterson
Index No. 1000008322/95 *Affirmation in Opposition* Patterson pro se.

Supreme Court of the State of New York County of New York,
Congregation Bnei Moses Joseph Anshei Zavexhast and Zausmer Inc. Plaintiffs
v.
Ralph Feldman, Isaac Fried & Clayton Patterson
Index No. 1000008322/95 *Affirmation* Patterson pro se.

United Sates District Court Southern District of New York
United States of America, Plaintiff,
v.
Bensiyon Man-of Jerusalem, aka, Bensiyon Brasch, Defendant
95 Cr, 865 Summation *Request for Dismissal* Bensiyon Man-of Jerusalem & Clayton Patterson.

United Sates District Court Southern District of New York United States of America, Plaintiff,
v.
Bensiyon Man-of Jerusalem, aka, Bensiyon Brasch, Defendant 95 Cr, 865 (PKL) *Opinion and Order* Clayton Patterson.

Other Court Cases:
Eire House case to save Engine 17:Joel Myers and Clayton Patterson Pro Se Plaintiffs/Petitioners
v.
The City of New York Defendant/Respondent. Index No. 28608/90 (Diane Lebedeff, Judge) (I.A.S. Parts).

Numerous papers, responses and answers. Minority Report (32 pages)
Report on Tompkins Square Park Police Riot and related matters.
By Joel Myers and Clayton Patterson
For the Tompkins Square Park Task Force of Community Board 3 1989.

On The Tompkins Square Police Riot and Related Matters:
In Response to Judge Alfred H. Kleiman
Clayton Patterson & Joel Myers
Case of Clayton Patterson May 9, 1989

Marc
Friedlander

by Miss Joan Marie Moossy

Marc S. Friedlander, formerly known as Mark Zero, is an accomplished downtown New York artist currently living on Wyoming Street in Kansas City. His medium is film and video, but to call him a filmmaker is misleading because it implies certain boundaries that Marc has clearly transcended in his work. He lived and worked in New York City for twenty years doing "street photography" with motion picture and video cameras. If you were around in the 1980s, you may not have known him, but you would have seen him everywhere with one of his cameras. What he achieves in his work is poetic and beautiful. His images work as language and he uses archetypal images as metaphor. His major influences are Diane Arbus, Robert Frank, and Albert Maysles. Tragically much of his work was lost in the immoral eviction of the tenants and destruction of the building and its contents at 178 Stanton Street where Marc had an apartment. Some of his work, however, is in the permanent collection of the Museum of Broadcasting, and has won over twenty international awards. He continues to work and is currently in pre-production on a feature film.

```
Mark Zero at Rocket's memorial
```

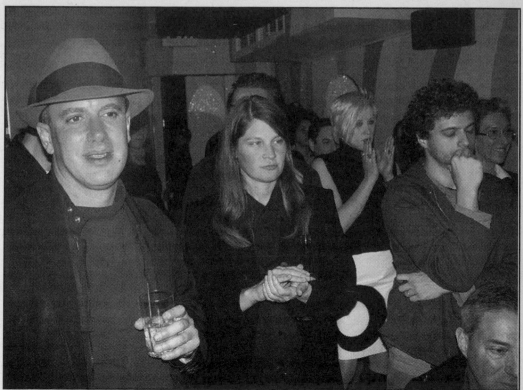

Clayton Patterson

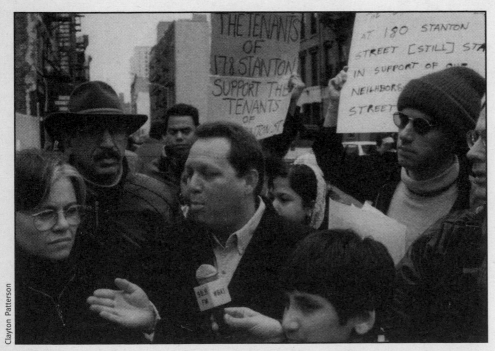

Councilwoman Lopez

The Eyes Have it

by Clayton Patterson

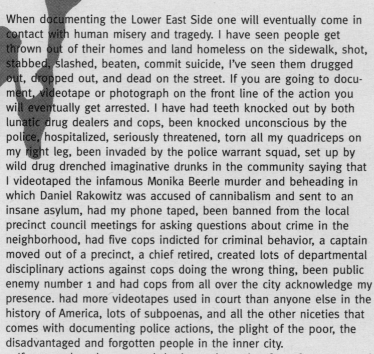

When documenting the Lower East Side one will eventually come in contact with human misery and tragedy. I have seen people get thrown out of their homes and land homeless on the sidewalk, shot, stabbed, slashed, beaten, commit suicide, I've seen them drugged out, dropped out, and dead on the street. If you are going to document, videotape or photograph on the front line of the action you will eventually get arrested. I have had teeth knocked out by both lunatic drug dealers and cops, been knocked unconscious by the police, hospitalized, seriously threatened, torn all my quadriceps on my right leg, been invaded by the police warrant squad, set up by wild drug drenched imaginative drunks in the community saying that I videotaped the infamous Monika Beerle murder and beheading in which Daniel Rakowitz was accused of cannibalism and sent to an insane asylum, had my phone taped, been banned from the local precinct council meetings for asking questions about crime in the neighborhood, had five cops indicted for criminal behavior, a captain moved out of a precinct, a chief retired, created lots of departmental disciplinary actions against cops doing the wrong thing, been public enemy number 1 and had cops from all over the city acknowledge my presence. had more videotapes used in court than anyone else in the history of America, lots of subpoenas, and all the other niceties that comes with documenting police actions, the plight of the poor, the disadvantaged and forgotten people in the inner city.

If anyone has documented the inner city action for a few years and they have no scars to prove it, then they have not been in the action. You cannot play on the front line of a football game and never be injured. It comes with the territory. But out of all of this, two persistent images keep floating up and reappearing into my consciousness. These persistent eyes are haunting, sad, sorrowful, wounded and deeply lost faraway eyes.

One set of eyes belonged to a mother whose son had been murder, the other pair belonged to an artist who lost his life's work.

I met the mother at her son's funeral. Her son was a member of the Lower East Side Satan Sinner Nomads street gang that I had been documenting. Her son was assassinated in some kind of a dispute. The mother was outside the funeral home and I went over to pay my condolences. Our eyes met, and it was painful for me, like looking into deep pools of tragic sorrow as she stood in front of me but not really there. Her eyes faraway, lost in mourning. I almost cried.

The other set of eyes belonged to Mark Zero.

Clayton Patterson

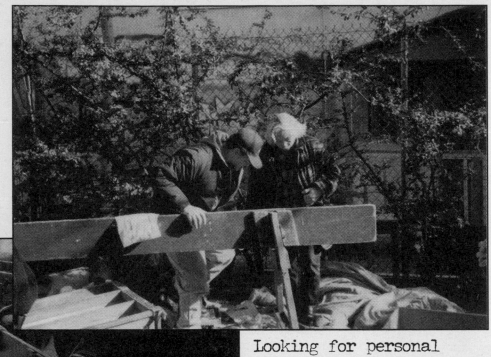

Clayton Patterson

Looking for personal belongings

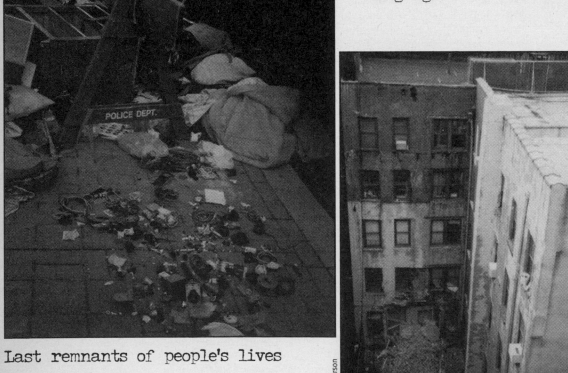

Last remnants of people's lives

Clayton Patterson

The alleyway's fallen bricks

Documenting this story in the beginning was not too bad. On January 24, 1998, at 172 Stanton Street, after a steady rain, the 100-year-old mortar holding a small section of bricks on a back wall of the five-story tenement let go, leaving a partial hole in the retaining wall about five feet wide and six feet tall.

The damage did not look too extensive. It was Saturday. I knew Ralph, a building owner, a builder, and a housing expert that was attending the Stanton Street Synagogue down the block. The service was over and he was hanging around the shul, socializing and having a coffee. Because he owned property on the block, it was possible to get by the police lines—which were specifically closed off to Elsa and me, but free for almost anyone else with a camera—so we got access into one of Ralph's adjoining buildings, went across the roofs, and get a clear shot of the damage on the back side of this building. Ralph said the damage was moderate, a couple of guys, a pallet of bricks, a bag of cement, a yard of sand, 8 hours, and that is all it would take to correct the damage. No big deal.

We felt reassured. Then at about 10 a.m., Mayor Guliani showed up with the engineers, the lawyers, the police chiefs, the fire chiefs and all the other ingredients it takes to make a pork barrel decision. Tenants had been anxiously waiting several hours to get back into the building. Because everyone had evacuated the building at 5 o'clock in the morning, a number of the people were inadequately dressed, some were wearing pajamas and jackets, some had on house slippers, and others were completely dressed.

The incident did not seem to merit too great a concern, because the Red Cross was not even there.

The building, as long as anyone could remember, had always been a little rickety, but everyone knew it was not in imminent danger of collapse. The building was about 125 feet long, the fallen bricks were on a small exposed back alley side, much of the rest of the building was buttressed up against another building, and the fallen bricks were a long ways from another retaining wall. This was a small pocket on the back side, which meant that even if more bricks fell off, the building seemed safe. Certainly it was possible to bring in some large timber and make a supporting brace. The mayor and all the big cheese left.

The anxiety level and nervous energy around the tenants, including the elderly, mothers and children, people on medication, foreigners, was recognizably high, everyone was a little insecure about what was going on. People were also tired, waiting to get this over and get back into their homes.

Finally, the word came down from the top. Tear the building down. What? "But I am a retired children's book illustrator, my life's work is in that building, I spent most of my life working as a waiter, I do not trust banks and my money is in there, we are from Bangladesh, the only picture that we own of our dead father is in the building and all of our legal papers are in there, our school work, my cat is in the building, my bird in there, please let us go in and collect our few worldly possessions, my name is Mark Zero, my whole career, my archives, my reason for living is in that building. Can we go in and get our important work?" No! Just for 10 minutes each? No! Can we be escorted in, one at a time? No! After hours of high anxiety, biting nails, groaning stomachs, playing by the rules, everyone spent the next few days impotently witnessing the building slowly coming down. Watching as the lives of whole families and individuals were shattered in the dust, in the slow agonizing process of demolition.

Animals were murdered, retirement money was lost, dreams were shattered, memories were crushed, lives were destroyed, and all for what: a bad inhuman decision of expediency and a total disregard for what makes us human beings. The empathy of a cold-blooded murder.

The lawyers used the tape and pictures that Elsa Rensaa and I made. The tenants, after a lot of legal wrangling and time, won a good sum of money, but crisp new bills do not wash away the loss of everything of personal importance.

Had this been a so called act of G*d and the action was outside of ones' control then it would have been a tragedy. Tragedies are hard. Tragedies are about suffering, but there is a place of acceptance and coming to grips with the loss, but since the building was not going to fall and could have been saved, none of these people should have lost their property. This was waiting, watching, and then being told, "Watch some more, because we are going to rip your heart out one muscle at a time."

After the loss, Mark was totally emotionally wrecked. His joy, his reason for living, his hopes and dreams were scattered as each brick was taken down one by one. As the building came down, pieces of people's lives were strewn on the street and what the workers did not steal was laid out on the sidewalk for everyone to go through, including the dust and the wind. Children's school papers, broken alarm clocks and other household nicknacks. Residents picking through the debris, slowly, meticulously turning all shards of broken lives over and over again in their fingers. When I saw Mark around he was a broken person. The last time I saw him was at Rockets Redglare's funeral. Rockets was his sometimes roommate. Mark still had that haunting look in his eyes. I really hope that he can make it back and I know that he is really trying. Sometimes time will wash away the horror. I hope so.

There are other stories of artists losing their life's work. Harry Smith spent long periods of time in the garbage dump, sifting through mountains of garbage, looking for his work that a landlord had thrown out in an eviction process. Lionel Ziprin claims it was after one enormous loss that Harry started to drink heavily.

A new court case is breathing down our necks. Recently a detective came by, picking around trying to find out what tapes and photographs Elsa and I made when the Irreplaceable Artifacts building was torn down. The building was filled with saved national architectural treasures salvaged, saved and something stolen from the demolition of New York City buildings. The owner, it seemed, was trying to get over, doing work without permits, qualified workers, and he was greedy and stupidity took too big a bite. The neighboring low-income building was almost lost because of damage caused by the collapse. His eyes are different. His eyes are searching for money. A subpoena is suppose to be coming to our door. Tap, tap, tap, Hello. These eyes I can fight with.

The Non-narrative Life

by Alan Steinfeld

In John Cage's *An Autobiographical Statement* he says, "I once asked Arragon, the historian, how history was written. He said, 'You have to invent it.'"

The recent history of the East Village shows the influence of the non-narrative life, which I feel is the only life worth living. With that understanding came the lessons of not being afraid to look at anything, inventing yourself and looking for the patterns in things—not in the plot.

In 1980, I had just graduated from SUNY Buffalo and went to New York City looking for the avant-garde. Here was the one place in the world that existed outside the normal social consciousness of America. New York was like a Ferris wheel of creative openness; and the East Village was the hub of it.

"This is the one place in the 4,000 square miles of America where life is lived in different ways and experiments with different perspectives develop and this is the source of it historically." That is the opening comment in my documentary *A Walking Tour of the East Village*. The quote is from filmmaker and café sitter Al Robbins describing how the East Village became a mecca for art, music and alternative cinema. The documentary was filmed mostly in a single day in June of 1985, when the East Village was at the peak of its delicate balance between the old neighborhood people, the new, young gentrifiers and the blossoming fashion scene.

The East Village for me was a place that birthed the invention of life, art and creativity. A sort of non-narrative life began for me in the '80s; a decade of transition for the East Village. Every day I would step out of my apartment onto East 6th Street and be caught up in the river that was the East Village. It was about never knowing what each day may bring and having rent low enough not to care. I was swept along in the adventures of the day.

One of the things that inspired me to document the life of the East Village: One evening, as I was walking up the Bowery with my friend and film producer Richard Schlesinger I was relaying to him how William Burroughs, while very drunk, shot his wife between the eyes while playing William Tell. Just then a car careens to a halt in front of us and out jumps William Burroughs, Gregory Corso and Allen Ginsberg, posing for a picture that Ginsberg took in front of Burroughs' old Salvation Army loft on the Bowery called the Bunker. From reading about these characters in Jack Kerouac's books to meeting them on the street—it was like walking into an ongoing movie. And it is this ongoing explosion of expression that has characterized the neighborhood from the 1950s onward.

I was then compelled to document this unique way of life any way I could. Looking for the non-narrative life. Inventing oneself. I photographed and videotaped the Avant-Garde Arama at PS 122, the political art performance pieces at the Franklin Furnace, the street performers at Tompkins and Washington squares, all to get a sense of the diversity of creation.

At college I had taken a filmmaking course with Dave Lee, a teacher of alternative non-narrative genre. There I found the rewarding difference between Hollywood and experimental films. It was like the difference between poetry and prose. Lewis Klahr was also a student in that filmmaking class and seemed to already have a handle on understanding that things can tell their own story without a narration. In the absence of a linear story the mind makes one up and that in some ways can be much more satisfying. Lewis showed a film about a series of fences, then one of houses, which were very inspiring.

In the early '80s (and probably before that) the East Village was the place where the linear 9-to-5 life need not apply. People lived outside the social box and would invent a life for themselves instead of trying to fit into someone else's world. Realizing this, I thought

of what ee cummings said in his *six non lectures*, ". . . so far as I am concerned, poetry and every other art was and forever will be strictly and distinctly a question of individuality . . . poetry is being, not doing." I knew that when I discovered the essence of that I would take another step up.

He goes on to say that the artist's responsibility is to be oneself ". . . the most awful responsibility on earth. If you can take it, take it and be. If you can't, cheer up and go about other people's business; and do (or undo) till you drop."

My first introduction however, to non-narrative was with Ed Emshwiller, a visiting filmmaker to my high school on Long Island. It was a revelation to me at the time when I got that, "You mean the film does not have to have a plot? It can talk about other things, other dimensions and other ways of perceiving?" My film *Evolution/Involution* demonstrates the progression of forms that leads to an internal narrative.

Although the idea of the internal narrative continued to be a revelation to me it was what everyone in the East Village seemed to know anyway. What made me realize this was when, in my wandering around the village in the early '8os, I saw an interesting crowd entering the downstairs of a church on St. Marks Place. I followed.

I felt distinguishingly out of place. With a button-down shirt and sideburns, as a college student of the '7os, I was meeting the new fashion of short-cropped blue and purple hair, and women in dresses that suggested a revival of the 1950s. It was my first of experience of the punk future and the retro past colliding. Club 57 was a place out of the narrative time and the start of an influence in New York that still survives.

When MTV showed up in the mid '8os, the non-narrative of the East Village become prime time fodder. Keith Haring was part of the Club 57 crowd. I went to his loft for a party one day and he said, "Take a picture of me, I am going to be famous." I thought, no way, this is just some guy who is making chalk drawings on subways. That will never catch on. Some time around then I went to the Fun Gallery, when it was on 11th Street between 2nd and 3rd Avenues. One of the first shows there was Kenny Scharf's drawings of the Flintstones. Like my reaction to Keith Haring, I thought, "Who is going to be interested in this?" The same was true of Basquiat. When I saw his paintings inside the relocated Fun gallery, I thought, "This is just graffiti on canvas." But as the East Village art scene exploded in the '8os, I felt like Winston Churchill who said, "I often had to eat my own words and I find the diet very nourishing."

A major inventor of personality was Andy Warhol. Occasionally I would bump into him and photograph him. He was a very difficult person to have a conversation with, because he would only repeat back what you said to him. If you said it was a nice day he would say, "Oh, it's a nice day." One exchange that I do remember was saying to him, "Wow, the critics really did not like your last book." He said, "I know, isn't it great! All the publicity." He did take me aside one day and asked me what the key to longevity was, but at the time I said I was not sure and just said, "Taking care of yourself."

Jackie Curtis, as the Lou Reed song goes, "was just speeding away." He really did think he was James Dean, and not just for a day. In addition to James Dean he also thought he was Marilyn Monroe and Gary Cooper all rolled into one. I know because when I sublet him my first apartment in the East Village, he made it a shrine unto himself; with all his Jackie-he-and-she pictures and his *Chelsea Girls* memorabilia. Jackie invented himself as a hybrid of personalities, charisma and addiction. He would take speed to get him up in morning and a quart of beer to bring him down at night. Once, when he and his fiendish friend Margo Howard stopped by my new place, they raided my medicine cabinet, and all they could find was magnesium supplements, so they downed half a bottle to get some kind of buzz, which kept them up all night watching television. It was from these people that I realized that it was the inventing of personality, style, and marketing that made the difference.

Then there were people like Harry Smith, one of the kings of the non-linearity. I only had some vague notion of him as a filmmaker. Others said he was known for his music ethnicology. But when I met him in at his room in the Breslin hotel in 1980 he was engaged in some large-scale paintings on his coffee table. And when he talked in his exaggerated tones I had no idea what he meant.

Yet I was fascinated with what he had to say. Years later, after I got to know him better, I

videotaped his toy collection from around the world. For each piece in the collection he would give a comparative explanation about childhood coordination, and how cultures from Africa, Asia, and South America all had similar ways of assisting with the developmental skills of children with the simple mechanical toys. All the while he would throw out comments about Isaac Newton and alchemy or how he thought he met Alistair Crowley once. When I asked him what he meant he would say, "Oh never mind."

I remember being with him when he was recording the night sounds of New York at a certain time of evening, although I think I never understood exactly what he was doing. He would then make comparison studies over a period of time to see if there was some overall patterns to the highs and lows of the New York night.

I realized now that Harry was a "Seer of Patterns." It seemed to me that what he was doing in his films, paintings, music and collections was establishing relationships with abstractions that would again allow the mind to tell its own story. The way Kandinsky abstracted the world to express the internal stimulation Harry was doing with sound and colors and shapes. Harry wanted to show to the world ways of seeing and hearing patterns that we all knew existed, but were not consciously realized.

Dave Lee, my film teacher from Buffalo, was also living in New York at that point and he showed me one of his films that influenced me a lot. He would take a camera and shoot the winos and the homeless of the East Village and the Lower East Side. What was so disturbing about this film was that he would keep the camera on these people for a brutally long time, like five to ten minutes close up on the face or body. These were usually shot from the hip in order not to be obvious. These long takes forced me to look long and hard at all the details of these homeless people. Dave Lee compelled the viewer to break the barrier of perception and give more than a passing glance at this pool of humanity. This film showed me the commonness of all people with the flies crawling over these sleeping faces or wine drool seeping out of their mouth. I had never before realized the power of film to direct people's attention to look at things they normally would not see or would avoid.

Sitting next to John Cage one evening at the New Museum in 1986, we were watching a performance piece where two people would stare at each across a wooden table for eight hours a day. They would just sit and stare. John Cage and I and a few others were there for the last day of this three-day performance. As the lights came up after eight hours of watching these

Alan Steinfeld relaxing

Clayton Patterson

people watch each other I turned to John Cage and said, "So what did you think?" And he said, "Now I know how busy I've been my whole life." Hearing that from somebody who wrote four minutes and thirty-three seconds of silence for piano was like a flash of lightning. In that moment I understood something beyond the surface of appearance. That started me in a new direction of looking to Eastern religions as inspiration for being and not doing.

Allen Ginsberg was a familiar figure in the East Village, and for me the first to show that you can be an artist and a seeker of enlightenment as well. Once I asked him if his connection with Tibetan Buddhism influenced his poetry. He gave me a long drawn out answer about some of his practices, but he basically said "no it did not" influence him and that they were two different parts of his life. I thought that was strange. But of course he was one of the original dharma bums and his stream of conscious rants were Zen moments for all times. Buddhism was merely a defining label of expression for his lyrical poetry.

But Buddhism was my doorway into the general field of metaphysical studies. In the 1990s I started to do my cable program *New Realities* on Manhattan Time Warner cable. It was inspired by what I had seen in the 1980's in the East Village. In my exploration of new realities I was able to take everything I had learned in the twenty years of hanging out in the neighborhood to another level. I knew that I could reinvent myself, because I saw some of the extraordinary characters that have inhabited the East Village do it.

My orientation of seeing men parading around as women, dancing in drag on the top of the Pyramid lounge bar, was taken a step further. Now I met people claiming to be ancient warriors from Atlantis, or having been taken aboard UFOs. I met others who claimed to have discovered a new form of cosmic healing energies or Investigated the anomalous phenomenon of geometric pattern the fields of England. And it all brought me to higher levels of stimulation I had grown to thirst for.

Creating my life, seeing the patterns, and not being afraid to look at what others wouldn't, I found a new rich niche in the New Age. And there was nothing, not even the most outlandish, that was too bizarre for me, because I had been initiated into the cult of the most strange, which was the East Village in its day.

My association with the unique and original figures that I met in the East Village convinced me that anything is possible, especially if you invent the scenario yourself. I openly embraced UFO abductions, gurus from the East, and trance mediums from all time-space dimensions and magnetic personalities, which were just as authentic as any inventor of style on the fashion scene.

For me the New Age was a continuation of the lessons I had learned from the Masters of the East Village; seeing the underlying patterns of things; comprehending the illusion of time as in non-linearity of reality that quantum physics suggested; and inventing yourself and the reality you wanted. What began as looking for the avant-garde went to the limits with new realities, because it was all part of the experience of exploring that vanishing line between the impossible and the outrageous. After all it was still a non-narrative that I was living.

Alan Steinfeld still lives in the East Village and his cable program New Realities can be seen every Friday at 7:30pm channel 56 on Manhattan Neighborhood Network.
For a catalogue of the programs guests over the last seven years
check website: www.newrealitiestv.com
To contact him e mail: alan@newrealitiestv.com

The Pravda of the Matter

by Robert Coddington

"The media right now is confusing the population a lot more than it's enlightening anyone, because we are being fed things that are manipulated by them to make good consumers."
—Nelson Sullivan

Nelson Sullivan moved to New York in 1970, part of the post-Stonewall wave of young gay men who were then heading to either San Francisco or Manhattan to partake of the more emancipated lifestyle they had been reading about in newspapers and magazines. He landed a studio apartment in the West Village and soon made a decision to pursue a career as a composer. By day Nelson worked at Patelson's, the famous classical music store behind Carnegie Hall. He moved regularly from apartment to apartment over the next ten years, never getting one quite large enough to comfortably fit his piano. In 1980 he saw a building on the corner of Gansevoort and 9th Avenue in the Meat Packing District with a "For Rent" sign on the door. The price was right, and the dilapidated old duplex was soon the center of a unique, revolving universe of friends and scene-makers. It also became a hotel and halfway house for people either visiting or moving to the city from elsewhere. Artists, musicians, and performers dropped by at all hours to hang out, and it was this feeling of an ongoing 24-hour salon that gave Nelson the idea to begin videotaping his life.

Like many people in the early '80s, he recognized an unlimited potential in the advent of the cheap, new hand-held video cameras then coming onto the market. First using a VHS-loading camera in '82, and later upgrading to 8mm, Sullivan became a tireless documentarian of Manhattan and its Downtown culture. He captured art openings, avant-garde nightclub performances, and some of the infamous outlaw parties held throughout the city. Nelson knew, because he was witness to it, that Downtown was a new society being born. It was a renaissance time. Not just another Bohemia,

Clayton Patterson

Nelson Sullivan

Clayton Patterson

Santa and Nelson Sullivan

but a post-Pop society driven and unified by the desire for fame.

Sullivan spent almost every night going out and documenting his surroundings. During the last six years of his life he shot over 1800 hours of tape, capturing himself and his friends in the glossy facade of Manhattan's Downtown life that has been perpetuated in urban legend. Sullivan chronicled the rise and fall of many of his friends and peers, including Dean Johnson, Ethyl Eichelberger, Cookie Mueller, Michael Alig, and countless other denizens of a demimonde being ravaged by AIDS, heroin, and anomie. Nelson himself died tragically from a heart attack on July 4, 1989 - only three days after quitting his full-time job so that he could produce his own cable television show of his footage.

A prolific, yet relatively unknown videographer, Nelson Sullivan was a visionary. His revolutionary style is a combination of cinematic and in-camera editing techniques. Carrying the camera at arm's length, he was able to gracefully move about his subjects, embracing them on tape. His technique is so fluid that viewers often see Nelson walk across the screen and wonder who's pointing the camera. Nelson's relationship with his audience is so synergistic at times as to simulate personal memory as opposed to dispense information. It's a neat trick, one that any great filmmaker or photographer probably learns to produce, but with Nelson it was natural.

As well as being a frequenter of the galleries, clubs, and bars of the Lower East Side and Greenwich Village, Nelson was on the periphery of the later incarnations of the Warhol crowd. He counted among his friends a variety of that scene's characters, such as Andy's young friend Benjamin Liu, the singer Joey Arias, and fashion designer Alexis Del Lago. All of these were to one degree or another drag queens. In fact, Nelson's fascination with his friends' cross-dressing was to become a leitmotif of his work. RuPaul and Nelson were friends, and for years RuPaul would stay at Nelson's whenever he visited New York, before he moved from Atlanta in 1986. Many of Nelson's other friends who traveled up from the south were part of the new drag underground, including Lurleen Wallis, Lahoma van Zandt, and The Lady Bunny. With their bizarrely disingenuous Southern wit and blinding '70s retro outfits, they struck a chord in a downtown that had run its black-and-gray post-punk attitude into the ground. They made the Pyramid their clubhouse, putting on parties and shows that packed the place. Warhol himself ventured down occasionally, and future stars like John Sex, Lypsinka, and Dee-Lite joined in the fun onstage as well.

Sullivan knew he lived in interesting times, and he worked hard to capture more than a video freak show. In addition to taping up-and-comers such as RuPaul and Michael Musto, Sullivan sought to tape New York's outcasts, the wannabes, the has-beens, and the never-will-bes. Whether his subjects were on the way up, or trapped in a downward spiral, Nelson strived to candidly capture life under the shadow of the Statue of Liberty. These videos were Sullivan's labor of love; they provide a window to the past, and invite viewers to experience the lows and highs of an almost mythical era.

Nelson Sullivan's oeuvre is more than one man's diary. It is a portrait of society's misfits gathering to create something rich and strange from almost nothing and against all odds. It is the essence of the American dream, or as Nelson said, "The pravda of the matter."

The Art and Video of
Elsa Rensaa

by Lane Robbins

The new summer air is hot and muggy and the sun is beating down on the Lower East Side. I walk down Avenue A, past Houston where it becomes Essex Street to Clayton and Elsa's apartment and studio space. Clayton sees me through the front window and lets me in. We make small talk and I follow his partner, Elsa, into the studio space for an interview about her artwork; that's why I'm here.

It is a sparse room and I admire Clayton's colorful mosaics around a black French door frame across the wooden floor. The air is comfortable inside. I sit down in a chair and she on an adjacent couch and place the tape recorder on the arm of the couch between us.

"So what kind of things do you do—what kind of art? Film? Video?" I ask.

"I used to do paintings that appear to be medieval and religious but I stopped. I was also a chromiste for about three years."

"A chromiste?" I inquire, never hearing of this occupation before. A chromiste, Elsa informs me, is a person who redraws images either directly on litho stones or on mylar transferred to litho plates so the images can be printed. This was during the 1980s when Reagan gave tax credits to people making art prints.

"Except for local artists, most of my chromiste work was Salvador Dali or Picassos from Marina Picasso's estate."

"So now what kind of art are you making?"

"I still make hats," she says. Between 1986 and 1990, Clayton and Elsa successfully sold embroidered baseball caps that were showcased in several magazines—in *Elle* magazine twice and on the front cover of *Face* magazine. Recently they sold four hats to Yoko Ono, and Mick Jagger owns an embroidered leather jacket they made. The hats are made from flat fabric and five antique sewing machines are utilized in piece assembly (the oldest circa 1850). *GQ Magazine* writer Richard Merkin called the "Clayton Cap" one of the two best baseball caps in America.

"I loved going to sewing machine auctions," she says. Elsa has nine different industrial sewing machines she bought in auctions after the garment industry "dropped dead" in the mid 1980s.

Elsa and Clayton have lived on the Lower East Side since 1979, when they moved from the Bowery. They bought their first video camera in 1986, but Elsa didn't get involved with shooting video until later when Clayton was busy taking photographs. She currently makes DVDs from material in their video archives.

"At the end of July 1988, a small group of so-called 'anarchists' had a skirmish in Tompkins Square Park with police from the 9th precinct over a newly instituted park curfew. When they refused to leave insults and objects were thrown and the police left saying they were coming back next weekend, 'and we're going to get you.' On the weekend of August 6th, 1988, we noticed convoys of police starting to circle the blocks near Houston and we noticed a lot of police action all around the area. We went to the park about 8 p.m. From 1 a.m. to 6 a.m. police ran rampant through the area beating people in what is now called, based on Clayton's tape, the 'Tompkin's Square Park Police Riot.' There were about 130 complaints of police brutality . . . police were going into clubs and beating up people on the pool table—beating up people inside restaurants. It was completely out of hand."

Clayton has a three hour and thirty-three minute videotape of this riot. At that time video camera batteries lasted barely fifteen to twenty minutes, so Elsa was going back and forth between their apartment and the park, getting recharged batteries.

"At one point the cops came running down the street and I actually crawled under a car. There's not much space under there."

Various people came to look at the tape, including three people from the *New York Times* who wrote about it in the Sunday *Times*, August 14, 1988, starting on the front page and continuing for one and a half pages inside.

Clayton's 1988 "riot tape" led to the early retirement of the highest-ranking officer at the park that night, and to the transfer of the captain of the 9th Precinct. The tape was used in criminal trials of several officers identified by the tape, and although it was not "public knowledge," Elsa claims several officers were also fired.

At this time Clayton began to have problems with factions in the police department—whenever he stuck his nose out the door of his apartment. Elsa began to go everywhere with him so she would know his whereabouts. She also went to get a hold of the video/photo equipment if he was arrested.

On August 6, 1989, Clayton was arrested while videotaping the police making a "bogus" arrest. He was found guilty of "obstructing governmental administration," a made-for-demonstrators charge in the 1980s.

"As he was being arrested I came in low and he handed me his video camera," Elsa said. She continued to tape the arrest.

The trial began on the last day of the Sentencing Reform Act of 1987, which gave the judge (Bruce Allen) the option to try the case himself with no possibility of a jury. The testimony was from four police officers who said that Clayton, with his plastic camcorder, struck one of them repeatedly on the upper torso, but Clayton was not charged with assault at the time of the arrest. The judge did not allow as evidence the video Elsa and Clayton had taken of the arrest. Crucial court transcripts, statements by the "injured officer," were lost and therefore were not considered.

"In 1993 the New York court system was in total disarray; complaints of lost documents were not uncommon. Clayton had an appointment at One Centre Street but walked into the wrong room where he saw official transcript boxes in stacks, sides torn open, contents spilling, crushed, or tottering off the pile top. He also saw a wall of transcript boxes painted gray. When he found his appoint-

Elsa and Dick

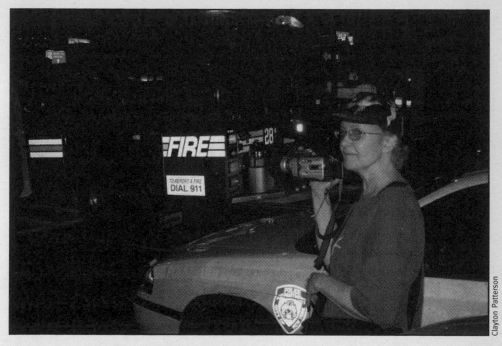

Elsa on street videotaping

ment room he asked why they were painted. The clerk replied, "They were making a movie in there and didn't want to clear them out." Clayton and a journalist returned later and put the story in a neighborhood newspaper—the big papers were not interested. At that time it was still possible to bring cameras into government buildings, so Clayton has lots of pictures from inside."

Elsa and Clayton were also amidst the rubble of the World Trade Center on September 11th.

"A friend of ours, Jeremiah Newton, called us after the first plane had hit and said there's an accident in the World Trade Center. At that time we both had press passes, and we went to the subway and got on a train immediately."

They walked into the besieged environment just before it was shut down, and videotaped the destruction about a block from the World Trade Center.

"When World Trade Center Two started to fall you could hear tinkling noise. It sounded like thousands of wind chimes, but it was the glass breaking and falling. There was a noise so loud you couldn't hear anything, and you couldn't think. Everything just turned white. You couldn't breathe either. I started running with the video camera pointed at the ground and someone behind me pushed me. I fell really hard and got a concussion, a black eye, and my leg was all banged up so I could barely walk. My doctor diagnosed my shoulder problem as a neck injury until an MRI showed a full thickness tear of my rotator cuff. It took a year to discover this and have surgery. My arm is still not fully functional."

"How did you feel when the Trade Center was coming down?" I asked.

"There was one person way at the top, waving a table cloth, or a big white sheet, and a helicopter came by and we thought it was possible that they were going to rescue them, but the other building then fell. It was a pretty strange experience . . . it was a real tragedy . . . I did not see the people hanging out the windows backwards until days later when I looked at the tape."

The worst thing Elsa says she ever taped was a fire on 2nd Street, at a bar where two brothers had been using heavy duty glue in the basement and the glue fumes exploded.

"A neighbor came and got me—Clayton was not home at the time. When I got to the bar I saw one man who I think was supposed to be lying down in some kind of special foam but he kept jumping up so I assumed he was going to be okay. When I got home I looked at the tape briefly and I swear I will never look again. The news later said the man was burned over 90 percent of his body and had died."

As far as lighter video work goes, Elsa has also taped elements of Santeria.

"We've done a lot on Santeria, the Hispanic version of voodoo. We did footage with our friend Baba Raul, who unfortunately died a few months ago, making eleguas. An elegua is a little personal image you buy, or you have the Santero, a priest of Santeria, make for you. Baba Raul was very faithful to the religion and he did the things he was supposed to do. Elegua is usually a sculpted object that is created based on your personality and the things the Santero determines about your character. The bottom is hollowed out and they put certain objects in there, like dust from four corners of a road that crosses, dust from a bank, water from a stream, and all kinds of different things that you go around and gather. Clayton went with Baba once

and walked around the Bronx picking up the things as were required, putting inside the elegua, and then sealing it. It was consecrated using chicken blood, and then it's given to the person who earned it, who is then initiated into the religion of Santeria."

On July 20, 1998, 8,000 crickets "attacked" spectators at a city-owned-property auction. This was the "Police Plaza Cricket Riot in the Manhattan Bunker Police Plaza." The crickets entered by the front door, escaping detection through high-tech surveillance devices.

"They are not conventional metal weapons, or photographic/video equipment," later remarked one of the protestors.

"Clayton and I were attending with a real estate investor who bought two Manhattan lots at the auction; we were not protesters. Clayton was tripped by an undercover cop and jumped on by ten rookies in a schoolyard football tackle skirmish. Three officers alleged injuries after falling on each other. Clayton was charged with assaulting three officers, trespassing, resisting arrest, and disorderly conduct. Fortunately I was able to videotape this incident from directly outside PP [police plaza] front door."

Elsa also used to go on the street and interview drug users who were usually high and happy to be on camera.

"We frequently had TNT parking outside our window . . . TNT means 'Tactical Narcotics Team,' also known locally as 'Tuesday 'n' Thursday,' because that's when they'd show up. They'd park outside our place around 3 p.m., and then about 4 p.m. they'd race off down the street with their siren going in unmarked cars. Sometimes we'd follow them to see what they were doing, usually drug busts. We videotaped these for a number of years."

"It used to be a very different neighborhood, huh?" I asked.

"Yes, it was. Our first night here we were sitting in the store window when a man was shot across the street; they killed him. That was the first night here, but things like that didn't happen very often."

Now Elsa says their area gets hysterical at night. There are mobs of yuppies frequenting 25 plus bars in the three by five block area between Delancey and Houston, and Norfolk and Allen. For years there was one bar, and now there's a lot more garbage strewn on the sidewalks. Before it was a neighborhood. She says it's beginning to look like what somebody called New York ten years ago: "rat city." But she still likes living here.

Other memorable demonstrations the pair has videotaped:

"On August 31, 1989, Clayton was one of two people who went through the system after being arrested on the Brooklyn Bridge while we were videotaping 'Day of Outrage,' a huge march comprising mainly African Americans from Brooklyn. Police kicked Clayton's video camera across the bridge into the crowd. The camera body and tape were recovered by Chris Borgen, Channel 2, who took it to the station and played it on the evening news. Steven Ferry, a Gamma Liaison photographer, picked up the two remaining pieces, a battery and the electronic viewfinder just before he was arrested. I lost sight of Clayton and did not know he had been arrested. Later I spotted his hat in the crowd and headed for it. The man who was wearing it did not know Clayton or what had happened to him, he said he found the hat on the ground and gave it back to me. The elec-

tronic viewfinder turned out to be broken so I sent it to Panasonic for repair. They said the individual parts to repair it would come to over $600 so they sent me a used working one for free!"

"The one time I did not go with Clayton was to a fire on East 4th Street on July 07, 1993, where the police beat Clayton up. Unfortunately the people who were with him, the Satan's Sinners Nomads, a Puerto Rican street gang, did not know how to turn the camera on. Anyway, after Clayton was arrested and taken to the hospital, they brought the camera back to me. A French girl who saw this incident swore that Clayton was dead!"

After this Elsa became very apprehensive about letting Clayton go to demonstrations (or anywhere) on his own. She began to do most of the street video while Clayton took photographs.

Another of Elsa's interesting video experiences was involved with the squats on 13th Street. There were five buildings the city was reclaiming by the way of riot police, a battering ram, and a tank.

"We were in one of the building on the second or third floor—we'd been there all night and [the squatters] said in the morning they were going to barricade the door so we would all be locked inside. We started videotaping out the window and saw the huge buildup of police at the end of the block, and the tank. They started entering the other buildings but we were probably the best fortified. [The squatters] had a huge eight by eight timber that was holding the door, and it was a metal door. They did eventually get in with a battering ram. Anyway, we were watching out the window and there was a squatter kid that had crawled under a car, and the police actually turned the car over to get him out. We decided we better get out of there—we wanted to save the videotapes.

'During a lull we saw a friend of ours, John McCabe, passing by under our window and we dropped the videotapes to him. We got them back a couple of days later, but in the meantime we felt that our other tapes were threatened. So we got out the back door into the backyard that was completely covered in bicycle parts, which were almost impossible to walk on. We finally got across that and climbed over a fence with barbed wire, a stone fence, and we ended up in this backyard that was completely enclosed. We dug a hole in the ground and buried our tapes. The police were on the roof of the building we just left, and they said that there were two perps in the backyard, go and get them. And we thought, "Uh oh." It was by a miracle that the back door opened and it was a Chinese restaurant. We thanked the guy and ran through. He had no idea. Later that day we went back and got our tapes. This was probably one of the more freaky incidents."

Elsa and I talked for a few more minutes and I thanked her for the wonderful interview. I knew nothing of this Lower East Side chromiste, painter, graphic designer, protestor, videographer, hat designer, and printmaker before today. But now I am on my way back into the summer heat and the beating sun, wary of the police and considering investing in a video camera.

Clayton and I

by Anntelope

I first met Clayton Patterson in the mid-eighties. He was walking behind a rather boisterous and motley crew of drug addicts and pot dealers who were being led by my dearly departed friend Linda Twigg (r.i.p.) who was busy talking loudly and in an angry, animated manner, pumping herself up emotionally for what she believed was going to be a physical altercation of some kind.

Clayton is a tall, handsome and capable looking man with long, gray streaked hair, a moustache and goatee. Add to that a few gold teeth and some very dramatic eyebrows and you're starting to get the picture. He was also wearing an odd type of baseball cap, something I hadn't seen before, with all sorts of strange symbols sewn on to it, including a large white embroidered skull. To complete the unusual package, he was carrying a huge video camera on his right shoulder. Any one of those things would have commanded attention, even here on the eccentric streets of the Lower East Side, but together, they were riveting as I noticed people studying him with great interest, something he appeared oblivious to—himself far too busy behind the eye of his video camera to notice who was watching him. I will say that in spite of his commanding presence, when it comes to making tapes of events, he's always managed to have the ability to work unnoticed and becomes nearly invisible as he tapes.

For instance, when they had the Mollen Commission (regarding police corruption) open to the press, Clayton too attended except unlike the others present, a conservative crew indeed, all with hair no longer than one fourth of an inch and dressed in jackets and ties, Clayton went in his usual attire—casual—a black T-shirt (usually something with a cartoon of the devil for fun), and of course, his ever present hat with the skull on it. Anyway, it still makes me laugh to remember how he was just videotaping away in the middle of all these suits—and nobody took notice of him except for his significant other (Elsa Rensaa) and me, who were home watching it all on television and hysterically laughing, barely able to contain ourselves.

And this time with Linda, (albeit insignificant compared to the Mollen Commission), Clayton was no different as he ignored everything but the event, which was about to unfold. You see, he had come to tape a possible altercation between Linda and another person she was convinced had stolen something from her—what it was I was never clear on, even to this day, but anyway, as it turned out, other than a lot of yelling and screaming and much posturing and Linda strutting about like a banty rooster, nothing much happened. You can be certain this was to my huge relief, since I was Linda's supposed protection—this because I was the only person amongst her friends who owned a working can of mace. Thus my title "bodyguard," although at the time I hardly even possessed a body, so skinny was I from years of drug use—weightless and about to blow away

Clayton Patterson

Anntelope and poet Ira Cohen reading at Candor film
Center for Marty Metz Memorial

in the first strong breeze.

Clayton wasn't really pleased that my first impression of him would be this one and explained quite quickly that he didn't usually tape this sort of encounter. And, as it turned out, this was true. Linda just rooked him into it, like she rooked everybody into everything, clever manipulator that she was.

I'll never forget one horrible time in both mine and Clayton's lives, and not too pleasant for Linda either. Linda had gotten involved with that GHB designer drug and had become convinced it was the cure for methadone and heroin addiction. I don't know what it was or wasn't—but it sure did make her messed up—causing her to have convulsions and literally jackknife her entire body, smashing her face on whatever was in the way—including the heavy machinery she used to make poker chips (a little home business she was trying to get off the ground).

Eventually, from banging herself around that way, she looked worse than Linda Blair in *The Exorcist*, so swollen and bloody her face. Meanwhile, poor Clayton tried everything to convince her family to get her committed where she could receive the help she desperately needed but to no avail. He even begged the attending physicians at Bellevue to commit her, keep her there and save her—but instead of listening to him, the doctors were convinced that HE had beaten Linda up himself and even went so far as to keep asking him as he tried to explain how she got in that condition, "Yeah, but why did you beat her up?" I mean, he could have wound up being charged for this horror himself when all he was doing was trying to help. And not only that, but if Linda ever found out he was the one who called the ambulance—she might have attempted to have him beat up or killed—so crazed a state was she in at the time.

Anyway, briefly—Linda had called him at five in the morning to come and record her injuries on videotape. When Clayton arrived, Linda's behavior was beyond bizarre as she ran about in her blood soaked T-shirt and cut-off shorts—talking about things that made no sense and even going out on the street in this condition to harass the people who were there making a movie on her block at the time. For some reason, she was infuriated at this and was doing everything she could to make their job impossible—in particular, blasting her stereo speakers out on the sidewalk—playing the same song over and over—"Goodnight Irene."

After a few hours of this insanity and close to exhaustion himself, Clayton called me in dismay—overwhelmed and not knowing what else to do—hoping I'd have an idea. Of course, I was no more able to figure out what to do either, and so reluctantly, he called an ambulance. Well, in the meantime, Linda had prepared her self for bathing—so covered with blood and street grime was she—and at the time, she was using this little set up—an old fashioned deep sink that she barely fit in—with a shower like device hooked up over it. Of course, water was getting all over the floor and by the time the ambulance arrived, Linda was sitting in this sink in the middle of a huge puddle, with an electric wire running through it. She was in danger of being electrocuted obviously and guess who was the one to tiptoe into the middle of the puddle and move the electric chord? The brave police? Nooooo. The heroic EMS workers? Guess again. Clayton? Yes, Clayton. That's right. While six burly policemen and four competent EMS workers stood watching uselessly from the sidelines, Clayton was the one who risked his life to save a friend from danger.

I would like to especially get this point across about Clayton and his involvement with the members of the local community. He has walked where angels feared to tread and wise men NEVER would go. Not to compare him to Mother Theresa, because you can be sure that Clayton's no saint: However—in some ways, when it comes to being "hands on"—he was and is comparable to Mother Theresa. Just like she and her troop of nuns weren't afraid to get their hands dirty and would think nothing of sweeping and mopping the floors of the poor and destitute (including India's lepers and untouchables)—neither was Clayton afraid to enter even the gates of hell if he thought there was somebody who deserved a chance to speak their story. And, although Clayton has never run a soup kitchen or been known to be anybody's sucker, neither is he or Elsa good at turning their back on strays—having brought everything home from a pigeon that fell in an open vat of liquid glue, to an abandoned kitten, to a loveable soup hound with huge ears (r.i.p. Lucy) that they rescued from the pound to a pedigreed Skipper T dog they found running around unclaimed, to a poor little abused dog that had been amongst other things thrown out a second story window which resulted in her hips being fractured and for which she received

Clayton Patterson

Shooting Gallery

no medical attention until Clayton and Elsa saved her from her bizarre owner who fed the little dog only cat food. Too cheap to buy a dog coat for the winter, she instead wrapped the tiny pooch round and round with this long pink scarf that turned the poor thing's skin pink from the dye in the material. In fact, it was at possible danger to themselves that they saved that last little dog, never knowing if the eccentric owner would try to get them hurt for stealing her property—as she often referred to their rescue of the dog. Along with animals, they rescued a huge variety of lost people too, including and especially many artists who were down on their luck.

As I mentioned, I myself was a hope-to-die addict around the time that Clayton met me—hooked bad on heroin and cocaine (and speed if I could get my hands on it) or all three at once. I wasn't fussy—the only thing I didn't indulge in were those gorilla pills like Xanax and Valium etc. That made people think they were as strong as King Kong. I was also on methadone maintenance during this period—but it just wasn't enough to satiate the raging monster in my belly back in those days, so I supplemented my government issue with street drugs.

Needless to say, I was in the poorest of health, severely underweight and with a weakened immune system. I believe that in this state, I had possibly contracted or succumbed to a parasitic condition of some kind, although I could never get a doctor to listen to me or examine me for it—at least not in any sort of a way that was credible, serious or appropriate to a condition of this kind. Instead, I was met with ridicule and disdain, and it was always explained away as a reaction to the drugs—although I couldn't help but notice that they usually stood back about ten feet while informing me that there was nothing wrong with me.

One thing that made it difficult for me to get anybody to listen to my wild tales of parasites (nearly microscopic worms is what I believed they were) is that the only time it really was evident was right after I shot up coke or speed, at which point I would itch horribly and my skin would peel, right while I was watching. The problem with that, you see, is that most doctors aren't going to let a patient shoot coke or speed in their office—and so, consequently I was stumped. That's when I got the brainstorm—Clayton!!! That's what I would do. I'd get Clayton to videotape the entire thing from start to finish; that is, film me as I shot up the coke or speed—and then film the changes that occurred in my skin right after I took the drugs. Let the doctors argue with that.

And so, a good twenty or thirty or so times, Clayton would come running over to my house at all hours—prepared to watch me fix and then tape what happened to my skin. I mean, he really did try to get this on film but, alas, we just didn't have the proper equipment necessary to be able to see something that tiny—nearly microscopic.

Trying his best to help me—Clayton even convinced a friend of his to come and speak with me—a doctor, basically, except he just didn't have a license to practice in New York City, but for all intents and purposes, he was otherwise a full-fledged physician.

Unfortunately, the encounter did not work out the way Clayton had hoped. His friend was an utter and pompous asshole—a monster from hell—just awful—who began to mock and discredit my story the second I arrived, although he too wouldn't look at anything or even come near me. Finally, after I'd had more than I could stand of his ridicule, I left, dismayed and devastated. I later learned that this same person convinced Clayton that he had taken advantage of him, accusing him of expecting him to give me medical attention without payment. He then demanded that Clayton compensate him by giving him a VERY expensive and irreplaceable rare book. Poor Clayton, trying to fix things, actually did give him the book and it took him nearly ten years to get it back too, which was only fair since the man hadn't given me any medical attention anyway.

Clayton has never given me possession of these videos, something that bothered me for awhile because, understandably, I was concerned that somebody might see them—that they'd be presented in such a way as to humiliate or degrade me. However, it's been nine years or more and so far (at least to my knowledge), Clayton has never exploited me or those videos.

I've tried to understand why he wants them. I guess in a way I do understand. This is his world. This is his life and these have been his experiences. Just as people go to Africa and document what goes on: Clayton did the same, except he did it right here on the Lower East Side. And who's to say that the stories he's uncovered or documented are any less significant than whatever you might see in *National Geographic* magazine?

It is my opinion that the way the world is quickly changing, he's probably one of the few folk who's got a credible digest of the LES during the last twenty years. I mean you name it, a fire, a

huge bust, a squat eviction, police riots, anything going on in his community and Clayton was there with his video camera. For this, he has been cursed at, arrested and beaten, all for doing no more than a newspaper reporter does, except Clayton never received a salary but did it out of interest and love. Mind you now, he was never like a paparazzi and did not go stick his camera in people's faces when they were trying to eat their dinner or use the bathroom. These were public incidents he tried to record—but for some reason, he's been resented for this. I find it odd and unfair.

Meanwhile, I hope that someday maybe Clayton and I can figure out a way to make a positive use of those tapes of me back in my drug days. Maybe it would be good material to use to scare some of these younger kids with—to show them that drug use doesn't end with fun parties and that that's just the bare beginning. I want to find a way to show them, make them understand before it's too late, that after you get hooked on drugs—the parties all stop. The fun disappears and there's nothing left but you, all alone, wearing long sleeves in the hot summer and picking your sores and getting blood stains everywhere.

"Clayton's Lower East Side Side Show"

why do they do it
call him?
perhaps
because he comes

hanging on to the tips of the toes of madmen
he's run with them past the devil
just to get there in time

meanwhile
take it from me
no one ever believes
they'll be part
of this unusual theater

the decision only made
during the loneliest
last minute hour

when it finally occurs to them
that they want the tragedy
documented after all

their own "last syllable of recorded time"
. . . recorded.

and is he an emotional pawnbroker?
the jury's still out
on that one.

© Anntelope 2001

Whoremoans

by Anna Lombardo Ardolino

It was dark and quiet out on the back streets of the whore stroll. The hour was late and the moon low hanging. "Lil Bit" had apparently just finished turning a "car trick" and was now hopping out before the vehicle had even come to a stop after which she dashed into the tiny all night diner where the hookers hung out. I assumed she was trying to get change. You see, there's no way a girl will service you unless she's got the money in her pocket or her stash place first, I mean every penny too, all of it, up front and before anything else happens. If you're planning to have a date but haven't had the forethought to come prepared with the correct bills, well then, you'll just have to let the young lady hold the cash till after the dirty deed which is when you can both go get change holding hands. Otherwise, you were plumb outa luck cause no girl was gonna service you and get paid "later." After all, if the customer refuses to pay— who's she going to call? The Better Business Bureau? I don't think so.

So anyway, here comes "Lil Bit" tearing like a maniac into the coffee shop but instead of stopping at the cash register as I expected, she flew right past it and out the side door, then down the back alley and around the corner. I watched this activity with great interest and more than a small amount of amusement because it always tickled me to see "Lil Bit" try to run in her worn down high heels, she the only lady with legs skinnier than mine, plus hers were quite bowed in addition, making it even more awkward a spectacle.

I was puzzled as to why she was in such a hurry anyway, I mean, even if she had stolen the guy's wallet, the fellow looked much too old and feeble to give chase. This scary little white man appeared to be the type who probably would never even

Clayton Patterson

Anne Lombardo
Ardolino

dare to get out of his vehicle in such a foul neighborhood, never-mind go traipsing after some strange eyed lady down a dark alley.

Finally, curiosity got the better of me, so I ran after her, laughing and out of breath as I yelled towards her fleeing form "What the hell are you running for? That old man can't catch you."

That's when I received a really good lesson about just how raw things can get out there in the "sportin' jungle." because I was left speechless while "Lil Bit" ducked between two parked cars, raised her skirt, then squatted and spread her legs, and since she had no panties on, what she did next was wide open to my view and let me say, it was rank to witness as with no apology, she reached up into her hairy, steaming vagina with what appeared to be all four fingers, stirred them around, then popped them out abruptly. With that there came a rush of cum, leaving her hand shiny with the goo and I was aghast as she flung it, I mean she just let it sling off her person and go flying, finally landing on the window of somebody's car, after which it hung there in sticky strands, just a-swayin' in the breeze.

As she was doing this, "Lil Bit" was busy cursing the chap in the automobile, saying quite loudly for all to hear "WOULD YOU BELIEVE THAT LOW CLASS MOTHER FUCKER? WOULD YOU BELIEVE HE CAME OUT HERE FOR A FUCKING DATE AND DIDN'T EVEN BRING A PIECE OF FUCK-ING TOILET PAPER?"

Wiping her hands on the inside of her skirt, she lowered it back down, smoothed it out, then ran her filthy fingers through her greasy hair, preparing to go back to work, but not before she asked me if I had a cigarette, which I handed her quite gingerly, trying not to touch any part of her person in the process. While she was walking away, I heard her saying to no one in particular "I HAD TO GET HERE FAST BEFORE IT DRIPPED DOWN MY LEG."

Jim "Mosaic Man" Power and Video Work

Interviewed by Lane Robbins

My mosaics I started in 1985. I was doing my thing and they had ripped some work off and everybody was devastated. After realizing the effect it had on the neighborhood I kept going. I broke my leg that year, but I kept fighting. I went back out on the streets. It's all about public art—where's the public art? Fortunately I could document my stuff, and hundreds of other people have documented my stuff, if not thousands. I have a handful of videos that were made of me.

I started videotaping in 1991. My mother, who has passed away, bought me a Sharp VHS and I started videotaping. I just loved it. I've gone through about 15 cameras, and most of them cost about two grand. My mother actually helped me to get a number of those cameras—half of them at least. The idea was that I was able to videotape everything that I did.

At the time I was with a friend of mine named Don Anon, Don Anonymous, and we went to Woodstock. We were working doing mosaics up there and I was able to videotape from one end of the day to the other. Almost every little action I did I videotaped. We were up in Woodstock until 1994. I would come into New York City once in a while and check my work out, or videotape or whatever. Then in 1994, around the time of the Woodstock Festival there, I had the opportunity to go to a gallery opening—Fletcher Gallery in Woodstock. They were showing Peter Max's work there. As Peter Max arrived he gave me a thumb's up, but he didn't know who I was. He wasn't doing it for the camera. It was more because I was a cool guy in the crowd. Then he saw I happened to have this first Sharp camera.

I had the first of two absolutely brand new Hi 8 cameras in the entire country, and I didn't know it. The camera I had originally had a problem. It burned out or did something—I forget exactly. It was just before the Freedom Festival going on at that particular time too, in the original side of Woodstock, not the town. We raced around to get a new camera and wound up over in Connecticut. The only camera they had available was one of two they had in the store, that I later found out were two experimental cameras that weren't on sale. It was the new Hi 8 Sharp View-cam. So they gave that as a replacement for the other camera. Of course when I went to the gallery opening I was the only one with this new kind of camera. Peter Max asked me at the end of it if I would come to New York City and videotape. Of course I would. So I spent two weeks with Peter Max in his office, and I had the full run of his building up on 66th Street/65th Street. I did some great videos, and I actually have some videotape still left over from that shoot—tape that got put on the side.

Woodstock is a music town with lots of bands. I would go to Tinker Street Café and some of the other cafés that were there,

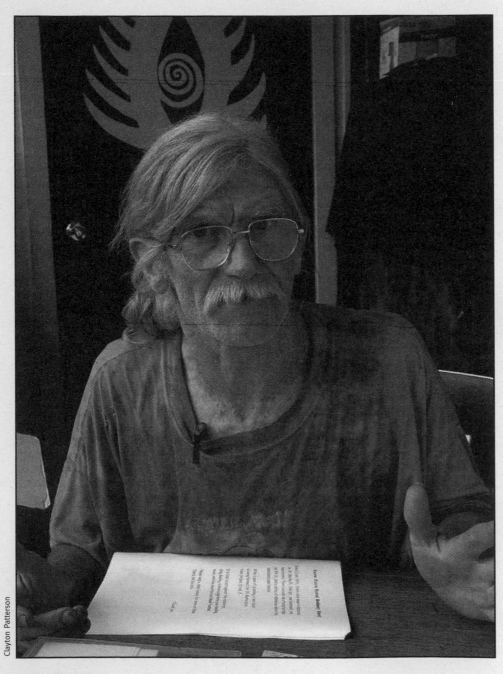

Clayton Patterson

Jim Power

almost every night of the week, and videotape a band. Other people were doing it, but they had better cameras and they weren't the kind of person I was, with the camera out and going all the time. I had all these bands and it was great. I did that for three years and then eventually came back to New York, and moved back down here in the November of '94. I started editing what I had done all along in Woodstock. I did four hours a week on a cable show using my footage. I would stay up for a couple of nights before and edit a two-hour show in two nights, which is very difficult to do. I'd get it on the air, sometimes with a little live stuff mixed in, but mostly I would just put these tapes on the air that were already prepared. Then I would run it again a second day. I got training in a little studio up there putting shows on the air. Two decks I would edit on, and hopefully there weren't any yellow lines running through the picture that would come from not using better editing stuff.

The difference with a Sharp Viewcam is that you can turn it this way and rotate it that way at the same time and still see in the camera, because your camera is in your hand. You can't do that with another camera at all. Take the same camera and have it zoomed out all the way, and immediately go down to a book of matches to test the camera, and you go from visual that way to visual on a book on matches with no focus problem. Do you ever see a focus problem with cameras, where when you move the camera it goes "zzzzzzzzzz" and then it focuses? Sony has a problem with that even to this day. There's something about Sharp electronics where they've got the jump on them. And they were the first ones to come out with that camera. It was analogue hi-8 video. Most of my stuff is on hi-8. I did switch over later on to digital, and I have quite a number of tapes with digital video on there, which I learned to edit in camera. I shot almost everything on a sixteen-nine format. A sixteen-nine format blocks the top and the bottom. So you have what looks like a movie.

Me and Clayton did something that was supposed to be run on MTV for five minutes or six minutes or so, two times. It was of Avenue A. We were doing an "Avenue of the Arts." That was our theme at the time. We spent a week videotaping and gave MTV two hours, and they ran that for six years almost every week. They digitized it and it turned out really well.

I videotaped police activities for like six years. I had a videotape that had to do with a couple of individuals but I didn't release it because that's not right to do. It's like waiting for them to do something wrong and then jumping on them.

But here's a story that I didn't get on tape: Officer Oaks, or Okey-Doke, was out there and had been hounding Clayton because of Clayton's contribution to order in the city of New York. Clayton was standing next to some garbage cans on 9th Street. He was trying to photograph an arrest the cops were making. When it was all over he was standing next to the garbage cans and next to the phone booth, which was blocking but just a little view—less witnesses. A scooter was parked there on the sidewalk, and Officer Oaks started up the scooter and he rode right up on the sidewalk and full-blast ran Clayton into the garbage cans. There was no place for Clayton to fucking go. It went right into his groin with the front of the scooter. He hit Clayton in the groin with his handlebars. It was just an "accident," though. I was one of the only witnesses. I was standing right there.

I covered drug dealers and I worked with people who had been on some serious drugs—heroin. Some of the individuals had been working with me doing mosaic work—it's no secret. I could probably make 100 movies of this stuff, a dozen or more that would be major.

I also did Manhattan Neighborhood Network shows here in New York, and I got rave reviews on them. I kind of got a taste of the wide range, but the most important thing that I am absolutely totally in tune with is that I can

take that video camera and operate: Boom! Now! Out in the streets all over and get all kinds of stuff; on the ball. It's not exactly in your face, but I'm there. And I use it. I think it's fabulous technology when it comes to watching your neighborhood; it's the only way to go and the best of all evidence. It's important because of the way I capture stuff, and the fact that I'm able to get humanity on camera in the most natural of all ways. People don't bug out because they're on camera; it's a relaxed situation. They don't feel that I'm ripping them off or I'm going to go make a movie and they're not going to get any. I capture humanity on a video camera like most people just don't really do.

Now I'm blind as a bat. I always have kept my camera on automatic. I'm not a photographer—I'm not someone who knows the intricacies of a camera, and because of my vision, most of my stuff is focused on what I'm doing and where I might zoom. Later on I'll take a look at my tapes and probably see stuff I just didn't notice I was doing because it was not the actual focus of what I was doing. You really have to look at some of the videos to catch the actual quality. I believe in letting things move through my camera, because then you can see them. My whole thing is to project artists out into the world.

The Movie of the Month Club 1991—92

by Matt Mitler

Okay, so what do we have in common? We love movies. Some of us prefer movies with a certain quantity of severed limbs and bloody viscera, but we all love movies. In fact, some of us love movies so much, that we want to make them ourselves.

I guess I've wanted to make movies ever since I was a kid. In high school, I took my dad's old Leica 8mm and tried my hand at single-frame animation. That inspired me to create a live action short for an English credit. I called the film *Funtus Officio*. It open with an animated title over Fats Waller's, "Don't Let it Bother You," then swooped into an open grave (tough to find), went on a tour of an embalming room (I told the funeral director it was an educational film), and ended with a Bacchanalian food orgy in bedsheet togas on top of a small crypt (we'd gotten all the footage we needed by the time the authorities came).

Oh, also in high school, I met Robert Prichard.

Now, let's grab the remote control and shuttle forward about twenty years. Gotta keep this exposition to a minimum.

Robert by this time had acted in *Toxic Avenger* (where he met Jennifer Babtiste) as well as *Class of Nuke 'Em High* and *Space Avengers*. I, meanwhile, had done more than a dozen grade Z flicks myself including, *Basket Case 2*, *Dead Time Stories*, and who can forget, *The Mutilator*, with its classic tag: "By hook, By pick, By axe, Bye-Bye"? So, we'd done a lot of drekky films, we'd also done a shit-load of theatre (including a weekly serial at the Pyramid Club about B movies, called *Grindhouse*) and we'd had enough. It was time to do it ourselves.

January 1991. I get a call from producer David Martin (*Fatal Turn On*, *Elvis Sightings*). He says he got my name from a theatre where I'd recently improvised a two-act play, solo. He believes a feature-length video can be shot in one day, improvising all the dialogue. The word is I know some crazy downtown actors, many from a performance series I was running called "No Shame"; he says that if I can put a project together, I can direct it. I'm sold. I tell David that my old friend Robert Prichard has a new VHS camera. David wants to shoot it himself, but relinquishes the position. We're on.

Kid Scarface was about a petty criminal just released from prison. I played the "kid." For our opening shot, we went to an East Village elementary school and framed out the P.S. number over the door. We shot it in one day, all over the neighborhood, but went back later adding some scenes and reshooting a couple we really weren't happy about. Everyone improvised. One actor I didn't even meet until he arrived on location minutes before his scene. Needless to say, there were no rehearsals. Once it was cast (by phone), I just told people what kind of part they'd be playing and that they should come up with their own wardrobe.

We appropriated a style of long takes (one master if possible), and shot for the cut with absolutely no coverage. My wife, Karen Hatt, made the food. We edited on ?", off the fly, from the ?", at a production house where we knew an editor, Kathleen Gallagher. We used the facilities after hours, for free. For the sound track, Robert pulled copyright infringement French R&B music from the '60s. The final product was about an hour long and cost $300. It used to be for rent at Kim's Video on Avenue A.

This was the birth of "The Movie of the Month Club," dedicated to shooting features on video, in one day, in sequence, and with all dialogue improvised by the cast. The criteria for scenarios were: no more than 30 scenes, all locations within a seven-block radius, and no more than a dozen principle players. We were all friends who liked to hang out together and figured it was more productive than bowling.

We parted ways amicably with David Martin, and Robert and Jenny (married now) seized

the opportunity to become full-fledged producers, incorporating under the banner Surf Reality LTD. We ended up creating six featurettes over the course of about two years and one feature-length project. All utilized the same stable of talent, and Robert and Jenny produced them all. I served as executive producer, although I've never been quite sure what that term means.

Here is an encapsulated production report:

Manic A Go-Go

Male exotic dancer pursued by wealthy madman finds shelter with fallen stand-up comedienne.

We moved up to video-8 on this one and bumped to ?" for the edit. Shot in one day. Written and directed by Bennet Thiessen, who'd brought us into his own personal hell on *Grindhouse*, but was worthy of a second chance. We had illusory dreams of grandeur and actually paid the cast. The rough cut was a shambles. Kimberly Flynn had done better work in *Kid Scarface* and Jeff Eyres was just a little bit uncomfortable being a 200-pound go-go dancer. We shot some insert footage and I overhauled the final cut myself, adding some creative titling effects throughout. Robert shot. Karen made the food. Bennet moved to Peoria.

Turf of Savage Homicides

Pathetic loser learns an alien conspiracy exists involving his wife, therapist, and dad.

Todd Alcott wrote and directed. Robin Grant shot on video 8. Big problems. Cost a few hundred and we shelved it. Up till now, we had thought that whoever brought in a good scenario could direct. We were wrong.

Todd is now a hot property as a Hollywood writer. I understand he's getting to direct. Boy, did he show us.

Thrill Kill Video Club

Group of amateur snuff filmmakers have trouble casting their feature.

Another step up: Hi 8. Robert wrote and directed. Robin shot. One day (with the exception of a massive audition sequence featuring *every* performance artist on the Lower East Side and a guy from *Dr. Who* in England). We needed to rush post-production since *Manic* had us backed up. So, instead of editing with our after-hours deal, Robert went to an on-line place. Even with a discount, it cost a small fortune. Once again, Karen made the food. For an extra touch, Robert produced an original opening title song.

Dick and Jane Drop Acid and Die

Government official lectures on the evils of LSD as we watch two young innocents fall victim to its deadly clutches.

Written by Jeff Eyres. Directed by me. Shot by Robin. Food by Karen. Now pregnant Jenny, played "Esalon." Jeff Eyres came back to play the LSD pusher, "Cosmo," a part that was recreated in our feature *Cracking Up*. One actor we cast because he said he had a VW Bug he was willing to trash. We had him paint it with day-glo psychedelia. For our "trip" scenes, we utilized the gain FX on Robert's new camera. Trails man!

The story climaxes with a lengthy "be-in." We had everybody in the cast invite friends to a '60s costume party and promised a good time. Shot on a weekday afternoon in an empty theatre, we'd brought in a band to play live on period instruments and concocted a punch of grain alcohol, 151 rum, and fruit juice. One cup was guaranteed to make you drool. Oh yeah, we also had very special "gourmet" brownies. We waited for the cast and extras to get "in the mood" and came out shooting. In three hours we were wrapped. Everyone thanked us profusely for the honor of being in our production and then staggered out into lower Manhattan going, "Wow, man! Those buildings are sooo tallllll!"

Editing was split between our free deal and a cheap, off-line, do-it-yourself spot called Rafik that everybody complained about and everybody used. One day, my scheduled editor came an hour late. That's when I learned how to edit. We mixed the sound track from the basement tapes of our '60s band, "A Thousand Tiny Fingers." This was our first use of original music throughout. Footnote: the band's home in an East Village basement was our acid den set and then used a couple of years later as our crack den set for *Cracking Up*. And we didn't have to decorate.

I Was a Teenage Bride of Christ

Young waitress is seduced into becoming a nun and working for The Man.

Ted Lorusso wrote, I directed, Robin was becoming difficult so Robert shot with his new Steadicam Jr., and Karen made the food. This one was actually shot in one day with no pick-ups. Eighteen hours. We had been working with many of the same actors all this time, and things were beginning to click but, because of scheduling conflicts, we couldn't use our first choices. Fortunately, we *always* had a back-up cast list, and they turned out just fine. We'd had problems in the past with sound on exterior shoots, especially in the wind. This shoot was no exception. Robert and Jenny eventually acquired a boom and a "fuzzy," but this one we had to tackle in post. Also, our off-hours editor, Kathleen, got laid off so I had to finish the editing at Rafik's. By this time we'd stopped paying actors and everyone still wanted to work with us. Musicians, too, it seemed. So we had our first "composed" sound track. Richard Porterfield created the music and it was recorded on an actual church organ.

Les Enfants Miserables

Brother and sister are lovers. They are forced to marry others or forfeit their inheritance.

This was our French surrealist homage. We stripped out the color when we transferred the Hi 8 footage to ? inch to make the piece black and white. I directed, Nancy Fichman wrote it, Robert manned the camera, and Karen made the food. Karen and I had recently moved to Park Slope, Brooklyn, so we filmed there: our first time outside the East Village. We actually did pre-production on this one, dressing sets and lighting them the night before. Nancy had written a bunch of exterior scenes, but it was pouring on the shoot day so we just changed everything so that we could do interiors and dove in.

Everyone had fun on this one (due, in no small part to the fact that we really had our chops down by now). Cast members hung out hours after finishing their scenes. At one point, Karen and I found a bunch of them all lying down on our bed together. Clothed, of course, nothing kinky. We were quite happy with the atmosphere we had created. Here were people coming all the way to Brooklyn to make a movie,

THE 10 COMMANDMENTS OF LOW-BUDGET PRODUCTION

- Feed people. And not just a Snickers bar and a muffin but three square meals, if they're there that long, and make sure it tastes good and is reasonably healthy.
- Have a holding area. If it's winter, make sure it's heated. Nobody likes to wait around uncomfortably. Fewer like to wait around in the cold.
- If you're pissed off, don't express it on the set. Negative emotion is poisonous. A whole day's morale can be blown to smithereens with one uncontrolled outburst. A controlled outburst is something else entirely.
- Do your homework but be flexible to change. Things *always* change.
- Have a small group of peers whose opinions you value and trust (even if you don't agree with them) and utilize what they have to offer. Don't solicit opinions indiscriminately.
- Only ask for permission to shoot somewhere if you're sure you'll get it. Otherwise, "hit and run," and if someone stops you, tell them you're shooting a segment for "America's Funniest Home Videos."
- Look like you know what you're doing.
- Have a premiere party even if it's in your living room. Everyone wants to see what he or she worked on, and you need all the publicity you can get.
- If you want your local video store to stock your movie, shoot a scene there.
- Feed people.
- A friend of mine was once working for Cassavetes as an editor. She asked him one day, "How can I make my own films?" He answered, "Do it."

Good luck with your production.
Matt Mitler
Twenty years later.

Some lessons are hard learned so, please allow me to share the above.

spending all day and night, not getting paid, and having a blast. Through conscious efforts, we'd finally realized the true spirit intended since the first Movie of the Month. And the quality of the final product shows it. I did the bulk of the editing at Rafik's, and finished it off at a (secret) facility at NYU. Nancy had a pro composer/musician friend of hers, Mitchell Forman, come up with a sound track.

In between *Dick And Jane* and *Teenage Bride*, we shot a bigger budget feature, *Macbeth, King Of Scoutland*. A comic, surreal adaptation of Shakespeare's tragedy, done as boy scouts, which we had performed with a core ensemble of six actors in theatres and cabarets for over a year. We'd need another essay to cover this production, but suffice it to say that we shot the whole thing on Beta SP in one week at an old scout camp in the Catskills. For most of the gang, it was a big party. For Karen and I, it was not. We rough cut on VHS, and mastered on one inch. Post-production took a year at Otterson TV, in off hours at a discount. Running time clocked in at 100 minutes. We learned the lesson of "put your time into pre-production and your money into production or you'll double your cost in post."

We ended up winning the "Certificate of Merit" at the Chicago International Film and Video Festival and had a fantastic premiere party at Gusto House on 4th Street and Avenue A. Most of the Movie of the Month Club videos screened at Gusto House. It was my favorite performance space in the whole city and I'd done a number of solos and group shows there myself. If you missed it, you can see it immortalized on celluloid in *Cracking Up*. We made it our central location and shot half the film there. Kim's Video on Avenue A used to have us on the "local filmmakers" shelf and Robert and Jenny released the videos independently under Surf Reality LTD, which had become a hot spot performance space on Allen Street.

You've heard me mention *Cracking Up* a few times now. All the time we were making our videos, we were aiming to shoot a feature on film. In fact, the videos were our practice drills. *Cracking Up* was shot on Super 16 in the spring of '93 with over 70 speaking parts, including just about every actor who'd joined the Movie of the Month Club. We had over 30 locations, most of which were East Village haunts we'd used in the videos. And production was completed in 18 days. Don't ask about post.

Cracking Up won a slew of awards including "The People's Choice" at The New York Underground Film Festival, and "Best Film" at The Venice International Film Festival Critic's Week. Some years later, after touring festivals all over the place, *Cracking Up* and I returned to the East Village. Jonas Mekas called me up after watching a screening cassette and said, "I loave thees feeelm!" We were offered an incredible three-week run at Anthology Film Archives, on the big screen. For the record: I wrote, directed, acted, edited, and produced; Robert and Jenny co-produced; Karen did the food.

Bill Morrison
Filmmaker

by Bill Morrison

I was born and raised in Chicago. But the East Village was the first place where I felt like just another regular guy walking down the street. Not a white guy, not a student, not a freak. I was just an anonymous guy in a neighborhood too diverse to notice me, and too busy to care. I very much appreciated that.

I arrived in the East Village in August 1985. I was 19, and the East Village gallery scene was in full swing. Posters of RUN-DMC Kings of Rock were plastered everywhere. The smell of marijuana permeated the air all over the city, and people drank, smoked, slept, and urinated openly in public. Things left in cars vanished instantly, and marginally talented painters were making obscene amounts of money at galleries that would open and close overnight. I got a place on East 3rd street across from the Hell's Angels, who patiently explained to me what I could and could not do near their vehicles.

I came here to attend Cooper Union. I quickly befriended filmmaker Jeanne Liotta, who was a model in my life drawing classes. Jeanne invited me to a number of events she was involved with in the neighborhood, thereby introducing me to the world of avant-garde theater and film outside of Cooper. She also sublet me her super cheap, super dark 11th Street apartment where I lived for the rest of my Cooper days.

While at Cooper, I studied with Robert Breer, the visionary animated filmmaker, who was a midwesterner with a super-dry sense of humor. Like Breer, I ended up gravitating from painting to film, embracing a type of filmmaking that strings 24 paintings together in a single second.

After my senior show at Cooper in June 1989, I was approached by Cooper alum Matthew Harrison to screen my nine-minute film *Reserection* at PS 122, as part of the Film Crash series. The next year I was invited by Film Crash to make three films to be used in the Ridge Theater production of "The Manson Family Opera," which was staged at Lincoln Center as part of the Serious Fun! Festival. This was to be the first of a long and fruitful

collaboration with Bob McGrath and Laurie Olinder of Ridge Theater, a relationship that has produced some fourteen different projects since 1990.

Much of my film work has originated in some form as the projected backdrop for a Ridge production. After the performances, I edit the material down into films that I can send to film festivals and programmers. In March 1995 the Museum of Modern Art presented the early films in a Cineprobe program. MoMA eventually acquired prints of five films that in some way originated with Ridge Theater.

In recent years my work with Ridge has introduced me to a whole new community of composers and musicians through our collaborations with Michael Gordon, David Lang and Julia Wolfe of Bang On A Can. My film *Decasia* was originally conceived of as part of the Ridge staging of Gordon's symphony in Basel, Switzerland, in November 2001. The film was then re-edited to match recordings of the rehearsals we made in Basel to take the form it is today.

After 18 years in the East Village, I have only had three different apartments. Every day I'm in New York I work in my apartment on East 7th Street, which I have had since the Daddy Bush recession of 1991. The old Ukrainian guys are slowly dropping off, and I imagine one day being one of them, asking the anonymous 19-year-old kid in my building to hold the door, or carry my groceries for me.

Notes from an East Village filmmaker

by Larry Fessenden

I lived in New York all my life, since 1963, but I moved to the East Village in 1981 and ever since I've called it home. As a kid I went to all the downtown movie theaters: Cinema Village (*Night Of The Living Dead*, *Clockwork Orange*), The Quad (*Stranger Than Paradise*, *She's Gotta Have It*), The Bleecker St. Cinema (*Come And See*, Andy Warhol's *Frankenstein*), Theater 80 (*Citizen Kane*, *Touch Of Evil*), St Mark's Cinema (*Eraserhead*, *Blade Runner*), Downtown Thalia (*Faces*), The Old Film Forum (*Broken Mirrors*, *Working Girls*). The Yiddish theater that's become Village East on 12th and 1st played movies one summer and I took a girl named Janet to *The Texas Chainsaw Massacre* there. It was our only date. I worked at the Bleecker St. Cinema one stifling summer while I was living on 4th Street and B beside the American Nursing Home (dinner was liver at Leshko's on Avenue A: $1.99 with two vegetables on the side). I got fired for having "paint on my hands," but I'm sure it was the day I came out 160 bucks ahead. The manager and I split the booty, but I think I lost his confidence that day.

I grew up to be a filmmaker, saw the whole aspiration to make movies go from mystifying and rare in the '70s to a '90s cliché. As I saw the cinema I grew up watching becoming more fringe, less mainstream, as the '80s blundered onto the scene. I moved to Stuyvesant Street and 7th where a cop once climbed in my fire escape window in a panic with vertigo. Later I moved to 12th Street and Avenue A, where I looked south at a view of the Twin Towers standing tall against the downtown skyline.

Living in that sixth-story walk-up, I made the 140-minute caper movie *Experienced Movers* with a Sony video camera and Beta II porta-pac. I shot half the film at Blanche's on Avenue A and Lucy the bartender would make me spicy vodka shots in the morning to kill my dry-heave hangovers. Film Video Arts was on 12th Street, across from Rafik and the Strand (all my friends worked at the Strand), and that's where I mastered the Epic with a video artist named Irit Batsry.

"a darkly beautiful, genuinely scary movie"
—L.A. WEEKLY

WENDIGO

ContentFilm presents a Magnolia Pictures release of a Glass Eye Pix / Antidote Films production "WENDIGO"
PATRICIA CLARKSON JAKE WEBER JOHN SPEREDAKOS and ERIK PER SULLIVAN
casting SHEILA JAFFE GEORGIANNE WALKEN MARY-CLAY BOLAND production design STEPHEN BEATRICE costume design JILL NEWELL
sound design NICK MONTGOMERY mix TOM EFINGER original song TOM LAVERACK music & soundscape MICHELLE DIBUCCI
effects photography JAY STEPHEN SILVER effects producer DAYTON TAYLOR director of photography TERRY STACEY
producer JEFF LEVY-HINTE writer, director, editor LARRY FESSENDEN

Larry Fessenden Wendigo

In the spring of 1986 *X-MOVERS* screened in bars and storefronts around the East Village on 11 TVs hooked in an RF cable daisy chain. We never got any press; it was neither art nor cinema, but it's how I learned to make and distribute movies. Round about then my buddy Matt Harrison started Film Crash with Scott Saunders and Karl Nussbaum, and they'd have movie nights in East Village storefronts, later at PS 122 and then Slamdance and each one would eventually get into Sundance with movies of their own.

In 1987, I bought 3/4 inch video equipment and started making tapes for local artists, got on the periphery of the performance art scene, working for Pat Oleszko, Penny Arcade (Penny had me video Jack Smith's house. I crawled across the walls in single takes, all muraled and festooned. Gotta find that tape for MM Serra), Instant Girl, Ridge Theater, The Impact Addict, and David Leslie. With Leslie I found the right pop-pulp collaborator, and we spent years documenting and editing his death-teasing stunt events into self-proclaimed cultural events. David would finance his pieces with handouts from local sponsors like Two Boots. The whole Village was our canvas; we'd poster for our shows, cruise lower Manhattan in a cube truck, two guys, my girl, Beck, and a dog named Joe, owning the neighborhood when hype was still charming the way Warhol saw soup can labels.

I shot a 16mm film starring and written by Heather Woodbury called *Hollow Venus: Diary Of A Go-Go Dancer*. It was a great excuse to go to titty bars for research. That project stayed modest but started me documenting Heather's performances and she's still at it today. We premiered *Hollow Venus* at that crazy fortress on 2nd Avenue, Anthology Film Archives, and had a party under the church down the block.

Round about now, Steve Buscemi was in *Parting Glances*. He'd been doing stand up performance shows with Mark Boone Jr. for years in the East Village ("Deer Park that's good water" at King Tut's Wah Wah Hut; I'll never forget that skit). Now he was on a movie poster. He was one of the locals that "broke out."

Clayton Patterson

But then you realized they were all over; that your neighborhood people were actually part of a bigger story. Richard Hell, Philip Glass, Jarmusch, Lurie, Killer Films is here, Tod Haynes and Christine Vachon had screenings at Anthology years before *Poison*; Mark Tusk was always lurking about the hood before he left Miramax and produced *Hedwig And The Angry Inch*. *Stomp, Blue Man Group*. And then you heard that Ginsberg had lived down the block on 12th Street, and Charlie Parker, and the lineage stretched back; there's been a continuum in the neighborhood, and it's still there. This big city can have such a small-town feel.

I made a movie called *Habit* here in 1994. We shot everywhere in the East Village: streets, bars, parks, and rooftops. We shot on Ludlow Street the year before it blossomed into some sort of little San Francisco. When *Habit* came out on video, the Blockbusters on Houston Street had 24 copies for rent. Now that's a small-town feel. Even the franchises make quirky choices in the East Village.

I've always had Hollywood ambitions, but small-town instincts. During my years here, the East Village has been a place for both.

*Larry Fessenden made the art-horror movies **No Telling**, **Habit** and **Wendigo**. He made the East Village videos **Experienced Movers** and **Hollow Venus: Diary Of A Go-Go Dancer**. He has collaborated with performance artist David "The Impact Addict" Leslie since 1986 and played in the band Just Desserts since the '70s.*

Larry Fessenden

Robert Beck Memorial Cinema:
Weekly Visit to the Supernal Realms

by David Finkelstein

Every Tuesday evening, without fail, the Robert Beck Memorial Cinema lights up the ample screen of the Collective:Unconscious at 145 Ludlow Street with shadows, visions, primal screams, mathematical musings, and personal revelations. Hungry eyeballs are satisfied with endless investigations of the play of light and color. Starving ears are fulfilled with electronica and subtly altered birdsong.

Informal, guaranteed to start a bit late and go a bit longer than necessary, the Beck has provided me over the past year with an oasis where film and video are allowed to speak with a personal rather than a corporate voice. I have seen found-footage films, where old 16mm reels explaining the life cycles of rats have been scratched, bleached, blacked out, and otherwise altered, in silent explorations that reveal the teeming life and energy hidden in the mundane. I have seen surreal collages in which women writhe on Tibetan prayer wheels, and shadow plays in which men are transformed into birds. I have seen glorious celebrations of fucking, and cries of sexual rage and fear. A mock documentary in which an underground cult of desperately ill people cure themselves by using toxic waste. An exploration of the vastness of an American military compound, and George W. transformed into a teletubby.

I have seen film projected onto broken mirrors, so that it flies off the screen and onto the ceiling, walls, and floor. Film projected on smoke, through tissue paper, film mixed from an orchestra of projectors into a live, improvised collage. I have been invited to sit around a "campfire" and watch an installation of films about hoboes, to join in birthday celebrations and memorials, and to get myself stoned and dive into psychedelic bliss. One Tuesday, after seeing some fine films and enjoying cake and wine in celebration of Robert Beck host Bradley Eros's 50th birthday, I noticed out of the corner of my eye that projectionist extraordinaire Joel Schlemowitz was waltzing around the space with a movie camera. Several months later, at a special benefit screening for the Beck at Galapagos in Williamsburg, the resulting film, *The Birth of Eros*, was premiered, and I found myself watching myself on the screen, along with the other celebrants.

I have also seen truly terrible films, but remarkably few, considering the far-ranging and risky nature of the Beck's presentations. I have seen a wonderful show as part of an audience of two, followed the next week by a wonderful show with so many in attendance that people were stuffed into every available inch of space and into the projection booth, and still had to be turned away at the door.

And who, people inevitably ask, was this Robert Beck who is being so extravagantly memorialized? (The Cinema has been referred to on occasion as the "Roberta Beck." It is only fitting that a venue, which is so dedicated to personal redefinition, should itself be transgendered.) This question is answered in not one, but a whole series of short films produced by members of the Beck collective. A soldier in

Clayton Patterson

Bradley Eros

World War I, Beck suffered from hysterical blindness and deafness as a result of shell shock. On a trip from his sanatorium to a movie theater, a Buster Keaton film caused Beck to begin laughing and spontaneously recover his sight and hearing. Thus, the healing and redemptive power of film art is fittingly celebrated at a weekly temple for cinephiles on the Lower East Side.

Robert Beck Memorial Cinema www.rbmc.net

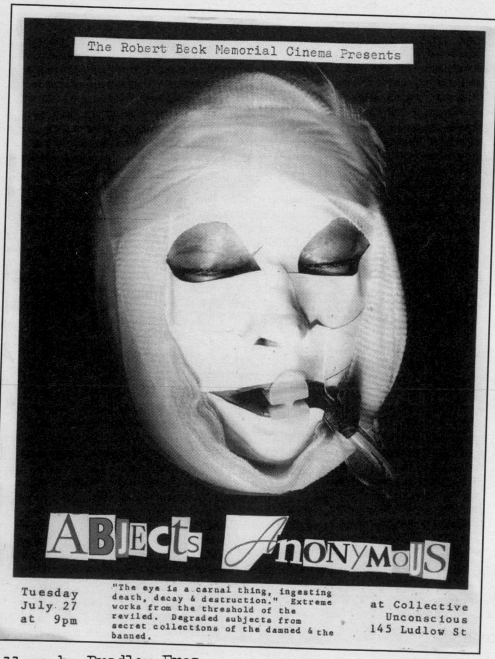

Collage by Bradley Eros

Bradley Eros and Brian Frye

Interviewed by Ed Halter
Transcribed by Mika Deutsch

Ed Halter: Could you talk a little bit about how and when Robert Beck got started?

Brian Frye: Okay. I guess I can start and Bradley will pick up. I moved out here in the fall of '97. For the first year at NYU, I was just going to school, but I was interested in doing some curating. I had done a couple of shows in San Francisco, just curated from the Art School Library. When I got to New York I rather had it in the back of my mind that it would be nice to do shows at some point. That became a stronger feeling when I realized that it just didn't feel like there were venues that were showing some things that I had really enjoyed seeing in San Francisco, at the Cinematheque especially—more local and experimental film on a regular basis.

So after I'd been in New York for about a year, Amy Greenfield mentioned that the people at Collective: Unconscious wanted to do a film series. I had never been over there and I didn't know anyone there but I went there to talk to them about it and see what they were interested in doing. When I saw the space it looked pretty doable and they basically had plenty of slots available—at the time they didn't have that much programming—so we sort of set it out that I would do shows on Tuesday nights at nine o'clock, which I figure is late enough that it wouldn't conflict with too many other film events going on in the city. Originally we set the price for admission at $3 and they made a real easy deal with us where the first $50 at the door went to cover the expense of the space, the next $50 would go to me which basically I'd wind up passing on to the artist—although it was sort of a moot point at that situation because I didn't know what kind of stuff we were programming—and then split half-and-half after that. Now with $3 of course it was rare that we were going to get over $100 at the door.

They said, "Oh, we want to do a film series. Can you start like, basically, in a week?" So, I started out by just getting some films and it was a very last minute thing. I just went into my library and checked out a couple of films from there. I got Emile De Antonio's *Underground* and the Nixon *Checkers Speech* and that was the first show that we did at the Beck. I just did a little poster and had maybe fifteen or twenty people show up or something. I think—Bradley, were you at that show?

Bradley Eros: I was there every show, yeah.

BF: So Bradley started coming then and almost immediately thereafter was making suggestions about things to program in the future, which I readily accepted since I still didn't know that many people in New York and he knew pretty much everybody. By I would say three or four shows later it was clear that we would end up doing it as a team, as opposed to just me.

EH: So what were some of the initial ideas you had together?

BE: Well the first show that I did was the fourth show; Brian had done that first show and then a collection of home movies and things that he had collected, and then we did a one person show with Eric Waldemar, who was at that time from Boulder. Then so the fourth show, I think maybe either you didn't have something or maybe you were even going to be gone that week and I said, "Oh I have a bunch of science films that I had just collected, some from the Donnell Library that I had just gotten." I said, "Well I'm going to look at them anyway so why don't we just look at them with other people?" But then as that approached it was like, well you know this film could use some extra smell to go with it actually . . . this one actually would be really good if there was actually a flavor, like a

taste because it was about carnivorous plants, so we had the idea of people holding something in their mouths while they watched it. Another one could use an alternative soundtrack, like a hypnotic soundtrack would be better with this one. And then it was like this one would be better if we projected it on the floor, you know? So each one had a different alteration to it.

As it turned out, it was like a performative installation or an interactive show and it sort of started that kind of possibility there. Since it was a theater and they had a great sound system and lighting and everything else, there was the possibility of projecting anywhere in the room and working with sound and light elements. It just kind of opened it up.

BF: I think it's true. It's like that show became the first time it became really practically obvious just how conducive the space was to film performance.

BE: Expanded cinema. That show was called "Subterranean Science" and I think it was the first one we had a poster for as well. It was always just this open idea that anything that either one of us would do was welcome. So sometimes we would both do posters, sometimes both do descriptions—or counter-descriptions—or someone else would be invited to do that. In terms of the process of inviting things in . . . it was like anything that either one of us were excited about or had dug up or just had realized that had gone undiscovered or unexplored for decades sometimes. Just finding a new context for old things and an old context for new things. And the possibility of bringing in live elements and inviting other people to do their own curation and contextualizing their own work. A lot of times people would come and they'd have a new film, or maybe just half an hour of film, and we'd think, well, what would be the best thing to show that with? One of your contemporaries, something historical, something unknown, something kind of lost in history?

BF: Yeah, asking people to show something else makes them think about curation, which oftentimes filmmakers don't do even with their own films. People will sometimes just come and say, well I'm going to show everything new, and they don't even think about order. It's real tempting for filmmakers to just show things chronologically, or just put everything up on the screen. Forcing them show something else makes them think about it as a programming exercise and not just showing their films.

BE: That whole idea of contextualizing, to me that was appealing because it was even an idea of recontextualizing my own work either in terms of other contemporary artists or in terms of people historically, or even things we had collected or things that we'd found that were really unknown completely, and yet somehow we're influenced and there's a dialogue with that work. There were times when both poetry and music, some performative elements, slides were all part of the context of showing films there.

Something that's been really central to us is the fact that the Collective:Unconscious is this amazingly generous risky place, and that the people who run it have just trusted us carte blanc from the beginning and then to have this flexibility, and that's equipped in such a way but really just the spirit of them—That's one of the things that no matter how messy, how rude, how obscene it's something that they would never even question. The idea that we have no sort of red tape about that, well they have none whatsoever with us. It's just staying true to our commitment to the dates.

BF: And I guess it's true that sometimes it gets forgotten that for all I give to make these shows happen, the people in the Collective:Unconscious give more, because they have no investment in seeing the shows work and yet they show up every week and run the door and set up the house and sweep the floor and pay the rent.

EH: Are they a nonprofit space?

BF: They are a nonprofit.

EH: And how long have they been around?

BE: They've been around for, I think, something like fifteen years, I guess because they were over on Avenue B at the old Gargoyle Mechanique space before, so I kind of knew a few people from that environment before they even moved to Ludlow Street. They're primarily a theater, but they do everything from music to readings.

EH: How do those, the economics of what you're doing inform what you're doing or how is

what you're doing inform what kind of economics you decide to take on, and what's the relationship between those?

BE: Well, with Collective:Unconscious they must still have a kind of rent that allows them to do that. It's the kind of space that I'm sure could be tripled at any moment so they seem to have a relationship with the landlord that's favorable to take those kind of chances. Many spaces in history have just ended abruptly because they don't have the rent anymore to exist. They could move to somebody's living room, but in a sense you have that flexibility of a space and that has so much to do with the history of art in New York City, if not everywhere, just the availability of that and the way that it might shift to Williamsburg or some other neighborhood just because there's both energy there and economic possibilities.

EH: Also Collective:Unconscious is not an art space; it's a performance space, which is a big difference for you.

BF: I guess the Robert Beck could conceivably happen in other locations and there were moments at which we were worried that the Collective:Unconscious might not continue to exist in its present form primarily because of the rent issue, and we did discuss what other places might be a possibility. But it's hard to see what would offer the same kind of flexibility. To have a space where you don't have to worry about revenue is always good. And the nice thing is for all the small amount of funding which the Robert Beck does receive comes primarily from our back pockets, you know it hasn't been all that much because we haven't had any major expenses—equipment and shipping and photocopying, but those are all pretty minor. I don't mind subsidizing shows to the tune of a few hundred dollars a year if it means I get to see what I want to see. But beyond that, I don't think it would be feasible.

BE: It seems like we just have the best possible autonomy in this situation. Even if we had moved, let's say, to Anthology, where we just did a show last week, there would not be that autonomy there for us, even though we could do whatever show we want but we'd have to basically channel everything through them. They function very well but it would still be under their umbrella.

BF: It's different. It's really different.

BE: At the Collective:Unconscious we're actually seen as part of their team. We're not like someone who just does something; we're actually part of their family. We never go to their meetings. [Laughter.] The distant part of the family.

BF: We're the favored children. The prodigal sons. But I think we offer something to them that they're interested in, that they want to have happen there. So there's a kind of mutually beneficial relationship in a sense that they wouldn't be able to do what we do and we couldn't get what they offer anywhere else.

BE: Medea [DeVice], who I know from Williamsburg, who ran a series of films at one of the old galleries that was huge, called Brand Name Damage, I think it was called, over in Williamsburg, maybe twelve years ago. She was doing work at the Collective:Unconscious about a year or so before we got involved, before Brian went over there, and asked me if I wanted to do films at the Collective:Unconscious. And I said, nah, I don't really like their space. [laughter] There just was something about the theater they were doing at the time that kind of reminded me more of like . . . it seemed more like the Cinema of Transgression. It just had a sort of ambiance that was more like the early years of the Underground Festival or something.

EH: Like nasty Lower East Side stuff.

BE: It didn't seem quite right for the spectrum that I was interested in. Not that I wouldn't maybe be part of It but it didn't have the ambiance of that spectrum, so I just said, no, I don't really like it's the right space.

BF: Yeah that was my first reaction when I went over there too actually, and I just threw up my hands, like I don't care. I saw the space and I knew what was going on there at the time and I didn't feel like it was exactly the sort of . . . it wasn't like they were doing other things that tied in to what I wanted to do, and I was worried at the time that they weren't going to be interested in what I was going to be doing, and yet I just figured that we'd see what hap-

pened. And as it turned out, I was totally wrong.

BE: Yeah, no, I was wrong, too. It turned out to be exactly—I thought I guess in a sense it didn't seem it had the tip of the spectrum that was serious enough. I knew it had the other range in terms of outrageousness, in terms of obscenity, but just in terms of being able to do something like showing Jurgen Reble or something that would have, you know, the cathedral sense which might also be an experience that we wanted to have. Just the kind of sense of something that might be a more mystical, holy sense of cinema.

BF: Kind of transcendent.

BE: It did not seem like that was possible there, and that's just part of our spectrum, but it turned out to be that all of that was possible. Maybe just because it seemed to be so close to the street, and the kind of things that they chose to do primarily.

BF: Yeah but the funny thing is, once you turn the lights off [laughs] the space becomes whatever you want it to be.

BE: It's a dark cave.

BF: And it's been really great in ways that I never would have originally expected it could be.

BE: I really actually like the fact very much—and this is actually what would be a limitation in other spaces—is the fact that the projection is in the room. There's a kind of presence of where the film comes from, of its mechanics, of its materiality, that's just part of it. There are a few times when you think, well, it would be great to actually have absolute silence to do something of great subtlety that hearing the clack of the projector isn't possible with. But I suppose we could actually build a box for those occasions which we could do.

EH: But it's good also for those ephemeral films, it has a sense of home movie or movie club atmosphere that is something I can only imagine, I never experienced that firsthand.

BE: Yeah it's such a great thing to be able to do that do in the space itself like many times with Super 8 . . .

BF: Put a table up in the audience.

BE: Put a table in the audience and have it right there living-room style, it's beautiful for that.

BF: In all honesty, when I was first deciding to do film I was sort of torn between doing something like a screening series and wanting to do something that was more like a club for filmmakers—like just to get together for people on a regular basis to watch films together. I would have been happy actually going either way, in a sense, although I think ultimately what we ended up doing was in some ways better, but I would like to see the other thing, too.

BE: Yeah. sometimes it's almost both, because if you think about the most hard-core members, if we do something like that those are gonna be the only people that show up. In one sense it's reflective of *The Opium Den*, which is before Brian's time, but a lot of the same people in terms of that—Mark McElhatten, Keith Sanborn, Jeanne Liotta, Peggy Ahwesh—are involved in that and like there's that connection to basically doing shows for players only where everyone sort of brings something and everyone is involved in making the show happen.

EH: A player's club.

BF: Our audiences tend to be artists, curators, film critics, people with a really serious investment in film. And I think we're starting to get more people who are newer to the medium or are just participating in the sense of being spectators. But in general the people who have tended to come most regularly and most consistently have been people who have already been immersed in kind of experimental filmmaking for a long time.

BE: It'd be amazing to actually see the demographic, which is unrecordable but, of people who've come only once, for one specific show, and which people have brought the most people who only came once and never came again. Which people have brought the most people who come often to their shows.

Ed: I thought that when I saw Glen [Fogel's] show, his show seemed to bring all these people that probably never came back or maybe some of them did but it definitely seemed to be his

own crowd of people that he knew.

BE: We've had quite a number of shows like that where people just round up their own audiences, often the people from out of town and all their friends. Like someone would say, well, it's a good place for me to get together with all my friends in New York so they come to the show.

BF: I think Nick Zedd shows have always been like that, that people would come to those and almost never come back to Collective:Unconscious.

EH: So what's it been like in terms of finding filmmakers to show work? Has it been entirely based of word of mouth and personal acquaintances, or is there any further kind of process?

BE: Well, people approach us at times. One of the curious things is . . . well, people want to give us a preview tape, and we kind of say, well, we don't have to do that. Because then we'll have to tell people we don't like their work and we just want to show the work that we like. And we kind of have an ear to the ground enough, both in terms of what we've seen and what comes our way and we hear about, and we trust that. Yes, there are some things that some people would personally say "you should show this" or "you're ignoring this" and we'd give attention to it.

BF: I think that more often than not we curate people, rather than films. There are a limited number of shows that we've done where we've actually gone out and collected specific films that fit a certain theme, thinking that these will go well together and make for an interesting program. But I would say that's the minority of programs. More often than not we'll either ask someone else to select films, to see what they're interested in, because they're a person whose taste we think is interesting or whose ideas we think are interesting. Or we ask artists to just curate their own stuff, because we know that they're interesting people and we want to see what they do. But it's pretty rare, I think, that we look at things and say, "Okay, we want to pick this one and that film and can you send us a tape to look at?" People ask me about it a lot. I think I'm a little bit less . . . my attitude is more like when people ask me to take submissions I say that we don't take submissions but that if you give me a tape I'll watch it. I don't say anything more than that, because, once again, there aren't that many opportunities even when people send things to really curate them in a show because it's just not the way it would work.

BE: We've actually got a show coming up that we're going to do, I think the first of August, that's gonna be a whole show of unsolicited work.

BF: Get 'em all off our floor! [Laughter.]

BE: Basically we're gonna do a "Gong Show" with all the unsolicited work. Then we can kind of deal with it. And if they're really good, they'll stay on.

BF: If they're really good, you know, we can always show them again in the future.

BE: Yeah, they could turn up in another context.

EH: So after awhile you started being asked to do Robert Beck shows in other locations— other places in New York and outside the city. What kind of curatorial relationship do you think those shows had to the Robert Beck at Collective:Unconscious?

BE: I think a lot of times we would get there and once again we would do something totally new rather than say let's just transport something we've done. Let's create something for that context, for that space, for that city, or for who's asking us. In one sense, it might just be a person we know there like Greg Pierce [of Orgone Cinema in Pittsburgh] and it might turn out to be, well, let's do something that Greg would like to see.

BF: And I think it's done several ways. There's ones we've done together and then there's also ones we've done separately and I know for myself oftentimes people have asked me to put together a show and I just kind of decide to call it a Robert Beck show no matter what. In those circumstance I tend to curate more proactively, really try to put together a program that's more refined and hunt down films and so on. So it's a little different in that respect,

probably more heavily curated than Beck shows tend to be.

EH: Besides the fact that you're both doing it, is there any difference between a show curated by Robert Beck versus a show curated by Bradley or a show curated by Brian? Like, is there a collective sense that you two have together that you don't feel you have individually?

BF: I think so.

BE: Yeah, I think there's a certain dynamic that just works between us of things that we're simply in dialogue about.

BF: Because I think we have similar tastes but expressed in really different ways.

EH: Like what sort of things?

BF: Well I find that it's really rare that we disagree about whether a film is good or not. [Laughter.]

BE: I think the things that we probably share the most are forms of cinema that people have ignored that actually have amazing beauty and strangeness to them, that people don't consider art or that are sort of unproven as works in any kind of canon, and yet there are moments in them as beautiful and extraordinary as anything that's recognized as a work of art. That's what's interesting: to put them in a context with other things that may or may not have been influenced by them or may or may not have a dialogue with them, but we see . . . you know, there's something going on here, structurally, subject matter, in approach to form, just a focus on something, an aspect of phenomena.

BF: I think looking for kind of the ecstatic element In art, that little bit of a film that causes it to be more than the sum of its parts—sort of the superb.

BE: And that probably has something to do with the way collecting films comes into it. Because I think that's the tie to a world of filmmaking and film watching that's outside of the realm of that which others institutions show. Because they're pretty much unproven entities. Maybe something like that would show up at the Margaret Mead [Film Festival, at the Museum of Natural History], or something might show up sort of historically down the line, where someone would discover something like Jean Painleve or some kind of science films for other reasons. They might be showing it purely for content, for subject matter, but a lot of times it's like there's a strange sort of beauty to them that we tap into. They're just outside of the realm of anything proven or sort of dismissed as works that are worthy of showing in an art context or an institution because they're not in any canon—people can't even name them. And they're usually anonymous. And yet we both of us agree that there are films that are as extraordinary as anything that one could name made by an artist.

BF: I guess I would just say I think the difference between the kind of curating that we do and the kind of curating that happens at other places is that there's an element of what goes on I think in the Robert Beck that sort of verges on the pathological in a way.

EH: The pathological? How?

BF: Like loving the movies too much, which I think oftentimes in other kinds of venues there's more of a reserve.

EH: Are there other venues that you feel fit your pathology as well?

BE: Well if you look at say something like the fact that Anthology has a collection of Joseph Cornell's private films—that comes closer to it. Now in some ways they're admitting to it because it's an artist's collection and we know that other museums do have collections—but I don't know how often they air them out. So they're a little bit shy about their obsessiveness.

EH: You mean a collection of his collection?

BE: A collection of his collection, yes. And in Cornell's case it's pretty clear that there's an interaction between what he makes as altered works and what he collected. That distinction is contended at Robert Beck. But other places won't really admit to that pathology or to that obsessiveness.

BF: I think you tend to see it more in places where there's people showing films without the support of an institution.

EH: Like what kind of places?

BF: So things like the former Orgone Cinema, the former Total Mobile Home Cinema [in San Francisco] or Craig Baldwin's Other Cinema [in San Francisco].

BE: Yeah, like Craig Baldwin, definitely. He would probably be the master of that because his appreciation for that pathology is great.

BF: I think I can speak for both Bradley and myself in saying that the reason I started showing films is because I wanted to see them, not because I was interested in anything beyond the films themselves. So for me, showing movies on Tuesday nights has always been about gratifying my own desire to see what we're showing, more than anything else.

EH: So how do you think your organizational model—which is in some sense an economic model, really—interacts with your esthetic interests? How do see these factors interacting?

BE: Well it has a lot to do with the fact that the context was strong, in terms of other people being involved, and that, internationally, there are people who wanted contexts in which there's this kind of risk and this kind of trust going on. And that they would prefer that environment, ultimately, to see their own work in, even though there is the piddling amount that they might be paid going to someplace that has a state budget or a federal budget giving them some $200 or something. In this case, I think that for the artists we're talking about, the context of that community and the context of that dialogue with an audience—and with other obsessives even—is probably a stronger compulsion, because it's closer to the reasons why they make their work. I think that the economics is something about the passion. It's something about their reason for doing their work in the first place, because avant-garde film doesn't have a golden ring—there isn't such a payoff in any sense. Often we've argued that economically, even poetry, you know one in a thousand can get a book deal. But with avant-garde film there is no deal to be made. Even Brakhage doesn't live off it. In that sense, the reason for . . . the modus operandi for making films cannot be economic, pure in and of itself. So Robert Beck in a sense taps into that consciousness: that the stronger social system is that of the passionate environment.

BF: I think it also diffuses the temptation to compromise. We don't have to pander to anybody because . . .

Ed: Except yourselves. [Laughter.]

BF: Well except ourselves.

Ed: You're always pandering to yourselves. Pathetically.

BF: Exactly. But really, with what we show, there's no reason that it has to reflect anything but what we ourselves are interested in. So beyond feeling a certain amount of personal pressure from people who might want to show something, we don't actually have to do anything at all, and there's not even a tacit dictate from any institution saying, well, you need to reflect certain kinds of things that we would like to see you doing. And that's true, I think, in any institution where you've got funding coming from the outside, that the people who fund something quite rightly in a way are gonna have some influence on what the institution does. And the institution will in some way reflect the interests, desires, and needs of the people who are paying for this operation. We're not in a situation where that's an issue. We've been lucky enough at Collective:Unconscious that they intervene not at all in what we do, beyond perhaps telling us once in a while that well tonight you have to do it at a different time because we have a different event taking place beforehand. But they have never even asked us ahead of time what we were going to be showing.

BE: It's interesting that the federal government and the state government in some ways will often try to influence what they consider a "social ill," in terms of their funding. In one sense, we would say, well, the federal government deciding what should be shown is a social ill. So even though there's a corrective about a minority of anything not being represented, the pressure itself, in a certain anarchistic sense, of the federal government deciding that . . . I see that as an ill.

EH: Now as Robert Beck went on there developed a whole bunch of different screening societies in New York: Ocularis in Williamsburg, Astria Suparak's programming in various places,

Rooftop Films in Brooklyn, Fresh Film at Anthology. . . . Did you begin to feel a sense of where Robert Beck fit within that new constellation, or did it simply not influence you?

BE: Well in some ways we were involved in most of it! [Laughter.] It seems like the interest in avant-garde experimental film has often come in waves in New York and San Francisco. When the Collective for Living Cinema existed [downtown in the '70s to early '90s] there was always something running daily, as at Millennium and Anthology and some other ephemeral places, that have since passed. It seemed like at the very time that Robert Beck started, there was once again a dearth and the [New York] Underground [Film Festival] was changing, in my perception, changing its emphasis, broadening its emphasis. There was much more interaction with avant-garde work that seemed to be in concert with Robert Beck. And at the same time in a few other places, there seemed to be an intense dialogue or interaction between a lot of energy and a lot of emphasis on it and it just seemed like a wave that was very strong. In most situations like that it's usually just one or two individuals. If you look at any of the history of making places happen, you have a Jonas Mekas, a Craig Baldwin. That happened but it was basically one or two people that sort of made it that. And it seemed like an energy that just quantumly multiplied, but it is also because there is this great need that was just there, and there are so many filmmakers that would once in a while sort of beg for or make a deal to show their work every two or three years but they weren't contextualizing it themselves; they would sort of show up, do the show and leave in some ways. It didn't seem like that interactive a community. And yet people wanted it. It took that energy and just focused it.

BF: I think also that it's true that several other people started showing films and videos since we started doing the Beck shows four years ago and I think—my sense anyways—that one of the reasons for that, when people don't see anything happening, they assume it must be really difficult to organize screenings and so they kind of get scared off. But when they see somebody doing it on a regular basis, you're like an example that, wait a minute, if this guy could do it for nothing every week, and if these two guys can do shows every week, then it can't be that hard, it's gotta be easy because, dammit, it doesn't seem to be a problem for them!

BE: If people have equipment, and they have a friendly environment, like Jane [Gang] at the Pink Pony, or like Tessa [Hughes-Freeland] and Ela [Troyano] in various environments, someplace that would actually allow them to do it for almost nothing, or for maybe $50 at the door. . . . They have the equipment, often people have the context, and many shows people will actually organize themselves. Given the opportunity, many filmmakers would put together a couple of shows a year. There actually are that many people around—and the truth is, other people will actually come out with work that they had not found the right environment for, and will actually make more work, in a sense, because there is actually that excitement. For some people, they always work in isolation and other people actually work and live in the community; they actually make things when they know there is a dialogue among the artists.

EH: Now have there been artists who would not show at Robert Beck but you wanted, that you had asked?

BF: No . . . there were people who I have approached who were noncommittal but nothing like that happened. And there were people I've written an email or something to that never responded. There has never been anybody who has refused.

BE: That would be interesting, if there were people who maybe thought they were too big for it.

BF: I think there are people we wouldn't ask unless they suggested it.

BE: Maybe somebody like Robert Beavers, who is someone would like to have a certain control over the environment . . . but he actually has come and been very supportive. Some people would say this is actually the perfect environment.

Ed: A lot of people do say that about Robert Beck.

BE: it could be a little noisier, because the projection is actually in the space that in itself. In terms of silent films it can be a distraction understandably.

BF: I think there are certainly filmmakers who wouldn't see our space as one that would be conducive to showing the kinds of films that they make, and I think Beavers is probably the perfect

example. Most of his stuff is typically shown in 35mm, and we just can't do that. So we never even thought it was an issue as to whether or not we would be able to show his films.

BE: But it's interesting how a lot of people have come through . . . say, they just had a Cineprobe at MOMA, and they would instantly book and coordinate a show at Robert Beck to do something more orthodox with their own work. Something they've never shown publicly or something that they haven't shown for 20 years, or something that they want to put in their context themselves and excitedly doing an alternative show there. And that's when you see it doesn't necessarily have to compete with that. Those two things can go hand in hand. An audience has the possibility in the same week to see two different shows.

EH: Now as Robert Beck became more and more well known, did you ever get people who had strange kind of expectations of what it was? Maybe because people hadn't been to it, but just because they'd heard of it and they assumed it was something well funded or established?

BE: We got that in a couple versions. One of course is the fact that people might assume that there's a budget, because we did the shows every week, and I would say, well, resourcefulness is one of the key elements in that and you yourself as a curator or a filmmaker sort of need to figure that out and there's always a challenge to do that, and can you do it on no budget at all, or is it passionate enough that you actually throw some of your own money into it, because you're doing something rare. We do get requests sometimes—and this is a problem with unsolicited material—that's kind of like a narrative that New Filmmakers at Anthology is a much better place for, and we just send them over there. There are so many venues for indie narratives that we don't need to cover that. Not that there couldn't be something that we would love, and that we would show, because there have been some good so-called narrative films, but in general there's so many other venues, and it's like, go elsewhere, because that's covered.

BF: I think there are sometimes people who feel somewhat entitled to show their films wherever they want to and then they would get—

BE: That's those five-hundred-pound canaries.

Ed: Five-hundred-pound canaries? I never heard that phrase!

BE; Where does a five-hundred-pound canary sit?

Ed: Wherever he wants to!

BF: You know like people get a little miffed when we're not as interested as they think we ought to be. You know we just try to be politic about it, and I'm not going to say anything nasty about somebody's films to them. If I'm not interested, I'm not interested. But, there are certainly things that people have felt like they couldn't understand why we weren't interested in showing something. But, you know, we don't have to.

BE: There's no protocol, there's no red tape, there's no bureaucracy. If we're interested in it, we do it. And that could happen a few days before the show.

BF: And our criteria are a lot more flexible and a lot more volatile than a lot of other—

BE: Somebody asked me that: Did you ever decide right before a show? Well, we've actually decided while the films are actually on what to show. Like there could be something in that bag that we didn't intend to show and suddenly five minutes later it's on the screen.

EH: Now two of the things that I've noticed with the Underground Festival—and I wonder if you've noticed a similar thing—that I didn't expect going into it is that the way it influenced filmmaking. Not just that A) it often encouraged people to make films, because they knew there was a place to show that type of work but B) we would sometimes get films that seemed to be pandering to what they thought we wanted, which can be very bad or they can sometimes be good. You know, trying to fit what they perceived as the aesthetic of the venue. Did you ever sense that happening?

BF: I don't think specifically, but I would say that I think the fact that people have seen us doing the show every week and showing the kinds of things that we show—like kind of raw, more austere, unfinished—and being sympathetic to that kind of filmmaking has encouraged people to make those kinds of films. Maybe not even start making them, but to make them more regu-

larly and make more of them, and to show them more frequently. Because I think that when people feel like no one is interested in something, it's harder to do it. And I have felt like there have been a lot of people who suddenly started making films that we were interested in, who maybe hadn't been that before or hadn't been doing that as regularly. And it's also encouraged people to bring out things that they did a long time ago and they maybe didn't think so highly of then, but look back at it now and realize that there's actually a venue for it.

BE: Sometimes, it made people take more seriously the fragmentary, the unfinished, the home movie. That's strange, because already some people could have said both Brakhage or Mekas or someone like that could have influenced that aspect of it. But maybe they sort of skipped over that and they figure that influence had maybe waned, and what are young people doing today?

But you see it sometimes coming out of film schools that emphasize experimental work, like Binghamton, and San Francisco, Bard and places like that, where you have someone there who already takes that work seriously, those kind of approaches seriously. We may show work by students. And often there's a question of well are these people actually . . . ok, they made some films, are they filmmakers? Just in the passionate sense, do they embrace that? Once they get over the scare that you're not going to make a living doing this, and they still need to do it, then there's that question of what are they going to do with their films. And in one sense, they say, here's the kind of place that they can be shown, and then they realize this is the kind of place they themselves could keep alive. We always kind of joke about it but in the old Che Guevara sense, two, three million Robert Becks, they could spring up like mushrooms all over the place. And if there's that interest and pathology and passion, then they should.

EH: Now what about Robert Beck's relationships with galleries or non-profit art spaces—which is another venue that experimental film and video gets shown.

BE: Well we've had a very great dialogue with, say, the Whitney and also MoMA.

EH: Those are the film departments of those museums. I'm talking more about things like your show at Exit Art.

BE: Yeah we did a series of shows at Exit Art. That was kind of historical, but of course, in our sense rather than just do it historically we actually did all new shows there that were related to the mammoth Super 8 series that they had done. One was related to The Opium Den and one was related to Conspiracies, which were all kind ephemeral situations that had existed [in the '80s and '90s].

BF: I will say however—and I don't know about Bradley—but I think both of us found the experience of working with galleries especially incredibly fucking frustrating.

EH: Yeah? Like how so?

BE: Well because they have so much red tape, they have so much protocol, so much bureaucracy.

EH: Are you talking about nonprofit spaces or for-profit galleries or both?

BE: Both. Anything where you've got a director and employees, they have to stay in command. They have this hierarchy and everything often has to pass through that.

BF: Everyone has to cover their ass.

BE: There are some situations where someone is going to be like, we trust you, we like what you do, do your thing. But in many situations—

BF: —More often than not . . .

BE: —it's like everyone is protecting themselves and I think sometimes they're afraid of funders, sometimes they're afraid of being critiqued for subject matter.

BF: And I think every single place, they want to be in a position to take credit for a success, and to pawn off a failure on somebody else. And I think the difference with us is we're not afraid of failing.

BE: We actually encourage failures and mistakes. It's one of our credos. But let's say a gallery that's run by a single individual and they trust us, the interaction could be great and that has happened.

EH: Now what about the film and video that you see at galleries? Aside from the context in which it's produced, what kind of relationship do you see that with the world that you're dealing with?

BF: Well I think people who are in galleries are just starting to realize that film and video can be art, and not just movies, that moving images are appropriate for a gallery/museum context. But I think they have yet to realize that there is a history and an idiom that has existed for quite some time that they're not familiar with, because of partial self-segregation and partial willful ignorance on the part of the people in museums and galleries. There hasn't been a whole lot of back and forth between people who make experimental films and people who work in a fine art context and I think it's as much a failure of the filmmakers as it is on the galleries, because I think most filmmakers like to think of themselves as directors. At least a little bit in the back of their heads, people still want to see their movie showing at the Ziegfeld. That's how every filmmaker fell in love with the movies, and then started doing something that didn't quite fit with that, but a little bit of them still feels like they make *movies,* you know . . .

BE: There are people who—and this is probably more where we come from—which is the model of the artist-filmmaker, of the filmmaker-artist which comes out of the European avant-garde tradition of the '20s.

BF: But even they fell in love with the movies.

Ed: But also those artists were shown at the movies. They weren't just shown at little cinematheques.

BF: That hasn't happened for a long time. Mary Ellen Dietch at Radio City Music Hall, but that didn't last very long. But I think that the fact that gallery owners and museum curators who aren't film curators are trying to come around to the idea that moving images can be art is kind of forcing them little by little to realize that there's a whole lot of stuff out there that they don't know about that's really great and in fact in many cases predates and is much more effective artistically than the kinds of things that they're actually showing by people who didn't really learn how to make movies, and don't really even necessarily understand how films work. So I do think there's a kind of growing awareness among people in the museum world of experimental film. I think the reverse has always been the case. Artists who make films tend to know at least a little something about the fine art world, and the reverse is rarely the case.

BE: I think they know that because they do approach it as art, and so they keep their ears to the art world. But there is that aspect in which, as a dematerialized object, this kind of film makes perfect sense in a gallery. But then there's just always that question of the propriety sort of reification of film: you know, can they sell it as an object? Does it have to be exclusively in the art world? Because that, for me, seems like the major reason why there isn't a crossover. It has to do with the economic aspect of it as an object, and that if a gallery wants to deal with it as something, as a commodity, it's difficult unless it's limited and that's been more of the history of it. If the object is basically seen as a film that's highly reproducible, they're not going to be able to market it, in that sense. And galleries do have an emphasis on that. So that one of the main reasons why there isn't this crossover; it's not the artists themselves, it's more about the economic system in which their work might be viewed. And I think that's often dictated by the galleries themselves saying, well if you're going to try to deal with this as a product, as an object you're going to have to limit it and often not show it in the context in which it's de-emphasized in terms of its economic value. And that means rarifying it.

BF: I agree in a certain sense, although I would kind of twist it around a little bit and say that I don't think that it's the lack of an object to sell that's a problem, but the lack of a market to sell it in. Because, in fact, I think when it comes right down to it, film prints are self-limiting. A film print is a de facto limited edition by stint of the fact that A) people can't afford to make very many prints and B) as the available film stocks and available materials change there's a de facto sort of "historical print" versus "brand new print." You can no longer make a Kodachrome print of a Brakhage film; the number that exists now are as many as there are ever going to be. So, by definition, these are now limited editions.

BE: Right. It has to do with educating the art world of that idea.

BF: But I think that the thing that's missing is really the demand, and the demand is going to exist eventually no matter what, because I think the work is important enough and valuable enough that eventually people are going to figure out that it's worth owning, and if it's worth owning, it's worth buying and selling and has a value, and once it has a value, there'll be a market. It's just a question of how long it's gonna take, what it's gonna look like, and really what's going to be bought and sold. But I think the sooner the better, quite honestly. Nothing preserves artwork like value. Once it's worth something, people are going to be a lot more interested in showing it, and a lot more interested in keeping it in good condition, and a lot more interested in getting it out there. Because, the fact of the matter is, galleries want the things that they're showing, especially when they're not worth that much yet, to be shown as frequently as possible because the more often people see it, the more people want it and the more valuable it is.

BE: Right, but that also means that they need to have an exhibition copy and a preservation copy.

BF: Sure.

BE: Because in many situations it could be they just like at it as preservation and then there's a film that's kept but not shown.

BF: But I honestly don't really think that happens very often. I think that unless something's already valuable, people realize that if you want to sell it as an object people need to be able to see it in order to value it, and it needs to be out there or else it won't be worth anything.

BE: Yeah, that's the truth of the art world.

BF: And the fact is, film's not worth that much yet. So, it's in filmmakers' best interest to show them as frequently as possible no matter what the economic situation. And filmmakers know this, because you see how most beginning filmmakers approach showing their films. In most other art contexts, people don't pay to have their stuff shown, and festivals sort of amount to artists paying other people to show their films. It's not even that they're showing them for free; they're actually giving them money in order to show their stuff. Filmmakers know that until the stuff is out there, if people are seeing it they're thankful. So in a way I kind of feel like that's the way in which the Co-op distribution model, which was started in the '60s and looked like a really good idea then, has proven a little bit of a boondoggle, in retrospect, because it actually limits the availability of films in a certain sense, because it doesn't play to the needs a lot of the people who are making films now. I think it serves filmmakers who are more established pretty efficiently, but for younger artists, it doesn't work very well because if people don't already know the films, they're definitely not going to pay $20 to rent them, sight unseen.

Ed: Yeah, and the cooperative model doesn't engender any kind of curatorial outlook to frame the work, to say, this is why this work is important or this is how you might show it.

BE: It also will limit the direct contact that the artist has to the people who are interested, because often there's no communication there and that's actually one of the most important things in terms of the work having a social life, is that the artist themselves have contact with the people that have interest in their work and therefore find other connections through that.

BF: Also I think like a nontheatrical model, like the Co-op distribution model, assumes you're going to maximize revenue by showing the film repeatedly to paying customers, rather than selling it as an object, and I think in the case of experimental film that may not be the case.

EH: Now we've gotten off Robert Beck a little bit but just maybe as a last question, at any point during the process of doing Robert Beck, did you develop a sense of its future, of what was to come, or was it a month by month type of thing?

BE: Well I think because both of us have a lifelong interest in both making films and seeing films and having contact with artists that outside of the limitations of other things in our life, it's an ongoing prospect. There is that venue which has allowed a sort of great amount of flexibility—Collective:Unconscious—I don't immediately know of another venue but I think they could exist but it has a lot to do with the shifting economics of New York City. But I think that

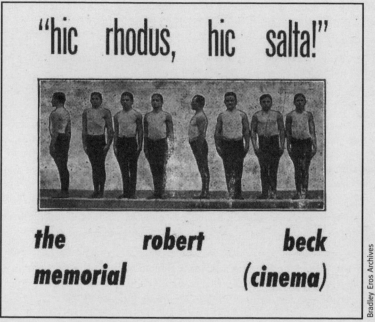

Robert Beck Theatre Invite

our interest in being involved in it, even if Brian goes away temporarily, there's the possibility of a version of Robert Beck springing up elsewhere and the possibility of other people being involved in New York, and expanding that and Brian coming back and—

BF: Yeah, in a way I kind of see it almost as a necessary next step, that the kind of the shows have to change now to include other people who hadn't . . . it's like forcing people to make that additional commitment because it's not really feasible to do it all by yourself. I would not have been able to do the shows if Bradley would not have started doing it with me. It would have been impossible to really do that by myself.

BE: It is a good way to gauge the necessity of it, you know the fact that people will commit themselves to it because they want it to happen. They want to perpetuate it.

BF: Like forcing people to put their money where their mouth is.

EH: So maybe you want to explain in your own words what exactly you are doing at this point, like what is happening now that Brian's going away.

BE: Well there's an invitation to sort of our hard-core members to be involved in the functioning of Robert Beck in terms of curating, in terms of doing . . .

BF: I think less than curating. It's the mundane things, like making sure the equipment works, making sure the calendars go out, making sure that people show up for the show ahead of time and set things up. Those are the things that are less immediately rewarding for a lot of people, and the kind of thing people don't jump on right away. It's easy to curate shows; that's the fun part. It doesn't take virtually any effort to find people willing to curate shows. The hard thing to do is to get people to commit to coming every week and doing a job.

BE: Actually doing the projection, actually doing the calendar, actually doing publicity.

BF: To do things for other people that don't benefit them directly.

BE: Actually being a host. But in that sense, we would share the curating because then that's the plus side of it. So that would motivate people and if people have ideas and contacts outside of us. Normally people would just share those things with us and then we would include them, but in this sense, it's sort of like their own motivation allows them to be in the driver's seat.

Why the Lower East Side?

by James Tully

Both my parents were New York natives, and after my father left the city for the Second World War, he decided the living was more gracious out west. As a kid in Denver, my earliest images of New York were a complex bundle of scenes from *Taxi Driver* and *Kojak*. To this very day, the city is a sort of lawless, feral playground for arrests of any medium. For me, as a filmmaker, New York resonates a continuous hymn that goes back to Warhol, E. B. White, Burroughs, Fitzgerald, and Henry James. These influences spoke to me as an alternative endorsement for the fulfilling life this city offers.

Over the past 15 years it is the East Village that keeps me here, provides me shelter (at a dear price), and feeds my work as an artist. My research on the neighborhood's past has revealed that my very street once lead to the Dutch governor's estate, and was a well-trafficked Native American trail before that. Something is very central about the place where I live.

Clayton Patterson

James Tully 2003

There is an insularity to the Lower East Side that fosters a tightly knit community. Tompkins Square Park, although it is far from the geographic center of Manhattan, seems very much like an alternative Central Park. No wonder this turf was so contested during the 1980s, when the city government and developers began to see the artistic and the free spirited as an inconvenient (and under-funded) nuisance.

My work as a painter and filmmaker has bonded me with a legion of similarly driven—and at times similarly misguided—individuals. Collaboration is freely given here. Someone will often volunteer to perform without pay when my film is without funding, or to operate the sound boom. I do the same for several colleagues, and also act as an amateur projectionist when my film and video gear is requested. The Lower East Side has always harbored a certain irreverent intellect and spirit that would not be tolerated elsewhere in this commerce-driven city. This spirit is still here, although endangered.

JAMES TULLY
VIDEO ARTIST & SUPER 8 FILMMAKER
Growing up in a military family, I was repeatedly told that New York City had slipped from its previous glory and influence; a city to be avoided by the sane and the virtuous. I suppose from that point on I was destined to move to Manhattan.

Videos of
Angel Orensanz

by Jessica Glass

The evocative videos of Angel Orensanz reveal an artist of seemingly boundless creativity. This impression owes much to the on-camera presence and enthusiasm of Orensanz himself, despite the fact that the videos actually adhere to a distinctive formula defined by a certain set of stylistic elements.

One could characterize the Orensanz videos as experimental documentary; but they are better described as visual poems. There is no spoken word, nor voice-over. Yet each video follows the artist's path as he creates or modifies an installation, or stages a public "intervention" with his sculptures. Experienced in an entirely different way than a live event, the videos become new works in

Clayton Patterson

Angel Orensanz on the craters of Mars set.

their own right. The soundtracks vary widely but always consist of frequently changing selections from a wide range of musical genres, which complement or contradict the action. Literary excerpts introduce, appear within, or end a piece, helping to create a certain mood or enhance our understanding of the content.

The complexity and dynamism of these elements and a fluid camera and editing style are brought together by the presence of the artist on camera, who interacts with his work, often in public. There is clearly a closely-knit team collaborating on the production of these videos. The result is a set of video works with moments that are by turns harmonious and beautiful, raw and uneven, but as a whole, always compelling and thought-provoking.

* * *

The philosophical, the existential, the surreal: these ways of looking at the world are never far from the aesthetic realm of Angel Orensanz. *Kunstluft* begins with a provocative quotation from Hegel, who speaks on the aim of art to fill the heart and "stir the human breast in its depths and its manifold aspects and possibilities." Orensanz appears in the video's prelude, shot from a dizzyingly high angle looking up at his creations; spinning these long, thin, graceful perforated metal cylinders, he gives them life as they hang in a stairwell. In *Kunstluft,* many incongruous objects hang suspended in mid-air, fly across cities, and are reassembled to create a whole new installation.

The second movement of the video begins. Snow-white store mannequins sculpted in that inhuman way are pressed into service to become angels . . . a tango partner . . . and finally corpses. The artist as puppet-master drags a female form draped with a hooded cape into position, joining the others and the sphere, his signature giant plastic inflated orb. Surrounded by beams of daylight streaming In from the vaulted windows and radiant patches of primary colors, the only movement is the insidious smoke wafting through the space, and the mannequins' cloaks rippling in the air. Here the suspended mannequins truly look like angels, and the male and female forms standing at the altar clearly evoke Adam and Eve. The dynamic camera movement and solemn solo organ piece by Buxtehude integrate the elements of the installation. Is the scene eerie or transcendent? You be the judge.

Suddenly the music switches to the saucy and triumphant *Bolero* by Ravel. Orensanz is holding the orb above his head like Atlas, flying with his rigid guide over New York and Paris. The superimposed mannequin's snow-white surface appears in sharp contrast to the background, shown in negative color. Elements of the surreal are heightened as the artist appears both grandiose, like Charles Foster Kane from a low angle and playful as he waves his dangling legs over the apocalyptic cityscape. He is The Little Prince on a fantastic voyage.

Then flames and an explosion: we are back in the old synagogue, Orensanz' frequent studio. What has happened while they were gone? The angels lie on the floor; they have become corpses. Their flying companion spatters them with leaves and flower petals. A fire pit nearby adds movement to the tender, inert wreckage of the scene. Insistent strings sound like wailing.

Sequences from the film *Blade Runner* come to mind with their rich, dark imagery and guarded optimism; the thin line between human and android in *Blade Runner* resonates with the artist and mannequins, the real world and the imaginary in *Kunstluft.* Even in the sanctuary of this space, one cannot escape destruction and death; one can only appreciate the beauty of decay and change.

The rhythm of the music, the camera moves and the editing are in perfect sync.

Although the mood is desolate, the change to a light orchestral piece of music suggests a certain poignancy and the ruins become a beautifully composed landscape. The scene is an elaborate texture made up of hanging metal totem poles, clusters of light and plants, floating mannequins, painted and draped plastic sheeting, white birch trees and two spheres—an amalgam of Orensanz' sculptures thrown into controlled chaos.

Yet true to its title, *Kunstluft*, Orensanz picks up a female form and dances a traditional tango with her. He then places her upright among the birch trees so that she can watch the fire. Next it is *Charlie and the Chocolate Factory* as a bunch of kids appears, twirling umbrellas with the artist who is dressed in a white suit and hat. They dance and explore the space with glee.

Kunstluft ends with another quotation from Hegel that celebrates the purpose and complexity of art: ". . . to make intelligible misfortune and misery, wickedness and crime . . . and finally, to set imagination roving in idle toying of fancy, and luxuriating in the seductive spells of sense-stimulating visions . . ."

Spheroid Memories features Orensanz' infamous "globo" or sphere. Through the metaphor of the sphere and the circle, the movement of the artist and his objects through time and space in this work covers a wide range of Angel Orensanz' work, from the joyful and celebratory to the sorrowful and poignant.

Spheroid Memories begins with a quote from Aristotle: "The perfect things move in circles." In one of his more narrative videos, Orensanz' circular journey takes the sphere from The Lake in Central Park, NYC to The Orensanz Center on the Lower East Side in Manhattan to Venice and back to The Lake. This work is a travel diary of Orensanz' interventions using spherical objects.

In the opening sequence we see the giant inflated plastic sphere, painted with strokes of color, floating in The Lake. Then at The Orensanz Center, a former 19th Century German synagogue, the artist flings it off the balcony; this is intercut with prescient shots of the building's exterior. As he rolls the sphere around the space we see the intricate textures, the soaring forms and the decayed elegance of this gothic interior architecture lit with blues, reds, yellows. The hypnotic solo organ music with chant that accompanies this sequence is punctuated by a shot of the artist gesturing at the camera, as if he's a magician casting a spell on the viewer.

There are several unforgettable sequences in *Spheroid Memories.* At the beginning of Orensanz' odyssey with the sphere, he rolls it down the steps of the Lower East Side building and out into the street. There he does a sort of dance, perhaps blessing it and making it streetworthy before rolling it down the middle of the street. There is a cutaway to a small child staring in bewilderment at this totally incongruous activity, straining to comprehend. It's a very funny moment and this shot instantly gives us another perspective on the scene. The cinema verité pioneer, Al Maysles would say that capturing these kinds of undirected, natural, spontaneous moments have the most poignancy and meaning. It's a treat to see a real, spontaneous reaction, which was pioneered by *Candid Camera* and morphed and bastardized by more recent reality TV shows. Later we see Orensanz rolling the sphere through the streets of Venice. He sets up a long strip of plastic sheeting and paints it for the crowd. Suddenly he is reaching out to take the hand of a chimpanzee in costume on a leash. The soundtrack of a traditional Yiddish tune adds to the Absurd, as he hands the monkey a paint stick, encouraging it to contribute to the artwork. The monkey takes it, sniffs it, and throws it down.

Steel and Cherry Trees is a visual festival of man-made colored fabric discs and other objects that are placed on cherry trees which are in full bloom. Along with a rusty old bicycle, painted plastic sheeting and an empty picture frame they all seem to have sprung forth from nature. The sunlight shimmering through a blue disc, the minimalist music and a quotation from *Death in Venice* by Thomas Mann evoke "a late-summer sultry feeling . . ."

If you saw a still from the video *Cherry Trees,* you might immediately think of *Figure in front of the Sun* from 1968 or many of the other middle and later works by Joan Miró in its use of vibrantly colored shapes and lines on a flat ground. The use and placement of these oversize discs in red, blue, yellow, and white in the trees is further abstracted in the video because we never get a typical landscape view; everything is in close-up, creating an abstract impression of color, texture and shape.

Yet seen in other contexts they take on more apparent meaning.

Orensanz clearly revels in the flying slicing movement of his large colored discs, and releases them from their static roost.

In a square in Venice, the artist joyfully shares his round creations and invites bystanders to participate. They fling the discs into the air and like boomerangs they return intact, back to the starting point. The discs are a catalyst for action wherever they go. One is flung skyward and a flock of birds takes flight. The discs are like the flock of birds themselves that we see over and over, beautiful together in flight when disturbed from rest. For Angel Orensanz it is

not enough to create beautiful objects and arrange them in an artful way; if they can move or be carried or thrown or pushed, they must be used to intervene in the routine of daily life, to upset the expected.

Even when they are still, placed back among tree branches to roost along with the rusty bicycle and old picture frame, they become part of a tableau that re-defines still-life. It looks like several layers lifted out of a cubist painting, broken apart and rendered three-dimensional. Orensanz examines the round wheel of the bicycle and the circular sound hole of the guitar; the shots are cut to the beat of middle-eastern electronica. Other sections flow to a jazz collage . . . it is the pure interplay between the music and the visuals in *Steel and Cherry Trees* that is most enchanting.

Later Orensanz is gesturing in front of a giant sculpture that features metal balls at the ends of radiating poles. The camera captures fantastically dizzying angles of the flat colored discs and great transparent sphere. Suddenly there are other people too, and discs and the sphere, all euphorically defying gravity. Not merely toys, although they were made to be played with, these objects and the way they are used in the video is really the essence of dynamic sculpture.

* * *

Public art vs. private art; sanctity of The Object by The Artist vs. participation by random strangers; the synthetic vs. the organic...to Angel Orensanz, there is no boundary line between what is restricted and what is to be explored. It is this link of non-conformity and originality, more than the obvious connections of culture and geography, that connects the Spanish artist Angel Orensanz to the other Spanish artists Joan Miró or Luis Buñuel.

Many images from *Steel and Cherry Trees,* for example, in their depiction of simplified colors and forms and distorted composition are unmistakably akin to the mid-to-later period works of Miró. And in *Earthface* and other works, Orensanz' exploration of the irrational, use of symbolic and organic forms, and a playful approach can be linked to that of Miró throughout his oeuvre.

Orensanz clearly feels a creative kinship on many levels with Buñuel, and has paid homage to the Spanish master with such sculptures as *Buñuel : The Exterminating Fire* and *Razor in the Eye, (Bunuel).*

Certainly the works of all three can be compared in terms of surrealist tendencies, demonstrating a worldview that regards organized religion and bourgeois or mainstream society as absurd or false. Whether it's painting, film, sculpture or a public art intervention, their work explores imagination and fantasy in a way that is unfettered by the Norm, conventional notions of Reality. Yet as both Miró and Buñuel refused to identify themselves strictly as Surrealists, Orensanz also prefers to operate outside the bounds of genre or School. He continues to find inspiration in unpredictable places, and links incongruous elements in ways that make sense. Orensanz and his collaborators have developed an oeuvre of video productions that, like Orensanz' other art, explores controlled chaos, celebrates the act of surprising people and inviting them to participate, and creates intersections between life, art, literature and music.

Orensanz does not live in an insular world of whimsy, however. *Spheroid Memories,* for example includes some extremely poignant moments in reaction to the 9/11 tragedy. Yet even when confronted with conflict Orensanz maintains a great sense of humor and a healthy skepticism. In *Steel and Cherry Trees*, there is a quotation from *Death in Venice,* in which Thomas Mann describes a scene with a young artist who held his audience "...breathlessly enthralled with his cynical pronouncements about the dubious nature of art and the artist himself."

Jessica Glass is Video Producer, Metropolitan Museum of Art, New York.

Angel Orensanz:
Times and Spaces

by Aalbert Stracke

In a video documentary of 1989, Anselm Kiefer is visiting the studio of Angel Orensanz on Norfolk Street with a view to develop a major temporary installation. An assistant of the German painter asks Orensanz why he purchased this historical building and how he feels about working there. Orensanz raises his sight to the 45-foot-high ceilings, extends his arms and says: "To me this is a like a rock, like a cloud, or like a cave". Then he expands that metaphor into more specific comments about the uncertainties that lay outdoors up to Tompkins Square Park, down to Grand Street, west to the Bowery and Broadway, not to mention eastwards, to the Projects. There are rows upon rows of abandoned and burnt down buildings. The city is falling into a climate of anomy. But the dangers down those mean streets are not a big deal in comparison with the threats that any New York artist has to face down the the dirty boulevards of the markets and the culture wars. Angel Orensanz (Spain, 1944) opened his studio in New York in 1986 after working with several American architects, including Marcel Breuer, Martin Gelber and John Portman. He has carried major installation concepts for environmental shows such as Holland Park, London; Red Square, Moscow; Roppongi-Park and Senso-ji, Tokyo; the Brandenburg Gate in Berlin; and Six Avenue., New York. An excellent angle to this work is given by Carlo McCormick: "Orensanz travels the world leaving his multicultural impressions—not so much as statements of self but more as parenthetical questions that challenge all that is given and taken for granted in the landscape. Orensanz is truly a social artist in the more democratic sense of the word, providing a provocation simply as a command to re-imagine the world by allowing his art a surface, a pure interface with audience and environment".[1]

During the early 1990s he developed a prolific body of work in performance, conceptual art and video. These pieces often carry a marked political and social commentary, reinforced by a very personal poetic language. Such is the case with "The Shattered Tent" during the wars of the Balkans, or his recent multimedia installation "Burning Universe" for Venice (Summer and Fall of 2003) and Budapest (currently on view); in the same vein he has moved through Europe during 2003–2004 "Razor in the Eye (Homage to Bunuel)" in Lido, Florence, Paris and to Calanda, Spain, the birthplace of Bunuel. The interface of Orensanz and the Norfolk Street landmark came a high point this past winter when he put in motion a series of installations indoors and outdoors in Norfolk St. These were the ambitious installations "In NASA's Lab" and the "Steppes of Mars" during the months of January and February of 2004. The indoor space at Norfolk became a delirious take on NASA's explorations of the outer space; and the snowed playground across, a Martian desolate landscape. Right at the time when passengers were strapped in airports nationwide under advisory red and orange codes and the TV sets were bringing live the landing of the rovers Spirit and Opportunity in Mars.

When Angel Orensanz arrived in New York in the mid '80s. Jasper Johns was just closing his studio one block away of Norfolk Street and Jean Michel Basquiat was setting up his tent

north of Houston Street, in the eye of a storm of gallery activity. A big crisis fell soon on the real estate market, the art market and the art scene of the East Village. The art would never be the same. Angel Orensanz had acquired this most historic space in Norfolk St. (built in 1849), a neo-Gothic masterpiece by a German architect born in Berlin who soaked it with the flare and visions of Beethoven, Schinkel and Heinrich Heine. This glorious historical baggage was extremely conducive in the Orensanz's vision. The building has sparked the interest of artists, filmmakers, philosophers, poets and musicians, making it a de facto public learning space. Philip Glass, Spike Lee, Kronos Quartet, Jacques Derrida, The Whitney Museum, PS1, Lou Reed, Alexander McQueen, The New York Institut for the Humanities at NYU, Elie Wiesel, Maya Angelou, Sir John Burton, the Artangel Foundation, The Goethe Institute, the French Ministry of Cultural Affairs, Sequentia, The Estonian National Choir have attracted a crowd close to half a million people over the last 18 years.

These new forms of Orensanz's art that emerged at the end of the 1980s kept evolving for a long period that covers most of the '90s with an intense program of travels. He does experiments throughout New York (Williamsburg, Queens, the shoreline of Long Island) and in distant enclaves such as rural Northern Japan, the Pyrenees in the Spanish/French frontier, and Mexico/Baja California.. Open nature projects are followed soon after by a long series of "interventions on urban icons" mostly throughout Italy at such historically charged locations as the Piazza della Segnoria in Florence or the Colosseo in Rome; and in Montparnasse in Paris; sites of Vienna and Warsaw; and a returning special insistence on such German landmarks as the Cologne Dom, the Brandenburg Gate, Rendsburg and the Oder/Neiss region. Throughout the developments of these "interventions" the "objectual" art pieces gradually give way to the growing importance of video and digital images.

Thomas McEvilley curated in 2002 the show "Angel Orensanz: Italian Installations and Interventions, 1991–2001," and insisted to have it presented in the very spaces where the artist designed the concepts and to where he brought back many of the pieces/props that accompanied him from the Veneto to the coasts of Sicily. In the accompanying catalogue, McEvilly noted: "Now for the first time, the entire building will be presented to the public as a living working whole, integrated with a single continous cultural event happening on all three floors. It is appropriate that the first full use should be for an exhibition of Angel's Orensanz work. Not only was he instrumental in rescuing the ancient place, but his work carries on a theme that relates directly to it, the Old World flowing into the New in a variety of uneven stages."[2] A good part of his creative process is the practice of consistent and thorough documentation of his work-in-progress, and the creative process itself, through photography and video. From the very beginning of his artistic carrier he always used photography and video as a means to gain perspectives to the process. He uses the reflections and charged meanings of these mechanical images as a guide for his inner eye. Seminal ideas have matured in his space of New York and brought out to their destination in various countries, carrying a magnetic reference to the rock, cloud and cave. And vice versa, Orensanz has brought back to his building in Lower Manhattan some colors and shapes that remind you of Venice and Rome for the façade, and from Northern Japan for the interior of the building. Interestingly enough, Karl Friedrich Shinkel, the master architect of Berlin absorbed those colors in the early 1800s from his trips to Italy, France and Greece. Our architect Alexander Saeltzer would bring those colors to Norfolk Street inspired by sights of Berlin.

Lately it is the video shorts and digital diaries that come to prominence. The artist's mobility and flexibility are boundless, since no tools or materials are involved. The end result is no longer strictly "objectual" but mostly digital. The mental elaboration, the sensorial reconstruction and the craft associated with all art output are now immensely more encompassing, gripping and combine several overlapping artistic dimensions. An exhibition in 1991 in Tallinn, in a not yet independent Estonia, also brings Orensanz to St. Petersburg and Moscow. And with the help of a group of local artist friends he erects in Red Square a large installation called "Bridges." It is the tense summer that witnessed the brutal challenge of the freedom processes in Russia with a clash between the political forces represented by Mikhail Gorbachev and Boris Yeltsin. During this process, in a historically charged moment, Orensanz discovered that the documentation and preservation on video was not his sole compensation for the fragility

Clayton Patterson

Angel Orensanz in NASA'a lab.

and temporality of his artwork—its accessibility by the media worldwide was an added bene-fit. The "objectual irrelevance" of the video piece became relevant with far reaching conse-quences on a whole new level by the preservation of a special moment. Orensanz has returned several times to Moscow and St. Petersburg. Actually, this coming Spring the Pushkin Museum in Moscow and the Russian Museum in St. Petersburg will present a major show of his work. Is it not there a recurrence of the strong ties of Russia en the forging of the soul of the Orensanz Foundation building and of the Lower East Side being revived? The Lower East Side as we know now is a direct import from the political, artistic and literary convulsions of St. Petersburg and Russia from the 1880s on with the violent activities of the norodniki, to the 1920s with the ascent of Lenin. And the temple on Norfolk Street played a significant role in that climate; it is not a coincidence that its name then was Ansche Slonin, The People of Slonin.

While in the Balkans, the Middle East and most of Africa whole regions are invaded, dis-membered, disenfranchised and uprooted, Orensanz takes upon himself, in the mid '90s to start a lonely journey through Europe and New York armed with a huge transparent sphere and a couple of video cameras. Very few people participate or even attend those events. The vastness of the surroundings silences the individual production but the flowing images of chal-lenge and questioning end up in several newscasts in various parts of the world. Soon after "The Shattered Tent" comes another pilgrimage of Orensanz. This time it is with his sphere, that Orensanz rolls to Senso-ji in central Tokyo, to memorialize the bombing of Downtown Tokyo by the American air forces at the end of WWII; to Berlin for similar tragic memories, and down Fifth Avenue at the wake of 9/11.The structural nature of this art resides in its pure installation and performance conditions, with renewed and increased fragility as measured in terms of "work" but with ever increased visual and sensorial vibrancy.

Within the program of ancillary exhibitions of the Biennale, Angel Orensanz brought to Venice in June of 2003 a major show to be housed at Palazzo Malipiero over the Gran Canal. It was a series of rooms with video installations and sculptural constructions under the concept of "Burning Universe" in which he distilled his impassioned pain and rebellion in the face of a world that breaks away in flames. The show was one of the most attended exhibition o f the season in Venice and is now in Budapest. Eva Forgacs writes in the catalogue of the Hungarian show "Digital Poetry of a Galaxy in Ruins": "Disrupting the existing system by introducing new elements, new objects into it is the old modernist concept, but Orensanz's work has left behind modernist rigot. He is often highly esthetic, negotiating beauty and poignancy as an undertone to his alarming themes. His global presence underlines the nomadic aspect of the work. The objects he throws into everyday life of various scenes illuminate quotidian reality, but they also evoke the horrors, dangers, and the outrageous realities of the world, which are, by the great majority of Westerners, conveniently swept under the carpet. By creating a sphere, which symbolizes perfection, and by many artistic gestures including the photography and musical quotations accompanying the cinematic documentation of his works, Orensanz appeals to classical beauty. Estheticism and global social consciousness do not square, but their blend is a credible report on what one individual can tell and do about desire and reality in the face of the overwhelming facts we are all forced to here and now."[3]

Aalbert Stracke is an art critic and curator of video and film in Berlin and New York

1. Carlo McCormick, *Towards a methodology of the work of Angel Orensanz*, in "Burning Universe"; Venice, June, 2003, pags. 14-16. Carlo McCormick is the senior editor of *Paper* magazine, art curator and social commentator of politics and social trends.
2. Thomas McEvilley, "Angel Orensanz: Italian Installations and Interventions", New York, April 2002. Thomas McEvilley is a prominent art writer and world specialist in classical and eastern philosophies. His recent book "The shape of Ancient Thought" is a landmark in his specialty.
3. Eva Forgacs, *What one can do. Angel Orensanz's Solitary Activism and Object Event*. In "Digital Poetry of a Galaxy in Ruins"; Budapest, 2004. Eva Forgacs is an art historian and art critic. She is a professor at the Art Center College of Design in Pasadena, California.

Cool Actor Luis Guzman

by Mark Binelli

If you spend enough time in the hood with Luis Guzman—his 'hood, New York's Lower East Side—you will be introduced to people named Scheme and Ito and Slim. "You don't want to loan Scheme any money," Guzman warns as soon as Scheme is out of earshot. "That's why they call him Scheme." You may not recognize Guzman's own name, but you know his face. A Puerto Rican character actor with a serious pompadour, a prominent brow and an expression set permanently on scowl, Guzman has spent the past two decades stealing scenes in an impressive roster of films, from *Boogie Nights* to *Traffic* to the recent Adam Sandler–Jack Nicholson comedy, *Anger Management*. On the fametracker.com website, Guzman's bio is located in a section called "Hey! It's That Guy!"

But back to the 'hood: we're squeezed into a booth at Two Boots Pizza, a longtime neighborhood joint owned by a couple of Guzman's buddies. Joining us are Guzman's wife, Angelita, and a steady stream of family and friends. The forty-five-year-old Guzman orders a Sierra Nevada and a broccoli-sausage pie and explains how he was "discovered" a few blocks away, in the early eighties. Another old friend, who had gone on to become a writer for Miami Vice, ran into Guzman on the street and suggested he audition for the pilot. Guzman was working as a youth counselor and tenants' rights advocate at the time; he lived for a spell in the Charas commune, the nexus of Loisaida activism, on Ninth Street. "It was mostly ex-gang members a lot older than me. If you got a girl to come up, you had to do it on a night all the other guys were out. It was like living with a pack of wolves. But the parties were slamming. You'd wake up the next day at five and be happy to be alive."

Luis Guzman

Clayton Patterson

Guzman's only acting experience had been in street theater productions like, "We Don't Want Cheese, We Want Apartments, Please." "I thought I might make some extra cash, buy a used car, so I could drive to Orchard Beach instead of taking the train," Guzman recalls. He went up to a casting office on Park Avenue and was kept waiting for three hours to audition for a three-line role. "I finally got in there," he recalls, "and the lady said, 'Kill me with your eyes.' I said, 'Three hours for a mean look? What is this shit?'" Still, Guzman gave her a look, got the part (a Columbian drug lord) and a few weeks later he was flying first class to Miami.

Actors with mugs like Guzman's are generally stuck playing choice roles like Gang Member Number Three. And sure enough, early in his career, Guzman did portray his fair share of heavies. "I'd play a rapist, a robber, a gypsy cab driver," he says. After his first son died at birth, Guzman says he lost his passion for youth counseling, and decided to ask for Angelita's blessing to pursue acting full time. He'd always been a keen observer of people, and he brought traits from various characters in the neighborhood to his roles, giving them a greater depth that made directors like Steven Soderbergh and Paul Thomas Anderson take note; both have used Guzman in multiple films. "Like, I'm watching you right now, the way you write, the way you're sitting, in case I ever play a journalist," Guzman says, adding after a pause, "I'd probably comb my hair, though." Hey now. We make the jokes here. Someone else brings up the "There's a Riot Going On" size of Guzman's former afro. Scheme, who is also his brother-in-law, says, "In *Carlito's Way*, Luis got to relive his glory days. I remember when my sister first brought him around, I said, 'Angie, what are you doing? You got some work to do here.'"

Angelita snorts. "The afro was easy to get rid of. The polyester pants were the hard part." Guzman glowers, deadpan. "Tell him some more," he says. Just then, another friend walks up. "Yo, what's up?" Guzman shouts, then says, "This is my boy Shante. The only Puerto Rican ever born in Vermont."

Vermont would be Guzman's current 'hood. He and Angelita live on a 130-acre farm with their five children. "When I'm not acting, I'm there, mucking the barn—that's digging out the horse crap," Guzman explains. "We're gonna start making maple syrup. It's liquid gold, bro. Forty dollars a gallon." He shrugs. "It's better than dodging bullets. It's better than being on the F train at eight in the morning." Then he shrugs again. "In this neighborhood, you grow up with characters," he says. "Other actors, they have to sit down and conjure up these things, I guess. I lived these things."

NYC Smoke

by Howie Statland

Living the life of an artist in New York City is a fateful experience that one must ride like a wave, falling and catching oneself by instinct.

The first job I fell into when I came to the city back in 1993 was a job at a high profile theatre company, Naked Angels. I lived in SoHo back then on Sullivan Street, in some illegal loft rental. My roommate said he knew of a woman who was running a theatre company and needed an assistant. In our interview at the Space on 17th Street, where there now is a thrift shop, we immediately hit it off and she gave me the job.

I was instantly thrust into situations I never dreamed of being a part of. My first week of work, I met with John Kennedy Jr. up at the Kennedy office compound, and met Al Pacino and Jackie Onassis at her last public appearance in NYC. I was suddenly observing great writers and directors like Joe Mantello and Jon Robin Baitz direct master actors like Marisa Tomei, Mathew Broderik and Ron Rifkin. I realized later

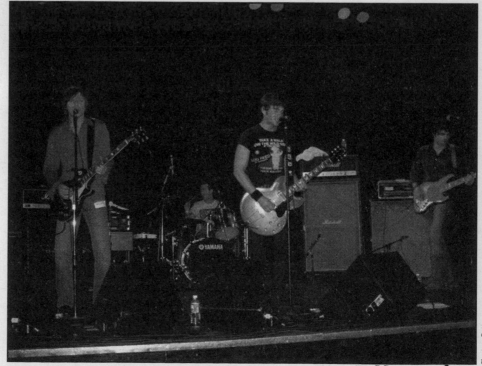

New York Smoke Benefit at the Bowery Ballroom for FEVA

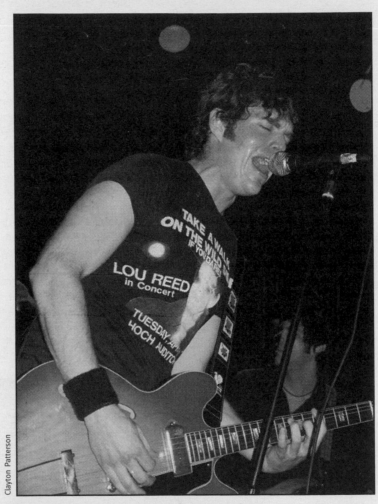

Clayton Patterson

Howie Statland

on that many of my early songs were inspired by the plays I watched being rehearsed over and over, the lines being drilled into my head like a brainwashing. Never a huge theatre guy, I sort of fell into the job and it worked.

This job led to another in film, working on the *The Substance of Fire* with Tim Hutton. I was asked to come onto this project by one of the members of the Naked Angels board. While working the day job, my band, Thin Lizard Dawn, was paying its dues in the downtown clubs: Brownies, Mercury Lounge, Tramps, Under ACME. We had some killer shows and it was amazing to watch our audience grow from nothing to sell-out crowds. Our first EP was titled "Naked Angels," as the theatre company gave us their space on 17th St. for a whole summer to rehearse. There we completely reinvented ourselves. We played in the city and on the road for four years when suddenly we blew up and had sell-out crowds and a big record deal with RCA.

During this period, I lived on 6th Street between 2nd and 3rd Avenues. I would do much of my writing in Kiev or Veselka (both restaurants are now remodeled), while chowing down pierogies and chicken soup. The East Village was a big influence on my writing then and has remained so to this day.

I left Goldheart Films in 1996 when Thin Lizard Dawn was signed to RCA. For the next four years I spent my time touring the country, playing some nights to 2 people, some nights to 4,000 people. We'd tour for months, then come home for a few days or weeks, and go right back out. An amazing period of ups and downs.

Our debut record came out and sold nothing. Our sophomore effort we made; and they never released. By the time we made our third record we all hated each other and the label and we never sold another copy of anything. I knew in the back of my mind that when we signed our deal that it was sour, and I slowly watched us spoil and fall from the tree we had nourished for years. This was a heartbreaking experience.

When we would come back from tour, sometimes I had to go back to my friends in the film industry for work to make ends meet. By 1997 and 1998, I was homeless on the streets and spending my nights in after-hours clubs doing whatever I could to keep my spirit alive. My New York City dream had turned into a numbing nightmare, or a real New York experience, depending on how you look at it.

While homeless, I took my energies and put them into what I had learned in the theatre, how to direct, and combined it with my music. I had always been inspired by musical films like *The Wall* and *Tommy* and *Quadrophenia*, and wanted to make my own.

So I found some collaborators, some money, and directed a film called *Low Flame* about a garbage man who cannot deal with his reality, so he makes a family of trash. Through two mystical women, he comes to terms with love and throws his family of trash into the river. It was inspired by my early images of people always wearing masks, pretending to be someone they are not. One must be careful who one pretends to be, because one is who one pretends to be.

Based on the music I never gave to the label, and saved for my own sacred projects close to my heart, *Low Flame* was a musical film I could play live to. I filmed it on the Lower East Side and this location plays a major role in the film and the music. I actually completed the film, performed it live at P.S. 1 and entered it into festivals; all while Thin Lizard Dawn was disintegrating.

Shortly thereafter, I formed NYCSmoke and began playing clubs, building an audience and making our debut CD, "For the Posers." Finally suffering for no one else's music but my own. Philip Glass came to see *Low Flame*, saw the potential and invited me to collaborate on a piece he was working on. We wrote a piece together and performed it at the 2nd Avenue Film Archives, and then in Europe.

Through *Low Flame*, I also met the woman who showed me the strength—through her wisdom—to pursue my artistic endeavors whole-heartedly, and she remains my most trustworthy friend to this day. It's the choices people make and the courage to stick to them without worrying about being judged that make life fruitful.

As I was getting back on my feet, I worked some odd jobs like being a Xerox boy up on 53rd street for some company that made their living making Xeroxes of case files for lawyers. Boy was that a barrel of fun. I was also a dresser at the opera for a period of time.

Eventually I found a great job at Rivington Guitars, where I work to this day selling vintage guitars from the '50s, '60s and '70s, and fixing other people's guitars so they play well. Besides writing songs and performing, this is what I know and it works for me. It pays my rent and supports NYCSmoke.

I guess the lesson to be learned from my experiences here in NYC is to peel away the rinds of what doesn't work and get to the fruit of what does work. The only way to find this out is through experience: the experience of falling and catching yourself.

This is where happiness and peace will find you in the Big Apple.

When I Met Clayton

by Anne Hanavan

Some things that were going on in the early nineties are still very hazy, and some are crystal clear. I know now that I was a mess, though at the time I had no idea. Life had completely closed in and become very small and in some ways had become very simple. Small in the sense that I rarely left the Lower East Side and simple because my needs were reduced to a bundle of dope, some cocaine and a handful of hypodermic needles a day. Although life as a junkie hooker made things horrific and dangerous, again, it simplified my existence. Gone were any previous dreams and aspirations, except for hooking with the next trick—especially the ones that liked getting high almost as much as I did. They were my favorites.

At the time I was living with the artist Richard Hambleton, with Steven, who used to run a magazine that folded, and this crazy Canadian girl named Bonnie, who I never liked very much. She could usually be heard by our neighbors, and whoever was passing by the building, screaming about being dope sick and slamming doors. Bonnie believed that the louder she would yell the sooner one of us would shut her up with a bag of dope. It usually worked, but on more than one occasion the cops would show up, and at this point were on a first name basis with her. Actually they knew all of our first names and we knew them by their last names. In

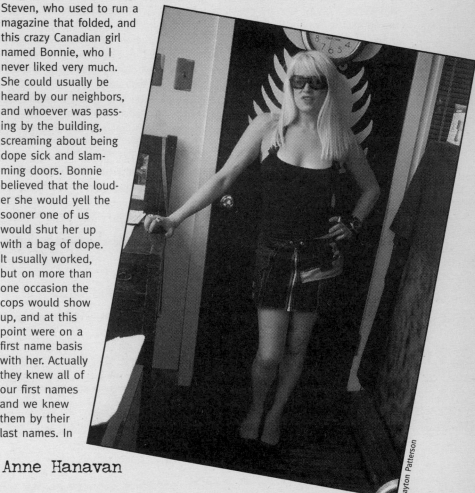

Clayton Patterson

Anne Hanavan

any case we were all very familiar.

We all lived together in a decent-sized one bedroom on Orchard Street above a store that only sold men's ties that is now *Cafe Lika*. The apartment was a living crime scene. The place always looked like it had been ransacked. Clothes, books, drug paraphernalia, papers, and who knows what else were strewn all over the place. And one of us was always holding. There was blood everywhere; on the walls, floors ceilings, tables, chairs, counters, doorknobs, bedposts, sinks, showers, our shoes, the radio, Steven's TV, Bonnie's dog, Richard's bike, and the windows, too—you get the picture. Coming in you would normally be greeted by me sitting with my foot propped on the kitchen table trying to get a hit in my leg. Steven and Bonnie would be hanging out trying to get you to share what ever drugs you had by pretending they were dope sick. Richard, on the other hand, was painting. He was always painting. His dedication to his work always amazed me. He would use anything including his blood and sometimes mine for his paintings. The living room was converted into his studio. I loved it. As a girl with my occupation, screwing five or more guys a day to feed my habit, I didn't have much room for relationships or a libido but I felt a crazy borderline infatuation with Richard.

One day, after a ninety-eight-hour binge, I fell asleep. I must have been in a coma for two days. I woke up to a video camera aimed at my track marks, held by a huge man who looked like a viking. I flipped. "What the fuck is going on, Richard? Who the fuck is this?" Turns out the viking was Clayton and Richard had invited him over to shoot the studio and I was indeed at that moment part of the studio. Clayton was completely calm and unaffected by the surroundings, I was intrigued. He smiled and introduced himself—he seemed nice enough. I soon learned that Clayton was genuinely fascinated by our lifestyle and had a connection to the subculture. Clayton's name was familiar to me. I had heard about his famous documentation of the Tompkins Square Park riots and the following lawsuits. He was the same Clayton who made Nicky D's cool baseball hat that he always wore to Robots. I decided to like him. Hanging out at his storefront on Essex became a favorite pastime. He and Elsa were always very kind. They were passionate about the Lower East Side. Not only were they documenting the people and events that filled the neighborhood with stills and video but they were also archiving even the dope bags that decorated the streets. This collection is priceless. Each brand of dope had a name and an individual stamp that separated it from any other. Some were simple, others intricate, all were beautiful. This extraordinary couple has preserved these artifacts forever. They have an understanding and acceptance of people from all walks of life.

After getting clean I still enjoy Clayton and Elsa's company. Not only do they help me with putting together some sort of time line to my insanity but also they inspire me. I will always love them for who they are and their mission of preserving the Lower East Side.

Thom Corn as East Village Video/Filmmaker...

by Thom Corn
from the East Village July 7, 2003

This article should be easy because my career as a video filmmaker is literally just beginning in earnest! The fact that what I am creating and committing to video crosses imagined barriers and divisions of established genres in so-called schools, and thusly has yet to be officially categorized, should go along way to ensuring my future enshrinement as innovator and/or martyr! (I so love it when irony abounds on the Lower East Side and irony truly abounds in my Ave D and 9th Street perch.) In my career as a devoted artist multi - disciplinarian, I've managed to spend time on both sides of the canvas, both sides of the stage, as well as both sides of the camera - always with exploratory joy in the creation

Thom Corn

Thom Corn on Wall Street

process. (Thank you Hartford Art School, Nuyorican Poets Cafe and those independents who've found me to be an interesting and notable subject over the years.)

What I like to think I bring to the video table now is a refreshed and cleverly artsy refined take on what is currently known (and in certain circles excoriated) as "reality television." My love of history (all kinds) and the comparative studies that this love ignites found its natural outlet in video, which always (in theory at least) has the potential to reach the so-called "masses." Hopefully my continued offerings may even touch a few of the "asses" who are currently not moving very far from the triangular trap represented by their TV, refrigerator and toilet! (Thank you Manhattan Neighborhood Network . . .)

Corn On Cotton, which documents and expands on one of my concurrent art projects, i.e., cotton homegrown on the Lower East Side as a meditation on rebirth/renewal/conciliation and international organic awareness paired with sustainable life is my latest offering. In this video I bear witness to the history of and the contemporary uses of a plant that touches us all! Yes even that slug on the couch glued to the "Spike" channel is wearing fruit of the loom!

My video filmmaking style is based on my vision and mission statement as gentle educator (no one needs to be hit over the head when subtle stroking will do just fine), rooted in my conceptual sense of extended collaboration in which I seek to artistically manipulate my chosen technical collaborators as an extension of my decidedly Duchampian/Warholian–inflected, multiculturally inclusive, African American Pop sensibilities. My directorial models, for purposes of technical creation and production, range from Michael Moore to Dino Delaurentis with a healthy dose of influence from Ousmane Sembene and Luis Brunuel.

In *Corn on Cotton* I have paired my vision of the documentation of my performance travels through New York City carrying a live homegrown cotton plant with the technical skills of cameraman John Veit. Veit and I made beautiful music during the co-editing and co-postproduction sound process. I make it a point to balance the exploration of a darkly serious and enveloping subject with goodly sense of pointed wit. Veit's use of straight cuts in a real-time mode gives the finished 29-minute film a snap and pop that puts the film in a groove that never lets the viewer down. Working together we were able to get the best of my performance delivery style (which can be frenetic at times) encapsulated into a winning and highly watchable presentation that delivers a real-time narrative feel. It was great working with Veit, who I am sure will have great success in future collaborative and solo projects…AND NOW IT'S TIME FOR A WORD FROM THE SPONSOR: PLEASE VISIT www.cornoncotton.com.

Gentri fucked

by Scot-Free

The skyline of Manhattan is what first attracted me to New York City, but it was the wild and crazy East Village that made me fall in love. It was young, exciting, dangerous, dirty and sexy but most importantly, affordable. I was underage but bars in the neighborhood didn't care back in the early '90s, and, thankfully so, because it was over drinks at Two Boots that I met Nick Zedd. He was an East Village legend and a great filmmaker whose movies I'd seen and greatly admired. When I told him what a big fan I was he cheerfully replied, "Great, buy me a drink."

Nick was the first to take the punk rock aesthetic and apply it to film. He and other filmmakers like Richard Kern and Tommy Turner were angry and had things to say and film was their launching pad. "Continuity to us is when the film runs through the projector," Nick once said. He believed that all film schools should be destroyed and any film that didn't shock wasn't worth looking at. The opening shot of *Police State* is Nick spray painting the title of the movie onto the back of a real NYC police van.

Bars weren't the only place to meet filmmakers though; Anthology Film Archives on Second Street hosted many film screenings and parties. Working as the theater manager there one night I got to meet John Waters and Ricki Lake. They came to see *Hated*, a documentary we were showing about punk legend GG Allin, who had recently died (before his death, GG and his drummer were the only two to come to some prior screenings). Showing my respect for Mr. Waters and feeling the effects of the numerous beers I had earlier, I wouldn't allow him to pay and insisted he go and enjoy the movie. "I want to contribute to the theater," he said but I stood firm and wouldn't take his money. Getting angry with me he grabbed some books we had for sale and asked me how much they were. I told him the price and he paid me then put them back on the shelf and went into the theater.

Some nights I was alone running the theater and

had to sell the tickets, lock the door and go project the movie. When I would see someone leave the screening room I'd run downstairs to see if they needed anything. One night we showed a documentary about graffiti artists called *Style Wars*. After the movie was done everyone pulled out spray cans and tagged the entire theater, lobby and Catholic school across the street. When the cops came and asked me who was the theater manager I said me. When they told me I was responsible and had to pay for the damages I quickly changed my tune and said I was only a volunteer, which wasn't far from the truth (I barely got paid and actually secretly lived in the theater behind the screen for a short while). I called the owner of Anthology, the great filmmaker Jonas Mekas, and when he saw the graffiti he wasn't mad at all. He loved it; he wanted to leave it!

Scot-Free

Movie still

I had first seen Rockets Redglare in Nick's film *Police State*, and met him under pretty strange circumstances. He asked my then girlfriend at the time, and wife now, Darryl, if she would like to go to the Millennium with him to see a retrospective of Nick's films. When she told him about me he told her, "Bring him along, the more the merrier." On the way over to the space I told him how great he was in *Police State* and he asked me what I thought of the scene where he's torturing Nick, and asks, "Have you ever had your dick cut off before?" I told him I didn't remember that specific line but he refreshed my memory and told me he had come up with it. He then told me, "Nick was expecting me to say, 'I'm gonna cut your dick off in the scene,' but when I surprised him with that instead, you can tell by the reaction that he gave that he was really scared and confused." I knew right then that he was a great actor, even though he hit on Darryl all night in front of me.

When I asked Rockets if he would star in my second short film *Fabulous Disaster*, he was in the hospital with a bad back. He said he would do it for a small fee and assured me he would be out of the hospital in time for the shoot. Although he needed a cane to get around and was in a lot of pain during filming to look at his performance you would never know it. Even though I had to rewrite all the scenes where Rockets walks, as soon as I yelled "Action," he was totally in character. The pain that showed on his face would immediately disappear and he delivered all his lines like a true pro. He brought great insight to the dialogue I had written and even improved a few of the lines, just like he did on Nick's film.

The East Village is a lot different now. Gentrification has made it impossible for up-and-coming artists to live there, and most of the cool bars and clubs were shut down by the city. But don't get me wrong: it's still a vibrant exciting place to hang out. Anthology Film Archives is still there as well as Two Boots. Thankfully, some things never change.

Amy Greenfield

by Robert A. Haller

Nine years ago, Amy Greenfield's cinema took a new turn. This filmmaker who had done some of her best-known work while in SoHo in the 1970s, and then moved to Staten Island in the 1980s, returned to Manhattan where she presented two large, live multimedia performances (live dance, music, words, multiple-film, video, and slide projections) at Anthology Film Archives in the East Village in the mid 1990s. The first of these, a tribute to Charlotte Moorman, was saluted by *The New York Times* as one of the ten best dance and performance works of the year. From the videotapes shot of those projects she has made five extraordinary motion pictures. She started with videotape, electronically processed the images with digital technology, and made for the screen "dance works" of a kind that shed most of the character of live stage performances. All of them use nude or semi-nude dancers, but these women now inhabit new sites defined by pulsing light and sound, and new rhythms created by Greenfield as the director/editor. Even as I write this she is completing two more of these films, one featuring East Village dancer Andrea Beeman who is in *Wildfire*.

Amy Greenfield

Dance Sequence

In 1996, introducing the second of these live performances, "Raw-Edged Women," Greenfield said that the costs of filmmaking were obstructing her wish to make new films-so she turned to live performances where she could "work with other women who want to use their bodies as an expressive medium." Unexpectedly these performances gave birth to imagery that have given Greenfield new opportunities to make films of the kind she has been making for many years—films that reveal the body as a vessel that can transcend space, time, and even death. With *Wildfire*, the third of these five films, she encompasses the whole history of cinema, beginning with the 1894 Edison film *Annabelle the Dancer*, and then springs forward to our own time with four nude dancers whirling through space like *Annabelle*, but moving forward and backward in time, in slow motion and in superimposition, in some of the most rapidly edited movements ever set on film.

The videotape, edited using an original mix of digital and analog technology, has been transferred to luminous 35 mm film, with a score by Philip Glass, and Greenfield taking us into the experience of the women. She share's a "mind's eye" vision of the grace of bodily gesture as it is experienced/imagined/performed by her dancers who themselves now exist outside of time, or rather have joined with *Annabelle* who danced in East Village vaudeville and then entered a purely cinematic space as first fashioned by Thomas Edison—before any of us were born.

The Film, Video, and Animation History of
Todo con Nada 1988–2000
(incomplete and fragmented)

by Aaron Beall with Laura Zambrano

Disclaimer: The Todo con Nada archive is currently in storage and unavailable for this story. It is frequently in peril of auction (a monthly occurrence), but through some hazy intervention brought about the muses of the eternal ephemeral—The Theater itself (you know who you are, and thank you) the archive remains in the world. In lieu of archival resources, Laura and I sat down with a pitcher of margaritas at The Hat, a restaurant at the corner of Ludlow and Stanton, to review memories.

Aaron Beall (me): A guy who ran a storefront theater at 167 Ludlow Street on Manhattan's Lower East Side from 1988-2000 variously known as Theatre Club Funambules, Nada, Todo con Nada, and Nada Classic. It was an empty space where 2500 different productions took place, mostly theatrical but also film, video, and a lot of animation. This piece is about the intersection of art forms—the visual ones—on a stage 22 feet across by twenty deep (a big stage by downtown standards) with seven-foot ceilings and a pole smack dab in its middle. It is about what happened on that stage during those 12 years. It is also about the crush of experience.

Laura Zambrano (herself): The Theater's technical director from 1988-2000 who lived in an apartment directly over the theater. A collector of memories and a living chronicler of the marriages, associations, affiliations, births, illnesses, deaths, legacies and creative output of a generation of bohemians during that time span and beyond.

Note: The Theater at 167 Ludlow Street will be referred to hereafter as Nada.

"Nada was always Multi-stuff"

Nada was always "multi-stuff" (a Laura Zambrano term) meaning that since it was a theater, a real one and not a movie palace, it was wide open, a free zone for the manufacture of visions, there was no curatorial agenda (at least at first) and so it was a bit of a mosh pit where all media could intermingle and often did. Anything could happen . . . and often it did. By design it was it was *very* undisciplined, but all disciplines were welcomed. In the late eighties (we opened June 1988) and nearly all the way into the nineties, we were pre-digital. The digital age didn't really start to impact the theater until late, until 1998 when the first laptops were plugged into the soundboard and sound designers starting showing up with mini-discs.

We had no real gear. No big screens. We weren't the Wooster Group. What we were was always broke, but for some reason something great always happened at Nada. If we needed

something, a hatbox or a piñata, more often than not, it could be found in the backyard or in front of the space at the moment we needed it. That kind of strange magic went on all the time. In a way all of us who worked at Nada (and the subsequent Nadas) were slightly spoiled by this constant serendipity and synchronicity. At Nada, it somehow always worked out and since poverty is perhaps the mother of all creativity—nada y nada y nada es todo y todo y todo—miraculous events were the constant.

Two intriguing, perhaps revolutionary, theatrical movements (of many but these two pertain to this strain of the Nada experience) were born out of Nada (and the subsequent theaters that were spawned from the original space that have made up the Todo con Nada "empire": the Piano Store, the House of Candles, the Pink Pony Theater, the Tenement Theater, Nada 45, Todo con Nada Show World, and finally, Todo 45 where this text was created). They have relevance to worlds of film, television, video, and animation, and so are worthy of discussion.

Supertheatrics and Cinetheatrics

Supertheatrics: a theatrical technique that allows an artist to sample or DJ any or as many theatrical techniques unto a theatrical text as desired. There is no one consistent style of play in a Supertheatrical production. The more the better. . . . "By *any* theatrical technique necessary" is the rallying cry of the Supertheatricarians to achieve the theatrical effect desired, which is a true or truer reading of the text that conventional theatrical methods would not allow.

"No method, all methods" can also work as a motto. So the next time you see a production of Ibsen's *A Doll's House* that starts off slow and suddenly turns into a puppet show followed by a Bollywood dance break and ends with Super 8 film of Nora leaving Torvald for good you will know that you have witnessed a Supertheatrical event. The term Supertheatrics came about as an attempt to describe the nightly transformations, the shifts in perspective that occurred within the running time of theater pieces taking place on all the downtown stages during the 1990s.

The term Supertheatrics was first used in 2000 by Aaron Beall to describe the theatrical technique/effect desired for his production of Chekhov's *The Seagull* at Todo con Nada Show World during the Pure Pop Festival's 33 Swoons: A Portrait of Anton Chekhov.

Cinetheatrics: the obverse of Supertheatrics (in that it focuses on one medium not all) but uses many of the same "cheap" theatrical devices as its sister technique. The language of Cinetheatrics, as well as the rhythm and pacing of the technique, are directly taken from the realm of cinema and television; however, the goal of Cinetheatrics is to create a theatrical event using the laws of movie and television . . . theatrically. For example: two curtains on either side of the Nada stage become two different scenes in a film.

As one scene from Ed Wood's *Plan 9 from Outer Space* plays the other is setting up. When the scene is done and a "jump cut" is required, one curtain is closed quickly and the other opened rapidly and, voilá, the cinematic jump cut between scenes has been achieved at the cost of a curtain track and two curtains (sometimes tough to scrape together). While that scene plays the next scene in the "film" is being set up for the next "cut."

Similar Cinetheatric devices are created for the dissolve, the fade-in and other staples of cinematic language. The benefit of Cinetheatrics for future generations is that it allows any film or television script to be translated quickly and cheaply into a theatrical event without adapting or changing the screenplay or teleplay in anyway. The term Cinetheatrics was first used by Aaron Beall in 2000 to describe the work he saw emerging from Nada (then known as Nada Classic and under the artistic direction of Ian W. Hill) during the Pure Pop Festival's Natural Born Pop: The Complete Works of Ed Wood.

The Visual History
(in monologue form for scholars off-planet in a future time)

From the most primitive technologies to the dawn of the digital age Nada covered the entire visual spectrum. From shadow puppets (Arden Party's *Dangerous Clowns* 1988 and 1992 with Aaron Beall, Karin Coonrod and James Urbaniak), to animated flip boards (Dale Goodson's solo pieces plus his live comic book epic co-created with Lynn Freer: *We Die, You Die*), low-tech animation done as slide shows (Raw Comics' Bob Sikoryak, his Bazooka Classics' *Good Ol' Gregor*

Brown and Dante's *Inferno* starring Bazooka Joe 1989–1990, Jim Torak's *Faust* slide shows for the Faust Festival 1995), live animation cartoons (drawn live on bodies and on paper—Bob Sikoryak yet again) at Carol Brys' legendary (at least to us) House of Ill Repute, and films —a lot of films, films within theater pieces and films within films, a lot of cool stuff just part of the vast continuum of experimentation that defined the LES/East Village since the end of the 19th century. The first piece of film inside a theater piece was Lisa Kotin's piece, done in 1989 or so; she staged her grandmother arriving in America by shooting a Super 8 of herself playing her grandmother on the Staten Island Ferry in gorgeous black and white. I think that piece was called *Chicken Soup*.

There were Super 8 extravaganzas, like Mark Kehoe's sublime homage to the Ridiculous Genre – *Destroy All Blondes*, uncompleted though the film was at the time it was one of my favorite nights ever at Nada with Kehoe providing the soundtrack live on a child's turntable. I learned so much about the mystery of filmmaking that night . . . the raw mechanics of the illusion. You have to remember it was Ludlow Street, a tiny storefront space with two steps up to the street, car alarms, street noise, each summer had a song that was played over and over and over again on the stoops outside the theater.

Clayton Patterson

Aaron Beall

In 1988, it was *Down with O.P.P.*, drug dealers, drug busts, and film shoots. It was a huge teeming decameron of possibilities that would really get going after dark and the theater for its twelve years was a major part of that rhythm with its 7:30, 10, midnight shows all different, different productions all the time it never stopped moving. Different shows cruising in and out, one on top of the other, a blur of constant transformation. The prime example of theater pieces becoming film at Nada is Gary Goldberg's three theater pieces (which he always intended to make into films) that he built at Nada starring Taylor Mead and Bill Rice. He rehearsed them live, in front of sparse audiences, *Plates* (1990) *Mesmer* (1991), and *Usher* (1991). *Usher*, I believe, was shot at Nada and I believe one of the scripts makes this book . . . and flip back to me . . . gotcha . . . Becketian . . . Keatonian, right?

From around 1989–1993 our monthly flyers were often cartoons drawn by Mo Wilems who lived in the building and went to NYU where he studied cartooning and was one half of the sketch duo the Normals with Bradley Glen. He drew the Nada universe on the flyers he created as a sort of beatnik paradise, all the groovy multi-culti beat kids came in all shapes and colors but you could always tell the beatniks cuz they had little black berets drawn on signifying their beatnik allegiance. (The bohemian-beatnik tribe . . . a universal generational constant worldwide whose gravitational epicenter was Ludlow and Stanton in the 1990s . . .) Mo also incorporated animated elements into his *Monotony Variety Series* (1995) his Nada swan song . . .

Elyse Singer's *Private Property* was the first full use of video both as backdrop and as character in a play. Remember a lot of ideas were going around downtown in 1992 about replacing actors with video projections and even some very early internet rumblings about multi-site theatrical events, the reality was it took us days to set up a couple of VCR's and that piece taught me the dangers of trusting technology theatrically and how *not* to use video in a piece.

1992 was a big year for video experiments at Nada Matt Wilder's *Battles of Coxinga* by Chikamatsu featured director Ann Bogart (on video on a little black and white television) as God in the play . . . it also featured no curtains on the windows to the street and lots of nudity and violence a treat for the neighborhood kids. I would muse for years over the lessons learned in the summer of 1992 about using video in theater.

Robert Group's *Don Juan in Manhattan* (1996) used live video feeds and tape loops much more effectively—Don Juan's entrance by motorcycle (live video with effects) made a splash. . . . My first production of Kirk Wood Bromley's *Icarus & Aria* (1997) featured live news reporting with the video camera the chorus of the play . . . also my production of Foreman's *Rhoda in Potatoland* (1997) featured constant taping of the show by characters, often potatoes or tourists, from within the staging of the show . . . some of the best tapes of the era now lost . . .

Connie Tarbox's *The Naked Show* (1999) at Todo con Nada's briefly held Pink Pony Theater featured an entirely naked cast and homemade erotica screened at the top of the show . . . very pop . . . and so it goes on and on an infinity in a 12 year time span all the ideas, attempts, brave mistakes, careers started and some ended, dreams developed and undeveloped rehearsed and improvised within that little box of multiplicitis visions.

Towards the end of the decade Nada really focused on the language of films zeroing in on the problems of staging screenplays and teleplays directly unto the Nada stage (so much great material to plunder) . . . at Nada, remember, anything written down could be staged and was fair game . . . found text . . . so screenplays, soap opera scripts, comic books anything with a primary visual element became theatrical text . . . EVERYTHING WAS SCRIPT . . . EVERYTHING WAS TEXT . . .

Ian W. Hill's staging of the classic Temperance drama T.S. Arthur's *Ten Nights*

in a Ballroom (1999) as a George Romero, sci-fi zombie epic with a staged copyright notice read aloud over the mike is the likely link between Supertheatrics and Cinetheatrics. Ian W. Hill and David McIntyre's *Once in a Jungle* owed a huge debt to Coppola's *Apocalypse Now* and much of the three years of the Richard Foreman Festival (curated by I.W.H.) owed much to the Marx Brothers (who started out in vaudeville). John Issendorf's company ATM (Alternative Theater Machine) staged James Whale's 1932 *The Old Dark House* fantastically and really pushed the limit with their production of Strindberg's *The Pelican* supercinetheatrically freely mixing in full scenes of Hitchcock's *The Birds* with Strindberg's last chamber play with a great electronica soundtrack . . .

By the time Nada got evicted in November 2000 to make way for bars and restaurants, boutiques and guitar stores the fusion was complete. A two-pronged theatrical language had been forged: two techniques, two sides of the same penny, Supertheatrics (heads) and Cinetheatrics (tails) crafted out of the vast experience that is the sum of thousands of shows, a huge ambitious generation of artists essentially locked out of the larger institutionalized nonprofit theaters who made their own way downtown in that now ancient analog pre-digital age.

So many personalities swirling past the storefront windows creating an always changing movie (life) passing through the spaces at 167 Ludlow Street and 158 Ludlow Street (the Piano Store) and 99 Stanton Street (the House of Candles), 671 8th Ave (Todo con Nada Show World), and 445 West 45th Street (Nada 45 and now in '00 Todo 45)—the Nadas: Rockets Redglare, Matt Mitler, Duck, Josh the Drug Dealer, Megan Raddant, Heidi Tradewell, Elevator Repair Service, Uli, Edwin Torres.

The pony-tailed videotarian Tom Zaffien documenting, documenting, documenting, the ubiquitous video camera at nearly every performance, documenting, documenting, documenting, where are all those thousands of hours of tapes now? Honor Malloy, Shelly Mars, Arnie Saiki (Nada's first intern also lived upstairs, he organized one of the first video art raves at House of Candles called *Ghost Boat* in 1993, a total forerunner of *Unity Gain*), Raphael Shirley, Mace, Mo, Joe the Broom Man, Heather Woodbury, Larry Fessenden, Dayton Taylor (the guy who invented and patented the Matrix cam was also a Nada playwright—*Wow and Flutter* 1994); the ghosts of Jack Smith, Charles Ludlam, Joseph Papp hovering over us all.

Clayton Patterson archiving, archiving, archiving, Rae C Wright, *Marisa's Peaches,* Heather Fenby, Woody and Joe, Richard Basciano, Djuniba: Drums of Africa, Tim and Babs Carryer, Gene, Mark Greenfield's Faux Real Theater Company, Caraid O'Brien as a title role in Rhoda in *Potatoland*, Sara Gaffney, Camden Toy, Todd Alcott, the crush of people, performers, the weight of a generation and audiences audiences audiences watching watching watching (the remote viewer as Laura Zamprano has said), a neighborhood overrun with creative potential.

And of course right before the marshal came to shutter Nada deep in the millennial year—we closed with two final performances: a flash staging of Mac Wellman's *Crowbar* and a benefit performance of Capra's *It's a Wonderful Life,* staged, of course, Cinetreatrically. And now after the Ludlow epoch has ended the work about or influenced by the responses to the scene are arriving Art Wallace's DV feature a black comedy *Melon in the Sky* (2003 all about Nada) being one of the first to screen.

Endgame

And so the landlords and the merchants and the realtors won, but they always do—a neighborhood was gentrified, made safe for commerce, the

drug dealers were swept away and the artists who didn't OPEN A BAR or BUY A BUILDING or didn't have a TRUST FUND were forced into other parts of the city or were pushed by economic forces out of it altogether. That, the tale of artists making a neighborhood global and then forced out by the world's desire to be around all that FREEDOM is an old one. (ParisSanFranciscoNewYorkLondonLosAngelesAmsterdamMoscowBerlin . . .)

For a time the corner of Ludlow and Stanton (where we finish our margaritas, our reminiscing nearly done) was the epicenter of "it," that corner of the universe where potent potential became the norm and the zeitgeist became a cyclotron of myriad accomplishment. The place where everyone wanted to be. What remains of course is the record of what happened . . . that whatever of what survives . . . the film, video, and animated elements of the theater pieces at Nada, as well as the films, videos, and animation that stood on their own, were facets of a bigger unity, pieces within pieces, interconnected components feeding off each other in new ways creating new ideas: a new time and a new generation.

A moment in a city's life that swiftly passes and moves unto the next. But in that moment: ETERNITY!

We the artists the creators the chroniclers who were there who lived it day in and day out for that lucky span—however brief, however long—remain as ever one step ahead drawn towards that strange attractor that cruel lover that mystery the eternal ephemeral: a theater where anything is possible.

East Village Memories

by Ann Magnuson

Some of the best times of my life were spent in the East Village (as well as some of the worst). The best because when I arrived in NYC as a theater and film student in the late 1970s I found my surrogate family there. The worse because I would lose so many of them to AIDS in the decades that followed. At the beginning we bonded over No Wave and punk rock and Dada and bad monster movies and together we went on to start our own clubs (like Club 57 on St. Mark's Place and later the Pyramid Club and 8 BC) and galleries where we created our own art, played in our own bands, threw our own parties, engaged in multiple love affairs and laughed ourselves silly. Downtown New York was a dream come true in the early '80s. You never had to go above 14th Street to get what you wanted (nor did you want to since everything uptown was abhorrently square). In the East Village you walked the streets with your heroes (Allen Ginsberg, Patti Smith, Richard Hell, Jackie Curtis), could live on next to nothing thanks to the cheap rents and the breakfast specials at Leshko's and Odessa, could clothe yourself in the most fabulous fashions because the thrift stores were full of amazing finds for a quarter and, best of all, everyone you knew was just as poor as you were except it didn't stop anyone from making art, putting on shows, designing fashions, writing poetry, starting bands, making underground films or publishing our own 'zines.

Like everything, the scene was eventually co-opted. First by art collectors who began to cruise the streets in their limos, then by MTV. Drugs killed off some, AIDS claimed many and then Giuliani and the dot.com feeding frenzy finished everything off.

I've lived on Avenue A for 22 years. My landlords are trying to evict me so they can quadruple the rent. Maybe it's time to leave but it kills me to think the East Village will no longer be my home. I have never felt as complete as I did when I first got to the East Village and was running Club 57, living for the moment, creating for no other reason than it was fun and I *HAD* to do it or die and, best of all, being surrounded by kindred spirits who, though many are no longer living, will always be my best friends.

Phil Hartman and son

10 Questions for Phil Hartman

by Leon Hartman

Leon Hartman: #1. What first interested you in film?

Philip Hartman: I was always crazy about going to the movies; my family used to tease me that I loved every movie I saw when I was a kid. At about 14 my mom sat me down to watch *Citizen Kane* on TV and I dug its larger-than-life characters and larger-than-life technique. Then I came of age during Hollywood's Golden Age in the '70s and was a champion of Altman and Scorsese and Rafelson and Ashby and Malick, guys working on the margin, making movies about marginal people.

LH: #2. Who are your greatest influences in the film industry?

PH: Well, there are a very small handful of filmmakers that manage to stay true to their vision without getting sucked into the black hole of Hollywood. My favorite film is Nick Ray's first, *They Live By Night*, which feels like an "independent film," and I love Rosselini's *Open City*, which does, too, and I love all of Morris Engel's films which were landmark early indies. Jim Jarmusch is a current example of someone who's staked out his own turf and refuses to budge; Alexandre Payne and Wes Anderson will hopefully be two others. Anyone who's not making Hollywood audition tapes, those are my biggest influences—and inspirations.

LH: #3. What does it mean to you to have made two completely independent films after writing Hollywood screenplays?

PH: Well, the frustrations of writing within the system (albeit at the margin of it) motivated me to finally get my own films done. When I started working as a studio screenwriter, there was no indie film community, so that when John Sayles came along, and Wayne Wang and Spike Lee and Jarmusch, it was like discovering religion, and I fled from my old church for the new one—where I finally felt at home.

LH: #4. What first interested you in the East Village?

PH: The darkness, the despair, the dinginess—it was love at first sight. My first visit to the EV was to see a movie—three movies, actually, for $1.50 at the St. Mark's Cinema! The EV has always been a place to redefine yourself, and it helped me get my priorities straight and stay true to what I wanted to do.

Bulging out into the river, geography plays a big part in the EV psyche, especially the east East Village. No one passes through "Alphabet City" on their way to anywhere else; it creates a small-town feel, an intimacy that is extraordinary in the big city. That, combined with its traditional ethnic diversity, makes it the best place to live in the world.

LH: #5. How has film affected the East Village?

PH: It's a film noir kind of place, with a touch of Fellini thrown in. . . . Actually, if I had to name two films that reflect the East Village aesthetic they would be Godard's *Alphaville*, which is a post-modern noir, and Jarmusch's *Stranger Than Paradise*, which is a post-modern road movie. The neighborhood adopted the black-and-white, sadly comic style of both.

LH: #6. How has the East Village affected the film industry, and its outlook on independent film?

PH: Well, I'd like to think that the East Village is kind of the conscience of the film

industry, constantly supplying an antidote to their bloated, over-hyped product. We've got people like Larry Fessenden and Tamara Jenkins and Michael Almereyda and Alex Rockwell expanding the margins of what the industry accepts as independent filmmaking. And then we've got directors like Nick Zedd who represent the far end of the spectrum and keep everyone honest. Especially gratifying has been the success of *Raising Victor Vargas*, which proved that grassroots filmmaking about real people in a real place (our people, our place!) is economically viable if its honest, true—and funny.

LH: #7. If/when the EV has its own singular film festival, how should it be different than Sundance or Tribeca?

PH: Well, we got it, starting August 20th, 2003. The EV Film Festival will be a celebration of fifty years of alternative filmmaking—with retrospectives and tributes and a few premieres. It includes films that have East Village roots or have the EV spirit in their celluloid hearts. No prizes, no limos, no entourages, no air kissing; just films and filmmakers. A film festival should be organic to its place, feel like it sprang from its soil—the East Village Film Festival will be grassroots and real.

LH: #8. Is the EV too gentrified, or Hollywood-ized?

PH: Well, the stampede into the neighborhood over the last two decades has definitely trampled much of the precious stuff that drew those hordes to begin with. That's what we trying to do with the HOWL! Festival—remind people why they flocked here: for the art, for the idiosyncrasy, for the unique countercultural spirit, for the cultural diversity, for the sense of adventure and experimentation. And much like Hollywood has co-opted the concept of the independent film, the EV is in danger of being co-opted by market forces. There needs to be a healthy balance between "progress" and "regress." We need to look to the future, while maintaining the legacies of the past. There's always got to be a place that the counter culture calls home; the EV's been that place for fifty years, and we hope, for at least fifty more.

LH: #9. When shooting your first film *No Picnic*, did the EV influence or help your production?

PH: Well, the EV was the film, was the production. On the video box the credits read: "A film by Philip Hartman and Doris Kornish and half of the East Village." *No Picnic* was part-narrative and part-archival, in a desperate attempt to capture places and faces that would soon be extinct. The community was amazingly responsive, becoming a part of many of the film's scenes—with one exception, the night gunshots rang out on Ridge Street, and we had to throw our camera in our VW van and haul out with our heads ducked between the seats.

LH: #10. When are you going to make your next film?

PH: When—and if—I ever stop HOWL!ing. I'd like to make another EV film . . . kind of a companion piece to *No Picnic* . . . an after-the-deluge kind of thing. And I never stop writing . . . screenplays usually, but I'm now finishing a novel about—you guessed it!—hard life and times in the East Village. And it might make a good film someday . . .

[Leon Hartman is participating in the First Annual East Village HOWL! Festival and is about to enter his sophomore year in the Film Program at Boston University]

LES

in Video

by Alfredo Texidor Irizarry

My name is Alfredo Irizarry, and I'm a native New Yorker, born on East 112th street, El Barrio, and raised on the Lower East Side. Growing up I attended the Church Of All Nations' after-school program at 9 East 2nd Avenue where I was first exposed to a multicultural environment. Church Of All Nations was the first place where I got a sense of being surrounded by many different cultures and languages. It was an oasis; a shelter from all the gang fights and violence. At the church I was taught that it was more important to love your neighbor than to hate them. In 1964, I became involved in an Organization called LEAP (Lower East Side Action Project) created by Larry Cole. LEAP was a grassroots organization geared to help inner city disadvantaged kids. Larry Cole was a black belt Judo expert who studied martial arts in high school in California. He believed that training kids in the discipline of martial arts would help them academically and socially. During my time with LEAP, I became interested in photography, music, art and martial arts. In 1967, I took a course in video with the Porta-Pak in a young film maker's organization located on Chrystie and Rivington Streets. There I learned the art of videotaping, interviewing, and monitoring audio. In 1969, the Vietnam War was escalating so Larry Cole and my counselors, Paul Ramos and Don Turner, convinced me to join the Navy to escape being drafted and sent to the jungles of Vietnam. I spent four years in the United States Navy, from 1969 to 1972.

I grew up during a great era when everyone worked together and watched out for the kids in the neighborhood. I also grew up watching all the great classic actors, like Laurel and Hardy, Keystone Cops, Abbot and Costello, James Cagney, the Bowery Boys, Charlie Chaplin and so on. All this was a great influence on me. My immediate influences are Larry Cole Director of LEAP, Paul Ramos and Don Turner, and Jose Garcia, my film teacher in college, and Paul Goodman, my personal tutor as a kid. Paul Goodman was my first major influence. Goodman established the first Montessori school on First Street where I grew up. We used to play handball together and Goodman would come to my house to tutor me in academics while he worked on his PhD in education and ran the school. The school was called the First Street School, and Goodman wrote a book called *The Lives of Children in the First School*. Goodman was allowed to come into the neighborhood when gangs ruled the day. When he died, a group of us created C.U.A.N.D.O, Inc., Cultural Understanding and Neighborhood Development Organization, in Goodman's memory to continue his school. C.U.A.N.D.O was housed in the Church Of All Nations for many years before we lost the building.

When I got out of the Navy in 1972, I entered College at Old Westbury where I took several courses in media. I took "Media and minority," and studied film with film-maker Jose Garcia, the author of *The Invaded Island*, a film about the Navy occupying the island of Vieques in Puerto Rico. This is the first time I realized how media impacts society. While in college I experimented further with media creating the college newspaper, *The Catalyst Newspaper*. I called it the *Catalyst* because we united with black, white, and latino students to create it. It was so successful the newspaper is still in use today and is circulated to the state universities on Long Island. By the time I graduated in 1976, the Lower East Side was in shambles, buildings were being torched for insurance, drugs were out of control, and the city Of New York didn't have the money or resources to help. I immediately got involved with the Loisaida movement. The Loisaida movement was created to combat the problem that was eroding the quality of life that many remember growing up here. The word Loisaida was created by Bittman "Bimbo" Rivas in a poem called by the same name. I decided to create a newspaper in the area to help people keep track of new developments changes and improvements in the Lower East Side. Bimbo created the name for me to use in the magazine. I then met with Mary McCarthy, from Larchmont, NY, who had already made a dummy copy for a magazine called *The Quality Of Life*. Sister Susan from Adopt-A-Building set the meeting up when she found out both she and I wanted to create some kind of publication to help keep the residents informed. I asked Mary to combine both names and we created *The Quality Of Life in Loisaida*. Mary sold her house and moved down to Loisaida to help in the quest to change the neighborhood. She became the editor in chief and trained many people in journalism. We published the magazine for sixteen years. In 1978, I met Carlos Diaz, a New York University film student looking for a project. I convinced him do a documentary on the housing movement. *El Corazon De Loisaida*, the heart of Loisaida, was created for PBS's channel 13. The film is the story about the first building bought in the Loisaida housing cultural artistic movement by me and my brother, Luis Angel Irizarry. The building was converted into the first Tenant Co-op, 219 East 4th street in 1976–77.

When we started the magazine, Loisaida was first housed in 402 East 4th St, our townhouse building. I then rescued the abandoned school building, 609 East 9th Street for Charas/El Bohio and began operating multiple agencies. We recovered and saved over 35 buildings in the Lower East Side, when we teamed up together to fight the city's neglect, drugs, housing deterioration and the eroding quality of life we were experiencing not only in the Lower East Side but in the entire country as well. Many other projects came out of this, like the Solar Energy building, 519 East 11th street, Adopt-A-Building, the Merchants Association, the Nuyorican Poets Café, and many others. Charas became the heart and soul of the Loisaida movement, with leaders like Armando Perez, the artistic director and co-founder of Charas, Bimbo Rivas, the artistic director of the El Teatro Ambulante, Chino Garcia, director and co-founder of

Charas, and Miguel Algarin, the founder and director of the Poets Café. As a direct result, the Loisaida movement has been a resounding success that has been repeated over and over again in other cities and countries.

After the success of the magazine and the documentary in the Lower East Side, I went to work in the South Bronx District Nine school district. I was the assistant director in the media department and created a program called, "District Nine at a Glance." We had one day every week and one Saturday every month on Channel 25 WNYE. We basically covered all important events in the school district but I expanded the program to include community activities as well. I worked there for about seven years, sharpening my skills in interviewing, editing, and camera work. It was a great experience for me to expand my experiences in the Lower East Side. I have to mention Arnold Clark who was my mentor and director during this time. He was a great videographer who was committed to creating works of art to enhance not only the Board of Education but our communities as well. "District Nine at a Glance" was my training ground in television productions and it taught me the craft in a professional setting.

I covered the Manhattan chess club tournaments held in Roberto Clemente State Park when chess Master Garry Kasparov visited and played the best students in the City. I covered programs like the magnet schools and art programs with then-school Board President Jerome Green. I also greeted the arriving Russian students and their coach when they arrived from Russia for a chess tournament. I said, "Dobre Utra Nasdrovia Pan." "Good morning, my Russian friends." They were very surprised to find out I was a Puerto Rican who spoke a little Russian. We covered community events with Fernando Ferrer at the Bronx Courthouse when he was the Bronx borough president. I also covered the first event to place advertising on buses for cops shot. It was non-stop activities and events for seven years. It was a great training ground for me personally in video productions, pre productions and post-productions.

Then I transferred to District One to start a media department in my neighborhood. After what seemed a lifetime of waiting and run around I eventually joined Manhattan Neighborhood Network (MNN) in the early '90s as an independent producer to work and train neighborhood kids. At MNN I've come full circle; I worked with the America Corps kids, University Settlement, Henry Street Settlement, and Charas/El Bohio with Recycle a Bicycle. In addition, worked on projects like "An Eye In the East Village" with Dennis Redman, "Hear us out" with Aquila Wilkinson, "Latin Close Up," with Linda Rios, "On Two," with Mercedes Cruz, and my own project, "Global Healing," co-hosted by Carlos Diaz and Rosalind Castro. Global healing was about examining the alternative healing remedies as opposed to the traditional cures. We compared house remedies, North American Indian remedies, Caribbean Taino remedies, and so on.

In 2000, after eight years of being a producer, I was hired at MNN, which is the largest public access center in the country, and it has been the fulfillment of my dreams and experience to work here. The most important person to me at MNN is Oliver Richardson, who was a fantas-

tic mentor and friend and who taught me the craft of television production. He was a great musician, and incorporated his love for music with his love of video. When he first saw me behind the equipment room desk he was shocked and said, "Al, what are you doing behind the desk?" I told him proudly, "I now work here." He beamed back smiling, "It's about time we finally have one of our own working here." That's when I knew I was in the right place at the right time. Since I've been here I've had the great privilege to facilitate for some incredible shows and people. In the past three years I have facilitated hundreds of shows like "Conversations with Harold Channer," "Community Cop" with Ozzie Thomsen, "Ancestor House," with Camille Yarborough, "Gilchrist Experience" with Winston Gilchrist, "Each Hit And Die" with Lee Tepplezsky, and many others. MNN has given me the opportunity to expand my ability to become a professional television producer working with legends like Oliver Richardson, and Felipe Luciano. Yesterday, I used to say video productions are only a hobby, and today I say it is my career."

Third World Newsreel

by Christine Choy

Newsreel, the prolific, in-your-face, agit-prop filmmaker's collective that emerged out of the turbulence of the 1960s, was one of the American New Left's most potent consciousness-raising tools, a veritable Celluloid Vanguard that its cadres hoped would usher in a brave new world of people's democracy. With an image of a machine gun spitting out its logo, Newsreel films were militant and confrontational: at the opposite pole from the syrupy Hollywood feature. In the years before television, the documentary newsreel occupied quite a different place in American popular culture, with millions of moviegoers afforded a once-a-week glimpse at world and national news via the newsreel trailers that accompanied feature films and cartoons at neighborhood movie houses from coast to coast. During World War II, the newsreels even served as unofficial propaganda vehicles, showing American troops triumphing in Europe or the Pacific. Always narrated by male baritone voices with an unmistakable undertone of "truth, justice, and the American way," the newsreels of the 1930s and 1940s reinforced the view that all was right with America.

From 1970 to 1971, I lived in a $65 per month apartment across from the famous Katz's deli on Houston Street. Subsequently I moved to one of the most famous avenues in New York, the Bowery, for ten years. At that time, there were very few activities in film production, both in Chinatown and Little Italy. The Newsreel that I joined in 1971 was at the opposite pole of this pollyannaish world-view. Newsreel (with a capital N) burst onto the media scene in 1967 during a time when American complacency was being shaken to the core by the Vietnam War, urban unrest, and a youth culture that trusted no one over 30. So what if the grainy, black-and-white footage would never make it to Hollywood: It was the message—not the medium—that mattered. These were, after all, noble and self-righteous documentaries that would change the course of history. Besides, they were irking the system big time, no mean accomplishment in a climate when the FBI was infiltrating many countercultural and antiwar organizations.

According to Norman Fruchter, an early Newsreel participant who in 2003 heads the Institute for Education and Social Policy at New York University, Newsreel got its start during the marathon demonstrations at the Pentagon in 1967. Such cine-activists as Marvin Fishman and Jonas Mekas (now head of the Anthology Film Archives in New York) persuaded sympathetic filmmakers to pool their footage and come together as a collective to lend greater clout to their creative efforts. With the release of that Pentagon film, titled *No Game*, Newsreel was born. About three or four dozen filmmakers were then participating in the group, which incorporated under the umbrella name of Camera News Inc. and was bankrolled in part by some left-leaning families whose flower children were eager members of the collective. Chapters popped up all across the country: in New York, Boston, Washington, Los Angeles, San Francisco, Detroit, and Vermont.

One of the most unwavering of the early Newsreel activists has been Roz Payne, who since 1972 has maintained a film, photo, and document archive and distribution facility in Vermont, where she and other filmmakers continue to create video documentaries. She teaches at Burlington College and is at present shooting a history of the retired FBI agents who worked in COINTELPRO against Don Cox, an

exiled Black Panther, and Marilyn Buck, the white woman who was a major supporter. Roz Payne's website (www.newsreel.us), which archives dozens of Newsreel's offerings, is a valuable resource of the collective's past and present history. When she joined Newsreel in the late 1960s (in those days there were only four mainstream networks: ABC, CBS, NBC, and PBS) it was with the sense that these establishment news organizations could not be counted upon to present an unbiased version of current events. At Newsreel, it was taken for granted that these media outlets were part of the "Military/Industrial Complex" and could be trusted to do nothing more than maximizing a profit for corporate America and brainwashing the public with reportage that supported the status quo. Roz Payne says, "The only news we saw was on TV and we knew who owned the stations. We decided to make films that would show another side to the news. It was clear to us that the established forms of media were not going to approach those subjects which threaten their very existence."

As its first post-Pentagon offering, Newsreel Boston made *The Boston Draft Resistance Group* early in 1968 about Noam Chomsky and a bunch of antiwar actvisits. Flush with its early enthusiasm, Newsreel tried to put out a film a week during that early period. John Douglas and Norman Fruchter and others started working on *Summer of '68*, a film about the efforts to disrupt the Democratic Convention in Chicago that August. The following year, Norman Fruchter, Robert Kramer, and John Douglas went to North Vietnam at the invitation of Ho Chi Minh's government to make *People's War*, a film that documented the impact of the American bombing sorties. They were disappointed in not being able to capture Ho himself on film, due to the venerable leader's growing invalidism.

Like many countercultural organizations of the era, Newsreel met in a series of basements in the East Village and Lower East Side sections of Manhattan, those familiar incubators for radical and progressive organizations. It later established more permanent office in the West 20s and 7th Avenue, near the garment district and Madison Square Garden. Each week, about thirty members of the collective got together to hash out political issues and film treatments, organizing themselves into smaller sub-groups comprised of students, women, Third Worlders and, in Roz Payne's words, "the infamous sex, drugs and party committee." And as with many countercultural activities, the commitment to a cause was not always accompanied by a commitment to organization. Roz Payne attests to the random nature of the process. "Sometimes films were made and some times not," she writes. "Most often they were made too late and did not go to the people who could use them best

In its heyday, Newsreel aimed at making two films a month and distributing a dozen prints of each across the country, where they'd be shown on college campuses or to meetings organized by other chapters. A mobile project was set up in which collective members would drive into an urban neighborhood in a van loaded with projection equipment and a portable screen, or show the film against a convenient wall, creating an instant inner-city drive-in theater for the masses. The hope was that these screenings would be catalysts for similar grassroots films in the communities where they were shown. Newsreel's output can essentially be categorized according to seven themes, according to Bill Nichols, whose 1975 UCLA dissertation *Newsreel: Documentary Filmmaking on the American Left* was published by Arno Press in 1980. I must say at the outset that Nichols's analysis is by no means a comprehensive account of the early days of Newsreel: he interviewed only a few of the key players and he did not have access to important archival material that would make his account a truly definitive study. But it is useful to see how he categorized Newsreel films by topical themes. These seven themes were Institutional Oppression—antiwar films about Vietnam, and documentaries about prison, the military, civil rights, police oppression, urban unrest; Women's Liberation; Ecology; Working Class Struggles; The New Left Movement; National Liberation Struggles; and Views of Socialist Societies—Cuba, North Vietnam, and the People's Republic of China. Films about other causes, such the as gay or lesbian movement, anti-Semitism, issues dealing with the physically or mentally challenged, were non-existent. In an attempt to encourage a more diverse pool of talent, I started agitating for the creation of Third World Newsreel in the early 1970s that would empower filmmakers from Asia, Africa, and Latin American, and women, to create films from their perspective and experience. Plain and simple, the credo of Newsreel was not to create a touchy-feely, hypertolerant rainbow nation; it was to smash the capitalist oppressors and con-

front the military/industrial complex that was leading America and the world toward a police state.

The first Newsreel film Roz Payne worked on involved the student takeover of Columbia University in the spring of 1968. Students had seized five buildings and there was a Newsreel film team in each one. It was not uncommon for Newsreel filmmakers to take an active participatory role in the events they were documenting, not being content to serve as disinterested observers. As she recalls, "Our cameras were used as weapons as well as for recording the events. Melvin had a W. W. II cast-iron steel Bell and Howell camera that could take the shock of breaking plate glass windows."

Payne recalls the contributions of many women in the early days of Newsreel, like Lynn Phillips, Bev Grant and others. "The Columbia film could not have been completed without the editing skills of Lynn Phillips," she says. "Jane Kramer did some amazing things in working with Allen Siegel on *Amerika*. There was also Jerri Ashur, now deceased, who did *Janie's Jane*. Deborah Shaffer went on make many significant films about human rights, winning Academy Awards and also this year's best-filmmaker award from Human Rights Watch. I don't feel like women were totally oppressed."

Newsreel sent official representatives to such radical groups as Students for a Democratic Society, the Black Panthers, and the Young Lords. Roz Payne recalls that every Monday night, she used to go up to Harlem to screen Newsreel films that were used by the Black Panthers in their recruiting efforts. Some Newsreel activists participated with the Panthers in grass-roots community organizing, such as the High School for Dropouts project in Newark, New Jersey.

This sense of "the personal is the political" pervaded Newsreel and other leftist organizations of the time. Newsreel is based on the premise that as humans we create our own histories based on facts, memories, and selective memories. From the vantage point of 1971, my past had been a blur. I was brought up in Shanghai, People's Republic of China, but as an expatriate. My father was a Korean freedom fighter who ended up there temporarily during the Japanese occupation of his homeland. Several years earlier, in 1969, I'd arrived as a teenager in the world's most advanced capitalist society, eager to begin my studies at an American university during a period when the very system was under siege. By 1971, after years of antiwar agitation and community organizing, I and many of my peers had no ideology or direction, nothing but the burning desire to change America from top to bottom, to free all political prisoners, to damn the rich and uphold the poor. Newsreel at that particular moment in time was going to be my vehicle for putting thought into action I admired the passion and commitment that inspired the collective to churn out a film a week on such burning issues du jour as the displacement of poor Latinos to make way for Lincoln Center, the phenomenon of women on welfare, the ideological bias of textbooks used in schools and universities, and, always, the Vietnam War. It was grueling work, the work of youthful idealists as much under the influence of marijuana, rock and roll, and the sexual revolution as that of any ideology. As the poet had written nearly two centuries earlier, "Bliss was it in that dawn to be alive/But to be young were very heaven."

Those were fierce times. The Vietnam War entered a new and deadlier phase with the bombing of Cambodia. At home, National Guard troops had fired on student protesters at Kent State, killing four of them outright. Dozens of protesting prisoners were massacred at Attica in upstate New York. The FBI launched its vicious COINTELPRO counterintelligence program to root out so-called subversives in the antiwar and civil-rights movements, as in the Weather Underground or Black Liberation Army. There was massive infiltration of the protest culture, and arrests. In the face of this, Newsreel began degenerating into factions, with arguments over white privilege, issues of class and sexual orientation. People were at each other's throats, becoming factionalized, sinking into a haze of paranoia. We were too young and naive to understand how the collective and the movement were being undermined by strategies of "divide and conquer." Like a bad marriage, Newsreel started coming apart at the seams. The middle-class white males lost their direction; the working class members had to choose their sides. Caucuses emerged around the "haves" and the "have-nots", and Third World members. It was purely a matter of where people were born and what school they went to. There were purges and resignations, and factions such as the ideologues and the cineastes. Depending on

how you looked at things, it was either the height or the depth of the sexual revolution, and it was not uncommon for one member to be sleeping with five others, making "the personal as political" even more convoluted than ever. Many of the "haves" went back to graduate school for their PhDs, or became shrinks, or went into community service or Legal Aid. Some of the whites were purged, others deserted, and I was left with reels and reels of unidentified film which I tried to archive. In such disarray, Third World Newsreel was born in 1972.

Even so, the revolution had to begin at home: Newsreel at this time was comprised of white males (Anglo-Saxon or Jewish) who passed their time watching pirated copies of *Salt of the Earth* and reading Franz Fanon and all the populist ideologues of the period. Films were being made *about* blacks, women, and (rarely) working-class whites, but none of these subjects had access to power within the collective. As in the larger culture, the women (almost all white) were subordinates and sex objects. With the exception of a single member in San Francisco, a Puerto Rican woman named Joanna Rodriguez, I was the only non-white woman in the entire collective. In New York, there was also a group of black students from Seward Park High School: David Wallace, Robert Zellner, and Martin Smith. Though I was neither Chinese nor Communist, I was cast in a stereotypical role: that of embodying the proletariat as defined in then-fashionable Maoist terms. Regardless of my specific experiences, I was no revolutionary from the East. I simply had read Marxist dialectics when I was a six-year-old in Shanghai, a watered-down version, of course.

I was livid. How could an idealistic collective like Newsreel attempt to speak for the masses when it wouldn't let people of color or women control their own media? In retrospect, without such a commitment, we would never have a complete past for ourselves and the generations to come. I had to challenge the structure of an organization that purported to speak for the masses from an essentially white-male point of view. Thus was born Third World Newsreel, a collective of people of color and women making films out of their own experience. Without recruiting and training people of color, we would never have a future. Simply put, most films coming out of Newsreel at that time did not reflect a crucial multicultural attitude. Exceptions were Allan Siegel's *Amerika*, the collectively produced *Breaking and Entering, El Pueblo Se Levanta* (The People Rising Up), and *Beat Up People* (about the Black Panthers, though it was never completed). Robert Kramer's *Ice* and Jerry Ashur's *Janie's Jane* were also exceptions, though these were not done under the aegis of Newsreel. Even some of the films we imported from England, the Netherlands, France, Australia—about national struggles in Vietnam, Cuba, Guinea-Bissau, Angola, South Africa, Algeria, Laos—were often created by all-white production teams. This was colonialism in action.

By 1972, Newsreel had lost much of its original steam and many of the key members began going their separate ways. The Vietnam War was winding down, and the countercultural movement had lost a lot of the in-your-face energy that had characterized it during the late 1960s. Some people were simply burned out, others moved on to other pursuits, or dropped out of the factionalization and disarray, or couldn't stand the government's unrelenting pressure. The movement itself disdained institutions, so it was not surprising that it did not sustain an infrastructure to continue its work. Roz Paine says that some people wanted to move on to other priorities. She had been working with the Black Panthers and Young Lords for years and now wanted to start organizing white people. She and some other Newsreel people drove cross-country for a few months to figure out what the next phase of the struggle would be like. Though she admires Third World Newsreel for taking up the torch, she says that TWN was more interested in distribution than in organizing. "We were collectivists, we were revolutionaries using our cameras as tools and weapons for social change. We went out with our projectors into communities all over the country teaching people how to change the world through film."

By 1972, there emerged a surge of black voices finally becoming visible in American media. There was a group of black UCLA film students, notably Hali Gerima, Charles Burnett, Julie Dash, Billy Woodberry, and Nima Burnett, who were beginning to empower themselves by making films about African American issues. Some noise was coming from the Latino community, too, though no films were made during this period. Native American filmmakers who contributed to Third World Newsreel included Chris Spotted Eagle and Larry Little Bird. Loni Deng,

Carter Choy, Chris Chow, and Bob Nakamura were doing work on the West Coast, but no one from the Asian community on the East Coast was doing anything until I came along. It was under these conditions that Third World Newsreel was born.

My first film for Third World Newsreel, *Teach Our Children*, was done in collaboration with Sue Robeson, whose grandfather, actor Paul Robeson, had been an outspoken advocate of racial justice a generation earlier. It was a critique of the educational system and how it transmits values that are inimical to the advancement of marginalized peoples in our society. The topic was on the Attica Prison rebellion, but was done without any serious training in filmmaking. The film looks amateur, but it was made with 100 degrees of passion. Ironically, it won many awards at black film festivals but was hardly noticed in the Asian community.

I was determined to continue the legacy of the Newsreel spirit, but instead of smashing the establishment, I was going to be pragmatic, using corporations and the state to advance our own interests. I decided to emphasize distribution, and to have distribution, we had to have a catalogue. I wrote a proposal that convinced the McDonald's hamburger people to give us $10,000 to finance these projects. It was arguably Ronald McDonald's finest moment. In 1974, I applied to the New York State Council of the Arts for $10,000 to make four films. I was amazed that they granted the entire amount. Thus was born another of my early Third World Newsreel films, *From Spikes to Spindles*, which I did in cooperation with Tsei Hak, the Spielberg of Hong Kong. This film acknowledged the oft-repressed story of Chinese immigrants—the men who migrated to the West in the 1860s to build the railroad, and the women who in 1974 were toiling in garment sweatshops of America's Chinatowns from coast to coast. This was a landmark film: an agit-prop documentary shot in color. Even so, I realized my own narrow perspective in thinking that Asian America was composed only of Chinese and Japanese immigrants. I was naive enough to ignore the contributions of Filipinos, Koreans, and Pacific Islanders who were also pioneers of the Asian American experience. I was shy. I didn't think my people's story was worthy. We, after all, were indentured servants, scholars, entrepreneurs, a notch above the blacks who were victims of the slave system. Other films followed in quick succession: *Inside Woman Inside*, a film I directed about women in prison; *Fresh Seeds in the Big Apple*, which I did with Allan Siegel. Allan and Ernie Russell also worked on a film called *Mohawk Nation*, about the Native Americans who were trying to assert control over their own land. The film was never completed.

In 1983, Renee Tajima joined Third World Newsreel as associate producer of *Who Killed Vincent Chin?* Third World Newsreel received a large grant of $135,000 from the Corporation for Public Broadcasting (CPB). On the one hand, it was cause for celebration. On the other hand, it was destructive. It meant that Third World Newsreel began heavily relying on institutional support. For an organization that was born in struggle and protest, that marked a significant change. I took on a number of roles: cinematographer for a film about Audre Lorde; with JT Takagi I was director/producer of *Homes Apart*, a film about families separated by the political division of North and South Korea, for which we received a moderate grant from the National Endowment for the Humanities (NEH). At this time, the Public Broadcasting Service (PBS) was seeking alternative visions and we were in the right niche at the right time. But we were divided over who was getting or who should be getting the money.

As a founder of Third World Newsreel, I was engaged in every single project, as producer, director, cinematographer on the various films described above. My loyalty was split within the organization. Finally in 1983 I resigned from Third World Newsreel to establish another incorporated entity: the Film News Now Foundation.

However, the Film News Now Foundation had been the receiving entity for Newsreel's trust fund since 1968. When I pulled out from Third World Newsreel, we had tax-exempt status, enabling donors to take a tax deduction on their contributions, so Third World Newsreel had to reincorporate as Camera News, Inc. and receive its own tax-exempt status. Thus, from 1983, the entity was known as Third World Newsreel d/b/a (doing business as) Camera News, Inc. The Film News Now Foundation became its own entity. There was a new production entity: Camera News, Inc.. Newsreel was never a legally constituted corporation in its own right. Today, Third World Newsreel/Camera News, Inc. is the legal entity, and Film News Now Foundation is completely independent.

In retrospective, the history of the Left since the 1960s has been extraordinary, full of dreams and idealism. But, as seen in the experience of Newsreel, the Left had so many sectarian factions, a reflection of the American Left as a whole. People of color have maintained and archived material from both Newsreel and Third World Newsreel. Much material has been located at the University of Wisconsin and in individual collections. Now that Newsreel is celebrating its 35th anniversary, old films from its early days are resurfacing at prestigious film festivals in the U.S. and abroad, including the Asian American Film Festival and Latin American Film Festival in New York, and at Yamagata in Japan. Newsreel is one of the oldest organizations of its type.

As a founder, I feel extremely proud that capable people are continuing its mission, such as Dorothy Thigpen, who now capably heads Third World Newsreel. The organization is continuing the vision I had at its founding: to be an entity where people of color control their own representation in film. As Bill Nichols points out in his otherwise flawed *Newsreel: Documentary Filmmaking on the American Left* (published by Arno Press in 1980): "[Third World Newsreel has] also radically reshaped the nature and purpose of Newsreel." The documentary filmmakers of the 1960s and 1970s offered a perspective that is still useful for contemporary activists seeking to offer important visual critiques in today's era of terrorism and globalization.

APPENDIX: When I joined Newsreel, some of the other members included late Jerry Ashur, Janet Kransburg, John Douglas, Norman Fruchter, Tammy Gold, late Rober Kramer, Beverly Grant, Robert Lacativo, Joyce Miller, Stephanie Pulaski, Allan Siegel, Florence Summergrad, Barbara Koppel, Jonas Mekas, Flo Jackson, Robert Mackover, Peter Barton, Tammy Gold, Larry Mead, Bill Floyd, Deborah Shaffer and Marilyn Mumford. Original members of the Third World collective included Christine Choy, Sue Robeson, Robert Zellner, Martin Smith, and David Wallace.

The Search for the
Invisible Cinema

by Sky Sitney

The starting point of this paper is a photograph in a family album. My father, P. Adams Sitney, sits to the left of Jonas Mekas and Peter Kubelka in a highly unusual-looking theatre that appears to have peripheral blinders between the seats, eliminating the possibility of interaction and distraction from the sides. While my curiosity about the theatre, which Kubelka, its designer, called the Invisible Cinema, was temporarily satisfied by various familial anecdotes heard throughout the years, it wasn't until I became a graduate student in cinema studies that I grew interested in learning more than surface details about it, and was surprised to discover that only a few reviewers and theoreticians had written on the subject, and disappointed to learn that historical documents (such as program notes, financial records and blueprints) no longer existed.

The theatre operated for four years from 1970 through 1974 at Anthology Film Archives, which was first located at Joseph Papp's Public Theatre on Lafayette Street in New York City. In the expression of its designer Kubelka, the theatre's "revolutionary and controversial design was based upon the notion that like the other machines that a film depends on—cameras, developers, printers, editing machines and projectors—the room in which one sees a film should also be a machine designed for film viewing." That it should "make the screen his whole world, by eliminating all aural and visual impressions extraneous to film." . . .

The Invisible Cinema was constructed by Giorgio Cavaglieri and funded by the great art patron Jerome Hill. Only a couple of years after the construction of the theatre Jerome Hill died of cancer at the age of 67. With two years left on the contract to Joseph Papp and without Jerome Hill's support, the founding members of Anthology found themselves unable to pay the rent. In 1974, only four years after the construction of the theatre, Anthology Film Archives lost its lease and moved to 80 Wooster Street. No attempt was made to reconstruct the Invisible Cinema and Joseph Papp quickly converted it into a more conventional design. What follows is an oral history of the Invisible Cinema based on interviews that I conducted with the founding members of Anthology Film Archives: P. Adams Sitney, Jonas Mekas, Stan Brakhage and Ken Kelman. I did not have access to either James Broughton, who was peripheral, or Peter Kubelka, who was essential, but depended upon other sources for his voice in this matter.

JONAS MEKAS:

Jerome Hill was like a renaissance kind of man; he was a composer, a painter, an architect, and a filmmaker. But in the first place he loved modern art, he loved cinema. In 1968, Jerome's close army friend, Burt Martinson, was the chairman of Joe Papp's Public Theatre. After they got the landmark Astor Library on Lafayette Street, they began transforming it into theatre spaces. Martinson asked his army friend Jerome if he wanted to use some of the space in the building. So Jerome called and asked me if I wanted to do something with it. I said, "Yes, why not?" It happened that Peter Kubelka was in town at that time so we all got together: Jerome, Peter and myself, and we sort of worked out in principle the idea that later became Anthology Film Archives.

LETTER TO P. ADAMS AND JULIE SITNEY FROM JONAS MEKAS
dated April 25th 1968
Dear P. Adams and Julie,
. . . Greetings from rainy New York . . . Jerome came up with an idea to put an [avant-

garde film academy] in the Joe Papp building. . . . While Peter was still in town, we all went to the building and we decided that it is the place where Peter's old dream of the EGG theatre could come to reality. So, that's what it will be. The work is going already, and the theatre should be ready by the first of January 1969. . . . Peter gave all the instructions of his dream to the architects, and left for Vienna. Jerome is supervising the construction. The idea is to make this theatre (120 seats) into the first avant-garde film repertory theatre. There will be a board of say five or six film "authorities" (say, Kelman, Brakhage, Kubelka, Sitney and myself) who will decide which films should be admitted to such a repertory theatre. Once we decide on films, the prints will be acquired and kept in the library, for repertory screenings. There will be one director, one coordinating director who will do the programming, prepare notes, and guide the promotion—in close cooperation with the five program directors. Our first idea was to invite Peter to be the coordinating director. But we gave up the idea. It would be too diffi-cult for Peter himself, knowing how choosy he is. And then, he has to make his films; he shouldn't be tied down. Third reason: Stan said that if Peter would run such a place, he wouldn't have anything to do with it. Otherwise Stan is completely behind the idea. So we sat and sat thinking about this matter and decided that you are the best man to run such an institution. . . . Now this will affect your travels. You'll have to make up your mind. You'd have to come back a few months before the opening of the theatre so that you'd have time to pre-pare the whole thing. . . . So, I'm enclosing $100—which is to go out and drink plenty of Irish beer and take your time and make up your mind and send a telegram to Jerome Hill. . . . End of page, end of letter. Beginning. Love to both, Jonas.

PETER KUBELKA INTERVIEWED IN THE DESIGN QUARTERLY 93 ISSUE ON FILM SPACES

The concept of Invisible Cinema has nothing to do with the special aims of Anthology Film Archives. I conceived the cinema in 1958 in Austria, after I made my Schwechater film, and I attempted several times to have it built, but never succeeded. After several years I had almost forgotten the project when happy circumstances brought Jonas Mekas, Jerome Hill, and me together. Jonas said that we would have a chance to build a projection room for Anthology Film Archives. I remembered my old project and said I know exactly how to build such a pro-jection room. . . . After only four years the cinema was taken apart due to economic circum-stances and that was a very severe blow. But it was built and the idea is there.

P. ADAMS SITNEY

Kubelka couldn't stand Giorgio Cavaglieri, the theatre's architect. It was one of my many dif-ficult jobs to go between the two. Cavaglieri had decorative ideas; he was interested in put-ting up marble here and there. He wanted the theatre to look nice, and Kubelka wanted everything to be devoted to the efficiency of his vision. Cavaglieri built the seats but was hav-ing a great deal of difficulty figuring a way to build the hoods. Actually, first they were to be entire booths, and that would have taken up a great deal of space. One of the big problems was how to get the maximum number of seats into the moderate space. If it had been done strictly according to Kubelka's plan, we probably would have been left with about thirty seats. That is, the seat in front of you was to be at about the level of your knees, the booths being completely around you. All of this takes up space and we had a very limited piece of space to work with. So, I was trying to keep it at 100 seats, and we ended up with 90-something. Raimund Abraham, Kubelka's architectural advisor, suggested bringing in this carpenter from Rhode Island—a woodworking guy—who built the hoods. So, Cavaglieri had completed his job with a set of seats in a row and then the hoods came afterwards.

PETER KUBELKA

I gave this concept of cinema the name "Invisible Cinema" to underline the fact that an ideal cinema should not be at all felt, should not lead its own life, it should practically not be there. The cinema as built for Anthology Film Archives was comparatively small in size, seating less than 100 people. Ceiling, walls, seats were all covered with black velvet; the floor was covered with black carpeting. Doors and everything else were painted black. In the whole room, only the screen itself was not completely black. Consequently, the screen and the film projected on

the screen were the only visual points of reference. In a cinema, one shouldn't be aware of the architectural space, so that the film can completely dictate the sensation of space. Due to the blackness of the room, there is no back reflection whatsoever on the screen.

KEN KELMAN

My own feelings about the Invisible Cinema were that it worked in a certain way. It tended, I think, to discourage talking. Not necessarily rattling papers, or heavy breathing and coughing. In fact, the theatre I felt, and still believe, made it worse. It was a very hard theatre, the shells were over you and noises bounced around a little, but this is a minor point, I mean it's negligible. I think it discouraged people from talking to the person next to them, and in those terms of counteracting certain disturbances the theater largely succeeded. Where it was a little annoying for me was that the black hood overhead had a shine. That was a little distracting, because right in front of me was this shine that didn't exactly reflect the movement of the screen. Anything more or less at eye level, you're going to see, and so the Invisible Cinema was not invisible. But certain things in it were, like the people, they were invisible, and hopefully inaudible as well.

PETER KUBELKA

[In the darkness of the theatre] a color film has much stronger saturated colors, it radiates like a church window, and the blacks in a black-and-white film are really black, and the white does not have any tinting from the reflection of colored walls, as so often occurs in so-called "normal cinemas." The cinema had, of course, no curtains in front of the screen, as unlike most film spaces, it was not conceived as an imitation of theatre. In order to completely eliminate everything but the screen from the visual field, special seats were designed which shielded sight to both sides and made it impossible to see one's neighbors. The rows were elevated so that the row in front of the beholder did not interfere with the sight lines of the screen. A wooden structure rose above the heads of the people in the row in front and bent forward so as to hide the head. The shell-like structure of the seat completely shielded the upper body from neighbors and people in back and front and it also had an acoustic purpose. Similar to hearing devices used in the Second World War they were simulations of big ears which concentrated the sound coming in directly from the screen and subdued sounds coming from other directions in the room, thereby creating a maximum of silence within which the sound from the film would be undiluted.

P. ADAMS SITNEY

There were things about the theatre that were interesting. For instance, it was designed to have a full-time theatre manager sitting in the theatre during every single projection with an automatic focus control and an automatic sound control independent of the booth, plus a telephone to the booth, so that there should be no excuse for the film ever going out of focus or for the sound not being right. Many, many filmmakers endured miserable screening conditions and, because of that, the idea of someplace where there would be focus at that time seemed very important.

STAN BRAKHAGE

There was always a joke that the seats got very erotic in the Invisible Cinema. I suppose that one could have sex on the floor or ceiling of these little boxes, or play with someone's feet and hold their hand, and so on, without anyone knowing. But generally, people really had a sense of drifting in a black space, a black box, and black ahead of you, nothing visible except the screen. So there you were in this velvet box watching these jewels of films.

P. ADAMS SITNEY

There were big cast-iron columns in the room—the room was quite small—so we had to make certain that the throw of the screen didn't interfere with the columns. Kubelka insisted that these columns were just confectionary. I spoke with Jerome and he said, "Well, if you damage them, they'll have to be taken down." So, I went in at about 6 o'clock in the morning with

a giant sledgehammer and decided that I was going to break the confectionary columns. I gave one an incredible bang and the building shook like a giant bell . . . my arms were in agony. The sledgehammer went bouncing out of my hands . . . the columns were staying.

REVIEW IN *VOGUE* MAGAZINE BY BARBARA ROSE, NOVEMBER 1st, 1971

In many respects, Anthology represents a new maturity of American film consciousness. Dedicated to the premise that film now deserves that kind of self-awareness which distinguishes the modernist arts, Anthology shows some two hundred or so films from a permanent collection in a five-to-six week repertory cycle, permitting the serious student to re-examine a given work many times. But Anthology is more than a film museum; it is also a unique cinema with a unique viewing facility that have caused as much controversy as the highly selective group of works assembled . . . I find the viewing situation at Anthology the best I have ever experienced, but that is because I can live without the communal experience of my neighbor blowing bubble gum in my face.

P. ADAMS SITNEY

The raking of the seats was rather steep, but we had to have enough room under the ceiling for the projection booth above the last seat. So we compromised here and there. For instance, if a person stood up in the last row, they would block the booth and their shadow would appear on the screen. One of the things we immediately realized was that human torsos are not at all on a single scale. Some people had very long legs while others needed six or seven pillows to see the screen.

KEN KELMAN

The seats never struck me as being too small. I suppose my friend Pinkwater would have been the great test for that, though we never thought to bring him in when he was 400 pounds. But Kubelka himself was a fair test and if he thought the seats were okay, I don't think they could have been all that narrow. I have long legs, I had no problem with my knees getting skinned; it may have been a little close, but not all that much.

P. ADAMS SITNEY

There were a couple of problems that Kubelka never admitted. One very serious problem had to do with the nature of air conditioning. When one sat in the enclosed seats, one generated a great deal of heat. If you stood up the room felt like a refrigerator, but as long as you were sitting in that small box it was very hot. It was an extremely soporific problem, one became very drowsy.

KEN KELMAN

The dozing off phenomenon I believe if I'm not mistaken can be attributed to a psychological rather than a physiological effect. I think that people in the isolation of this little booth—a kind of womb-like thing—sort of had a tendency to drowse off a little more than they would have normally. Of course, a clausterphobe would also have certain problems. I can't begin to address the psychological quirks of people involved in sitting in that kind of situation. It may have reminded some people of a baby carriage with a little black hood coming over you. Some people may have had an infantile regression at the time and started sucking their thumb and going to sleep for all I know. But I don't know if there was any science, I don't think anyone ever measured what was going on in the air.

REVIEW in the *SAN FRANCISCO SUNDAY EXAMINER* by STANLEY EICHELBAUM, JANUARY17, 1971

The Invisible Cinema is a fascinating and eerie chamber, like no other movie house we've seen. I asked Mekas how it was possible for anyone to find his way into an all black theatre. He replied dryly that no latecomers are admitted. The house lights are extinguished immediately before the program starts. He further disclosed that the museum's ground rules called for no subtitled version of any films. "Everything is shown in its original state," he said, "nor do we allow 16mm prints of works made in 35mm. It took us two years to find the prints we

have, the whole idea is to respect the filmmaker as an artist and show the film as it was intended to be shown. Subtitles destroy the rhythm and form of a film. We've had complaints, but we're not concerned with the audience. We're interested in film."

TONY HISS in his column TALK OF THE TOWN in *THE NEW YORKER*, DECEMBER 5, 1970
. . . A few days later we went to a press review and luncheon party for Anthology Film Archives . . . Mr. Kubelka himself has designed the theatre, we were told, and he also cooked the lunch and made the wine served with the lunch. We found this impressive—especially after we tasted the lunch, which was a hearty collation of cold roast veal, cold roast pork, a strange and delicious casserole, an Austrian cake called Guglhupf (google-hupf), and an unusual and delicious cheese. . . . We decided to talk to Mr. Kubelka. He has short blonde-and-gray hair and bright-blue eyes. "The theatre was designed to insure absolute privacy to everyone," he told us. "In most theatres, you hate the other people because their noise inter-rupts your concentration. Here you like the others. You hear them, but everything is subdued." We told him we were even more interested in his food and he looked gratified. "The meat is very simple," he said, "The pork is cooked in its own fat and with caraway seeds. The veal is roasted with butter, no spices, so the flavor of the meat will be retained. The wine is simplici-ty itself . . ."

P. ADAMS SITNEY
Opening night was an enormous party, by invitation. We had a big bar in the lobby and everybody was given a ticket when they entered, because not everybody could go into the cinema at the same time. So for instance, we would call out for yellow tickets, and only those people could go into the theatre for the half-hour demonstration. It was a wonderful bash. A lot of film people, a lot of public celebrities. It ended hilariously with a fight. We had a rule that you couldn't go into the cinema after a film started. A guy named Cohen—a big, burly, bearded guy, who was also a drunk—tried to force his way into the theatre and Kubelka told him not to. He pushed Kubelka, but Kubelka was a New York State Judo champion at the time, so he held his own quite efficiently. Cohen got so mad that he went up to a waiter—an elder-ly man carrying drinks around, and Cohen smashed the tray of drinks out of his hand and pushed him around—the waiter might of gotten cut on the glass. At which point Kubelka, and several other people in the theatre, picked this enormous guy up, took him out the door, and literally threw him into the street.

PETER KUBELKA
When you were seated, only your eyes were shaded from your neighbor, approximately from the shoulders on, but you could touch your neighbors, and since there was not a complete partition, you always felt there was someone on your side. You knew that there were many people in the room, you could feel their presence, and you would also hear them a bit, but in a very subdued way, so they would not disturb your contact with the film. A sympathetic com-munity was created, a community in which people liked each other. In the average cinema where the heads of other people are in the screen, where I hear them crunching their popcorn, where the latecomers force themselves through the rows and where I have to hear their talk which takes me out of the cinematic reality which I have come to participate in, I start to dis-like the others. Architecture has to provide a structure in which one is in a community that is not disturbing to others.

STAN BRAKHAGE
For some films, the Invisible Cinema was really wonderful. For hand-painted Melies, for exam-ple, it was the greatest, or for any kind of color animation: Larry Jordan's or Harry Smith's. I liked it very much with my hand-painted films such as *The World Shadow*. For other films, I didn't think the theatre was so good. I didn't care for it with films of my making such as *Scenes from Under Childhood*. I can't say exactly why, but that it is a more stalling movie that does not fit this enclosed sense. There was a nervousness about it. The minute they tell me I can't pee, for example, I suddenly have the sensation that I have to. If you get up and leave, you can't get

back in. So, there you are, parted between the vision you are seeing and bodily functions. Quite a strain, I thought, in that sense. I don't want to make it sound like I'm running it down, it was the most unique theatre ever architected and certainly Peter deserves enormous credit for it.

KEN KELMAN

I had in fact, one of the most unfortunate in a way experiences I've ever had in the Invisible Cinema. Jonas showed Ernie Gehr's film, *Still*, to be voted on. After he screened it there was utter silence. We felt as if we had been watching an empty screen. I didn't understand why Jonas had even shown the film to us at all. Now I am not blaming that on the theater, but it happened in the Invisible Cinema. A year or two later, it must have been the last time we ever met, or near, at the Chelsea hotel, in the worst kind of screening conditions—it was the afternoon, in a hotel room, the light was coming through the windows, the blinds weren't very good—Jonas screens *Still* again. At the end of the screening I said, in effect, this is one of the greatest films ever made. The point of course is that we had first seen the film in the ideal circumstances and it was nothing, and the second time we saw the film, in the worst possible conditions, it was one of the greatest films ever made.

P. ADAMS SITNEY

The Invisible Cinema was dismantled in 1974, shortly after Jerome Hill died of cancer, because we couldn't afford to stay at the Public theatre without Jerome's support. When we moved to 80 Wooster Street, Kubelka wondered why there wasn't a question of the Invisible Cinema's reconstruction. Quite simply, Jonas had nixed it; there was no money to rebuild it. For me it was sad to end the Invisible Cinema, for Jonas it wasn't at all. Jonas was very much in favor of the move to Wooster Street, because it was an important step towards necessary independence.

KEN KELMAN

When we moved, rebuilding seemed like no issue at all. It was like there was no question. My own feeling is that the Invisible Cinema was primarily a manifesto and once the statement had been made, and it had been put down in the history books, it didn't have to be made again.

PETER KUBELKA

The principle has not changed for me. Of course there were several compromises involved in the solution, which I hope will not be there in the next realization. Compromises such as exit lights to the side in front, which we could not eliminate because of building codes. . . . It is a pity that the new location of Anthology did not seem to allow a new realization of the Invisible Cinema. But as I said, I am very confident that the principle has been proven correct and there will be not one but many cinemas designed to this principle in the not distant future.

STAN BRAKHAGE

Whatever the difficulties of the Invisible Cinema, it was a success because it created the idea of such a thing. Because of the extraordinary sacrifices of people like Jonas Mekas, it has an existence, a continuum—it doesn't go away.

JONAS MEKAS

The Invisible Cinema was controversial, but it was also very exciting. It was an attempt to try something different in cinema and in theatre design. We hired a publicity agent and there were a number of articles as soon as we opened, more or less announcements and descriptions, but there was no critical response as such for the theatre. . . . Our movies, what we were showing, were not for everyone; it was often experimental in nature so our audience was different. But those that liked it kept coming back because of the situation. Jerome was a visionary so he went for the design of the Invisible Cinema; nobody else would. If I were to offer it now, people would think I was crazy. It was the best situation for seeing film. It was an idea that lasted three years. Dreams are very difficult to repeat, and that was a dream.

Taylor Mead

Underground Legend

by Robert Cavanagh

Taylor Mead currently resides in a tiny fourth floor apartment on Ludlow Street in the Lower East Side of Manhattan, an apartment he has called home for the last 27 years. As a home, it is far from luxury; not only is it small, quite hot in the summer, and featuring a cockroach problem, but also is at the top of four steep flights of stairs that Mead, now in his eighties, must battle every day and has fallen down before.

The length of Mead's tenure in the Lower East Side means that he has seen the neighborhood change radically—changes with which Mead has a somewhat complicated relationship. On the one hand, Mead, having lived through the time when the Lower East Side was one of the most dangerous areas in the city—Mead was mugged twice—welcomes the gentrification of the neighborhood. Indeed, Mead was instrumental in bringing in owner Lucien Bahaj to save the Pink Pony. On the other hand, Mead has become a symbol of resistance to the gentrification of the Lower East Side, as he resists attempts by his landlord to buy him out or forcibly evict him from his apartment, and thus prevents the building from being renovated and leased out for astronomically higher rents. This somewhat contradictory position is evidence of the curious nature of Taylor Mead's life. He was born into one of the wealthiest and most politically prominent families in the United States, and as an artist he has been involved with some of the most significant names and events in avant-garde art for over 50 years. Intriguingly, many of those names—people Mead has not only worked with but called friends—went on to experience a significant amount of commercial success, something which has eluded Mead. Given the situation regarding his apartment, it is worth examining Mead's life and career in an

attempt to understand why he has become connected to his current place, particularly in terms of the commercial success and public recognition for his work. In examining this aspect of Taylor Mead's career, one can see more clearly the definition and difficulties of the label that is so often used to describe him: underground legend.

For Mead, the issue of commercial success is an extremely important one, and understandably given his current situation, it is one that dominates his view of his career. In an interview, Mead traced a tradition of incidences, and indeed with specific people, in which he feels that, for whatever reason, he has been denied the support or recognition he feels he deserved or might otherwise have received.

The first such figure in Mead's life is his father, Harry Mead, who was head of the Democratic Party in Wayne County, Michigan, which includes both Detroit and Grosse Pointe, one of the wealthiest areas in the country, particularly at a time when, as Mead puts it, "the automobile was second only to agriculture" in the United States. Mead's relationship with his father was clearly strained, and Mead points out a number of incidents that indicate his father's "cheapness." And, according to Mead, this includes not only a lack of financial support, but a failure to support his work as an artist-such as when his family failed attend his performances in school plays. Without placing too much emphasis on stories of childhood, it is clear that Mead's father believed he should work for a living, something Mead had little interest in, and perhaps even felt he shouldn't have to do, given his family's wealth and standing.

It was certainly with an eye towards forcing Mead to work for a living that his father got him a job at Merrill Lynch in Detroit, a job Mead says he was good at but which he found stifling, as it prevented him from seeing his friends in Grosse Pointe. Consequently, Mead quickly left Merrill Lynch and began to roam around the country. It was after this period of wandering that Mead moved to New York, a place, he says, he initially planned to avoid, but was drawn to because of the diversity and, ironically, anonymity the city offered. Mead lived in the Upper West Side and Greenwich Village, before moving to the Lower East Side, due to the changes in the Village, particularly the skyrocketing rents. After embracing that anonymity for a short time, Mead decided to perform again, and began reading poetry and performing in Greenwich Village coffeehouses alongside people like Bob Dylan, Bill Cosby, and Allen Ginsberg. He became a relatively well-known figure in the Beat movement, performing not only in New York, but in San Francisco as well, where he not only read poetry but also acted in Ron Rice's classic underground film *The Flower Thief*, which has been called "the purest expression of the Beat sensibility in cinema" (Sitney, 300).[1]

Unquestionably, and perhaps unfortunately for Mead, he is most often remembered for his work as one of Andy Warhol's "Superstars," including the films *Imitation of Christ*, *Tarzan and Jane Regained. . . . Sort of*, and *Lonesome Cowboys*. Mead's relationship with Andy Warhol is a complex one, made even more so, perhaps, because his work with Warhol, which represents only a small portion of Mead's career, casts a large shadow over the rest of Mead's life as an artist. Mead describes Warhol in the same terms as he does his father; he sees both as being "cheap," as having plenty of money, but refusing to be generous:

"Andy had it [cheapness] too. Of course, Andy was brought up in such total poverty. But still he was making millions and giving a shit

and not giving us a goddamn dime. At least 20 of us should have been given a token hundred grand or something. 500 million went to the foundation. He could have spared a couple of million for the people that helped make him more and more famous. It's his diversity that kept him on top, made him into a great world icon."

While the lack of financial support from Warhol and his father looms large in Mead's life, given their wealth and stature, Mead's career is much larger than his work with Warhol, and the reasons why recognition and success have eluded him can certainly not be limited to the actions of these two people. Indeed, Mead sees these two figures as part of a larger pattern, a trend of situations in which his work has not been given the chance to be successful. In 1964, Mead starred in two plays, Frank O'Hara's *The General Returns from One Place to Another*, and LeRoi Jones' (now Amiri Baraka) *The Baptism*. Mead won a Distinguished Performance Obie for his role in *The General*, despite only being performed a handful of times, a constraint Mead feels cost him dearly: "the way Dustin Hoffmann and Al Pacino and Sylvia Miles, the way they got their Hollywood start was from an Off-Broadway play, but our play wasn't allowed to breathe, except for four or five performances." He is equally frustrated with Amiri Baraka, who, he says, lied to Mead and Frank O'Hara to stop performances of "The Baptism," which was an integrated play, to focus on plays such as his previous work "The Dutchman," which had been extremely successful.

"He lied, and that was one of the most important events of my life. I would have had a fucking Hollywood contract, made tons of money and died of AIDS from the hustlers in Hollywood . . . either he saved my life or destroyed it."

Mead sees a lack of proper promotion and exposure for his work as having been similarly damaging to his career, even up to his recent work in Jim Jarmusch's *Coffee and Cigarettes*, which he feels Jarmusch, out of modesty, opted not to heavily promote. Perhaps the most significant example of this, and one of the more frustrating from Mead's perspective is the manner in which his films have been collected and archived in various museums and institutions, perhaps most significantly in the Anthology Film Archives, headed by Jonas Mekas. Mekas' Anthology was the natural choice, in many ways, for many of the avant-garde films of the '50s and '60s, as Mekas was a champion of the "underground cinema" in New York from his position as a critic for the *Village Voice*. Today although he recognizes that Mekas rescued many of his films from destruction, Mead sees archives at universities, museums and places like Anthology as places where films die from lack of exposure, where they are stored but never shown.

As an artist whose most prominent characteristic may be his sheer quantity of output (he has appeared in 3–4 films a year since 1960), Mead is perhaps most prolific as a writer. He has had three books published, Anonymous Diary of a New York Youth, volumes 1–3, and has over 4,000 pages of handwritten manuscripts, a portion of which he hopes to publish soon as "Son of Andy Warhol." He continues to write poetry, and performs weekly poetry readings at the Bowery Poetry Cafe. His writing efforts have, he says, fallen into some of the same traps as his work in film and theater. The first two Anonymous Diaries were published as mimeographs, and, according to Mead, sold all their copies. The third diary, subtitled *Taylor Mead Across on Amphetamines in Europe*, was published, but never fully distributed, as the publisher was only interested in publishing and editing, not in distributing the book.

Ironically, Mead's prolific and diverse output may, in some ways, hurt his reputation and overshadowed the significance of his work Even Mead describes himself as "a dabbler in the arts," a label that veers dangerously close to "dilettante," and which ignores his commitment as an artist which has kept him involved in avant-garde art into his 80s. In the late '90s, for example, Mead hosted a streaming video talk show on the website Pseudo.com, which was one of the very first programs to be created expressly for Internet broadcast.

The question remains, of course, about why Mead is an "underground legend," and never achieved mainstream or commercial success. Mead's stories of the missed opportunities and

"slights," as he puts it, that have hindered his career as an artist are compelling, and provide an insight into how success and recognition as an artist can hinge on any number of factors. But they must be viewed in a larger context to better understand why Mead has had to struggle. The vast majority of Mead's films are low-budget, one-take affairs, and his writing is almost entirely done in handwritten note-books. In the world of commercial film and publishing, the spontaneity that Mead emphasizes in his work and seems to value is, in fact, an additional obstacle to commercial success. His films were largely designed to be self-exhibited, and the thousands of pages of hand-written manuscripts, existing in scattered notebooks, would be difficult to publish. This is no doubt a product of the financial constraints Mead and other artists are working under, but it is nonetheless part of Mead's unique talent as an artist.

Mead's struggle to stay in his Ludlow Street apartment is a battle fought out of necessity, a fight not only for his home of 27 years, but more simply for affordable housing so that he can remain in the Lower East Side, a neighborhood that he has strong connections to, even if he does not see it as any kind of artistic community. But it also reveals his tenacity and commitment to a life as an artist. While com-mercial success is not a particularly accurate or meaningful measure of art, or of an artist, Mead's desire and need for commercial success, which causes him to be somewhat bitter about his past, illustrate his seriousness about his art in his absolute and unswerving refusal to make a living doing anything else.

Based on an interview with Taylor Mead on 8/23/2004.

Bibliography/Works Cited

1. Sitney, P. Adams. Visionary Film: The American Avant-Garde, 1943-2000. Oxford: Oxford University Press, 2002.
2. Jones, Jonathan. "You've been framed. Taylor Mead wanted to make underground cinema for the people. Jonas Mekas wanted it for him-self and a few mates. Today Mekas is the prestigious historian of early US independent cinema while Mead lives in abject poverty." *The Guardian*. Manchester (UK): Oct 16, 1998. pg. T.012

Index

Page numbers set in italic indicate a photograph unless otherwise noted.

A

AAA, 194
A B Bla Bla Bla, 202
Abbey Road (Beatles), 452
Abbot And Costello, 549
ABC No Rio, 287, 306, 313–318, 319, 320,
 322, 335, 341, 349, 352, 370, 385,
 395, 399–402
Abdullah, Yahya Salih, 216
*Abe Lebenwohl Park-Summer Music
 Events*, 147
Absolution (band), 448
Abu-Lughod, Janet, 433
The Abused 209
Academy of Music, 109
Academy of Music, 109
Accoci, Vito, 186, 201,323, 423, 447
Achinger, Katrin, 90
Acid Test Show, 305
Acker, Kathy, 270
"Ad It Up" (Serra), 380
Adams, Don, 156
Adams, Sitney, 568
Adler, Alfred, 108
Adler, Jacob P., 108
Adler, Luther, 108
Adopt-A-Building, 550
The African Queen, 176
A Gallery, 203
The Agent (Bellis), 323
Ahearn, Charlie, 122, 127, 128, 175, 176,
 226, 398
Ahearn, John, 176, 398
Ahwesh, Peggy, 379, 504
Albert, Marv, 365
Album, Joey, 264
Albury, Simon, 132
Alcott, Todd, 492, 543
Alda, Robert, 108
Alexander, Jane, 111
Alfredo (Jarmusch), 312
Algarin, Miguel, 307, 551
Alice in Wonderland, 116
Alien Portrait, 177
Alig, Michael, 472
All Color News And Communication
 Update, 177, 180, 398
Allan 'N' Allen's Complaint, 132
Allen, Bruce, 474
Allen, Michael, 102
Allen, Radny, 216
Allen, Woody, 108, 233
Allin, GG, 208, 272, 448, 535
Almereyda, Michael, 238, 382, 548
Alphabet City (Poe), 173, 303

Alphaville (Godard), 547
Alt Café, 338
Altered States Of America, 305
Alternative Theater Machine, 543
Altman, Judy, 145
Altman, Robert, 395, 547
Ambler, Ned, 333
Ameche, Don, 109
America Corps, 551
American Film Institute, 98
*American Magus: Harry Smith A Modern
 Alchemist* (Igliori), 451, 459
American Museum, 108
American Mutoscope Company, 110
Amerika (Siegel), 555, 556
Ames, Todd, 333
Amodeo, Rachel, 288, 293–294, 346
AMOKOMA, 90
"An Eye In The East Village" (Irizarry), 551
An Autobiographical Statement (Cage),
 467
Anarchist Switchboard 209, 210
The Anarchy Art Show, 305, 306
"Ancestor House," 552
And What Is A Fact Anyway, 106
Anderson, Laurie, 423
Anderson, Paul Thomas, 526
Anderson, Wes, 547
Andre, Michael, 144
Andres, Jo, 263, 388, 392
Andy Liss Story (Bellis), 323
Andy Warhol Museum, 242
"Angel Orensanz: Italian Installations and
 Interventions, 1991–2001," (McEville),
 522, 524
Angelou, Maya, 522
Anger Management, 525
Anger, Kenneth, 85, 92, 101, 104, 150,
 242, 245, 247, 353, 377
*Anger, The Unauthorized Biography Of
 Kenneth Anger* (Landis), 459
Animal Factory (Buscemi), 395
Aniston, Jennifer, 382
Annabelle the Dancer (Edison), 538
Annon, Don, 487
Anntelope, 479, *480*
Anonymous (Verou), 341
Anonymous Diary Of A New York Youth
 (Mead), 567
Anthology Film Archives, 85–88, 102, 118,
 179, 187, 202, 279, 314, 417, 418,
 419, 451, 498, 503, 506, 508, 509,
 535, 537, 553, 559, 560, 562–564,
 567
Anticipation of the Night, 98
Antonio, Emil de, 417, 501

Apocalypse Now (Coppola), 543
Apple Heart Daisy (Jones), 344, 345
Applebroog, Ida, 122
Arbus, Diane, 461
Arcade, Penny, 15–24, 125, 498
Arcane Device, 209
Ardolino, Anne Lombardo, 444, *485*, 485,
 486
Area, 370, 371
Arias, Joey, 429, 472
Arihood, Bob, 439
Aristotle, 518
Arithmetic, Rik, 362
Arledge, Sara, 98
Aronson, Jerry, 134
Arrabal, Fernando, 241
Ars Electronica, 202
Art & Commerce Gallery, 400
"Art Around The Park" (Schloss), 147, 401
Art Party Pravda (group), 456
*Art Party Pravda, A History Of Art Party
 Pravda* (Patterson), 459
Art Today, 143
Artangel Foundation, 522
Artaud, Antonin, 302, 307
Artaud, Tzara, 143
Arthur, Paul, 106
Arthur, T. S., 542–543
Artists Space, 186, 424
ARZ Productions, 206
A's, 193–206, 196, 197, 199, 200, 202,
 203, *203*, 205
Ashby, Hal, 547
Ashton, Dore, 188
Ashur, Jerry, 55, 556, 558
Asian American Film Festival, 558
Astor, Patti, 172, 173, 174, 176, 177, 181,
 182, 183, 349
Auden, W.H., 134
Auder, Michael, 189–192, *191*
Aueer, Jochen, 432, 435, 456, 459
"Avant Gardarama," 389
Avant-Garde Arama, 467
Avery, Caroline, 374
Aviles, Rick, 392
Ayler, Albert, 226
Azzouni, David, 124, 128
Azzouni, Jody, 125, 126
Azzouni, Rafic, 121–130, *125*, *126*, *129*

B

B, Beth, 122, 126, 173, 176, 180, 247,
 371, 398
B, Scott, 122, 176, 180, 247, 269, 371,
 398

Babo, *73*, 116
Babtiste, Jennifer, 491, 492
The Baby (Auder), 190
Bad Brains (band), 448
Bahaj, Lucien, 565
Bailey, Robert, 349
Baillie, Bruce, 85
Baird, Jones, *352*
Baldessari, John, 423
Baldwin, Craig, 507, 508
Balint, Eszter, 174, 178, 395
"Ball Of The Freaks" (Piñero), 300
Ball, Bert, 400
The Ballad of Sexual Dependency (Goldin),
 181, 354
Baltz, Jon Robin, 527
Banana, Ana, 195
Bandwagon, (Schultz) 350
Bang On A Can, 496
Baphat, Shridar, 186
The Baptism (Jones), 567
Baraka, Amiri *see also Jones, LeRoi*, 350,
 567
Barfield, Velma, 269
Barg, Barbara, 349
Bargeld, Blixa, 90
Barnett, Charlie, 393
Barnstone, Lisa, 346
Barnum, P.T., 108
Bartlett,Paul, xv
Barton, Peter, 558
Barton, Rebecca, 418
Basciano, Richard, 543
Basket Case 2 (Mitler), 491
Basquiat (Schnabel), 206, 261, 374
Basquiat, Jean Michel, 174, 182, 289, 370,
 384, 389, 399, 430, 468, 521
Bassi, Cosimo, 346
Bates, Kirsten, 183
Bateson, Gregory, 217, 218
Batsry, Irit, 497
Battles Of Coxinga (Wilder), 542
Battleship Potemkin, 85
Baudelarian Cinema, 179
Baumgardner, Lisa, 343
Baylor, Richard, 316
Bazooka, Joe, 541
"Be Bop a Lula" (Vincent), 174
Beall, Aaron, 539–544, *541*
Bear, Liza, 389, 392, 398, 426
Beard, Peter, 92, 94
Beat Punks (Bockris), 306, 308
Beat Up People (Newsreel), 556
The Beatles (band), 169, 452
Beatty, Maria, 377, 379
Beausoleil, Loyan, 405
Beausoliel, Bobby, 247
Beauty Bar, *393*
Beauty Becomes The Beast (Dick), 175
Beavers, Robert, 508, 509
Beck, Julian, 144, 219
Beck, Robert, 375, 376, 499–500, 501,
 504, 505, 508
The Bed (Goldberg), 359

Bed Sty, We Cut Heads (Lee), 287
Beecher Center, 197
Beeman, Andrea, 537
Beer Mistics, 210
Beerle, Monica, 433–434, 458, 463
Bees, Ray, 448
Beethoven, Ludwig, 522
Beldock, Myron, 439
Belizzi, Tone, 145
Belladonna (B), 122
Belle, Albert, 311
Bellis, Mary, 323, 369–372
Benet, Alex, 144
Benigni, Roberto, 232
Bennett, Lilly, 97
Benton, C Bainbridge, 124
Bernadi, Francoise, 147
Bernal, Dick, 271
Bernhard, Sandra, 350
Berrigan, Daniel, 72
Berrigan, Ted, 349
Berry, Chuck, 392
Berry, Wallace, 109
Bertei, Adele, 176, 177
Bertoglio, Edo, 174
Bertucci, Fred, 305
Besinger, Charles, 218
Betty Parson's Gallery, 200
Beuys, Joseph, 206, 351, 352
*Beyond Recognition: Representation,
 Power And Culture* (Owens), 308
Bickle, Travis, 244
The Bicycle Thief, (Sica)120
Big Baby (Goldberg), 359
The Big Doll House (Corman), 242
The Big Thumbs (Lippman, Lippman), 145
The Big Wack (Klein), 287
Bigelow, Kathryn, 177, 180
Bigtwin, *410*, 411–414
Bikini Girl Magazine (Baumbardner), 343
Binelli, Mark, 525–526
Biograph Theatre, 110
The Birds (Hitchcock), 543
Birnbaum, Dara, 423
Birth of a Nation (Griffith), 85
The Birth Of Eros (Schlemowitz), 499
Bitzer, Billy, 110
Black Box (B, B), 176, 247
Black Gate, 119
Black Liberation Army, 555
Black Panthers, 555, 556
Black Snakes, 266
Black Sun Press, 143
Black, Jeanne, 194
Black, Steve, 205
Blackhouse, 209
Blade Runner (Scott), 497, 518
Blair, Linda, 481
Blake, Eleanor, 345
Blanchett, Cate, 232
Blank Generation (Kral, Poe), 170, 173,
 178, 240, 398
Bleed (Zedd), 268, 271, 273
Bleeker St. Cinema, 497

Blixa for Dandy, 90
The Blob, 266
Block, Mark, 209
Blond Cobra, 117
Blondie, 170, 173, 174, 176
Blood Sister (band), 210, 448
Bloomberg, Micháel, 203, 445
Blossfeld, Marika, 188
Blowdryer, Jennifer, 275–276
Bluck, Bruce, 313
Blue Man Group, 389, 498
Blumberg, Skip, 217
bOb, 400
Bockris, Victor, 306, 308
Body and Soul (Garfield), 108
Bogart, Ann, 542
Bogosian, Eric, 177, 189, 190, 206
Bohio, El, 291
Bohren, David, 346
Bolero (Ravel), 518
Bolger, Mary, 369
Bonds, 392
Bonge, Steve, 341, 440, 447, 455, 456,
 459
Bongwater, 176
Bonk, Keiko, 303
Bonous, Phillipe, 401
Boogie Woogie Nights (Guzman), 525
The Book Of Logic (Ziprin), 451
The Book Of Shots (Ziprin), 451
*The Book On Palo Deities, Initiatory
 Rituals And Ceremonies* (Canizares),
 459
Boon, Mark Jr., 228, 263, 297, 388, 389,
 391, 392, 394, 395, 498
Borden, Lizzie, 177, 182, 389
Borgen, Chris, 477
Born Again In Flames, 208
Born In Flames (Cantsin), 177
The Boston Draft Resistance Group (News-
 reel), 554
Borofsky, Scott, 220
Borroughs, Abe, 139
Bowen, Michael, 79–84
The Bowery, 109, 111–112
Bowery Boys, 549
Bowes, David, 334, 389
Bowles, Paul, 177
Boxer, Joel, 98
Boxheads (Goldberg), 359
Boy Genius, 210
Bracco, Elizabeth, 395
Braddock, Carol Anne *see also* Braddock,
 Edward; Ed, Red, 367–368
Braddock, Edward III *see also* Red, Ed,
 331, 367–368
Brady, Mark, 293, 294
Brahage, Stan, 85, 88, 98, 101, 104, 119,
 156, 322, 376, 507, 510, 511,
 559–564
Brain Eaters (band), 448
Branca, Glenn, 202, 206
Brand Name Damage, 503
Brandenburg, Jason, 264

Bratt, Benjamin, 384
Brawley, Tawana, 438–439
Breaking And Entering (Newsreel), 556
Breathe In, Breathe Out, 176
Breathless, 171
Breé, Germaine, 303, 308
The Breed (Oblowitz) 177
Breer, Emily, 156, 374
Breer, Robert, 87, 104, 156, 495
Brener, Alexander, 457
Bresson, Rober, 233
Breuer, Marcel, 521
Brezinski, Edward, 299, 304–305
The Bride of Frankenstein (NYUI), 145
Bridge Theater, 117
"Bridges" (Orensanz), 522
The Brig, 96, 118
Brigante, Louis, 98
Brigit, 211
Brinckmann, Noll, 106
Broadcast Magazine, 217
Broderik, Mathew, 527
Brodeur, Chris, 415
Broken Mirrors (Gorris), 497
Bromley, Kirk Wood, 542
Brothers, Whitney, 98
Broughton, James, 85
Brown, Bill, 350
Brown, Dorothy, 97
Brownies, 529
Bruce, Lenny, 95, 243
Brus, Gunter, 456
Brys, Carol, 541
Buck, Marilyn, 554
Buckley, Jim, 243
Buffalo Dreams (Neu), 359
Bugarcic, Gary Ray, 263–264
Bukowski, Bobby, 389
Bukowski, Charles, 166
Bunker, Edward, 395
Buñuel, Luis, 303, 520, 534
"Buñuel, The Exterminating Fire" (Orensanz), 520
Burchill, Brian, 127
Burckhardt, Jacob, 122, 127, 128, 132, 238, 239, 295–298, 349, 350
Burckhardt, Rudy, 87
Burdon, Eric, 141
Burgess, Hovey, 217
"Burn This," 209
Burnett, Charles, 556
Burnett, Nima, 556
Burnham, Linda, 206
"Burning Universe" (Orensanz), 521, 524
Burns, Tim, 130, 177
Burroughs, William, 98, 144, 306, 349, 396, 451, 467, 515
Burton, John, 522
Buscemi, Michael, 395, 396
Buscemi, Steve, 173, 174, 177, 227, 228, 232, 238, 257–285, 263, 350, 387–396, 389, 393, 395, 498
Bush Tetras, 175
Bush, George W., 499

Buskers Club, 287
Butler Museum, 197
Buxtehude, Dietrich, 518
Bykert Gallery, 194, 197, 200
Byrne, David, 399
Byron, Bruce, 353

C

C., Jim *see also* Cornwell, James, 183, 299–302, 300, 301, 303–308, 351, 352, 401,431–434
C.H.U.D., 178
Caan, James, 111
Caciula, Gabriel, 144
Caesar, Arthur, 111
Café Les Deux Megots, 113
Café Metro, 113
Café Nico, 144, 145
Cage, John, 90, 113, 196, 202, 421, 467, 469, 470
Cagney, James, 549
Cain, Nancy, 217
Cain's Book (Trocchi), 139
Caligula, 175
"Call to Wobulate" (Perlman), 399
Calmx, 367–368, 368
Camelot (Klein), 287
Camera News, Inc. *see also* Third World Newsreel, 553, 557
Camouflage (Higgins), 208
Camper, Fred, 106
Camus, Albert, 303
Camus and Sartre: Crisis And Commitment (Bree), 308
Candid Camera, 519
Candyman (Rose), 177
Canizare, Baba Raul, 450, 451
Canizares, Raul, 447, 459
Cantor, Ellen, 377
Cantsin, Monty, 208, 210, 212, 401
Capra, Frank, 543
Captured (Aniston and Stiller), 382, 384
Car, Lisa *see also* Lung, Leg, 268
Caris, Valerie, 320, 321
Carlo, Eva De, 313
Carlo, Marylou, 303
Carne, Judy, 272
Carroll, Noel, 106
Carryer, Babs, 543
Carryer, Tim, 543
Carson, Rachel, 412
Carter, George, 369
Carter, Michael, 183, 299, 299–302, 305, 350
Cartwright, Louis, 139, 141, 142
Casa Nada, 300, 306
Casanova, Ron, 442
Cassady, Neal and Carolyn, 131
Cassandra *see also* Mele, 317
Cassavetes, John, 86, 114, 169 234, 395
Cassel, Seymour, 177, 394, 396
Castro, Rosalind, 551
The Catalyst Newspaper, 550

Catherwood, Frederick, 108
Cathode Ray, 210
Cavaglieri, Giorgio, 559
Cavanagh, Robert, 565–568
Cavass, Jamie, 197
Cave Girls (Cooper and Smith), 399
Cave, Nick, 90
CBGBs, 170, 171, 173, 174, 185, 210, 211, 224, 241, 392, 298, 429, 448
Ceausescu, Nicolae, 143
Cedar Tavern, 349, 411
Center For Media Arts, 199
Chafed Elbows, 116
The Chair (Goldberg), 359
Chair Man I & II (Goldberg), 359
CHAMA, 408
Chamberlain, John, 219
Chamberlain, Wynn, 219
The Chameleon Club, 210, 302456
Chance, James, 175, 176, 228
The Chandelier, 306
Chandler, Paula, 302, 307
Chaney, Lon, 182
"Chang In A void Moon" (Jesurun), 388
Chanse, Anthony, 353
Chapin, D. D., 305
Chaplin, Charlie, 549
Charas *see* Films Charas
The Charles Theater, 98, 99, 234
"Charlie Victor Romeo," 417
Chase, David, 167, 396
Chasing The Dragon (Auder), 190
Chatham, Rys, 186
Chatwin, Bruce, 188
"Checkers Speech" (Nixon), 501
Cheers, 167
Chekhov, Anton, 540
Chelsea Girls (Andy Warhol), 189, 137–138, 190, 242, 247, 322, 468,
Chi, Tseng Kwong, 429
Chicago Underground, 339
Chicken Soup (Kotin), 541
Chico Mendes Garden, 350
Chikamatsu, Monzaemon, 542
Child, Abigail, 373, 374, 375, 379
Chomont, Ken, 375, 377
Chomont, Tom, 375, 377
Chomsky, Noam, 554
Chop Shop, 209
Chow, Chris, 557
Choy, Carter, 557
Choy, Christine, 553–558
Chrisman, Eddie, 262
Christadora House, 437
Christmas On Earth (Rubin), 120, 377
Chumlum, 116
The Church Of Shooting Yourself (Little), 289, 350, 362, 364, 365
Churchill, Winston, 468
Cinema 16, 419
Cinema Descrepant, 179
Cinema of Transgression, 173, 265–273, 276–280, 315, 316, 317, 321, 350, 400, 503

Cinema Village, 497
Cinematheque, 501
Circle Arts, Inc., 208, 210
Circus Of Power (band), 448
Citizen Kane (Welles), 85, 497, 547
"Civilian Warfare," 400
Clark, Arnold, 551
Clark, Michael, 370
Clark, Shirley, 86, 114, 117, 120
The Clash (band), 177, 392
Class Of Nuke 'Em High (Haines), 491
Clayton Archives, 447–460 *see also*
 Patterson, Clayton
Clayton Gallery, 447
Clayton Patterson Presents, 247, 432
"Clayton's Lower East Side Show" (Annte-
 lope), 484
Cleopatra, 189
Cleveland, Buster, 195
Clifford, Michelle, 241–248
Clinton, William Jefferson, 167, 450
A Clockwork Orange, 174, 497
Club 57, 180, 182, 241, 245, 256, 287,
 289, 343,388, 429–430, 468, 545
Coachman/Red Milk, 206
Cochise, 453
Cocks And Cunts (Rubin), 377
Cocteau, Jean, 303
Coddington, Robert, 471–472
Coffee And Cigarettes (Jarmusch), 567
Cohen, Ira, 145, 147, 451, *480*
Cohen, Stanley, 439
Colab *see also* Collaborative Projects, 176,
 177, 180, 287, 352, 398, 400, 426
Cold Crush Brothers, 176
Cole, Larry, 549
Cole, Russ, 404
Coleman, Joe, 272, 275, 287, 288, 306,
 400, 455
Coleman, Nancy, 287
Coleman, Ornette, 213, 226
Collaborative Mail Art, 209
Collaborative Projects *see* Colab
Collective For Living Cinema, 314, 375,
 419, 499, 501–514, 242
Collective Unconsciousness, 289, 329,
 407, 415–420
Collichio, Richard, 343
Collins, Margaret, 130
Collins, Susan, 106
Coltrane, John, 213
Columbian Wedding (Auder), 192
Come And See (Klimov), 497
Comic, Alien, 354
"Coming To Power: 25 Years Of Sexually
 Explicit Art By Women," 377
Community Board 3 Meeting, *441*
"Community Cop," 552
Condo, George, 389
Conie Island Freddy, 455
Connecticut Papoose (Gusella), 188
The Connection, 114
Connelly, Chuck, 389
Conner, Bruce, 104

Conor, Harry, 111
Conrad, Tony, 104, 188
"Conspiracies," 374
The Contortions (band), 175–177, 452
"Conversations With Harold Chaner," 552
Cook, Marguerite Van, 299, 305, 400
Cool Hand Luke (Rosenberg), 366
Coonrad, Karin, 540
Cooper, Ellen, 399
Cooper, Gary, 468
Copjec, Joan, 106
Copland, Aaron, 349
Coppola, Francis Ford, 543
Coragiio, Linus, 208
El Corazon De Loisaida (Diaz), 550
Corber, Mitch, 145, 349, 350, *421*,
 421–422, 423–428
Corea, Chick, 305
Corman, Roger, 176
Corn On Cotton (Corn), 534
Corn, Thom, *533*, 533–534
Cornell, Joseph, 85, 88, 506
Cornwall, James *see also* C., Jim, 299–302
Corrigan, Kevin, 350
Corso, Gregory, 113, 120, 131, 144, 147,
 189, 190, 260–261, 306, 421, 467
Cort, David, 217
Cortez, Diego, 183, 398, 426
Cortez, Ricardo, 107
Cosby, Bill, 566
Costello, Elvis, 392
Cote, Tome, 346
Couch, 116
County, Wayne, 170, 173
*A Coupla White Faggots Sitting Around
 Talking* (Auder, Indiana), 190
Courtney, Matthew, 313
Cover Magazine, 350
Covert, Scott, 245
Cox, Don, 553
Craig, Ann, 319
Cracking Up (Mitler), 492, 494
Cramer, Peter, 313, 316, 317–318, 320,
 322, 338, 3439, 374, 384, 400
Crane, Hart, 143
The Crime Show, 314
"Crimes Of The Beats" (Unbearables), 421
Critical Mass, 106
Crowbar (Wellman), 543
Crowe, Matthew, 404
Crowley, Aleister, 243, 266, 450, 469
Cruchfield, Robin, 144
Cruz, Mercedes, 551
CUANDO (Cultural Understanding And
 Neighborhood Development Organiza-
 tion), 398, 549
Cubiero, Emilio, 275
Cuddy, Jack, 214
Cultural AMNESIA, 147
Cultural Understanding And Neighborhood
 Development Organization *see*
 CUANDO
Cultural Weekly, 143
cummings, ee, 468

Cuomo, Mario, 444
Curtis, Jackie, 138, 190, 349, 468, 545

D

D.O.A. (Kowalsi), 303
Dafoe, Willem, 177, 391
Dagmar Poisoned The Pizza (Chase), 353
D'Agnillo, Anne, 307
Dali, Salvador, 473
Dallesandro, Joe, *115*, 120
Daly, Sandy, 353
Dance (Goldberg), 359
Dance Tube, 317
Dancenoise, 354, 388
Danceteria, 206, 302, 306, 370, 371, 400
Dancing Barefoot (Kral), 170
Dandy (Sempel), 89
Dangerous Clowns (Party), 540
Daniels, Bill, 111
Dann, Mike, 217
Dante, Alighieri, 540
Darinka, *263*, 263–264, 306, 390
The Dark Of The Screen (Petersen), 279
Darling International (Reeves, Serra), 379
Darling, Candy, 138, 190
Dash, Julie, 556
Davian, Joe, 247
David Zwirner Gallery, 377
DaVinci, Leonardo, 448
Davis, Douglas, 218
Davis, Jim, 98
Davis, John, 206
Davis, Miles, 231
Dawes, Joanna, 400
*Day in the Life: Tales From the Lower East
 Side, An Anthology Of Writings From
 The Lower East Side, 1940–1990*
 (Moore and Gosciak), 308
Day, Doris, 107
Daze, 301
DCTV, 287
de Antonio, Emile, 71–78, 87, 119
de Fabrik, 209
de Haulleville, Olivia, 120
de Hirsch, Storm, 114
de la Reguera, Luis Fernandez, 256, 262
De Landa, Manuel, 180
De Mo Mo / Scream And Scrap Metal, 208
The Dead Boys, 392
Dead Language Press, 120
Dead Last, 235
Dead On My Arm (Mele), 277
Dead On My Arm (Stark), 268
Dead Time Stories (Mitler), 491
The Deadly Act Of Survival (Ahearn), 175
Dean, Angel, 344
Dean, James, 468
Death In Venice (Mann), 519, 520
Death Of An Arabian Woman (Stark), 268
The Death of Neoism (NYU), 211
Death, Donna, 265
*Deathtripping: The Cinema Of Transgres-
 sion* (Sargeant), 402

Deauville Film Festival, 172
Decasia (Morrison), 496
Deelanda, Manuel, 265
Dee-Lite, 472
The Deep And Dreamless Sleep (Matthew), 235
"Deer park that's good water" (Buscemi), 498
DegaRay, 209
deKooning, Willem, 349
Del Rio, Vanessa, 243, 247
Delaurentis, Dino, 534
The Del-Byzangteens, 175 177, 180, 181
Delmbard, Cricket, 265–272
Demme, Jonathan, 177
DeMontebello, Roger, 344, 345
Denby, Edwin, 349
Deng, Loni, 556
Department Of The Interior (Fonoroff), 375
Der Elvis (Moritsugu), 354
Deren, Maya, 85, 87, 88, 101, 279
DeRienzo, Paul, 442
Derrida, Jacques, 522
Desaccord Major, 209
Desperately Seeking Susan (Seidelman), 226, 349
Destroy All Blondes (Kehoe), 541
DeVice, Mediea, 503
Devyatkin, Dmitir, 186
Di Prima, Diane, 139
Diamond Lil, 109
Diamond, Neil, 107
Diaz, Carlos, 550
DiCillo, Tom, 173, 182, 310,389, 393, 396
Dick And Jane Drop Acid And Die (Mitler), 492, 494
Dick, Vivienne, 122, 175, 180, 226
Dickson, W. K. L., 110
Dictators (band), 448
The Dictionary of Experimental Arts 143
Dictionary Of The Avant-Gardes (Kostelan-etz), 459
Die Hard With A Vengeance (McTiernan), 366
Dietch, Mary Ellen, 511
Dinkins, David, 441, 443, 444
Diodato, Baldo, 451
Dirt (Heliczer), 120, 350
"District Nine At A Glance" (Irizarry), 551
Ditch Witch (band), 448
Djuniba: Drums Of Africa, 543
DNA (band), 174, 177
Doane, Mary Ann, 106
Dog Eat Dog, 392
Doing Time In Times Square (Ahearn), 176
A Doll's House, 540
The Dom, 113
Domination Blue (Davian), 247
Don Juan In Manhattan (Group), 542
Donahue, Ellen, 300, 305
Donahue, E.M.306
"Don't Let It Bother You" (Waller), 491
"Doom Show" (No! Art), 456
Doren, Tom, 237

Dorf, Stephen, 350
Dorsky, Nick, 374
Double Trouble, 176
Doubling Cube, 140
Douglas, John, 554, 558
Down By Law (Jarmusch), 231
Downey, Robert Sr., 98, 116, 118, 119, 234
Downs, Fred, 214
Downtown 81 (Basquiat, O'Brien), 174, 399
Downtown Film And Video Festival, 291, 315
Downtown Thalia, 497
Downtown Writers Group, 421
Dream (Jarmusch), 311
Drink, 119
Drinking With Rockets Redglare (Vesecky and Christman), 262
Driver, Sara, 122, 177
Drooker, Eric, 442
Druzd, Harry, 129
Dubleyew, Didi Susan, 349
Duchamp, Marcel, 209
Duchamp, Marius de Zayas, 143
Duck, 543
Duggan, Kevin, 237
Dujour, Hoop, 367
Dunbar, Diane, 249, 250, 251, 253
Dunne, S. K., 359
Durr, Shawn, 339
The Dutchman (Jones), 567
Duvall, Robert, 111
Dylan, Bob, 132, 361, 566

E

Each One Teach One (Casanova), 442
Eak, 455
East Village Film & Video Festival, *286*, 289, 548
"The East Village Other" (Village Voice), 145
Easy Rider (Hopper), 220
Eat and Sleep (Warhol), 119
Ebony, David, 144
Eco-fest at TNC, 147
Ed Sullivan Show, 193
Ed, Red *see also* Braddock, Edward III, 367–368
The Eddie Cantor Story, 107
Edison, Thomas, 110, 178, 272, 293, 294, 310
Edwards, Doug, 376
Egypt, Arlene Krebs, 206
Eichelbaum, Stanley, 562–563
Eichelberer, Ethyl, 306, 313, 389, 472
8 BC, 291, 388, 400, 430, 545
Eight-Eyed Spy (Lunch), 175, 177
Eins, Stefan, 424
Eisenstein, Sergei Mikhailovich, 301
Elder, Bruce, 87
Elevator Repair Service, 543
Elle (magazine), 473
11th & B (Bonous, Martine), 401

Ellington, Duke, 226
Eluard, Paul, 143
Elvis Sightings (Martin), 491
Emily Harvey Gallery, 147
Empty Suitcases (Gordon), 177
Emshwiller, Ed, 186, 468
Engel, Morris, 234, 547
Eno, Brian, 185
Entermedia, 234
Eörsi, Istvan, 134
Epperson, John, 298
Eraserhead (Lynch), 303, 497
The Erasers 174
Eric and Co. Video, 249
Eric, Kai, 389
Ernst, Max, 163
Eros, Bradley 265, 313, 281–286, 289, 314, 315, 374, 377, 400, 418, *499*, 500–514, *500* (collage)
Eros-Liotto, Bradley, *280, 282*
Erotic Cinema, 374, 375, 377
Erotic Psyche (Eros), 313, 315, 400
Eroticus, Dr., 145
Escano, Raphael, 438
Eshleman, Clayton, 350
"Essential Cinema," 85, 86, 87
Etra, Bill, 186
Evans, John, 144, 195
Evans, Walker, 454
Evelyn, Annette, 342
Evolution, Involution (Steinfeld), 468
Exit Art, 374, 510
The Exorcist (Friedkin), 481
Exotic Landlordism Of The World (Smith), 298
Expanded Cinema, 185
Experienced Movers (Fessenden), 497–498
Export, Valie, 104
Extremist Show, 314
Eyres, Jeff, 492

F

Fab Five Freddy, 429
Fabulous Disaster (Scot-Free), 536
Face (magazine), 473
Faces, 497
The Factory *see also* Warhol, Andy, 242, 349
Faison, Frankie, 177
Faithfull, Marianne, 177
The Fall of America, 89
"FamiliarDesertOfTheModernImagination" (Jones, Liotta), 404
Fanon, Franz, 556
Fantasmagoria (Byron), 353
FAQ, Ray Kelly, 210
Farm, Ant, 218
Fashellio Pagenita Absurdia (Nelson), 335, 336
Fass, Bob, 442
Fassbinder, Rainer Werner, 303, 305
Fast Verns, 327

The Fat Black Pussycat, 189
Fatal Turn On (Martin), 491
Faust (Torak), 541
Faust Festival, 541
Faye, Alice, 109
Fear Of Fiction, 176
Feedbuck, Jeff, 253
Feedbuck, Missy, 252
Feet (Schloss), 194, 200
Feinstein, David, 457
Feldman, Ralph, 457
Feldman, Ronald, 352
Fellini, Federico, 327, 547
Fenby, Heather, 543
Fend, Peter, 426
Ferlinghetti, Lawrence, 144
Ferrara, Abel, xiii–xiv, 370
Ferrer, Fernando, 551
Ferris Bueller's Day Off (Hughes), 178
Ferry, Steven, 477
Fessenden, Larry, 497–498, *498*, 543, 548
Fichman, Nancy, 493
5th, Madison and Park (Dragan), 353
51 X Gallery, 343, 398
Figurelli, Alessandro, 145
Film And The Anarchist Imagination (Porton), 459
Films Charas, 234, 236–240, 239, 291, 314, 332, 349, 353, 375, 376, 398, 446, 525, 550, 551
Film Crash Series, 235, 495, 498
Film Culture, 86, 114
Film News Now Foundation, 557
Film Night, 349
Film Video Arts, 186, 287, 497
Filmculture Magazine, 95
Filmmakers' Cinematheque, 86, 103
Film-makers Cooperative, 86, 238, *372* (leaflet), 373, 376,
Filmmaker's Distribtuion Center, 86
Film-makers' Showcase, 86
Films Of Transgression *see also* Cinema Of Transgression, 332
"Filmthreat," 275
Finders Keepers (Jarmusch), 312
Fine Art News, 251
Fingered (Kern), 182, 266, 270, 275, 386
Finkelstein, David, *284*, 499–500
Finley, Karen, 181, 306, 400
Fire & Ice (Goldberg), 359
Fire, Lucy, 456
First Street School, 549
Fischinger, Oskar, 98
Fish, Ken, 439
Fisher, Ebon, 403–409, 411–414
Fishman, Marvin, 553
Fitzgerald, F. Scott, 515
Fitzgibbon, Coleen, 399
Five Spot, 113, 213, 216
Flaming Creatures (Smith), 25–28, 86, 95, 117, 120, 247, 350, 373, 386
Flaming Steam Irons, 210
Fleishner, Bob, 117
Flesh, 247

Flesh, Henry, 137–138
Fletcher Gallery, 487
Fletcher, Suzanne, 129, 177
Floating Point Unit, 253
Florian, Mircea, 143
The Flower Thief (Mead), 98, 114, 359, 566
Floyd, Bill, 558
Fluxus, 86, 87, 113, 323, 324
Fly, 405, 406
Flynn, Jim, 459
Flynn, Kimberly, 492
Flynt, Henry, 196
Fogel, Glen, 504
Folk City, 388
Fonda, Henry, 109
Fonoroff, Nina, 375
Foodveyor, Bulk, 405, 406
For Ever Godard, 312
For The Posers (NYCSmoke), 530
Ford, Charles Henri, 145, 147
The Foreigner (Poe), *172*, 173, 174, 177, 178, 224, 398
Foreman, Richard, 87, 417, 542, 543
Forgacs, Eva, 524
Forma, Anthony, 195, 199
Fortier, Amanda, 11–14
Foucault, Michel, 412
400 Blows, 220
Fox, William, 110
Foy, Eddie Jr., 109
Frampton, Hollis, 85, 87, 104, 188
Frank, Robert, 86, 87, 95, 114, 120, 126, 131, 134, 310, 461
Frankenstein (Warhol), 497
Franklin Furnace, 200, 467
Franz, Bob, 346
Freddy the Fence, 173
Freddy, Fab 5, 176
Freed, Katherine, 455
Freeland, Tessa Hughes, 122, 129–130, 173, 265, 266, 269, 277, 291, 315, 332, 350, 353–354, *354*, 371, 400, 508
Freer, Lynn, 540
French Ministry Of Cultural Affairs, 522
Fresh Seeds In The Big Apple (Choy, Siegel), 557
Friedlander, Marc *see also* Zero, Mark, 461
Friedlander, Miriam, 435
Friedman, Bart, 217
Friedman, Ed, 349
Friedrich, Su, 87, 104
"Friend Of The Court Brief" (Patterson), 459
Friends (Jarmusch), 310, 311, 312
Froese, Dider, 186, 196
Frogs for Snakes (Poe), 173
From Pagan To Pentecost (Pryor), 271
From Slumlord To Shooting Myself (Little), 364
From Spikes To Spindles (Choy, Hak), 557
From Urban Village To East Village: The Battle For New York's Lower East Side (Abu-Lughod, Blackwell), 433, 459

Frost, Robert, 454
Fruchter, Norman, 553, 554, 558
Frye, Brian, 415–420, 501–514
The Fuck Factory, 170
Fuck False Art, 144
Fuck You: A Magazine of the Arts, 131
Full Moon Show, 388
Fuller, Buckminster, 217, 218
Fuller, Sam, 109, 247
Fun Gallery, 182, 344, 398, 468
Funtone Records, 335, 336
Funtus Officio (Mitler), 491
Future-Sex, 145

G

Gable, Clark, 111
Gacy, John Wayne, 272
Gaffney, Sara, 543
Gagliotti, Davidson, 213–218, *214*, *215*
Gajeck, George, 359
Galapagos, 499
Gallagher, Kathleen, 491
Galleria La Mama, 145
Gallery East, 98, 99, 100, 113–114
A Gallery Sculpture Garden, 203
Gallo, Vincent, 173, 389, 429
Galm, Ruth, 101–104
Gamper, Christa, 301
Gang, Jane, 375, 418, 508
Gangs Of New York (Scorcese), 365
Garcia, Butch, 341, 455
Garcia, Chino, 550
Garcia, Jose, 549, 550
Garfield, John, 108
Gargoyle Mechanique, 403–409, 411–415, 502
Garnett, Tay, 98
Garniez, Rachelle, 301, 305
Garrin, Paul, 362, 439
Garrin, Paul, 439
The Gas Station, 375, 376
The Gate, 119, 205
Gatewood, Charles, 456
Gaunt, Percy, 109
Gautier, Fabienne, 311
Gazdag, Gyula, 134
Gearey, Dave, 186
Gehr, Ernie, 87, 564
Gehrin, Paul, 238
Gelber, Martin, 521
The General Returns From One Place To Another (O'Hara), 567
Generator, 209
Gentle Swastika Reclaiming The Innocence (Manwoman), 453, 459
Geoffrois, Patrick, 451, 452, 457, 459
George, Carl, 313, 314
George, Crystal, 138
George, Robert, 346
Gerima, Hall, 556
Gershuny, Phyllis, 217, 218
Gershwin, George, 108
Gestapo, Jimmy, 448



Get Down On 14th Street (Landis), 244
Getting Off (Lynch), 350
"Ghost Boat (Nada)," 543
Ghost Dog (Jarmusch), 226, 231
Giambattista, Vico, 217
Gibbons, Joe, 374
Gigantic: A Tale Of Two Johns (Schnack), 264
Giggliotti, Davidson, 186
Gilbert Hotel (Lerer), 148, 164, 165, *165*
"Gilchrist Experience," 552
Gilchrist, Winston, 552
Giles, Johnathon (Naval Cassidy), 128
Gillette, Frank, 217, 218
Gilligan's Island, 166
Gilmore, Geoff "Gizmo," 301
Gina, Green, 367
Ginsberg, Allen, 89, 92, 95, 98, 113, 118, 120, 131–134, *132*, 135–136, 139, 104, 144, 145, 147, 189, 190, 213, 306, 349, 350, 421, 427, 428, 442, 449, 451, 454, 467, 470, 498, 545, 566,
Giongiorno, John, 190
Giorno, John, 349
Giuliani, Rudolph, 89, 203, 240, 289, 309, 365, 445, 450, 451, 455, 465, 545
Glass, Jessica, 517–520
Glass, Mark *see also* Weiss, Avie, 452
Glass, Philip, 209, 498, 522, 529, 538, 416
Glen, Bradley, 542
Glenn Branca Symphony #4 /Physics, 202
"Global Healing" (Irizarry), 551
Global Villaged, 287
Globus Brothers Studios, 344
G-Man (B, B), 176, 181
GMLab, 406, 407, 408
Go Go Girl (Jones), 348
God Is My Co-Pilot (band), 209
Godard, Jean Luc, 104, 169, 189, 229, 301, 303, 547
Goese, Mimi, 388
The Goethe Institute, 522
GoGo Girl (Jones), 344
Gold, Tammy, 558
Goldberg, Franck, 400
Goldberg, Gary, 357–360, *358*, *359* (drawings), 359 (filmography), 542
Golden Boy (Odets), 108
Goldheart Films, 529
Goldin, Nan, 122, 177, 181, 354
Goldin, Susan, 411
Goldstein, Al, 243
Goldstein, Jack, 188
Gonzales, Delia, 417
Good Ol' Gregor Brown (Sikoryak), 540–541
Goodman, Paul, 549
Goodson, Dale, 540
Gorbachev, Mikhail, 522
Gordon and Breach, 218
Gordon, Bette, 177, 389
Gordon, Cyd, 406
Gordon, Kim, 206

Gordon, Michael, 496
Gordy, Bill, 295–298
Gorilla Art Show, 306
Gormley, Peggy, 128
Gosciak, Josh, 308
"Gospel According to St. Miguelito" (Piñero), 300
GQ Magazine, 473
Gracie Mansion, 302, 306, 351, 398
Grade A, 306
Grafstrom, Anders, 177
Graham, Dan, 423
Graña, Cesar, 304, 308
Grand Homosexual Outrage At Sickening Televangelists (GHOST), 271
Grandmaster Flash, 175, 392
Grant, Beverly 555, 558
Grant, Robin, 492
Green, Dan, 407, 415
Green, Jerome, 551
Greenfield, Amy, 417, 501, *537*, 537–538
Greenfield-Sanders, Timothy, 350
Gregor, Baby, 323
Gregorits, Gene, 262
Grey Gardens (Maysles), 314
Grey, Stuart, 346
Griffin, Jack, 214
Griffith, D. W., 110, 238
Grim Humor, 316
Grim, Beth, 405
Gringo (Kowalsi), 303
Groff, Agi, 350
Grogus (Corber), 425
Grote, Jason, 189–192, *191*
Ground Center, 329
Ground Zero Gallery, 400
Group Theatre, 108
Group, Robert, 542
"Growin' At The Limbo" (Bonk), 303
Growing Up In America (Markson), 132
Guerillere Talks (Dick), 175
Guerrilla Television, 218
Guggenheim, Peggy, 143
Guinness Book Of World Records, 455
Guns of the Trees (Mekas), 98, 118
Gusella, Ernest, 87, 185–188, 201, 204
Guttenplan, Howard, 101, *101*, 103, 103, 104, 129, 356, 376
Guzman, Luis, 238, 525–526, 177
Gwar, 456
GZA, 232

H

Hagandazovich, Lina, 182
Hagen, Nina, 182
Hagen, Phillipe, 175
Hak, Tsei, 557
Half Note, 213
Halleck, DeeDee, 1-4, 120
Halleck, Tovey, 249, 346
Haller, Robert A., 417, 537–538
Halter, Ed, 373–380, 501–514

Hambleton, Richard, 249, 301, 531
Hammanin, Barbara, 197
Hammer Brain (band), 448
Hammer, Barbara, 95, 374
Hammid, Alexander, 87
Hampton, Fred, 217
Hanavan, Anne, *531*, 531–532
Handelman, Michelle, 376
Hanke, Herbert, 147
Hannaford, Susan, 429
Hannah, Duncan, 171, 173, 174
Hannibal (Scott), 178
Hansen, Duane, 243, 303
Happy Death (Camus), 303
Happy-face, 323
Hare Krishna, 451, 452
Haring, Keith, 182, 206, 242, 245, 249, 303, 343, 429, 430, 447, 468
Harrison, George, 452
Harrison, Matthew, 209, 235–236, 495, 498
Harry Smith (Jones), 347
Harry Smith: An American Magus, 347
Harry, Debbie, 172, 174, 240, 399
Hartman, Leon, 546–548
Hartman, Phil, 122, 233, 238, 240, 349, 350, 380, 458, *546*, 546–548
The Hat, 539
Hated (Phillips), 535
The Haters, 209
Hatt, Karen, 491–494
Haunted House Project, 407
"Having A Great Time Wish You Were Here" (Anarchist Switchboard), 209
Hawkins, Screamin' Jay, 227
Hawks, Howard, 98
Haynes, Todd, 238, 314, 354, 498
He Stands in the Desert Counting the Seconds of his Life (Mekas), 90
"Hear Us Out" (Irizarry, Wilkinson), 551
Hearn, Pat, 304
Hearn, William, 186
The Heartbreakers, 170, 176
Heart Of New York (Caesar), 108, 111
Hearts (Goldberg), 359
Heat (Morrissey), 182
Heaven And Earth Magic (Smith), 245
Hedwig And the Angry Inch (Mitchell), 498
Heer, Johanna, 183
Hegel, Georg Wilhelm Friedrich, 518, 519
Heilman, Mary, 204, 308
Hein, Birgit, 104, 106
Heine, Heinrich, 522
Heino, 209
Heliczer, Piero, 120
The Hellfire Club, 375
Hell, Richard, 170, 171, 173, 176, 232, 272, 294, 498, 545
Hellman, Daphany, *443*
Hemphill, Bert, 453, 454
Henderson, David, 350
Hendryx, Nona, 295
Henke, Oliver, 384
Henry, Pierre, 209

Her Fragrant Emulstion (Klahr), 374
Herron, Annie, 307
Herzog, Werner, 303
Heyward, Julia, 423
Higgins, E. F., 208
Higgins, Ed, 401
Hilferty, Robert, 374
Hill, Chris, 106
Hill, Henry, 373
Hill, Jerome, 85, 86 559
Hill, W., 540, 542, 543
Hills, Henry, 401
Hine, Louis, 111
Hiss, Tony, 563
"The History Of Honey," 349
Hitchcock, Alfred, 376, 543
Hoberman, J., 106
Hochschild, Rosemary, 181, 182, 183
Hocking, Ralph, 186
Hoffman, Dustin, 111, 567
Hoffman, Richard, 335
Holden, William, 108
The Hole (Ming-Liang), 229
Holland, Barbara, 209
Holland, Gill, 350
Hollow Venus: Diary Of A Go-Go Dancer
 (Fessenden), 498
Hollywood Babylon, 245
Holman, Bob, 239, 349
Holstein, Mark Von, 287
Home Invasion (Little), 365, 401
Home Living (Club), 307
Homes Apart (Choy, Takagi), 557
"Hooked–The Madness In Methadone
 Maintenance" (Landis), 246
Hoolboom, Mike, 106
Horovitz, Leny, 144
Hot Rods (magazine), 157
House Of Candles, 540, 543
House Of Ill Repute (Brys), 541
House of Strangers (Mankiewicz), 108
House on Unamerican Activities (HUAC),
 111
Household Affairs (Ginsberg), 133
Houston, Montana, 266
How She Sees It By Her (Schloss), 202
How To Squash A Squat (Goldberg), 401
Howard, Margo, 468
HOWL! Festival, 334, 339, 340, 341, 380,
 401, 454, 458, 548,
Howl Project, 226
"Howl!" (Ginsberg), 327
Hoyt, Charles H., 109
Hughes, Robert, 188
Hughes, Ted, 201
Hughes, Tessa, *see* Freeland, Tessa Hughes
Human Arts Ensemble, 206
Human Rights Watch, 555
Humoresque, 108
Huncke and Louis (Vazakas), 139
Huncke, Herbert, 139, 140, 141, 144, 350,
 454
Huncke's Journal, 139
Hundermark, 456

Hurricane Streets, 350
Hurst, Fannie, 108
Huston, John, 395
Hutton, Peter B., 87, 239

I

I, a Goddess (Philly), 316
I had Nowhere To Go (Mekas), 93
I Only Have Eyes For You (Jarmusch, Gauti-
 er), *309*, 312
I Was A Teenage Bride Of Christ (Mitler),
 493, 494
Ibsen, Henrik, 540
Icarus & Aria (Bromley), 542
Ice (Kramer), 556
Ichaso, Leon, 384
Ickelberger, Ethel, 322
Idealism, Angela, 208
If Bwana, 209
Igliori, Paola, 451
Igneous Ejaculations (Hill), 373
I'll Fly Away (Chase), 167
I'll See You In My Dreams (Curtiz), 107
Illic, Dragan, 353
Illusion of Safety, 209
Imitation Of Christ (Warhol), 566
"The Impact Addict" (Fessenden, Leslie),
 498
Imura, Takahiko, 417
"In A Modern City" (Hendryx and Lake),
 295
In Carlito's Way (De Palma), 526
In Memory Of Joseph Beuys, 351
"In NASA's Lab" (Orensanz), 521
In The Soup (Buscemi), 258, 396
In the Year of the Pig (de Antonio), 119
Indiana, Gary, 176, 190, 299, 306
Indio, 456
Inferno (Dante), 541
Inside Out: the World Of The Squats (Pat-
 terson), 459
Inside Woman Inside (Choy), 557
Instant Girl, 498
Institute For Education And Social Policy
 (New York University), 553
Interfere, 209
Intro Bulletin, 98
The Invaded Island (Garcia), 550
The Invisible Cinema, 269, 559–564
IRACK, 339
The Island Show (No Rio), 314
Irizarry, Alfredo Texidor, 549–552
Irizarry, Luis Angel, 550
Is There No Justice (Anarchist Switch-
 board), 209
Issendorf, John, 543
It Don't Pay To Be An Honest Citizen
 (Burkhardt), 132
It Was Twenty Years Ago (Albury), 132
It's A Wonderful Life (Capra), 543
"It's All True: Imagining New York's East
 Village Art Scene of the 1980s" (Kir-
 win), 308

J

Jackson, Flo, 558
Jackson, Michael, 249
Jacobs, Heshy, 457
Jacobs, Ken, 87, 100, 102, 103, 105, 114,
 117, 118, 119, 420
Jacobson, Marion, 317
Jadwick, Ray, 343–348
Jadwick, Z, 346
Jaffé, Louis, 217
Jaffe, Sheila, 396
Jagger, Mick, 473
Jaglom, Henry, 350
James Chance (band), 452
James, David, 105
James, Henry, 515
Janie's Jane (Ashur)m Shaffer, 555, 556
Jankowski, Matti, 207–212, *211*
Jannuzzi, Angelo, 145
Janos Gat Gallery, 433, 456
Jarmusch, Jim, 104, 124, 173, 175, 177,
 178, 180, 182, 221–232, *222*, 309,
 370, 388, 389, 391–393, 395, 498,
 547, 567
Jarmusch, Tom, 130, 309–312
Jazz Passengers, 295
The Jazz Singer (Crosland), 107, 425
Jen, Reverend, 379
Jenkins, Kiley, 346
Jenkins, Tamara, 238, 548
Jepsen, Anna, 220
Jeriko, Orion, 265, 273 313, 388, 391
Jim Jones, 242
Joans, Hety, 147
Jodorwosky, Alejandro, 241
Joe The Broom Man, 543
Joel, Billy, 255
Joe's Apartment (Payson), 366
Johnny Suede (DiCillo), 310
Johns, Jasper, 113, 521
Johnson, Arthur, 452
Johnson, Becky, 216, 226
Johnson, Bruce, 216
Johnson, Danny, 429
Johnson, Dean, 472
Johnson, Ray, 145, 195
Johnston, Becky, 174, 175, 177, 180, 398
"The Joke Is In the Mail," 209
The Jolson Story (Green), 107
Jon Gerstad Gallery, 400
Jonas At The Ocean, part 2 (Mekas), 92, 93
Jonas in the Desert (Mekas), 94
Jonas in The Jungle (Mekas), 93
Jones, Baird, 351–352
Jones, Jonathan, 568
Jones, LeRoi *see also* Baraka, Amiri, 567
Jones, M. Henry, 127, 142, 245, 264, 288,
 293, 343–348, *344, 345, 347,* 354
Jones, Sarah, 439
Jones, Steve, 403–409
Jordan, Larry, 156, 563
Josh The Drug Dealer, 543
Jost, Jon, 104

Joyce, Dick, 214
Judson Church, 449
Julty, Dagen, 208
Just Desserts (band), 498
Juxtaposition, 142

K

Kaboom, Inju, 415–420
Kaceri, John, 194
Kahn, Gus, 107
Kamikaze, 306, 400
Kandinsky, Wassily, 469
Kane, Charles Foster, 518
Kaplan, E. Ann, 106
Kaprow, Alan, 200, 201
Karl, Max, 181
Karol, Matt, 346
Kar-Wai, Wong, 230
Kase, Carlos, 85–88
Kasparov, Garry, 551
Kassos, Ricky, 266, 354, 400
Katz, Alec, 239
Kaufman, Roger, 455
Kaye, Stanton, 100
Keaton, Buster, 500
Keen, Michael P., 207
Keep Refrigerated, 406
Kehoe, Mark, 264, 541
Keller, Marjorie, 87
Kelley, Ray, 401
Kelly, John, 313, 322, 353, 389
Kelly, Ray, 201, 206, 249, 300
Kelly, William, 350
Kelly, Zatar, 206
Kelman, Ken, 85, 559–564
Kelman, Richard, 265
Kembra, 319, 321, 322, 323, 332, 335, 342
Kemp, Lindsey, 334
Kennedy, Chuck, 217
Kennedy, Doug Bert, 403, 404
Kennedy, John Jr., 527
Kennedy, Michael, 439
Kerdouche, Rascid, 128
Kern Noir (Kern), 275
Kern, L.I. Richard, 354
Kern, Richard, 122, 126 169, 173, 182, 220, 264, 265, 266, 270, 271, 272, 275, 275–276, 277, 306, 314–316, 386, 389, 400, 535
Kerouac, Jack, 113, 131, 139, 213, 206, 467
Kerwin, Elizabeth Seton, 308
Kicked In The Head (Scorcese), 235
Kid Scarface (Mitler), 491, 492
Kidnapped (Mitchell), 174, 180
Kiefer, Anselm, 521
Kiev, 361
Killer Films, 498
Kim, Tabitha, 405
King Blank, 177, 182
King Of Sex (Kern), 266, 273
King Tut's Wah Wah Hut, 498

King, John, 206
Kinney, Kathy, 391–392
Kirves, Dietmar, 433, 456
Kirwin, Liza, 304
Kissany, 322
Kissing Jessica Stein (Herman-Wurmfeld), 384
The Kitchen, 185, 186, 195, 199, 204, 424
Kladdach, Jim, 399
Klahr, Lewis, 156, 374, 467
Klein, Julius, 287–292
Kline, Phil, 175, 312
Kluge, Alexander, 87
Knipfel, Jim, 337, 456
Knitting Factory, 145, 349, 400
Koch, Edward, 353, 435, 436, 443, 444, 451
Kohler, Anna, 388
Kojak, 515
Kolm, Ron, 209, 421–422, *422*
Konk, 178, 392
Koponen, Sandra, 113–120, *115*
Koppel, Barbara, 558
Kornish, Doris, 229, 233, 237, 238, 240, 349, 350, 548
Korot, Beryl, 217, 218
Kostabi, Ena, 300
Kostabi, Mark, 301, 351, 352
Kostabi, Paul, 367
Kostelanetz, Richard, 194, 195, 323, 459
The Kosthappenings, 351, 352
Kosuth, Joseph, 104
Kotin, Lisa, 541
Kowalsi, Lech, 303
Krack Down (band), 448
Krakow, Peter, 404
Kral, Ivan, 170, 173, 398
Krall, L. Brandon, 350
Kramer, Jane, 555
Kramer, Robert, 554, 556, 558
Kransburg, Janet, 558
Kraut, Shelly, 349
Kronos Quartet, 522
Krueger, Myron, 251
Kruger, Barbara, 182
Kubelka, Peter, 85, 86, 559–564
Kubota, Shigeko, 189
Kuby, Ron, 438
Kuchar Brothers, 156, 322, 328, 333, 342, 369, 376
Kuchar, George, *see also* Kuchar Brothers, 322
Kuchar, Mike, *see also* Kuchar Brothers 315, 322
Kuhn, Father, 362
Kuhn, Wolf, 382
Kunstler, William, 438
Kunstluft (Orensanz), 518
Kuntzleman, Scott, 209
Kuper, Peter, 442
Kupferberg, Tuli, 143, 144
Kurosawa, Akira, 223
Kusterman, Peter, 209
Kuzminsky, K. K., 456

Kwaloff, Peter, 447

L

La Bodega Sold Dreams (Piñero), 300, 305
La Mama, 113
La Prade, Erik, 35–40, 57–58
Labyrinth Books, 144
Lacativo, Robert, 558
Laden, Bin, 448
Lader, Marty, 214
The Lady Bunny, 472
Lago, Alexis Del, 472
Lake, Oliver, 295
Lake, Ricki, 535
L'Amour Fou (Serra), 375
Lamprecht, Majka, 183
Land, Joey, 346
Landazuri, Bob, 404
Landazuri, Davo, 404
Landis, Bill, 241–248, *246*, 343, 459
Landlord Blues (Burckhardt, Gordy), 295–298, *295* (collage), *296*, *297*, 350
Landlord Pictures Inc., 197
Lane, Mark, 119
Lang, David, 496
Lang, Fritz, 98, 303
Langlois Foundation, 218
Langsford, Walter, 117
Lanier, Jaron, 251
Lapidus, Kyle, 415–420
Larson, Rodger, 5–7
The Last Beer On Earth (Little), 362, 364
Last Rights (B), 176, 269
Last Rites, 120
Latin American Film Festival, 558
Latin Boys Go To Hell, 315
"Latin Close Up" (Irizarry, Rios), 551
Lattanzi, Barbara, 106
Laurel And Hardy, 549
Le Grice, Malcom, 104
Le Petit Versailles, 317
Lea, Larry, 270
Leaf, June, 134
Leary, Dennis, 350
Lebel, Jacque Luc, 456
LeCompte, Liz, 391
Lee Way (band), 448
Lee, Cinque, 232
Lee, Dave, 467, 469
Lee, Francis, 87, 98
Lee, Peggy, 107
Lee, Spike, 178, 287, 297, 522, 547
Left Aside (Jarmusch), 311
Leg, Lung, 264, 265, 268, 277, 400
Legere, Phoebe, 126, 130, 206, 277, 350
Legs, Lung, 275, 354
Lehrer, Phillis Bulkin, 145
Lemmy, 90
Lemmy (Mekas), 90
Lennbachhaus Galerie, 204
Lennon, John, 242

Leo Castelli Gallery, 398

Leone, Sergio, 382

Leopold, Gregory, 186

Lerer, Jeffrey, 149–168, *152, 153, 154, 157, 158, 159, 163*

Les Enfants Miserables (Mitler), 493

Leslie, Alfred, 86, 114, 131, 380, 498

Lesniak, Rose, 349

Lester, Albert, 322

Lestrata (Fellini), 327

Letters To Dad (B, B), 176

Levett, Helen, 111

Levine, Les, 185, 423

Levine, Saul, 376

Levy, Julien, 143

Lewinsky, Monica, 450

Lewis, Jerry Lee, 392

Lewis, Joe, 207

Lewis, Steve, 302

Lhotsky, Tina, 398

Liberty's Booty (Dick), 175

Liebman, Stuart, 105

Lies Lies Lies (Rockets Redglare), 258, 269

Life and Times of Allen Ginsberg (Aronson), 134

Life Café, 220, 299, 401

Lightning Over Water (Wenders), 178

Lillian Russell, 109

Lilly, John, 413, 414

Limbo Lounge, 299, 303–304, 329, 353, 388, 400

Limbo, Michael, 303

Limelight, 400

Limosner, Pilar, 429

Linblad, rune

Lind, Sally, 213

Linda, Little, 271

Lindsay, Arto, 174, 177

Linklater, Richard, 350

Linn, Garrett, 264

Liotta, Jeanne, 281–282, 400, 404, 407, 495, 504

Liquid Liquid, 392

Liquid Sky (Tsukerman), 303

Liquid Television, 263

Litt, Richard, 297, 298

Little Bird, Larry, 556

"Little Johnny Jewel," 173

Little Stabs at Happiness (Jacobs), 117, 119

Little, Booker, 216

Little, Gerard, 297, 298

Little, Rik, 289, 349, 361–366, 401

Liu, Benjamin, 472

The Lives Of Children In The First School (Goodman), 549

Living In Oblivion (DiCillo), 310

The Living Theater, 118, 306, 307

Lobst, Anne, 388

Loisaida, 550, 551

London Filmmakers Coop, 183

London, Barbara, 186

Lonesome Cowboys (Warhol), 116, 138,
566

The Long Island Four, 177

Loos, Jessica, 7–10

Lopez, Councilwoman, *462*

Lorde, Audre, 557

Lords, Traci, 276

Lorusso, Ted, 492

Losey, Joseph, 98

Lost Weekend (Wilder), 110

A Lot Of Fun For The Evil One (Serra), 379

Lotus, 340

The Lounge Lizards (band), 174, 392

Love Crimes (Borden), 177

The Loveless (Bigelow), 177

Lovich, Lene, 182

Low Flame (Statland), 529

Lowe, Leslie, 314, *316*, 317

Lowe, Marcus, 110

Lowe, Nick, 392

Lower East Side Action Project (LEAP), 549

The Lower East Side 1988–2000 (Patterson), 458

"A Lower East Side Poem" (Piñero), 307

Loy, Mina, 143

Lubar, Cindy, 391

Luck, Fran, 349

Ludlam, Charles, 104, 543

Luminous Motion (Gordon), 177

Lunch, Lydia, 175, 176, 177, 180–183, 264–266, 275, 315, 386, 400

Lure, Walter, 176

Lurie, Boris, 433, 456

Lurie, Evan, 176

Lurie, John, 174, 175, 176–179, 181, 2224, 225, 228, 370, 389, 398, 498,

Lynch, David, 303

Lynch, Julie, 350

Lynch, Kate, 263

Lyons, Jimmy, 226

Lyotard, Jean-Francois, 385–386

Lypsinka, 472

M

"M. M. Serra's Electric Sex Machine," 373

Maas, Willard, 98

Macbeth, King Of Scoutland (Mitler), 494

MacDonald, Scott, 106

Mace, 543

Maciunas, George, 86

Mackover, Robert, 558

MacLise, Angus, 120

MacLow, Jackson, 104

Mad Magazine, 156, 157, 161

Maddox, Alton, 438

Made For TV, 181

Madonna, 249, 377, 385, 401

Maeck, Klaus, 90

Mag City, 349

Magenta, Anna, 350

The Magic Gallery, 299, 300

Magick Warrior (Geoffrois), 459

Magnuson, Ann, 176, 177, 181, 343,
429–430, 545–546

Magritte, Rene, 161, 163

Mail Art Marksma, 209

"Mailaise In Malysia," 349

Maise, 331

Maiwald, Christa, 186

Major, Borisch, 389

Malanga, Gerard, 120, 349

Malick, Terrence, 547

Malina, Judith, 144, 147, 219, 307

Malloy, Honor, 543

Maltz, Albert, 111

Man Ray, 143

The Man with a Movie Camera (Vertov), 118

Manhattan Love Suicides (Kern), 265, 266, 273, 386

Manhattan Melodrama (Van Dyke), 110

Manhattan Neighborhood Network (MNN), 551

Manhattan Project, 206

"The Manhood Series," 389

Manhunter (Mann), 178

Manic A Go-Go (Thiessen), 492

Manic Panic, 429

Mann, Thomas, 519

Manning, Roger, 350

"The Manson Family Opera," 495

Manson, Susan, 268

Mantello, Joe, 527

Manwoman, 453, 459

Mapplethorpe, Robert, 353, 374

The Marbles (band) 173

Marco Art, 339

Mare, Aline Psyche, 265, *283*, 283–286, 313, 314, 315, 400

Margret Mead Film Festival, 506

Marine, Marie, 401

Marisa's Peaches, 543

Marked For Life: A Gallery Of Tattoo Art (Bonge), 459

Markopoulos, 98

Markovich, Nick, 404, 405, 406, 414

Marks, Laura, 106

Markson, Morley, 132

Marriage (Corso), 260

Mars, 340

Mars, Shelly, 543

Marshall, Ed, 25–28

Martin, David, 491

Martin, Phillip, 317

Martinez, Alfredo, 312

Martinson, But, 559

Marx Brothers, 543

Marx, Carlo, 303

Marzano, Joseph, 98, 117

Mason, C. Vernon, 438

Mass, Steve, 172

Massey, Rob, 238

Masters, Greg, 233–234, 349

Matz, Marty, 454

Max Fish, 373, 375, 377, 382

Max, Peter, 487

Max's Kansas City, 180, 224, 343

Maya, Frank, 389
Mayorca, Eli, 352
Maysles Brothers, 170, 314, 519
Maysles, Albert, 461, 519
Mazar, Debi, 429
McCabe, John, 478
McCabe, Michael, 459
McCarthy, Mary, 550
McClard, Michael, 181, 399
McClintock, Nick, 231
McClure, Bruce, 417
McCormick, Carlo, 299, 306, 521, 524
McDonnell, Allen, 275
McElhatten, Mark, 374, 504
McEvilley, Thomas, 522, 524
McGough, Peter, 429
McGrath, Bob, 496
McGregor, Baby, 370
Mcguinn, Roger, 132
McIntyre, David, 543
McKay, Windsor, 122
McLachlan, Kyle, 350
McLard, Michael, 177
McLaren, Malcolm, 305
McLean, Steve, 382
McLow, Jackson, 97
McLuhan, Marshall, 217
McMannis, Sheila, 237–238
McNeil, Lynn, 370
McQueen, Alexander, 522
Me Minus You (Zedd), 266
Mead, Harry, 566
Mead, Larry, 558
Mead, Taylor, 79–84, 114, 116, 174, 189,
 190, 232, 338, 349, 359, 542,
 565–568
Megaphone, 208
Mekas, Adolfas, 98, 114
Mekas, Jonas, 85, 86, 87, *87*, 88, 89–96,
 97–100, 103, 113, 114, *116*, 117, 118,
 186, 234, 242, 340, 343, 377, 419,
 451, 508, 510, 536, 553, 558,
 559–564, 567
Mele, Casandra Stark, 124, 130, 264, 265,
 268, 277–280, *278*, *314*, *316*, 317,
 400
Melies, George, 376
Melon In The Sky (Wallace), 543
Men In Orbit (Lurie), 176, 180, 228
Menace, Max, 174
Menken, Marie, 98, 376
Mercedes, Denise, 132
Merchants Association, 550
Mercury Lounge, 529
Mereness, Jamie, 415–420
Merkin, Richard, 473
Mesmer (Goldberg), 359, 542
The Message, 246
Messenger, Ruth, 435
Metasex Magazines, 241, 243, 245
The Metropolitan, 244
Metz, Marty, 144, 147
Meyerling, Max Von, 107–112
Meyers, David, 209

The Miamis, 173
Michelangelo, Buonarroti, 448
Michelet, Jules, 217
Michelson, Annette, 105
Midgets, The, 287
Midnight Blue (Benet), 144
Miles, Sylvia, 567
Millenium Film Workshop, 101–106, 118,
 122, 156, 169, 172, 242, 247, 287,
 314, 322, 349, 373, 376, 418, 420,
 438, 508, 536
Millennium Film Journal, 104
Miller, Dick, 176, 427
Miller, Eric, 249–254, *252*
Miller, Gretta Wing, 206
Miller, Joyce, 558
Miller, Marc, 402
Miller, Norman, 214
Miller, Shelley, 350
Ming-Liang, Tsai, 229
Mingus, Charlie, 165
Minh, Ho Chi, 554
Miró, Jean, 520
Miro, Jennifer, 174
Mirren, Helen, 350
Missing Foundation, 364
Missing, Peter, 364
Mitchell, Eric, 172, 174, 175, 176, 177,
 180, 181, 182, 226, 349, 389, 392,
 398
Mitler, Matt, 491–494, 543
MIX, 375
Miyake, Kiki, 132
Model Release (Kern), 275
Modern Primitives (Vale), 456, 459
Modern Young Man (Smith), 175
Moeller, Bernie, 455
Mohre, Terry, 399
Molati, 452
Molina, Alfred, 177
Mollen Commission Report, 444
Monahan, Gordon, 209
Monday-Wednesday-Friday Video Club,
 397–402
Mondo Cane, 242
Monk, Meredith, 196, 197
Monk, Thelonious, 226, 227
Monroe, Marilyn, 468
Monster Movie Club, 343
"The Monster Movie," 429
Monsters (television), 177
Montaug, Haoui, 370
Monte, Gil, 456
Montgomery Variety Series (Wilems), 542
Montgomery, Jennifer, 417
Montgomery, Ken, 209, 210, 211
Mooney, Elina, 201
Moore, Alan, 182, 197, 305, 308, 350,
 397, 397–402, 425, 426
Moore, George, 207, 208
Moore, Michael, 189, 534
Moore, Peter, 200
Moore, Rosemary, 297
Moore, Thurston, 206

Moorman, Charlotte, 537
Moossy, Joan Marie, 255–256, 461
Mora, Michael *see* Redglare, Rockets
Moran, Brian, 264, 266
Moriarty, Dean, 303
Moriarty, Tim, 214
Moritsugu, John, 265, 269, 314, 354
Morrison, Bill, 495–496
Morrissey, Paul, 35–40, 118
Mothers, 224, 289
Moto, Mini, 346
Motor morons, 208
Moverman, Oren, 396
Movie Journal, 86, 98, 114, 116
The Movie Of The Month club, 491–494
"Movies That Were Spawned in Bilgewa-
 ter" (Kern, Moran, Zedd), 264
Mowhawk Nation (Siegel), 557
Moynihan, Colin, 338, 431
Mr. Mike's Mondo Video, 177
Ms 45 (Tamerlis), 370
Muciunas, George, 196
Mud Films, 172
Mudd Club, 145, 179, 180, 182, 200, 206,
 224, 226, 242, 399, 430
Muehl, Otto, 272
Mueller, Cookie, 174, 181, 472
Mugianis, Dimitri, 140, 141
Mullins, Carol, 297
Mumford, Marilyn, 558
Munn, Robert, 345
"Murder Suicide Junk" (No Rio), 314
Murphy, Jay, 71–78
Murphy's Law (band), 448
Murrin, Tom, 388
Musee Mechanique, 404
Museum Of Broadcasting, 461
Museum of Modern Art, 104, 157, 162,
 166, 456, 496, 510
The Musketeers Of Pig Alley (Griffith), 238
Muslimgauze, 209
Musto, Michael, 336, 472
The Mutilator (Mitler), 491
MWF Video Club, 350, 401
My Last Bag Of Heroin (For Real) (Auder),
 189, 190
My Little Margie, 367
My Nightmare (Kern), 275
My World Is Empty (Goldin), 181
Myers, Joel, 442
Myles, Eileen, 349
Mylonas, Urania, xv, *410*
Mystery Train, 392

N

Nada Gallery *see* Todo Con Nada
Nadja (Alergda, Michael), 382
Nakamura, Bob, 557
Naked Angels (Thin Lizard Dawn), 529
Naked Angels, 527, 529
Naked Eye Cinema, 277, 313–318, *315*,
 316, 320, 321, 322, 323, 326, 332,
 338, 349, 350, 384, 400

The Naked City, 111
Naked Lunch (Burroughs), 95
The Naked Show (Tarbox), 542
Nanook of the North, 85
Nares James, 122, 174, 175, 177, 180, 226, 353, 389, 398
Nase, Ward, 207
Nathanson, Roy, 295
Naughty Animation, 101
Naum, Gellu, 145
Nazi And Money (Kern), 271
Near Dark (Bigelow), 177
Neel, Alice, 131
Neither/Nor, 299–300
Nelson, Gina, 405
Nelson, Gunvor, 87
Neschat, Shirin, 206
Neu, Jim, 359
Neue Gesellschaft Fur Bilende Kunst (No! Art), 432, 456
New American Cinema Group, 114, 377
The New Cinema, 180, 398, 400
New Earth, 270
New Line Cinema, 170
New Museum, 469
"New Realities" (Steinfeld), 135, 136, 470
New School, 102
The New World (Jarmusch), 178
New York Girls (Kern), 275
New York Hoods (band), 448
New York Smoke (benefit, Bowery Ballroom), *527*
New York Tattoo Society, 432
New York Underground Film Festival, 353, 354, 371, 376, 508, 509
Newman, Harley, 456
Newsreel, 553–558
Newsreel: Documentary Filmmaking On The American Left (Nichols), 554, 558
The Newstand, 302
Newton, Jeremiah, *105*, 141, 169–172, *170*, 432, 476
Ng, David, 237–240
"NGBK No! Art" (show), 456
Niblo's Beer Garden, 109
Nichols, Bill, 554, 558
Nickelodeon TV, 204
Nico Smith and Ground Zero, 190, 220
Night After Night (Raft), 109
Night and Day (Curtiz), 108
Night Of the Living Dead (Romero), 497
Night On Earth (Jarmusch), 229, 231
"Nightmare Call-In Theater," 399
9 1/2 Weeks, 226
9th Street Window Gallery, 20
The No Bar, 210
No Game (Newsreel), 553
No Japs At My Funeral (Nares), 175
No More To Say & Nothing To Weep For (Still), 134
No Picnic (Hartman and Kornish), 122, 233, 238, 239, 264, 349, 350, 548
No President, 100
No Se No Social Club, 300

No Se No, 197, 210, 249, 305, 346, 401
"No Shame" (Mitler), 491
No Such Thing As Gravity (Wittenstein), 271, 273
No Telling Habit (Fessenden), 498
No Wave (Movement), 173
No Wave Cinema, 173–178, 179–184
No Wave Music, 179–184
No! Art In Buchenwald (Lurie, Patterson), 433, 456, 459
No! Art, 432–433, 456, 459
Nobes, Bill, 289
Nomi, Klaus, 177, 429
Noren, Andrew, 122
Normal Love (Smith), 122
Normals, 542
Not For Sale (No Rio), 313
Not Nude Though: A Portrait Of Rudy Burkhardt, 239
Notebooks (Menken), 377
Notley, Alice, 349
Nussbaum, Karl, 498
Nuyorican Poet's Café, 145, 307, 534, 550, 551
NY Tatoo Society, 456
NYCSmoke (band), 527–530

O

"*O Pioneer! Mary Heilmann on Pat Hearn*" (Heilmann), 308
O, Janice, 287
Oblowitz, Michael, 177, 182
O'Brian, Dave, 272
O'Brien, Glenn, 174, 183, 399
Occ Occ (Goldberg), 359
The Ocean Club, 224
Ocularis, 507
Oddo, Steven, 272
Odessa, 340
Odets, Clifford, 108
The Offenders, 176, 181
Ofili, Chris, 450
O'Grady, Gerald, 186
O'Hara, Frank, 143, 421, 567
Ohno, Kazuo, 90
Oisteanu, Ruth, 145
Oisteanu, Valery, 143–147, 350
O'Kane, Dick, 213
Oland, Warner, 108
The Old Dark House (Whale), 543
Old Film Forum, 497
Oldenburg, Claes, 87, 113
Oldham, Todd, 350
Oleszko, Pat, 498
Olinder, Laurie, 496
Oliver, Edgar, 313
Olivier, Laurence, 107
"On Bohemia: The Code Of The Exiled" (Graña), 304, 308
On The Borderline, 177
On the Bowery (Rogosin), 110
On The Road (Kerouac), 213
"On Two" (Cruz, Irizarry), 551

Ona, 306
Onassis, Jackie, 527
Once And Future Queen (Verou), 335, 341
Once In A Jungle (McIntyre), 543
Once Upon A Time In America (Leone), 382
Ondine, 242
124 Ridge Street Gallery, 235
Ono, Yoko, 113, 473
Open City (Rosselini), 547
The Opium Den, 504, 510
Oppenhiemer, Peter, 406
Ordo Templi Orientis, 266
Orensanz, Angel, *517*, 517–524, *523*
The Orensanz Center, 519
Orgone Cinema, 505, 507
Original Wonder (Corber), 425
Orlofsky, Peter, 131, 132, 133, 134, 144
Orlofsky, Julius, 131, 132, 133, 134
O'Rourke, P. J., 242
Osberg, Susan, 188
Oswald, John, 209
Other Cinema, 507
Otterman, Tom, 127
Otterness, Tom, 124, 180, 398
Out For A Kill (Oblowitz), 177
Owens, Craig, 306, 308
Owens, Craig, 308

P

P.S. 1, 529
Pacino, Al, 527, 567
Paddles, 375
Paik, Nam June, 86, 95, 132, 185, 186, 218, 440
Pain Proof Rubber Girls, 456
Paine, Roz, 556
Painful But Fabulous, The Lives & Art Of Genesis P-Orridge, 459
Painleve, Jean, 506
Palazzolo, Francis, 381–386, *383*
Palladin, Patty, 241
Palladium, 365
Panic Theater, 241
Paper Tiger Television (PTTV), 399
Paper, Walter, 371
Papp, Joseph, 86, 543, 559
Paradise, Sal, 303
Paris, Mathew, 145
Park Row (Fuller), 109
Parker, Aloysious, 224
Parker, Charlie, 216, 226, 227, 498
Parker, Chris, 177
Parker, Robert, 249, 346, 350
Parnes, Uzi, 374
Parting Glances (Sherwood), 392, 498
Party, Arden, 540
Pasadena Film Forum, 376
Pasolini, Pier Paolo, 231
The Passion of Joan of Arc (Dreyer), 85
Patterson, Clayton, xv, 59–70, 128, 149–168, 193–206, 213, 220, 241–248, 265, 268, 319–342, 350, 362, 401,

431–458, 440, 443, 452 (card), *453,*
455, 462, 464, 482, 459–460 (court
briefs), *462–466,* 473, 474, 476, 477,
479–480, 483, 484, 489, *531–532,* 543
Patti Smith Group, 173
Patton, Will, 177
Payne, Alexandre, 547
Payne, Roz, 553, 554, 555
Peace Eye Bookstore, 113
Pearl Theater Company, 234
Pedro Paramo (Rulfo), 305
Peggy And Fred In Hell (Thornton), 375
Peirce, C. S., 217
The Pelican (Strindberg), 543
Penley, John, 455
Pennebaker, D. A., 361
Pennebaker, D. B., 189
People's Video Theater, 217
People's War (Newsreel), 554
Perez, Armando, 550
Performance On One Leg (POOL), 313
Perlman, Cara, 399
Permanent Vacation (Jarmusch), 177, 224,
225, 226, 229
Perron, Wendy, 199
Personal Cinema Program, 101
Peter Missing, 253
Petersen, Sidney, 279
Peterson, Vicki, 105
Pfahler, Kembra, 265, 272, 300, 306,
3313, 314, 455
Phace, Hapi, 317
Philisima *see also* Philly, 322
Phillips, Anya, 174, 175, 398
Phillips, Lynn, 555
Philly, 313, 317, 319–342, *320, 321, 323,*
325, 327, 328, 330, 333, 334, 337,
339, 369, 371
Piano Store, 540, 543
Picard, Lill, 145, 147
Picasso, Marina, 473
Picasso, Pablo, 473
Pickford, Mary, 110
Pierce, Greg, 505
Piersol, Virginia, 426
Piersol, Virge, 398
Piezo Electric, 400
Pilarski, Jason, 140
Pinchevsky, Leonid, 457
Piñero (Ichaso), 384
Piñero, Miguel, 299, 305, 306, 307, 349,
401
Pinion, Charles, 271
Pink Flamingoes (Waters), 170, 385
Pink Pony Theater, 340, 375, 508, 540,
542, 565
Pioneer Theater, 234, 237, 240
Pitore, Carlo, 209
Pizzorno, Luca, 220
Place, Pat, 175, 176
Plan 9 From Outer Space (Wood), 540
Plates (Goldberg), 359, 542
Plunkett, E. M., 144
Podak, Commie, 442

Poe, Amos, 104, 122, 126, 169–172, *170,*
171, 173, 174, 177, 178, 224, 240,
288, 303, 390, 398
Poetical Meditation, 145
Poetry Project, 144, 145, 349
Poetry Thin Air (Corber), 425
Poets & Artists Surreal Society, 144
Poets Society, 145
Point Break (Bigelow), 177
Point of Order (de Antonio), 119
Poison (Vachon), 498
Police State (Zedd), 182, 268, 273, 535,
536
Pollock, Jackson, 158
Poltergash, 264
Pop, Iggy, 232, 326
Popular, 235
P-Orridge, Genesis, 447
Porta, Richard, 129, 130
Portman, John, 521
Porton, Richard, 459
The Portrait Show, 314
Postcards From America (Palazzolo), 381,
382
Potato Lake, 209
Potatoland, 543
Powell, William, 111
Power, Jim, 487–490, *488*
Poynton, Jerome, 25–28
Prabhubada Sankirtan Society, 355–356,
451
Prabhubada, A. C. Bhaktivedanta Swami,
355, 356, 451, 452
Pratt Institute, 160
Pravda, 457
Presley, Elvis, 193
Price, Jeff, 237
Price, Zan, 333
Prichard, Robert, 491, 492, 493
The Prince Of Tides (Streisand), 175
Prince, 175
Princes Pang (band), 448
Private Property (Singer), 542
Prol, Rick, 220, 301, 306
Prong (band), 448
Prosthesis, 143
Pryamid, 472
Pryor, Eric *see also* Strange, Rik, 266,
270–271
PS 1, 522
PS 122, 263, 388, 467, 498
Psycho-Flesh (Henke and Palazzolo), *383,*
385
Public Nuisanced, 209
Public Theater, 559
El Pueblo Se Levanta (Newsreel), 556
Pulaski, Stephanie, 558
Pull My Daisy (Frank and Leslie), 7–10,
86, 114, 119, 131, 310
Punking Out, 173
Pure, Joe, 415–420
"The Pure Pop Festival's Natural Born Pop:
The Complete Works Of Ed Wood," 540
Purple, Adam, 249, 350

Putney Swope (Downey Sr.), 116, 234
Pyramid Club, 145, 256, 270, 289, 306,
313, 319, 320, 322, 323, 329, 331,
335, 336, 370, 371, 388, 400, 430,
447, 448, 491, 545

Q

The Quad, 497
Quadrophenia (Roddam), 529
The Quality Of Life In Loisaida (magazine),
550
Queen Of Sex (Kern), 271
The Queen of Sheba Meets the Atom Man
(Mead, Rice), 116
Quinones, Lee, 176

R

Ra, Sun, 98
Rabinowitz, Cantor, 107
Raddant, Megan, 543
Raden, Bill, 309–312
Radical Software, 217, 218
Radio City Music Hall, 511
Radio Free Dada, 144
Radio Thin Air, 349
Rafelson, Bob, 395, 547
Rafic *see* Rafik
Rafik, 121–130, *125, 126, 129,* 172, 183,
204, 369, 494, 497
Raft, George, 109
Raindance, 217, 218
Rainer, Yvonne, 87, 104, 423
Raising Victor Vargas (Sollett), 548
Rakowitz Case, 459
Rakowitz, Daniel, 220, 433–434, 463
Ralston Farina Memorial Show, 398
Ramen, Sukanya, 201
Rammellzee, 227, 228
Ramone, Dee Dee, 294
The Ramones (band), 170, 173, 305, 392
Ramos, Paul, 549
RAPP Art Center, 373–376
Rasin, James, 141
The Rat (paper), 456
Rat Trap (Turner), 266
Ratat Rat R, 306
Ratcliff, Mary Curtis, 217
Rather, Dan, 450
Raul, Baba, 476
Rauschenberg, Robert, 113
Ravel, Maurice, 518
Raw Comics, 540
"Raw-Edged Women" (Greenfield), 538
Ray Report, 367
Ray, Cathode, 212
Ray, Gary, 349, 390
Ray, Man, 143
Ray, Nicholas, 178, 310
Ray, Nick, 547
Raziel, Angel, 451
"Razor In The Eye (Homage To Buñuel)"
(Orensanz), 520, 521

Reagan Youth (band), 448
Reagan, Ronald, 473
Real Estate Show, 313
Reardon, Lisa, 164
Rebel Without A Cause (Ray), 178
Reble, Jurgen, 504
Recent Readings, 145
"Reciting Poetry Under the Influence Of
 Onions" (Corber), 424
Recycle A Bicycle, 551
Red Dragon, 178
Red Italy, 174, 177
Red Milk, 206
Red Spot, 306
Red, Ed, 251, 331
Red, Ed, 331
Redford, Robert, 111
Redglare, Roberts see also Rockets Redg-
 lare, 228, 255, 255–262, 261 (filmog-
 raphy), 263, 268, 294, 346, 349,
 370, 371, 388, 390, 391, 395, 400,
 401, 461 (funeral), 466, 536, 543, 551
Redman, Dennis, 551
Redrum, 266
Redtape Magazine, 299, 300
Reed, Ishmael, 119
Reed, Lou, 138, 350, 468, 522
Reeves, Jennifer, 379
Regelson, Ester, 346
Reggae Cowboy (Kelly), 350
Reilly, Maggie, 207
Reilly, Mike, 301, 302
Renaldo and Clara, 132
Ren-Lay, Judith, 389
Rensaa, Elsa, 431–434, 444 (card),
 447–460, 465, 473–478, 475, 479,
 532
Reserection (Morrison), 495
Reservoir Dogs (Tarantino), 394
Resnais, Alain, 303
Resnikov, Hanon, 307
Rest In Pieces (band), 448
Revolt, 346
Rhapsody in Blue, 108
Rhoda In Potatoland (Foreman), 542
Rhythm Club, 145
Rhythm Thief (Harrison), 235
Rhythms And Rituals In Bali (Oisteanu),
 145
Ribot, Marc, 295
Ricard, Rene, 174, 183, 349
Rice, Bill, 59–70, 130 175, 176, 177, 181,
 183, 232, 359, 542
Rice, Ron, 98, 114, 116, 118, 566
Richard Foreman Festival, 543
Richards, Betty, 216
Richards, Dick, 335, 336
Richards, Roger, 350
Richardson, Oliver, 551
Richman, Milt, 214
Richter, Hans, 114, 303
Ricotta, La, 231–232
Ridge Theater, 496, 498
Rifkin, Ron, 527

Rigby, Amy, 344
The Right Side Of My Brain, (Kern), 266
Rimanelli, Dave, 306
The Ring Our Way (Waters and Cramer),
 317
Rios, Linda, 551
Ristic, Liubisha, 144
Ritter, Bruce, 331
Rivas, Bimbo, 238
Rivas, Bittman, 550
Rivers, Larry, 131, 144, 147, 189, 190
Rivington Guitars, 530
Rivington Sculpture Garden, 210
Robbe-Grillet, Alain, 87
Robbins, Al, 186, 467
Robbins, Jake, 107
Robbins, Lane, 473–478, 487–490
Robert Beck Memorial Cinema (RBMC),
 289, 405, 417, 418, 499–500, 503,
 505, 507, 509, 513 (invite)
Robert Freidus Gallery, 194
Robert Gets His Nipple Pierced (Daly), 353
Roberti, Fabio, 264
Robeson, Paul, 557
Robeson, Sue, 557, 558
Robinson, Walter, 303
The Rock, 350
Rock Steady Crew (McLaren), 305
Rockets Redglare And The Bombs, 257
Rockets Redglare In Love, Morphine, And
 Memory (Gregorits), 262
"Rockets Redglare's Taxi Cabaret" 388
Rockwell, Alex, 548
Rockwell, Alexandre, 393, 396
Rodney-Sur, Sur, 145
Rodriguez, Joanna, 556
Rogosin, Lionel, 86, 110, 234
Rollins, Henry, 261
Romberger, James, 299, 305, 346, 400
Rome '78 (Nares), 175, 353
Romero, George, 543
Rooftop Films, 508
The Room (Goldberg), 122, 359
"Roommate Search" (Corber), 424
Roosevelt, Sara, 186
Rose, Audrey, 266
Rosen, Judy, 346
Rosenthal, Bob, 131–134, 133, 349
Rosselinni, Roberto, 547
Rossi, Jerei Cain, 265, 272
Roth, Big Daddy, 157, 162
Roth, Tim, 350
Rothenberger, Joshua, 221–232, 387–396
Rousimoff, Ari, 455
Rubin, Barbara, 120, 377
Rubnitz, Tom, 181, 429
Ruggins, Otto Von, 144
Rule Of 3 (Wilson), 391
Rules of the Game (Renoir), 85
Rulfo, Juan, 305
RUN-DMC, 495
RuPaul, 336
Rush to Judgment (Lane), 119
Ruskin, Mikey, 185

Russell, Allan, 557
Russell, Ernie, 557
Russell, Lillian, 109
Russo, James, 176
Rutt, Steve, 186
Ryan, Paul, 217, 218
RYO, 400
RZA, 232
Rzetelny, Bernie, 214

S

Saiki, Arnie, 543
Sakaki, Nanao, 428
Salt Of The Earth (Biberman), 556
Salvation (B), 176
Samoa, 313, 319, 321, 322, 323, 343
Samoa, 343
Sanborn, Keith, 374, 504
Sanders, 131, 144, 234, 400, 421, 432
Sanderson, Alister, 105
Sanford, David, 404
Sangster, Hugh, 186
Santaria, 449
Sante, Luc, 125, 175, 177
Sargeant, Jack, 183, 272, 402
Sargis, Joe, 214
Sarris, Andrew, 85
Sasaki, Tomiyo, 185, 201, 204
The Satan Sinner Nomads (gang), 453, 478
Saunders, Ed, 98
Saunders, Scott, 498
Savini, Federico, 350
Sawyer, Tom, 450
Sayles, John, 238, 547
Scab (band), 448
Scenes from 33 Garden Procession (Ois-
 teanu), 147
Scenes From Under Childhood (Brakhage),
 563
Schaffer, Pierre, 209
Scharf, Kenny, 182, 242, 245, 343, 429,
 468
Schiff, Harris, 132
Schifreen, Frank, 207
Schinkel, Karl Friedrich, 522
Schlemmowitz, Joel, 237, 377, 499
Schlesinger, Richard, 467
Schloss, Arleen, 186, 193–206, 198, 251,
 253, 323, 401
Schmidlapp, David, 288
Schmidt, Bruno, 429
Schmoozer's Lounge, 234
Schnabel, Julian, 206, 261, 371, 384, 389
Schneeman, George, 295
Schneemann, Carolee, 104
Schneider, Ira, 217, 218
Schnitzler, Conrad, 209
Scholz, Jonas, 89
Schoolman, Carlotta, 186
Schweitzer, Albert, 453
Scobie, Ilka, 350
Scorpio Rising (Anger), 353
Scorpio Rising (B), 247

Scorsese, Martin, 111, 235, 547
Scot-Free, 535–536, *536*
A Scotland Yard Murder Mystery (Ziprin),
 451
Scott Pfaffman Gallery, 400
Scraps (Klein), 287
Screen Test (Warhol), 120
Screw, 242, 243
Scully, Tom, 429
Seagal, Steven, 177
The Seagull (Chekhov), 540
Secret of Rented Island, 122
Segal, George, 188
Seidelman, Susan, 104, 369
Seig, Matt, 234
Seltman, R. L., 197
Sembene, Ousmane, 534
Sempel, Peter, 89–96
Sensory Evolution Gallery, 299, 305
"September On Jessore Road" (Ginsberg),
 89
Sequentia, 522
Serenity (Markopoulos), 98
Serious Fun! Festival, 495
Serra, M. M., 130, 238, *368*, 373–380,
 378, 498
Seven Days Of Creation (Philly), 313, 319
Seven Years In Tibet (Johnston), 175
Seven, Larry, 346
Sevigny, Chloe, 231
Sewage (band), 448
Sex And The City, 235
Sex In The Nineties, 147
Sex Pistols (band), 256, 305
Sex, John, 245, 343, 429, 472
Sex, Lies And Videotape (Soderbergh), 178
Sexton, Brendan, 350
Sexton, Lucy, 388
Shadows In The City (Rousimoff), 271,
 273, 455
Shadows (Cassavettes), 86, 114
Shaffer, Deborah, 555, 558
Shaiman, Marc, 430
Shaka, Nina, 129
Shambereg, Michael, 217, 218
Shannon & Weaver, 217
Shapiro, David, 105
Sharits, Paul, 104, 188
Sharka, 456
Sharp, Elliot, 392
Sharp, Willoughby, 426
Sharpton, Al, 438
The Shattered Tent (Orensanz), 521, 524
Shay, Kathy, 442
Shay, Paul, 442
She Had Her Gun All Ready (Dick), 175, 180
Sheer Terror (band), 448
Shell Shock Rock, 206
Sherman, Cindy, 189, 192
Sherman, David, 418
Sherman, Stuart, 104
Sherry, Reina Jane, 313
Sherwood, Bill, 391–392
She's Gotta Have It (Lee), 178, 497

Shhh, They're Getting Closer (Philly), 327
Shimada, Taketo, 140
Shine (Goldberg), 359
Shirley, Raphael, 543
Shirts (band), 173
"Shit Show," 456
"Shooting Gallery" (Patterson), 482
Shore, Pauly, 350
Short Memory /No History (Cramer and
 Waters), 317
A Shot Chance, 195, 199, 200
Shuttle Club, 145
The Shuttle Theater, 300, 306
Side by Side (band), 448
Sidney, George, 108, 111
Sieg, Matthew, 237
Siegel, Allan, 555, 557, 558
Siegel, Jeanne, 304, 308
Siegel-This, Rick, 145
Sifton, Sam, 337
Sikorski, Tomasz, 263
Sikoryak, Bob, 540, 541
Silence Of The Lambs (Demme), 178
Silver, Sheldon, 457
Silverman, Fred, 217
Simon, Ken, 144
Simonland (Turner), 265, 266
Singer, Elyse, 542
"Singing Al Jolson In Blackface" (Corber),
 425
The Sinking of the Lusitania (McKay), 122
Sirk, Douglas, 98
Sirowitz, Hal, 209
Sitney, Adams, 105
Sitney, Julie, 559–560
Sitney, P. Adams, 85, 186, 559–564
Sitney, Sky, 559–564
six non lectures (cummings), 468
Sixteen Candles (Hughes), 177
Ski-A-Delics, 208
Skidmore, Richard, 206
Skin Slappers, 208
Sleaze, Billy, 220
*Sleazoid Express, A Mind Twisting Tour
 Through The Grindhouses of Times
 Square*, 241–48, 343
Sleazy Rider (Moritsugu), 269
Sleepless Nights (Johnston), 175
Sleepwalk (Driver), 177
Slugs, 113, 213, 216
Slump, Beirut, 180
Small Time Crooks (Allen), 108
Smart, Victoria, 132
Smead, Jack, 194
Smead, John, 197
Smersh, 209
Smith, Duncan, 174
Smith, Evelyn, 177
Smith, Gary, 103
Smith, Harris, 173–178
Smith, Harry, 11–14, 85, 88, 89,132, 134,
 156, 245, 343, 344, 346, 347, 466,
 468, 563
Smith, Jack, 15–30, 87, 95, 98, 100,104,

 114, 117–120, 122, 146, 169, 174, 176,
 181, 247, 293, 298, 322, 350, 353,
 377, 400, 455, 498, 543
Smith, Kiki, 374, 399, 426
Smith, Louise, 183
Smith, Martin, 556, 558
Smith, Nico, *219*, 219–220
Smith, Patti, 170, 173, 240, 353, 545
Smith, Peyton, 391
Smith, Stephan, 350
SNAFU, 206
Snake Money Studio, 343–348
Snatch, 241
Snow, Michael, 85, 87
Snyder, Don, 120, 122, 129
So Coming To Power (Serra), 379
Sobchack, Vivian, 106
Soderberg, Stephen, 177, 178, 526
*Soho The Rise And Fall Of An Artist's
 Colony* (Kostelanetz), 459
Soi Meme (Serra), 379
Sokalmer, Arthur, 206
Solar Energy Building, 550
Solomon, Carl, 134
Solomon, Deborah, 304, 308
El Sol, Tu Corazon Y El Neosimo, 208
Soma, Andy, 353
Somoa, 335
Son Of Andy Warhol (Mead), 567
Sonbert, Warren, 87
The Songlines (Chatwin), 188
Songs For A Schizoid Sibling (Ziprin), 451
Sonic Youth (band), 178, 206
Sonnebend Gallery, 201
The Sopranos, 396
Soros, George, 188
Sort Of (Warhol), 566
Sosinski, Ronald, 305
Soul City (Jones), 343
Sound of Pig Music, 209
Southern, Nile, 124–125
The Space, 527
Space Avengers, 491
The Space Monkeys, 209
"Spain" (Corea), 305
Spare Me (Harrison), 235
Sparks, 455
The Specialist, (B) 176
Spectacolo Provolone (Cramer and
 Waters), 317
Spencer, John, 265
Spheroid Memories (Orensanz), 519, 520
Spider Webb (band), 448
Spielberg, Steven, 297
Spoerri, Daniel, 145, 147
Spooky, DJ, 347
Spotted Eagle, Chris, 556
Sprinkle, Annie, 189, 220, 272, 275, 276,
 379
Spungeon, Nancy, 429
Squat Theatre, 389
St. John The Divine, 449
St. Marks Church, 100, 102, 113, 118, 144,
 145, 190, 359, 449

St. Mark's Cinema, 497
St. Mark's Place, 226, 241, 343 398, 468, 545
St. Mark's Poetry Project, 210, 349, 421
Stanbury, Vicki, 132
Stanton, Frank, 217
Star Spangled to Death (Jacobs), 117
Stark, Casandra, *see* Mele, Casandra Stark
Starr, Kenneth, 167
Starr, Rachelle, 359
The State Of Things, (Wenders), 178
Statland, Howie, 527–530, *528*
Stearns, Bob, 186
Stedding, Walter, 289, 399
Steel And Cherry Trees (Orensanz), 519, 520
Stein, Chris, 176, 399
Stein, Gertrude, 143
Steinfeld, Alan, *135*, 135–136, 467–470, *469*
"Steppes Of Mars" (Orensanz), 521
Stevenson, Gordon, 180
Stewart, Lynn, 438
Stewart, Michael, 361, 401
Stewart, Michael, 435
Still (Gehr), 564
Still, Collin, 134
Stiller, Ben, 382
Sto, 367
Stockhausen, 209
Stockwell Gallery, 210
Stockwell, Pamela, 220
Stoller, Robert, 379
Stomp (Tusk), 498
Stone Age Lament (Zedd), 273
Stone, Barbara, 304, 308
Stone, Oliver, 104
Stonewall (Bar), 138
Storms, Dominique, *383*
Stotski, Loren, 346
Straayere, Chris, 376
Stracke, Aalbert, 521–524
Strand Bookstore, 497
Strand, Susan, 305
Strange, Rick, 265, 266
Strange, Rik, 270
Stranger Than Paradise (Jarmusch), 178, 221, 225, 226, 227, 232, 233, 261, 303, 309, 310, 311, 497, 547
Stranger To The System, Life Portraits Of A New York City Homeless Community (Flynn), 459
The Stranger, (Camus), 303
Strassberg, John, 393
Strausbaugh, John, 337, 451
Stray Dogs (Wojnarowicz), 386
Strindberg, August, 543
Strummer, Joe, 177, 392
Students For A Democratic Society (SDS), 555
Students of Ginsberg, 210
Studer, David, 405
Style Wars (Silver), 536
Style, Steven, 305
Subject To Change (West), 217

Submit To Me Now (Kern), 266, 275
The Substance of Fire (Sullivan), 529
Subterranean Homesick Blues (Pennebaker), 361
"Subterranean Science" (Eros, Frye), 502
Subway Riders (Poe), 173
Sui, Anna, 176
Sullivan, Nelson, 335, 336, 447, 471–472, *471, 472*
Summer of '68 (Newsreel), 554
Summergrad, Florence, 558
Sun Ra, 213
Sundance, 498
Sundaze Away (Schloss), 202
Sunset Boulevard, 174, 182
The Sunshine Theater, 384
Suparak, Astria, 507
Superstar: The Karen Carpenter Story (Haynes), 354
Surf Rality LTD, 492
Sussler, Betsey, 183, 398
Sutcliffe, Jim, 426
Swami, Kapindra, *355*, 355–356, 451
Sweeney, Skip, 186
Sweet Tooth, 246
Sweet, Tim, 405, 406
Symphony of Six Million (La Cava), 107

T

Taboo, 313
Tajima, Renee, 557
Takagi, J.T., 557
"Take A Walk On The Wild Side" (Reed), 138
Take Away (Verou), 341
Tales Of Beatnik Glory (Sanders), 432
Talk Radio (Stone), 261
Talking Heads, 170, 173
Tambellini, Aldo, 41–56, 119, 186, 456
Tamerlis, Zoe, 370
The Tape Beatles, 209
Tarbox, Connie, 542
Tartaglia, Jerry, 122, 130
Tarzan And Jane Regained (Warhol), 566
Tattooing New York City: Style And Continuity In A Changing Art Form (McCabe), 459
Taubin, Amy, 106, 265
Taxi Driver, 244, 515
Taylor Mead Across On Amphetamines In Europe (Mead), 567
Taylor Meade's Ass, 116
Taylor, Brad, 313
Taylor, Cecil, 226
Taylor, Dayton, 543
Taylor, Paul, 305, 308
Taylor, Steven, 132, 133
Teach Our Children (Choy, Robeson), 557
Teasdale, Parry, 217
El Teatro Ambulante, 550
Technoromantic, 413, 414
Teenage Jesus and the Jerks (band), 175, 182

Teitelbaum, Carl, 298
Templeton, Fiona, 389
Ten Minutes Older Project, 231, 232
Ten Nights In A Ballroom (Arthur), 542–543
Tenement Theater, 540
Tennille, George, 103
"Tent City," 441
Tentatively A Convenienced, 210
Tenth Street Coffeehouse, 113
Tepplezsky, Lee, 552
The Texas Chainsaw Massacre, 497
Thanatopsis (B), 176
Theater 80, 234, 497
Theater For The New City, 80, 317, 497
Theatre Club Funambules *see also* Todo Con Nada, 539
Theatre of the Ridiculous, 113, 119
Thelonius Monk, 113
Then The Fireworks (Oblowitz), 177
There's A Man In Your Room (Vachon), 374
Theresa, Mother, 481
They Eat Scum (Zedd), 265, 273, 385
They Live By Night (Ray), 547
They Might Be Giants, 264
Thiessen, Bennet, 492
Thigpen, Dorothy, 558
Thin Air Poetry Video Archives, 145, 423, 427, 428
Thin Lizard Dawn (band), 529
Third World Newsreel, 554, 556, 557
30 Seconds Of Less, 206
33 First Avenue, 146
This World (Oblowitz), 177
Thomas, Danny, 107
Thomas, Sam, 432
Thomasius, Jorg, 209
Thompson, Jim, 177
Thomsen, Ozzie, 552
Thornton, Leslie, 374, 375
A Thousand Tiny Fingers (band), 492
Thrill Kill Video Club (Prichard), 492
Through The Olive Trees (Kiarostami), 220
Thrust In Me (Kern, Zedd), 276, 386
Thunders, Johnny, 241, 272, 294
Tier Three, 224
Tietchens, Asmus, 209
Times Square Show, 176
The Tin Woodsman Dream (Smith), 343
TNC, 145
Tobocman, Seth, 441, 456, 459
Toche, John, 456
Todd, Tony, 177
Todo Con Nada, 45, 299–302, 351, 401, 539–544
Token Entry (band), 448
Tomel, Marisa, 527
Tommy (Russell), 529
Tompkins Square Park Police Riot, 435–446
Tompkins Square Park, 220, 355–356, 361, 362, 364, 366, 401, 432, 451, 454, 467, 474, 516, 532
Tony Pastor's saloon, 109

Torak, Jim, 541
Torres, Edwin, 543
Total Mobile Home Cinema, 418 507
Totem Of The Depraved (Zedd), 266, 273, 400, 459
Touch Of Evil (Welles), 497
"Toward A Methodology Of The Work Of Angel Orensanz" (McCormick), 524
Toxic Avenger (Herz, Kaufman), 491
Toy, Camden, 543
Tradewell, Heidi, 543
Tradway, Toni, 183
Traffic (Soderbergh), 525
Tramps, 529
The Trap Door, (B) 176
Trash (Warhol), 120
The Trees, 317
Trees Lounge (Buscemi), 395
Tremblay, Susan, 344
A Trip To Chinatown, 109, 110, 111
Trip To The Moon (Melies), 85
Trivers, James "Tripp," 263
Trocchi, Alexander, 139
Tropicana, Carmelita, 354
Tropicana, Elliana, 291
Trostsky, Leon, 134
Troyano, Ela, 122, 264, 265, 266, 269, 277, 315, 353, 354, 354, 508
Tschinkel, Paul, 143, 177, 181, 185
Tsukerman, Slava, 303
Tubby Boots (Zimbalist), 263
Tuff Darts, 173
Tull, Jennifer, 346
Tully, James, *352*, *515*, 515–516
Turf Of Savage Homicides (Alcott), 492
Turner, Amy, 265
Turner, Don, 549
Turner, Tommy, 264, 265, 266, 269, 272, 288, 346, 354, 400, 535
Tusk, Mark, 498
TV Party, 174
Twigg, Linda, 140, 479, 481
Twins (Ahearn), 175
2B Gas Staion, 400, 448
Two Boots, 233, 239, 340, 423, 498, 525, 535, 536
Two Small Bodies (B), 176
Tyng, Ann, 218

U

Ula, 456
Ulbricht, Walter, 209
Uli, 373, 543
Ulmer, Edgar, 98
The Unbearable Beatnicks Of Life, 210
Unbearables, 209, 421–422
Under ACME, 529
Under The Cherry Moon (Johnston), 175
Underground (Antonio), 417, 501
Underground Film Bulletin, 265, 273
Underground Film Festival, 375
"Underground Film Journal," 400
Underground USA (Mitchell), 174, 182, 349

Underground (club), 302
Undoshine, 291
Unimax Tattoo Supplies, 456
"Unity Gain," 543
University Settlement, 551
Unmade Beds (Amos), 171, 172, 173, 178
Unmuzzled Ox, 144
U-P Film Group, 122
Urbaniak, James, 540
Users' Manual (Rockets Redglare), 261
Usher (Goldberg), 359, 542

V

Vachon, Christine, 314, 374, 498
The Vacuum Bag (band), 287, 288, 306
Vadehra, David, 122
Vagabond Theatre, 89
Valk, Kate, 391
Vallery Gallery, 147
Vanderbeek, Stan, 98, *116*
Vanuatu Chronicles, 192
Variety, 177
Vasquez, Sean, 456
Vasulka, Steina, 185, 186
Vasulka, Woody, 185
Vaughn, Robert, 366
The Vault, 375
Vawte, Ron, 177, 181, 182, 391
Vazakas, Laki, 139–142
Vega, Jeanine Pomy, 144, 147
Vengrow, Jack, 400
Vera, Veronica, 379
Verbal Abuse (band), 448
Verou, Todd, 314, 325, 328, 334, 335, 341, 369
Vertov, Dziga, 301
Vesecky, Rich, 262
Vicious, Sid, 256
"Video Aktivist $29.95," 398
Video Art: An Anthology, 218
Videofreex: America's First Pirate TV Station & The Catskills Collective That Turned It On, 217, 218
VideoTeatro da Camera, 145
Village East, 497
Village Voice, 458
Vincent, Gene, 174
Vinyl (Warhol), 174
Violet, Ultra, 219
Viscous, Sid, 429
Visionary Film: the American Avant-Garde, 1943–2000 (Sitney), 568
Visiting Desire, 176
Viva Superstar, 190
Viva, 189, 190
Vlasta, 253
Vogel, Amos, 88, 245, 419
Voice Of Oz, 354
Voidoids, 176
Vontobel, Carol, 217
Vortex (B), 176, 247
Vostell, Wolf, 433, 456
Vox Poplin, 209

W

Wagner, Sokhi, 264
Wah Wah Hut, 388
Waiting For The Wind (Mitchell), 175
Waits, Tom, 232
Wajnarowicz, David, 381, 382
Waldemar, Eric, 501
Walden (Mekas), 118
Waldman, Anne, 144, 349
Waldorf, Carmen, 404, 405
Walken, Georgianne, 396
A Walking Tour Of The East Village (Steinfeld), 467
Walking With The Night, The Afro-Cuban world Of Santeria (Canizares), 450, 459
The Wall (Parker), 529
Wallace, Art, 543
Wallace, David, 556, 558
Waller, Fats, 491
Wallis, Lurleen, 472
Wang, Wayne, 547
War In The Neighborhood (Tobocman), 441–442, 459
War Is Menstrual Envy, Part 1 (Zedd), 220, 272, 273
War Zone (band), 448
Ward, Ben, 435
Warhol, Andy, 87, 90, 95, 100, 104, 116, 118, 119, 120, 137, 138, 169, 174, 182, 189, 190, 206, 219, 231, 242, 289, 322, 351, 377, 468, 472, 497, 515, 566–567
Warhol's Factory, 377
Washington Square Methodist Church, 103
Watanabe, Gedde, 177
Waters, Jack, 183, 275, 313, 314, 316, 317, 320, 321, 322, 338, 349, 384, 385, 400, 535
Watson, Carl, 313–318
The Way It Is (Mitchell), 174, 389
The Way It Was (Mitchell), 392
We Are Not To Blame (Stark), 268, 271, 273
We Die, You Die (Freer, Goodson), 540
"We Don't Want Cheese, We Want Apartments, Please," 526
Weather Underground, 417, 555
Webb, Spider, 447, 456
Webbittown, 368
Webo, 269, 375, 376
Webster, Sally, 402
Wegman, William, 423
Wehrli, Penelope, 314
Weidman, Jerome, 108
Weigand, Ingrid, 186
Weinbren, Grahame, 105–106
Weinstein, Arthur, 371
Weiss, Avie *see also* Glass, Mark, 452
Weiss, Ted, 399
Welles, Orson, 95
Wellman, Mac, 543

Wenders, Wim, 178, 303
Wendigo (Fessenden), *497*, 498
West, Don, 217
West, Mae, 109
Whale, James, 543
What About Me, 271–272, *292*
What About Me? (Amodeo), 288
"What About Me" (Ramone), 294
What Is It, Zach? (Burns, Gordon), 177
"What one can do. Angel Orensanz's Solitary Activism and Object Event" (Forgacs), 524
Whelan, Tom, 395
When Pigs Fly (Driver), 177
Where Evil Dwells (Turner , Wojnarowicz), 266, 269, 288, 354, 400
White Rabbit (Soma), 353
White, E. B., 515
White, Jack, 232
White, Meg, 232
Whitman, Scott, 430
Whitney Museum, 104, 510, 522
Whizzo, Captain, 354
Who Killed Vincent Chin? (Third World Newsreel), 557
Whoregasm (Zedd), 268, 379
Why Hitler (Klein), 287
Wicked, David, 268
Wiener, Lawrence, 423
Wiener, Norbert, 217
Wiesel, Elie, 522
Wigstock In Tompkins Square Park, (Vazakas), 147
Wilcock, John, 143
Wild Style (Ahearn), 176, 398
Wild World Of Lydia Lunch (Zedd), 400
Wild, Wendy, 343, 429
Wilder, Bill, 110, 182
Wilder, Matt, 542
Wildfire (Greenfield), 537, 538
Wildstyle: The History Of A New Idea (Auer, Patterson), 259, 459
Wildstyle (tour), 341, 432, 435, 456
Wilems, Mo, 542
Wiley, Major, 216
Wilkinson, Aquila, 551
Williams, Gigi, 297
Williams, Hank, 210
Williams, Lavinia, 250
Williams, Lee, 257–262
Williams, Lloyd, *117*
Williams, Megan, 217
Williams, Nik, 197
Williams, Saul, 174
Willis, Bruce, 366
The Willoughby Sharp Show, 399
Wilson, Michael, 455
Wilson, Robert, 391
Windows Of Chance/Change (Schloss), 201–202
The Windsor, 117
Witty, Richard, 356
Wojnaroiwcz, David, 220, 265, 266, 276, 299, 301, 305, 306, 350, 354, 386, 400

Wolf, Michael, 264, 269
Wolf, Mike, 346
Wolf, Potato, 399
Wolfe, Julia, 496
Wong, Martin, 397
Wood, Ed, 540
Wood, Wes, 432, 455
Woodberry, Billy, 556
Woodbury, Heather, 498, 543
Woodlawn, Holly, 120, 138
Woodstock Festival, 487
Woodward, Ann, 217
Wool, Christopher, 183
Wooster Group, 182, 388, 391
The Wooster Group 182
Words And Music (Schloss), 197
Working Girls (Borden), 177, 182, 497
The World Shadow (Brakhage), 563
World War 3 (magazine), 456
World War 3 (Tobocman), 442
Wow And Flutter (Taylor), 543
Wozinski, Ray, 349
Wrecked On Cannibal Island (Stark), 268
Wright, Jane, 186
Wright, Jeff, 145
Wright, Jeffrey Cyphers, 349–350, 384
Wright, Rae C., 543
Wright, Steven, 232
Wright, Tom, 389, 391, 394
Wright, Walter, 186, 401
Wyatt, Mindy, 125–126

X

X IS Y (Kern), 271
X-Men (Singer), 335
X-Movers (Fassenden), 498
XOXO, 287, 288, 289, *290*
Xtreme Erotic Poetry, 145

Y

Yalkut, Jud, 31–34
Yau, John, 349
YDL (band), 448
A Year From Monday (Cage), 196
Yelena, 192
Yeltsin, Boris, 522
Yes No Script (Goldberg), 357–358
Yeshiva Mesiftah Tiffereth Jerusalem, 457
Yiddish Theater, 349, 497
The Yin-Yang Gang, 145
Yokosbosky, Matthew, 179–184
You Are Not I (Driver), 177
You Killed Me First (Kern, Wojnarowicz), 268, 400
Young Filmmakers, 186, 205, 287, 399
Young Lords, 555, 556
Young, Felicia, 350
Young, Neil, 227, 230
Youngblood, Gene, 185, 218
Youth Gone Mad, 367
Youth Of Today (band), 448
Yuri Kapralov 5th Sense Gallery, 455

Z

Zack, David, 210
Zaffien, Tom, 543
Zaharia, Dorin Liviu, 143
Zambrano, Laura, 539–544
Zandt, Lahorna Van, 472
Zanuck, Darryl, 108
Zedd, Nick, 29–30, 122, 127, 173, 182, 206, 220, 264–274, *267*, 273, 274, 293, 303, 314–316, 334, 354, 371, 379, 380, 385, 386, 389, 390, 400, 402, 455, 459, 505, 535, 536, 548
Zellner, Robert, 556, 558
Zendada-Videos, 145
Zero, Mark *see also* Friedlander, Marc, 461, *461*, 463, 465, 466
Zeroboy, 405
Zimbalist, Michael, A., 263
Ziprin, Lionel, 451, 466
Zombie Hunger, 266
Zoviet France, 209
Zuckor, Adolf, 110